BRANCUSI

BRANCUSI

**PONTUS HULTEN
NATALIA DUMITRESCO
ALEXANDRE ISTRATI**

faber and faber
LONDON · BOSTON

Editor, English-language edition: Patricia Egan

All photographs taken by Brancusi and reproduced in this
book are, unless indicated otherwise, preserved in the Musée
National d'Art Moderne, Centre Georges Pompidou, Paris

Captions include: title, date, medium, present location
(if known), photographic credit, and catalogue number.
Works appearing in photographs of Brancusi's studio
are given catalogue numbers only where positive
identifications have been made

British Library Cataloguing in Publication Data

Hulten, Pontus
 Brancusi.
 1. Brancusi, Constantin
 I. Title II. Dumitresco, Natalia
 III. Istrati, Alexandre
 730'.92'4 NB933.B7
 ISBN 0–571–15075–6

First published in Great Britain in 1988
by Faber and Faber Limited
3 Queen Square, London WC1N 3AU
All rights reserved. No part of the contents of this book may
be reproduced without the written permission of the publisher

Designer: Jacques Maillot
Printed and bound in Italy by Arnoldo Mondadori, Verona

CONTENTS

BRANCUSI AND THE CONCEPT OF SCULPTURE

PONTUS HULTEN

BRANCUSI AND THE CONCEPT OF SCULPTURE

A work of sculpture was an object of a very special kind, according to the belief generally held at the beginning of the century. It still is, but meanwhile the context of that perception has changed considerably. Serious efforts have been made to establish what it is that sets sculpture apart, and during the process sculpture itself has changed. Clearly, Constantin Brancusi belonged at the heart of the struggle to clarify and redefine attitudes toward art, a struggle that transcends aesthetics as a momentous effort is apt to do in any field of endeavor.

When a work of sculpture is of the representational sort, its distinguishing features are, in some respects, fairly easy to pinpoint. It is an object fashioned from one or more materials in such a way that it resembles some other three-dimensional form. During the four centuries of the Renaissance tradition in Europe, the great majority of sculptures were objects representing the human figure. The key word in our discussion thus far is *object*: a work of sculpture is an object apart, isolated by its singularity, its difference from other objects, but it is still an object like any other, and its *difference* rests on a long succession of set ideas and cultural norms, some of them worn quite thin by the early twentieth century.

Brancusi, with his visceral need for truth, started very early in his artistic development to probe the reality and truth of the sculptural work as a singular object. Central to the Renaissance tradition is the concept that sculpture should be isolated from its surroundings, and the base or pedestal served to obtain this isolation, just as a frame "set off" a painting. At the outset of his career, Brancusi found his principal difficulty in the fact that a sculpture was an object, as well.

Parenthetically, this problem, which at the time was a general aesthetic dilemma, seems to have elicited the strongest reaction from artists reared within the cultural context of Eastern Orthodox worship. The special status accorded to icons in their religious milieu must have been a contributing factor. At any rate, it is striking that such Eastern European artists as Brancusi, Malevich, and Tatlin fueled some of the most heated controversies about the problem of the aesthetic object, and devised the most radical solutions.

A sculpture is a man-made object which must in one way or another stand out, and convey inescapable, emotional power. Once this assumption has been made, the traditional line of reasoning, that this object has special status because it represents something, begins to look timeworn. Brancusi defined sculpture as an object, then he concerned himself specifically with aspects *other* than representation. Early in his career, especially when he lived in Bucharest, Brancusi's quest was rather a solitary one, but in Paris he met an entire generation of artists absorbed by the

same issues, and came to know well the most doggedly innovative of the young French artists, Marcel Duchamp. Given the sharp differences in their upbringing and education, Brancusi and Duchamp did not arrive at the same conclusions. Duchamp ended up with "ready-mades," proclaiming that any man-made object could be considered a work of art *if one so decided*. Brancusi, whose past was in peasant traditions, took an unacademic approach to truth and decided that the strength of a work of sculpture must come from the form, from the configuration of the object itself.

THE *NEWBORN* SERIES

It is not by chance that Brancusi's evolving concept of sculpture as an autonomous object came to fruition in a series of works in the form of heads, the *Newborn* series. The head was the most emotionally charged form imaginable, for within it lies that mysterious electrochemical apparatus known as the brain. And the head of a newborn child, like the egg, so fragile, yet the guardian of life, corresponded exactly to the idea of an object having a high-powered impact.

Does this make the *Newborn* sculptures representations of heads? Not really. In any event, what matters far more is that from various materials the sculptor made objects whose outward form contains an inner force, in this case the brain. Form is the materialization of meaning or content, in this case the most potent of messages, the life force itself. With one majestic gesture, and within a very brief time, Brancusi had brought sculpture into a golden age, turning an object into a sculpture by investing it with existential power. It could be said that Brancusi's sculptures had become sacred objects, but they are not connected with any religion. From the beginning, once they were made they rested on no cultural conventions or guidelines, they made themselves felt through their intrinsic strength, with no literary or religious explanations or other sorts of embellishment. The existential force had to radiate from the form of the objects as plainly as light radiates from the sun. They had to be man-made objects that summed up human power.

THE IMPACT OF FAUVISM AND CUBISM

Brancusi was not alone in seeking the essence of sculpture, but his method was wholly original. This came in part from the fact that he was from an altogether different milieu from that of most young artists of his time.

He was also, of course, an extraordinary person. The Fauves and Cubists of Paris had begun to challenge the status of the work of art about the same time Brancusi did. Consciously and unconsciously, the debate revolved around the dilemma of illusion versus truth. How, they asked, could a work of art have anything to do with truth when it is basically an illusion, a depiction of something from the real world—a man, a landscape, a still life—in the form of another fragment of reality made of canvas and pigments? To be sure, art as a manifestation of highly complex human behavior is an intriguing subject for scholars and critics. But when one is an artist, a perplexing and all-embracing question arises: what part do *I* play? Is that what *I* am doing? The quest for truth has no connections with blanket solutions or conventional behavior patterns. Is there anything objective about color? Is it legitimate to pierce the flatness of a canvas by painting an illusory depth upon it? Once such questions have been raised, there can be no turning back. Painters began to paint shadows in blue because they saw them to be blue, but at the same time another truth hit home: *I* am the one who decides to make them blue. What's more, if it furthers my quest for the truthful realization of a painting, I'll make them some other color. I *can* do it. I *will* do it. I am true to myself, and that gives me independence, freedom, which may be more precious than truth. And that freedom, that exhilarating sensation that nothing is holding me back, is sensed in some degree by the people who look at my paintings, because the feeling is very contagious.

Generally speaking, avant-garde art followed two main lines of development in the early twentieth century: Fauvism and Cubism.

THE FAUVES

We mentioned above that color became liberated from its representational obligations; first this was done by such painters as Van Gogh, Gauguin, and Seurat, then zestfully by Matisse, Vlaminck, and Derain. Theirs was in a certain way a mainstream art, in that the Fauves were primarily concerned with fundamental, existential elements: life, women, landscapes, the beauty of flowers and children. The title of one of Matisse's first important paintings, *Luxe, Calme et Volupté*, drawn from Baudelaire's refrain, speaks volumes: the Fauvist line was voluptuous, beautiful, at times ornamental. Fauvist colors were sumptuous, occasionally leaning toward the gorgeous and summary. Thanks primarily to Matisse, Fauvism proved an exceptionally robust strain of art; what might have become elegant decoration remained, sometimes masked by its dazzling beauty, a single-minded search for the essence of life. Contrary to the opinion then prevailing, the Fauvists probably ventured closer to the ageless concerns of art than did, for example, their Cubist contemporaries. The tower-

The Kiss. 1912. Stone. Philadelphia Museum of Art (Louise and Walter Arensberg Collection). Photo Eric Mitchell (Cat. no. 69*a*)

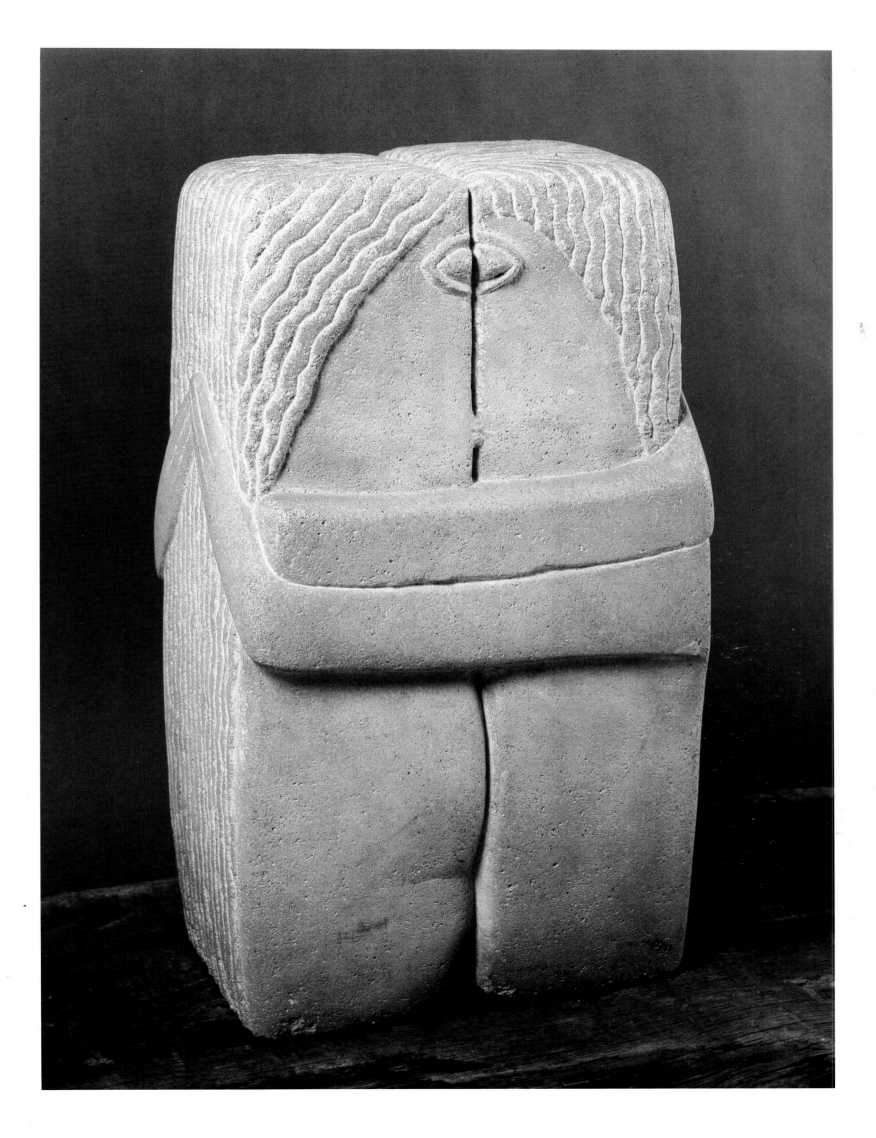

ing figure of Fauvism was Matisse; his art evolved throughout his life with no significant breaks, rather like the work of a craftsman of genius who is scarcely troubled by what is happening around him. From time to time, he would try his hand at a new method: witness his occasional excursions into Cubist composition. These experiments did not always yield his best work, so then, rallying his powers, he adopted a different tack. It is truly said of Matisse that in each painting an old problem is presented in a new way.

In the manner of leading their artistic lives, Brancusi and Matisse are rather two of a kind. Intuitive yet watchful, they kept up with their times and also with the liberated, expanded world which was theirs to explore and depict. They went about their work in rather a private manner, most of the time paying little heed to the other arts, developing distinctive ways of thinking and feeling. In so doing, they sloughed off the tremendous load of baggage that art had accumulated over four centuries, ever since Alberti, Brunelleschi, and Paolo Uccello worked in Florence. Brancusi and Matisse restored to art the power and simplicity of the cave paintings at Lascaux, their works belonging to an existential current within the grand humanist tradition.

THE CUBISTS

The effect of the Cubist movement on Brancusi was equally important, notably in his handling of sculpture as object and, between 1910 and 1920, in the evolution of his work toward abstraction. The Cubists (Picasso and Braque primarily) addressed the problem of representation in a resolutely analytical, almost scientific spirit. For them, the single most important question was: what is the relationship between the *subject*, whether for the artist or for anyone looking at a work of art, and the *object*, that fragment of the real world that the artist has chosen to treat in his work? What is the role of that mysterious catalyst of understanding we call a work of art? From the very start, the Cubists took it for granted that there were a certain number of problems, and thus decisions that they had to make. For one, there was the dilemma of surface and depth. A piece of canvas is a plane surface, but the paintings they were familiar with had displayed an imaginary depth that made a hole in the wall on which the picture hung. The deeper the analysis of the space in the picture, the greater the problem it raised. There seemed to be three possible solutions. Pictorial space could be extended into the space *behind* the picture; this would create the illusory recession that is conventional in Renaissance perspective. Or, pictorial space could remain *on* the surface, thereby becoming completely flat. Or, it could be extended *toward* the onlooker, into the space both he and the picture occupied.

Torso of a Young Man I. 1917. Polished bronze. Cleveland Museum of Art (Hinman B. Hurlbut Collection). Photo Brancusi (Cat. no. 102*a*)

12

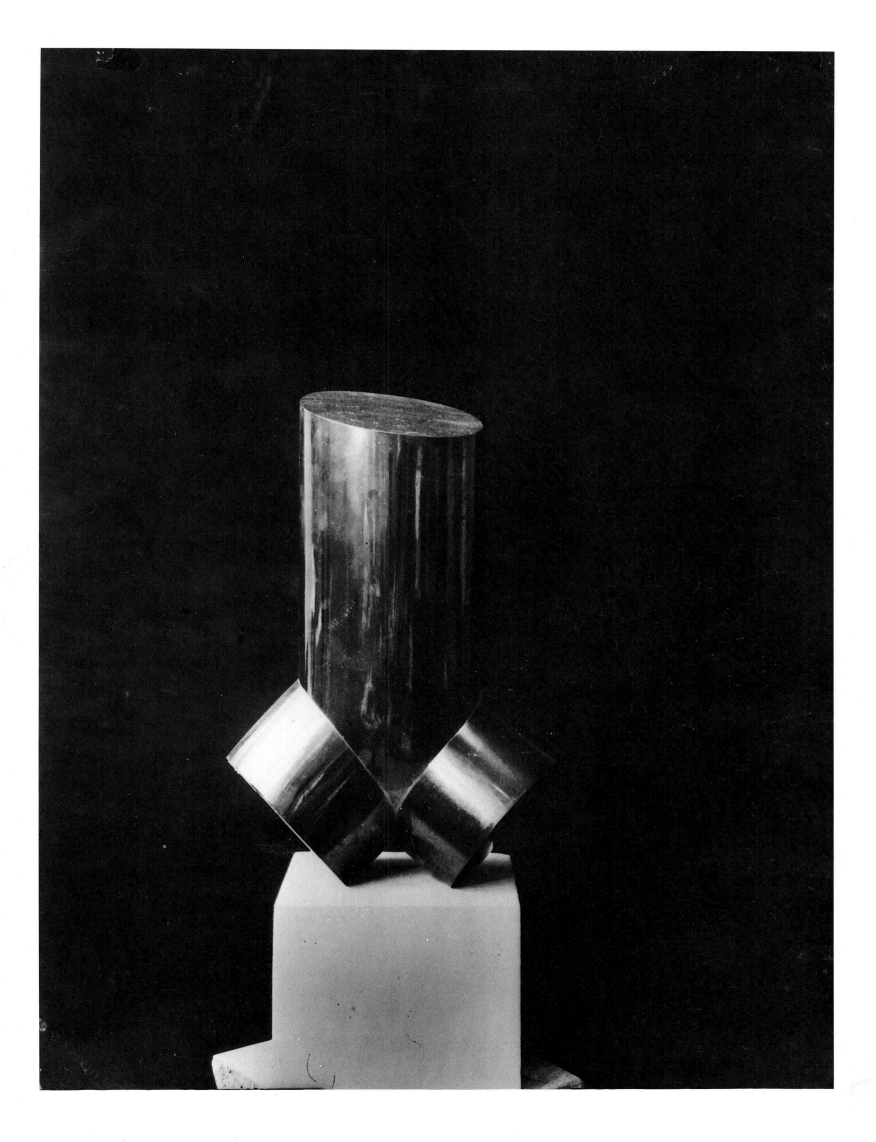

Since the solution of a totally flat painting then seemed too radical, the extension of its own space forward became the logical alternative. Pictorial space would have to develop from the canvas into the room where it hung, not into the wall behind it. If a picture were framed, the frame should push the painting away from the wall and into the room, not insert it behind the wall as a window frame does. This breakthrough in illusory space was an important step along the road that led from the painting considered as an illusionistic scene to the painting as a created object, whose meaning became autonomous. Since the painting was now comparable in some respects to other objects in the artist's studio, it no longer needed to be isolated by its special materials. Now a part of the reality of the studio space, wrought by an artist just as a table or chair has been crafted by a carpenter, the painter did not have to limit himself to the time-honored medium of oil paints. Rather, he had to demonstrate the point that if the painting was a fragment of the real world inside a studio, why should not a fragment of the real world be incorporated into the painting, thus introducing an element of certitude? And so, the collage was born. And with the invention of collage came an immediate result: art was brought down from its pedestal, and commonplace materials restored art to life—to a life galvanized by the highly charged atmosphere of the Cubist studio.

Curiously enough, the irony and serious playfulness that were part of the daily discoveries of the Cubists as they ventured deeper into their new world did not carry them away. They continued to follow a logical line of development. Having discovered—one could even say invented—the painting as a physical object, they quickly arrived at one conclusion: the bonds between the materials and the meaning had to be strengthened. The structure and the materials could then convey the message of the work; form had to function from the inside toward the outside. When that became clear, the outcome was inevitable and inescapable: art could be nonanecdotal, nonrepresentational. Illusion disappeared as a logical consequence of the work of art having been conceived as an object within the studio space.

Ideas took precedence in the Cubist world and art followed. The climate was one of intense, feverish discussion, of incisive analysis that penetrated the heart of the old conception of reality and the manner of treating it in art.

In the Renaissance scheme of things, man looked at the world from a single point in time and space; perspective was what the eye of a motionless person saw at a given moment. But how did this concept work in the real world? The domination of the idea that man was the measure of all things was no longer so absolute, at least not in the same way as before. The world of the Florentines—static, comprehensible, definable—had been transformed into a far vaster, more complicated universe in constant

movement, full of very different individuals. Their point of view became dynamic; they looked at things now from above, now from below, now from the side. If an object—glass, bottle, guitar, or what have you—was developed out of the canvas and into the studio space, it would have to be seen from several angles simultaneously. The Cubists took up Platonic idealism again and gave it a new twist. What they actually produced when they began to make a new reality was different from the perspective of the Renaissance. The Cubist artist did not aspire to represent the world he saw around him, but to create a new world that he had fashioned within himself.

BRANCUSI AND HIS CONTEMPORARIES IN THE EARLY TWENTIETH CENTURY

Brancusi was clearly intrigued by the work of the Fauves and Cubists, and we can see the repercussions of this interest in the development of his art. As so often happens with the greatest of the great, his art seems to have been part of several trends at the same time, and functional on several levels at once. Brancusi's work invariably stands apart from all other sculpture. There is something aristocratic, even regal, in his approach, and this attitude is in some way transposed into his work. His was a kind of splendid isolation. He was an extraordinarily proud and rather self-centered man, but probably much more inquisitive than he let on. Nothing escaped his notice; certainly he had his eye on the Fauves and Cubists. The way that his sculptures of heads and his *Newborn* series were evolved had affinities with both movements, but he made no attempt to experiment with new materials, at least at the outset. He was far too concerned that his work should survive intact for posterity to risk working with anything other than what he knew would retain its unaltered form as long as possible: marble, bronze, oak, and, once it was developed, stainless steel. He probably also set too much store by accomplished craftsmanship to want to glue or hammer together pieces of material into a composition, as Picasso or Braque did.

PHOTOGRAPHY

Brancusi was interested in modern machines that helped him work faster and better. He was also intrigued by the camera. Man Ray taught him to take photographs on glass plates with a bulky wooden camera that he

bought especially for him; Brancusi had been disappointed by the photographs of his sculptures that he had had taken by several photographers; although he could not help admiring Edward Steichen's superb photograph of *The Newborn*, he found in it too much outside interference with his conception of his sculpture. He decided that to show his works as *he* wished them to be seen, he had to take the photographs himself.

When he began to take photographs, he was soon concerned with the camera's capacity to be a useful tool in his works as a sculpture. As the splendid photographs in this book attest, pictures helped Brancusi to see his sculpture. They made him look at his work more objectively, as if through another's eyes, widening the gap between himself and his handiwork. To scrutinize these photographs, to observe Brancusi manipulating the light, the materials, and the settings, the arrangements of mass and form, is both our good fortune and an intellectual adventure of the highest order. Photography helped him to see his work freshly, but it also enabled him to see a number of his sculptures together, in a single glance, and to see his studio in its entirety. There is every reason to believe that through his work with photography, Brancusi was more and more aware that his environment was a kind of super-work. The next stage was his greatest discovery: assisted by his camera, he realized that his studio was a whole, and that every object in it, large or small, had its part to play. The environment ended by being his supreme work, the quintessence of his life as a sculptor. The placing of each piece became an uninterrupted project that lasted many years, a lifetime endeavor; Brancusi grew increasingly venturesome, pressing volumes of every sort into service. And not only sculpture but furniture too, fashioned out of great tree trunks to have just the right balance and support, and, toward the end, huge plaster casts of his works. All this while the camera made the task easier by giving him detached views of his surroundings.

He must have taken pictures of himself for much the same reasons: to see himself as others saw him, but to remain always in control, so to speak. Undoubtedly Brancusi's photographs reflect his attitude toward how he wanted onlookers to see his works. Inherent in these pictures is the notion of ideal display. We have reason to believe that, in many instances, his way of composing and centering his pictures (including the trimming and cropping at top, bottom, and sides) indicates the precise distance from which he wished us to view his sculpture. If the photograph is of a single piece, it provides us with the ideal parameter of observation. Since Brancusi was somewhat solitary, the camera became for him a kind of interpreter with whom he could discuss his work in confidence, providing him with the impartial, disinterested viewpoint he needed. Dependable, obedient, yet totally honest, the camera was a critic that could supply insight on demand. We will never know what cruel tête-à-têtes Brancusi may have had with this silent observer in the privacy of his darkroom.

THE CONCEPT OF ENVIRONMENTAL SCULPTURE

Brancusi had a passionate concern for the rapport of his sculptures with the space around them, and with himself. That he was quick to grasp the importance of this interdependence is manifest. He was very careful about the way his studio expanded; in time, what happened to the studio space became uppermost in his mind. He "tended" it daily, adjusting the volume and space of his immediate surroundings, controlling the large-scale interaction of fullness with void.

In all probability, Brancusi was the only artist to be preoccupied with such matters in the decade before the 1920s, but then again, he always lived in a world of his own. Not that he minded it; his isolation was, to an extent, self-imposed. The one other person who took such calculated efforts with an integrated environment was Kurt Schwitters, and his *Merzbau* in Hanover.

There is no reason to postulate any connection between these two individuals, and a meeting between them would have made for a comical scene indeed. Brancusi was Latin to the core, proud, earnest, thoroughly steeped in classical culture, brimming with confidence and a sense of humor that he would have reined in to avoid friction; engrossed in his work and its importance, his eyes sparkled with intelligence, but his demeanor was somewhat reticent, hesitant. The Germanic Schwitters was high-strung, talkative, always explaining, joking, and making ironic remarks about his own work, forever in doubt but staunchly confident of its significance in his heart of hearts and of his intrinsic worth. Would the two have understood each other? Perhaps not. Had their meeting taken place in Schwitters's *Merzbau*, Brancusi might not have cared for the Gothic, transcendental atmosphere of this miniature cathedral that flaunted its quirks, complexity, and humor. Had they met at 11 Impasse Ronsin, Schwitters might have found the setting too tasteful, too much in keeping with mainstream art, unabashedly classical. Its universality would have put him off, but then again, he might actually have liked it, alien though it would have been to him. It is astonishing that two men so dissimilar, active in different parts of Europe, should have embarked on the same kind of artistic experiment at about the same time.

Perhaps Brancusi talked over the questions of environmental sculpture with Marcel Duchamp and Fernand Léger, but we have no knowledge that such discussions actually took place. People who dropped by Brancusi's studio marveled at individual pieces within it; they may even have derived aesthetic pleasure from an unconscious awareness that they were in a flawless space, but no conclusive evidence corroborates this.

The camera was instrumental in helping Brancusi see his environment and providing objective pictures of the interrelations among sculptures in

his studio. Accustomed to seeing it in three dimensions day in, day out, as he walked there, worked on sculptures, and moved pieces about, his ability to see the studio spread out onto a piece of photographic paper became a vital counterbalance in the discussions he had with himself. Although he did not start to use large negatives until Man Ray taught him how to handle them in the early 1920s, he had tried his hand at photography before, as early as 1905. How did the concept of environmental sculpture look to him back then? His photographs give us an indication that his preoccupation with volume and space was already taking shape. We also know that, from the very start, Brancusi had worked out for himself a concept that he called the *groupe mobile*: two or more pieces of sculpture, with their bases or ''pedestals'' grouped in a close spatial relationship. In 1917 the sculptor sent the American collector John Quinn a photograph of three pieces—*Little French Girl*, *Cup II*, and a column (all later separated)—and on the back jotted down the title *l'enfant au mond, groupe mobil* (sic), a clear indication that the three pieces thus assembled constituted a whole new work. This simple yet astonishing statement has gone largely unnoticed by art historians. As might be expected, his idea must have met considerable resistance at the time, with most people probably refusing even to acknowledge its underlying premise.

John Quinn, at any rate, did not take the concept seriously, clinging to the conventional view that these were three separate works of sculpture. To put it bluntly, he was not interested in paying good money for the empty space between sculptures. Each component being in itself a fairly avant-garde work for its time, the radically innovative idea of the *groupe mobile* was, needless to say, anything but easy to grasp. Furthermore, to accept Brancusi's premise would be to violate one of the sacred notions in the world of art: the commercial value of an individual work.

Over the years, Brancusi's studio changed steadily. The sculptor relocated to another building in the same neighborhood, then enlarged his new studio as additional space became available. He continued to move sculptures, and to bring in new blocks of stone and pieces of wood. He cast large round plaster tables that were to become vital components in the studio space. He crafted other pieces of furniture out of tree trunks. He constructed the fireplace out of enormous blocks of stone. He devised a wooden archway framing the opening between two studios. And he never failed to record all of these changes on film. Indeed, Brancusi's immediate surroundings were like a laboratory, where he experimented with the solid, positive forms of plaster, stone, wood, and bronze in relation to the negative forms, the spaces around and between them. Now and again, Brancusi sold a piece of sculpture, and shipped off others to exhibitions; he then made new versions of the departed works, thereby creating new configurations. It was an environment continually in the making, but under the control of a resolute and strong will. Gradually, it took on an air of

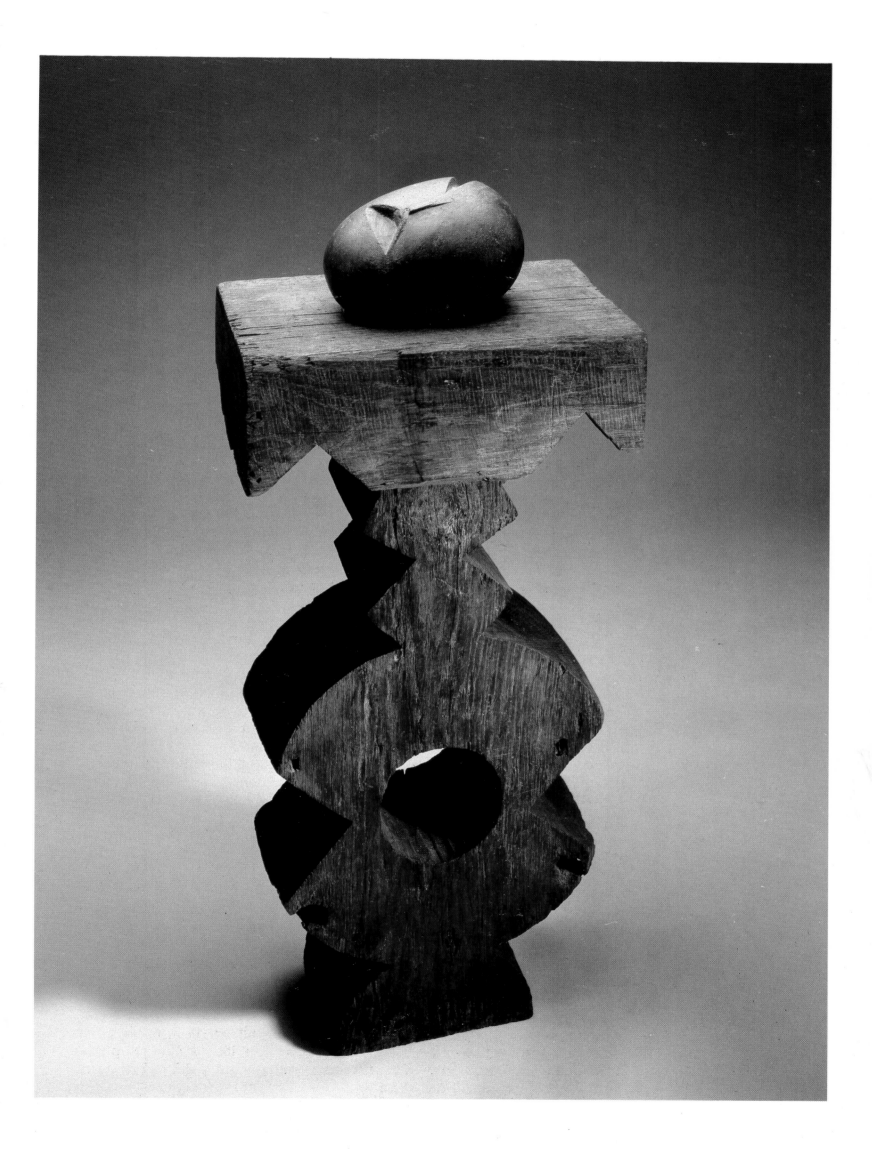

permanence; entire groups of large pieces seemed to have settled into a final place with respect to one another in the close environment beneath the skylight. By the end of Brancusi's life, his studio had become a great environmental work of prodigious complexity, where each detail had its part in the magnificent whole. Every object, every form and volume, was positioned so as to acquire a maximum of power and radiance. The observer's freedom to move within this work of art is, of course, of crucial importance, for thereby he becomes another component of the work; by his manner of moving about he can even be said, in a way, to create the work, or at least to create the way he sees it. The environment becomes a demonstration of trust and faith in the sensibility of others, or in their capacity to be touched by grace.

The direction that Brancusi's work with forms and volumes was taking, including his "mobile groups" and the increasingly rigorous arrangement of his studio, inevitably brought to the fore his interest in architecture. We know three architectural projects that he designed, and one of these that was actually built.

Certainly Brancusi's life had its share of frustration. He never had the chance to use his abilities fully, and he must often have dreamed of vaster and more awe-inspiring undertakings than those which came his way. It is also certain that few people were aware of what he was capable of accomplishing. The transformation of his modest Parisian studio into one of the most superbly innovative works of the twentieth century was a major achievement, but for all that, to Brancusi it must have seemed limited. He wanted to work with large volumes in the open air.

Endless Column is in itself a piece of environmental sculpture. It recapitulates many elements fundamental to the Brancusian world: symmetry, verticality, simplicity. In some respects it is his ultimate masterpiece, the pinnacle of his career. He wished to place it outdoors, in a suitable setting. His chance came at long last in Tirgu-Jiu, Rumania, not far from the place where he was born. It was the village he had gone to at age eleven, when he ran away from home.

Since the Tirgu-Jiu site was a vast space, the question of the visitor's movement cannot be addressed in the same way as in the Paris studio. The aesthetics of an outdoor setting introduces a new approach. Space that is open to the sky calls up different considerations: time, for example, becomes a more important factor, favoring the meditative mood of the spectator in this expanded area.

In 1935, Brancusi was asked to submit a design for a memorial to Rumanian soldiers fallen in World War I; the site was Tirgu-Jiu, a small rural community at the foot of the Carpathian Mountains near Hobitza, Brancusi's birthplace, in the district of Gorj.

Brancusi built his mighty monument in a park near the river Jiu during 1937 and 1938. It consists of four sections, placed along an axis perpen-

dicular to the river and over half a mile long, passing through the northern part of the little town. As Siegfried Salzman pointed out, a monument like that at Tirgu-Jiu would be the pride of any great capital or metropolis. All the expenses of constructing the memorial were borne by local women's groups and by the artist himself, out of love for his native land.

On the axis, which runs west to east, are located the *Table of Silence*, the *Gate of the Kiss*, the Church of the Holy Apostles, and *Endless Column*. Nearest to the river bed stands *Table of Silence*, a round stone table surrounded by twelve stools, each made of two hemispheres with their curved surfaces touching. From there a walkway, between two rows of three square stone seats, leads to the park entrance, to the commanding *Gate of the Kiss*. The visitor then proceeds eastward on a road named Avenue of the Heroes and reaches the church, rebuilt between 1927 and 1937, at the center of a circular area not unlike the site of *Table of Silence*. Continuing along the axis and beyond the railroad tracks, the visitor arrives at a last circular space with, at its center, *Endless Column*. The *Table of Silence* is of limestone, the *Gate of the Kiss* is of travertine, but *Endless Column* is of fifteen cast-iron rhomboids stacked one above the other, with a half motif at top and bottom. It was Brancusi's idea that the column would be plated with golden copper; at first it was painted bronze. (According to certain documents, two other elements were planned along the eastern terminus of the axis: a *Table of Ceremonies* and a matching monument.)

Simplicity and a rigorous, powerful interplay of elementary forms—these are what make the monument at Tirgu-Jiu so compelling, so fascinating. Brancusi, in constructing it, was evidently using forms he already knew well, that were even familiar. He was not tempted into useless, distracting complications, but drew on his repertory in masterful fashion.

Tirgu-Jiu has been compared with other great axial configurations, such as the famous Parisian axis that starts at the Place du Carrousel, passes through the obelisk in the Place de la Concorde and up the Champs-Elysées to the Arc de Triomphe, and beyond toward La Défense. But we must not forget that its proportions are completely different. Brancusi's monument is on a very human scale, inviting the visitor to use its constituent elements, to be seated for rest and thoughtful awareness. Tirgu-Jiu was not designed to impress visitors with splendor or solemn grandeur, but to create a mood of calm and repose, of silence and contemplation. Perhaps it is significant that this extraordinary urban complex was not built in a major European city, but on the periphery of the Continent, halfway to Asia, and with the help of only a small number of devoted men and women having no great financial resources. Both Siegfried Salzman and Alvar Aalto have noted that Brancusi's art lies at the crossroads of Western and Eastern sculpture, and the location of this great civic monument at the foot of the Carpathian mountains is altogether fitting.

It is clear that Brancusi's interest in environmental space led him inevitably to make architectural plans for terse, forceful, and totally controlled interiors. The designing of a room or an apartment, the utilization of light and water in an interior space, fascinated him. Apart from his Parisian studio, however, where he could hardly modify the architectural design of walls and roof, we know of only two such Brancusian projects: a *Temple of Love* and a *Temple of Meditation*. None of these hopes was to be fulfilled, for neither was built.

The most elaborate project, commissioned by Yeshwant Holkar, Maharajah of Indore, is commonly known as the *Temple of Meditation*, also called the *Temple of Deliverance*. It was to be a completely closed space with access only by an underground passage, thus avoiding the necessity for a door and for any interference with lighting conditions that the moment of entry would bring. The plans probably called for a single window, or rather an opening, in the ceiling, that would have oriented the light in a particular way with respect to the sculpture placed inside.

The interior would have been of modest dimensions, probably with a vaulted ceiling. There was to be a small pool of water and several sculptures: three *Birds in Space*, and a wood sculpture that was first entitled *Spirit of Buddha* (later changed to *King of Kings*). On the walls were to be three frescos, with one, two, and three birds respectively. The *Bird in Space* sculptures, all of the same size, would be placed on three sides of the pool: one of black marble, one of white marble, and the middle one of polished bronze. (All three were, in fact, delivered to the Maharajah. The bronze *Bird in Space* is now in the Norton Simon Foundation at Pasadena, California; the Maharajah's family sold the two marble versions to the National Gallery of Art in Canberra, Australia.) On important dates of the solar year, light streaming in through the ceiling window would have struck the polished bronze sculpture in a spectacular way.

A spirit of Zen Buddhism pervades Brancusi's design for the *Temple of Meditation*. This perfect environment, so fully controlled, has intrigued many artists in other parts of the world, some of whom were strongly influenced by the same Eastern philosophy. In southern California, such artists as Douglas Wheeler, Robert Irwin, Maria Nordman, and James Turell have worked with different kinds of illuminated environments, also controlled at will, that foster contemplation and self-communion.

We have even less information about the *Temple of Love*, Brancusi's other interior. Its form was to have been oval, the interior like the inside of an egg, with an underground entrance. The building, being neither large nor small, would have made the notion of scale irrelevant—and certainly it would not have been gigantic, for everything Brancusi designed was entirely to human scale. Unfortunately, we have nothing more than this general idea of his second architectural interior.

THE BASE

Much of the meaning and content of Brancusi's sculpture has not always been understood. Only a few artists—a handful of young American sculptors, in particular—perceived the scope and complexity of his work, and realized that it marked a renewal and transformation of traditional sculpture. Their understanding yielded handsome dividends. The obtuseness of their elders certainly came from a number of factors: one of these was the special beauty of each of Brancusi's works of stone or polished bronze, which distracted even rather seasoned art enthusiasts. They thought the *real* work of art was the particular piece of stone or polished bronze, and that the other parts of the base or pedestal were secondary. Sometimes an original base component of, say, unpolished stone—obviously meant to create a contrast of texture—was replaced by a smoother, "prettier" equivalent in cement; it also happened that wooden components, dismissed as mere "pedestals," were removed and discarded. On this important issue, the classical concept of sculpture misled even those who wery fairly close to Brancusi. How galling he must have found it to be appreciated solely for what was of lesser importance in his intellectual realm. The decorative side falsified the true content of his work, his completely revolutionary approach to sculptural thought. In all likelihood, the myth that enveloped the sculptor also contributed to this misapprehension, for not much was generally known about this seeming Rumanian peasant, who lived in Montparnasse and turned out beautiful works of art by intuition. He was thought to be an artist full of wisdom, possibly disingenuous, and capable of combining the obligatory simplicity of "modern art" with the compelling grandeur of classical art. People failed to take into account that his revival of sculpture was at least a generation ahead of everyone else around him. Avant-garde sculpture had, for the most part, taken a different course from his, another factor slowing the recognition of Brancusi's importance. European sculptors had become interested primarily in positive–negative contrasts within a work, in questions of motion, and in Duchamp's ideas on ephemeral and immaterial effects.

The base, footing, stand, pedestal—call it what you will—functions in Brancusi's sculpture as in no other art that preceded it, at least since classical Greece. For understanding the role of these bases, the photographs taken by the sculptor himself are, as in other respects, of great help, making it clear that from very early, Brancusi drew no distinction between the sculpture and its base.

What happened, probably, was that Brancusi began to experiment with sculptures having no base at all, such as some in the *Newborn* series, set directly on the floor, ground, or table.

There is an anecdote that the absurdity of using pedestals struck Brancusi while he was studying tomb sculpture in cemeteries: the supports placed beneath the sorrowing figures on and around the graves made them look only more preposterous.

The need to bring sculpture "down to earth" ties in closely with what we said earlier about sculpture as object. If a work of sculpture is an object, evidently it should not, to have maximum impact, need the subterfuge of a base to place it in a privileged position. It must take its chances like any other object, relying only on its inherent strength. Brancusi came to the conclusion, subsequently acknowledged by all sculptors, that a base is an unnecessary, even harmful interpolation between a sculpture and the world around it. He was also quick to anticipate the practical problems that arise when a sculpture is placed directly on the ground, especially when everyone present does not realize that it *is* a sculpture. He needed structures that would permit him to extend the sculpture in space as he envisioned it. The solution he found—to make the base in some way an integral part of the sculpture—seems a rather easy one. Actually, it is not. Had he done only that, the result would be simply a reversion to the previous stage: sculpture on the ground. The base had to be made part of the sculpture, it had to be sculptural, but it should not by its nature be quite the same as what it supports, or rather, what it lifts into space. The issue is not like the head and the body, but then again, it is not totally different.

Brancusi's photographs permit us to study his experiments in detail, and they were truly experimental ways of assembling volumes that no one had ever tried before. We see how the base turns into a sculpture. He places a cylinder, a cube, a parallelepiped, or other primary form on top of more intricate ones—several interconnected hemispheres, say, or two interconnected cones—and the result is an astonishingly strong work. He was careful not to show this kind of work to the public; no doubt he judged he already had enough misunderstandings to contend with. The momentous importance of these experiments has not been understood until recently. If we did not have the photographs, we would probably never have known anything about it.

There had to be some distinction between the old "pedestal," the lower part, and the upper part if the plan described above was to be realized; there had to be a sense of upward movement. The differentiation was often, indeed almost always, first achieved by using two materials, one for each part. The vertical movement, the straining toward the sky, comes from the superposition of various forms and volumes in a rhythm that rises in a kind of crescendo, lifting one piece of sculpture to an undefinable summit that has nothing whatever to do with its actual size. Rhomboids piled up angle on angle, a favorite Brancusian configuration used in the *Endless Column* series, recur in numerous variants on the theme.

To understand clearly the base-and-sculpture entity in Brancusi's work we must consider the size of the problem and the complexity of the situation that he faced. He wished to lift sculpture off the ground in its totality, and yet to keep it sculptural, so that he needed a very special kind of hierarchy. He would have to bring the work up gradually, that is, with no visual break, to its climax, its meeting with the sky. In realizing this project, the rhythm of the forms and volumes is important, but so are the changes in material and the contrasts of color and textures. The upward projection, the desire to conquer space, is an essential idea that is at the foundation of Brancusi's sculpture. In horizontally oriented sculptures, such as the *Newborn* series, he sometimes placed the sculpture on a reflective surface to separate it from the ground. In the bronze works, light is in the polished metal itself; he doubles that light by placing the bronze on a circular mirror, so that the ensemble is projected into space amid sparkling reflections. He created a similar effect with another horizontally aligned piece, *Fish*.

Many of the photographs in this book make it abundantly clear how important these bases were in Brancusi's studio and how frequently he used them as sculptural volumes (see pp. 31, 99, 135, 145). They satisfied the sculptor's need for an interplay of light and shadow, and their volumes became elements in the larger sculptural environment. It is certain that the interactions caused by the bases in the studio are at the origin of the environmental works. Did Brancusi ever go so far as to put a base on top of a sculpture? The question remains unanswered, but there is no doubt that the module which eventually became *Endless Column* was at first a base, or part of a support. In one of the versions of *Maiastra* (Museum of Modern Art, New York), the sculpture and the base are integrated. And a studio photograph shows us that, as early as 1907, Brancusi used a head as a base for a flowerpot, and not by accident (see p. 68).

In certain African sculptures the sculpture/base relationship and the subtly modulated transference of energy from the ground to the top can be altogether similar. In Africa, sculptures were often sacred objects placed on altars, but these are not the same thing as bases. Our altars are not mere supports for the objects—candlesticks, patens, chalices, and such—that are placed on them; the altar is part of a sacred precinct, and it has its own power as a focus and springboard for prayer even when there is nothing on it. (It may be startling to learn that the altar is hollow in back and serves to store implements in daily use.) In Africa, sculptures could be placed on an altar, but they could also be planted in the ground, which put them in contact with buried ancestors.

Brancusi was well aware that sculpture could be placed on an altar as well as on a bench, table, stool, column, shaft, lintel, or arch. He realized that there were many advantages to such settings, especially in changing the ways of seeing a sculpture, the interaction between sculpture and on-

looker. The direct physical contact of a work of art placed on a tabletop fascinated him. We use tables in many ways, but the most important is to "sit down at the table," to eat. To invite the spectator to look upon sculpture as nourishment—in this case, spiritual nourishment—is something Brancusi often did. (He was, we might add, a discriminating cook.)

THE BASE: SOURCE OF SCULPTURAL ENVIRONMENTS

Once Brancusi had seen that sculpture must rise from the ground, the base became part of the sculpture, the lower part of a carefully contrived rising motion from the ground to the summit where the sculpture meets the sky, the most critical point.

We see in the photographs of his studio how these lower components— and they could be truly massive volumes in their own right—began to establish horizontal relationships with one another, creating fields of forces that turned the whole studio into one sculptural environment. This is a phenomenon familiar to all sculptors, but Brancusi's case is unusual in two particular respects. His bases were anything but ordinary supports, and made the interacting sculptural forces far more interesting than usual. Next, he decided to take the consequences of what he observed to their logical conclusion: he began to see his studio as a work of art in its own right, and decided to preserve it as a form of environmental expression. From that time on, he undertook to examine every aspect of this new problem: environment as sculpture, as "installation," as "total" environment.

THE CORPOREAL VALUES OF SCULPTURE

In comparing Brancusi's oeuvre with all sculpture that had come before, a number of fundamental differences become evident. These are not always easy to define. Brancusi's works tend to absorb the space surrounding them, a critical aspect of sculpture that he had probably already observed in Rodin's work. It is created by breaking up the surface into a pronounced relief that makes the light dance across the bronze or stone, uniting the sculpture with its surroundings. Brancusi, too, implemented the concept that his sculptures generate their own space, but his sculptures absorb the surrounding space as part of their content as well as their form. Several elements become important in this process: in addition to the surface and the way it catches light, there are the scale, the di-

Portrait of a Woman. 1920–22.
Gouache and pencil on paper,
pasted on cardboard, 53.8 × 38 cm.
Private collection

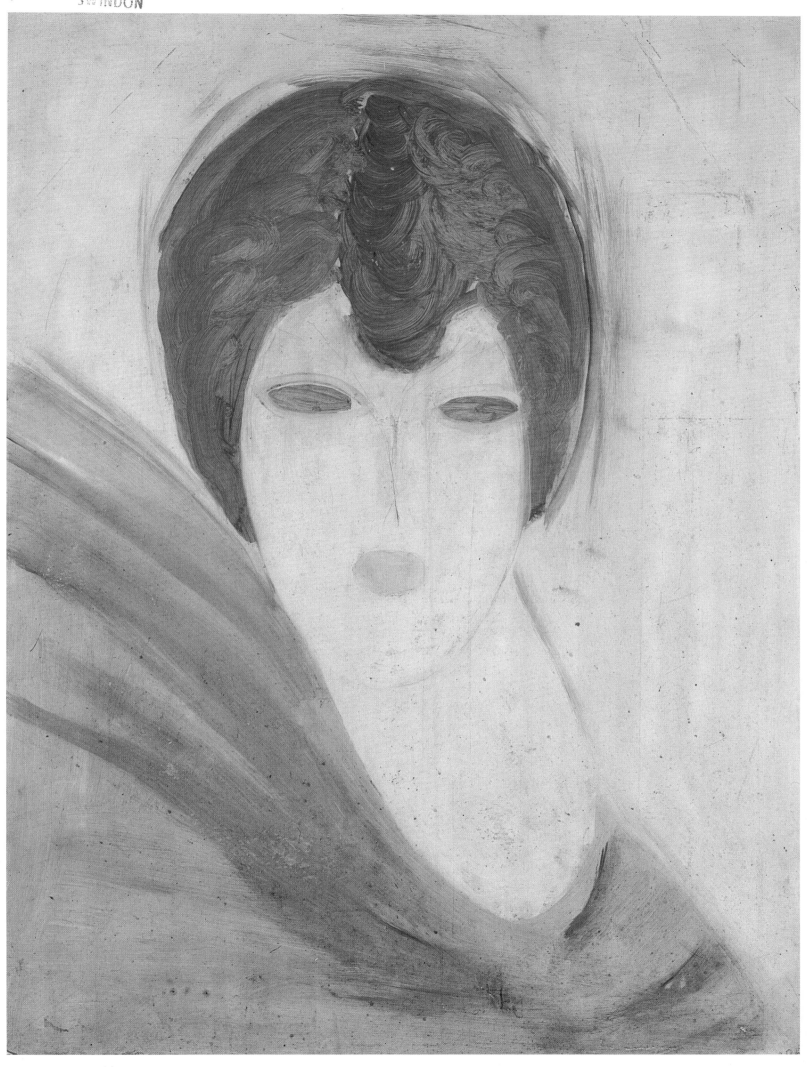

mensions, the relation to the onlooker and to his/her body; the way the sculpture is displayed, and the way this acts on its environment and on how the onlooker views it; and the onlooker's presence in the sculpture's space, his interaction with the sculpture and with their shared environment.

SIMPLICITY AS A PRINCIPLE

The simplicity of Brancusi's sculpture is comparable to that of the finest ancient Egyptian examples; one area of African art, which may well have its source in Egypt, also occasionally achieves this degree of conciseness. Simplicity can be one of the most effective, persuasive, and elegant methods of communication. Brancusi seems from the very start to have had this gift for going straight to the point—perhaps a heaven-sent talent bestowed at birth. As we all know, certain kinds of simplicity can become thoroughly tiresome; if not invested with a deep and compelling conviction that is all but religious in nature, simplicity is of no interest whatsoever. The line dividing the trite from the sublime is as fine as a hair, and on the one side lie the insipid and inane, on the other the universal and sacred. Spaghetti is made by mixing flour and water; even adding butter will not bring pasta making to a high level of sophistication. But pasta is not an easy dish to do well, and people cross continents—or at least go to Italy—to taste the pasta of a particularly gifted cook. So much for an uncomplicated food. We could also remark that some Athenians can instantly identify from which of the city's many springs comes the water they are drinking and have a decided preference for one spring over another.

Brancusi wished his work to be universal in its form and content, to be of all times and all places, to be comprehensible for everyone. He dealt with concepts that affect every human being: man, woman, life, death, love, eternity. He fashioned birds, fish, and newborn babies, and he wanted these images to affect us as when we gaze across vast oceans or at stars in the night sky. One way he achieved this compelling terseness was to work with primary forms: the cross, the circle, the cylinder, the oval, the hemisphere, the arc, the rhombus, the cube. Brancusi arrived at these universal forms just as he came to all his major decisions: by intuition. He used his internal compass, confident that it would point him in the right direction. As a child he had the good fortune to have many contacts with geometric forms, for the Byzantine tradition was still very much alive in Rumania. Architecture and rustic furniture there had beautifully simple forms, as strong as those used by the Church and the Byzantine emperors

to express, and to justify with unmistakable clarity, their right to govern. Brancusi turned to large geometric volumes in order to create something mighty and powerful, yet at the same time recognizable and accessible, not strange or intimidating. Elemental forms can do this. His forms suggest that the situation between sculpture and onlooker is unique; it can be repeated, but the encounter takes place on a high level, where nothing petty or insignificant can interfere. The use of primordial forms was only one of Brancusi's ways to bring about this spiritual uplift, this sense of a sacred presence, but it lends a prime value. The superb geometry of Egyptian, Greek, Roman, and Byzantine art had long since vanished from sculpture. Cézanne had reintroduced into painting strong compositions whose principal elements came from geometry, and had proclaimed that everything in nature could be reduced to a cube, a sphere, and a pyramid. But sculpture had to wait for Brancusi before it could revert to essential forms, to the power of universality and decisive expression.

Brancusi was convinced that his art could not develop along the right path unless he himself returned to the wellsprings of art, to concepts which had been all but forgotten: strongly emphasized horizontality, verticality, symmetry, and simplicity. In so doing he reestablished ties with classical and Byzantine art, and with the art of Egypt and Africa. But it is evident that he rapidly assimilated these time-honored ideas, transformed them, and used them in new ways, and from there he went beyond all that classicizing sculpture had achieved.

He did this so simply and discreetly that it is difficult to mark the various moments and stages along the way. Moreover, it took the art world a long time to discern the totally revolutionary nature of his work. There is a continuation of tradition that links Brancusi with such artists as Piero della Francesca, Vermeer, and Seurat, but he had other elements besides theirs, and other concepts. Whereas Piero, Vermeer, and Seurat belong completely within the Renaissance tradition, Brancusi's art overlaps with an important influence from Eastern thought, holding different ideas concerning sameness and repetition, rationality and irrationality.

The pride and modesty of Brancusi's outlook become easier to understand if we bear in mind the respect he had for the artisanal side of his art, for craftsmanship. He knew, very probably, that he was a genius, but he was too much of a peasant to let himself be taken for anything but a good artisan, a capable workman, a manual worker handy with tools. He considered himself a good professional, within the limits implied by this attitude. His association with prominent "dilettantes" in the Dada movement in Paris doubtless did much to offset this tendency: he took part in Dada's Grande Saison in Paris (1921) and signed some of the Dada manifestos. Probably most important for him was his lasting rapport with the freest spirit of the day, Marcel Duchamp.

The friendship of Brancusi and Duchamp warrants a brief digression.

Brancusi became closer with Duchamp than with anyone else in the circle of artists, writers, and critics he met in Paris. One reason was that Duchamp helped Brancusi sell his work; Marcel was his agent, after a fashion. The lives led by these two men had strong similarities as well as divergences. Both attacked the problem of the work of art as an artistic object with the same relentless zeal. Though they arrived at completely different conclusions, both succeeded in producing a universal form of art that would greatly influence subsequent generations. In their maturity, both men confronted the same almost total lack of comprehension of what was essential in their art; they were both, in their way, free from the conventions of usual lifestyles, and created their own ways of existence. Brancusi spent most of his time in his Parisian studio, making a few trips back to Rumania and to America, India, and Egypt. Duchamp was constantly on the go, almost always traveling. They stayed in touch; when Duchamp was not in Paris, he sent Brancusi a message every month, if not every week.

ENDLESS COLUMN

In its utter simplicity of form, *Endless Column* is probably Brancusi's most revolutionary work. Its most extraordinary aspect is the way it developed the idea of the interaction of sculpture with the space around it, giving it a new dimension. The fact that the column would not be changed if more or fewer rhomboids were stacked upon it rests on an astonishing concept: sculpture does not have to be defined exclusively by its forms, but rather by its purpose and its essence, by the opinion we have of it, by the residue it leaves in our memory.

Brancusi made several versions of *Endless Column*; the tallest one in his studio extended simply from floor to ceiling. In the chronological section of this book we will read of how Brancusi presented the authors with a large screw from a wine press when they moved to new quarters nearby, telling them to keep it as the "guardian spirit" of their studio. He said that the great screw had been the source of *Endless Column*. This statement seems confirmed by his drawing of 1937 for the Tirgu-Jiu project, in which the column is shown as a gigantic spiral or helix; another drawing shows a sort of twisting shaft that resembles the row of vertebrae down the spinal column of a person's back (see pp. 222, 223). In his drawings of a standing nude the back muscles are depicted as a series of rhomboids placed one above the other. It has often been noted that forms similar to those of *Endless Column* are common in the peasant architecture of Brancusi's native province: wooden balcony balusters, for example, made of

Torso of a Girl. 1922. Onyx. Harvard University Museums, Fogg Art Museum, Cambridge, Massachusetts. Photo Brancusi (Cat. no. 127a)

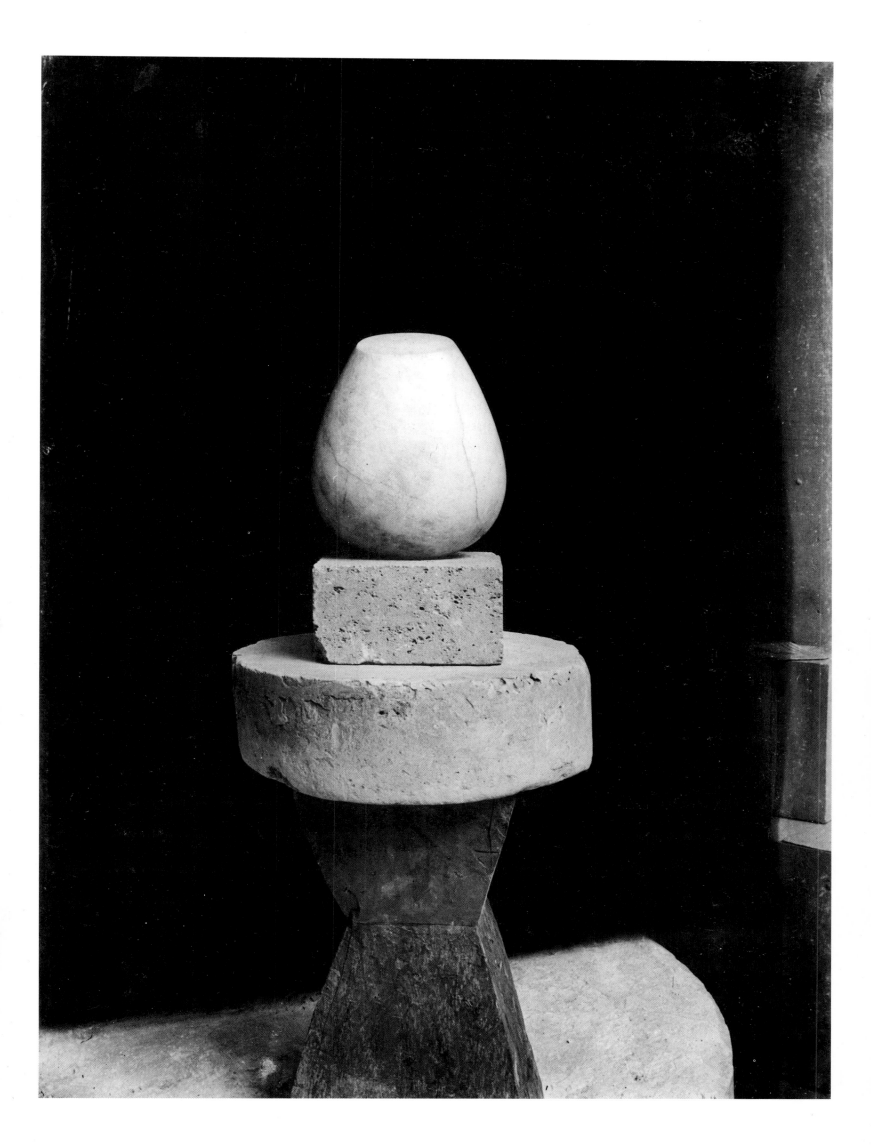

rhomboid sections stacked one upon another. One can guess that the idea for *Endless Column* originated, as often with Brancusi, in a fusion of geometric and organic forms, just as in *The Kiss* and the *Newborn*.

What is different about *Endless Column* from all sculpture before it is its manner of suggesting infinity, which it does in the simplest, most eloquent manner, by the repetition of identical units. Next to *Endless Column*, even an obelisk seems complicated. How this repetition of form works on the eye and mind, and how Brancusi intended it to affect the spectator, become clear in his famous photograph of the column soaring toward the sky in a mysterious manner that somehow shows its Eastern character (see p. 226). The column here suggests the beating wings of a bird as it flies upward. Brancusi, like many other artists, was preoccupied by birds and their flight throughout his life. In his admirable photograph of his own work, which he framed and hung on a wall of his studio, he wonderfully crystallized his yearning to approach the mystery of the flight of birds. To take a concept as timeless and elementary as the column and to be able to renew it totally, transforming it into an essential form of our own time—this is no small achievement.

Brancusi spoke and dreamed of making versions of certain sculptures in large scale, especially *Endless Column,* which he imagined standing 100, 200, even 400 feet tall, with perhaps an elevator inside. He came closest to realizing this dream in erecting the cast-iron (now copper-coated) *Endless Column* in the public park at Tirgu-Jiu, where it rises 30 meters high (98 feet). It would be interesting to see how Brancusi would have handled truly large scale; he left numerous instructions about this with friends, and often talked about large sculptures in an urban setting.

One can take the external measurements of sculptures like those by Brancusi—of height, length, width, and so forth—and these serve a purpose, but as Brancusi put it in one of his aphorisms, ''Measurements are useless, because they are already there, in the things. Things can mount to the sky or fall to the ground, without their measurements changing.''

But there are also internal measurements at work within a piece of sculpture—tensions and relations that we feel very strongly. These are a large part of our appreciation of stone sculpture, our impression of its volume, weight, texture, and of its identity as stone. There is something mysterious about a mass of stone, not only how it comes out of the earth and takes on a weathered surface, but also about the hidden mass, the inner earth-bound substance we shall never see. It is formed from the interior toward the exterior. This inner magic, as well as the dialogue between internal and external measurements, plays a large role in the dramatic values of sculpture.

Brancusi did not concern himself overmuch with developing the concept of negative volumes, or the play of positive and negative forms within the sculpture itself. There are examples in his work where he uses the

hole as a negative form, as in *Spirit of Buddha* (later entitled *King of Kings*), perhaps his largest wood sculpture except for *Endless Column*, but they are few in number. It is as if the *groupe mobile* took precedence, and the positive–negative dynamic intervened only when two or more pieces of sculpture became placed near or next to one another in his studio. Brancusi seems to have preferred the vaster play of forms and spaces that he could orchestrate in the studio space to positive and negative forms interacting within an individual piece of sculpture. Yet some of Brancusi's contemporaries defined sculpture as a volume created by the interaction of positive and negative space, or inner form with outer form; this is especially true of the work of Naum Gabo and Antoine Pevsner, and it is an entirely different development from Brancusi's. But it is interesting to note that Gabo, who was dedicated to probing the question of the inner cavity and of defining its envelope by one or more contours, began to work late in his life with stone, and made some of the most mysterious and baffling stone sculptures of the twentieth century. These works can be compared with certain pieces by Brancusi, although Gabo's shapes are more organic, suggesting shells or huge fossils.

SIZE AND SCALE

When today one visits Brancusi's Studio, the replica of 11 Impasse Ronsin reconstructed in a separate building next to the Pompidou Center in Paris, one is struck by the harmonious scale, the uncanny attuning of all the volumes to one another within this space. Equally important is the manner of their relation to the human body, to the visitor standing, seated, or walking about. The "environment" at Tirgu-Jiu in Rumania seems to possess the same characteristics, transposed to an outdoor site. This harmony is on a human level, in the sense that the human being provides the scale to which all of the sculptures are related in a natural dialogue.

Brancusi was not a very tall man, and any visitor to his studio who is over six feet tall will find that when he stoops a bit, something will then seem to fall into place. But this scale is less important than the feeling of intimacy and balance the sculptures project, the contact that is immediately established, the sense of pleasure and well-being that spreads like a warm glow from within. We probably sense this harmony of scale intuitively. True, the size and proportions of the sculptures are profoundly linked to the work of the sculptor's hand, the shape of his tools, and the height of the studio, but governing all of these may well be the body itself, a person's physical presence as it relates to the presence of the stones

Brancusi brought in, the plaster he accumulated, the tree trunk or piece of timber he used.

SYMMETRY

An overwhelming impression of symmetry almost invariably pervades Brancusi's sculpture. The symmetrical effect is often accentuated in one way or another by the lower part of the composition, the base, stand, or "pedestal." Symmetry is so strong in his work that the unsymmetrical parts, which do occur from time to time, seem to emphasize the symmetrical components and become themselves part of the symmetrical scheme. Exceptions to the principle of symmetry are there to heighten the general rule: the asymmetrical elements in the lower part bring out and strengthen the symmetry and its power in the upper part. Symmetry operates in Brancusi's sculptures as it does in any organism, be it a person, an animal, or a tree.

Symmetry is used as a means of imposing an idea or concept. One could say that a strongly symmetrical arrangement signals immediately the unmistakable presence of a fixed conception. Chance or accident plays no role. Symmetry is a means of emphasizing the presence of power. It is the dominant factor in all royal, imperial, and even fascist architecture: witness Versailles, or the great palaces of imperial China. In Beijing's Forbidden City, symmetry is carried to ridiculous extremes through endless repetition—it can become self-destructive. Gothic decentralization had no use for symmetry.

The notion that each of us has a physical double is an unfathomable, subliminal concept that runs through our very perception of what is around us. We are deeply aware of it, we feel a need for it, and we react to it, even unconsciously.

Brancusi made use of symmetry to inform his work with another fundamental attribute: simplicity. His symmetry becomes an archsymmetry, doubled by his concentration on simple forms. Like many of the interpretations of familiar facts that Brancusi proposed, his version of symmetry becomes compelling, supreme, quintessential. In Antiquity a well-known and often-cited saying circulated in the ancient sculpture studios: a good piece of sculpture must be simple and dense enough to roll down from a mountain undamaged.

The religious and existential aspects of Brancusi's work are brought out strongly by the way that he treats symmetry. The word symmetry implies a middle point, a central axis. The center, the concentration on the vital

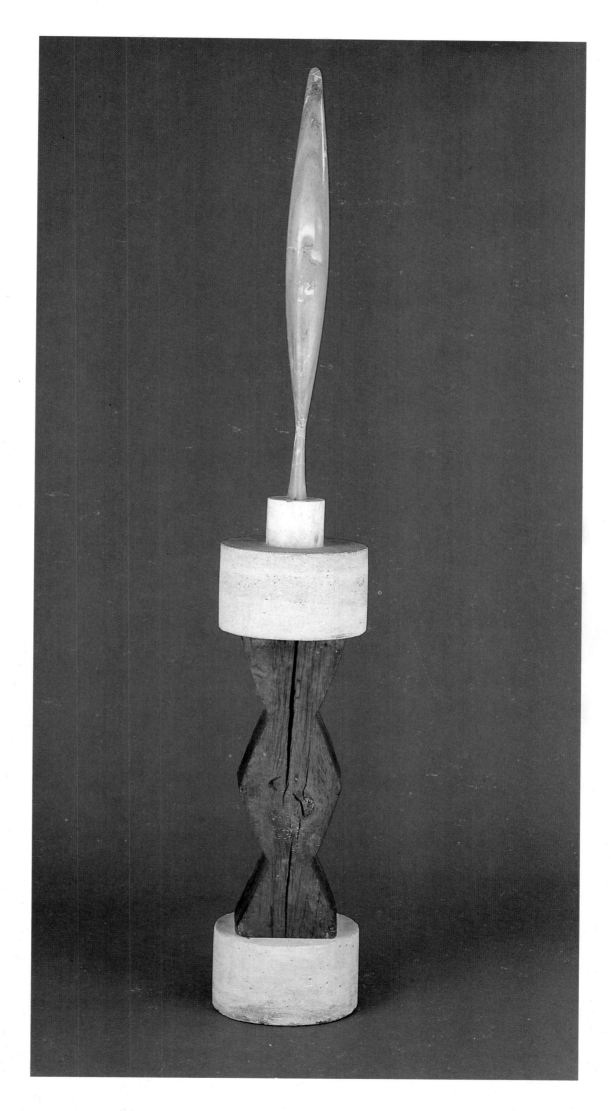

Yellow Bird (Bird in Space). 1925.
Yellow marble. Philadelphia
Museum of Art (Louise and Walter
Arensberg Collection). Photo Eric
Mitchell (Cat. no. 146)

line of the human body—we need only think of the location of our genitals to understand what centrality means for creation and existence.

MATERIALS

Brancusi used different materials to convey different messages and concepts. Stone and bronze were used for "serious" subjects: fish, birds, newborns, portraits. Wood was used for lighter, satirical subjects (*The Sorceress*, *Eve*, *Plato*), for the lower part of a sculpture (the "bases"), and for furniture. To this there is one important exception, the *Endless Column*: possibly no other material was available for a sculpture of these dimensions, but the column also evolved from his experiments with interlaced cones, base to base and tip to tip, such as those that Brancusi used for his bases. Or could it be that Brancusi was trying to preserve the relation of columns and upright trees? Yet when he erected the *Endless Column* at Tirgu-Jiu he chose, exceptionally, cast iron.

Brancusi handled each material in such a way as to extract the maximum of expression from it, and to underscore the direction in which he was working. The material seemed to want what he did, to give of its best, to be as beautiful as it could be. The oak which Brancusi used is almost the living material, its surface left rugged and raw, the cracks looking like wrinkles in a face. The marks of the sculptor's tools attest to unhurried, meticulous, dignified labor performed with love and patience. In an indescribable way, Brancusi's work radiates the peace and joy of his daily life in the studio and perpetuates his delight.

The surface of the stones is an important factor to consider in understanding how his sculpture affects the onlooker. The marvelous and mysterious semitransparency of polished marble, which can be made to look altogether like a beautiful skin, has an allure that renders the temptation to caress it almost irresistible. In his *Sculpture for the Blind* Brancusi made a strange and ambiguous commentary on this phenomenon.

With hands and tools, Brancusi created an epidermis for his stone. In *Fish*, the fluid motion of a fish gliding through water is already present in the blue-green veins running horizontally through the marble. White lines in the blue-gray marble streak like a noise through the entire body of *Seal II*, suggesting the powerful voice of that beautiful animal.

The large wood pieces, covered with cracks, have their own superb presence. Brancusi's furniture invites us in some way by its timeworn appearance, offering us a place of rest, visibly comfortable and already well used. Polished bronze, with its varying reflections caught in curved sur-

faces, imparts a lightness that confers a special life to sculptures. They draw back and thrust out at the same time and seem to have no fixed location in space, their reflections shifting as we move about them. It is easy to understand why the reflecting finish is so important: as soon as the bronze becomes at all tarnished, some of the magic is lost.

The choice of materials and a respect for their characteristics had high importance for Brancusi. He considered certain materials to be more appropriate for certain themes, and excluded others, according to a kind of hierarchy that functioned in at least two ways. The upper part of a large vertical sculpture was always of bronze or marble, Brancusi accentuating thereby the upward-thrusting movement within a work, a progressive buildup to the culminating point where the entire sculpture meets the sky or the space above it. This stratified choice of materials unquestionably contributed to the misconception that the upper part was the actual sculpture, the lower part merely a base.

But there was a hierarchy of another sort. We mentioned that during the 1920s and 1930s Brancusi used bronze and marble only for his serious subjects, such as *Fish*, *Bird in Space*, and the *Newborn* series. More amusing, facetious, or anecdotal subjects—*The Chief*, *Socrates*, and *The Sorceress*—were made of wood. Perhaps the reason for this distinction had to do with the fact that Brancusi could create sculpture of wood much more quickly and economically; wood offered him a somewhat more experimental approach. His ideas about materials and the values he assigned to them will probably never be exactly known, but it is clear that he had decided views about the treatment of materials, on their respective properties, and on the relationship between materials and forms.

We know that Brancusi also yearned to try out new materials, such as stainless steel. The surface and color of his sculptures are instrumental in establishing the identity of the medium and the content or subject. Bronze could take on various degrees of patina, as in the *Sleeping Muse* series, but it would appear that Brancusi wanted all of his vertical bronzes to have the brilliance and impeccable polish of a mirror, making them reflective as well as extremely hard. This surface gives great sharpness to the definition of shape and contour of the piece, permitting it also to reflect everything around it, including the movements of onlookers.

The color of the marble is used in an associative manner. The wonderful cold, blue-gray marble of such pieces as *Fish* or *Seal II* makes our thoughts drift to the sea and the frozen North, to compelling visions of a clean, pristine life. And the horizontal veins of the blue marble *Fish* slice through the water amid reflections between the polished marble and the mirror surface beneath it.

Brancusi's deep interest in materials evidently led to an interest in the immaterial. The empty space between the volumes of his works certainly held his attention: the concept of a "total environment" developed into a

major element of his art. It is formulated in the large upright pieces, such as *Bird in Space*, that rise to the space above them; and the shifting, elusive images created by the blue-veined *Fish* and its reflective surface can hardly be defined within the give-and-take of material and immaterial. The very form of the fish sometimes dissolves in glints and glimmers.

In the wood sculptures, Brancusi interposes an altogether different set of properties: what comes to the fore is the organic substance of the material, with its heft, its scars of growth, its rugged beauty.

A number of eyewitnesses have attested to the importance Brancusi attached to fine workmanship. Everything in the process of creating sculpture was important to him; no part took precedence over any other. The luminous simplicity and the beauty of his working methods, his use of commonplace tools, handled according to the rules of art and with the utmost composure—all of this is reflected in the finished product.

Isamu Noguchi, who learned to carve stone in Brancusi's studio in 1927, wrote a splendid article about his meetings with the sculptor over the years. He tells us that Brancusi stressed the importance of using each tool precisely for its intended purpose, with respect and patience. Respect for the material carries over into one's work methods, too, and is imparted to the final result. Axes should have an edge so keen that wood can be worked almost effortlessly; and a large saw, even Brancusi's five-foot monster, should cut through the wood by the action of its own weight, without the need of applying pressure.

VERTICALITY

In Brancusi's work the predominant direction is vertical, a verticality that is almost invariably linked with two other visual components: symmetry and simplicity. Verticality is obviously conspicuous in the *Bird in Space* series, but it is also important in other works. Always oriented toward the sky, never toward the ground, it gives a great lightness to the upper part of a complex construction, a rhythm from bottom to top that seems to defy gravity. Vertical movement traverses the entire piece, drawn upward from the ground. In the center section it can take on variations of an almost musical sort, and the impulsion toward the sky enters into full action in the upper part.

Brancusi's sculptures interact strongly with horizontals—with the floor, with the earth—but almost never with walls or other verticals. His works are raised above the floor, and the distance to the floor was, for Brancusi, an essential element that he defined most precisely.

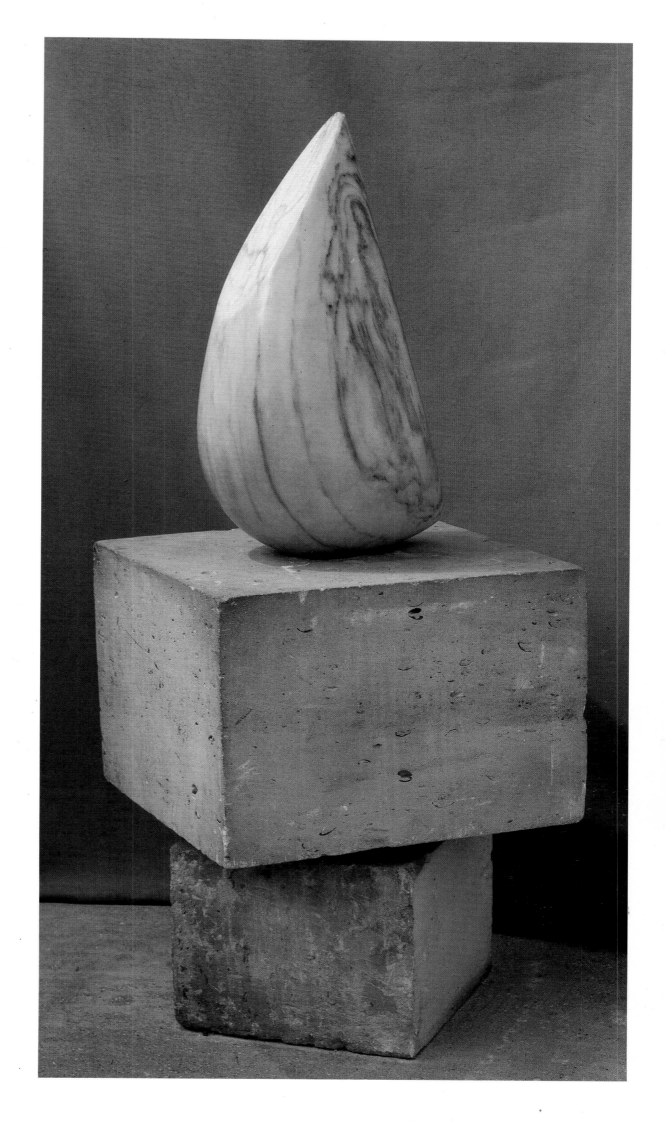

Little Bird II. 1929. Colored marble. Brancusi Studio, MNAM, Paris (Cat. no. 171)

Indeed, everything was done to make his studio seem as open as possible; the walls were used only exceptionally, as when the sculptor placed the great bronze *Bird in Space* against a red background. He treated his studio as he would an open space, or a forest. It is interesting to see how he photographed different bronze versions of *Fish*: he took high-angle shots as if looking down into the water of a river. The mirror beneath the fish becomes the flowing surface amid the shifting reflections created by the polished bronze. Is it "accidental" that one photograph shows a setting much resembling a river bed, with little stone sculptures strewn among huge plaster tables that look for all the world like boulders (see p. 176)?

The relation between earth and sky was omnipresent in his considerations. Centering on a clearly defined vertical axis was his simple, direct way of treating this relationship. And this centering is bound to three key factors in his work: verticality, symmetry, and simplicity.

BRANCUSI'S INFLUENCE ON CONTEMPORARY ART

It can be said with full assurance that Brancusi's work has already had an immense effect on art, and that its impact will surely continue for a long time. All sculptors since 1910 have had to take some position with respect to it. In its most conventional aspects it has influenced Arp, Moore, and Noguchi. It can be said that in some way he was of importance to Matisse, Gabo, Pevsner, Lippold, Giacometti, and Calder, for his ideas obliged each of them to take a strong stand of his own, and he considerably influenced Giacometti's early work. It has even been suggested that Marcel Duchamp's choice of *The Fountain*, the urinal he exhibited in 1922, can be credited to his affection and admiration for Brancusi.

But much more significant was Brancusi's profound influence on American sculpture in the 1960s and 1970s. It showed itself in a number of ways. For Claes Oldenburg, Brancusi's sculptures served as a source of inspiration in both form and content, and in ways varied and complex. Oldenburg's *Colossal Clothespin* (1972) is a reference to the formal relations of Brancusi's *The Kiss*, as Friedrich Teja Bach has noted; with extensive reworking, Oldenburg transformed Brancusi's pair of human lovers into a workaday manufactured object in Pop art style. So it goes in Oldenburg's world, a realm where objects have a mysterious power to affect us and ultimately become recognizable as part of the generally enigmatic world that is our daily environment. It would not be surprising to find other connections in the work of Brancusi and Oldenburg.

When Dan Flavin dedicated to Brancusi his first neon sculpture, *Diagonal of May 25, 1963*, he was signaling that his work using fluorescent tubes was derived from Brancusi's polished bronzes, in which substance and light are one. Had Flavin not mentioned Brancusi by name, this interesting connection might have gone unnoticed. By making the dedication he doubtless wished also to associate *Diagonal of May 25, 1963* with Minimalist sculpture in the grand tradition of art history, and to keep it from being dismissed as just another neon tube. In his absorbing discussion, Teja Bach stressed Brancusi's profound effect on Flavin, who was particularly intrigued by Brancusi's manner of "stacking" identical units, notably in *Endless Column*. As sometimes happens, we gain valuable insight into Brancusi by observing Flavin's interpretation of him. Through Flavin we understand more clearly how Brancusi took the separate parts and constructed his sculpture by adding one to another. We see with what daring this idea has occasionally been executed, as in *Endless Column*. The absence of a pedestal is also important. The unity of the work of sculpture—the fact that it rises from the ground, that all of its constituent elements are part of the work, and that this is one and only one piece—for Dan Flavin, this was a fundamental revelation.

In reevaluating Brancusi's work, Flavin, in some way, took on the role of catalyst for an entire group of Minimalist artists. Once the newness of the work became clear, a large field opened in the world of sculpture. In that generation of American sculptors, perhaps Richard Serra was the most influenced by Brancusi, before his work came under the sway of Malevich. Other Minimalists have found in Brancusi a powerful and enduring source of inspiration in a number of different ways, notably Carl Andre and Robert Morris.

Among the painters of that generation, Frank Stella was drawn the most to Brancusi's simplicity of form. The origins of some of Stella's early work are only comprehensible by his study of the symmetry and superposition of elementary forms as seen in Brancusi's sculpture. Granted, the generalized longing for a serene universality that followed the more literary and anecdotal Pop art certainly contributed to the new appreciation of Brancusi. One can rightly say that in this new light, a new dimension was discovered in his work.

In 1966, Richard Serra spent several months in Brancusi's studio as it was first reconstructed in the old Musée National d'Art Moderne on Avenue du Président Wilson. (Subsequently it was moved to the Centre Pompidou.) Serra commented on the definition of volume in pieces like Brancusi's *Cock* series and the *Caryatids*, and on how unambiguous and meticulous was the drawing of the lines of demarcation between the volume and the space around it. Still more significant for him, however, was Brancusi's manner of assembling elements by adding one identical unit to another, as in *Endless Column*. Many of Brancusi's photographs had not yet

been published and were then not widely known. Few had seen the famous pictures from 1921 and 1922 in which two identical rectangular volumes are poised atop a pair of twinned pyramids. There is no getting away from it: therein lie all the fundamentals of Minimalist sculpture. But even without the photographs, the contents of the studio are sufficient to show Brancusi's thrust toward the essence of sculpture. In 1969, Serra made his celebrated *House of Cards*; the connection with Brancusi is patent. To be sure, he added a fresh idea, delicately balancing several pieces on the floor instead of following the precarious verticalism Brancusi loved so much, that single form poised on a very small surface (*Bird in Space*, for example).

Another artist who elaborated on Brancusi's universal sculpture is Carl Andre, whose handling of wood also brought out its ruggedness and exposed its grain, baring its clefts and crevices. Andre so often insisted on the repetition of identical forms that it became a kind of personal trademark. His interest in Brancusi had surfaced as early as the late 1950s, in works like *Ladder I* and *Plexiglass and Wood*; in the 1960s, he became preoccupied with radicalizing a narrow range of concepts, such as the superposition of identical elements. *Lever* (1966), by the artist's own account, is nothing other than a recumbent version of *Endless Column*.

Clearly, as the Minimalists pushed some of Brancusi's ideas to extremes, they left aside other facets central to his art. Singling out certain aspects of his pioneering vision—the quest for the essence of sculpture, the fresh approach to form—they turned these into a mathematical art, totally abstract. Thus they stripped their own art of all sentimentality, but in the process they made it less human, more esoteric, more cerebral.

LIFE AS ART, ART AS LIFE

It has been said of many artists that their life and art were one and the same, and certainly this has been said of Brancusi, probably too often and without proper perspective. The chronological section that follows in this book gives us a clear idea of how thoroughly he integrated his life and work. If anything, the story of Brancusi's life has become too axiomatic, too fictionalized: there is even a novel, *The Saint of Montparnasse*. This oversimplification is dangerous, for it leads to misunderstanding his lifework. If the context is trite enough, the dignity of his art—universal and existential—will turn into something decorative, even commonplace. It becomes distorted through trivialization; what is complex and magnificent becomes simple-minded and nondescript. As the following section of this

book attests, Brancusi was inclined to aloofness and tended to be suspicious of the world around him. Perhaps it was this aspect of his mentality that drew him to the Tibetan mysticism of Milarepa and made Buddhist philosophy so appealing to him.

As Brancusi grew older, especially after World War II, he seemed to accept his role of a living legend all but beatified, the "wise old peasant of Montparnasse" totally wrapped up in his art, residing in Paris but living much like his Rumanian ancestors.

BRANCUSI'S LEGACY

One may ask: was Brancusi aware of his role as the great innovator in sculpture? It is a difficult question. There is reason to believe that toward the end of his life Brancusi became more willing to accept the myth that had been built up around him: the Rumanian peasant, robed in white, living in his ivory tower in the heart of Paris, surrounded by beautiful sculptures of carefully polished bronze and stone. This was the foolish myth of that time that formed the public image of the great sculptor. If Brancusi had not had the tenacious wish to protect the integrity of his studio as an environment, to safeguard its future preservation, this myth would probably be the most widely accepted image of the sculptor today and for a long time to come.

Brancusi brought completely new ideas to sculpture in three different areas. First, he pioneered the *groupe mobile*, the concept of an "environment" consisting of several pieces of sculpture that were to be viewed together. The Tirgu-Jiu "installation" and his Parisian studio were the examples of projects of this sort that he realized and that survive.

Secondly, Brancusi cleared the way for Minimalist sculpture by reducing sculpture to primary forms of a geometrical nature. In addition to his major work, *Endless Column*, striking examples of this approach appear in his photographs from the early 1920s.

Thirdly, Brancusi was the first to hit upon and develop the idea of serial sculpture: "infinite" sculpture created by assembling identical forms. Again, nowhere was this implemented to such overwhelming effect as in the *Endless Column* series.

There is one indication that lets us believe that Brancusi realized the range of his innovations. The story goes that when Brancusi delivered a speech at the dedication ceremony for the Tirgu-Jiu monument in 1937, he spoke of the work as "unfinished," and expressed the hope that future generations would complete it. Such a statement may be construed in dif-

ferent ways. Following the ''Peasant of Montparnasse'' myth, it simply referred to the Tirgu-Jiu monument and to the possibility that additional elements might be added. But there are at least two other possible interpretations. Brancusi may already have been aware, perhaps for years, that he had steered sculpture onto a new course, that he had introduced unprecedented concepts which would be developed in the future. An even more intriguing reading has been suggested: perhaps he meant that *Endless Column* itself could be enlarged, much as the pyramids of Mexico were increased in height and width by successive generations, sometimes over hundreds of years.

To see how tenuous is the ''wise old peasant'' image, we need only look at Brancusi's friends. It would be hard to draw up a list of more brilliant and cultivated individuals than those of Brancusi's circle: Jean Cocteau, Marcel Duchamp, James Joyce, Fernand Léger, Henri Matisse, Amedeo Modigliani, Francis Picabia, Ezra Pound, Raymond Radiguet, Man Ray, Henri-Pierre Roché, Henri Rousseau, Erik Satie, Edward Steichen, Alfred Stieglitz, Tristan Tzara. Satie and Duchamp were perhaps his closest friends. Duchamp, when he was not in Paris, wrote to Brancusi almost every week. (Their correspondence is now in the Brancusi archives.) A group of friends of this caliber hardly fits in well with the myth of the intuitive, more or less ignorant shepherd-peasant with a beard and a flair for cooking. But we can dispense with such lists; it is enough to look at the sculptures.

CHILDHOOD

''Everything I do is absolutely original,'' Claes Oldenburg has declared, ''I invented it when I was little.'' This is probably true of all fundamentally creative persons, and certainly it holds for Brancusi; in fact it is an important observation having profound implications. Brancusi grew up, if not in an untroubled family group, at least in a remarkably harmonious cultural environment, and according to all appearances, it affected him deeply. When he was a child, modern times had not yet caught up with Wallachia, a region at the foot of the southern Carpathian Mountains where folk traditions had remained firmly entrenched for a thousand years. Clearly Brancusi had to leave his native milieu lest he become assimilated by it, but he drew profit from the more positive aspects of his childhood experiences. The interests and thought patterns of a person take shape during about the two years preceding puberty; Brancusi was a shepherd for part of this time. He had ample time for meditation as he led his flock to pasture

Mademoiselle Pogany III. 1931. Marble. Philadelphia Museum of Art (Louise and Walter Arensberg Collection). Photo Brancusi (Cat. no. 192)

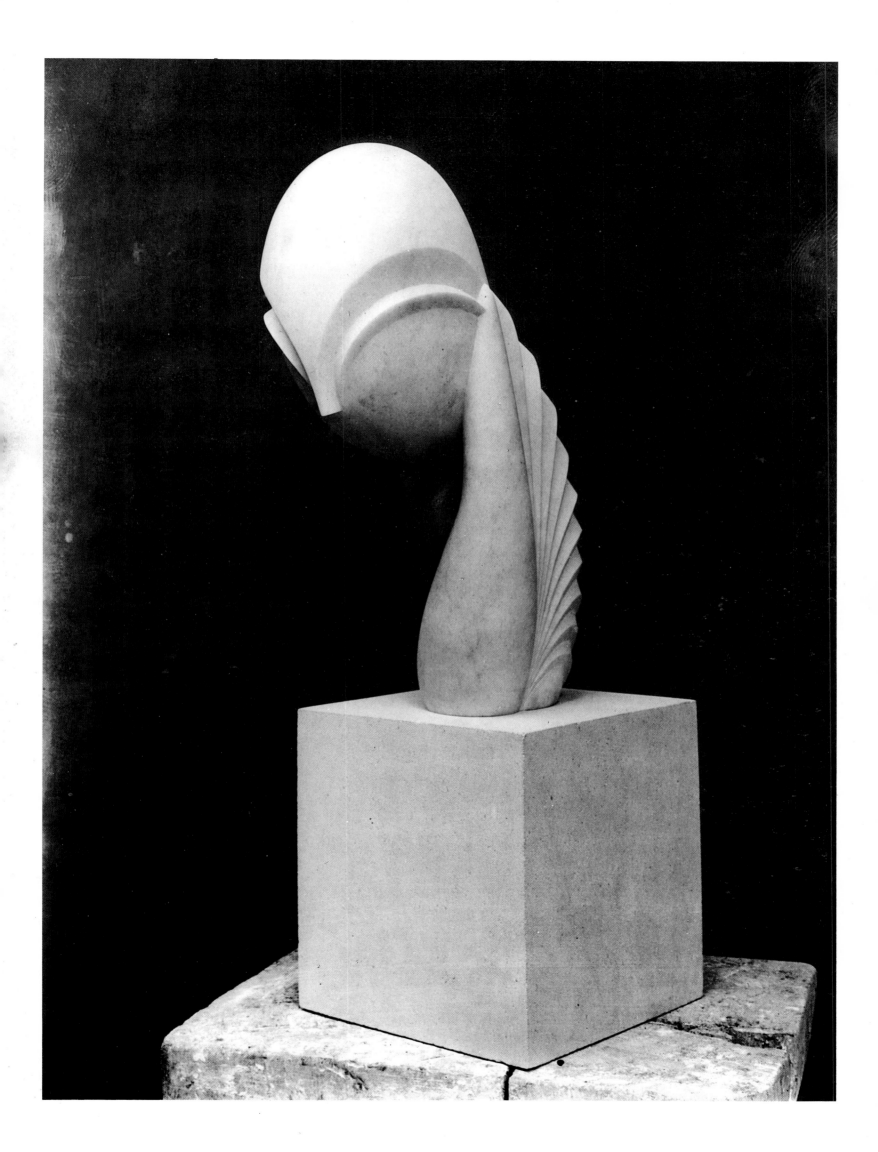

or to drink at the river's edge. The Bistrita River skirts the hamlet of Ho-
bitza where he was born, and he was often in the woods or along the
river, gazing at trees, carving and whittling wood with his knife, watching
the water and the round pebbles in the river bed, observing fish, turtles,
and birds. Birds and their flight drew him especially; later in life he would
make no fewer than thirty-nine different birds of bronze or stone.

Along with his uncompromising determination to conserve essential
forms in his art with the immediacy of his first vision of an idea, Brancusi
attached great importance to the insight of children and to the necessity
of keeping within ourselves something of the child we once were. "When
the child in us is gone," he once said, "we are as good as dead."

MUSIC

Music was everywhere in Brancusi's world. His love of music was not lim-
ited to any particular variety. He loved the great singers Chaliapin and
Paul Robeson, but he also liked all kinds of folk music and enjoyed listen-
ing to popular songs. Erik Satie's *Socrate* was one of his favorites, and the
composer was his close friend. Brancusi's entire oeuvre is inextricably
bound up in music. It has often been noted that the rooster's crowing is
audible in the very shape of *The Cock*. The musical quality of Brancusi's
work is no surface phenomenon; it is at the core of his approach to art.
He played the violin and the guitar. Using two 78-r.p.m. turntables, he
experimented with stereophonic sound and fashioned a loudspeaker out
of stone.

Harmony, dissonance, and the great role that intuition plays in music in-
form his sculptures in much the same way; intuition and intelligence are
used together, as they are in music, and there is a high degree of concen-
tration, presence, sincerity, and authenticity. Moreover, there was some-
thing musical about Brancusi's relationships with other people. His in-
sights into them were unerring. He did not always respond well to men
he had not met before, especially if they were younger than he, but he en-
joyed having women in the studio and was interested in them. Perhaps
because he had been a waiter in a restaurant in his youth and had ob-
served many people every day, he had an uncanny knack for seeing
beyond a person's appearance, for sizing up his abilities, moral qualities,
and intelligence. He had the same musical approach to his work as to peo-
ple, conversations with friends, and cooking. A wrong note, an unduly
sudden attack, a shift of mood in the day-to-day concert of his conversa-
tion, work, and meals—and he could fly into a rage.

SUBTLE RELATIONS

Our interactions with Brancusi's sculpture are as complex and richly textured as our dealings with human beings. The same may be said of how we relate to work by other sculptors, but with Brancusi, it takes on special significance. The ways in which his sculpture keeps its distance, changes as we move around it, glistens, plays with lights and shadows—the process is very like a meeting with another human being. It is a matter of presence, size, scale, and many elements, such as its content, color, and tactile appeal, as well as others more difficult to define.

TWOFOLD APPROACH

Brancusi seems to deal with sculpture on two levels simultaneously, which may have some bearing on the misconceptions that still hover about his work. On the one hand, he worked with the idea of total environment; on the other, with that of essential form. There is evidently no real contradiction between the two levels; to maintain otherwise would be rather like saying that nouns are more important than verbs, or vice versa. But it was so much easier to see only the beauty of an isolated piece of sculpture, the splendor of a fine work of art.

The Brancusian concept of essential form as "meaning materialized" is not easy to express. Perhaps an analogy with language may help: certain words seem to carry in their very sound the essence of their meaning. Actually, this comes as no surprise, since they must have been coined through a kind of common consent. From early childhood on, we identify the sound with the object, be it a hat, a tree, or a nose.

BRANCUSI'S STUDIO

Brancusi's studio at 11 Impasse Ronsin became his *magnum opus*, where his ideas about art, sculpture, and environment all condensed. By the late 1930s, Brancusi had to face the likelihood that the large sculptural environments he dreamed of would never be built—plans for the temple in India had fallen through, and the monument at Tirgu-Jiu would be his only

large outdoor environment—and quite naturally the studio became his haven, the place where he could crystallize the expression of his thoughts. In time, it came to mean more to him than anything else.

His studio was located in Montparnasse (15th arrondissement), a sprawling district that encompasses several sectors. Many artists had gravitated to Montparnasse after World War I. The Impasse Ronsin opens out to Rue de Vaugirard, a very long thoroughfare that runs through a good part of the Left Bank and is reputed to be the longest street in Paris. The neighborhood around the Impasse is lower middle-class, a patchwork of garages, cozy restaurants, and shops of every kind. Behind this cul-de-sac loom the buildings of the Hôpital Necker and the Hôpital des Enfants-Malades. Early in the century, the area was home to numerous studios; when Brancusi first moved to Impasse Ronsin, most of the buildings along it were, in fact, already studios. (Another dead-end street just like it runs close by, the Impasse de l'Enfant-Jésus.) By and large the Impasse Ronsin was a "studio district" (with, incidentally, a boxing hall), the buildings cheaply constructed, probably with materials salvaged from the world's fairs held in Paris in the later nineteenth century. Cement floors, wood-frame walls filled in with plaster, and sloping roofs with skylights indicate that they were put together as economically as possible. There is still much charm in their unobtrusive and prosaic simplicity. There was no running water indoors; all of the residents of the Impasse shared a single outdoor faucet, and sanitary facilities were of the simplest. During Brancusi's residence there, many of the neighboring studios were occupied by artists: Eva Aeppli, William Copley, Natalia Dumitresco and Alexandre Istrati, Max Ernst, Joseph Lacasse, the Lalannes, Larry Rivers, Niki de Saint-Phalle, and Jean Tinguely, to name only a few.

Over the years, Brancusi added to the comforts of his studio (actually, studios, for in time he "annexed" five living spaces), installing running water, a bathroom, and other amenities. This spacious dwelling with white-washed walls was not only where Brancusi lived and worked, but also a work of art in its own right, ultimately, his foremost work of art. In looking at his own photographs of his studio, we see the gradual progress of its elaboration. In the first phase, the different sculptures are the elements he used to create an "environment," the logical extension of his concept of the *groupe mobile*. Then other volumes began to figure prominently: the "tables" (actually, enormous flat-topped cylinders of plaster) that had so many uses, and, of course, the bases in the forms of cubes, cones, parallelepipeds. And then, in the final phase of arranging the studio space—which had now become his chief concern—he turned the towering hollow plaster mold of *The Cock* into the commanding centerpiece of his environment.

By the end of his life, every single object was assigned a specific location on the floor or on the tables, to within a centimeter. Whenever Bran-

Brancusi's studio, with **Bird in Space** (1929, plaster) and in the foreground, unfinished, **Grand Coq** (plaster). Photo Brancusi

48

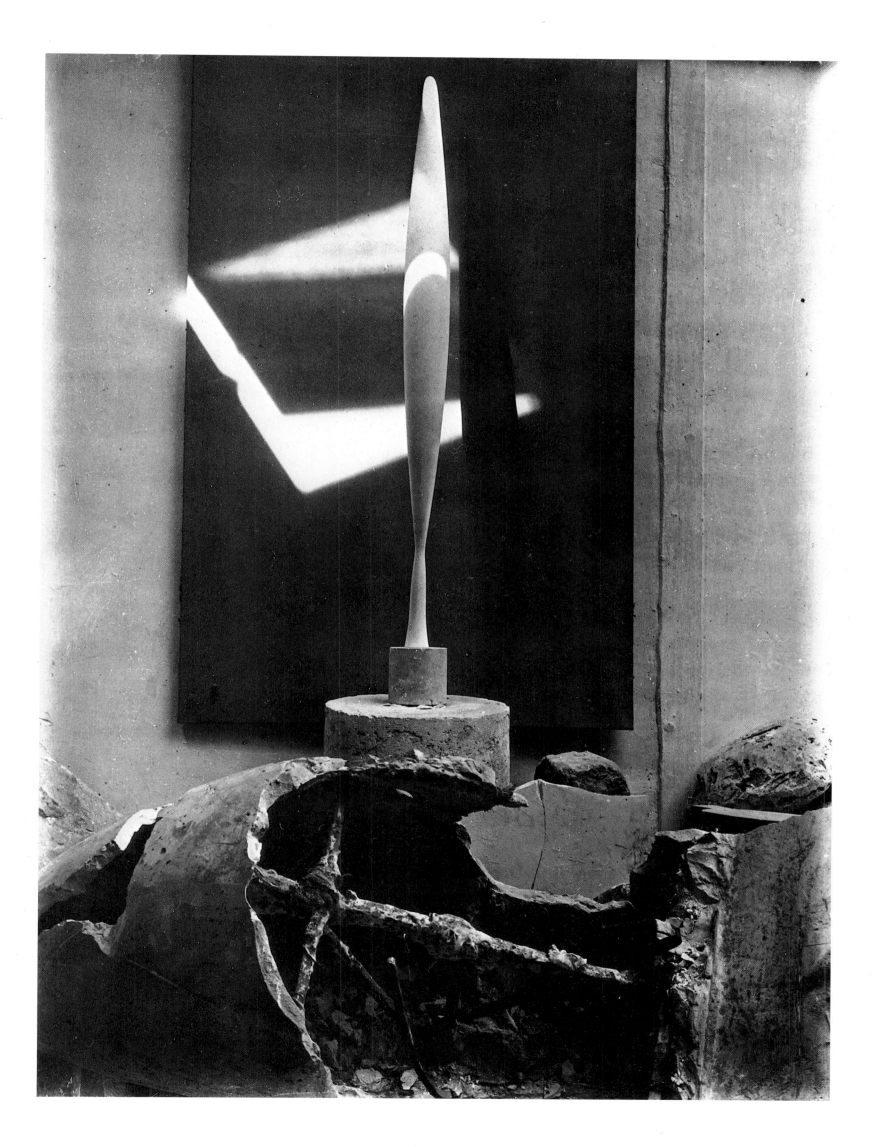

cusi sold a sculpture which would leave the studio for good, he would make a bronze or plaster cast of the work, preparing in advance for the spatial and spiritual void the sale would create. The new version of a comparable form would then "fill in," play the same part in the ensemble game of "positive" and "negative" spaces. We see in these photographs how it amused the sculptor to make these changes in materials and colors.

In his will, Brancusi bequeathed the studio as a finished work of art to France, with the stipulation that it be preserved intact. If it could not be kept at its original location on Impasse Ronsin—a planned addition to the hospital was never built, but the studio began to be demolished anyway in 1963, and the site remains vacant to this day—it was to be moved and reconstructed in its entirety inside the Musée d'Art Moderne. When Brancusi died in 1957, seals were affixed to the studio, and it soon fell into a poor state; Natalia Dumitresco and Alexandre Istrati kept it up as best they could.

Subsequently the studio was moved to the ground floor of the Musée d'Art Moderne, then located in the Palais de Tokyo on Avenue du Président Wilson. Since the ground-floor ceiling of the museum was lower than that of the studio, an *Endless Column* had to be cut down before it could be brought in. Light entered the room from the wrong side, the museum floor was not the same as the studio's, and the space allotted to the reconstruction was much smaller than the original studio. The installation was, at best, an approximation.

When Georges Pompidou unveiled plans for the Centre d'Art et de Culture, he decided at the time that the Musée d'Art Moderne should be relocated in the new center. Here was a chance to reconsider Brancusi's reconstructed studio; finally, after much debate, it was moved to the north side of the Centre Georges Pompidou. A few trees and a little garden were added to give visitors an idea of its original setting on Impasse Ronsin. This time, the studio was reassembled in the size, proportions, and layout of the original building. Some changes of building materials were necessary to conform to fire safety codes—concrete for plaster, steel instead of wood—but otherwise the new building exactly resembles the old one. Thanks to Natalia Dumitresco and Alexandre Istrati, the interior was arranged in comparable style. The contrast is most interesting between this small, cheap, and undistinguished structure and the imposing Centre Georges Pompidou, with all its technological complexity. It is a contrast between the kind of building where Brancusi's works of art were created and the sumptuous museum where they are exhibited today. The economic, sociological, and psychological implications of this gap are mind-boggling, especially when one stops to think that it has occurred in less than fifty years.

THE SOURCE OF A BRANCUSIAN FORM

During my conversations about Brancusi with my friend Ulf Linde, he mentioned that the odd shape at the bottom of the bronze *Bird in Space* sculptures, one which baffled us both somewhat, had an interesting explanation. This is the form that looks as though it might represent the feet of the bird, the tapered, lithe, streamlined little mound that connects the main volume of the bird with the surface on which it is poised. It could be taken for any pliable substance worked into a curved shape, such as butter or even a dog dropping, and it introduces a curiously supple form having a faint hint of Art Deco or the elegant affectation of Jugendstil. The form derives from nature, however, from the properties of the material itself, from the rather mysterious behavior of molecules in heated metal: when a rod of iron, bronze, or brass is heated white-hot and then drawn out until it breaks at a certain point, the two molten ends assume the shape that we see in the ''feet'' of Brancusi's birds. Could there be a better way to represent the moment of wrenching free, the moment of taking wing, of ''lift-off'' to the sky, than a form that is naturally produced when two bodies suddenly separate, subjected to tremendous force and stress?

Once I became aware of this, I saw in the *Birds in Space* an added measure of beauty. Again I was convinced that in great art by the greatest artists, nothing is arbitrary. Every facet of their work has an underlying motive or explanation.

BRANCUSI AS INNOVATOR

The epigraph of Carola Giedion-Welcker's book on Brancusi quotes James Joyce as follows: ''The movements which work revolution in the world are born out of the dreams and visions in a peasant's heart on the hillside. For them the earth is not an exploitable ground but the living mother.'' This wonderful quotation from *Ulysses* has profound implications for Brancusi's manner of creation and innovation. The formula reconciles the contradiction between Brancusi the uneducated ''shepherd'' and the man who brought three pivotal innovations into twentieth-century sculpture: environmental sculpture, minimal sculpture, and serial sculpture.

Our difficulty in accurately assessing the role of Brancusi stems in part from the fact that his momentous contributions to art came early in his ca-

reer. All three fundamental concepts were present in his work by about 1915. In some ways, all he did thereafter was to deepen and refine what was already there.

Needless to say, few, very few people grasped the significance of these concepts back in 1915. Erik Satie and Marcel Duchamp, the two persons who came closest to him on an intellectual level, probably had a good idea of what he was driving at. However, Satie died quite soon, in 1925, and Duchamp was engrossed in his own art, which in those years was evolving in an altogether different direction. (This, as we know, did not prevent him from having a deep concern for Brancusi's work, acting as his go-between for the next thirty years.)

As we mentioned above, most of Brancusi's pioneering ideas did not compel recognition until the 1960s, and to this day they are not universally accepted by contemporary art circles or by the general public. Conversely, the rather simplistic image of Brancusi as the "mystic peasant" has not made understanding his work any easier. Even if there is some truth in the myth, its crudeness hides from us the intellectual forces behind the sculptural renewal that he wrought between 1905 and 1915.

In the great metaphysical question that enveloped the artistic community during the first half of the century—representational versus nonrepresentational art—Brancusi could not remain totally neutral. His manner of meeting this issue may help us to understand how he was both interested in the theoretical problem, yet not really concerned about it; secondarily, it may offer some light on his thought processes and creativity. The issue sparked heated controversy within his immediate circle; one of the leading advocates was Guillaume Apollinaire. When the Galerie Druet opened its exhibition of Elie Nadelman's work in 1909, the proposition that the formal conception of sculpture should be based on geometry was promulgated with great ardor.

Brancusi withdrew from this debate, which probably seemed superficial to him despite the caliber and ability of his friends who participated in it. In a flash of insight akin to the Zen Buddhist "revelation," he decided that the form of sculpture should come from *within*, and that, consequently, it was only by gazing at the block of stone for long periods of time that the sculptor could achieve the complete fusion of what was in his mind and what was in the material. Of course, this affirmation was considered irrelevant to the discussion, but it was not forgotten. Brancusi also asserted that the physical labor, the energy the human body expends while making a sculpture, had its own importance. Breathing should be natural and, with the rhythm of the arms, should be integrated with the work itself; the sculptor's hand should be guided by an inner picture that has taken shape in his mind. He must look for the image that is found in latent form within the stone. The image must be neither wholly abstract, geometric, or nonrepresentational, nor a representation, a likeness, a repro-

duction of nature, some sort of motif, nor an imitation, an illusion, or in any other way based on a model.

Brancusi's semi-Oriental origin must have had something to do with the background of these ideas. Certainly his interest in Eastern religions, philosophy, and mysticism, such as Zen Buddhism and Tibetan Lamaism, went together with his approach to art, and were intimately connected with it. Brancusi's fascination with Zen and the writings of Milarepa seems to have been altogether intuitive, although it is common knowledge that he had met and talked with such people as George Ivanovich Gurdjieff, and had read Mme. Blavatski's theosophical *Isis Unveiled*.

If we consider the sculptor/shepherd analogy from a more detached, philosophical viewpoint, several aspects of his life and his life style may be seen in a new, highly interesting light. (To make a satisfactory comparison, it will perhaps be helpful to forget for a moment that Brancusi was born in the Rumanian countryside.) A shepherd is bound more closely to the elements than even a farmer; he lives with them constantly. For a shepherd, creation in some way takes place quite by itself, and certainly in a contemplative atmosphere. A farmer works the land, sows seeds, waits until his efforts bear fruit; he actively cultivates his fields. A shepherd keeps watch over the creative forces of nature so that they may operate unassisted. He waits for nature to use her own forces to give him what he needs, and he protects the life that he sees before him.

Kumlinge-Björkö, Åland
July 1983

BRANCUSI: 1876–1957

NATALIA DUMITRESCO AND ALEXANDRE ISTRATI

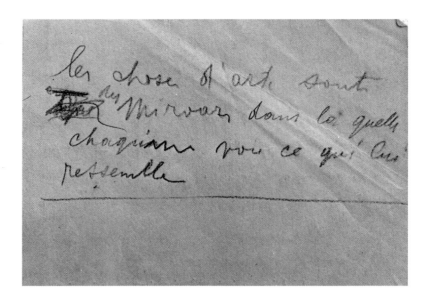

1876–1903:
The Years in Rumania

Here is how Brancusi described the beginning of the life he characterized as "a succession of miracles": "I was born in Rumania, in the sub-Carpathian region known as Oltenia. Life back then was enjoyable and harmonious. For thousands of years, people had been living there happily in accordance with a patriarchal way of life. At meetings, long-haired elders, always seated around a table, made the important decisions; the young men, standing behind them, would listen with respect and hold their tongues. Women were not present at these gatherings. Everything used to proceed in this untroubled fashion, generation after generation. And do you know why things changed? Big-city civilization caught up with us. Midwives and policemen settled in the village, and in no time everything fell to pieces. Abortions, quarrels, brawls, lawsuits—the newcomers stirred up trouble and disturbed the orderliness of days gone by."

Brancusi came from Pestisáni, in the southern Rumanian province of Oltenia. To the west lie the Carpathian Mountains and the Danube; to the east, his beloved Jiu, the river that was to play such an important part in his life. Thus, the region Brancusi called home was an out-of-the-way place, the population uneducated and clinging to traditions and folklore dating back to prehistoric times. Its distinctive architecture, house construction, woodworking techniques, clothing, the famous carpets and other functional objects, and dances like the *calusar* typify this land of vast forests and sweeping lands abounding in orchards and vineyards.

The child was born on February 19; his father notified the authorities on the 21st: "On this day, February 21, 1876, I declare that a male child was born the day before yesterday." For Brancusi, the two-day time lag was a source of great amusement, providing him with an excuse for celebrating his birthday for three whole days.

When Constantin was born, his forty-five-year-old father, Nicolae, already had three sons by a previous marriage. His second wife, twenty-four-year-old Maria Deaconescu, had already borne him two children—both boys—so he hoped eagerly for a girl. He was pacing up and down the courtyard in bitterly cold weather, when the woman next door, who was helping out with the delivery, appeared at the threshold.

"Well, then, is it a girl?"

"Boyar Nicolae, it's a boy. Let us wish him a happy life!"

"I'll send him out to tend the pigs," the father replied, furious.

Later, his wife did bear him a daughter, but he was denied the pleasure of knowing her. Eufrosina came into the world shortly after her father had left it.

Nicolae Brancusi managed the property that belonged at the time to the monastery of Tismana. Comfortably off, he traveled frequently, which was unusual in those days. He had seen Craiova and Bucharest. From the capital he had brought back a novel technique of enlarging windows and of replacing their traditional sheep bladders with fastened panes of glass that could swing open. It caught on at once.

The paternal homestead was a typical example of local architecture. It was built almost entirely of wood, and the roof of little overlapping slabs jutted out over the balcony that wound about the exterior. The hand-carved posts which supported the house were the first works of sculpture the child saw.

Constantin Brancusi's birth certificate, in Rumanian, 1876

This heavily wooded region stretches across the southern Carpathians, where religious ceremonies were observed every winter and spring. The grape-harvest festivities were most to Nicolae's liking. He would invite peasant musicians over to his place, and after work there would be eating, drinking, and dancing. Here is a story Brancusi once told us:

"During one grape-harvest celebration—I was a little over three at the time—they had set up a still in the barn to make plum brandy (*tuica*). To while away the time, some peasants were cooking pieces of pumpkin on the glowing embers under the still. Every now and then they would taste the brandy, to monitor the condensation process, which lasted several days and nights. I decided to ape them and, unnoticed by anyone, I filled my mouth with slices of warm pumpkin and drank the liquor from the hollow of my hand. I

dropped off almost at once on the straw, in a corner of the barn, not far from the still, and was so sound asleep that, when someone saw me, I was given up for dead. They called for help; general consternation; my mother wept. Toward evening, my father came home with the peasants and musicians who had been working in the vineyards, and saw the family signaling to him from a distance that something terrible had happened and that the merrymaking must stop. Everyone was distraught, and even my father was overcome, until someone thought to fetch Baba Brândusa, an old peasant woman and longtime family servant. She sniffed my breath, then picked up some horse manure and brought it right under my nostrils. All of a sudden, I sneezed.

"'He's not dead!' cried all the bystanders. 'He's drunk!'

"And the festivities resumed with renewed vigor, while I slept on. The following day, recovered from my misadventure, I went out into the bright orchard and met my father.

"'Go and gather some small branches!'

"I did this at once, not knowing what he wanted with them. He grabbed me, put my head between his legs, and thrashed my bottom.

"It was then," Brancusi would note whenever he recalled this incident, "that my first great truth hit home. The horizon and the sun were turned topsyturvy, and in a flash I realized that there was more than one way of looking at the world. As soon as my father let me go and set me back on my feet, the spell of this revelation was broken. Things fell back into place."

Constantin did not have an easy childhood. His older brothers thought he was too small and would beat him, not looking kindly upon this stepchild who had only his mother and grandmother to turn to for protection. "*Piei diu ochii lor*" (literally, "vanish from their eyes"), his grandmother advised him. One day, he went with them to the river to wash the horses. When he tried to mount one of them, it bolted and threw him to the ground. He bore the scar on his forehead the rest of his life.

According to one of his own biographical outlines, Brancusi attended the elementary school in Pestisáni from 1884 to 1887, then the school in the hamlet of Brediceni. But he was more inclined to play hooky and seemed bent on leaving home. "Around the end of March [1886]," he noted, "ran away from home for the first time, for one day." It happened again; then, with his father dead and

his brothers more and more unbearable, he told his grandmother in confidence that he had made up his mind to leave home for good. She presented him with a *traista*, a cloth pouch filled with meatballs. He left the village in 1887 and roamed the region for six years, sending home no news of himself.

Whenever Brancusi was asked to submit biographical information for catalogues, he would jot down notes about himself in French and Rumanian. The dates on these sheets of paper are not always consistent, but by comparing this material with the recollections we had heard, we can trace fairly accurately the events of those tumultuous years, when he performed what he described as "Herculean labors."

About the end of March, 1887, he arrived in Tirgu-Jiu, where he spent the next few months working for a dyer by the name of Moscu. He learned how to handle vegetable dyes and how to stain the wool used in manufacturing carpets. Prepared in small amounts as weaving progressed, colored wools give these exuberant specimens of Rumanian folk art their uneven shading and delicately graded tones. "I was a dyer, too," Brancusi was fond of saying.

After a stint as a waiter in a café run by one Doitescu, he left Tirgu-Jiu in 1888 and spent some time in Pestisáni with his half-brother, Nenea Ion, who ran a tavern. By March of 1889, he had made his way to Craiova, where he again worked as a waiter. His first employer was Troceanu, who ran a tavern at the city gates (the Bariera Severinului). Then, off he went to Ion Gheorghiu's tavern, where he picked a quarrel with an employee who did not wish to disturb the boss. Gheorghiu, hearing snatches of their loud conversation, emerged from the cellar and hired Constantin on the spot, struck by his decisive bearing. The work was hard. Since he was short, they would squeeze him through the narrow opening into the wine casks and make him scrub them clean with chains and brushes. The owner gave Brancusi permission to learn the violin in his spare time; while he was practicing one day, Gheorghiu was passing by in the courtyard and a cask came rolling over his feet. Incensed, he cried out, "A cask rolls over my feet while my employees play the fiddle!" Constantin stopped practicing long enough to reply, "If that's how it is, I'll be on my way!"

In June 1890 he took a job with Petre Runcanu, whose tavern was opposite the railway station. Constantin had to open up early each morning for the coachmen who would rap on the tavern front for coffee and

white wine. Since he was also obliged to stay at night until the last customer left, he got very little sleep. One morning he dozed off in the cellar, near the cask. He had neglected to close the tap. Discharged!

Ion Zamfirescu ran the main grocery store in Craiova, and there Constantin proved a satisfactory employee. He worked there until September 1892, when he left to work for a widow who ran a grocery store in the neighboring town of Slatina. He struck up a friendship with her daughter, Stela, and with her girl friends. One evening, there was a masked ball; Constantin dressed up as a girl and played the part so convinc-

ingly that the officers from the garrison made advances to him. One of them chased him into the street and was about to corner him in a blind alley when the counterfeit damsel shook him off with a first-class butt of the head. Now and again, he would tell fortunes by cards and read tea leaves. He learned all about one lady through her acquaintances, unbeknownst to her, and when he read her cards his remarks were so pertinent that she had unshakable faith in his clairvoyance from then on.

As ill luck would have it, the owner-widow ran across the village idiot one evening on her way back from market.

"Y'know what I saw?"

Brancusi's handwritten biographical outline covering the years 1876 to 1913. Archives I–D

Constantin Brancusi, born 1876 in Pestisani, Gorj, to well-to-do landowners from the hamlet of Hobiţa. In 1887, at the age of eleven, he left his village and roamed the country; there was no news of him for 6 years. In October 1894, C. J. Grecescu marveled at a violin he had made and enrolled him in the Craiova School of Arts and Crafts; he completed the usual five-year program of study in four years. In 1892, admitted to the Bucharest School of Fine Arts; diploma conferred in 1902. He then fulfilled his military obligation. The first work to be exhibited was his anatomical study, at the Ateneul Român in 1903. He made a bust of General Davila for the Military Hospital and by early June of 1904 he was in Bavaria, headed for Paris on foot with a pouch slung over his back. In 1905 he enrolled in the Ecole des Beaux-Arts in Paris and in 1906 exhibited work, a bust, for the first time at the Société Nationale des Beaux-Arts. He sent several works to this exhibition over the next four years. He was also represented at the Salon d'Automne, but when he was rejected in 1910 he sent a sculpture carved directly in marble and stone to the Salon des Indépendants in 1912. In 1913 he showed *Maiastra*, a bird in polished bronze. He is the first sculptor to make use of a number of different media. That year, he sent work to the [Allied Artists] exhibition in London and took part in the great International Exhibition [Armory Show] in New York.

"Well, then, what did you see?"

"Master Constantin and Miss Stela in the cellar, rolling in the hay together."

End of Brancusi's stint in Slatina (1892–March 1893). A few days in Bucharest, then back in Pitesti. Brancusi worked for a man by the name of Serbanescu, but left after three months without giving any good reason. He was intercepted at the railway station by the police commissioner, who claimed the right to search his bags on the grounds that his hasty departure might have been prompted by larceny. Finding nothing, the surprised commissioner asked, "Why did you walk out on this decent boss with whom you were on such good terms?" "Well, Commissioner," he replied, "I'm in love!"

Sure enough, Constantin was bound for Slatina to see Stela again, but before long he was back in Craiova and again in the employ of Ion Zamfirescu, 18 Madona Dudu Street. One day, as he was installing some shelves, a musician walked in and congratulated him on his handiwork. They chatted a while, and during the conversation the musician made the following observation: "This is all very well, but one thing you couldn't make is a violin." "Why on earth not?" Brancusi replied. "They are made by men, aren't they?" From that moment on, he was bound and determined to make a violin, and he told us how he did it.

He noticed some pinewood packing crates, pried off a few slats whose grain was still intact, and softened them in water. Then he outlined the exact shape of a violin on a piece of wood with nails and slipped the pliant slats between them; dried, they formed the sides of his instrument. Next, he cut out two thin pieces of wood for the top and bottom, treated them

with oil and shellac, and glued them to the frame. The result was a big success. The gypsies who patronized the tavern snatched the instrument away to play it. It dawned on him later that he had stumbled on Stradivarius's secret for making violins: a flat instrument with the grain running continuously across the wood guarantees superior tone.

Brancusi was to owe one of the customers, Grecescu, a debt of gratitude as long as he lived, for this man enrolled him in the Craiova School of Arts and Crafts, which Constantin attended from 1894 to 1898. Grecescu and Zamfirescu saw to his material needs during his first year at the school. Grecescu also gave him his first tools—a hammer, a saw, a plane—and Brancusi was so touched by the gesture that, as long as he lived, he would present tools to anyone who needed them. "In memory of Grecescu," he would add.

Actually, Brancusi was over the age for admission to the school, but the "admirable" Grecescu pressed the director to admit Constantin as an auditor. By way of a test, one of the teachers asked him to finish carving a lily leaf that the teacher had begun. He made such a good showing that it was impossible to tell his work from that of the teacher.

From then on, he worked like a man possessed, even during Christmas vacation. He was admitted as a regular pupil in his second year, won a scholarship, and managed to complete the last two years in one. In 1896, during the summer vacation, he traveled by boat to Vienna, where he worked for a cabinetmaker by the name of Roth. Vienna became his window on the West.

After returning to Rumania, he resumed his studies and built some pieces of furniture for an

Diploma from the Craiova School of Arts and Crafts, dated September 28, 1898. Archives I–D

Certificate, dated November 29, 1903, authorizing Brancusi to pursue studies at the Bucharest School of Fine Arts. Archives I–D

Autobiographical outline by Brancusi in French and Rumanian (1876–1920?). Archives I–D

examination. He looked on these as only school exercises in a conventional style and attached little importance to them, but on September 28, 1898, he received diploma no. 145. He then applied for admission to the School of Fine Arts in Bucharest and was accepted immediately, after passing his examination with a charcoal drawing of a plaster copy of the *Laokoön*. His teacher was Professor Ion Georgescu.

Life was still far from easy. Unable to attend to his share of the property and orchards he had inherited from his father, Brancusi assigned these over to one of his brothers on October 10. He washed dishes in brasseries and rented a room at 18

Certificate issued by the Bucharest School of Fine Arts for *Ecorché*, completed September 28, 1901. Archives I–D

Vitellius. 1898. Plaster. Muzeul de Arta, Craiova, Rumania (Cat. no. 2*a*)

Izvor Street. One of the friends he made there, Poiana, eventually moved to Paris and later on did Brancusi many kindnesses when he joined him there. Another friend, Croitoru, persuaded him to join the local choral society that he belonged to. Although Constantin had a fine tenor voice, he did not know anything about music. He kept a sharp eye on the chorus leader and would start to sing his part when the leader motioned to him. Croitoru taught him Gregorian and Byzantine chants, whose rhythmic expression seemed to Brancusi a uni-

Autobiographical outline in French and Rumanian. Archives I–D

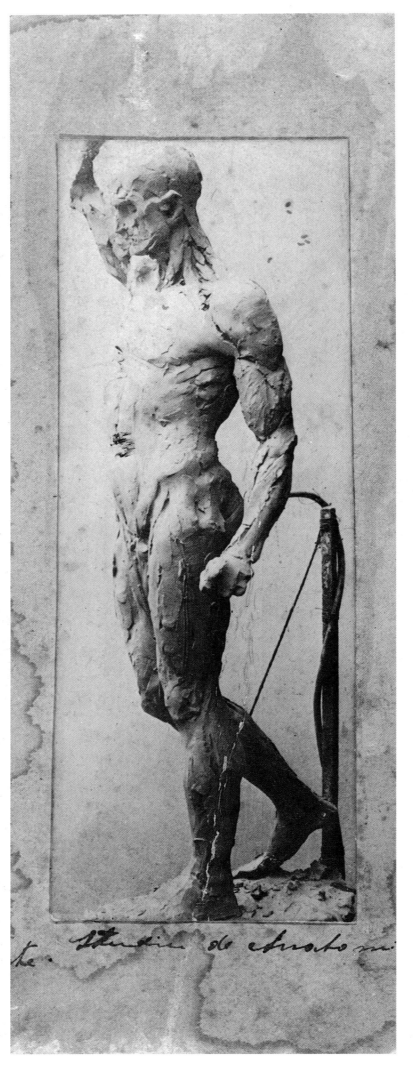

versal harmony, the very wellspring of music.

Izvor Street was also home to Kraus, an artist whose talent won Brancusi's admiration, but who was to die young in Berlin; Gheorghian, a medical student; and Titina, a dressmaker's assistant the friends took under their wing and referred to as "their daughter" for the sake of propriety.

At the end of his first year, Constantin received an honorable mention for his bust of the Roman emperor Vitellius (now in the Museul de Artă, Craiova), which shows great depth of feeling. In 1899, he was awarded a scholarship from the Bureau of Land Management through the Madona Dudu church in Craiova. The following year, he won a bronze medal for a bust after the *Laokoön*. Brancusi kept a photograph of the sculpture in his studio as evidence of his academic ability. "Take a good look at the ancient Greeks," he said to us. "When they depicted contortion and suffering in their sculpture, that was the beginning of their decline. Michelangelo himself fell into the trap."

At the outset, Constantin did not give serious thought to artistic anatomy; but Dr. Dimitrie Gerota, who taught the subject, persuaded him that it was a worthwhile study. On his advice, and at the urging of the director of the school, the painter Mirea, he began work on an *Ecorché* after a *Flayed Antinoüs* that the institution possessed. He was given access to the dissecting room in the School of Medicine, where he dissected the muscles of every part of the body, modeled them in plaster, and put them back together. It won a prize, and he spent the summer finishing it in a steaming hot studio that reeked of formaldehyde. According to a certificate, this anatomical study was completed on September 28, 1901. One copy of his *Ecorché* is in the School of Medicine; another is in the School of Fine Arts in Bucharest. It was first exhibited at the Ateneul Român in Bucharest in 1902.

Constantin finished school in 1902, but was given permission the following year (certificate no. 193) to go on with his studies in the school studio. Was this simply because he needed a place to work, or because he wanted to delay induction into the army? Be that as it may, Brancusi never mentioned making any sculpture as a student except for *Vitellius*, *Laokoön*, and the *Ecorché*. Skillful though he was, he dismissed all of these

Anatomical Study. 1902. Clay. Whereabouts unknown. Photo Brancusi (Cat. no. 14)

Opposite page:
Character Study. 1900. Clay. Whereabouts unknown. Photo Brancusi (Cat. no. 5)

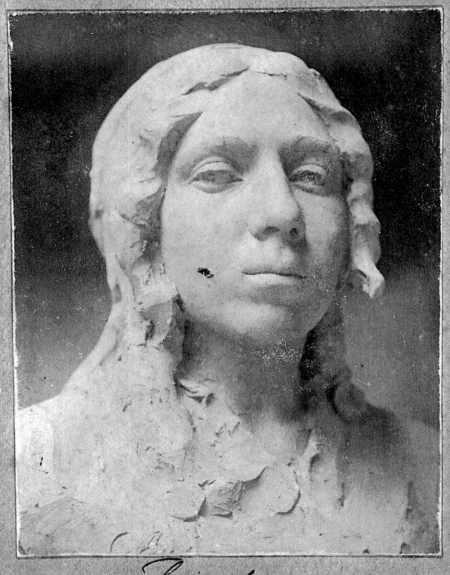

Studiu

Premiat la scóla
arte frumósa din
Bucuresti

Page from Brancusi's military
service record, January 15, 1903.
Archives I–D

exercises as impersonal copies of existing works, or as furniture. "Now," he said to us, "whenever anything from the School of Arts and Crafts in Craiova turns up, they attribute it to me."

In 1898, when Brancusi was first called up for military service, he was granted a deferment. The following year, he twice had to prove that he was actively pursuing his studies. Conscripted in 1901, he failed to show up and was declared a draft-dodger on March 30. He was released on January 22, 1902, and inducted in Bucharest into the sixth (Mihai Viteazul) regiment on April 1. Thanks to his diploma from the School of Fine Arts, he had to serve only one year instead of three; he spent even that year on sick leave and sundry leaves of absence through the help of his "in," Jean Steriadi, a painter friend whose father was an administrative official at Court and recommended the young sculptor to the regiment's commanding officer.

When threatened with fatigue duty by a malevolent warrant officer, Brancusi alerted his friend Steriadi and the threat would be averted; when detailed for guard duty, he would produce a last-minute exemption.

"Just what is the nature of your relationship with the colonel?" the peeved warrant officer inquired.

Brancusi with a double-bass, photographed in Rumania. Archives I–D

Opposite page and left: "Le Génie," Brancusi's poetical text based on his life story, c. 1925. Archives I–D

"Why, don't you know?" replied Brancusi. "My father is his father's father." The officer was left agape.

Brancusi was discharged on January 15, 1903.

According to his military record, Brancusi was a mediocre marksman. Yet, whenever we all went to the street fair on Boulevard Pasteur and the three of us tried to score at the shooting gallery, he was the only good shot. We always came home with an alarm clock or a kilo of sugar he had won and given us as a present.

In 1902, he found time to make a plaster portrait of Ion Georgescu-Gorjan, a Craiova notable and father of the engineer who later built Brancusi's *Endless Column* in 1937. In 1903, he made a bust of Surgeon-General Dr. Carol Davila for the Central Military Hospital, his first work for a public building and his only monument in Bucharest proper. At first, it did not meet with the approval of the military authorities; by the time they decided to have it cast, nine years later, the plaster had deteriorated and the artist was not present to oversee its repair, which was not well done. It was cast in bronze by Rascanu in 1912 and unveiled on September 9. Although dissatisfied with the restoration of the plaster, Brancusi eventually included his *General Dr. Carol Davila* in one of his handwritten biographical outlines.

General Dr. Carol Davila. 1903. Plaster relief. Liceul Matei Basarab, Bucharest. Photo Brancusi (Cat. no. 15)

destinée ou m armén

Tu destinée?

est ce que par des

chemins penible tu

veu que j apprand des

choses nouvelle, ou ver

une fin miserable

tu me tren?

1904: Arrival in Paris

Prodded by that sixth sense which guided him throughout his life, Brancusi set about developing the talent that his teachers had unanimously acknowledged. Feeling that the time had come, he was ready to try his luck with art in the West. In May 1904, he set out for Paris, which he reached on July 14. He made his trip on foot, a pouch slung over his shoulder and a flute for his traveling companion. After stopping first in Vienna and then working for a time in Munich, he reached Rorschach, near Lake Constance, where some peasants welcomed him and gave him food and shelter. He expressed his gratitude by presenting their son with his watch. He enjoyed reminiscing about his exploits and recounted them in the third person in a crude, but graphic French:

"After seven years of Herculean labors, fleeing from town in every direction without finding a job, he went to another, larger town where he learned the arts and sciences, all the while performing backbreaking tasks, and having done everything there was to do and learn in that town, he went farther away, traveling the world over, and arrived one day toward dusk at the shores of the lake in the Black Forest where the Danube begins. To alleviate his weariness, he undressed and went into the lake to freshen up precisely at the spot where the lake fairies disported themselves. But the Muses took offense and punished him, so that he could go bathing no more, the harshest punishment imaginable for him, for he had been brought up on the water almost like a duck."

He stopped off at *Armenhäuser* (shelters) and earned pocket money by doing odd jobs of carpentry. Once he was caught in a downpour and dried off by slipping newspapers inside his clothing. He was getting undressed to take them out when the following day was sunny, but he saw a group of nuns coming toward him and had to jump out of sight into a ditch. He resumed his journey, playing his flute.

He enjoyed telling the following story: "On the way to Langres, I suddenly understood what glory is. Some cows were grazing in a meadow, and I caught sight of one of them behind a hedge. She had her head raised and was gazing blissfully at me with her great big eyes. 'You've cast a spell over her with your music,' I said to myself, so I drew near to get a better look over the hedge and congratulate myself on her contented mood. She was taking a piss. I asked myself, 'What is glory?' As you see, cow piddle, that's all." Brancusi often used that expression and even illustrated it with drawings.

From Langres he sent a telegram to his friend Poiana, who

Three Cows in a Meadow. 1929.
Pencil on paper, 28 × 38 cm.
Archives I–D

had settled in Paris, asking him for a small loan. Poiana replied with a pair of *louis d'or* (twenty-franc gold pieces), enough to cover the cost of a hearty meal and a ticket to the capital, where people were celebrating Bastille Day with flags, brass bands, dancing, and fireworks. "So that's how Paris greets me," Constantin said to himself. "A splendid omen."

First he stayed with Poiana, then moved to 9 Cité Condorcet. He registered with the prefecture of police on September 12 and with his legation on November 12. Then he went out looking for a job, but to no avail. Perhaps there was something wrong with the way he was dressed; Poiana found him a tailor, but still no work came his way.

"I wandered about all day Wednesday, in the rain that morning, in sunshine that afternoon. I dropped in on many sculptors, but all I found was destitution. As I was leaning out a window, I caught sight of 'Costache' [diminutive of Constantin, i.e., himself] in a mirror hanging from the window frame. He was ashen, sad, dispirited. With trepidation I asked him, 'What's the matter, Costache?' He gazed and gazed at me with a gentle, an indescribably gentle look, and big teardrops started to trickle down his face."

At long last, Poiana found him a job as a dishwasher in the Brasserie Chartier. Brancusi noticed that the water heater for the kitchen was located above his sink, so he filled his tub with hot water and washed glasses in it; that way, they dried quickly. But a strapping fellow-worker who did not like him accused him of "brownnosing the boss" and, as the two were leaving work one day, he started to beat him up. Constantin felt he had the strength of ten and fought back, knocking him to the ground. A policeman who witnessed the scuffle touched him on the shoulder and said, "Enough, enough." The assailant steered clear of the dishwasher after that. Brancusi recounted this exploit with pride.

He took up sculpture again in his spare time. On June 23, after an interview and on the recommendation of Louis Herbette, a member of the Council of State, and Ghika, the minister plenipotentiary from Rumania, Brancusi was given permission to sit in on the studio of Antonin Mercié at the Ecole des Beaux-Arts. Since March 1905, he had been living in a garret at 10 Place de la Bourse. One day, he ran into Steriadi—the friend who had got his term in the army reduced—and told him about his plight. Whereupon Steriadi replied, "The priest of the Rumanian Orthodox Church on Rue

Certificate of registration with the police prefecture in Paris, 1904; renewed January 5, 1916. Archives I–D

Certificate of registry with the Rumanian legation in Paris, November 12, 1904. Archives I–D

Jean de Beauvais is looking for a sacristan for Easter. Go see him!" When Brancusi showed up, they asked him to sing something with that fine tenor voice of his… and he was hired to clean up, ring the bells, and light the censers.

"I would wave the censer, then draw back the curtain. When the priest read before the altar, I would light the candles in front of the icons. Then I pulled the bell cord and lighted all the other candles."

They dressed him up as a deacon, but—this was only the first mishap—he was unable to tell a worshiper when vespers began. The priest lost his temper and wanted to put him out then and there, but with the holidays fast approaching, what would he do without a deacon? The day before Easter, Constantin was instructed to be on the lookout for the minister and the Rumanian colony, so that when they arrived the priest could

Letter from Louis Herbette recommending Brancusi to Antonin Mercié, June 19, 1905. Archives I–D

give them a ceremonious welcome. Ensconced near a basket filled with brightly colored eggs, he felt ravenous and started to devour them with such gusto that he failed to notice that the minister had made his entrance. *"Mi-o facusi, Brancusi"* ("That was a dirty trick, Brancusi"), muttered the infuriated priest, and the next day, Constantin was dismissed. Later on, someone reminded him of that Rumanian expression and observed that he had worn many hats, but never that of priest. "Oh, yes I have, too," Brancusi retorted and, as proof, produced a photo of himself as a deacon.

In dire straits again, Brancusi wrote to the Minister of Education in Bucharest for a scholarship. "... Dr. Gerota is sending me 25 lei every month, which comes to roughly half of what I need to pursue my studies. If you would be so kind as to match that amount from your end, I could go on with my studies for a year, and afterward I could come back home." Not only was he granted a stipend of 600 lei, but it was renewed every year until 1908. Nevertheless, he wrote to Kraus in Berlin, "If you can live right where you are, even if it means having to tighten your belt, do not ven turehere. ... If you do come, let me know ahead of time so that I can sweep out the studio." But the letter came back; Kraus had died. In January 1906, Brancusi received a certificate from the Ecole des Beaux-Arts: "Shows promise and making steady progress," was the evaluation of Antonin Mercié.

About this time, two women from Rumania, Otilia de Kozmutza and Maria Bengescu (who had sat for Rodin), suggested that they could arrange to have Brancusi meet the famous sculptor, then at the pinnacle of his career. Brancusi had a meal at Meudon, and Rodin proved a genial host. Brancusi told us about it:

"Before the meal, a lady happened to pass by in the garden. 'Hey, Turtle!' Rodin cried out to her. But the lady did not answer. Whereupon Rodin turned toward us and said, 'The Turtle is cross today.' The woman who later became Rodin's wife had not been invited to the meal and had taken offense."

When we got back, the ladies asked Constantin what were his thoughts. "It was smashing all around. The thing I was most taken with was the champagne." "But don't you see?" they said. "Rodin has agreed to have you work with him. It's phenomenal!" "My dear ladies," Brancusi said calmly, "get it into your heads that 'Nothing grows in the shade of a tall tree.'" "He's right," Rodin conceded when this remark was

reported to him. "He's as stubborn as I am."

On October 27, 1906, Brancusi vacated his rat-infested lodgings and moved into 16 Place Dauphine. His work was first exhibited in Paris at the Salon of the Société Nationale des Beaux-Arts (*Bust of a Boy*) and at the Salon d'Automne (*Pride* and *Portrait of M.G. Lupescu*).

Constantin's vitality was irrepressible. He had no costume for the Bal des Quat'Zarts, so he wrapped himself up in a sheet and sported a colander instead of a hat, with a feather duster for an aigrette. He was present at the opening day of the 1907 Salon of the Société Nationale des Beaux-Arts, but some friends of his had to chip in because he could not afford to rent the obligatory top hat and tails. Four of his sculptures were accepted for that year's exhibition: *Portrait of Nicolae Dărăscu* (bronze), *Torment* (plaster), *Head of a Boy* (plaster), and a roughed out *Head of a Boy*. The catalogue also listed *L'Homme qui marche*, a striding headless figure by none other than Rodin:

"Master, you see my sculptures," Brancusi said to him. "what do you think of them?" "Not bad, not bad," muttered Rodin, a man of few words. Brancusi pressed him. "Anyone can answer me, 'Not bad, not bad.' But from you, Master, I expect something more." "Very well, then," Rodin replied, "you mustn't go so fast."

Nonplussed at first, Brancusi suddenly grasped what he meant by that remark. Rodin was right: virtuosity could be just an easy way out and might even prove an impediment. Hadn't he once turned out a nude in a single day?

Brancusi then met up with Antonin Mercié, and asked what was his teacher's opinion. "It's easy to do sculpture like this," said Mercié, pointing to Rodin's

work, "with no head ...," then pointing to his pupil's *Portrait of Nicolae Dărăscu*, "and with no arms!"

Struck by these conflicting reactions to sculpture, it dawned on Brancusi that there would have to be another way: his own. That opening day made a lasting impression on him, and he often talked about it.

On May 7, 1907, a letter from the Minister of Education in Bucharest informed him that his plaster *Bust of a Boy*, which the Tinerimea Artistică VI of Bucharest had exhibited in March that year, had been purchased for 700 lei by the Art Museum of the Rumanian Academy. (We know from a postcard that Stefan Popescu sent him on May 23 that Brancusi also exhibited a plaster, *Portrait of G. Lupescu*.)

Repose. 1906. Plaster. Whereabouts unknown. Photo Brancusi. (Cat. no. 24)

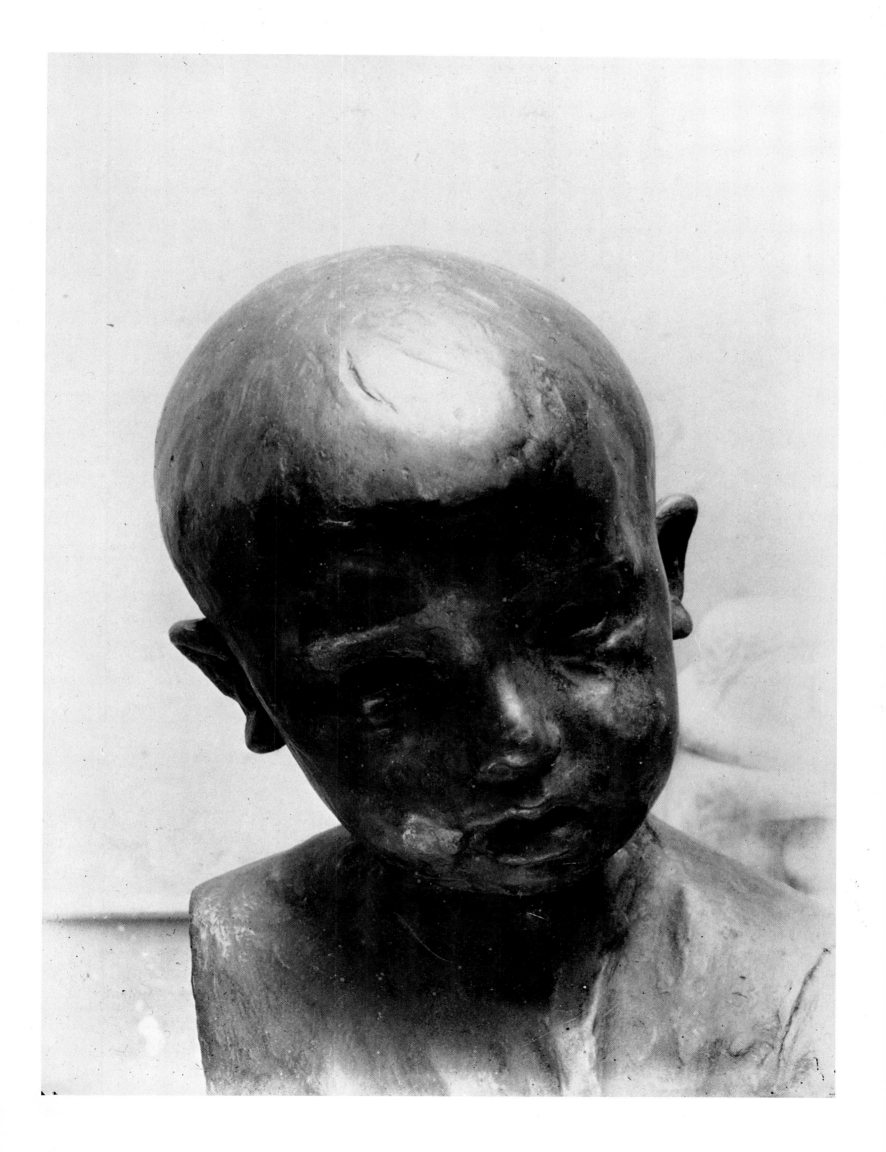

propos

La taille directe, c'est le vrai chemin vers la sculpture mais aussi le plus mauvais pour ceux qui ne savent pas marcher. et à la fin, taille directe ou indirecte cela ne veut rien dire, c'est la chose faite qui compte.

Le poli, c'est une nécessité que demandent des formes relativement absolues de certaines matières. il n'est pas obligatoire, même il est très nuisible pour certaines autres formes.

1907–1913:
The Turning Point

The year 1907 marked a turning point in Brancusi's work. The widow of Petre Stănescu, a prominent citizen, wished to erect a monument to her late husband in Dumbrava Cemetery in Buzău, Rumania; the commission went to Brancusi, on the recommendations of Prof. Gerota and Stefan Popescu, a Rumanian painter. The contract, signed on April 18, called for a large allegorical figure at the foot of a pedestal, six feet high, supporting a bust of the deceased. Given a project of this scope, Brancusi sensed that his style was about to undergo a radical change. The sheer size of the pieces in question dictated the use of a ground-floor studio, which he found at 54 Rue du Montparnasse; although he did not notify the police commissioner's office of his change of address until March 24, 1908, a postcard dated November 28, 1907, sent by registered mail from Irina Blanc in Rumania to Brancusi at 16 Place Dauphine, was forwarded to 54 Rue du Montparnasse, proving that he was already in his new studio.

The contract stipulated that the bust of Stănescu would have arms and that the allegorical figure at the foot of the pedestal would depict a mourning woman. Brancusi's initial plans harked back to his earlier work, but none of their concepts seemed to satisfy him. What if he were to do away with conventional approaches? "A realistic nude on a tomb is unthinkable," he said to us. "Kids would come along and tickle its buttocks and the soles of its feet."

After much hard work, he ended up for the mourner with *The Prayer*, a hieratic praying figure of great simplicity. He had confidently let himself be guided by his memory of Byzantine art, so deeply rooted in his native Rumania, toward a new approach that would prove to be a springboard for future work as well as a watershed in the evolution of contemporary sculpture.

At first, the kneeling woman had her arms stretched out in prayer, "But I didn't feel comfortable with it," Brancusi told us. "It looked to me as if, instead of praying, she felt cold." Since he did not seek to create a realistic gesture but to convey a sense of the concentration of

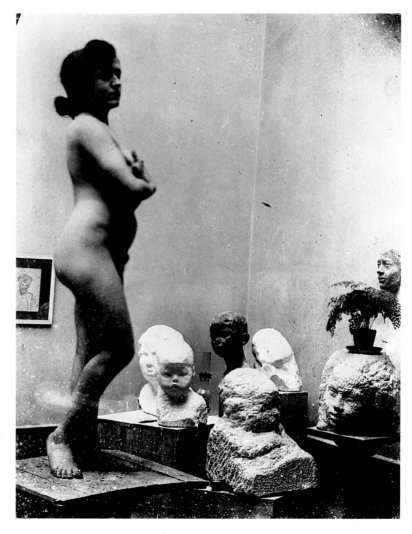

Brancusi's studio, 54 Rue du Montparnasse, with model, c. 1907, including **Torment III** (Cat. no. 33), **Child's Head** (Cat. no. 38), **Bust of a Boy** (Cat. no. 39), **Head of a Girl** (Cat. no. 37), and **Head of a Boy** (Cat. no. 30). Photo Brancusi

prayer, he tried a different movement for the arms: one was only roughed out, the other indicated entreaty. "At that moment," he added, "I succeeded in getting rid of the beefsteak" [i.e., "cutting off the fat"]. This marked the beginning of an asceticism that would work far-reaching changes in his art and, later on, his life.

The contract read as follows:

The undersigned, Elisa Petre Stănescu, landowner, residing in Buzău, Rumania, and Constantin Brancusi, sculptor, residing at No. 16, Place Dauphine, Paris, have agreed to the following:

I. I, Constantin Brancusi, promise to execute personally for Madame Elisa P. Stănescu a funerary monument for the sum of seven thousand five hundred (7,500) lei. This sum covers the execution of the monument in its entirety as well as its transport from Paris to the railway station in Buzău, Rumania.

The monument shall consist of the following pieces:

a) a stone base from 2 m. to 2.5 m. [6'6" to 7'8"] high;

b) an allegorical figure of a mourning woman next to the base;

c) a bust with arms, which likeness is to be made after photographs Madame Stănescu shall make available to me.

Both the allegorical figure and the bust shall be cast in bronze and shall be slightly larger than life size.

The work shall be completed no later than the end of February 1908.

II. I, Elisa Stănescu, promise to pay M. Brancusi 7,500 lei for his work as follows:

500 lei in May 1907, after which I shall remit a monthly payment of 500 lei until September 1907;

From October on, I promise to remit 250 lei per month until such time as the work is ready to be cast in plaster, at which time I shall send M. Brancusi 1,000 lei required for the procedure;

I promise to remit the entire balance due on the total of 7,500 lei at the end of January 1908, before the work is cast in bronze.

M. Brancusi shall not proceed with this work without my written consent.

Signed by both parties in Paris, April 18, 1907, in duplicate, with a copy to each signatory.

C. Brancusi
El. P. Stănescu

The moment a great artist makes an essential discovery, his creative impetus is transmitted to other artists. In 1907 Picasso painted *Les Demoiselles d'Avignon*, a seminal work of

The Prayer, project for the Stanescu Monument. 1907. Gouache (signed on right), 42 × 26 cm. Private collection

Preliminary model for **The Prayer.**
1907. Clay. Whereabouts unknown.
Photo Brancusi (Cat. no. 43a)

Opposite page:
The Prayer. 1907. Plaster.
Whereabouts unknown. Photo
Brancusi (Cat. no. 42a)

Below:
Stanescu Monument with **The
Prayer,** Dumbrava Cemetery,
Buzau, Rumania. Installed 1914.
Photo Brancusi (Cat. nos. 42b, 44)

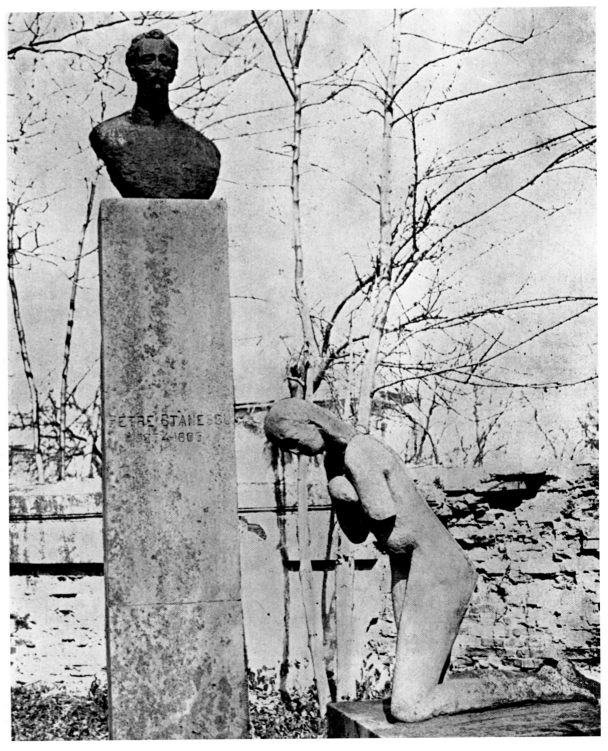

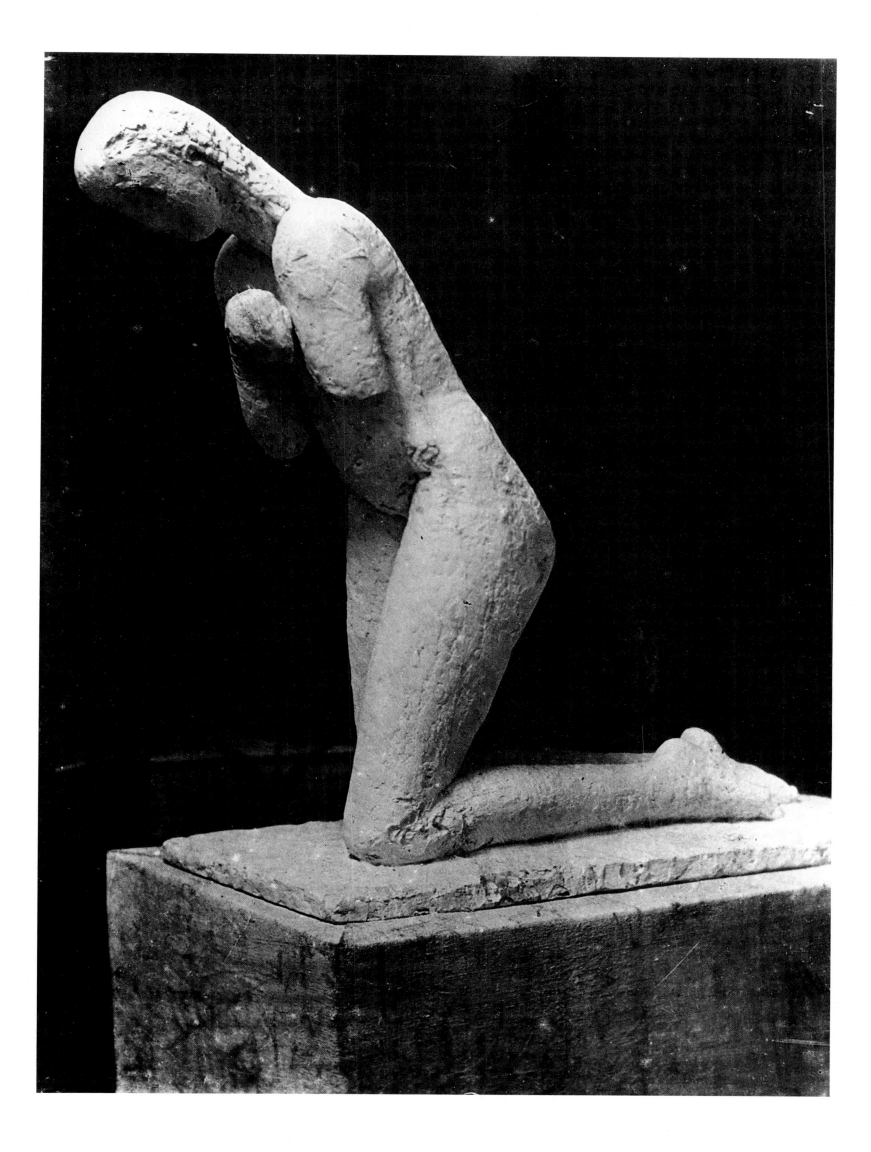

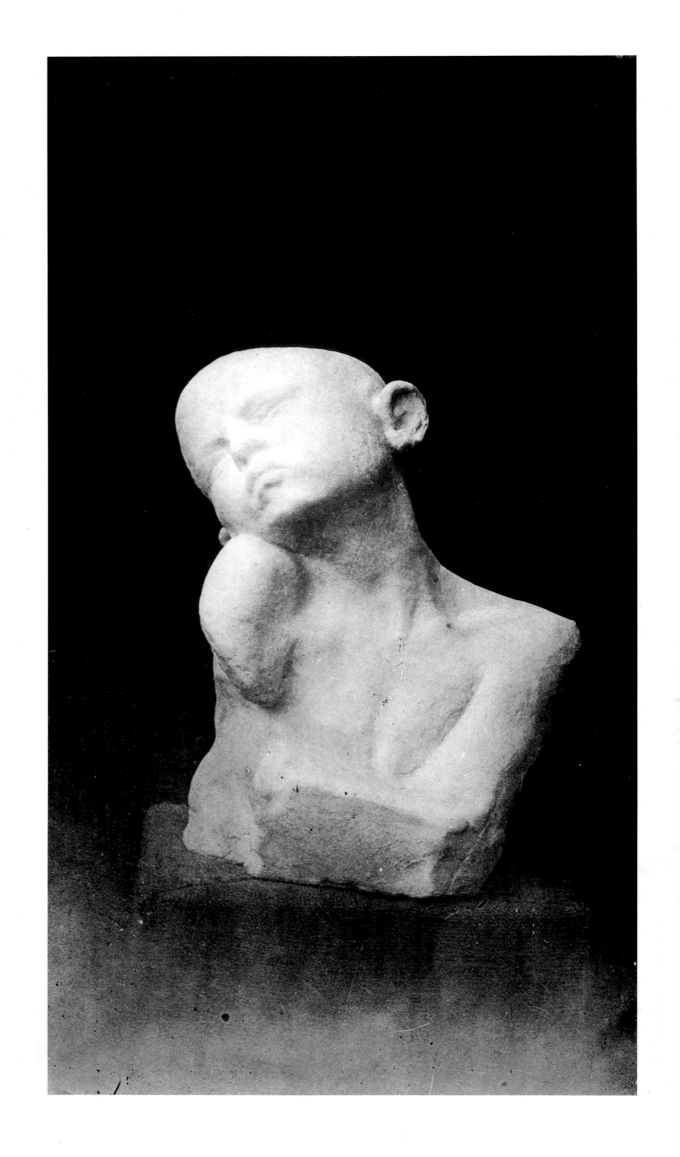

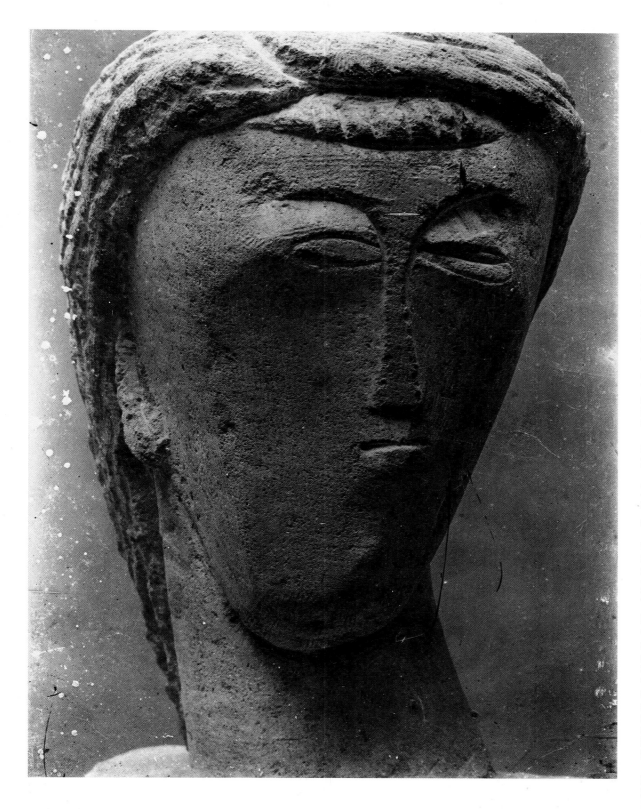

Head of a Girl. 1907. Stone.
Whereabouts unknown. Photo
Brancusi (Cat. no. 40)

Opposite page:
Torment I. 1907. Plaster.
Whereabouts unknown. Photo
Brancusi (Cat. no. 31*a*)

Cubist painting; *The Prayer* also
set the tone for contemporary
sculpture. The first Futurist
manifesto appeared in 1909; the
following year, Kandinsky
painted his first abstract
gouache and wrote *On the Spir-
itual in Art.*

The Prayer, cast in bronze by
Valsuani and exhibited in 1910
at the Salon des Indépendants,
was shipped to Rumania, creat-
ing some unrest among the citi-
zens of Buzău before it was
erected in 1914. But things
calmed down after the monu-
ment was in place. The Stănescu
commission was providential
both for Brancusi and for mod-
ern art. It seemed to bear out

the artist's well-known observa-
tion, ''My life has been a succes-
sion of miracles.''

Simplify form, weed out de-
tails... but where does reality
lie? In outward forms or in the
essence of things? One day, as
Brancusi was working from a
live model, it occurred to him
that the more he copied the real
world, the more he was ''mak-
ing corpses.'' His conclusion: he
would have to get at the essence
of things.

Little by little, he ceased to
work with clay, which is contin-
ually kneaded and added to the
roughed-out sculpture. As Bran-
cusi saw it, ''modeling [with
clay] is not sculpting. Sculpt-
ing—*sculptura* in Latin—con-
sists of carving directly into the
material so as to divest it of un-
necessary parts.'' This method,
known as direct carving (*taille
directe*), makes allowances for
the material being worked, with
each one calling for a particular
technique. Thus, a block of
stone can become a serious,
moving, pure work of art. The
more that what Brancusi called
''the beefsteak'' is cut away, the
closer the work of art ap-
proaches the essential.

From this year date also *Head
of a Girl*—all that remains is a
photograph of it with the nota-
tion *première taille directe*—
and another stone sculpture,
The Kiss. Brancusi exhibited at
the Salon d'Automne; *Luceafar-
ul,* a Rumanian newspaper,
mentioned this, and published a
photograph of the sculptor on
his way to Paris.

Brancusi continued to live at
54 Rue du Montparnasse until
October 10, 1916. (A rent re-
ceipt from 1907 suggests that he
also had a lease for premises at
23 Rue d'Odessa). In the studio,
which looked out onto a small
courtyard, he set up a forge and
anvil, and slept in a casually ar-
ranged bedroom upstairs. His
neighbor was Edward Steichen,
the American painter and pho-
tographer.

Through Mme. de Kozmutza,
Brancusi met Baroness Renée
Frachon and her husband in
1907. The elongated face of the
baroness was well suited to the
sculptor's current manner, and
she agreed to sit for him. The
sessions took place from Janu-
ary 1908 to 1910, for the Fra-
chons, indefatigable travelers,
were often away from home.

A correspondence began at
this time that was to continue
throughout the sculptor's life. ''I
have consulted my schedule for
this week,'' the baroness wrote
on January 1, 1908, ''and I could
be free on Saturday from two-
thirty to four.... I can also come

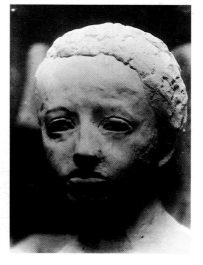

Head of a Girl. 1907. Clay.
Whereabouts unknown. Photo
Brancusi (Cat. no. 35)

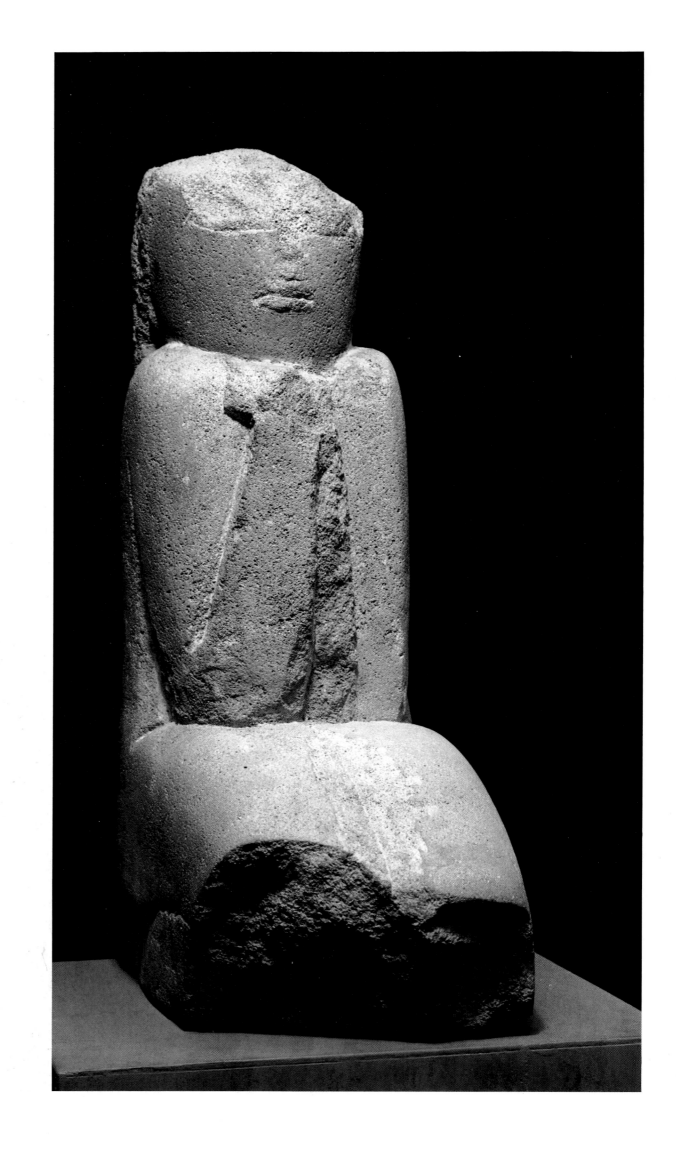

over on Monday the 8th and Tuesday the 9th...." "I shall come to see you and the studies for the 'masterpiece,'" reads a letter from 1909, "and I can't wait to admire it all." Later on: "I trust that in these ten sittings you will be able to finish the 'masterpiece.' I shall come over Wednesday to pose for the head, though I may not be able to wear a low-necked dress. But on Thursday, I shall pose only for the shoulders."

"I shall come over tomorrow at three-thirty," she wrote on June 30, 1910, "and I'll give you a good sitting which will be the last one this summer, as I am leaving in a few days." In 1917 she wrote, "The *Muse* likes it at my place." (Later she would present her version of *Sleeping Muse* to the Musée National d'Art Moderne in Paris.) At one time, the baroness maintained that Brancusi had his dates wrong and that she had sat for him in 1915. The sculptor, who kept all the letters from those years, smiled: "She's probably trying to make herself out to be younger than she is."

The first version in stone was titled *Baroness R.F.*; this was followed by *Sleeping Muse,* a recumbent marble head with cleaner lines (Hirshhorn Museum and Sculpture Garden, Smithsonian Institution, Washington, D.C.). Brancusi's portrait of Baroness Frachon marked the starting point of an evolution that was to culminate in the ovoid, a form developed both horizontally—witness the primordial perfection of *Beginning of the World* or *The Newborn*— and vertically, defying gravity and becoming all but ethereal.

In 1908, Brancusi also made what he considered his first direct carving in marble, *Sleep* (Museul de Artă R.S.R., Bucharest), which was bought in 1909 by Anastasiu Simu, who had a large museum built in Bucharest. Simu did not like Brancusi's most recent style, however, preferring Bourdelle and Rodin, and acquired no other works from this period, not even *Sleeping Muse,* though the artist offered it to him on favorable terms, anxious to have an example of his latest manner exhibited in Rumania. As things turned out, Brancusi later got a better price for it. ("Because of that sale," he said, "I managed to

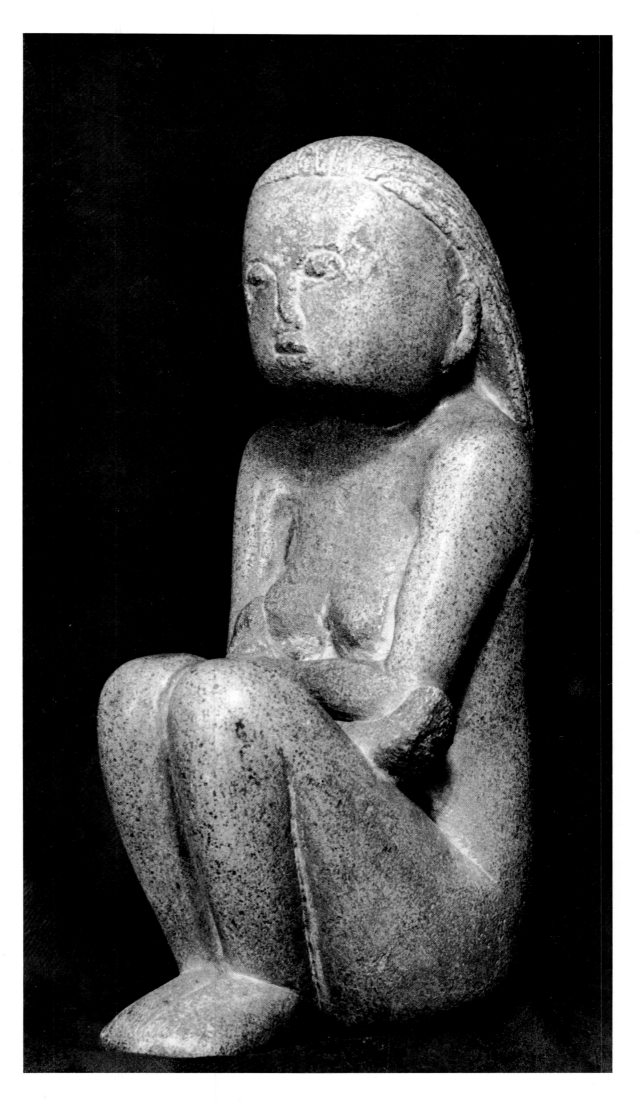

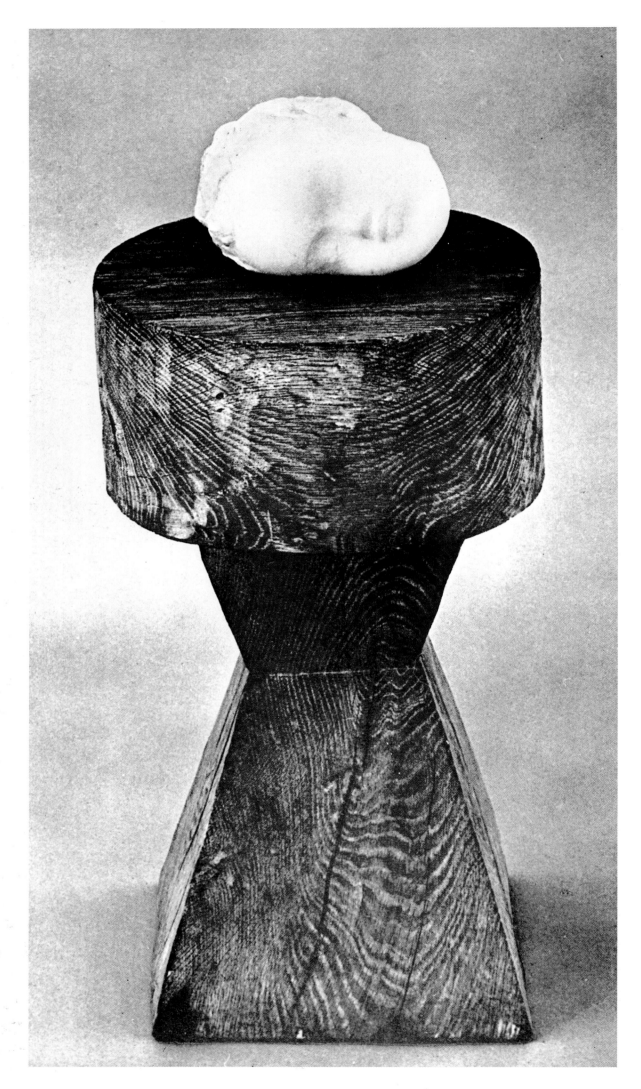

Right:
Sleeping Child. 1908. Marble.
Whereabouts unknown. Photo
rights reserved (Cat. no. 51)

Opposite page, above:
Sleeping Muse I. 1909–11. Marble.
The Hirshhorn Museum and
Sculpture Garden, Smithsonian
Institution, Washington, D.C. Photo
John Tennant (Cat. no. 60a)

Opposite page, below:
Sleeping Muse I. 1910. Bronze.
Brancusi Studio, MNAM, Paris (Cat.
no. 62a)

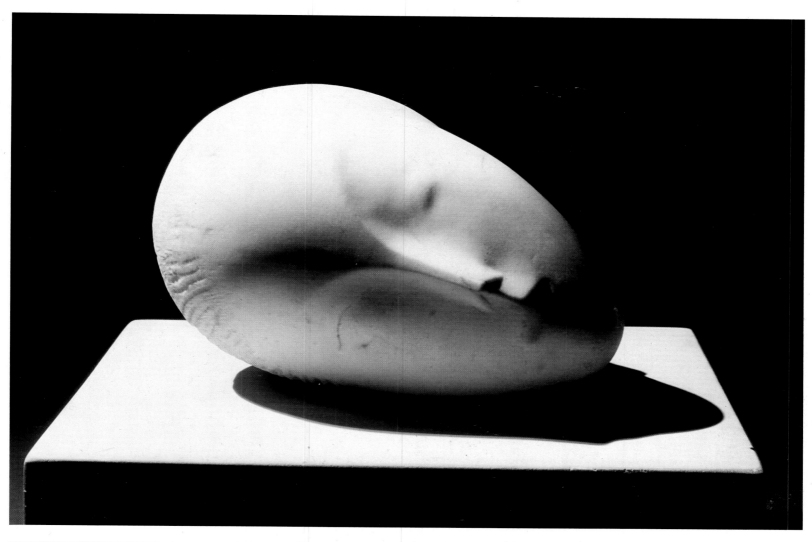

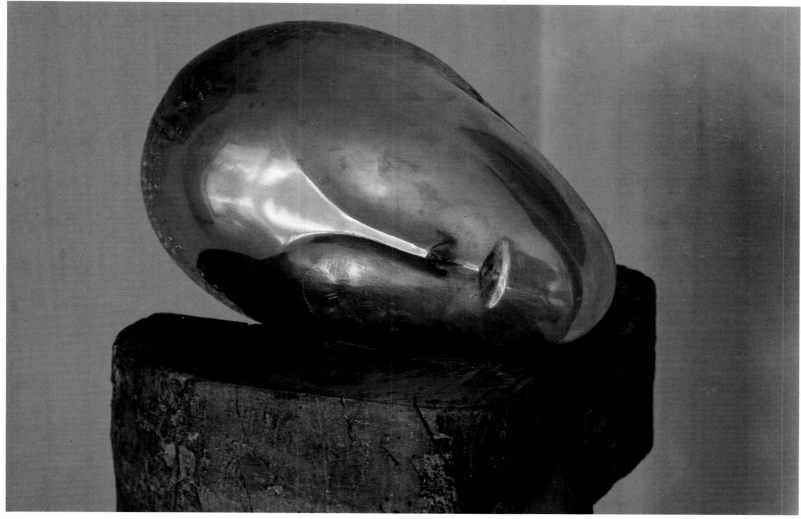

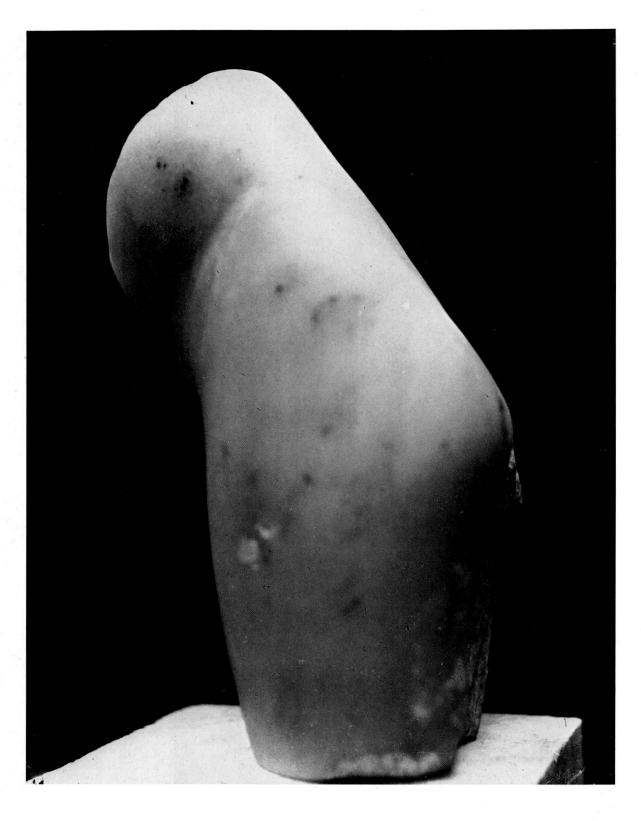

Torso of a Girl. 1909. Marble. Muzeul de Arta, Craiova. Photo Brancusi (Cat. no. 54*a*)

weather the whole trying period from 1914 to 1918.'')

In 1909, Brancusi met Amedeo Modigliani through Dr. Paul Alexandre. In addition to *The Kiss*, he made *Torso*, which was the prize for a raffle that some Rumanian friends arranged to help the sculptor out; the winner was Victor Popp, and Brancusi then sent him a postcard of every new work he turned out. After the raffle, the sculptor received a sum of money and a list of fifty people to thank. Writing fifty letters seemed an onerous task to him. He bought a straw hat, went to a brasserie in the Latin Quarter, and started to drink.

''While I was drinking beer, the orchestra played *O Sole Mio*. I clapped and ordered another one, then took it into my head to slip the musicians something so that they would play the tune again. Another round of applause, another glass of beer, another tip to the orchestra. A third time, and a fourth, and a fifth. People around me started to protest, but I went right on slipping coins to the orchestra. The exasperated customers started to pound on the tables. When the racket was at its height, I was asked to leave the premises.

''This had gone on so well, I couldn't stop there. I remem-

bered a dance hall in Montmartre. Off I went. As soon as I walked in, I started to dance and pinch the backsides of the waltzing ladies. I was asked to desist, but with the help of the beer I started all over again, and then some. The owner called a thug to throw me out. But a few people took pity on me, and the owner let me stay provided I kept quiet. But when the music started up again, I couldn't resist. They tossed me out onto the sidewalk. It occurred to me that I'd lost my hat. I asked for it back. They assured me when I went back in that I didn't have any. There was nothing left to do but say

Sleep. 1908. Marble. Muzeal de
Arta R.S.R., Bucharest. Photo
Brancusi (Cat. no. 50)

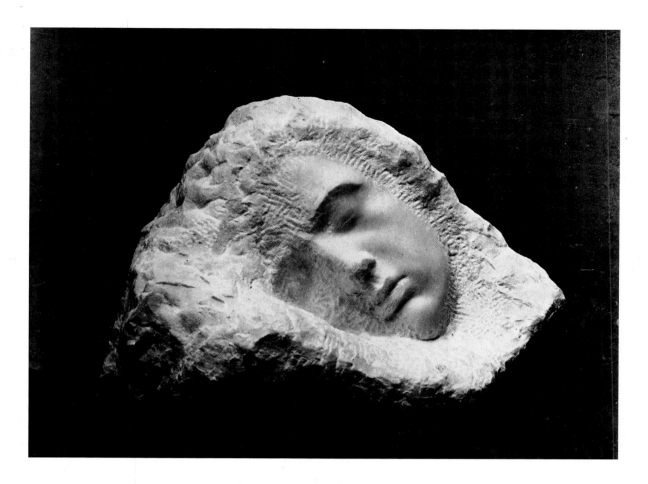

Below:
Sleeping Muse. 1909. Marble.
Collection Rumsey, New York.
Photo Brancusi (Cat. no. 60*b*)

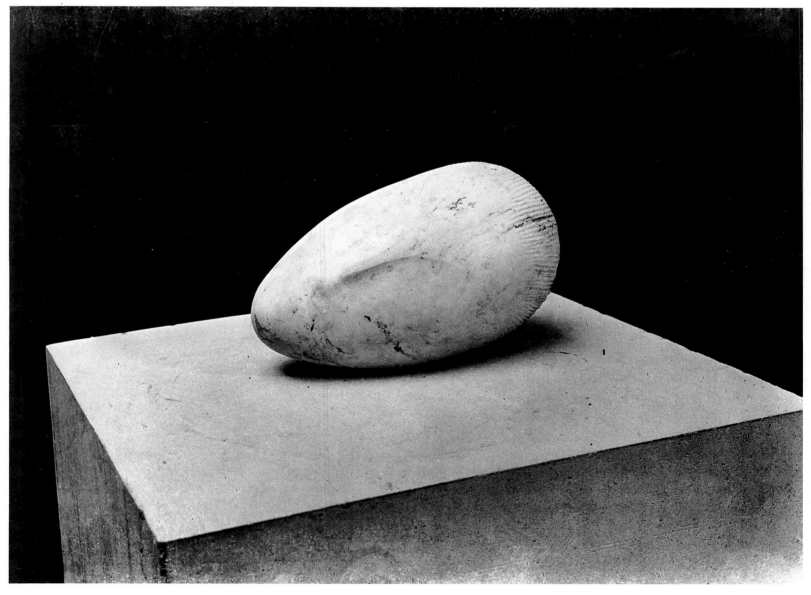

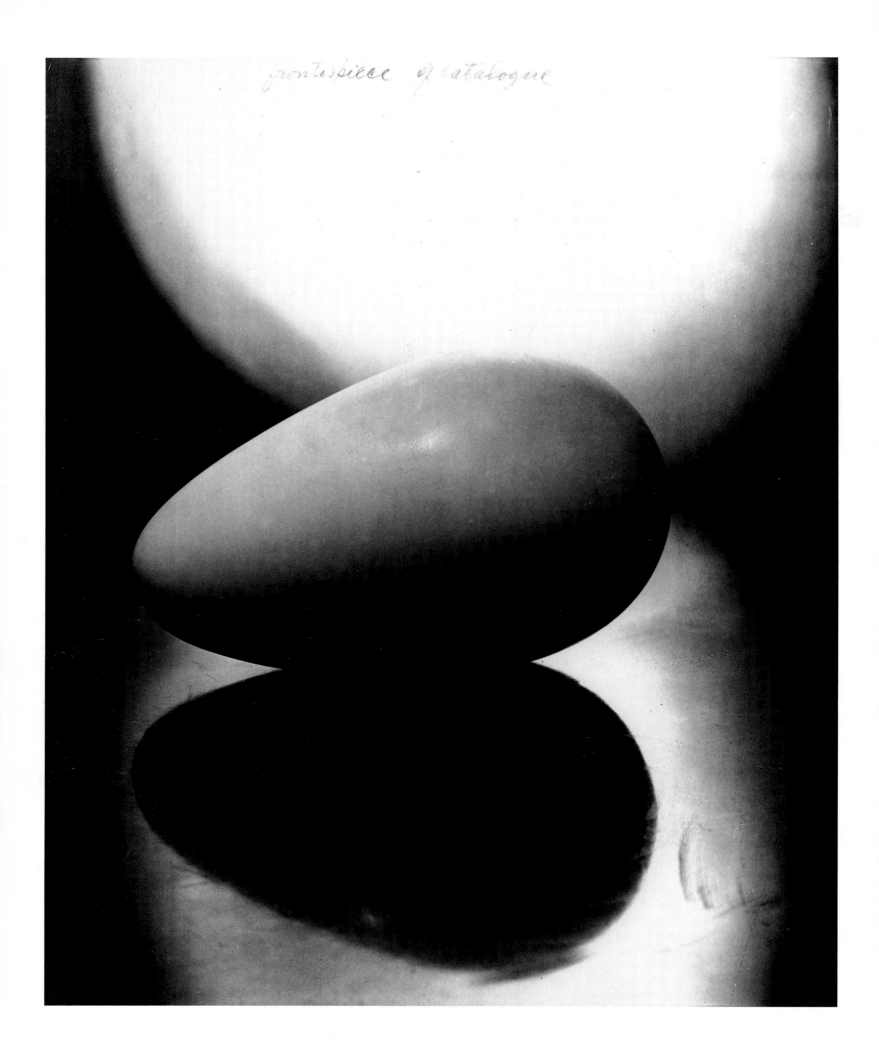

frontispiece of catalogue

Beginning of the World. 1920.
White marble on polished metal
disk. Whereabouts unknown. Photo
Brancusi (Cat. no. 115)

good-bye to it." The money from *Torso* had flown away, and with it the thank-you notes.

In 1907, Brancusi had carved a stone sculpture (28 cm; 11 ins.) on the theme of the kiss. He returned to it in 1909, and an unusual fate awaited this taller version (89 cm; 35 ins.). A friend of his, Dr. Marbé, put him in touch with the Rachewskys, whose daughter, Tatiana, had committed suicide after an unhappy love affair. At the parents' request, Brancusi suggested a monument that symbolized love and showed them *The Kiss*; in 1911, it was placed over their daughter's grave in Montparnasse Cemetery. The epitaph, which Brancusi carved in Cyrillic characters, reads "Tanioucha Rachewskaia/Born 6 April 1887/ Died 22 November 1910/ Dear, lovable, beloved." At the foot of the base grows ivy, one of the sculptor's favorite plants. (Later his studio on Impasse Ronsin was blanketed outside with ivy, and he gave cuttings to anyone who admired the plant.)

A letter from Dr. Marbé, dated October 14, 1911, suggests that *The Kiss* was not to the Rachewskys' liking:

"Dear Brancusi,

"After you left the laboratory, I told my colleague about my concerns regarding the bust of Tanya.

"You will recall that my colleague saw the bust you made of Tanya when he called at your studio. He became even more enthusiastic when he saw the same bust in plaster at my place. Knowing, moreover, that the Rachewsky family does not care at all for the 'artistic stele' you made for the grave, I convey at his suggestion the following changes, so that everyone will be satisfied. I will take the stele for myself, the bust you made will go on the grave, and a copy after the plaster bust will be sent to Russia. The idea is plain as daylight. That way, I'll have something by your hand, and Mr. and Mrs. Rachewsky will no longer feel uncomfortable when they go to meditate at the grave that is so dear to them. The artist's ego of Rachewsky the sculptor will be appeased; and as for you, if there's nothing to prevent you, you'll have another bust to do...."

The artist did not take Marbé up on his proposal, thinking that the only suitable theme for the grave of a young woman who had taken her own life for love was the symbol of love itself. With the intuition that inspired him when he made *The Prayer* at Buzău, Brancusi had again committed himself to the renewal of funerary sculpture.

While on the subject of *The Kiss*, the visit paid by a Polish

The Kiss. 1909. Stone, Rachewsky monument. Brancusi painted the background of the photograph in gouache to bring out the sculpture. Montparnasse Cemetery, Paris. Photo Brancusi (Cat. no. 56)

art historian to Brancusi shortly before his death should be mentioned. During the interview (in our presence), he mistook Brancusi's pronunciation of *l'amour* for *la mort*, and subsequently developed his slip into an article, maintaining that the design of the arms and legs forms the letter 'M' for *mort*. This interpretation, often quoted, is, we repeat once more, completely erroneous. For Brancusi, *The Kiss* was a tribute to love.

On September 2, 1910, Henri Rousseau, a man Brancusi marveled at and admired, died at the Hôpital Necker. "He was open, decent, and upstanding," said the sculptor. "He supposed that everyone was like him, and credited them with the same purity. He was not naïve but he did have much candor."

"In art," Brancusi wrote elsewhere, "you should not look for naïveté. What you see in primitive art is not naïveté, but strength and will. It's an indomitable will that comes from within, which nothing can alter or impede. It's the beauty that grows like a plant and develops as it was meant to." Brancusi once attended a gala that Picasso and his friends had arranged in Rousseau's honor. There were bombastic speeches, and Rousseau got so wrapped up in them, he did not realize that a

Far left:
Invoice from Schmit, a marble dealer, for the Rachewsky monument in Montparnasse Cemetery, Paris, April 13, 1911. Archives I–D

Left:
Document for the inscription on the Rachewsky monument, Montparnasse Cemetery, Paris

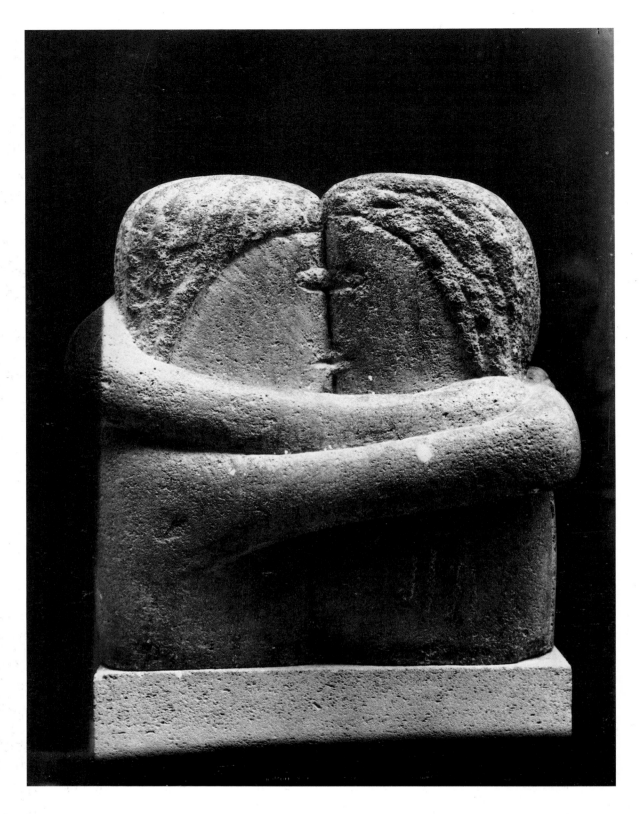

Above:
The Kiss. 1907–8. Stone. Muzeul de
Arta, Craiova. Photo Brancusi (Cat.
no. 45*a*)

Henri Rousseau's visiting card.
Archives I–D

Left:
The Kiss. 1909. Stone, Rachewsky
monument. Montparnasse
Cemetery, Paris. Photo Brancusi
(Cat. no. 56)

Opposite page:
Narcissus Fountain. 1910. Plaster.
Brancusi Studio, MNAM, Paris.
Photo Brancusi (Cat. no. 58*a*)

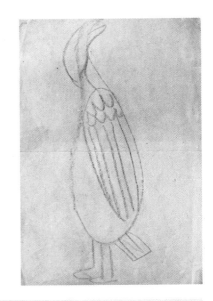

candle was dripping wax from a ceiling fixture, drop by drop, on his head.

The neighborhood shopkeepers, according to Brancusi, liked Rousseau and provided him with food in exchange for music lessons for their children. One hot day, Brancusi watched him paint the picture of Apollinaire and his muse (*La Muse et le Poète*?). Rousseau started at the top of the canvas and slowly made his way toward the bottom, carefully guiding his brush to give precision to the details. The butcher's son and the milkman's son were playing their violins in his studio under his supervision. Every now and then, their teacher would stop his work and turn toward them: "You played a wrong note; you have to shift to second position." Without further ado he went on with his work, all the while chatting with his pupils. When he got to the bottom of the canvas, he signed his name.

Rousseau, returning the favor, once stopped by Brancusi's studio. He said, the sculptor told us, "I see what you are trying to do; you want to transform the ancient into the modern"—a remark that would often be quoted, but not as Rousseau put it.

When Rousseau died, Brancusi was approached about making a monument, but cliques were formed and the sculptor was accused of trying to line his pockets. "What would I have stood to gain from making that monument?" he later asked. "At the most, enough to buy myself an overcoat." They settled for a tombstone into which Brancusi and Ortiz de Zarate carved a poem that Apollinaire had written out in chalk. Much later, in 1937, Brancusi, Cocteau, Delaunay, and Marie Laurencin, among others, formed the Association des Amis d'Henri Rousseau.

The marble *Maiastra* also dates from 1910. In Rumanian legend and folklore, Pasărea Măiastră is a miraculous bird that helps Prince Charming rescue his beloved. Brancusi's intention was to capture in this one bird the essence of all birds, for Maiastra also had a part in the creation of the world and the struggle between good and evil. For Brancusi, it symbolized spirituality.

In 1911, Brancusi contemplated the subject of Prometheus, but the academic treatment of the subject repelled him. "I could not very well depict this great myth by an eagle tearing at the liver of a man's body chained to a peak in the Caucasus," he said. Margit Pogany, a Hungarian painter, translated excerpts into French for him from Goethe's *Pandora* that were about the Titan's revolt. She sent them to Brancusi with the following note:

Right, above:
Maiastra. Drawings. Private collection

Right:
Maiastra. 1911. Polished bronze. Tate Gallery, London. Museum photo (Cat. no. 65)

Opposite page:
Maiastra. 1910–12. White marble. The Museum of Modern Art (Katherine S. Dreier Bequest), New York. Photo Brancusi (Cat. no. 64)

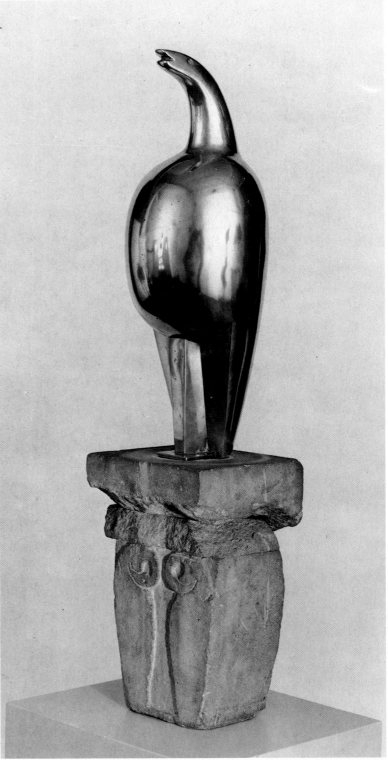

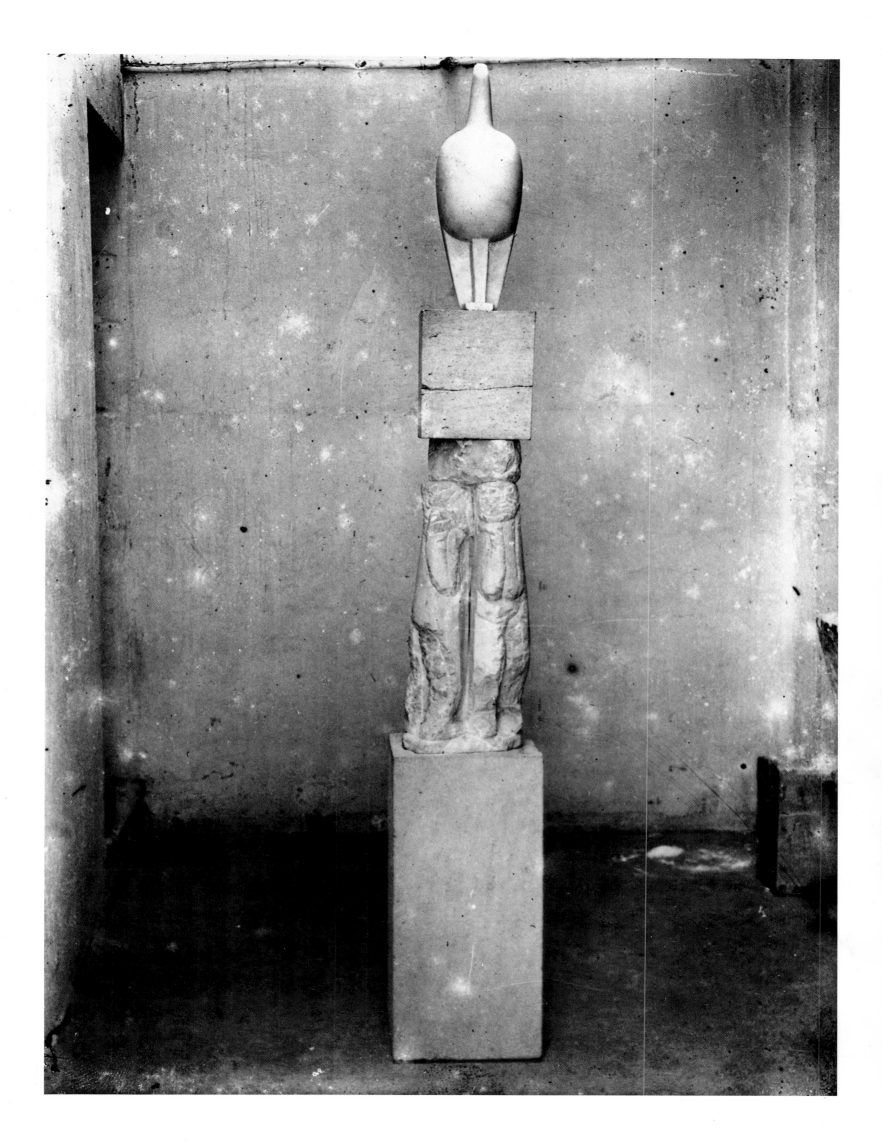

Mother and Son. 1911. Gouache and pencil on cardboard, 103.5 × 81,5 cm. Private collection

"My dear friend,

"Today I am sending you a potent cup of wine: Goethe's Prometheus. Don't let it go to your head. But do read it if you get a spell of weariness or dejection, and it will renew your strength. And it will show you that a glorious death is far less noble than a struggle. You have forgotten all about death, whether or not it is glorious, haven't you? You *have* put it out of your mind?...

Margit"

The childlike head of Brancusi's *Prometheus* is so advanced in its virtual absence of details that its spirit seems to dance about it like a flame. The form is so elementary, so fragile, yet it is charged with the nobility of human achievement. "Why did we come on earth as men?" Brancusi once asked. "Why not in some animal form? We would be punished less. See, humanity is the scourge of the earth. And the earth is in the belly of that good man we call God, and you can bet he does not get much peace with all the havoc of humanity. That confounded Prometheus, what devil drove him to give us fire, that we might burn with our God Himself?"

The Rumanian painter G. Pa-

trascu wrote to Brancusi from Bucharest on January 22, 1911, that a collector named Romascu was going to buy *Wisdom of the Earth*, which was at Mrs. Storck's at the time, for 1,500 lei.

On May 15, 1912, Brancusi rented another studio across the street at 47 Rue du Montparnasse. The sculptor set up his anvil under a tree that stood in the middle of the courtyard of the building. Using a photograph that shows him at work there (Archives, Musée National d'Art Moderne, Paris), he made a watercolor of himself and added an inscription at the lower left, *Dans le petit jardin + enclume, 47, rue Montparnasse*; and at the lower right, *Paris, 1915* and *C. Brancusi* (27 × 22 cm., Private Collection).

That year Brancusi carved the marble bust of *Mlle Pogany* (Philadelphia Museum of Art). Margit Pogany traveled frequently between Budapest and Paris, and the sculptor often called on her at her Paris *pension*. On one visit to his studio, she noticed *Danaïde*, a severe marble head whose roundness suggested her own face. Would he not make a portrait of her?

We know from two of her letters in the Museum of Modern Art in New York that she visited

the sculptor several times during one stay, from December 1910 until January 1911, when she left for Lausanne-Ouchy. From there she wrote him: "I thought of you the whole time, how very kind and affectionate you have been toward me. It's a little as if you had come along with me. I should like to give you as much joy as you are giving me."

After a number of preliminary tries, all successively destroyed, he sent the finished *Mlle Pogany* to the Armory Show in New York (February 15–March 15, 1913). Later that year, Brancusi had Valsuani cast a bronze for Miss Pogany, with black patina on the hair and eyes. They wrote to each other several times.

"I assume," she wrote from Budapest on December 5, 1913, "that the Berlin exhibition [actually, an international show at the Glaspalast, Munich, where Brancusi was part of the Rumanian contingent] will soon be over, and that in a little while the bust will find its way to me. Miss Waldenberg told me that you have had it cast in bronze. Which one will be for me? As for the money I still owe you, for the time being I have 1,400 francs you are welcome to, 200 of which I am sending you herewith."

In an undated letter (probably late in 1913), Miss Pogany thanked Brancusi for sending some stamps for her father. (All his life Brancusi removed the stamps from his letters and gave them to stamp collectors.) Then she added a word about the bust. "Once I've received it, I'll have it picked up at the station and do my best to sell it on the best possible terms. But this won't happen in a hurry." No doubt they had agreed that she was to find a buyer for this sculpture.

"I was at customs only yesterday to pick up the bust," she wrote on January 6, 1914. "It

Lease between Brancusi and the society "L'Avenir du Prolétariat" for the studio at 47 Rue du Montparnasse, 1912

Brancusi at the Anvil. 1915.
Watercolor. Private collection,
Bern. Photo rights reserved

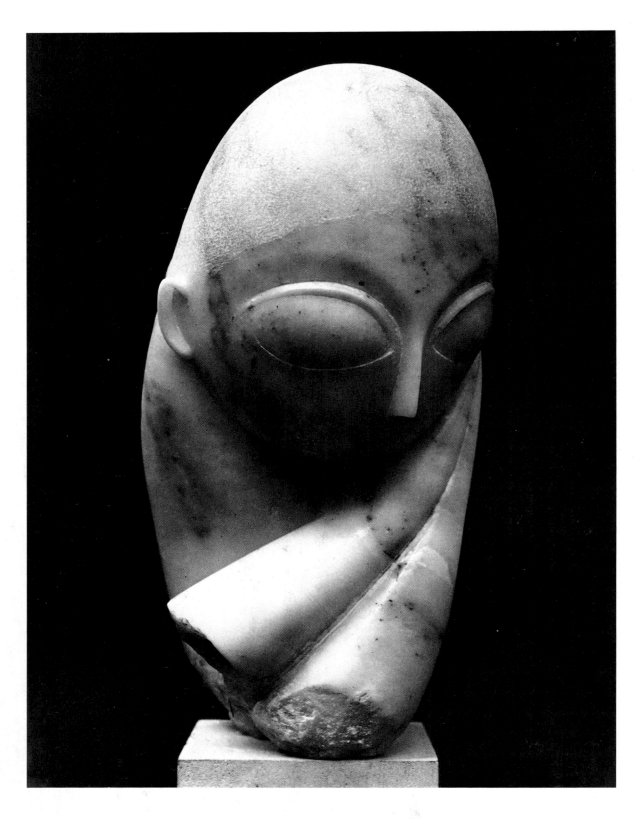

Mademoiselle Pogany I. 1912.
White marble. Philadelphia
Museum of Art (Gift of Mrs.
Rodolphe Meyer de Schauensee).
Photo Brancusi (Cat. no. 73b)

was so well packed that the trip
did not harm it at all, or the ped-
estal.... I am glad you sent me
the bronze; I like it better than
the marble. The color you
added makes it look much more
primitive and antiquated, yet
also gives it a more natural ap-
pearance.''

In May 1914, Brancusi stopped
in Budapest, but Miss Pogany
was not there; he did not meet

her again until 1925 in Paris.
Two letters of 1949 indicate that
Miss Pogany intended to sell
her version of *Mlle Pogany*, but
neither she nor the director of
the National Gallery of Victoria
(Melbourne, Australia), to which
she had loaned the bust, re-
ceived any answer from him.
Eventually, it was purchased by
the Museum of Modern Art in
New York.

The following is an excerpt
from a letter Miss Pogany wrote
to Brancusi from Camberwell,
Australia, on September 14,
1949:

''You will find in this letter
two small photos of the bust

[*Mlle Pogany*] in my possession.
Since almost my entire fortune
is gone, I must sell the bust, and
I think the museum here would
buy it. It is very well endowed,
and last year they bought a
painting by Modigliani.... I do
not wish to sell the other bust I
brought with me unless I can ar-
range for it to be delivered only
after my death. I should like to
have it added to the museum
collection after my death. I will
ask you to help me in these two
transactions by telling me the
approximate sum that I should
ask for them. Tell me in dollars,
if you can. I should also like to
know how I ought to clean my
bust, which has become tar-

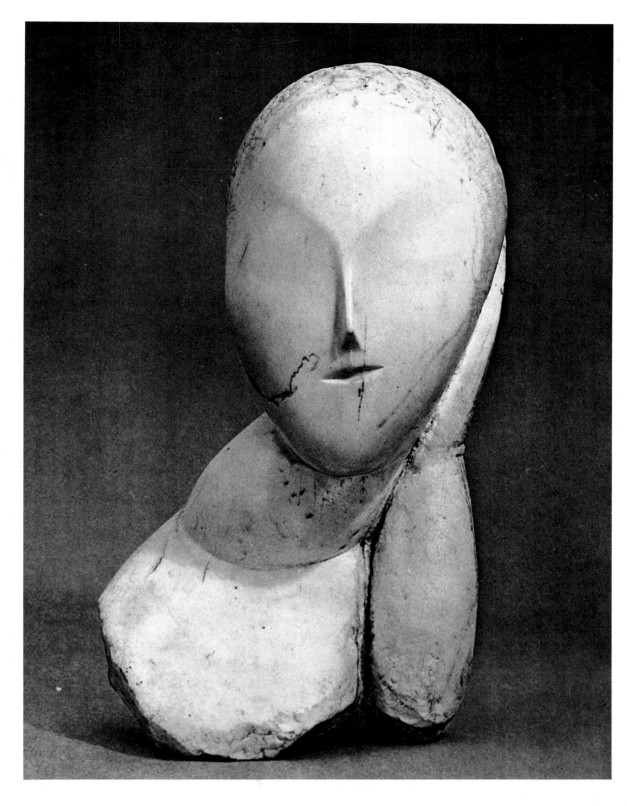

quest to have four sculptures (*A Muse*, marble; *Mlle Pogany*, plaster; *Sleeping Muse*, marble; *The Kiss*, stone) picked up and delivered to Pottier and Co. for packing. In addition, the marble *Torso II* was also exhibited at the Armory Show (no. 620 in the catalogue supplement).

That same year he sent *The Kiss*, *Prometheus*, and *Sleeping Muse* to the Salon des Indépendants. "Brancusi," wrote Apollinaire in *L'Intransigeant* (April 3, 1912), "is a sculptor, delicate and very personal, whose works are of the utmost refinement."

Two works (*Maiastra*, marble, and *A Muse*, marble) were shown at the Tinerimea Artistică in Bucharest. Later in the Arthur B. Davies collection, *A Muse* was purchased in 1956 by Ardé Bulova, who gave it in 1958 to the Solomon R. Guggenheim Museum in New York. When Bulova died, his widow sued the museum, maintaining that she, a native of Rumania, was the real owner of the sculpture, having been a longtime friend of the artist. She claimed to have worked on the sculpture with him and to have attended to him later in his life. The legal proceedings were widely reported, even in the international press, and the decision was in Mrs. Bulova's favor. Since then, the museum has been able to acquire the work once again.

The Muse. 1912. White marble. The Solomon R. Guggenheim Museum, New York. Photo rights reserved (Cat. no. 70)

nished. You will recall that, unlike your copy, you painted part of mine a very dark color, not just the hair, but also a little over part of the eyes. It's brown now, but I don't know if that's the way you meant it to be or if it's the effect of time. The bust was kept for years in a cellar for fear of the bombardments, and I have been afraid to clean it. . . . I leave the hair just as it is, correct? I like the fact that that part of the bust is colored; what's more, it is something you did yourself. Or have you changed your mind about it, since it does not appear on your other busts?"

At the time the bust was made, Brancusi was getting ready to take part in the Armory Show, a major exhibition organized by the Association of American Painters and Sculptors to combat academic art. The president of the Association, Arthur B. Davies, its secretary, Walt Kuhn, and Walter Pach, a painter, came to Europe in 1912 to find suitable works of art. In Paris they got in touch with Brancusi, and on December 12 he received a re-

Autobiographical outline covering the years 1876 to 1913. Archives I–D

89

1913:
The Armory Show

On February 17, 1913, the "International Exhibition of Modern Art" opened in New York at the Sixty-ninth Regiment Armory, a large building on Lexington Avenue. In all, 1,600 works were shown, 1,112 of which were listed in the catalogue and the catalogue supplement. A third of the exhibits came from Europe, primarily from France.

John Quinn, a New York attorney and collector, explained the purpose of the Armory Show on opening day. "The members of this association have shown you that American artists—young American artists, that is—do not dread, and have no need to dread, the ideas or the culture of Europe. They believe that in the domain of art only the best should rule. This exhibition will be epoch-making in the history of American art. Tonight will be the red-letter night in the history not only of American but of all modern art.[1]

"The members of the Association felt that it was time the American people had an opportunity to see and judge for themselves concerning the work of the Europeans who are creating a new art. Now that the exhibition is a fact, we can say with pride that it is the most complete art exhibition that has been held in the world during the last quarter century. We do not except any country or any capital." (Quoted in Milton W. Brown, *The Story of the Armory Show*, New York Graphic Society, New York, 1963, pp. 26–27.)

The Armory Show closed in New York on March 15; it reopened at the Art Institute of Chicago, then the Copley Society, Boston. Chicago students affiliated with the Law and Order League, who saw the avant-garde as a threat, burned Matisse, Brancusi, and Walter Pach in effigy.

The correspondence between Brancusi and Pach sheds light on both Brancusi's initial contact with the American public and the development of his work. "Everything is going well and the exhibition is splendid," Pach wrote on February 21, shortly after the show opened in New York. "The matter at hand just now is your sculpture of *Mlle Pogany*. A very enlightened collector would like to buy the marble version.... You are a huge success at the show—people like your work and the newspapers are full of it."

On June 30, Pach informed Brancusi that he was sending him the money for the bronze *Mlle Pogany* that Robert W. Chanler had ordered. He also thanked him for the casts Brancusi had given Davies and himself. On July 25, he notified the sculptor that the bronze *Mlle Pogany* had arrived in New York.

"At last," Pach wrote in the September 6 issue of the magazine *La Vie*, "here is a new man for this country, one whose output has seemed too strange for most people to understand right away. Nevertheless, one visitor known the world over, Sir William van Horne, said that he liked a Brancusi marble as he would a Greek marble."

The sculptor's participation in the Armory Show did not prevent him from sending work to the sixth annual exhibition of the Allied Artists Association in London, of which he was a member. Visitors to the Albert Hall had a chance to see *Head* (bronze, no. 1167), *Sleeping Muse* (bronze, no. 1167A), and *Head* (stone, no. 1167B). The latter was loaned to the Doré Gallery and never turned up again,

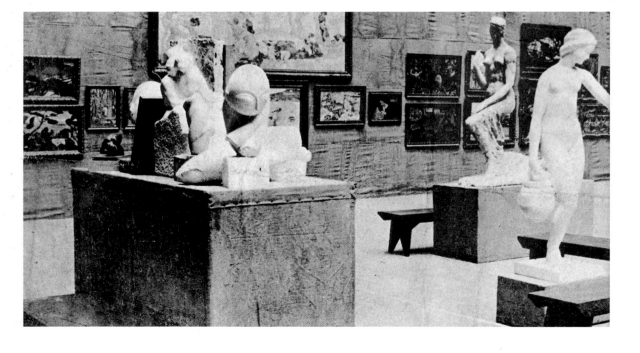

Armory Show, New York, 1913, with Brancusi's sculptures: **The Muse** (Cat. no. 70), **Torso of a Girl** (Cat. no. 74), **Sleeping Muse I** (Cat. no. 60), **Mademoiselle Pogany I** (Cat. no. 73*a*), and **The Kiss** (Cat. no. 69*b*). Photo rights reserved

Opposite page:
Mademoiselle Pogany I. 1912. White marble. Philadelphia Museum of Art (Gift of Mrs. Rodolphe Meyer de Schauensee). Photo Eric Mitchell (Cat. no. 73*b*)

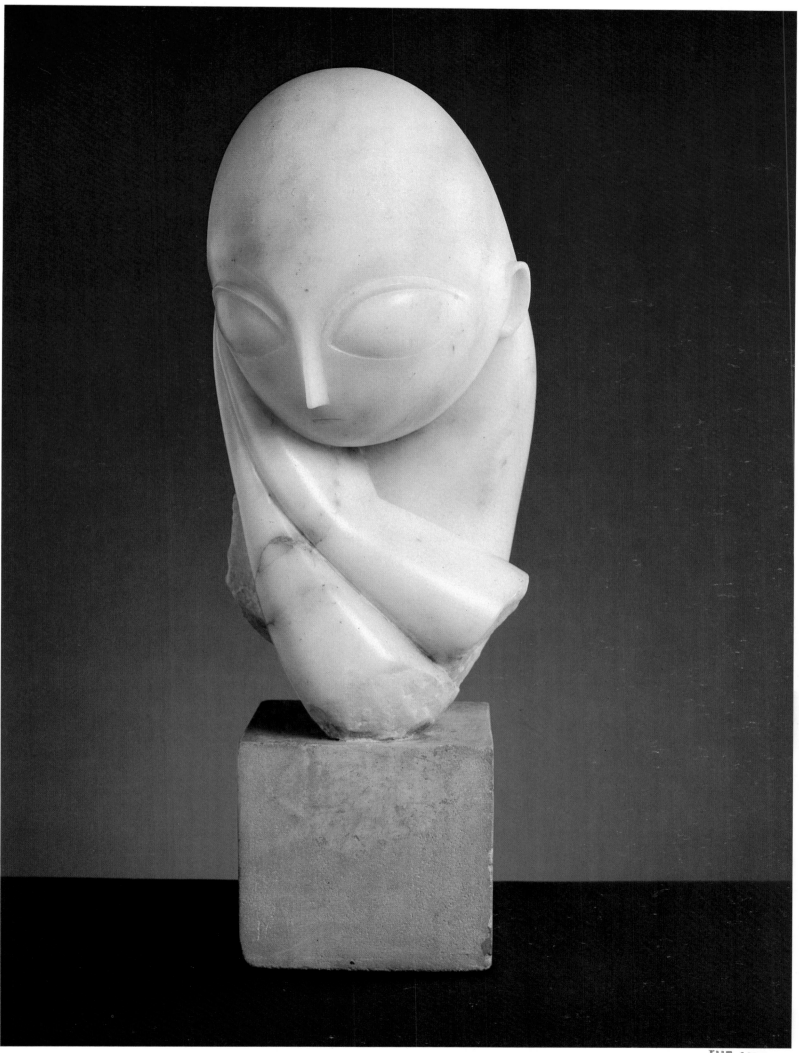

INTERNATIONAL EXHIBITION
OF MODERN ART
ASSOCIATION OF AMERICAN
PAINTERS AND SCULPTORS
69th INF'T'Y REG'T ARMORY, NEW YORK CITY
FEBRUARY 15th TO MARCH 15th 1913
AMERICAN & FOREIGN ART.

AMONG THE GUESTS WILL BE — INGRES, DELACROIX, DEGAS,
CÉZANNE, REDON, RENOIR, MONET, SEURAT, VAN GOGH,
HODLER, SLEVOGT, JOHN, PRYDE, SICKERT, MAILLOL,
BRANCUSI, LEHMBRUCK, BERNARD, MATISSE, MANET, SIGNAC,
LAUTREC, CONDER, DENIS, RUSSELL, DUFY, BRAQUE, HERBIN,
GLEIZES, SOUZA-CARDOZO, ZAK, DU CHAMP-VILLON,
GAUGUIN, ARCHIPENKO, BOURDELLE, C. DE SEGONZAC.

LEXINGTON AVE.–25th ST.

Poster, Armory Show, New York

Results of sale at Allied Artists'
Association show, London, August
1913

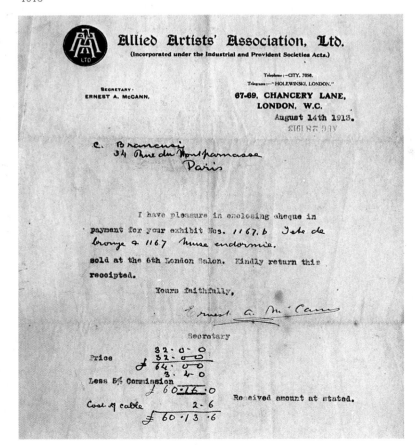

despite Brancusi's efforts to locate it long after the show closed.

"Sir,
"We have the honor to inform you that we have sold your two bronze heads at your asking price—232. As for the other head (in stone), Mr. Frank Rutter, curator of the Leeds Art Gallery, is getting a Post-Impressionist show ready for the Doré Gallery in London this fall and was wondering if you would let him include it in the exhibition.
"Yours truly,
Ernest A. McCann,
Secretary"

After the exhibition, the critic Roger Fry wrote, "As far as sculpture goes, the works by Brancusi were the most remarkable in the show."

We should point out that Brancusi's work was also seen in his native Rumania (13th Tinerimea Artistică, Bucharest). It was about this time that he had the "revelation" he so often told us about. While visiting the Paris Air Show (1912) with Léger and Duchamp, he noticed a propeller. "Now that's what I call sculpture!" he exclaimed, wonderstruck. "From now on, sculpture must be nothing less than that." The experience strengthened Brancusi's resolve to bring modern form to perfection, but it had a different effect on Duchamp, who noted:

"Propeller (Delights thereof).
It's all over for painting.
Who could better that?
Tell me, can you do that?"

Here is Fernand Léger's version of what transpired at the Air Show. "Before the Great War, I went to see the Air Show with Marcel Duchamp and Brancusi. Marcel was a dry fellow who had something elusive about him. He was strolling amid the motors and propellers, not saying a word. Then, all of a sudden, he turned to Brancusi. 'It's all over for painting. Who could better that propeller? Tell me, can you do that?'"

The Armory Show of 1913 had given a new audience the chance to appreciate Brancusi's sculpture. Ever since the great turning point of 1907, his change in style had, by and large, met with disapproval. When Rumanian critics saw his Wisdom of the Earth, they called him a lunatic and a humbug—not that he minded it. It had taken two years of work and isolation, but now his work was in full flower.

Opposite page:
Mademoiselle Pogany I. 1913. Bronze, patina on hair. The J. B. Speed Museum, Louisville. Museum photo (Cat. no. 76c)

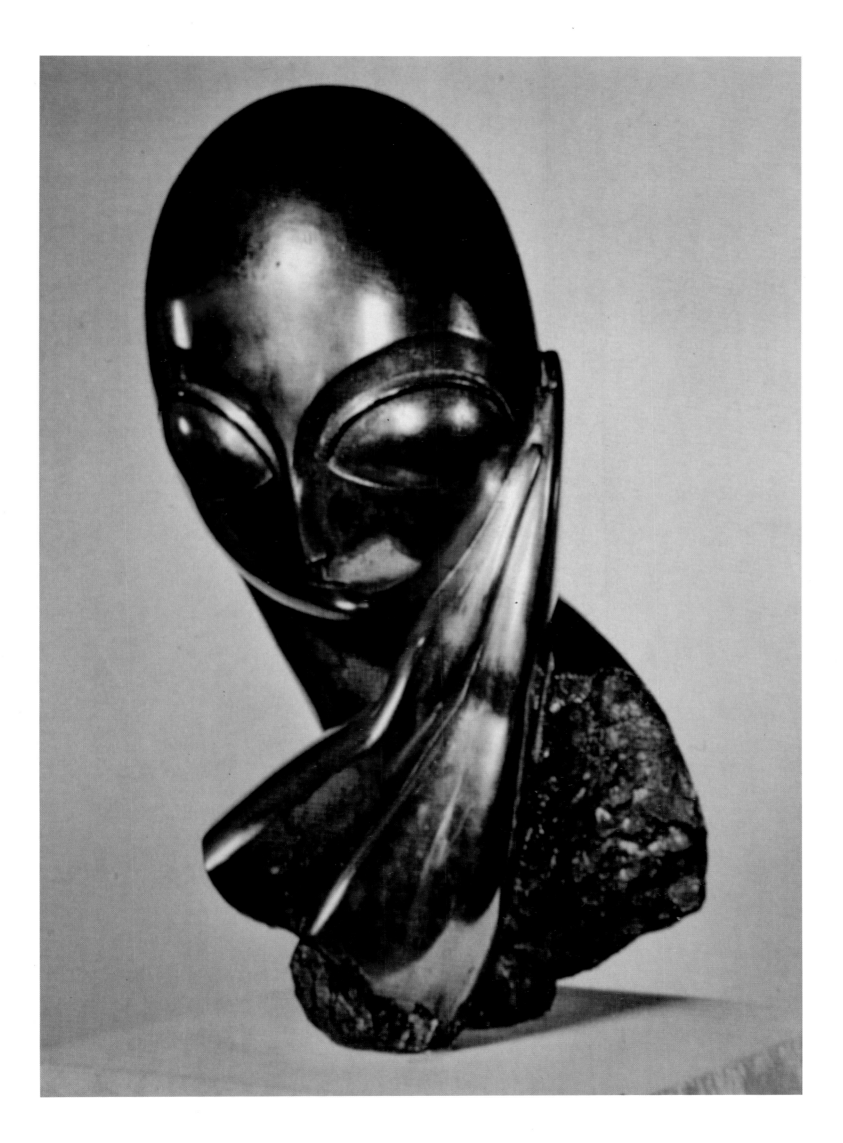

1914

Early in 1914, the art critic Alexandre Mercereau urged Brancusi to send five works to an exhibition "Modern French Artists," in Prague's Kinsky Park, featuring work also by Mondrian, Duchamp-Villon, Archipenko, and Czech artists.

The sculptor wrote as well to Walter Pach to sound him out about the advisability of exhibiting work at Stieglitz's gallery.[2] "As for Stieglitz," Pach replied, "it is a ticklish question you put before me, and my answer must be kept strictly confidential. Stieglitz is a rich, or comparatively rich man who fancies himself the protector of art in America. He is a pretty decent sort, but he does not push an artist's work the way a dealer would, nor does he have the self-interest of people like us, whose whole career is at stake.... Frankly, I feel you would be doing yourself a disservice if you sent him your marbles. Ask Picasso (and others) how much Stieglitz sold for him (nothing) and the impression it made (none). I don't mean to be unkind, but I would advise you to get the lay of the land before you set foot on it."

Four days later, on February 10, Pach notified Brancusi that he was sending him a check for 2,750 francs in payment for *A Muse*, which had been sold to Arthur B. Davies. Again he urged the sculptor not to send any work to Stieglitz for exhibition at his Photo-Secession Gallery. The artist went ahead and sent them anyway.

"As I told you," he later wrote to Pach, "I made up my mind to send the marbles to New York. They are on their way now, and they'll be there before long. They are to be shown at the Photo-Secession Gallery.... You will see some new things at the exhibition, too. There is a wood sculpture and two bronzes. The marble *Mlle Pogany*, too. If your plan to give it to the museum should materialize, nothing would please me more."

He also wrote to his friend Edward Steichen (a member of the Photo-Secession Gallery) about the upcoming show:

"Dear old chap,
"I did not send the marble *Maiastra*. I thought you'd be too busy with other things to have that still on your mind, but I am sending you two photos. If there are any prospective buyers, the

Opposite page:
Three Penguins. 1912–14. Marble. Philadelphia Museum of Art (Louise and Walter Arensberg Collection). Photo Eric Mitchell (Cat. no. 71)

List of eight works and prices for exhibition at the Photo-Secession Gallery, New York, February 1914 (Brancusi's first one-man show). Entry "F," *Golden Bird*, is the *Maiastra* from 1911 (Cat. no. 68), listed as *Pasarea Maiastra* in the catalogue. Archives I–D

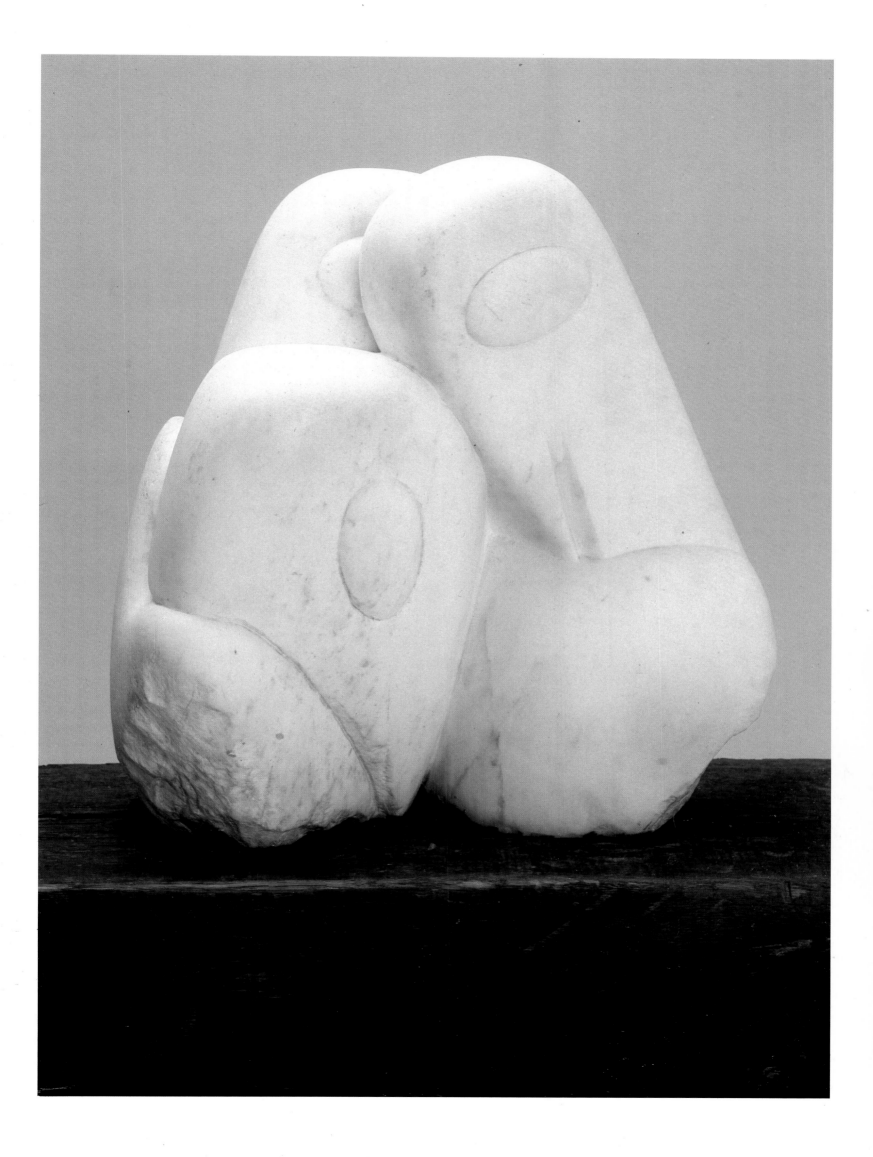

sold to Mr. Davies. The two unsold pieces are at the packer's and shall be shipped in the near future. We trust that they will get to you in time. We have turned over to Mr. Steichen a check made out to you for 4,000 francs. We will get the balance off to you as soon as we have the money in hand. So far, the buyer of *Mlle Pogany* has only come forth with an advance and has asked us to allow him some additional time for the final settlement. Since he is completely creditworthy, we have agreed to his request for an extension.

"Thanking you again for the kindness you have shown us, and with our sincere admiration,

Alfred Stieglitz"

Both Pach and Stieglitz felt that the show was a complete success.

"April 24, 1914.
"Dear Mr. Brancusi,
"We are still having problems with customs. Your eagle and its base are at customs, but

price is 2,000 francs for the works (base included). I trust that the other sculptures got there all right. Keep me posted.

"When your telegram arrived, they were already on their way. I do not know what arrangements Mr. Foinet made for the insurance, because I haven't gone back to see him since; but I left them in his care and told him to do what he usually does. I gave him the titles and their full value, and I was present at the packing, which was very well done.

"Speaking of titles, I made a mistake with the wooden youngster. Its title should be *The Prodigal Son*. It's the one I'm working on now that is entitled *The First Step*. Correct that, please...."

In a conciliatory letter dated March 8, Pach told Brancusi that he was doing everything he could to see to it that his show at the Photo-Secession Gallery would be a success. The sculptor professed his delight in his reply on March 17. The exhibition opened March 12 and ran until April 1, a milestone in Brancusi's career: his first one-man show. He was thirty-eight years old.

"April 14, 1914.
"My dear Mr. Brancusi,
"We have the honor to send you herewith a memorandum of the outcome of your show, which is self-explanatory. We have sold the objects for the prices you yourself named at the outset. We sold *Danaïde* to Mr. Davies for 3,000 francs, but we had already clinched the sale when Mr. Pach got your letter in which you said you were prepared to allow at least 25% off your prices for any work of yours which he or Mr. Davies might be ready to buy. Hence, we were unable to abide by your wishes. You will see on the memorandum that we are not deducting any commission from

the sale of this piece, because your welfare means more to us than our own. Mr. Steichen must have told you that we are not looking for bargains. Therefore, we have deducted only 15% commission from the sale of the other pieces to cover the considerable expense we incurred to insure against fire and theft, as well as other costs. We feel that your show has been a complete success, artistically speaking, and we hope that you will also look upon it as a complete success, financially speaking. All of the pieces that were sold are in as good hands as the one

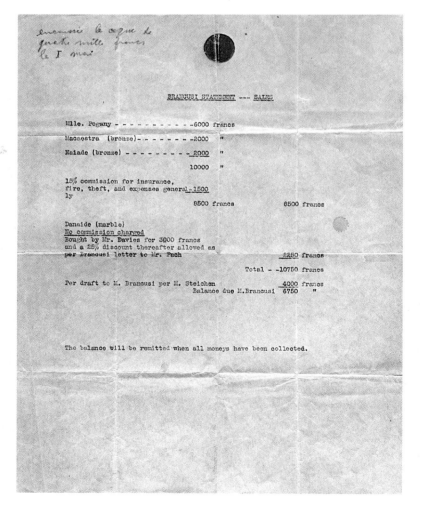

your agent, Mr. Foinet, neglected to forward the consular invoice required for delivery. We thought he knew that this is always required for shipments to the United States. Therefore, would you be so kind as to locate Mr. Foinet and ask him to fill out a consular invoice for the most recent shipment he made on your behalf on April 10. He will have to provide the information on the form for *consigned* goods. It is essential that Mr. Foinet make out this invoice for:

"'1 crate marked L.L.F. 313, sent April 10 on the *Savoie*, addressed to Mr. Alfred Stieglitz, 291 Fifth Avenue, New York.'

"The declaration on the consular invoice must further state:

"'Marble eagle, original sculpture by Brancusi;

"'Base, original sculpture by Brancusi, 4,000 fcs.'

"Mr. Foinet will have to send a copy of the consular invoice by registered mail to Alfred Stieglitz, 291 Fifth Avenue, New York City, as soon as possible. We are asking you to have him put down the figure of 4,000 francs on the invoice so that it will not conflict with the papers Mr. Molon sent to us from Le Havre. Mr. Molon did not send us a consular invoice, only a notification of shipment. Since we had written you to send the eagle if the price was indeed 2,000 francs, we assume that Mr. Molon put down 4,000 francs by mistake. Barring problems with customs, in which case we'll send the eagle back to you at our expense to spare you any outlay, we shall send you 2,000 francs for the eagle and base. We had asked you to send the eagle and its base if the price was 2,000 francs. If there has been a misunderstanding, kindly cable at once:

"'Stieglitz 291 Fifth Avenue New York.

'Send back.'

"... Please be sure to telegraph us at once if there has been a misunderstanding, because if you do not, we shall assume that you find the price of 2,000 francs acceptable. However, we reiterate that Mr. Foinet must put down 4,000 francs on the consular invoice in any event, for the reasons we have given you.

"Very truly yours,

Alfred Stieglitz"

"I am sending you some photos," Brancusi replied. "I should like to have sent more, but my photographer did not do them satisfactorily, and even the ones I am sending you are not as they should be. Now I'll see to it my-

Little French Girl. 1914–18. Oak. The Solomon R. Guggenheim Museum, New York. Photo Carmelo Guadagno (Cat. no. 82)

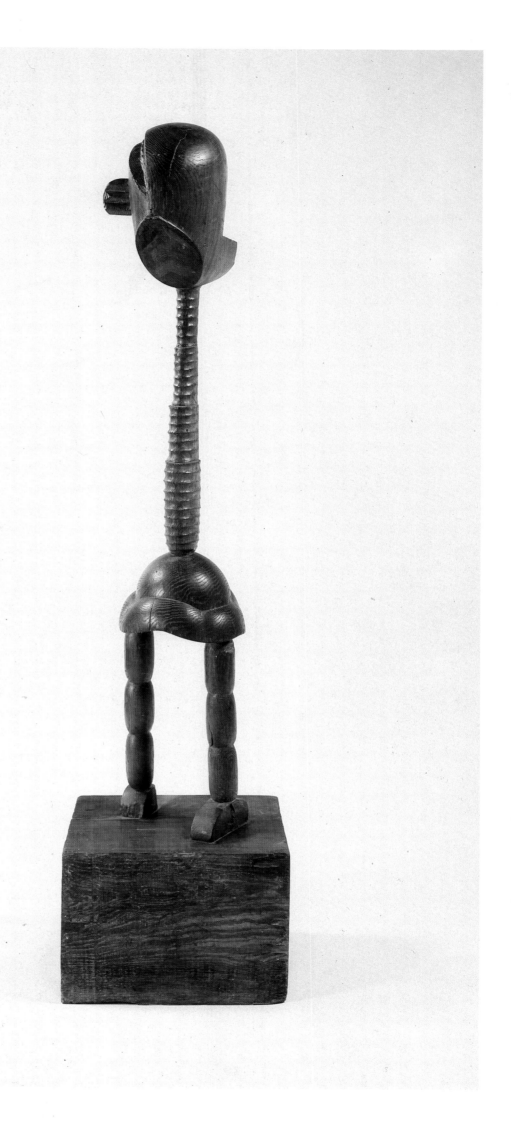

self, and I'll be sending you a complete collection, and soon.

"I trust that the marble *Maiastra* and the base got there all right. While we're on the subject of the base, I forgot to tell you that if the buyer would rather have the big stone... and even the little one that broke and I repaired, you are welcome to them both, and I can send them out to you at once should you so request...."

Dissatisfied with the results he was getting from professional photographers, Brancusi now started to take pictures of his work himself. As for *Maiastra* and its base, the sculptor insisted on 4,000 francs—to Stieglitz's astonishment, since the price they had agreed upon was 2,000 francs. The artist felt that *Maiastra* actually consisted of two separate pieces, so he had simply doubled the price.

Shortly thereafter, Brancusi left for Rumania to oversee the completion of the Stănescu monument in Buzău. On the way, he stopped in Budapest to look up Miss Pogany and Mrs. de Kozmutza (now Mrs. Bölöni), to no avail. We know that the monument was finished on May 31, because that is the date on the receipt issued by the workman in charge of the operation: the installation of two bases of Magura stone, one bearing the bust of the deceased, the other, the kneeling figure of *The Prayer*. It is safe to assume that Brancusi returned to France on July 19 or thereabouts, as he signed a lease on that day for studio no. 6 at 36 Avenue de Châtillon.

One of Brancusi's outstanding works from 1914 is a wood sculpture entitled *Madame L.R.* A patroness of the arts, Léone Ricou enjoyed having artists around her. It was at her place that Brancusi had met Alexandre Mercereau, the man responsible for the exhibition in Prague. Since she lived near Brancusi's studio, she often dropped by with Papini, Paul Fort, and other art lovers.

Every Tuesday Paul Fort, "Prince of Poets," presided over gatherings at the Closerie des Lilas café. His guests included Léger, Cendrars, Cocteau, Satie, and, later on, around 1918, Germaine Tailleferre and the other composers who made up Les Six (Honegger, Milhaud, Auric, Poulenc, and Durey). Brancusi was also a regular at Apollinaire's "Passy dinners" and the receptions the Duchamp brothers held in Puteaux.

These get-togethers were lighthearted affairs often marked by unbridled whimsy. Here the artist met Jeanne Augustine Adrienne Lohy—she would become Mrs. Fernand Léger in 1919—who was on friendly terms with him and called him "Papa." Later on, Léger and his wife would send Brancusi postcards and letters. On October 27, 1921, they sent him a *pneumatique* (local express letter) to tell him that they would be coming over that evening, but if they missed him, they should all three meet at a brasserie on Boulevard de Strasbourg.

Léone Ricou had an estate in Ardèche, and Brancusi was once a guest there. When it came time to do her portrait, the artist decided on wood, a medium he felt at home with. In addition to the oak, maple, cherry, and other varieties of wood he bought through dealers, he liked finding old oak beams in wreckers' yards along the embankments of the Seine. He was especially partial to the big ones, hard as stone, that were no longer useful in building.

He got large axes and would spend a whole day sharpening them on his grinding wheel. Then he could be seen holding the wood straight up and down on the workbench with his left hand and hacking away at it with his right, his razor-sharp tool moving in a steady rhythm, as it "freed" the desired form little by little.

Now and again, he would chalk an outline drawing of the sculpture directly on the wood. This truly was direct carving, and the material guided him in some way during the act of creation. He asked, "Isn't a piece of wood ready to become a work of art? To turn it into sculpture, all you have to do is cut it right." Or: "Every substance has its own characteristics. A marble piece is not a bronze; a bronze is not a wood. The point is, you don't ruin a material to coax it to speak the way *we* would like, you let it speak for itself and tell us things in its own language."

Some critics have seen fit to draw a parallel between Brancusi's wood sculpture and African art, even going so far as to assert that the Rumanian sculptor found in it his source of inspiration. Comparisons of that sort made him bristle. What did he have in common with African art, designed to exert magical power, when his own aim, essentially, was to purify the forms he invented?

Time and again, critics have also credited him, absolutely incorrectly, with the statement that "only Rumanians and Negroes know how to work wood." It was not Brancusi who said that, it was ourselves—and we were not referring to any creative spirit, but to the manner of working wood—and to nothing more. If a source must be found for Brancusi's passion for wood, it should be sought in the ancient heritage of his native land, for woodworking techniques there have been handed down from generation to generation since the ancient Dacians.

The story of *Madame L.R.* is filled with events. As is customary among artists, Léger and Brancusi exchanged work with one another, and when the painter once gave him a painting, the sculptor reciprocated with the famous portrait in wood of Léone Ricou. During World War II, Léger left France for the United States, and the bust of *Madame L.R.* was stored in a cellar. Damage resulted to part of the base; this was not discovered until the work was brought out again, by which time both Léger and Brancusi had died. It was then clumsily restored, braced with a large metal rod inserted into the lower, very narrow, part of the sculpture.

We had a chance to see *Madame L.R.* and its base before it was restored, and that same day we were shown another base as well, also unquestionably the work of Brancusi. Imagine our astonishment later on to see *Madame L.R.* and its restored base in a Parisian gallery—both now perched atop the other base, which had nothing whatever to do with it! So preposterous a presentation must have been devised to give the piece added height. It would have been auctioned off in that state at the Palais Galliera on December 5, 1969, had we not raised objections and had the catalogue not described the work as Brancusi originally designed it, without the additional base. (It found no buyer at the sale, but in a short time a private collector purchased it.)

After war was declared in 1914 Brancusi put his alien status in order by submitting a certificate of residency, dated August 4, and signed by the concierge of his building, with whom he was on good terms. Thus, albeit a Rumanian subject, he stayed in Paris throughout World War I, while several of his friends were required to return to their homeland.

Brancusi's studio, 8 Impasse Ronsin, c. 1920: **Portrait of Madame L. R.** (Cat. no. 81), **Endless Column** (Cat. no. 104), **Plato** (Cat. no. 111), and **Yellow Bird** (cat. no. 109). Photo Brancusi

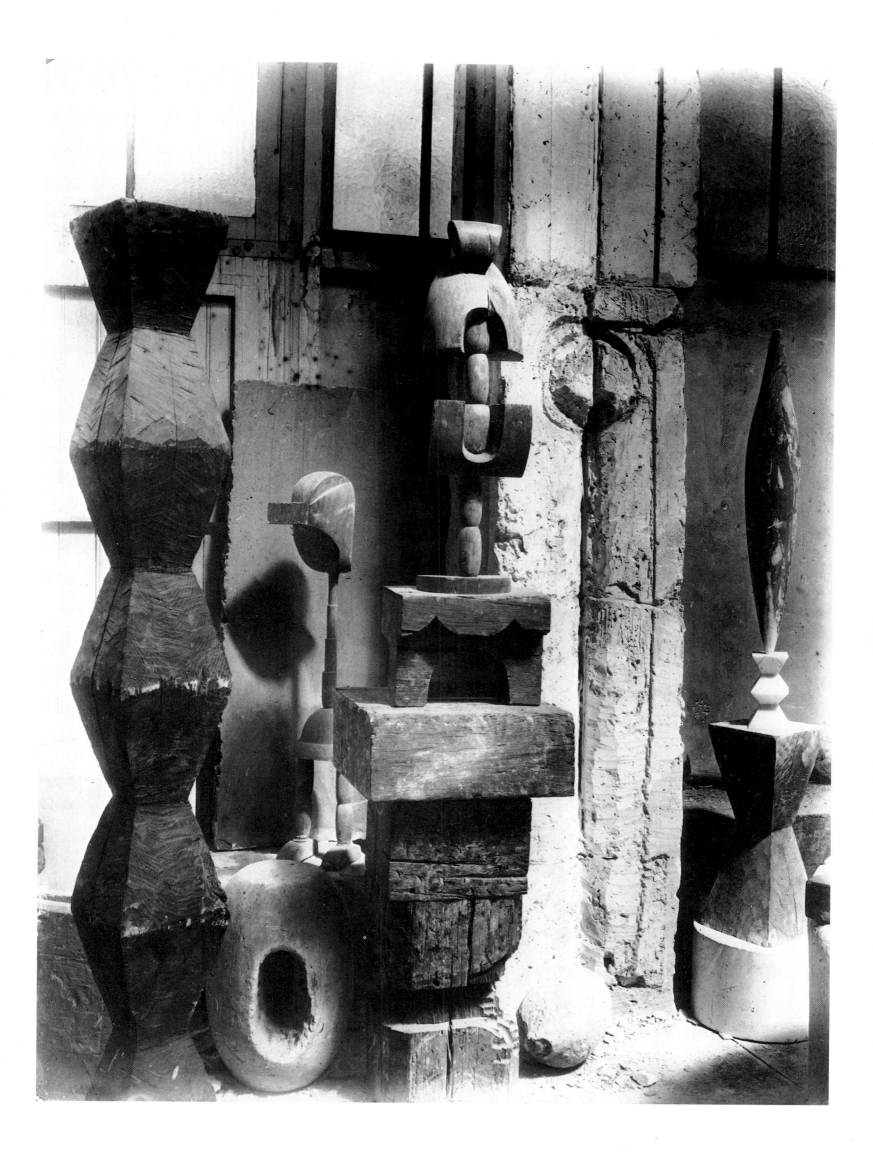

1915

During the next few months, Brancusi went out to Voulangis with a woman friend of the Steichens. He would bring wool with him for anyone who was knitting balaclavas, mufflers, gloves, and socks for the soldiers at the front. He had even written to the Red Cross on August 20, 1914, offering them the use of one of his studios.

American artists, including Steichen, left Paris as soon as war broke out, and in 1915 a number of their French counterparts—Picabia, Gleizes, Crotti, and Duchamp, among others—joined them in New York, where they met Man Ray and Alfred Stieglitz. The Arensbergs' apartment was one of their gathering places.

The war caused no break in Brancusi's ties with the United States. On September 17, he received a letter from Mrs. Eugene Meyer, Jr.—he had met her and her husband, of the *Washington Post*, through Steichen—informing him that Stieglitz was about to open another gallery at 500 Fifth Avenue. It would be both a business venture and a way of increasing American collectors' exposure to modern art, she wrote, and if Brancusi was of a mind to send some of his work, an associate would come over to discuss possible subjects and how they might be shipped.

"... I spoke to you in Paris about Mr. John Quinn," Walter Pach wrote Brancusi on September 23, "who is by far the most enlightened of our collectors of modern art. He is the one who bought the marble *Mlle Pogany* and *Golden Bird* [*Maiastra*, 1910-12]. He is also the owner of extremely beautiful and important things from just about all the great men of our day, from Cézanne on. He had me over for dinner last night and asked me

what had become of the original version of my cast of *The Kiss*, and when I told him that I had seen it at your place, he asked me to inquire as to its price.…

"He would also like to see photographs of such works as you may have finished subsequently and was especially interested when I told him about those gates you were making out of beams from old houses. He has a house in the country where he may have use for them.

"Duchamp is showing tremendous interest in goings-on here and is meeting people and is pleased about his stay. Gleizes has just arrived."

Pach closed by asking the sculptor if he had any intention of coming to the United States one day.

Jean Cocteau, who lived through the artistic revolution that gradually came about during the war years, described the conditions artists lived in at the time in an article ("Mon Maître Picasso") that appeared much later, in the March 20, 1957, issue of *Arts*:

"… Back then, the Montparnasse district had a countrified air about it. It looked as though we were just killing time, but we weren't, really, or you might say we were loafing to the extent that youth appears to be loafing, loitering, idling away the time.

"Certain districts are the pacesetters of Paris. Now it's the turn of Saint-Germain-des-Prés. At one time it was Montmartre, and in our day (which people now call the heroic age) Montparnasse had just come into its own. That is where we hung out—not loafed, mind you—with Modigliani, Kisling, Lipchitz, Brancusi, Apollinaire, Max Jacob, Blaise Cendrars, Pierre Reverdy, Salmon—all those people who, almost without realizing it, fomented a veritable

revolution in art, letters, painting, and sculpture.

"This upheaval took place in extremely unusual circumstances: at the height of World War I, a war so strange that, though we were stationed at the front, we shuttled between the home front in Paris and the front where the troops were. That is what Apollinaire used to do—it wore him out in the long run—until the armistice, when he died and we thought the city was decked out in his honor as well as in honor of our artistic patriotism.

"The revolution took place without anyone's noticing it, and when those who had something to fear from it did notice, it was too late to fight back. We took advantage of the fact that the city was nearly deserted, that it was there for the taking; and take it we did, because the work of the people I have been talking about has been gaining in stature ever since."

On December 28, 1915, an exhibition opened at the Bernheim-Jeune Gallery (25 Boulevard de la Madeleine), followed by a raffle, with Paul Signac presiding, to benefit Polish artists who were victims of the war. The list of donors included Renoir, Rodin, Brancusi, Bonnard, Bourdelle, Matisse, and Picasso.

In the depths of war time, Brancusi created one of his pivotal sculptures, *The Newborn*. "What do you see when you look at a newborn? A mouth, wide open and gasping for air." The sound of a bawling child just coming into the world had always moved him. His *Newborn* is a perfect ovoid with only the faintest hint of an eye, but the mouth is open wide as this creature lets out its first cry. As air rushes into its lungs, a brand new being comes into the world, along with its life-force and its anguished confrontation of the mysteries thereof. "Newborns come into the world angry," Brancusi wrote, "because they are brought into it against their will."

Another work dating from 1915 is *Chimera*.

Brancusi in his studio, c. 1915, sitting on the still unfinished **Doorway** (Cat. no. 88). Photo Brancusi

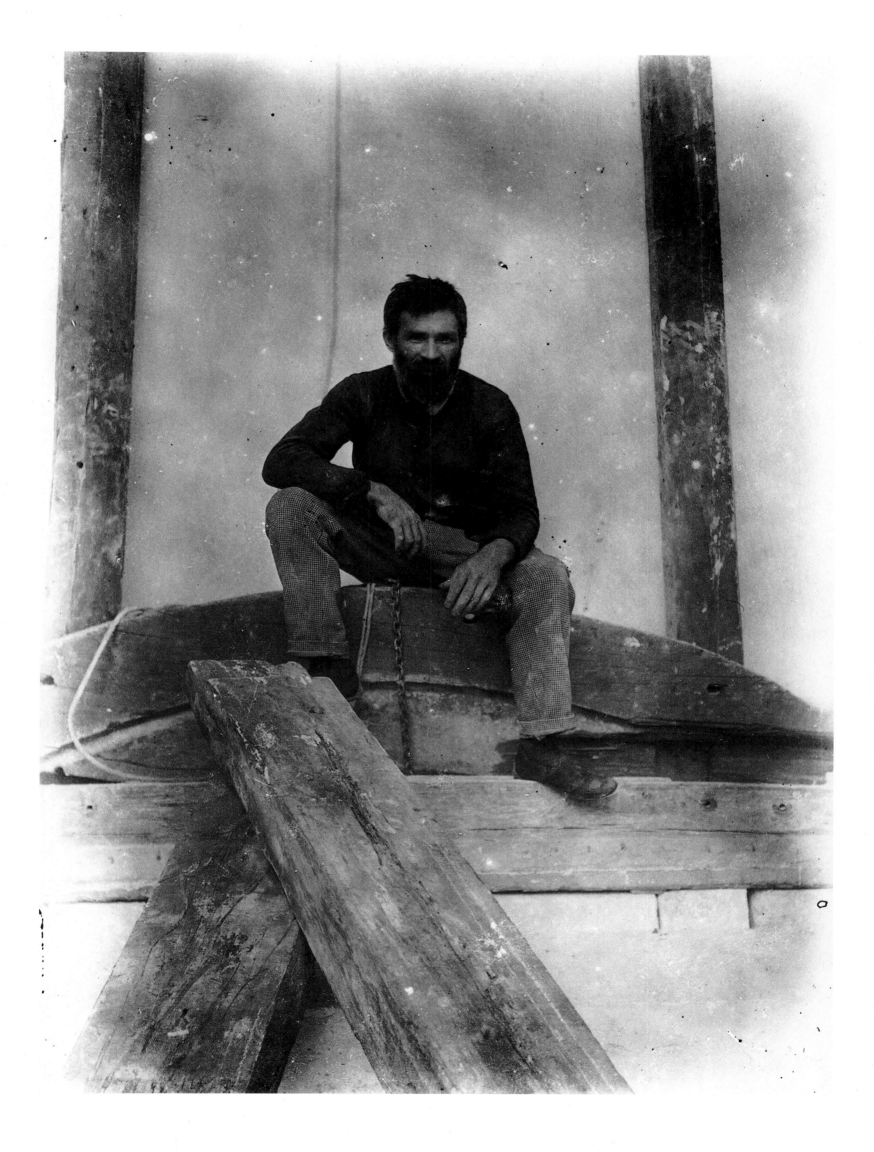

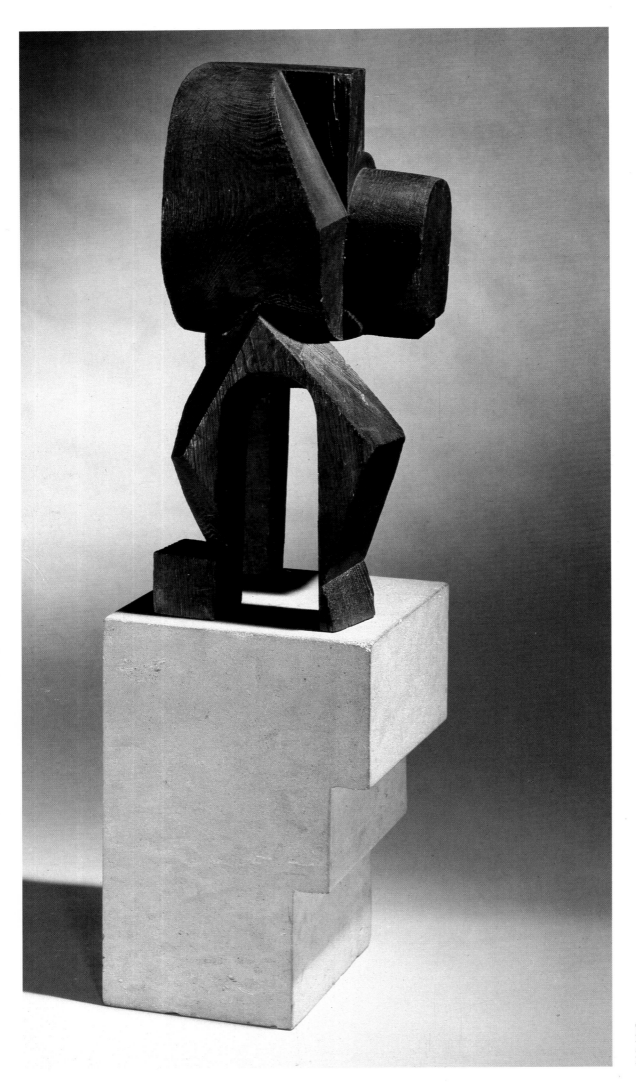

The Prodigal Son. 1914. Oak.
Philadelphia Museum of Art (Louise
and Walter Arensberg Collection).
Museum photo (Cat. no. 83)

(handwritten note at top of page, in French)

le bon Dieu
est mort c'est
pour quoi que le
mond est en derive

1916

The war neither slowed down Brancusi's pace nor interfered with his projects. Had working conditions been more favorable and his studio more spacious, he would obviously have turned out work at a still faster rate. On January 1, 1916, he rented a studio at 8 Impasse Ronsin where he made his home, although he held on to the studio at 54 Rue du Montparnasse a while longer.

A cul-de-sac, the Impasse Ronsin did not lack charm. During the summer, there were flowers everywhere and trees gave abundant shade. Postcards attest to its countrified, somewhat old-fashioned appearance. For a while, the Steinheil townhouse at No. 8 had made the Impasse Ronsin front-page news.

The studio was high, spacious, and bright. On the second floor there was a bedroom. Whenever the sculptor spoke of it to us, he called it "the most wonderful place I ever lived in."

As a ration card tells us, the studio was still lighted by gas jets. It was there that Brancusi's ideas best expressed themselves in his work and daily life. Art, for Brancusi, was part of life; on the subject of ancient Greek Art, he attributed its perfection, simplicity, and purity to the fact that it expressed their way of life, their behavior, their philosophy. Now he was eager to bring to logical conclusions, in a creative as well as practical way, the ideas that had been taking shape in him since 1907. His photographs of the studio attest to the urgency of his need at the time to bring his immediate surroundings into harmony with his yearning for spirituality. In the earliest ones, we see a clutter of sculptures on commonplace bases with a nondescript chair nearby. (Brancusi painted a gouache of the chair and

showed it to us. "Here," he said, "is the last trace of conventional furniture in my place.") In the later photographs the sculptures rest on sturdy bases and are felicitously arranged as the master saw fit. The plaster table at which he took his meals looks like a circular piece of sculpture; the wooden bench he napped on has a rugged, unfinished look to it; stools have replaced chairs. Even his clothing changed: a white garment for working, a white hat to protect him from dust and marble chips, wooden shoes. Everything in keeping with more natural, more uncompromising toil.

Ever since he arrived in Paris, Brancusi had surrounded himself with books on Greek philosophy. Later on, he leaned toward Eastern thought. He enjoyed reading the French and German philosophers and gladly loaned his books to those who might share their ideas with him. A number of books, such as Jacques Bacot's *The Tibetan Poet Milarepa* (Bossard, 1925), would become fixtures at his bedside as long as he lived. When his fits of sleeplessness became more frequent, he put in a shelf behind his bed to keep his favorite tomes within easy reach.

For Brancusi, the immortality of the soul was an article of faith. He was drawn to the ideas of Socrates as set down by Plato and shared the belief that the soul, before it merges with the body, beholds the timeless world of Ideas—the very world Brancusi was trying to embody in his work.

His desire to mortify the flesh and liberate the soul from the enticements of the material world resulted in a self-discipline that sometimes bordered on asceticism. He was able in this manner to set his ideas free, permitting them, in turn, to assume a material form, and on and on in a continual exchange.

Why not try to fix in a work of art that instant of pure thought? This idea runs through notes he used to jot down on the spur of the moment, such as the following, hitherto unpublished group he entitled *A Thought a Day by Dodoïca* (Rumanian for "yours truly"):

"Art is creating things one is unfamiliar with."

"If whatever it is we are making is not tied in with an absolute need for growth, it is useless and detrimental."

"If we restrict ourselves to making exact copies, we stunt the development of our inner selves."

"The greatest happiness is the contact between our essence and the eternal essence."

"When we choose not to be Master, everything comes our way; when we long to possess, it's nowhere to be found. Such is the forbidden fruit."

Did this asceticism fulfill a need of his innermost being? And did the practice of his art, without his always realizing it, satisfy some longing for detachment? The isolation he so often sought, his celibacy and simple diet, the rugged furniture that discouraged indolence—all of these are signs of a wisdom inspired by the life of Milarepa. And what about the discipline he imposed on himself daily, clambering up to the loft by a knotted rope because he had not noticed that there were no stairs?

Rumania had promptly declared war on Germany in August 1914; by October, it had been occupied by the Germans. Brancusi, from the day he arrived in Paris in 1904 until 1909, had neglected to put his military status in order, but his service record shows endorsements from 1909 until February 14, 1916. On October 23, 1916, the Rumanian military attaché granted the sculptor an appeal

Lease between Dussart, landlord, and Brancusi for the studio at 8 Impasse Ronsin, effective January 1, 1916. Archives I-D

for deferment and, on December 14, a deferment on medical grounds. On December 18, he went before the army medical board and was granted a deferment until October 15, 1917.

Brancusi's success in New York was meanwhile still bearing fruit. The Modern Gallery, opened there by Mrs. Eugene Meyer, dispatched its director, Marius de Zayas, to Paris to get in touch with the sculptor. An exchange of letters ensued concerning a marble head *(The Newborn)* the gallery was intending to purchase.

"...I should very much like to know," Marius de Zayas wrote Brancusi on January 19, 1916, "whether or not you have finished the little marble head you showed me in Paris, the oval-shaped one with one or two features, and if you have in mind to sell it and for how much"

"We are interested in the marble I have already spoken to you about," wrote De Zayas again, on February 24. "We agree to your price of 1,000 francs, which will be sent to you as soon as your sculpture reaches us. I am writing Mr. Foinet, instructing him to pick it up at your place and to see to it that it is shipped at once.... If you have photographs of any other sculptures, I should be very grateful if you would send them to me. It is understood, I believe, that the piece we are buying from you has no copy."

Brancusi's reply is dated March 23, 1916. "Mr. Foinet has picked up the marble to send to you, and please get the consular declaration. The marble is indeed the original."

Mrs. Meyer also brought up the matter of her bronze *Danaïde*, which Brancusi had patinated in part, to bring out certain features. Later, concluding that such an overly naturalistic highlight detracted from the purity of his work, he decided against partial patination on a different bronze, and polished the entire surface. When Mrs. Meyer saw this polished sculpture in the United States, she asked the artist if he would remove the patina from her bronze, which he agreed to do.

"...It was very kind of you to send Mrs. Meyer's bronze," Brancusi wrote to De Zayas on August 23, 1916. "I should very much like to get Mr. Stieglitz's and do his once and for all, too.

Portrait of Mrs. Eugene Meyer, Jr. 1916. Wood. Brancusi Studio, MNAM, Paris (Cat. no. 94)

Opposite page:
Portrait of Mrs. Eugene Meyer, Jr. 1916. Wood. Photo Brancusi (Cat. no. 94)

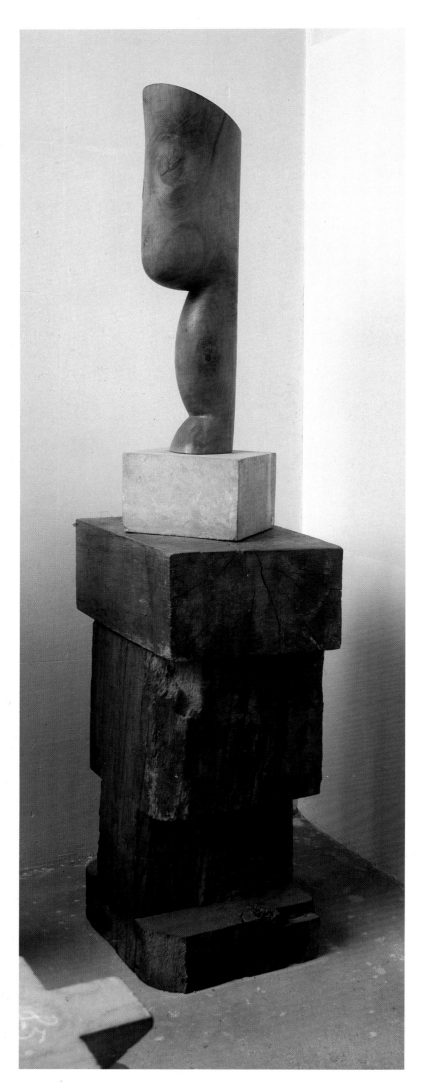

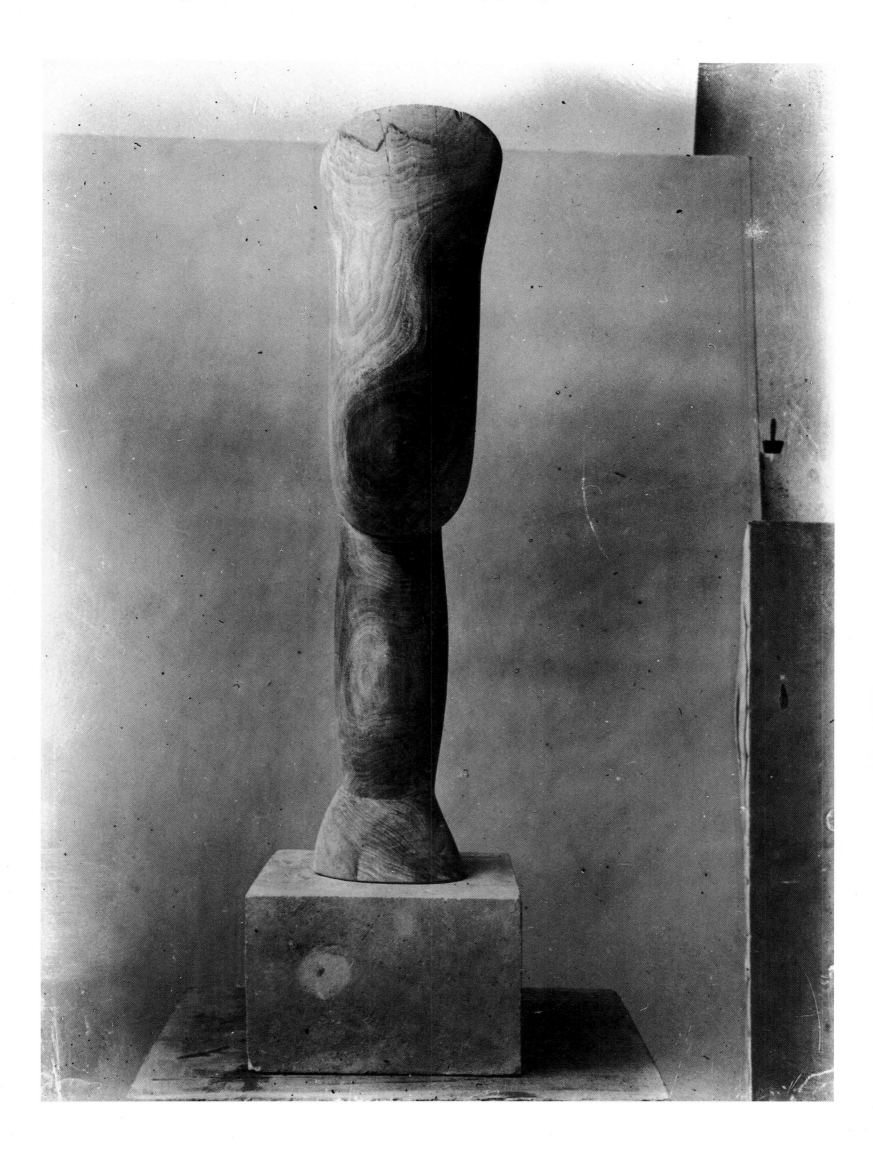

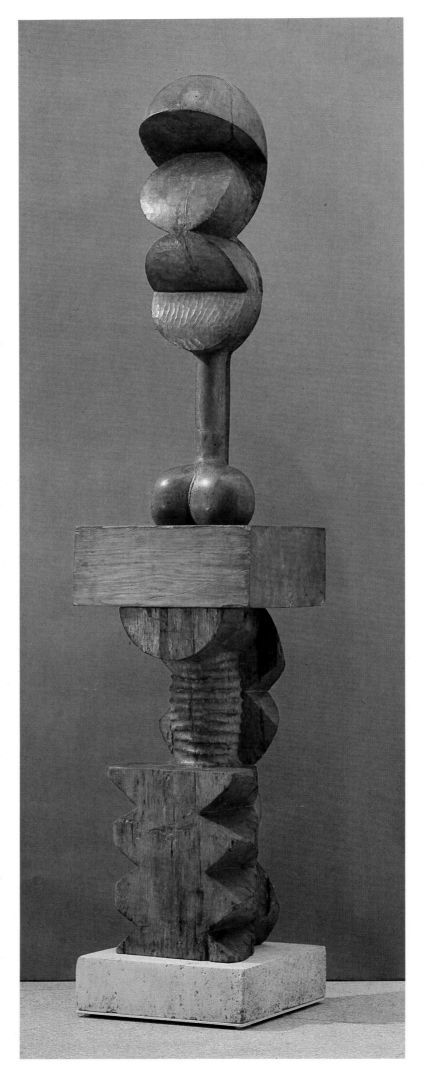

Adam and Eve. 1916–21. Old oak. The Solomon R. Guggenheim Museum, New York. Photo Robert E. Mates (Cat. no. 122)

It so happens I was meaning to write him about the bronze—see if he won't send it back. It will be quite beautiful afterward. As for the work involved, that is no concern of yours. You won't have to pay anything more. It worries me that the piece you took back with you changed—see if it doesn't come up by rubbing it with a piece of cloth. If not, and if you don't mind sending it back, I'd be delighted to do it over again, *well* this time. As for the marble you are asking me for,[3] I find it a bit difficult to do it again, and I cannot commit myself categorically, but should I find the right kind of marble, and should I do it, I'll let you know...."

On September 13, Brancusi sent word to Marius de Zayas that a shipment was on its way. "...Last week I sent you two sculptures: the marble and bronze [versions of] *Madame P.D.K.* The bronze[4] is entirely polished, and it turned out so beautifully that it would have been a great pity to cover it over with any patina, however lovely. I am sure you will feel the same way I do. See to it that they don't damage it at customs, and if it gets there a little rusted, have it cleaned the way you would any other metal; use only liquid products (the pastes they make for this generally leave faint marks). Moreover, I believe it would be advisable not to show them together. As for the marble you've asked me for, I could not come to a decision any sooner. To begin with, I was not sure I was staying in Paris, and then, I had other things on my mind. But, if you wish, I could do it for you for 3,000 francs. *Golden Bird* is ready, and for you the price is 1,000 francs. The bronze you sent back for the patina has not yet arrived, and I don't understand why not.... See if Mr. Stieglitz wouldn't like me to do his over. I'd be very happy to do so.... Have you received my letter of August 23rd? I have just been before the army medical board, and I have been found unfit for the war."

On September 28, Marius de Zayas acknowledged receipt of Brancusi's letters of August 23 and September 13 and thanked him for sending the two sculptures. For the time being, he could only send a check for 750 francs. "According to our agreement," he wrote, "I am supposed to pay you 4,000 francs for three sculptures. Including the check enclosed herewith, I have already given you 1,250 francs. I still owe you 2,750 francs. Would you please sign the receipt and send it back to me."

On October 20, De Zayas acknowledged receipt of two sculptures (the marble and bronze versions of *Madame*

P.D.K.) and added, "I hope you will keep me posted on how your work is progressing and will always give me preferential treatment."

"...In your letter of September 28," Brancusi replied on October 31, "you mentioned nothing about *Golden Bird*,[5] and when I got your cable, I didn't have it any more. I explained this to your brother Georges, who came to see me.[6] I do hope there has been no misunderstanding. I am enclosing the receipt for 750 francs. Your calculations are correct. You owe me another 2,750 francs. Did you get the bronze and the marble? Are they in good condition? I am still working on Mrs. Meyer's bronze, and I'll send it out soon."

Meanwhile Brancusi kept in touch with Walter Pach, his go-between with the American collector John Quinn. Pach had written:

"...Mr. Quinn, the fortunate owner of your *Golden Bird* and *Mlle Pogany*, has asked me to inquire what is your price for the original version of the sculpture *The Kiss*, a cast of which is in my possession. He has asked me for news of it on several occasions and now asks me to write to you again. Meanwhile, he has purchased the bird group *Penguins*, which De Zayas exhibited and which went over pretty well."

"...We have had several splendid exhibitions, and with Duchamp, Gleizes, Picabia, and Crotti in New York, it looks a little like Paris"

"Dear friend Brancusi," wrote Walter Pach again from New York on March 3, 1916, "...I reported to [Quinn] that you spoke to me about doing *The Kiss* in stone, and he has instructed me to order it for him. He says in his letter that he would have liked to know the price beforehand, but that you needn't wait to let him know, because he has every confidence that you will set a fair price, and he asks you to have the sculpture carefully packed once it is finished and to ship it insured with *war risk*, all at his expense. I am very pleased to pass this commission on to you, all the more because it is for a collection of ever-increasing importance. He is also very much interested in that big gate and has asked me to tell you to be sure and take a picture of it and send it to us. I'll also be most interested to see the other photographs you mention. As for *The Kiss*, you know the piece I am referring to, the one

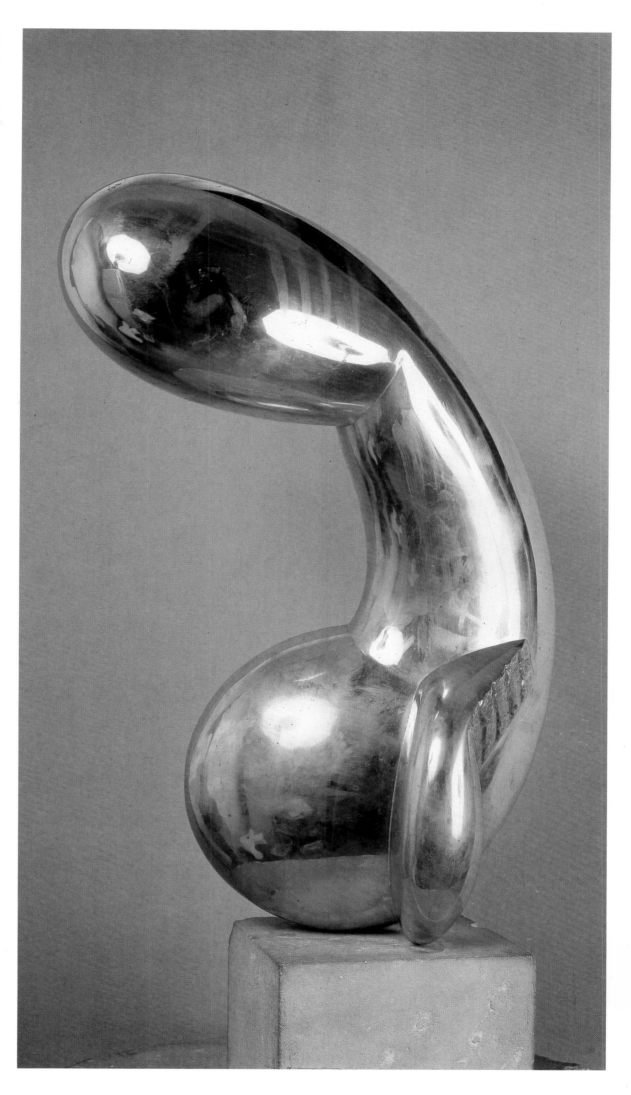

Princess X. 1916. Polished bronze. Brancusi Studio, MNAM, Paris (Cat. no. 89*c*)

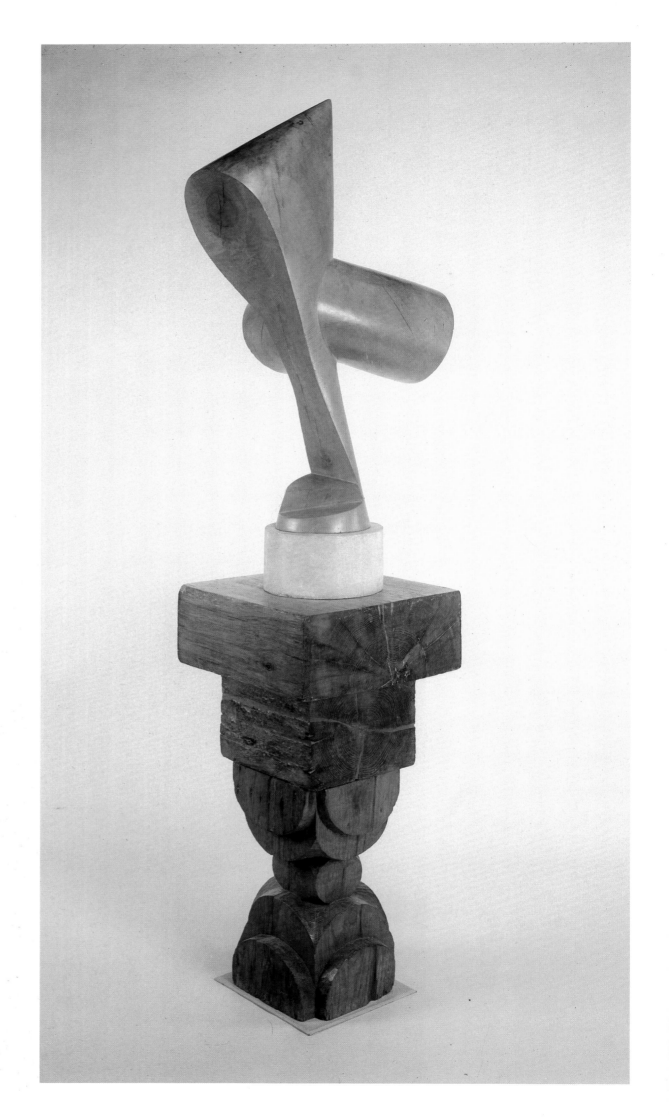

The Sorceress. 1916–24. Maple. The Solomon R. Guggenheim Museum, New York. Photo David Heald and Myles Aronowitz (Cat. no. 91a)

that only goes down as far as the chests, not the full-length one like the monument in the cemetery. Quinn also wants to know if you don't think a pedestal would be in order, at least a few centimeters high, so that the sculpture has a suitable base.

"Here is a newspaper clipping that will give you an idea of what's being done here with the cooperation of Mr. Stieglitz. The sentence stating that this exhibition is calculated to divert the public's attention from European artists and focus it on Americans (and promote 'national art') will prove to you that I really have my work cut out for me here to fight the good fight.

"Sincerely yours,
Walter Pach"

Pach wrote again from New York on July 17:

"Dear Mr. Brancusi,

"Yesterday I got a phone call from Mr. Quinn, who told me that he had come to a decision concerning your architectural wood pieces and asked to wire you that he is ordering them. I immediately sent you the following telegram:

"'Quinn willing to pay your price twelve thousand francs for Cariatide, bench, gate, and Kiss on condition that he have option on your next important marble. Letter follows.'

"I think that ought to be clear, but I'll spell it out just to be sure. In your letter you told me that you were making The Kiss in stone, similar to the sculpture I have a cast of, only larger. You said that the price of this piece and of the three wood pieces, together, would be 12,000 francs. At Mr. Quinn's request, I wrote you that he was confirming his order for The Kiss, but that just then it was impossible for him to make up his mind about the wooden pieces. Now his mind is made up, as you can see, but he is doing this provided that you let him know before anyone else when you have another important marble (that is, the next one only), and that he reserves the right to buy it before anyone else. He feels he can make this request since he is purchasing four pieces together at your asking price; that seems reasonable to me, too. If you do send them, he will assume that you agree to his stipulation and that you will notify him when you do your next important marble and that you will give him the option to buy it before anyone else. He asks that you attend to the packing of the four pieces he is ordering from you at this time. Pottier has always done this work satisfactorily. Don't forget to go to the American consulate and sign in person the certificate of origin we'll need to pick up the four

pieces at customs. That is very important. Then advise us at once as to the date the works are leaving and the name of the ship, because we need that for the insurance. Address the crate to John Quinn, 31 Nassau Street, New York.

"Payment shall be as follows: 4,000 francs on receipt of the works, another 4,000 francs two months later, and the remaining 4,000 francs two months after that (that is, four months after receipt of the objects). Forgive me for writing a letter that is all business, but I want to get back to my work, and I am dashing this off so that it makes today's packet boat. Everything going well with me, hope it's the same with you. Hearty handshake, then, and au revoir.

Walter Pach"
"Duchamp is well"

"It is understood, dear friend," Brancusi replied on August 16, "that Mr. Quinn shall have the preference as to the purchase of my next important marble, and the payment for the sculptures he is buying now shall be according to his wishes as you indicate them to me. I have made arrangements to ship the sculptures, and as soon as the packing is finished and I know the name and date of the ship for the insurance, I shall telegraph you and drop Mr. Quinn a line. Apropos of the marble [The Newborn], I really should have liked to do more, because people could say there's nothing to it; but I did put a great deal of work into it and it turned out the way it did despite myself. Soon you will see at De Zayas's another, more important marble he bought not long ago; he commissioned a bronze after it, and I am finishing it now and will send it along with this marble.

"In addition, I wouldn't want people to mistake these things as imitations of the antique—that wasn't at all what I had in mind—all I tried to do was to bring out the beauty of these pieces of wood I'm so partial to, and I did not build them as I would have with new materials; and if I quoted a price for all of them together, it's because I made them to be that way, and I am glad Mr. Quinn has taken them all, especially because, as you recall, they were meant to be placed around sculptures that are for the most part at his place. The Kiss is slightly larger in size than the one you have, and I started this work again with the intention of improving upon it, not to make a copy of the other one.

"I trust that an original will be more to Mr. Quinn's liking, but in any event, if there is anything amiss, please come right out and say so, as I shouldn't want anything done reluctantly.

"As for the base you mentioned for The Kiss, it would be advisable to position it just as it is on something separate; otherwise it will always look amputated.[7] I shan't be going off to war, because the army medical board did not find me fit for duty, but I am very glad that my country is in it."

"...I myself could not be present at the packing," Brancusi informed Pach on October 4, 1916, "because just then I was called before the army medical board for the war, but Pottier has assured me, and confirmed afterward, that he packed them really well. Now, I made a few minor changes on Caryatid and the Bench, and it's for the best. Furthermore, I did not fasten together the two upper sections of Caryatid, to expedite shipping and installation. The two ends of the bench are completely unattached, too, but with the numbers and the photos you have, they will be very easy to put back together."

On December 29, Pach sent word to Brancusi that the sculptures had arrived in perfect condition a month earlier and had been reassembled with the

help of the photographs Brancusi had sent. Both Caryatid and The Kiss were set up at John Quinn's, and he sent the sculptor a check for 4,000 francs.

We should note that the marble dealer Henraux and Co. issued an invoice on October 9, 1916, for an order Brancusi placed for some marble and for the onyx that later became Torso of a Young Woman (1918). This was also the year Brancusi finished Sorceress (maple, $39\frac{3}{8} \times 22 \times 22\frac{7}{8}$ ins., The Solomon R. Guggenheim Museum, New York).

Base for **The Sorceress.** 1916. Photo Brancusi

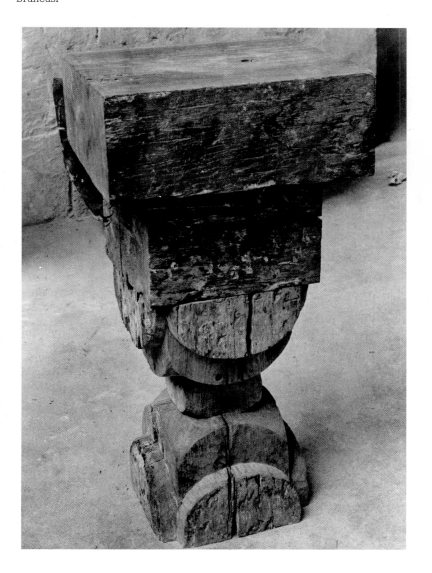

*chaque matière a son individualité propre
que nous ne pouvons[ton] detruire à notre [guise]
[Seulement] mais lui faire parler [illegible] prop langue*

1917

Czar Nicholas II abdicated, the Russian Revolution was under way, the first American troops landed in France—and Brancusi had a dream. He was used to these extrasensory phenomena, and he enjoyed recounting them:

A few decades later he told us one evening, "Once I had a biblical dream, too. I dreamt that Rumania was deluged. The seas had overwhelmed it on all sides, and I was on a hill that rose out of the waves. Not far from me, King Carol I, with his ministers and other dignitaries all around him, was anxiously wondering if there were any way to save the country from this tragic predicament. Someone turned to the king and asked, 'What can we do?' whereupon Carol pointed at me and replied, 'Ask him; he knows.' Just then I saw a shovel near me. I took firm hold of it and started shoveling the water. No sooner did I touch the wet surface than the flood subsided, and I kept it up so vigorously that eventually it vanished."

From the sidelines of the European cataclysm, artistic life was forging ahead. "Tremendous changes seem to be taking place in sculpture," wrote *Le Journal des Nations* on August 20, 1917. "The works that artists such as Brancusi, Duchamp-Villon, Laurens, and Archipenko have already given us herald the emergence of an important trend." Even as Rodin died at Meudon and the Photo-Secession gallery in New York, which had done so much to promote French art in the United States, closed its doors, new currents were surfacing.

In Leiden, an avant-garde group and its periodical, both known as De Stijl, were crystallizing from the principles that Theo van Doesburg and Piet Mondrian had set forth in 1916. (Brancusi was a close acquaintance of Van Doesburg and remained on friendly terms with his wife, Nelly, after Van Doesburg's death.) An illustration of Brancusi's *Blond Negress* appeared in the No. 77 issue of *De Stijl* (1926), a publication whose impact on the history of contemporary art is well known.

From now on the sculptor wrote directly to John Quinn, who would eventually have in his large and unusually choice collection no fewer than twenty-seven Brancusis. Before answering Quinn's letters, Brancusi often wrote out several rough drafts, which are worth quoting because they give detailed information about the artist's scruples as well as about his methods of work and the care of his sculptures. Moreover, Brancusi's rough drafts have not been available before now, whereas Quinn's correspondence is in the New York Public Library.

"Through Mr. Pach," Brancusi wrote on January 19, 1917, "I have received from you the sum of 4,000 francs, first payment toward the sum of 12,000 for the sculptures he asked me to send you. He wrote me that you were satisfied and that everything is all right, save for the inconvenience of not being able to put them all together. After the war, I intend to come see America and my friends, and if by then you have not been able to find the best solution, perhaps we can find it together...."

"I received on March 3d your letter of January 19th," Quinn wrote back on March 14. "The next payment of 4,000 francs on account of the sculpture I will send you direct without troubling our common friend Pach. ... Pach is very active in getting up an exhibition of Independents[8] at the Grand Central Palace in this City. He asked me yesterday whether I would be willing to lend the Bench and Doorway for exhibition there, and I said I would be glad to do so....

"Now I wish to inquire whether you would be willing to make a bronze for me of the woman's head, a plaster cast of

Cup II. 1918. Wood. Brancusi Studio, MNAM, Paris (Cat. no. 106)

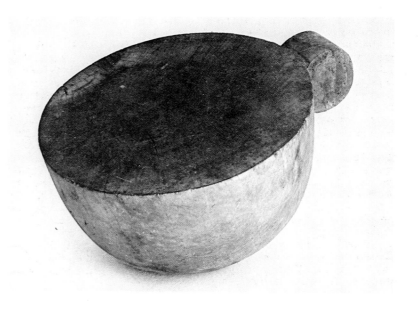

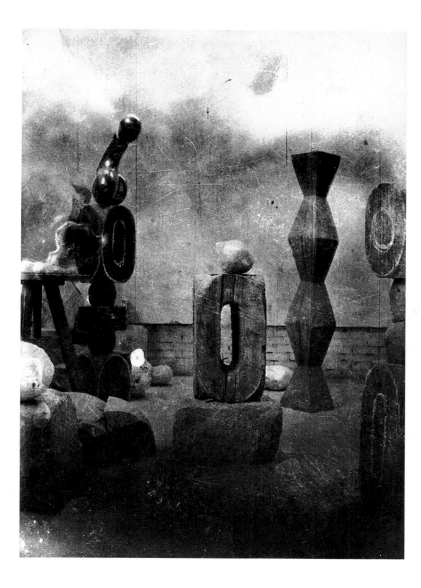

Brancusi's studio, 8 Impasse Ronsin, c. 1917: **Princess X** (Cat. no. 89), **Prometheus** (Cat. no. 66), **Endless Column** (Cat. no. 92). Photo Brancusi

who unpack it at the Custom House do not put their hands on the metal, so as not to stain it; and if it reaches you slightly tarnished by the humidity, will you please also see that it is well rubbed with a chamois skin ([rub] the smoother parts only) to give it brilliancy.

"I am sending you several photos of each [piece], and I hope that you will be able to form an idea of what the sculptures are. I have numbered the

prints on the back and I have written above the exact dimensions. Among the new things there are also two repetitions (nos. 5 and 6)—the Bird and the Sleeping Muse—which must not be considered as reproductions for they have been differently conceived, and I did not repeat them merely to do them differently, but to go further. They are not yet finished, but you can see what they will be. (The round flaw on photo 6 does not appear on the marble.)

"No. 4 is one of the first marbles I made, and I intended to keep it. But as you have nearly all of my works which followed it, I thought that perhaps this marble might interest you.

"I enclose herewith a run-

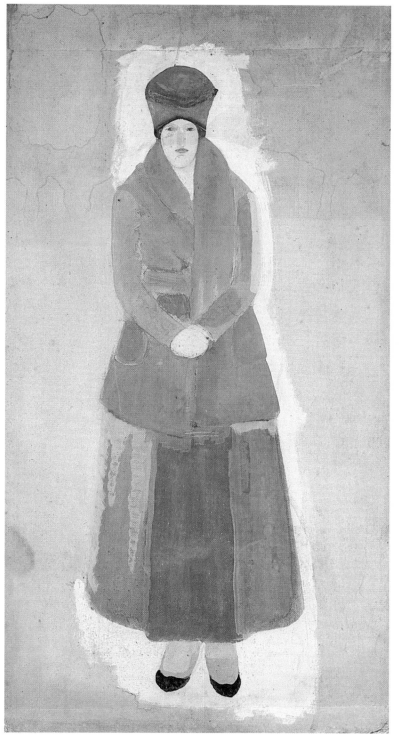

Standing Woman in Blue. 1917. Gouache on paper, pasted on cardboard, 75.5 × 38.5 cm. Private collection

which was at the international exhibition held in this city some years ago [the Armory Show], and was bought by Mr. Arthur B. Davies[9].... You must have the plaster of it. Would you be willing to make a bronze of it for me? What would your price for a bronze be, a bronze finished by you yourself personally?..."

Brancusi's reply is dated June 20. "...Now I can commit myself to making you a bronze for the price of 3,500 francs, if you wish the aftertouches, which I think indispensable if the bronze is to be really good. The bronze will be completely polished and patinated in gold, and the work will be entirely done by me.... But I will send you shortly photographs of what I am expecting to finish.... The second payment of which you advised me I have not yet received.... May I ask you to cable it ... and if you do not trouble Pach about it, I shall be pleased ... I am making you a sketch of the sculpture you've asked me [to make] a bronze of, and I feel sure that it is the one in question.... P.S. At the New York International Exhibition [Armory Show] this sculpture was given the title of 'A Muse.'"[10]

On July 26, Quinn notified Brancusi that he had cabled him

5,000 francs that day, leaving a balance of 3,000 francs. "I am glad to know," Quinn went on, "that you are willing to make the bronze figure that I wrote to you about, and of which you sent a sketch in your letter. The price that you put upon it of 3,500 francs is quite satisfactory to me. I am very glad that you will put the after touches upon it. I quite agree with you that they are indispensable for the bronze to be really good.... I shall look forward with interest to the photographs of the work which you are expecting to finish...."

On December 27, 1917, Brancusi sent Quinn the photographs and a list of the sculptures, detailing their subjects and prices. "...I have also just finished the bronze and it is being sent at the same time as this letter. It is a success, and I have taken all precautions that it may reach you in good condition. I hope you will be satisfied. You will also receive a stone suitable for a base on which to place it.... I would ask you to see that those

down of subjects and prices, which I intend to make you as fair as possible.

"Now I would ask you to answer me as soon as possible about these sculptures, so that I may dispose of them if necessary.

"I have not yet received the remaining 3,500 francs, and if you have not sent it I would ask you to cable it, for I have rather been counting on it.

"Subjects and Prices

"No. 1. Wood, *The Child in the World*, mobile group,[11] 12,000 francs

"No. 2. Wood, *Chimera*, 3,000 fr

"No. 3. *Madame L.R.*, wood, 3,000 fr

"No. 4. *Prometheus*, marble and wood [base], 6,000 fr

"No. 5. *The Bird, Maiastra*, marble and wood [base], 10,000 fr

"No. 6. *Sleeping Muse*, marble, 10,000 fr

"...and now, dear Mr. Quinn, the hardest calvary is ascended [the worst part is over], and I remain

"Sincerely yours,
(sgd) C. Brancusi"

As the year 1917 drew to a close and war convulsed Europe, the sculptor's military deferment permitted him to go on with his work. On November 1, the Rumanian legation asked him to appear in two days at the army hospital in Le Val-de-Grâce for examination by the medical committee, and on November 8, the military attaché issued a certificate permanently exempting him from all service. Brancusi was now free to pursue his career without fear or uncertainty.

Urged on by a need to create, he kept on buying materials out of sheer enthusiasm. However, conditions in Rumania were very much on his mind. He had not heard from his mother, so he asked a fellow Rumanian who was returning home if he would make inquiries; Brancusi received only a postcard from him, with none of the requested information, for his countryman had gone north as a refugee.

Finally, Brancusi received a letter, mailed on October 13, from the writer Henri-Pierre Roché, who would play an important part in his life. Gifted with a flair for new trends in art, Roché had had the idea of opening up artists' studios to foreign collectors who were in Paris, to acquaint themselves with contemporary French art. In this way, Roché had not only met artists like Picasso, Henri Rousseau, and Marcel Duchamp, but helped them sell their work, all the while building up a sizable collection of his own.

Right, above:
The Muse. 1917. Bronze. Portland Museum of Art (Gift of Sally Lewis), Portland, Oregon. Museum photo (Cat. no. 99c)

Right, below:
The Muse. 1917. Pencil on paper, 6.9 × 4.7 cm. The New York Public Library (John Quinn Memorial Collection). Photo rights reserved

Opposite page:
Timidity. 1917. Stone. Brancusi Studio, MNAM, Paris. Photo Brancusi (Cat. no. 97)

Certificate of Rumanian legation exempting Brancusi from military service, November 8, 1917. Archives I–D

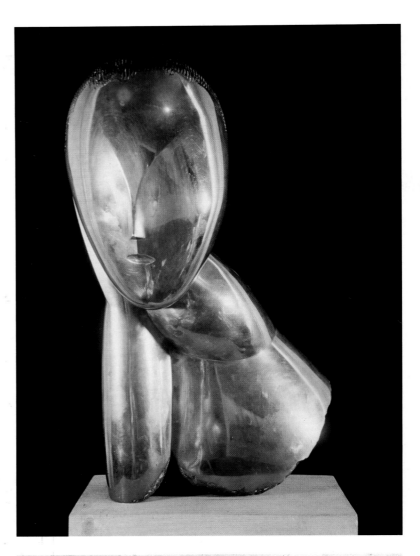

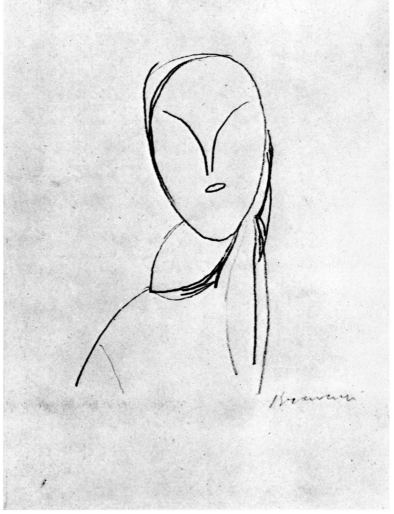

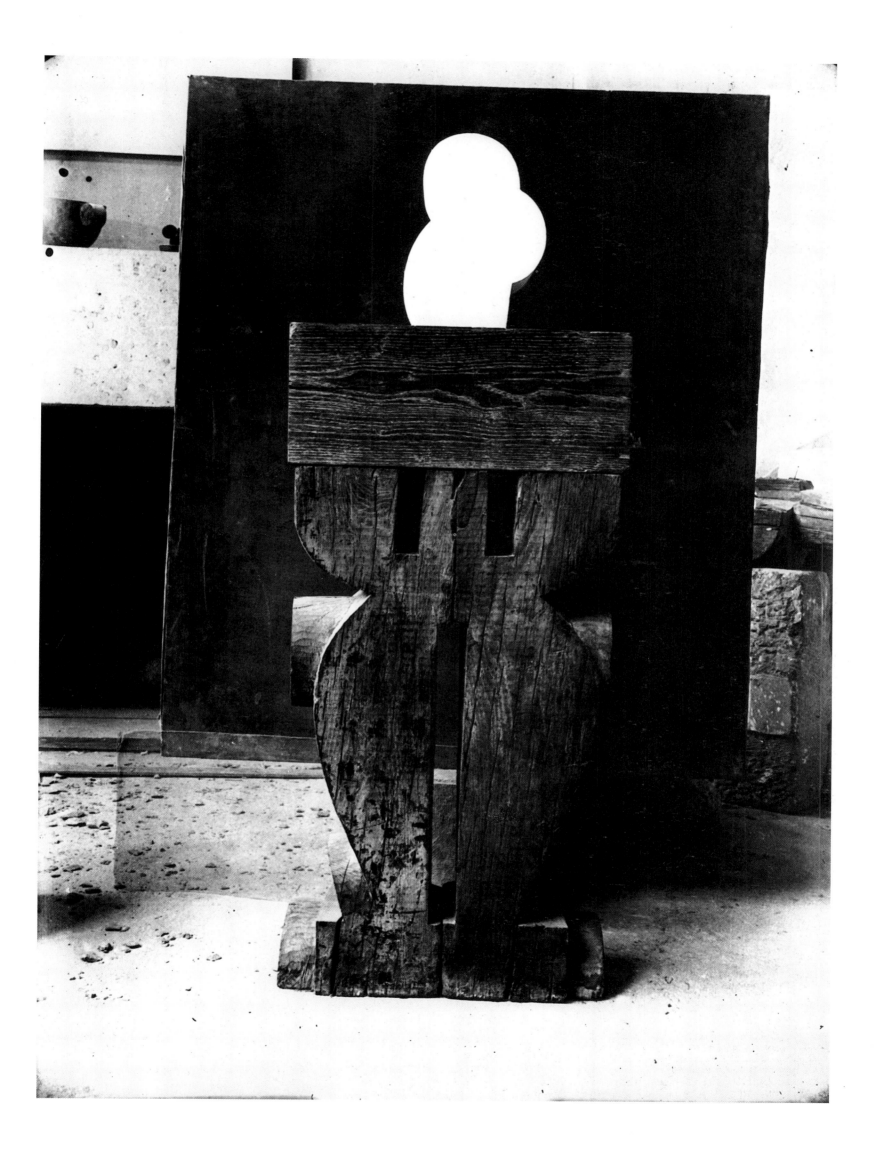

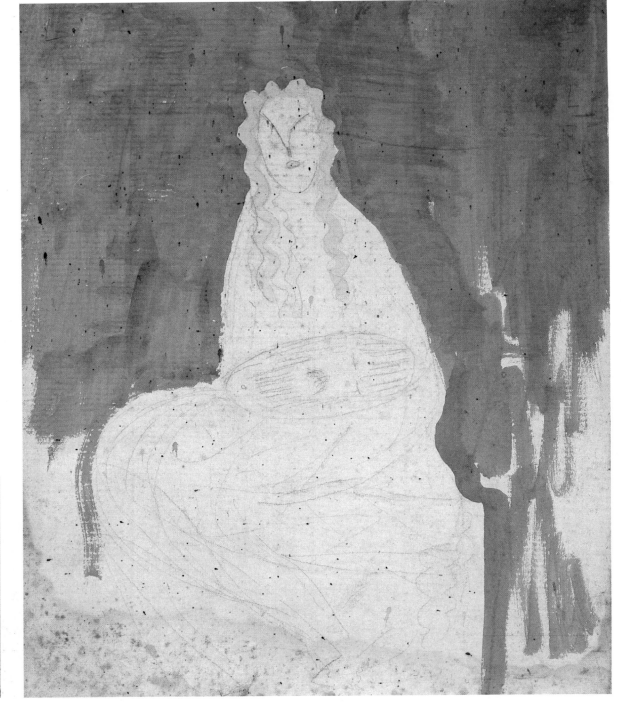

Portrait of a Woman. 1917.
Gouache on paper, pasted on
cardboard, 55 × 42.3 cm. Private
collection

Right, above:
Salomé. 1917. Gouache and pencil
on paper, pasted on paper,
34 × 26 cm. Signed and dated at
lower right. Private collection

Right:
**Portrait of a Woman with Green
hair.** 1917. Paint on paper, pasted
on cardboard, 37 × 31.5 cm. Signed
and dated at lower right. Private
collection

Far right:
**Portrait of a Woman with Green
Hair.** 1917. Paint and pencil on
paper, pasted on cardboard,
37.8 × 32.2 cm. Private collection

Opposite page:
Torso of a Young Man I. 1917.
Polished bronze. Cleveland
Museum of Art (Hinman B. Hurlbut
Collection). Museum photo (Cat. no.
102a)

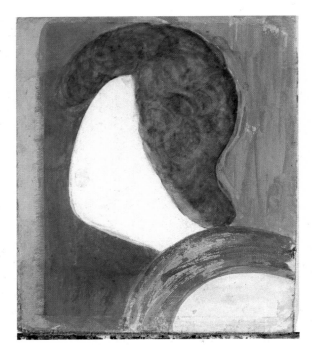

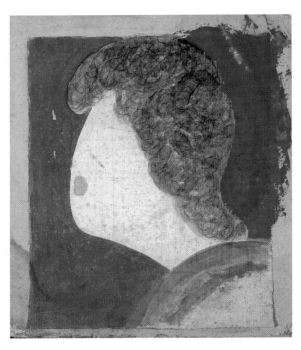

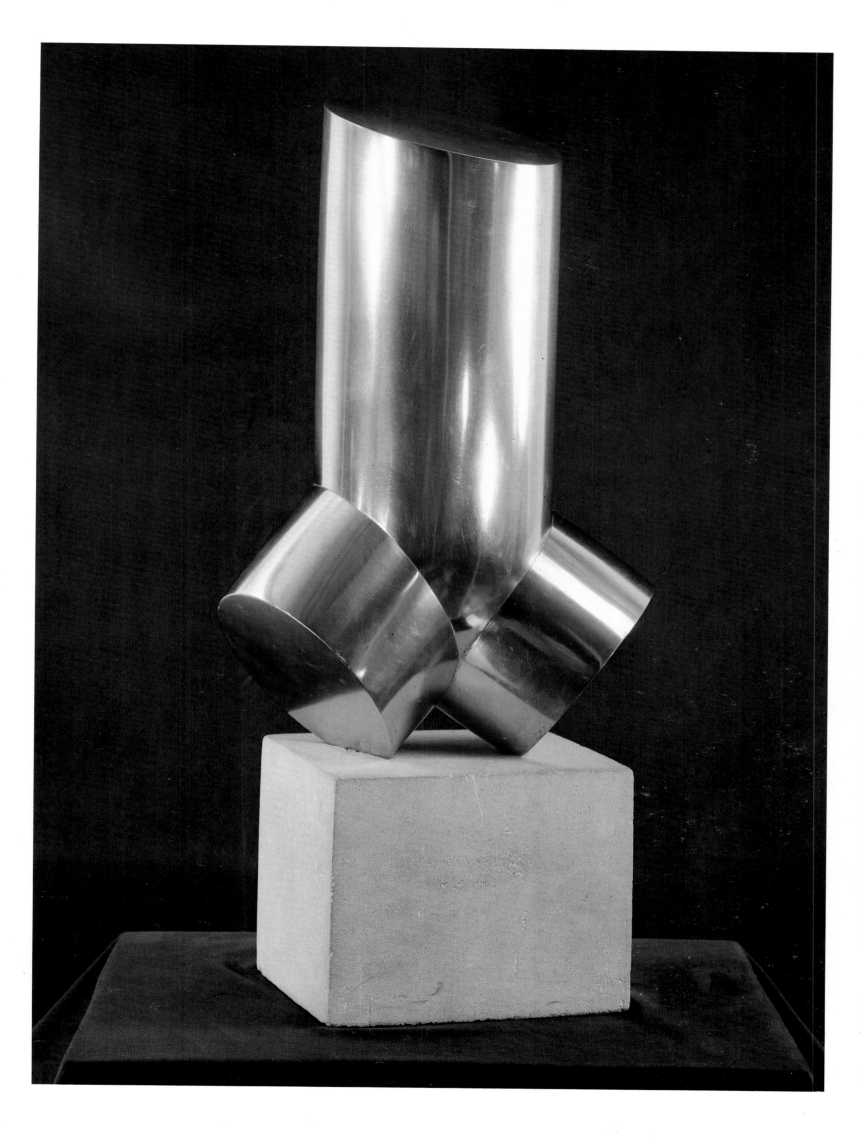

1918

On January 23, John Quinn wrote Brancusi that he had not yet received the photographs and was still waiting for *A Muse*, which he had requested a year earlier. "I congratulate you upon the definiteness and precision of your letter. When the photographs come and with your letter before me, I am sure that all will be quite clear. Your letter is more definite and precise than those of most artists."

The next letter (dated March 23, 1918), written by Quinn's secretary, informed the artist that the *Muse* had been delivered on March 14 and that a check for 3,500 francs would be sent to the sculptor. "Mr. Quinn asks me to say to you that he is delighted with the bronze and that he is very much indebted to you for sending it to him. He has, as you know, the marble 'Mlle. Pogany,' and he regards this as a good and interesting complement to that.... But it had been tarnished in some places in transit. The straw in which it was packed was wet and mouldy...."

Brancusi's reply to Quinn is dated June 5, 1918.

"I received Mr. Curtin's letter of March 23rd with check for 3,500 frs in payment for the bronze *(A Muse)*, and I thank you for your promptness....

"As for the patina of the bronze, I purposely left certain parts ungilded to make a contrast. It is a pity, however, if excessive moisture during transportation has brought on tones other than those I had intended—although Mr. Curtin writes that the stains do not look badly and that you are pleased with it. To keep it brilliant, you must have it wiped fairly often with a chamois skin—two or three times a week—or whenever it is convenient to do so, without removing it from its place for that purpose, and per-

haps it would even be better not to employ any professionals for this, for professionals sometimes know more than is necessary. If later on the patina gets to look badly, kindly advise me and I will attend to it....

"I am writing you these lines under the thrilling emotion of the great events toward which all thoughts are turned. We here all have the firm hope that things will turn out well—they have already begun to do so, and the relief is great. I cannot close this letter without telling you all the admiration I have, not only for heroic France but also for noble and brave America.

"Very sincerely yours."

A friend of Mme. Ricou's, Odette de Saint-Paul, had a house in Chausse (Gard) that she was planning to convert into a shelter for war refugees who would earn money by working the surrounding land. However, repairs were needed first. In early June, as the German army advanced to within striking distance of Paris, she suggested that Brancusi should stay there for some time. He accepted, and after three days in the Hôtel des Quatre-Saisons at Chamborigaud, he moved into the house at Chausse, writing from there on June 13 to Odette de Saint-Paul with requests for tools, plaster, wood, and dishes.

On July 8, after the laborers who were helping with repairs had gone for the day, Brancusi went up to the attic to tend to a sagging roof beam. Suddenly the beam gave way and broke his shinbone. He shouted and threw things outside to attract attention, but no one came: the house was rather isolated and surrounded by high walls. He remembered that when animals break a limb, they stretch out and remain motionless, and during the night he managed to tie two small planks to either side of his leg to keep the bone

immobile; then with extreme difficulty he got down from the attic. In the morning, the peasant woman who brought the milk heard his calls. A child scaled the wall and opened the gate from the inside. Neighbor women rushed to the scene. At nightfall, they all came and lighted candles. Brancusi, racked with pain, spent the whole night with a haunting tableau of silent women keeping vigil at his bedside as if he were dead.

He spent thirty-eight days in the hospital at Alès among wounded soldiers from the front, then another twenty-five days in a local convalescent home. In his notes he outlines the accident as follows: "July 8: leg broken. July 17: plaster cast (rigid dressing) applied. August 10: cast removed. August 20: walking brace." Later on he avowed, "I would have been better off treating myself and not going to the hospital."

The two ends of his fractured shinbone had been badly set, and the bones did not knit properly. In addition to the pain, his right leg, now shorter than the other, gave him constant discomfort. The doctors wanted to operate. Brancusi preferred to return to Paris, for the news from the capital, to judge from a letter from a neighbor on Impasse Ronsin, was not encouraging.

"We had a few days of peace and quiet here, then Big Bertha started up again Monday and, of course, her first payloads landed in our district. One of the shells fell right behind the house, on the grounds of Hôpital Necker, others on Rue Lecourbe, in the shantytown, at the far end of Avenue de Vaugirard, and so forth. The next day, the first one landed at the corner of Rue Brown-Séquard and Boulevard de Vaugirard; it exploded on the sidewalk, killing a child, wounding the

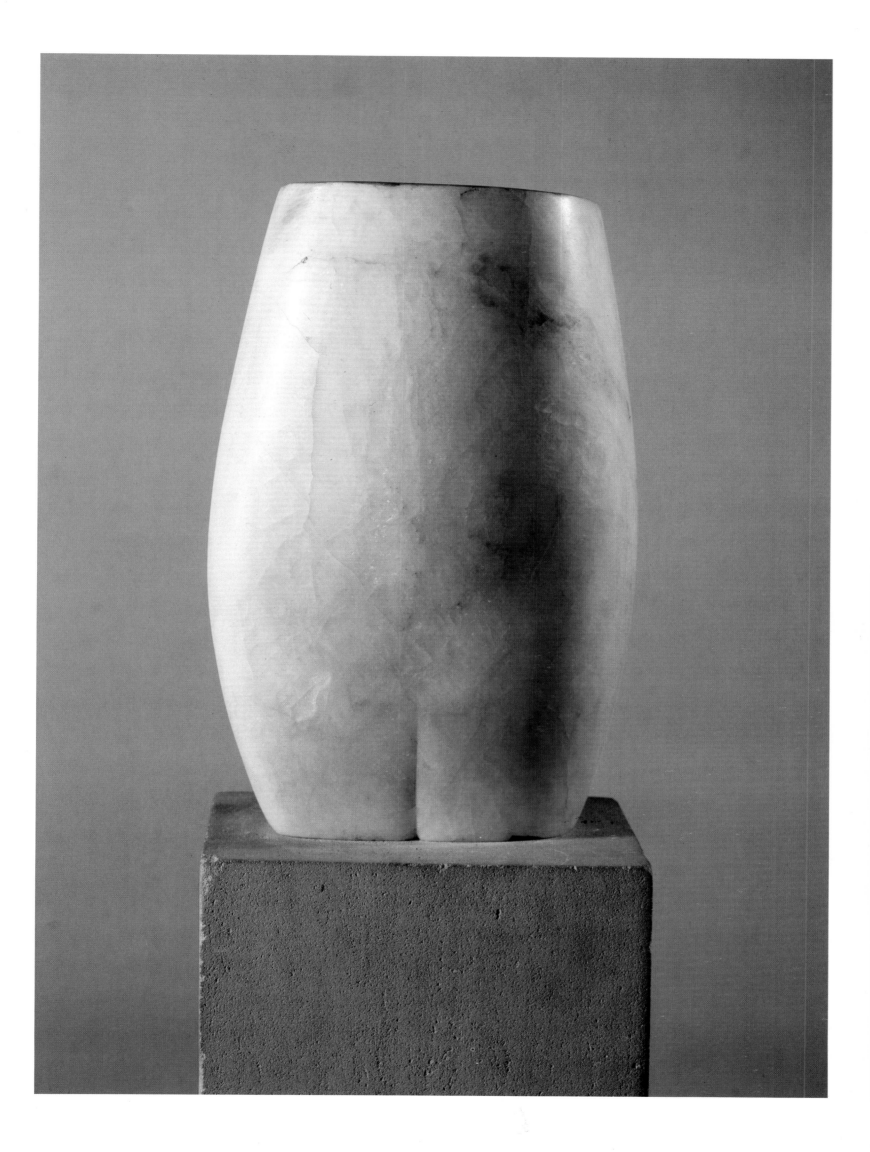

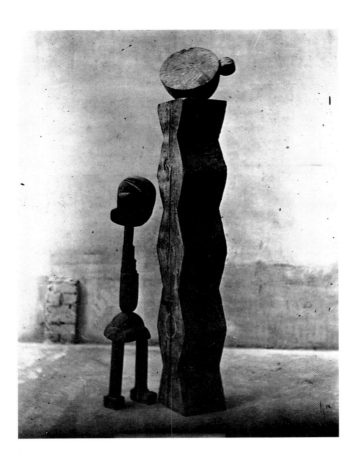

Opposite page:
Architectural Project. 1918. Wood.
Photo Brancusi (Cat. no. 105)

Left:
''Mobile group'' entitled **The Child in the World,** consisting of **Column, Plato,** and **Cup II.** 1918.
Photo Brancusi

Below:
The Artist's Studio. 1918. Gouache and pencil, 32.8 × 41.1 cm. The Museum of Modern Art (Joan and Lester Avnet Collection), New York. Museum photo

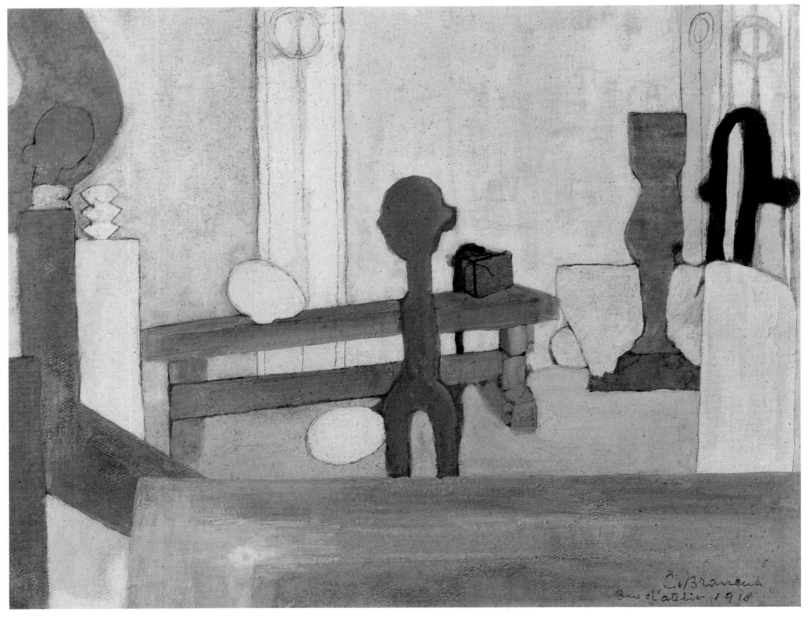

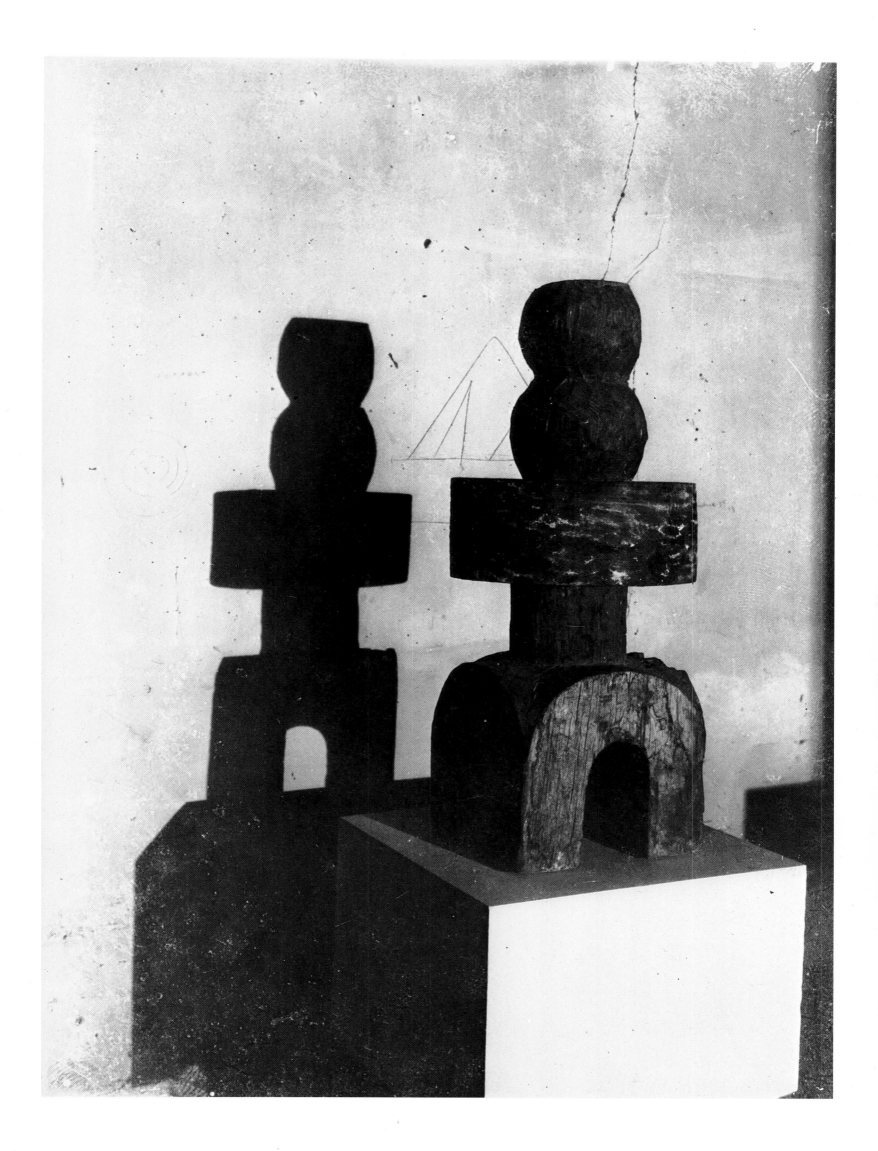

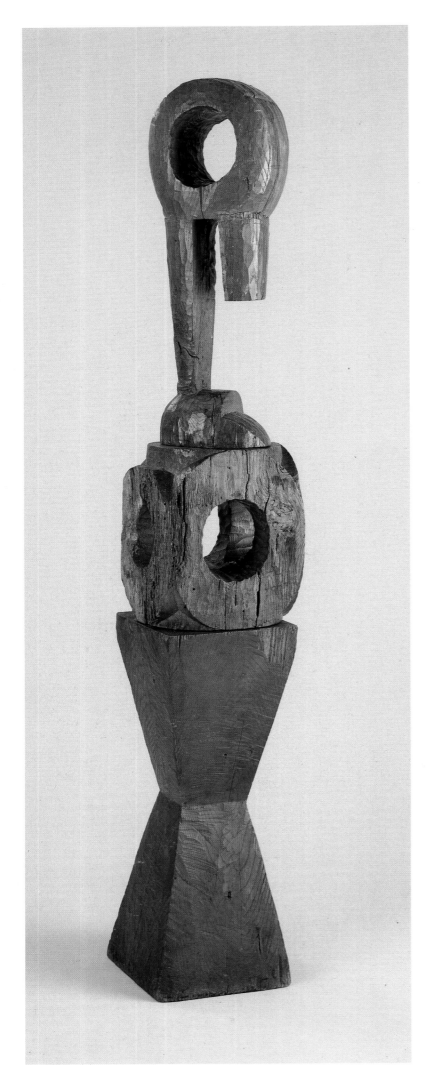

woman mortally who runs the dairy store at No. 52, and more or less severely some women who work in a store at No. 50. Those two locations along the boulevard are in a shambles. At 5:20, another landed at the beginning of Impasse de l'Enfant-Jésus, that is, 25 meters from the corner where the Steinheil house is! At this spot there are usually some kids playing, caravans of army trucks rolling by, nurses from Necker at the ground-floor windows of the corner building; there are almost always people at the grocery stands across the street. The bomb could have done a lot of damage. But by a stroke of luck, it embedded itself so deeply in the ground that the explosion did nothing more than make a big hole. It didn't even affect the buildings nearby!

"In our place, we didn't feel more than a jolt that was strong enough to blow out the gas in the stove, where we had some tomato soup and some stew simmering for dinner!..."

A nurse from Alès wrote Brancusi to thank him for some "pretty slippers," and the letter suggests that he had returned to Paris on or about September 11. On Dr. Marbé's recommendation, he was admitted to Hôpital Necker for four days of tests, but he found the food so bad that he decided to be put in traction at home rather than in the hospital. He fitted out his bed in the studio with a system of weights and pulleys designed to stretch his shinbone, and thus immobilized, he began to make drawings, paintings, and gouaches. His leg never mended completely; fatigue always brought on the pain.

On October 26, John Quinn sent a letter that must have added to his distress:

"... I have been compelled to limit my activities very much. ... I gave too much of my strength and energy and money to appeals of all kinds. Not being a married man and not having any woman to protect me, I am the victim of self-seekers of all kinds. That includes some artists but not many....

"This has no relation whatever to you, and the artists have been the least of the drain upon my strength. On the contrary, art has been a relief and a recreation....

"I know you only want my candid opinion. I am not so much interested in this later work of yours as I am in the earlier work, although from your personal point of view as an artist it may be a necessary development. I am much more interested in your stone carving than I am in your wood carving.

"Then too I think that your prices are much too high, considering these war times and other things....

"I am willing to make you an offer for No. 4, which you state is one of the first marbles you made, of 3,000 francs. That is what you call Prometheus; the marble head and the wood base. I am willing to make you an offer for No. 5, 'The Bird Maiastra,' with a wooden base, of 4,000 francs. I am willing to make you an offer for No. 6, marble, being 'The Sleeping Muse,' of 4,000 francs.

"That makes a total of 11,000 francs for those three items, and considering all things and considering war times and prices and the expense of insurance and shipment and other things, and considering what I have bought of you, I think it is a fair price. You may not agree with me, and if you do not all well and good, there will be no hard feelings on my part; but if you do, you may send them to me and I will pay for them one-half upon receipt of the three works and the other half two months thereafter...."

On November 9, 1918, two days before the armistice, Guillaume Apollinaire died of influenza. Brancusi, Léger, Picasso, Derain, and a few others attended the funeral service in the Eglise Saint-Thomas.

And what remains of the war years? More letters, rough drafts, invoices, receipts, newspaper clippings ... but among them a ration book and sugar coupons.

Chimera. 1918. Oak. Philadelphia Museum of Art (Louise and Walter Arensberg Collection). Photo Eric Mitchell (Cat. no. 87)

Je pleur - il fait
tellement beau dan mon
âme; ~~·~~ mon cœur se
déchire ~~·~~ persone au
Tour de moi - persone

1919

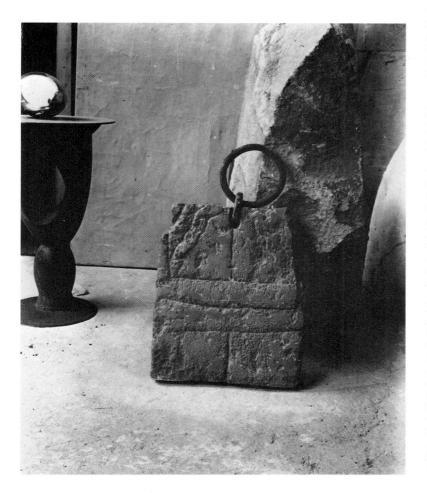

Medallion of The Kiss. 1919.
Volcanic stone with iron rings.
Brancusi Studio, MNAM, Paris.
Photo Brancusi (Cat. no. 107)

Both Brancusi and Dr. Marbé were friends of Marie-Louise Gravier, whose lengthy correspondence with the sculptor suggests that she owned some of his drawings.

"My dear friend," she wrote on January 19, 1919, "your letters are at the bottom of the sea, near Messina. You must have read about the disaster of the ship *La Chaouia*. Of the 750 people on board, more than 500 perished. Mr. Gravier is fortunately among the survivors."

"Dear friend," Brancusi replied, "I read in the news-papers about the disaster that nearly swallowed up your husband, and I am truly happy that he escaped. Good fortune is in the hands of God; all that matters is life. Life is something so beautiful, so wonderful, so divine, nothing can take its place. ... If you partake of real life, you don't need anything. Everything lies before you; it is there for the taking. But we do not see real life except by reflections, and there is nothing to guide us but pride and envy, which make playthings of us."

On January 27, after considerable procrastination, Brancusi finally answered Quinn's letter of October 26, 1918. However, the simplified version he ended up sending the collector does not express his displeasure as forcefully as do his rough drafts (December 1918 and January 24, 1919). Here are some excerpts from the first draft:

"The candor of your letter pleases me very much. You have opened my eyes to many things, things which, as you say, have no relation to me....

"As for the prices I quoted you, bear in mind that right on the list of prices I wrote, word for word, 'And now, dear Mr. Quinn, the hardest calvary is ascended.' All that meant was that I had set a fair price [although] on the surface it may not have seemed to be the case. I had no reason to give you any further explanation....

"If I offered you the two marbles, *Sleeping Muse* and the *Bird*, it is because I look upon them as entirely different from the first ones; I shall send you the prints [photographs] shortly.I still would have liked to set one price for all of them with a substantial reduction, because the important thing for me would be to see my works brought together; but I was afraid you might be tempted to buy them simply because they were not expensive, even if they were not entirely to your liking. And I was right, because you *don't* like the wood sculptures; and right or wrong, you are entitled to your opinion. But I am not to blame if I do not handle wood the way I do stone, or stone the way I do marble, or marble the way I do bronze, and so forth. It's just that I cannot say with a block of marble what I can with a piece of wood, or with a piece of wood what I can with a block of marble, and so on with other materials. Simplicity is not my goal, either, because all I am trying to do is attune what is in my mind to the materials that come my way. Each material has a particular language that I do not set out to eliminate and replace with my own, but simply to make it express what I am thinking, what I am seeing, in its own language, that is its alone (which is part of the beautiful). So, you will understand that wood [sculpture], or for that matter marble [sculpture], is by no means the result of a fluke; it comes from very hard and very long work and from a concern for absolute impartiality.

"To get back to the matter at hand, ever since I've been up and around, I've been working at my bedside to reach the end of my marble [sculpture]. And I do mean reach the end, for when one sets out upon the road to the beautiful, it becomes like that castle in a fairy tale: the closer it looks, the farther away it gets. I've done everything I could with my ideas [for it] and am sending it to you shortly with the other marble.

"I cannot send you the *Bird (Maiastra)* because it broke during the shelling of Paris. I stuck it back together, but now I don't have the heart to finish it. I am not sending you the wood base for the marble, either, because placed in a different environment it will do the marble more harm than good. However, if you are dead set on having it,

you are welcome to it. The prices are your own, and please rest assured that if mine seemed to you inordinately high compared with prewar prices, it is not to get more money out of you but because, as you yourself said, life is three times more expensive than it used to be, and the work [on these] was harder than for the others.

"Lastly, as per your request, it was agreed in my letter to Pach that you have the option to buy the work I am now making, or shall make, before anyone else. I don't think I'll ever be able to determine which is the most important. Besides, I do not see why someone other than you would buy it, since you have the bulk of my work, and I should be very glad to see as many of my works brought together [in one place] as possible....

"The only thing is, this way of going about it is not good for me; for there you are in New York and here I am in Paris. I've been working a very long time on my sculptures (some of the wood pieces in the photographs

Portrait of Brancusi's mother. 1919 (?). Photograph with gouache

you have were begun before the war), and in the interim people have seen them and occasionally asked me for them, and I have to turn them down pending word from you, and as you see, everything is not to your liking."

The second draft is essentially a restatement of the first, but adds important details concerning the way *Sleeping Muse* and *Prometheus* should be shown—a matter that often raised problems.

"... As for the placement of No. 6, the marble *Sleeping Muse*, it would be better for it to lie on its left side, the way it does in the photograph, and if possible approximately 1.10 to 1.20 meters [about 40 ins.] above the ground; and for No. 4 *(Prometheus)*, to lay it on the right side and much lower than No. 6, and not to give it any base...."

Shortly thereafter, the Modern Gallery in New York bought some of Brancusi's work as soon as he made them available. "I understand from Mr. De Zayas," Quinn wrote on October 25, 1919, "that you sent him the new bird in marble which had got broken but which had been repaired." On March 27, Brancusi jotted the following on a loose sheet of paper: "Received check 9,500 F toward the sum of 12,000 F for *Bird*, marble, broken; *The Muse*, bronze; two *Head of a Child*, bronze; *Chimera*, wood."

While staying at Baroness Frachon's place in Château-Cardesse (Basses-Pyrénées), Brancusi received a registered letter from his sister, Frăsiná Brânzan, that plunged him into sorrow: "My dear brother, I am writing to let you know that we are in good health, but that our mother died. My husband died, too, on the field of battle. I am myself the worst off of all the children. As for our brothers, all are in good health and think the same way. Our mother died of the heartache her children caused her; they forgot they had a mother. As for the letter you sent us, we got it all right, but the money you told us about in the letter (100 lei) has not found its way to us. I long for your return, my brother.

"Frăsiná G.I. Brânzan [Eufrosina]

"May these lines find you in good health! My husband Gheorghe is dead, and I don't have anyone anymore. My brothers don't care for me, and I've been left with three children. I have no government pension.

"This letter is written by your nephew I. Brânzan. Please write us when you get it."

Maria Brancusi, who had given birth to Constantin at twenty-one, had died at the age

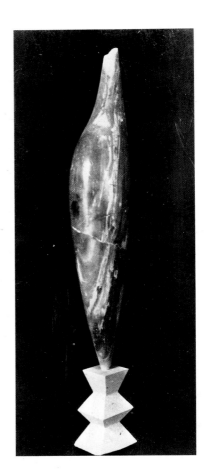

Yellow Bird. 1919. Yellow marble. Yale University Art Gallery, New Haven. Photo Brancusi (Cat. no. 109)

Draft of letter by Erik Satie for Brancusi (1919), authorizing Garcia and Co. to clear through customs a **Bird (Maiastra,** Cat. no. 85) that was being returned, damaged, from New York by De Zayas. Archives I–D

Opposite page:
Maiastra. 1915. White marble (damaged). Photo Brancusi (Cat. no. 85)

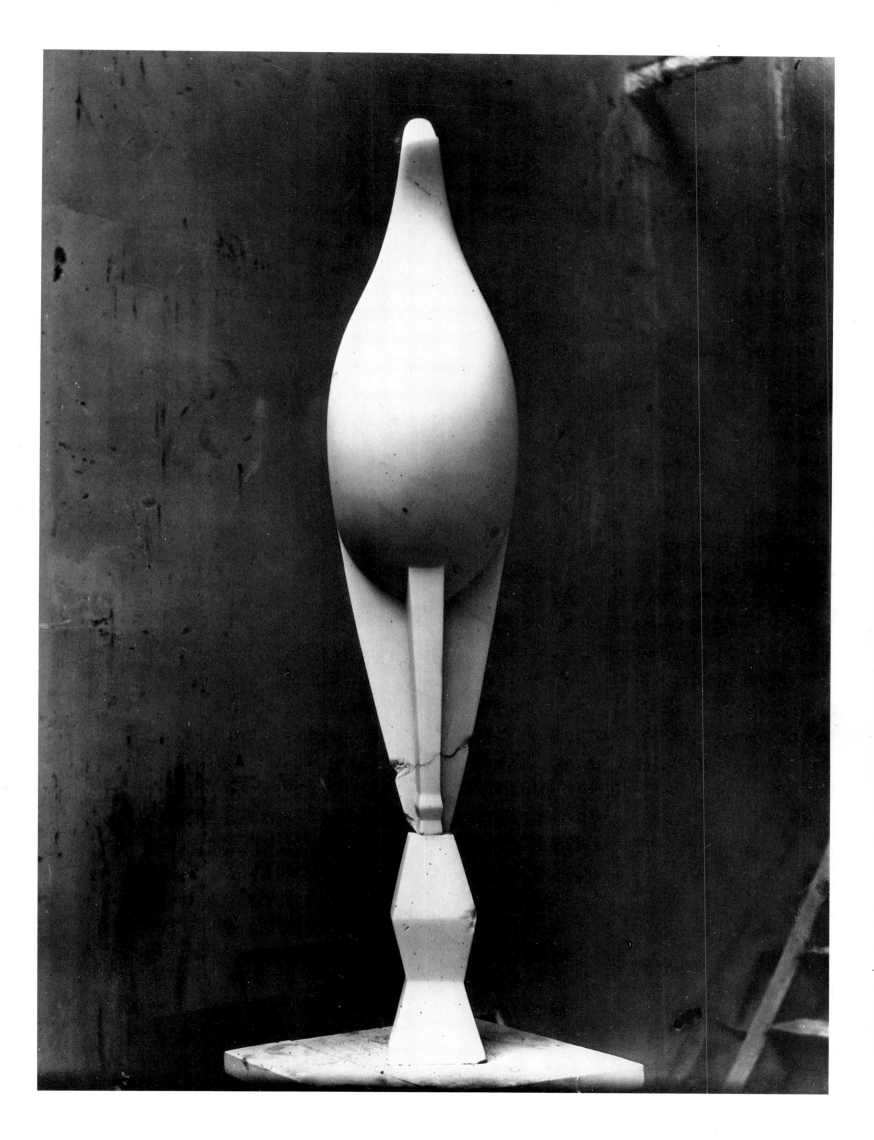

of sixty-seven. Brancusi returned to Paris at once and broke the news to his friends. He bought some black-edged notepaper and had prayers said for her in the Rumanian church as long as he lived. "Please excuse me for again writing you such a brief letter," he wrote John Quinn on September 23, "but I just lost my mother, whom I loved very much, and I am quite overcome."

On July 14, L'Hoir published the first volume of *Rumania in Pictures*, which included an article on Brancusi by Marie Bengesco and plates of five works. Here for the first time in the artist's career occurs the title *Head Carved from a Pebble*, doubtless an allusion to a remark he used to make whenever he heard complaints by young artists about not working for lack of a studio or materials. "When one has something to say and the inclination to work, one can take a pebble—they're all over the place—and turn it into something, using a point and hammer."

This was the year Brancusi finished *Golden Bird*, a work which, as it evolved, would lead him to the pinnacle of his creativity. The feminine ovoid of *Maiastra* has become more elongated, the form streamlined to enhance the feeling of upward thrust. "This simplification," Brancusi wrote, "is not what one aims at in art. One achieves it unintentionally as one tries to make real things that are not the carcass we see, but what it hides from us."

Brancusi also made some major purchases in 1919, including a jack for 37.60 francs on June 2. It was intended to move and maneuver blocks of stone and marble that the sculptor had recently ordered. Later he taught us how to handle it with precision.

Lastly, the firm of Henraux, a supplier of sculptor's marble, issued him an invoice on August 3: "4 pieces andesite, 150 F; 1 block yellow marble, 100 F; 1 block yellow marble, 250 F." Another bill from the same concern is dated April 16, the purchase being for "1 block old bipollin marble, 65 F."

Plato. 1919. Wood. Destroyed, except head. Photo Brancusi (Cat. no. 111)

Head. 1919–23. Wood. Tate Gallery, London. Photo rights reserved (Cat. no. 112*a*). This is the head of **Plato** (Cat. no. 111), detached and shown as a separate piece of sculpture.

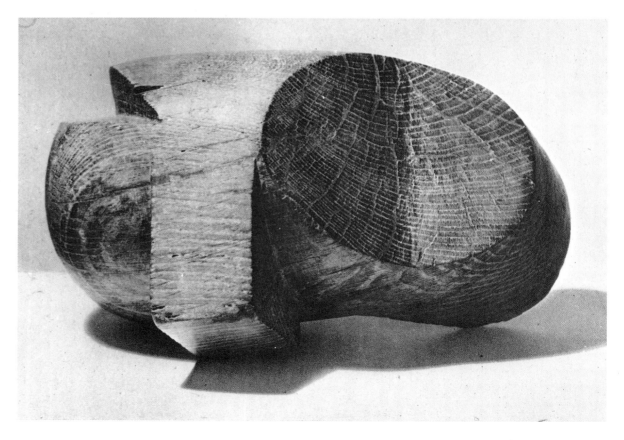

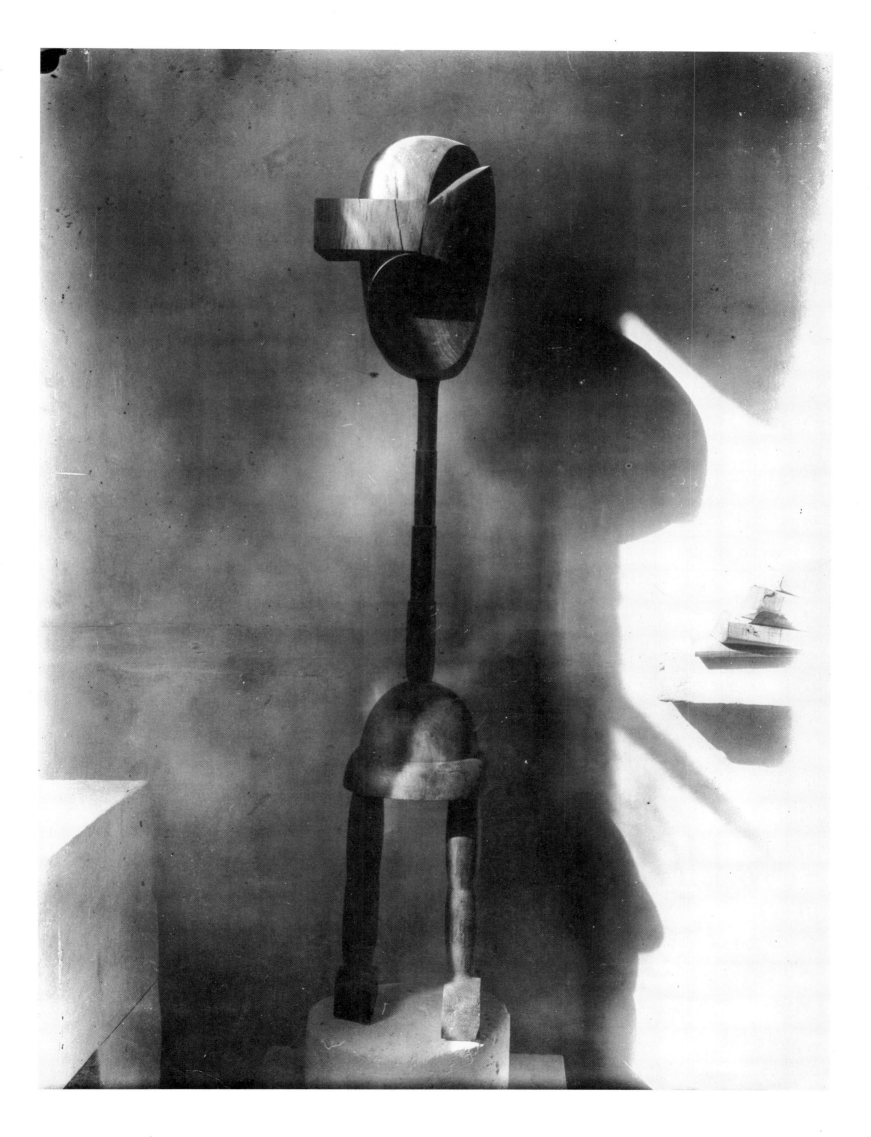

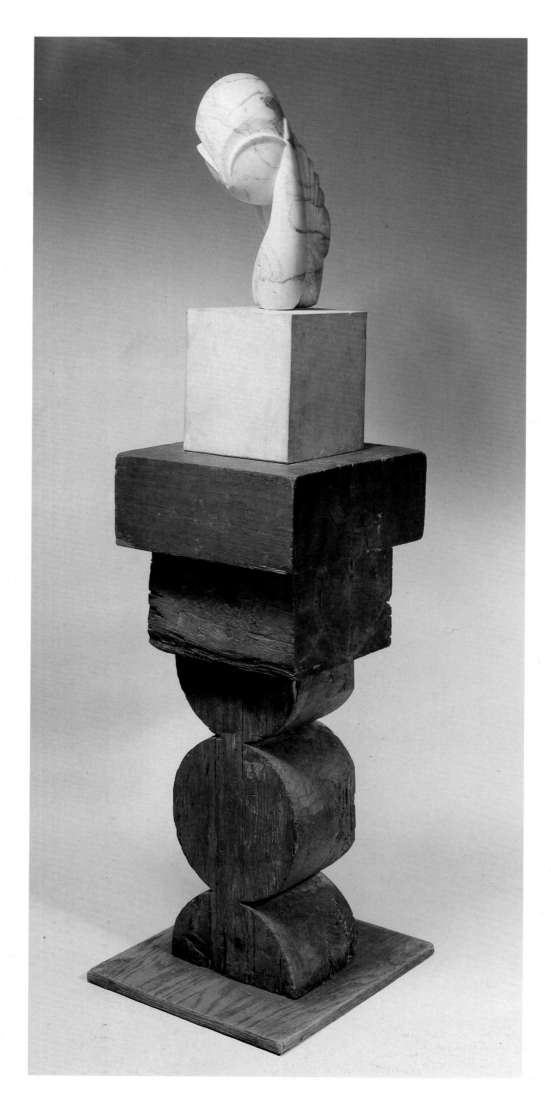

Mademoiselle Pogany II. 1919.
Veined marble. Collection Mr. and
Mrs. James W. Alsdorf, Winnetka,
Illinois. Photo Michael Tropea (Cat.
no. 110)

Opposite page:
Brancusi's studio, 8 Impasse Ronsin,
1920: **Golden Bird** (Cat. no. 108),
Mademoiselle Pogany II (Cat. no.
114). Photo Brancusi

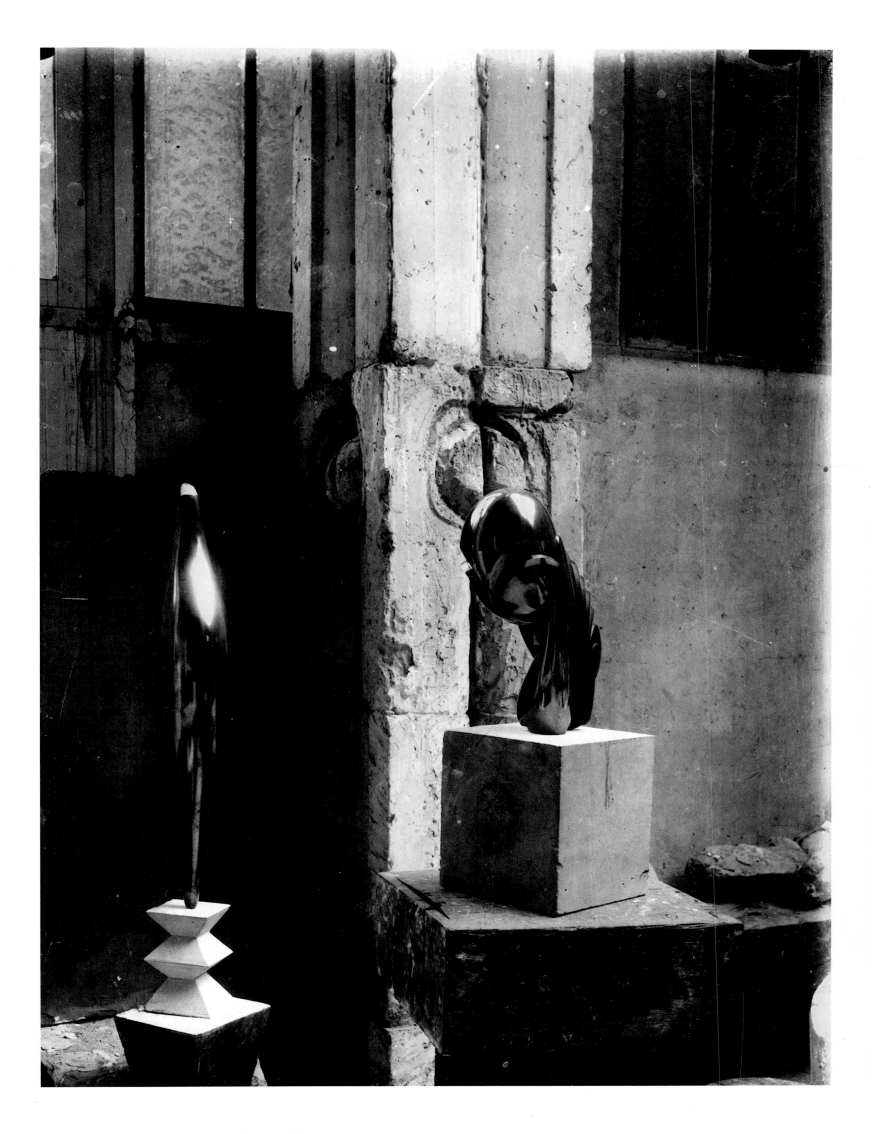

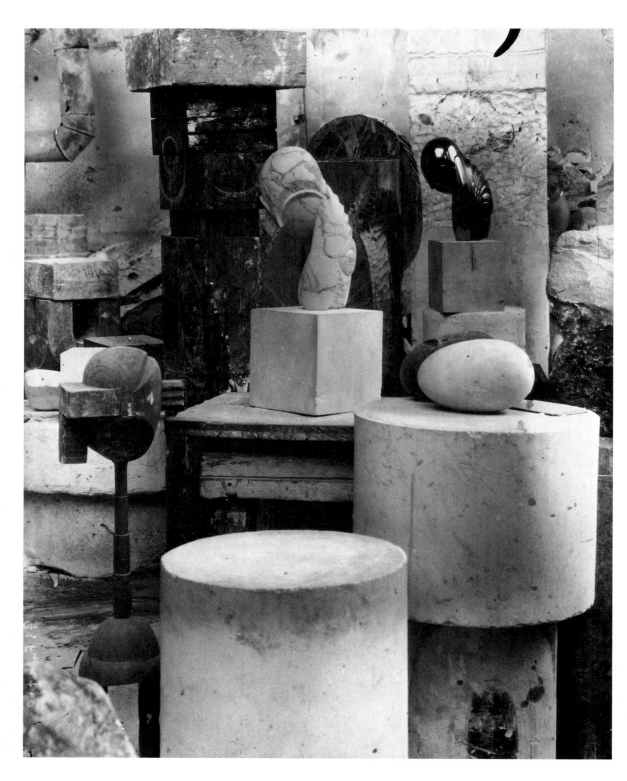

1920 Mars 5

C'est aujourd'hui
que je coupe le
cheu de la remorque
et que sur l'Ocian
immense je me lesse Bogue
vers L'Inconnu, que ma
foi me guide —
et si je ne viens vers
toi Dieu, ce n'est
qu'une folie!

Brancusi's studio, 8 Impasse Ronsin,
1920: **Plato** (Cat. no. 111), two
versions of **Mademoiselle Pogany
II** (Cat. nos. 110, 114), **Beginning of
the World** (Cat. no. 115). Photo
Brancusi

128

Portrait of a Woman. 1920.
Gouache on paper, pasted on cardboard, 57 × 40 cm. Private collection

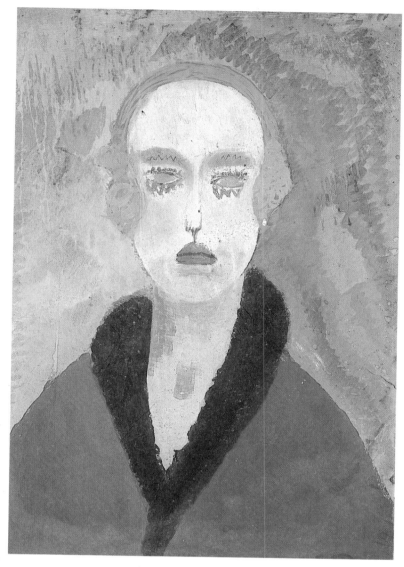

Mademoiselle Pogany I. 1913.
Plaster. Brancusi Studio, MNAM, Paris (Cat. no. 76e)

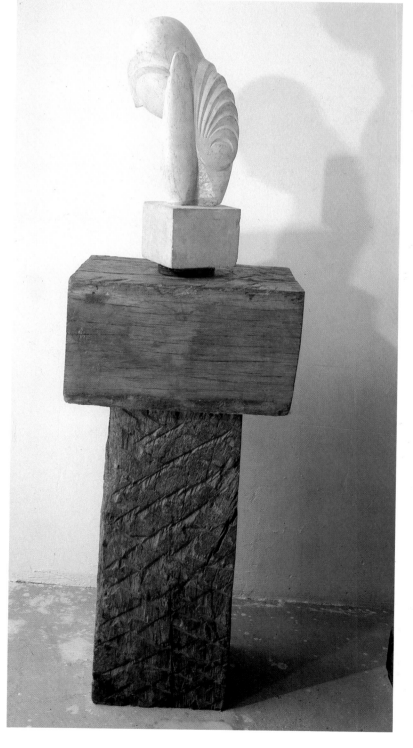

1920s: Paris and New York

At the beginning of 1920, Katherine Dreier paid 6,000 francs for *Little French Girl*, a wood sculpture that is now in The Solomon R. Guggenheim Museum in New York.

On January 16, John Quinn offered Brancusi his condolences on the loss of his mother. "[It is] ... one of the greatest and often the greatest loss that a man is ever called upon to endure in this life." He went on: "If you have any interesting work in marble or bronze, and have photographs of it, I should be glad to hear from you direct, with a note on the back of the photographs indicating the size of the objects and your idea of the prices."

Amedeo Modigliani, whom Brancusi had met through Dr. Paul Alexandre in 1909 and who became one of his friends, died in Hôpital Necker at age thirty-six. Modigliani had started to carve marble from the block back in Livorno and Carrara, but Brancusi's spare style had spurred him to take a much

more active interest in sculpture. On Brancusi's advice, he moved from Montmartre to a studio nearby in Cité Falguière. Brancusi found him there one day, unconscious, near the block of stone he had been carving. He had dropped from exhaustion.

Brancusi liked to reminisce about Modigliani. He had once found him collapsed in front of his door, helped him to his feet, dragged him to bed, and waited until the painter came to. In those days, Modigliani frequented an opium den located in a cluster of studios, No. 11, at the far end of the courtyard formed by Impasse Ronsin. The landlord had it torn down, saying the tenants were insolvent.

"One evening," Brancusi told us, "some artists from Cité Falguière chipped in to buy two casks of wine and asked some friends over. We caroused, we danced and whirled about the kegs, singing 'Dig-a-dig-a-dee, we don't give a f—k, dig-a-dig-a-da....' Someone suggested going over to Les Halles [the old central market] for onion soup. And so we did, washing it down with plenty of wine. As we were all emerging from a tavern,

we—Modigliani and I—broke away from the crew and grabbed one of those baskets of vegetables that truck farmers set out on the sidewalks back then. There we were, handing out vegetables to all the passers-by on our way back to Montparnasse. Things had got to the point where we were shinning up a street lamp to take down a hairdresser's sign when the police came running. Modi got away, but they nabbed me, locked me up, took away my papers. I thrashed about, insulted the cops; they chucked a pail of water in my face. Since I insisted on seeing the chief of police, they threatened to put me in the paddy wagon that stopped by every morning on its way to headquarters. This line of reasoning calmed me down immediately, and in the wee hours of the morning they threw me out. I was in such a state that I waited for a clothing store to open and bought myself a raincoat, so I could walk past my concierge without losing face...."

A polished bronze sculpture entitled *Princess X* got him into a predicament of a different sort. While doing the portrait of a lady, Brancusi had been struck by the graceful way she gazed at herself in a mirror. She was the inspiration for *Woman*

Looking into a Mirror (1909), a stone sculpture that could still be classified as representational. (Only a photograph of it survives.) Then, by a process of simplification, it evolved into *Madame P.D.K.*, a marble bust, and the bronze *Princess X* (1916), both of which were exhibited to admiring New Yorkers in 1917. Such, however, would not be the case in Paris, where, on January 28, 1920, he showed this polished bronze, along with *Yellow Bird*, at the Salon des Indépendants.

As they were setting up the sculptures, Matisse happened to walk by. "Why, it's a phallus!" he exclaimed when he saw *Princess X*. His remark made the rounds of the Salon and reached the ears of the long-time president, Alfred Signac. Concerned about the Salon's good name—never before had the Grand Palais deigned to house an exhibition of the Indépendants—Signac warned Brancusi that he was risking trouble with the chief of police. Infuriated, Brancusi stormed off to the police station himself to protest and give his view of the matter. Léger went along and did his best to calm him down. It was a lovely day, and Léger's words had so soothing an effect that the sculptor's ire abated.

A rough draft of a letter on

yellowed paper gives us information about the incident, probably written shortly after it took place. We do not know if Brancusi actually sent it, but he addressed it to Signac: "As I was setting up my sculptures at the first Salon des Indépendants [to be held] in the Grand Palais, you warned me in person that I would have to answer to the chief of police concerning one of the works I was exhibiting, *Princess X*. You stated that, in any case, I should never be able to prove to the Committee that this work does not depict a phallus. A few hours later, you shouted in front of Picabia (whom I call as witness) that you could not 'march the minister past a pair of balls'—those were your very words. So, not wanting to be troublesome, I put my work in the third row an hour later. On January 20, around five o'clock, when you walked past with the censors, you yourself actually saw them refuse to take my sculpture away. The following morning, around eleven-thirty, the chief of police of the Champs-Elysées precinct, at the urging of what he called certain individuals and anonymous letters, came to have a look for himself. Word for word, here is what he said: 'I am trying to see what people have told me, but I don't believe I've found it. I see no reason why this work should not be exhibited.' I call as witness Alexandre Mercereau."

The sculpture was removed before the minister walked past, but the press got hold of the story. On January 28, *L'Ere Nouvelle* published an interview with Brancusi by Roger Devigne. "'You do see, don't you, sir, that my statue is of Woman, all women rolled into one, Goethe's Eternal Feminine reduced to its essence....' And the sculptor with the childlike eyes and grey beard takes a photograph out of his pocket. A woman with a sublime smile is leaning forward, bringing to mind those beautiful angels on cathedrals. 'That, sir, was my first version. Then for five years I worked, I simplified, I made the material speak out and say the inexpressible. For indeed, what exactly is a woman? Buttons and bows, with a smile on her lips and paint on her cheeks?... That's not Woman. To express that entity, to bring back to the world of the senses that eternal type of ephemeral forms, I spent five years simplifying, honing my work. And at last I have, I believe, emerged triumphant and transcended the material. Besides, it is such a pity to spoil a beautiful piece by digging out little holes for eyes, hair, ears. And my material is so beautiful, with its sinuous lines that shine like pure gold and sum up in a single archetype all

Medallion. 1920. Oak with iron rings. Whereabouts unknown. Photo Brancusi (Cat. no. 120)

Opposite page:
Princess X. 1916. Polished bronze. Photo Brancusi (Cat. no. 89c)

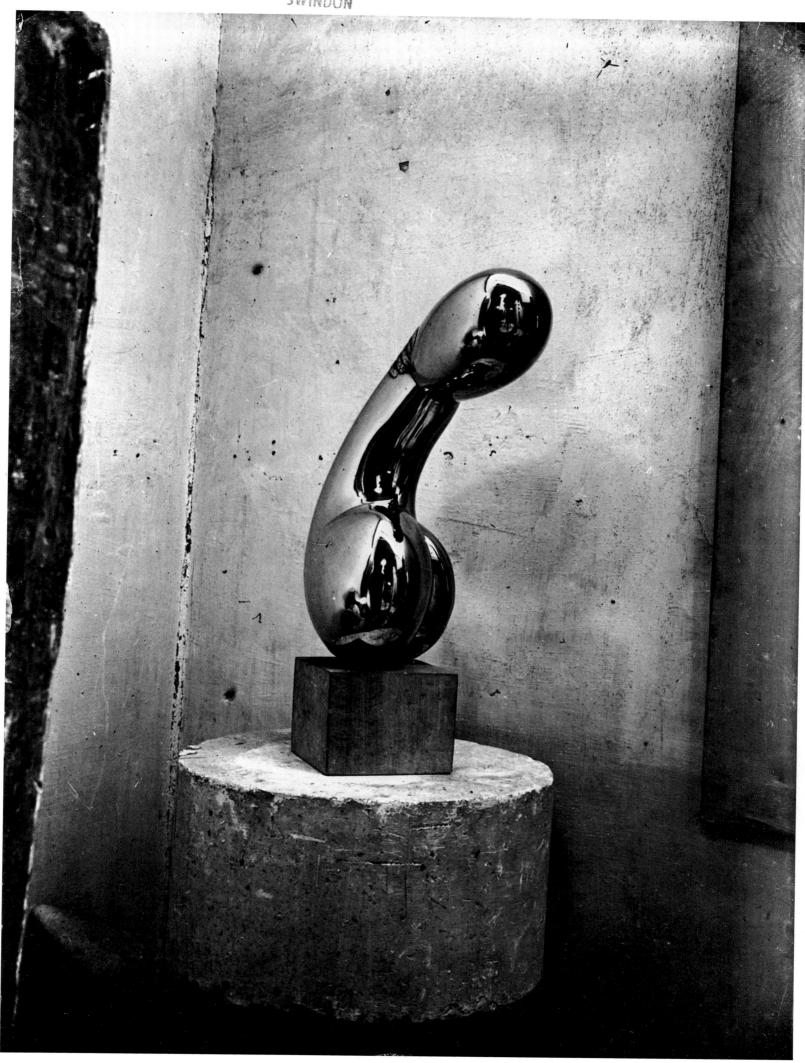

of the female effigies on earth...' His voice is full of conviction, his eyes follow a dream, his chaste hands stroke the metallic symbol."

One would think this ended the matter, but not in the least. Shortly thereafter, Brancusi received the following "confidential" letter, dated February 12, from the Office of the Secretary of the 31st Salon des Indépendants.

"Dear Comrade,
"Pursuant to a complaint from the Council of State, the Prefect of Police, Monsieur Raux, appeared at the Secretary's office of the exhibition and asked us to withdraw your metal sculpture, No. 554."

Enclosed was a copy of the letter from the Prefect of Police:

"I have received protests concerning a work in the Exhibition of Independent Artists, listed no. 554 in the catalogue under 'sculpture.' I went to see your show today, and in so doing realized that the work by the sculptor Brancusi is liable to create incidents. Accordingly, I should be grateful if you would kindly request the artist to withdraw from the exhibition a work which apparently is not meant to be brought to the notice of the people who frequent the Grand Palais...."

Voices sympathetic to Brancusi also made themselves heard, however: "Your show at the Indépendants is magnificent,"' Henri-Pierre Roché told him in a letter dated February 12. "... I have written about it in America."

Blaise Cendrars expressed his support on March 11:

"Today I found out by chance what transpired at the Indépendants.

"Believe me, dear friend, I am entirely with you in this matter. I find scandalous the action that has been taken against you—a disgrace! But what better can one expect from young philistines, all so ignorant and greedy, who campaigned to exhibit at the Grand Palais. We don't belong with them, but with the people of Belleville, with the enormous and marvelous nouveaux riches, and with those few international Europeans. I should like to make a special trip back to Paris just to shake your hand, dear Brancusi. With affection for that beautiful smile of yours,
 Blaise Cendrars"
"I am alone in the snows like you in your all-white studio."

"I got your letter," Brancusi replied on March 30, "but I wasn't able to write back right away. I am like someone who's been knocked senseless in the dark, and what's sadder still, the ones who've brought this on me are comrades who feel that exhibiting in the Grand Palais is the end-all; and the most heart-rending part of it is that they have seen fit to saddle the police with it."

The press got worked up, too. On February 25, the following appeared in *Le Journal du Peuple* under the punning title "Pour l'Indépendance de l'Art":

"A work of art that the sculptor Brancusi was exhibiting at the Salon des Indépendants has just been withdrawn by order of Monsieur Raux. He feels that 'it is liable to create incidents' and states in a letter that apparently it is 'not meant to be brought to the notice of the people who frequent the Grand Palais.' However, the good faith of the artist, who never meant anything immoral by it, is manifest. The work they've now blacklisted was shown by the Society of Independent Artists in New York in 1917, and the American public that beheld it back then raised no protest.

"The artists, collectors, aestheticians, critics, and writers whose names appear below feel that misjudging the statements of a sincere artist and of the most highly qualified among his peers is a dangerous business, especially at the time when, under the unjustifiable pretense of art, disgraceful posters cover the walls of Paris.

"The Grand Palais was consecrated to the glory of art. It does that glory a gross disservice to care so little for the freedom of a true artist, who finds it so essential and is incapable of abusing it.

"André Salmon, V.G. Paléolog, H.-P. Roché, Baroness Frachon, F. Picabia, Mme. Cartel, Albert Glaizes, Dr. Geiger, Metzinger, Ruanet, G. Braque, Dr. Alois, Mme. Vassilieff, A. Derain, Louis Vauxcelles, Germaine Taillefer [sic], Picasso, Guillet de Saix, De Gonzague, Frick, Mme. Goncharova, A. Mercereau, G. Thonimbert, Sébastien Voirol, Auguste Perret, F. Léger, Mme. Perdriat, Hellesen, J.-G. Lemoine, H. Laurens, J. Cocteau, C. Skripitzine, M. Raynal, P. Reverdy, Yvan Goll, Juan Gris, A. Billy, A. Warnaud, Blaise Cendrars, D. Guegan, Larionov, Louvigne, Du Desert, R. Dufy, Nicolas Beauduin, Erik Satie, G. Auric, F. Bernouard,

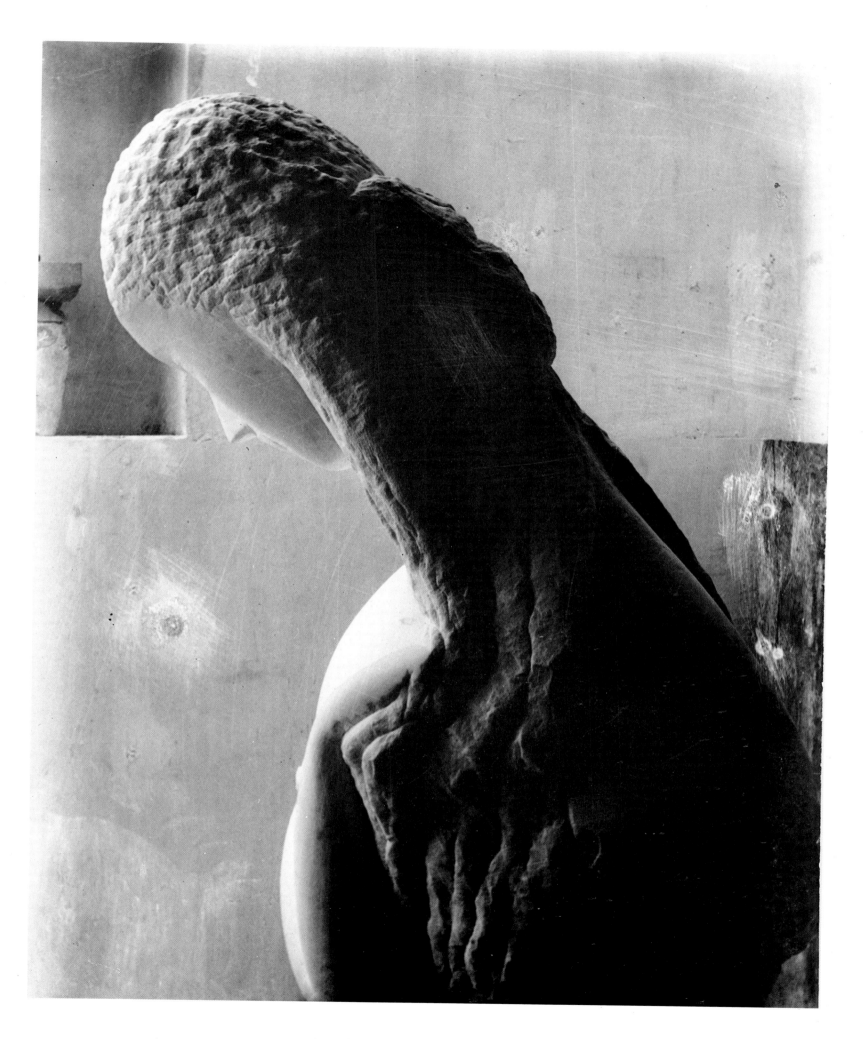

Woman Looking Into a Mirror.
1909. Marble. Whereabouts
unknown. Photo Brancusi (Cat. no.
55)

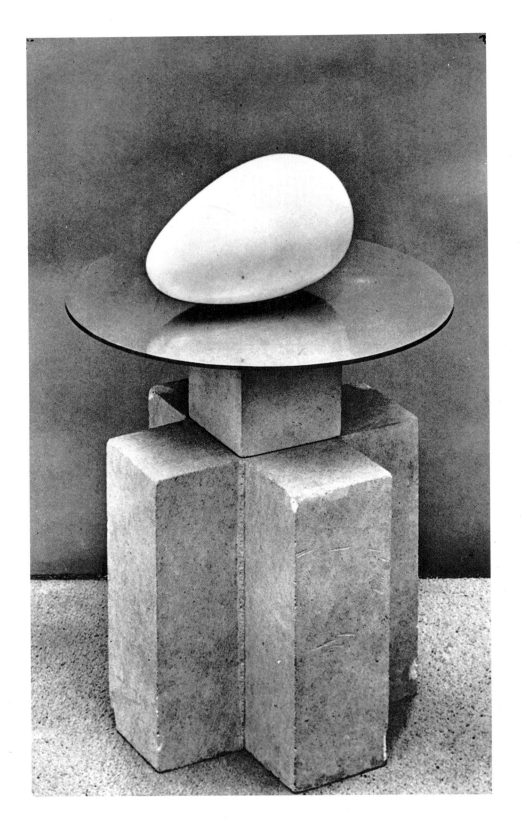

Beginning of the World. 1920. White marble on polished metal disk. Whereabouts unknown (Cat. no. 115)

Nouillot, J. Lipchitz, Ribemont-Dessaignes, F. Fels, A. Lhote, Duthuit, Mme. Rousseau, Mme. Curie, Canudo, Florian Parmentier, Dr. Marbé, Banville d'Hostel, Mme. Lara, Mme. Laura Paléolog, P.M. Roinard, Mme. Ricou, Colomer, Irène Lagutte, S. Ferat, Archipenko, Sauvage, etc.''

L'Intransigeant had already come out with an article on January 30. ''Great to-do yesterday at the Salon des Indépendants. When the sculptor Brancusi got there on varnishing day, ... he noticed that a work of his was no longer where he had put it.... He was then informed that the police, perturbed by the somewhat bizarre forms that *Portrait of the Princess* assumed, had had it removed so as not to shock the Minister.

'''Understand, now,' railed the artist to a surrounding group, 'they've tried to find obscene allusions in this polished copper [sic] bust, but I myself have never seen any. It was exhibited in New York, and no one there found any reason to be outraged ...'

''In a word, they put the work back after an explanation was given. But the minister had already passed by. In light of this unforeseeable to-do, Brancusi made a point of putting photographs near the *Princess*, showing the two states of the work prior to its present state.''

On February 20, a letter from a friend in Bucharest confirmed his fears that news of the *Princess X* scandal had reached Rumania. ''Above all,'' Brancusi had said in an interview, ''don't talk too much about it. I feel no need to take vengeance on anyone. I don't bear anyone any grudge, and I dread publicity.'' One can well imagine how this report from his homeland must have annoyed him.

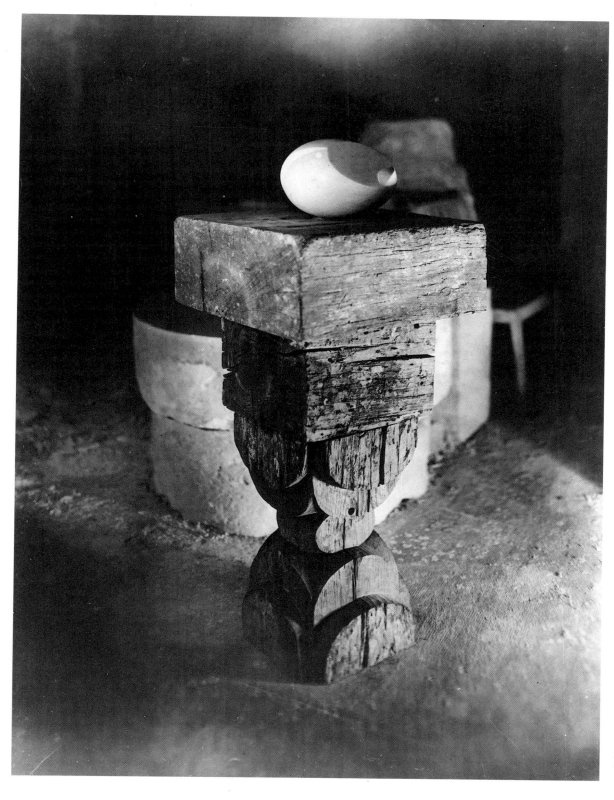

The Newborn II. 1920. White marble. Moderna Museet, Stockholm. Photo Brancusi (Cat. no. 118)

On April 22, Roché asked Brancusi to send some photographs of the bronze *Bird* and of *Socrates* to Walter Arensberg, the American collector. On April 30, 1920, the Société Anonyme, founded by Katherine S. Dreier, Marcel Duchamp, and Man Ray, opened its first exhibition at the Museum of Modern Art in New York. It included works by Brancusi, as did their third exhibition in 1922; the second was devoted to Kurt Schwitters.

According to two of Brancusi's letters (November 24, 1920, and February 1921), he purchased in September thirteen pieces of timber and a wooden winepress. The large screw inside the press, often visible in pictures he took of his studio, came to have special meaning for him. In 1948, when we moved into Impasse Ronsin, he gave it to us as a housewarming gift, proclaiming, "May it become the spirit of your studio, too!" Indeed it had, in his eyes, a profound meaning. "It gave me the idea for *Endless Column*," he said on more than one occasion, thus undermining the oft-expressed view that the column of Tirgu-Jiu had been inspired by the carved pillars of Rumanian peasant houses, or even by a drawing by Modigliani.

We paid close attention to the operation of the creative process in Brancusi's work, and could see the importance he attached in this case to the motion of the eyes spiraling endlessly upward, analogous to the movement of the spirit as it soars boundlessly. The *Endless Column* that Brancusi set up in 1920 in the garden of Edward Steichen's house at Voulangis stood over 23 feet high.

On September 19, Roché notified Brancusi that he had advised Quinn to buy two marble sculptures, the *Bird* and *Head of a Woman (Mlle Pogany II)*. On November 14, he did:

"My dear Brancusi,

"Quinn wrote me in confidence (with respect to others, not you) that he bought the two marbles and the two bronzes for which I myself had expressed such admiration, the ones you sent him the photographs of.

"I am pleased and I congratulate him—but I envy him, too. If I had had the money to buy those works, he would not have gotten them.

"See you soon.

"Your friend,

H.P. Roché"

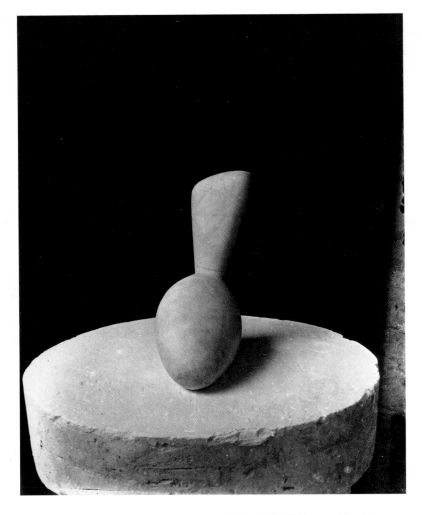

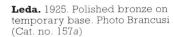

Leda. 1920. White marble. Art Institute of Chicago. Photo Brancusi (Cat. no. 116)

Leda. 1925. Polished bronze on temporary base. Photo Brancusi (Cat. no. 157a)

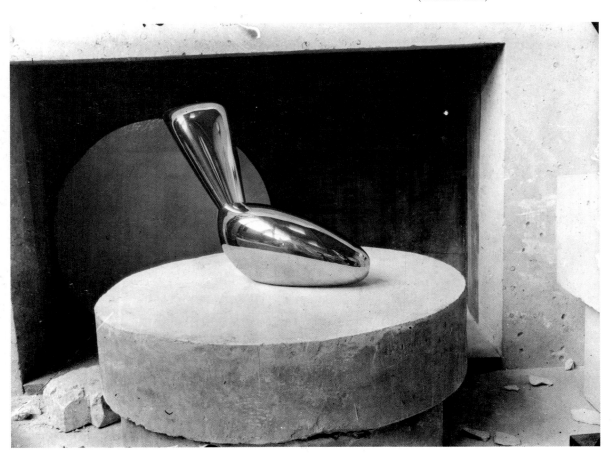

Albeit on friendly terms with Tzara, Picabia, and Duchamp, Brancusi stayed on the fringes of the Dada movement. He was, however, in the audience when André Breton read Picabia's *Manifeste Cannibale* in the Théâtre de l'Œuvre on March 27, 1920, while some member perched on a ladder yelled "Dada, dada, I am dada!" The audience pelted Breton with tomatoes, shouting "Enough, enough!"; the Dada partisans reacted vehemently. Brancusi stood in the wings near a young woman, an artist's model, who had been instructed to walk out nude before the audience and shout "Shit!" but she was riveted to the spot, panic-stricken by the uproar. "So," Brancusi told us, "I persuaded her to put everything out of her mind and walk right out there saying 'shit' over and over in a loud voice. She confidently strode out before the audience, and it all went over pretty well."

On May 26, Brancusi, with Léger, took part in the Festival Dada in Paris and signed a manifesto entitled *Contre Cubisme, contre Dadaïsme*.

Exhibitions during 1920 included the "Section d'Or" at the Galerie La Boétie (March 3–16), which also featured work by Archipenko, Léger, František Kupka, Jacques Villon, Natalia Goncharova, and Marcoussis, among others. On March 21, two Brancusis from the Bogdan-Piteşti collection were shown at the Arta Româna exhibition in Bucharest.

It was also this year that Brancusi carved a marble version of *Leda*, a traditional subject to which he gave a distinctive twist. "I could not imagine the Greek god of gods consenting to change himself into a swan," he later confided to us. "On the contrary, I thought, he would have found it better to transform the swan into a woman." And that is the metamorphosis Brancusi suggests by having the female form emerge from the ovoid form of the bird. He said something else along these lines one day. "What a delight for children if, one morning, as they went off to play in the garden, and found, instead of a conventional sculpture like Monsieur Untel's, a *Duck* by Brancusi with no base, just sitting there on the lawn. They would get up on it like a horse and knock it over! A sculpture has to remain a sculpture, right side up or not. A sculpture has to be seen from all sides."

Opposite page:
Leda. 1925. Polished bronze. Brancusi Studio, MNAM, Paris (Cat. no. 157a)

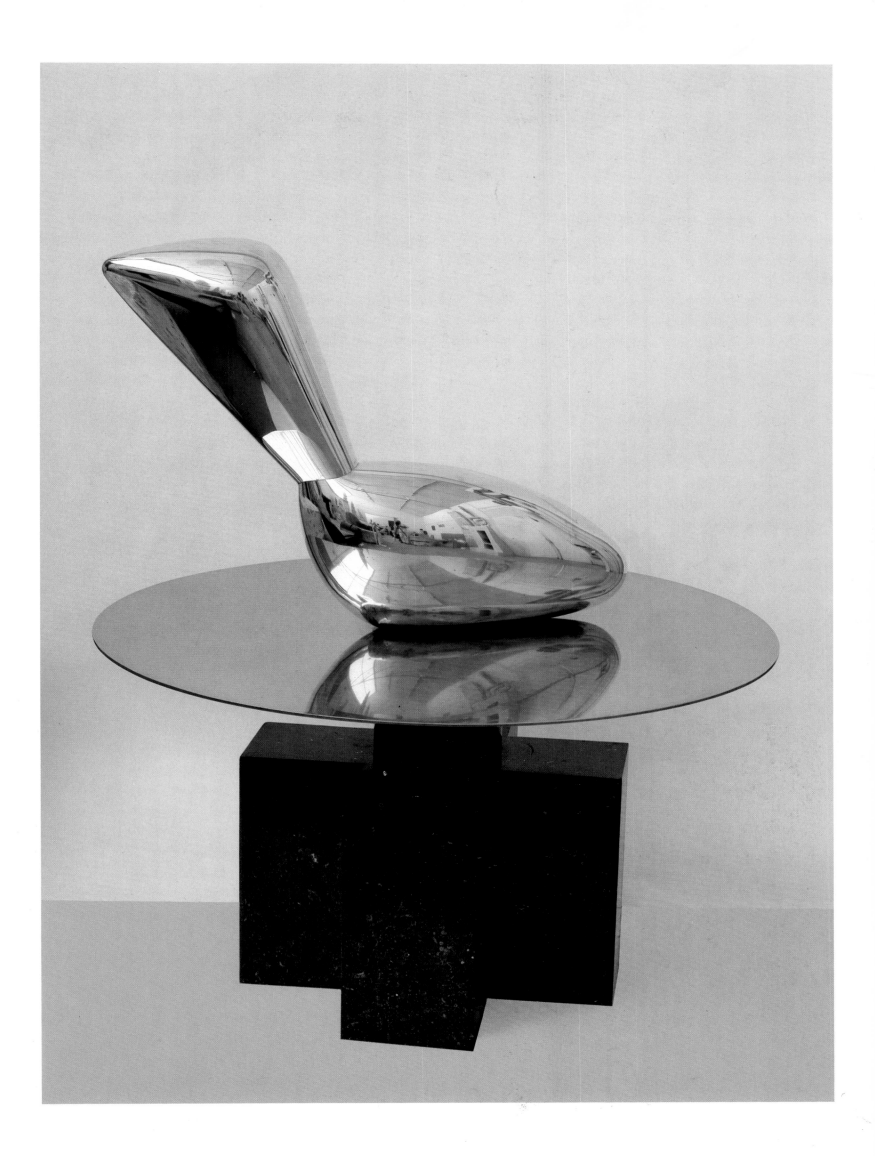

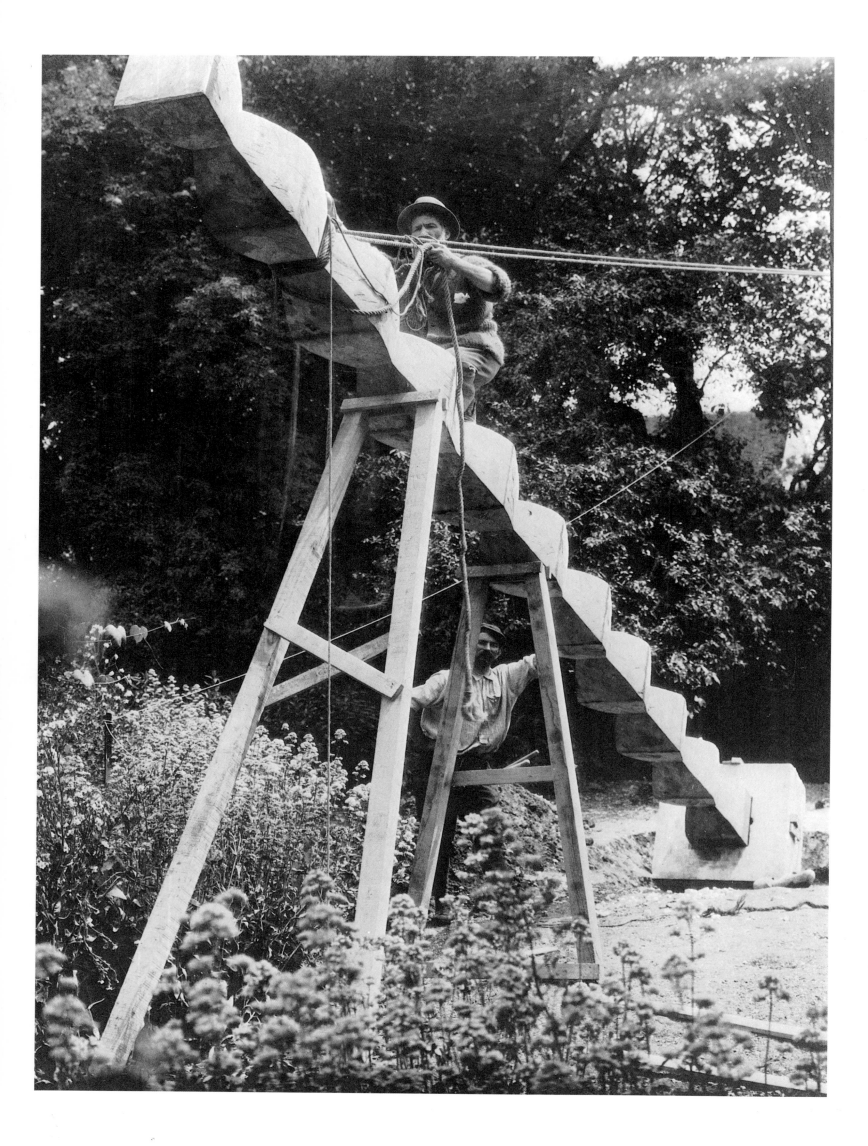

1921

Jacques Doucet paid 5,000 francs to add Brancusi's *Danaïde* (1918; now Tate Gallery, London) to his collection; and meanwhile there was no letup in the correspondence between the sculptor and John Quinn.

On June 3, 1921, Brancusi left for Rumania, by way of Italy, Greece, and Turkey. On the way back (June 21–22), he stopped in Berlin. Writing from Paris on August 22, he informed his brother Dumitru that he had sent 3,000 lei as a donation to the church in Pestisáni. And in a postscript: "I sent Frăsiná the money for the church, and [there's] even a little extra for her. See how you and your brothers might go about supporting her until the children get a little bigger. Tell Gregory [another brother] that I am sorry I couldn't meet him. I'm thinking of a trip to Pestisáni next summer to do the monument for the heroes slain in the war, and we'll be able to see a lot of each other then. Good health and love to you all, to everyone we know."

A letter from his village, dated December 20, indicates that arrangements were being made to transport blocks of stone for the war memorial, but this was not to be. The monument, when it was built in 1937, would stand in a different site: Tirgu-Jiu.

The most remarkable event of the year for Brancusi came in the fall, when *The Little Review* in New York published a "Brancusi Number," an entire issue devoted to him, as the cover proclaimed in large red letters. The periodical was issued from its own gallery, the Little Review Gallery at 66 Fifth Avenue. With Margaret Anderson as editor and Picabia as foreign editor, this special issue was made possible by the participation of Jean Cocteau, Jean Hugo, Guy Charles-Cros, Paul Morand, Francis Picabia, and Ezra Pound. Pound wrote the first major article on the sculptor,

Opposite page:
Brancusi installing **Endless Column** (Cat. no. 119) in Edward Steichen's garden, Voulangis. Photo Steichen. Archives I–D

Poster for *The Little Review*, New York, 1921, signed by contributors (Brancusi's signature at upper left). Archives I–D

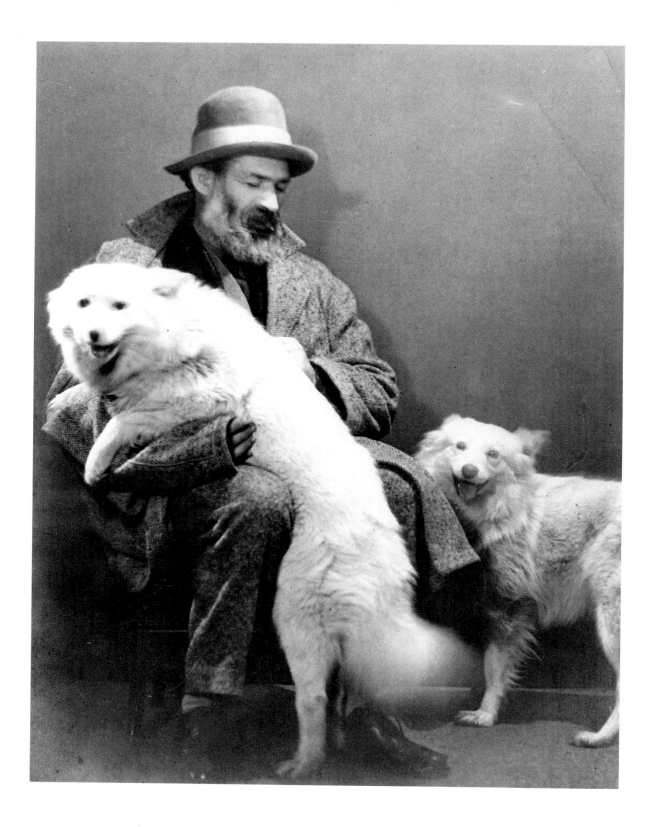

Brancusi with his dogs, c. 1922.
Photo Man Ray. Archives I–D

complete with twenty-four plates. This, together with the article that appeared in *This Quarter* in 1925, is probably our most reliable source for dating certain works. Apparently, Ezra Pound was contemplating a book on Brancusi, but Brancusi was not enthusiastic about the idea, judging by a letter the American poet sent him on October 14.

On October 30 began Brancusi's troubles with his landlord. The owner of the studio, a sculptor named Dussart, gave notice that the rent would be increased by 33 percent; would Brancusi agree to this? "My most fervent wish," wrote Dus-

sart, "would be to regain possession of my studio. Although I am entitled to do so under the law, in light of your status as a non-mobilized alien, I would rather pay 4,000 francs for my smaller premises than to have any but friendly dealings with you." Brancusi acquiesced to the increase, and the threat of having to move again was averted for 1922.

On December 16, he sold a *Golden Bird* to the painter Mariette Mills and her husband for 15,000 francs. A note from Brancusi indicates that he was ill at the time and would deliver the sculpture a little later. The Millses owned a kennel, and it was

there that Brancusi bought Polaire, the dog so often seen with him in photographs.

Tristan Tzara paid him a visit in December; we know that Brancusi did not see the New Year in at the Cacodylate party that Picabia threw at Marthe Chenal's (the singer who had wrapped herself in a flag and sung the *Marseillaise* on the steps of the Opéra when the armistice was signed), for he sent Picabia a note that he was indisposed and could not come.

The sculptor's purchases in 1922 included: some bilinga, an exotic wood (invoice of July 6); walnut (invoice of August 10); a block of onyx; and four blocks

of alabaster (invoice of March 9). In this year he carved *Adam and Eve*, considered one of his finest wood sculptures. "I put Adam below Eve," he later observed, "so that he would bear the weight of them both. At the same time, this brings him in contact with the earth as though he were putting down roots."

This was also the year when Brancusi, still dissatisfied with the photographs of his sculpture and anxious to improve his technique, happened to meet Man Ray. In *Self-Portrait*, Man Ray tells about going to see Brancusi to take his picture. The sculptor was not willing, but he was interested in good photographs of his work. "Until then," Man Ray[12] tells us, "the few plates he had seen were disappointing. Then he showed me a photo[13] Stieglitz had sent him, taken at the time of his New York exhibit. It was of a marble sculpture, flawless in terms of both lighting and texture. He conceded that that photo was lovely; but it was not a good likeness of his work. Only he could photograph it. Would I help him get the necessary equipment and give him a few pointers? With pleasure, I replied. The following day, we purchased a camera and a stand. I suggested that a photographic firm make the prints, but Brancusi intended to take care of that, too. So, he built a darkroom in a corner of his studio. The walls of the darkroom were whitewashed on the outside, of course; that way, it blended in with the rest and became invisible.

"I showed him how to take pictures and how to develop them in the darkroom. From then on, he proceeded all by himself and never consulted me again."

141

In Brancusi's studio, 1921–22. Left, the sculptor; next to him, Tristan Tzara. Photograph. Archives I–D

Letter from Tzara to Brancusi. Archives I–D

Jeudi soir
12,7. de Boulainvilliers (16e)

Cher ami,

Mme Picabia, Man Ray, une dame américaine et moi, nous avons l'envie de venir vous voir demain après — dîner — Est-ce qu'on ne vous dérange pas? Je serai très content de vous voir, mais ne vous gênez pas de me dire, si nous tombons mal. Dans ce cas, prévenez-moi à la Librairie Six (pour Tzara)
6. Av. de Lowendal (7e)

Très cordialement
TZARA
les yeux ouverts

Opposite page:
The Baroness. 1921. Plaster.
Brancusi Studio, MNAM, Paris.
Photo Brancusi (Cat. no. 124)

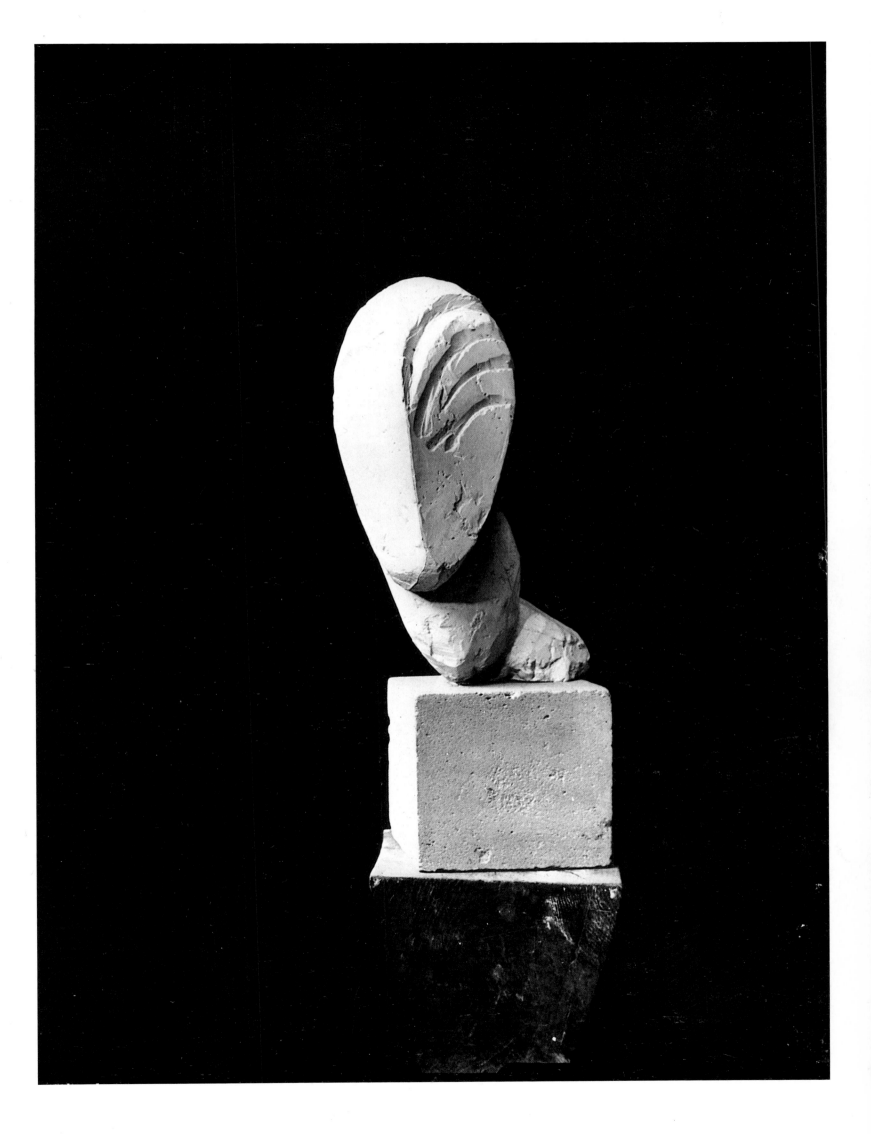

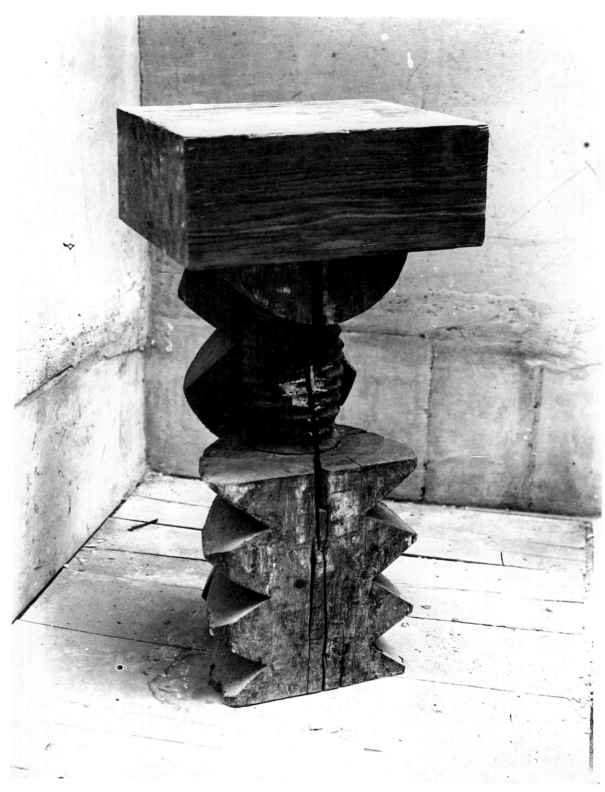

Adam. 1921. Wood. Photo Brancusi
(Cat. no. 121)

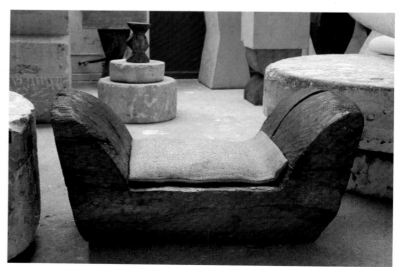

Bench. 1921–22. Wood. Brancusi
Studio, MNAM, Paris. Photo
Dumitresco (Cat. no. 126)

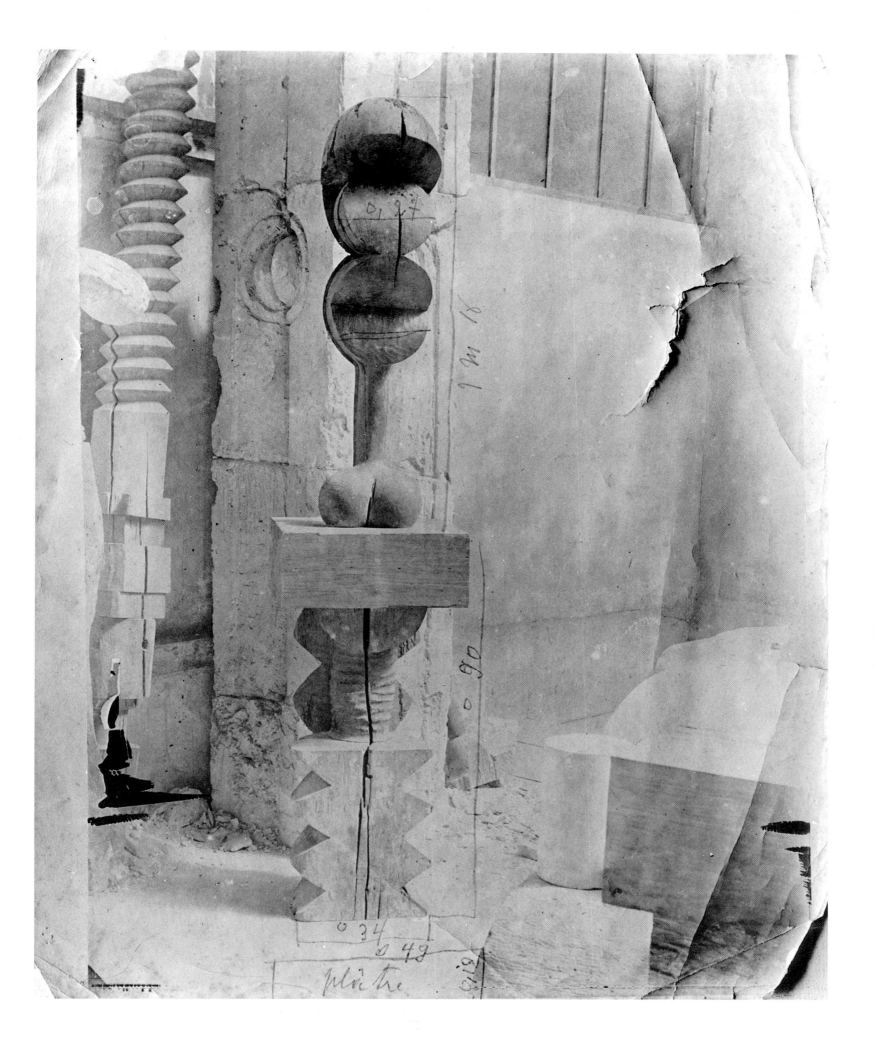

Adam and Eve. 1921. Wood. The
Solomon R. Guggenheim Museum.
New York. Photo Brancusi (Cat. no.
122)

145

1922

Raymond Radiguet was Cocteau's young protégé and the author of *Le Diable au Corps*. He dropped in on the sculptor now and then; Paul Morand wrote in *Adieu à Brancusi* (*Arts*, March 20, 1957), "Radiguet and I often got together there [Impasse Ronsin] in the evening; there'd be new wine on an anvil block, and Brancusi himself would grill the steaks."

One day, Brancusi and Radiguet were talking about traveling. They could hear a whistle blowing from Montparnasse Station nearby, and the sounds of a train pulling out. "What do you say we leave right this moment for the Riviera?" Brancusi suggested, in all innocence. "You're on!" Radiguet replied with enthusiasm. So Brancusi grabbed a small suitcase, and they were on their way. Sheer madness! "If we had thought more about it," the sculptor later told us, "we never would have gone." At Nice, a ship was winding up its anchor for Corsica. "What's to stop us from going to Corsica, too?" suggested Brancusi. No sooner said than done. They bought wine and some oranges, got their tickets, and went aboard. Once in the cabin, Brancusi started tossing the oranges, one by one, into the luggage net. A lady passenger took offense and complained to the captain, who appeared as Brancusi was throwing the last orange. "So," lectured the captain, "we're throwing oranges at the heads of passengers, are we?" "We're doing no such thing," Brancusi replied triumphantly, deftly chucking the bottle of wine into the net next to the oranges. "We're tidying up!"

The trip continued like this. On shore, since Radiguet seemed to have an eye for the girls, Brancusi approached a man who ran a tavern: "Tell me, sir, where can we find a girl here, not for me, but for my son." "Be quiet," replied the proprietor, "or you won't know what hit you."

Their hotel bills show that the wayfarers spent January 14 and 15 at the Grand Hotel in Ajaccio and January 18 and 19 at Le Cyrnos in Bastia. There they bought some brandy. As it was prohibited to import Corsican spirits into France, they hid the bottle in a bunch of flowers, and once successfully past the control, Brancusi sang a little ditty: "'Anything to declare?' he said, and so I passed right by his head!"

Alas, in Paris the climate had changed. At the Café La Rotonde, friends gave Brancusi a chilly reception. "You've got to get back your reputation," said one of them; at this, Brancusi started to leave the table, but Cocteau, though Radiguet's close friend and infuriated over their trip, quickly pointed out that there was no reason to blame Brancusi for it. The following day, he wrote the sculp-

Letter from Jean Cocteau to Brancusi, January 22, 1922. Archives I–D

146

tor a letter of apology. Radi-
guet, for his part, wrote Brancu-
si a number of times to express
his friendship and tell him of his
pleasant memories of their trip.

On February 17, Brancusi re-
ceived a letter urging him to be
present at the Closerie des Lilas
café to protest the proposed
"Congrès de Paris" that
marked the beginning of the rift
between André Breton and Tris-
tan Tzara. The proposal first in-
veighed against restrictions on
modern art and against those
"bent on annihilating that which
is living," then it got specific:
"People have dared to re-
proach a certain person who
comes from Zurich [an allusion
to Tzara]. All personal issues
aside, we think it is time to put
an end to this pontificating and
to stand up for our freedom."
The letter was signed by
Eluard, Ribemont-Dessaignes,
Satie, and Tzara. At the meeting
a resolution was adopted, and
signers included Arp, Cocteau,
Satie, Radiguet, and Van Does-
burg; Brancusi added "In art,
there are no foreigners" next to
his signature.

On March 10, John Quinn
wrote to inform the sculptor that
he was planning to send several
of his Brancusis to the forthcom-
ing "Exhibition of Contempo-
rary French Art" at the Sculp-
tors' Gallery in New York
(March 24–April 10, 1922). The
American collector sent a few
photographs of the show before
it officially opened.

"Thank you very much for the
photographs of the exhibition
and for all the trouble you've
gone to," Brancusi replied on
May 25. "What a pity the sculp-
tures could not be placed far-
ther from the wall. Roché trans-
lated Mr. Bride's and Mrs. Fos-
ter's flattering articles for me;
it's positively delightful. He also
stopped by to inquire on your
behalf about the price of Wood-
en Column (No. 1), Eve (No. 2),
and Adam (No. 3), and con-
firmed afterward that you had
purchased these sculptures. I
thank you and am sending you
photographs of them, along with
others (sixteen prints in all), in-
cluding the base I promised you
(No. 4), the Torso you saw last
year (No. 10), and Coq Gaulois
(No. 9), my most recent wood
sculpture.... If the base [No. 4]
is less to your liking than one of
the others, please take which-
ever one among Nos. 5, 6, 7, or
8 you like best.

"Thank you very much for
your wishes. The winter has
gone very well. I've been a little
tired lately, but now I'm all right
and working a great deal.

"Awaiting good news of you,
I send you, my dear Quinn, my
kindest regards.

"I asked Roché to write you
regarding the base for the Col-
umn: if that stone is too heavy

for your apartment, you may
dispense with it.

"It was intended solely for ex-
hibiting the Column in a large
room."

Enclosed was the following
list:[14]

Column (1), Eve (2), Adam (3)
Stipulated price per Roché
cable, 30,000 Frs
No. 4, base for the Torso al-
ready in your possession, as
promised
No. 5, base, wood and stone,
2,000 Frs
No. 6, base, wood and stone,
2,000 Frs
No. 7, two bases, yellow
wood, 3,000 Frs for both
No. 8, base, old oak (99 × 49),
3,000 Frs
No. 9, walnut sculpture (Coq
Gaulois),[15] 10,000 Frs
No. 10, Torso, onyx, 15,000
Frs

On September 6, Brancusi de-
posited 11,000 francs into his ac-
count in anticipation of another
trip to Rumania, this time by
way of Greece and Italy. Shortly
before he left, Eileen Lane, a
young American who was living
in Paris and moved in the same
circles as Brancusi and Satie
(the composer called her
"Miss"), broke off her engage-
ment and told the sculptor about
her distress. "Why don't you
come along with me to Ruma-
nia?" he asked, with no hesita-
tion. "It will give you a fresh
slant on things. Above all, don't
fret. I'll introduce you as my
daughter wherever we go."
Later on we met Eileen Lane
and realized that she had been
the model for some of Brancu-
si's gouaches and drawings.
She told us how wonderful that
trip had been. They stopped off
at Sinaia (where Brancusi wrote
Quinn a letter, dated September
12) and visited some stone quar-
ries with a view to the memorial
to the war dead of Pestisáni.
They proceeded to Tirgu-Jiu
and Pestisáni. Everywhere they
went, people gave a warm wel-
come to the young lady Brancu-
si introduced as his daughter.
They stayed at the Hotel Savoia
in Rome and the Hotel Splendid
in Marseilles. A fair with an Afri-
can theme, part of the govern-
ment's propaganda for its colo-
nial policies, was in Marseilles
at the time, and in a café they
noticed a young African woman
selling souvenirs. She was strik-
ingly beautiful, her hair pulled
back into a chignon; they
bought some postcards from
her.
Back in Paris, Brancusi invited
Eileen to lunch in due time and
on a table stood something cov-
ered with a piece of cloth. He
unveiled it, a marble bust of the
beautiful African woman with
the chignon. Later, Brancusi
also presented Eileen with Mo-

THE SCULPTORS' GALLERY
152 EAST 40TH STREET

EXHIBITION
CONTEMPORARY FRENCH ART

BRANCUSI—BOURDELLE—DEGAS
RAYMOND DUCHAMP-VILLON—LEHMBRUCH
MAILLOL—MANOLA—MATISSE—PICASSO
POUPELET—RODIN—BRAQUE—DERAIN
DUFY — DE LA FRESNAYE — LAURENCIN
ROUAULT—ROUSSEAU—SEGONZAC—SEURAT
—From the John Quinn and other collections

MARCH 24 TO APRIL 10 1922

ADMISSION 50C. ARTISTS FREE

Catalogue cover, Sculptors Gallery,
New York (March 24–April 10,
1922). Archives I–D

digliani's drawing of him (often attributed to Brancusi himself), and a lovely cane in soft wood he carved especially for her.

After his Rumanian trip he had carved a wooden distaff used for spinning wool, and drew a design in pencil on the middle of it; much later, he gave it to us.

A deep and abiding friendship united Brancusi and Erik Satie. The sculptor and the musician often got together to exchange ideas and talk about whatever was concerning them. The theme of Socrates, which fascinated both men, would give rise in each of them to a work of art. Satie's *La Mort de Socrate* for sopranos and chamber orchestra (1918) was first heard at the Société Nationale in January 1920; two years later, Brancusi (whom Satie was fond of calling ''brother of Socrates'') finished his tribute in wood to the great philosopher.

For Brancusi, the upper part of *Socrates*, round and hollowed out, symbolized the passageway for the ideas drawn from the universe that he later imparted to the world. ''The whole universe flows through,'' wrote Brancusi. ''Nothing escapes the great thinker. He knows all, he

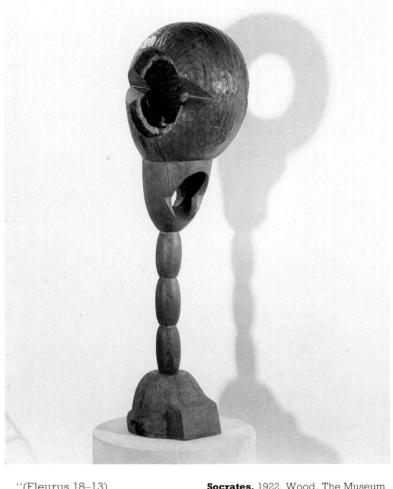

Socrates. 1922. Wood. The Museum of Modern Art (Mrs. Simon Guggenheim Fund), New York. Museum photo (Cat. no. 130)

Distaff. 1923. Wood. Collection Istrati–Dumitresco (Cat. no. 222)

''(Fleurus 18–13)
''Paris
''January 24, 1922
''Dear old chap,
''Come. I'll be here the whole afternoon ... You have no idea how sick I was the other day. I thought I'd croak!
''With much love,

Erik Satie''

''Arcueil-Cachan, Nov. 14, 1922.
''Dear delightful friend,
''Radiguet told me about your friendly invitation for Thursday at 7 p.m. Thanks. Don't you dare stick your arm in the flue pipe. If there's soot, that's no concern of yours. Leave it where it is.

''Yes.
''A thousand nice thoughts to the kind little 'Miss' *(mademoiselle).*
''Yes.
''Are you all right?... Just now I'm cold in my spine and my ears are too hot. Yes.
''Till Thursday, dear friend.
''Yours,

Erik Satie''

Fernand Léger wrote Brancusi on November 21:

sees all, he hears all. His eyes are in his ears, his ears in his eyes. Not far from him, like a simple and docile child, Plato seems to be soaking up his master's wisdom.'' Here is a clear explanation of the sculptor's desire to make a group from the teacher and his disciple, with a wooden cup—recalling the drink of hemlock—poised on the head of *Socrates*. This idea was not to be, and there remains of it only one photograph showing the cup in that position (in Brancusi's studio, Musée National d'Art Moderne, Paris). Eventually, *Plato* was reworked, and Brancusi kept only the head, placing it on its side.

Satie sent his friend two peculiar letters in this year:

Letter from Erik Satie to Brancusi, November 14, 1922. Archives I–D

Note from Erik Satie to Brancusi, January 24, 1922. Archives I–D

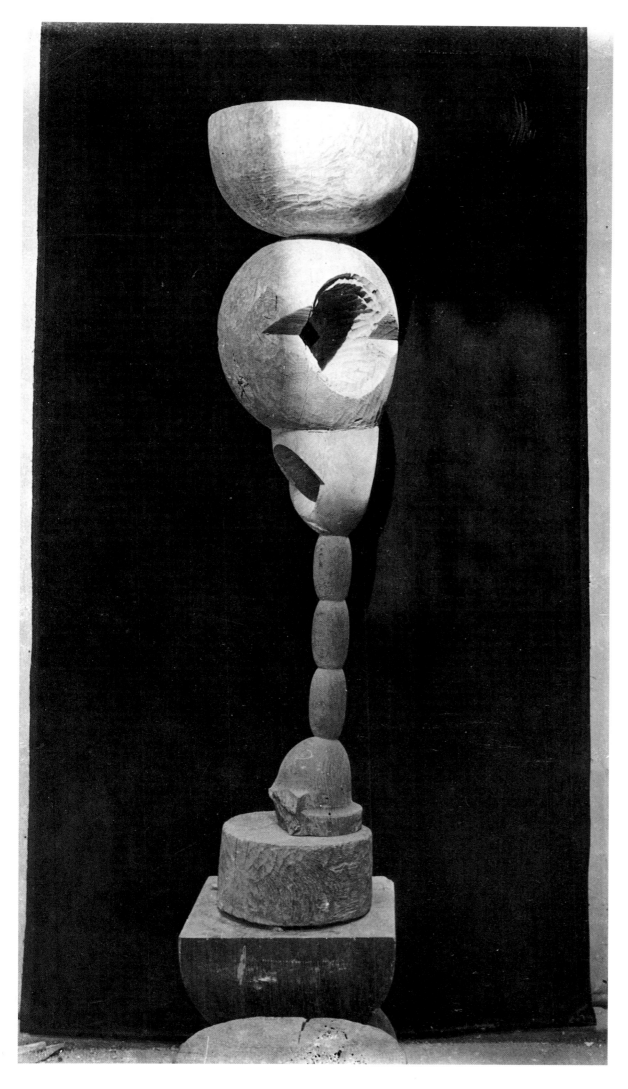

"My dear Brancusi,

"I've got some sketches of 'frescoes.' I'd like you to see them and get your opinion. Would you stop by my place one morning? How about *Thursday*, 10–11? If you can, I'll be expecting you.

"Cordially,

F. Léger"

"I'd have gladly come over to your place but have been very busy these past two days.

"F.L."

During their conversations, Brancusi and Léger often touched on the problem of frescoes and the technique they involved. Brancusi's thinking on the subject was clear-cut: sculpture placed in the middle of a room was ideally complemented by frescoes painted on the walls. This wish to integrate the two had come to him from the tradition of decorating the interior (and, at times, the exterior) of Orthodox churches in Rumania with frescoes on lime plaster. The technique must have intrigued Léger, too, as his letter indicates, and he looked forward to showing the sculptor his sketches.

Brancusi himself painted a few small frescoes, among them a preliminary design for the *Temple of Meditation*. He spread a mixture of unslaked lime and fine sand over the support, a piece of sheet metal with the edges turned up. Before this hardened, he made his drawing, then added powdered colors so that all would dry together. The heat of the lime as it seasons gives a special luminosity to the fresco.

Lastly, an interesting document lists the castings Brancusi ordered from Valsuani, a founder, between 1911 and April 19, 1922. The invoice was sent to him on July 22 from the Institut Comptable de France, an accounting firm that was putting the foundry's books and financial standing in order.

On July 29 is an invoice marked "paid" from the Grand Foundry for three bronze heads over plaster (doubtless casts of *Sleeping Muse*).

Socrates. 1922. Wood. Photo Brancusi (Cat. no. 130)

149

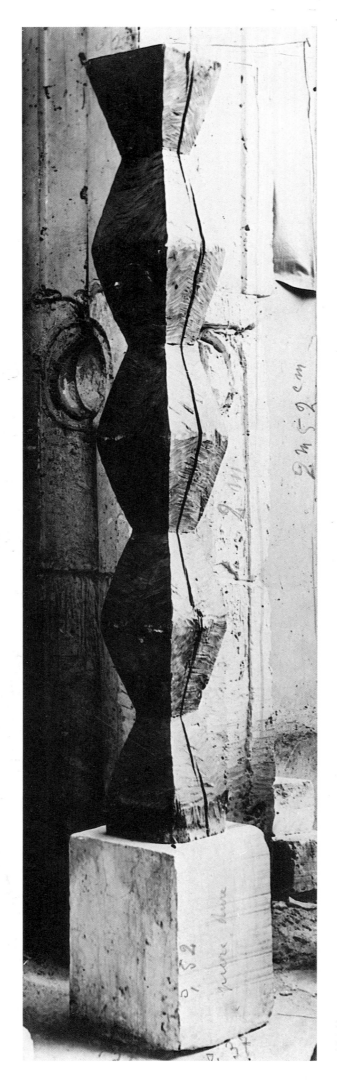

Endless Column. 1918. Old oak.
Collection Mary Sisler, Palm Beach,
Florida. Photo Brancusi (Cat. no.
104)

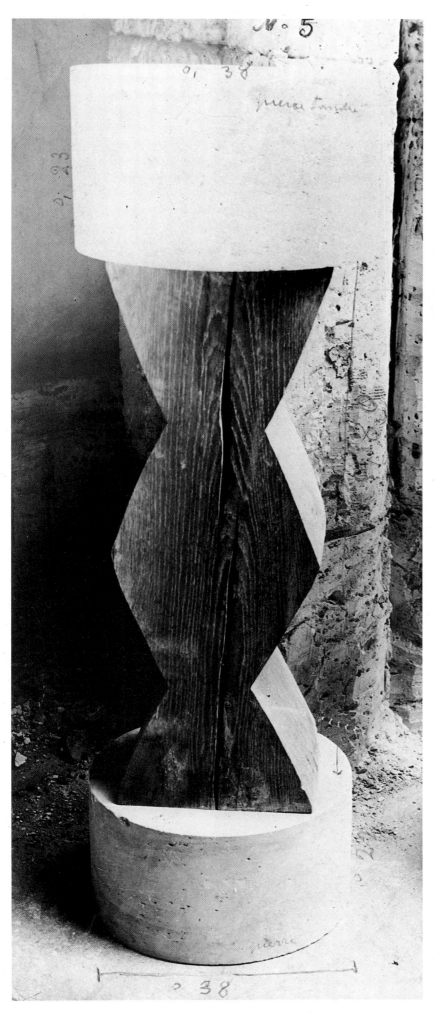

Stone and wood bases for **Bird in Space** (Cat. no. 146). Photo Brancusi

Right:
Stone and wood bases for **Yellow Bird** (Cat. no. 109). Photo Brancusi

151

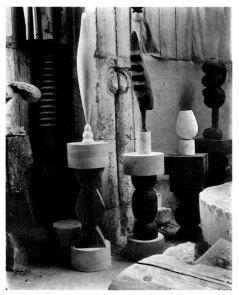

Brancusi's studio, 8 Impasse Ronsin, c. 1923: **Bird in Space** (Cat. no. 137), **The Cock** (Cat. no. 139), **Torso of a Girl I** (Cat. no. 127), **Adam and Eve** (Cat. no. 122). At left, winepress screw. Photo Brancusi

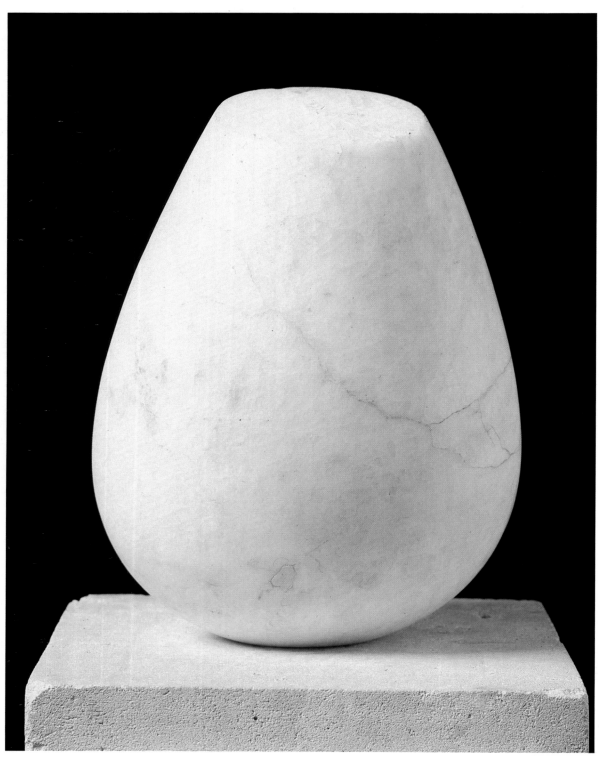

Torso of a Girl II. 1923. Onyx. Philadelphia Museum of Art (A. E. Gallatin Collection). Museum photo (Cat. no. 136)

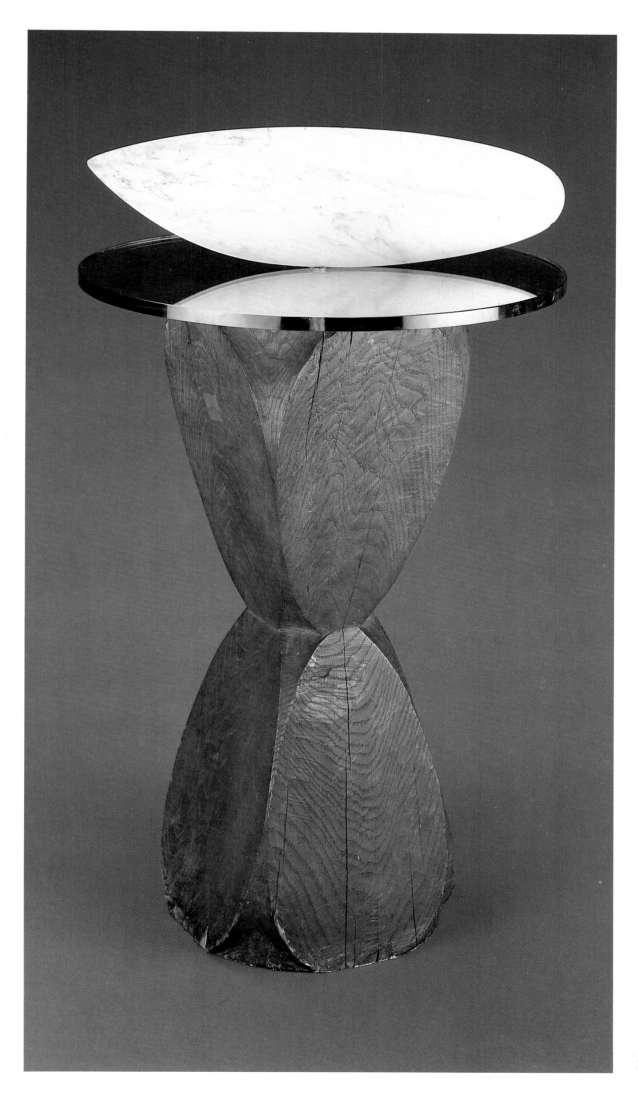

Fish. 1922. Yellow marble on circular mirror and oak base. Philadelphia Museum of Art (Louise and Walter Arensberg Collection). Photo Eric Mitchell (Cat. no. 129)

1923

Whether in response to ossified establishment art, or simply to express a new trend, there are times when artists on the same wavelength will band together. Such was the case when Picabia invited Brancusi to André Breton's, where Blaise Cendrars and other artists were waiting for them.

Brancusi and Satie were seeing more and more of each other. When a show entitled *"Le Pou qui Grimpe"* ("The Clambering Louse") opened in the exhibition rooms of La Belle Edition (7 Rue des Saints-Pères, Paris), Satie sent the sculptor the following letter:

"Arcueil-Cachan, January 26, 1923.
"Dear old chap,
"Hello. You are expected tomorrow—*Saturday*—at 5 p.m. at the *Pou qui Grimpe* exhibition. Please come.

"I was good and sick the other day; all day long all I did was puke. I am too sensitive, too frail a sort to indulge in heavy-duty revelry. Yes.
"Now I'm feeling better. I'm looking better. Little by little

Letter from Picabia to Brancusi, January 6, 1923. Archives I–D

this wasted stomach of mine is recovering—thanks to Pink Pills for Pale People. With all my affection,
"Your old friend,
E.S."

Satie also wrote an extraordinary piece introducing the exhibition. Here is an excerpt:

"... The louse, that humble sidekick of Man whose clinging fidelity rivals that of the dog, is their patron. Lice are also under the protection of a kindly local saint: viz., St. Pinxit, whom you certainly know by name and perhaps even by sight (in painting, obviously). Vehemently slandered, the louse is no dirtier than any other creature. Hence, to dread the louse is a timeworn prejudice. A parasite?... Him?... No more so than the horse, and costs a thousand times less to feed and breed than the famed charger. Yes. Let us insult lice no longer, please; let us squash them no more with our fingernails, with our contempt.... As for St. Pinx-

it, he is the all but living prototype of the true painter—why, an artist! Without him, Painting could no longer exist. 'The louse and he make a pretty threesome, both of them,' a beautiful Lady was telling me yesterday.
"My dear Friend has a point, doesn't she?
Erik Satie"

Another letter from Satie to Brancusi is dated June 27:

"Dear old chap,
"What's become of you? I found out that you've been feeling a little under the weather but that you've recovered. That's all to the good. Roché told me that I stood you up. When, dear Friend? If I did—I must have, since you say so—please accept my apologies. I'm

Opposite page:
Brancusi's studio, 8 Impasse Ronsin, c. 1923: at center, **Bird in Space** (Cat. no. 137). Photo Brancusi

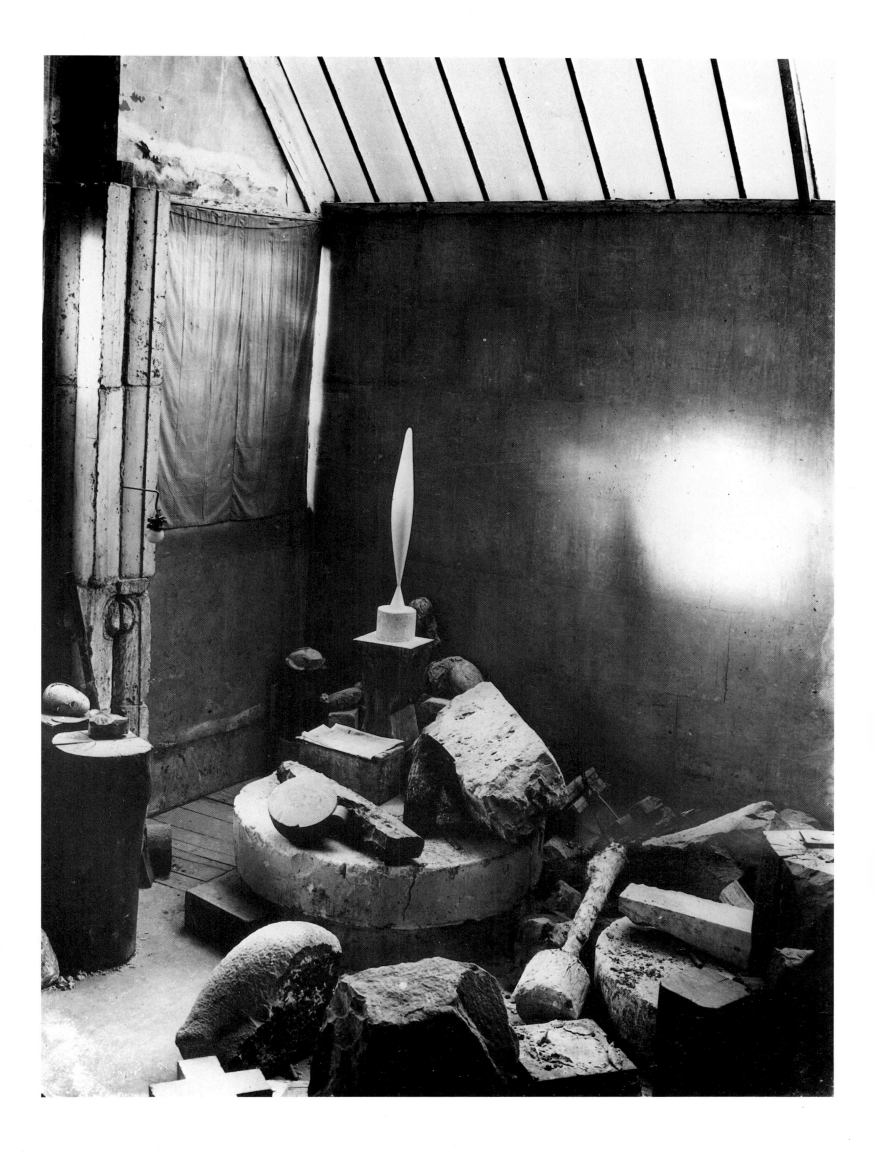

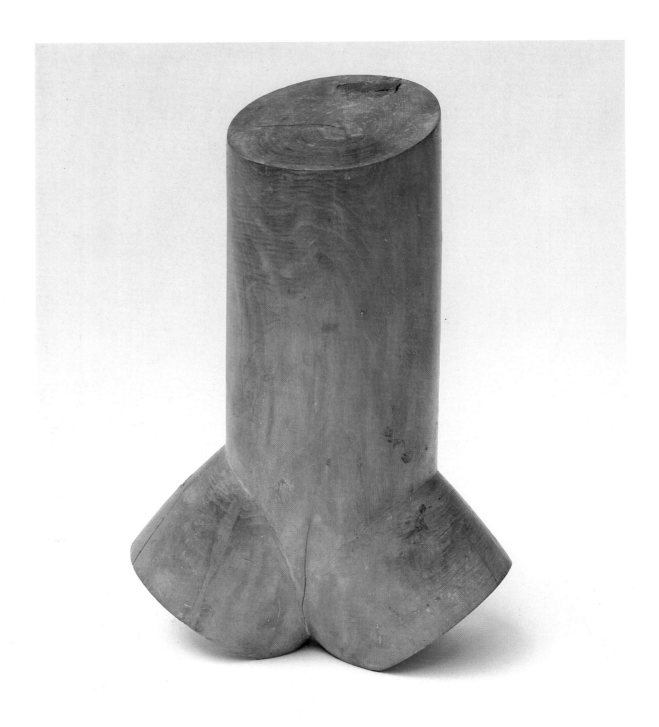

Torso of a Young Man II. 1923.
Walnut. Brancusi Studio, MNAM,
Paris. Photo Flammarion (Cat. no.
134)

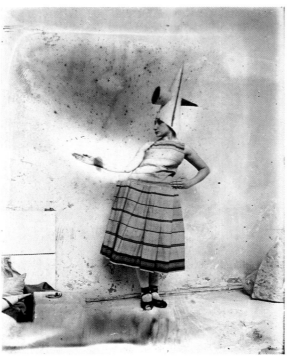
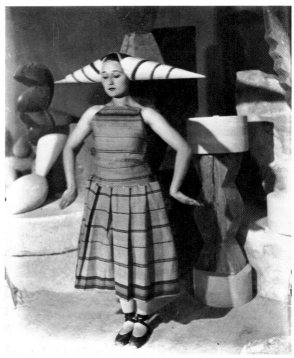

Brancusi's costume and
headdresses for Mme. Codreanu,
then appearing in Satie's
Gymnopédies. Private collection.
Photos Brancusi

nothing but a little scatterbrain, very naughty, who begs your forgiveness.

"I'm counting (on my fingers) on stopping by to see you, with the *naked eye*, before long. You will see a man who has aged a great deal, especially these last twenty-five years. Yes.

"I need rest badly; the doctor advises diversion: riding, swimming, ballooning, and countless other recreations.

"With great affection,

E.S."

On February 16, John Quinn wrote a letter to let Brancusi know that the sculptures had arrived in due time, but that, overburdened with work, he had not been able to open the crates, stored in his cellar, until four months later, on January 8. Quinn took good note of the artist's decision to replace the round plaster base of *Adam* with a stone base; he expressed interest in Brancusi's new work, and complained of terrible migraines.

Roché sent Brancusi a message by *pneumatique* on September 18. "Quinn arriving tomorrow incognito (he doesn't

Golf foursome: Brancusi, Jeanne Foster, Satie, Roché

want word to spread that he's in Paris). He'll stay about 10 or 12 days. I came back this morning to welcome him. Are you in Paris?"

Another *pneumatique* from Roché, dated October 5, sets a meeting at Brancusi's studio. We also know that the collector took this opportunity to invite Brancusi, Roché, Jeanne Foster, and Satie to his club in Saint-Cloud for a round of golf. Mrs. Foster and Satie settled for being spectators. When Brancusi drove the ball so forcefully that it got lost, Satie remarked that golf had evidently been invented by Scotsmen and Anglo-Saxons, and concluded, "It's no game for Rumanians." Brancusi said nothing but pulled his wits together, and ended up winning the round. His prize was a set of

golf clubs, which he proudly displayed on a wall in his studio for the rest of his life. That evening, when all of them were seated at dinner, he could not keep from recalling, "Satie strolled about with us like a mother hen watching over her ducklings."

By December, several pieces by Brancusi that Quinn had seen and picked out were on their way to New York.

"I have sent you the sculptures a little later than I would have liked," Brancusi wrote on December 18, 1923, "because the base of the *Bird* required more work than I expected. I could not get them to Pottier before the 10th of this month; on the 13th I signed the consular invoice. But by mistake the value of the wooden *Torso* with stone base was given as 8,000 francs, and I did not correct it so as not to have to redo all the papers,

but I went back to Pottier and had him take out insurance for the full price of 12,000.

"The white marble bird with stone base is 25,000 F
"The marble fish 8,000
"and the wooden head 8,000
"The round stone base for *Adam and Eve* is marked on the invoice along with the wooden head....

"I duly received from Roché the balance of 32,000 frs. from the purchase of last year and also 12,000 frs. for the wooden *Torso*. That leaves a balance of 41,000 frs. for the bird, the wooden head, and the fish; and if upon receipt of this letter you can wire me part of it, I shall be very much obliged and thank you in advance.

"I have made the base of the bird of very soft stone; if it should be jolted a bit the bird will not break when it is set up, but in any case the utmost care is to be taken, and to make the

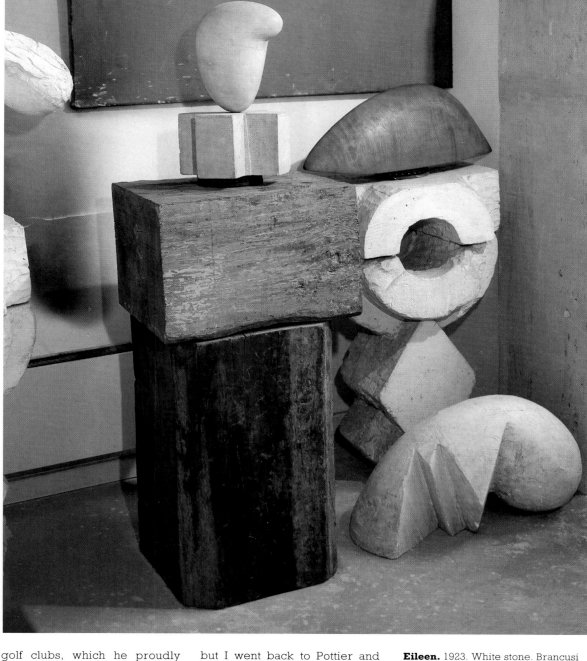

Eileen. 1923. White stone. Brancusi Studio, MNAM, Paris. Photo Flammarion (Cat. no. 135)

bird vertical, it will be necessary to make sure, by means of a level, that the stone base is perfectly horizontal before placing the marble on it....

"I am sending you a photograph I recently took of the *Bird*, and I hope that you will receive everything soon and in good condition."

Purchase orders from that year indicate that the sculptor bought substantial quantities of marble and onyx, as well as a block of fine black Belgian stone (invoice dated January 23, 1923).

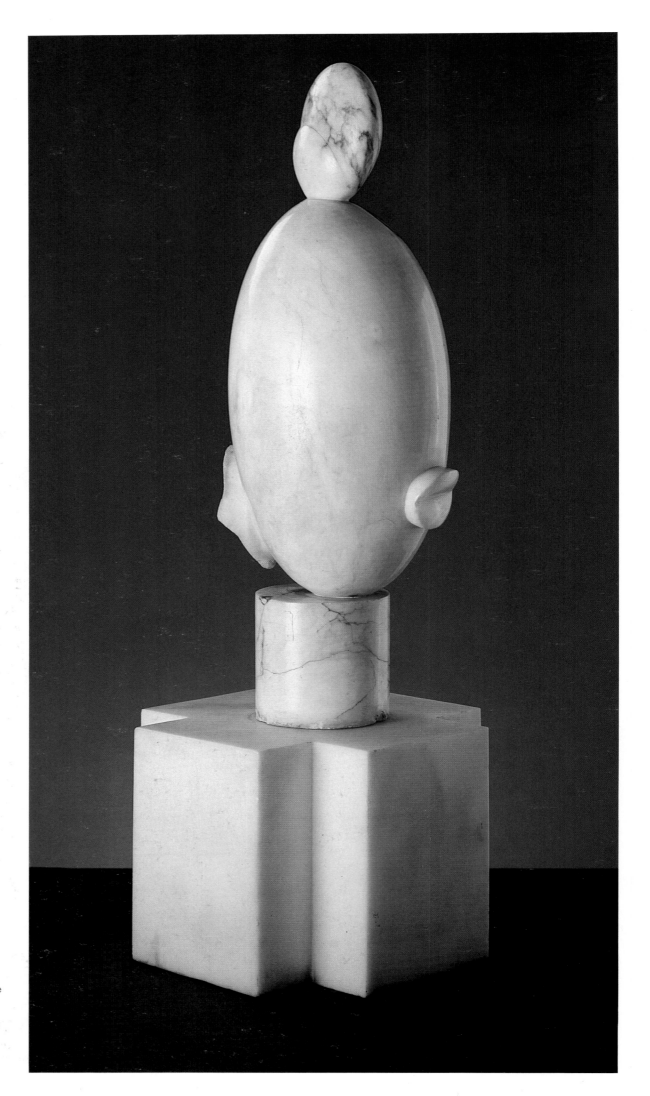

White Negress I. 1923. Alabaster.
Philadelphia Museum of Art (Louise
and Walter Arensberg Collection).
Photo Eric Mitchell (Cat. no. 138*a*)

Opposite page:
White Negress I. 1923. Alabaster.
Photo Brancusi (Cat. no. 138*a*)

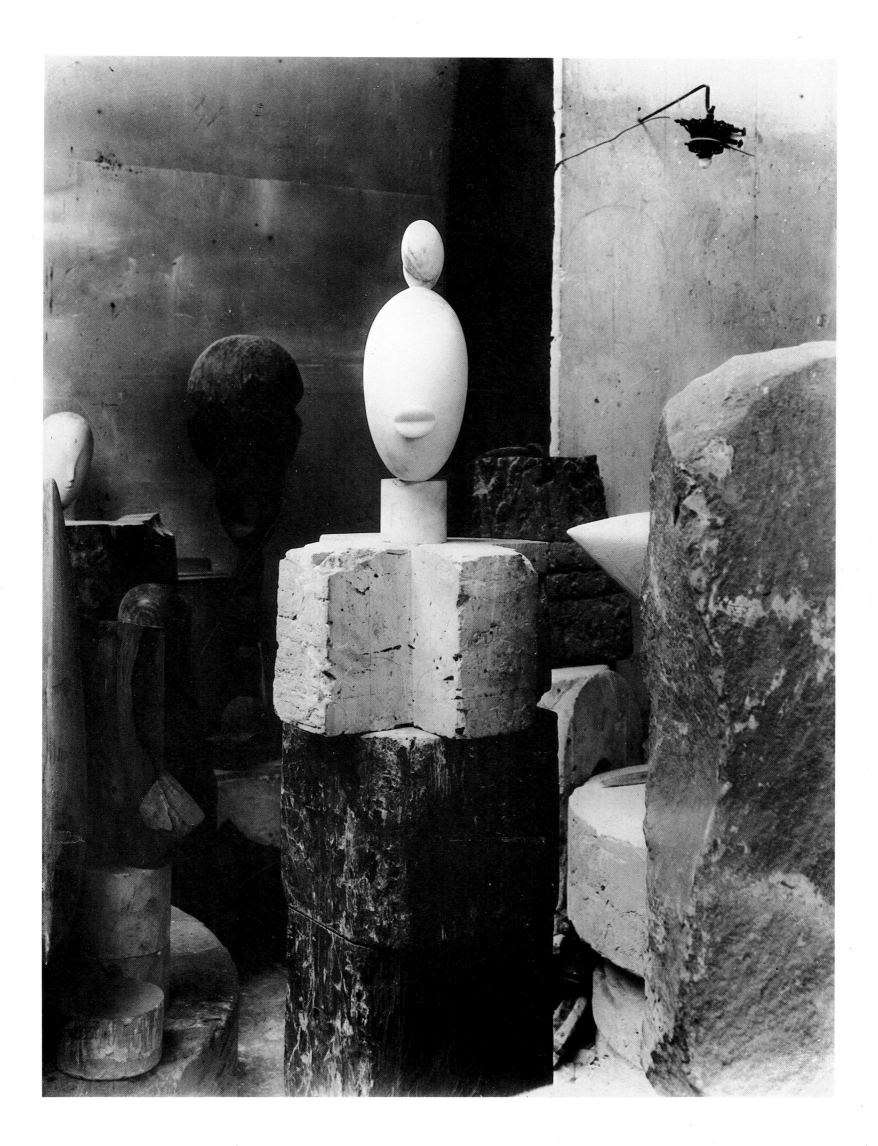

Le poli c'est une nécessité que demandent des formes relativement absolues de certaines matières. il n'est pas obligatoire, même il est très nuisible pour certains autres formes.

1924

In 1924, a Berlin publisher came out with an album of colorplates of paintings by Picasso, Bonnard, Matisse, Signac, and Chagall, as well as photographs of sculpture by Brancusi, Maillol, and Lehmbruck, among others. The caption accompanying the Brancusi reads "*Marbre 1920*, property of John Quinn."

This was the year Brancusi began a monumental work, *Grand Coq*. A photograph from 1925 shows how it looked at that time, with a short, narrow foot, poised on a fairly tall base (approximately 35 ins.). But something about the foot didn't look right to him; he worked on it until the foot had more volume, and was lengthened enough to give the sculpture as a whole its balance and energy, and that ascending tension that irresistibly evokes the bird's glorious crowing in the morning light.

By 1947, when we arrived in Paris, *Grand Coq*, including the base, soared sixteen feet into the air. The surface was rough plaster, the forms imprecise. Noting our enthusiasm, Brancusi instructed us to finish the sculpture, preparatory to having it cast in stainless steel. The photograph of 1925 in *This Quarter* is, in a sense, of the core work to which the definitive plaster version of *Grand Coq* may be traced.

In 1924, Léger invited the sculptor to the premiere of *La Création du Monde* (music by Darius Milhaud, libretto by Blaise Cendrars, sets by Léger), performed by Rolf de Maré's Ballets Suédois. Also in this year, Brancusi struck up a friendship with composer Marcel Mihalovici; Soutine used to join them on outings to the Bobino and Mille-Colonnes music halls. But there was also a warning from his landlord Dussart, who notified him that he had sold Brancusi's premises and in-

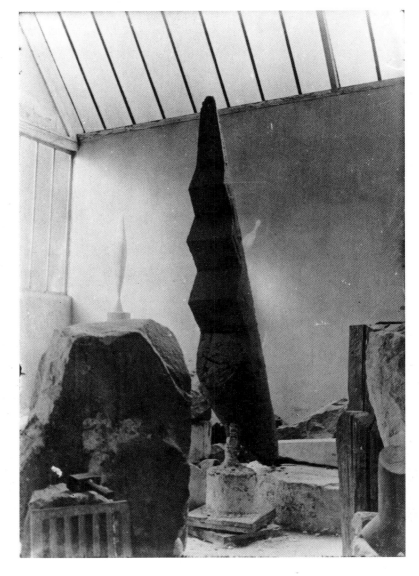

The Cock. 1923. Plaster. Photo Brancusi (Cat. no. 139). This was the first version of **Grand Coq IV** (Cat. no. 218)

tended to remove the shelves and chimney pipes. Tenant requested a postponement, with compensation for the delay, granted by ex-landlord and agent.

Brancusi was impulsive; very demanding on both himself and those who worked for him, he could have violent rages over clumsiness, arrogance, or failure to understand what he meant. He would shortly regret

what he had done or said. His bronze founders were not spared these outbursts, as a legal document dated February 26 attests: "Whereas on February 4, 1924, Monsieur Grand [a founder] came to ask for monies

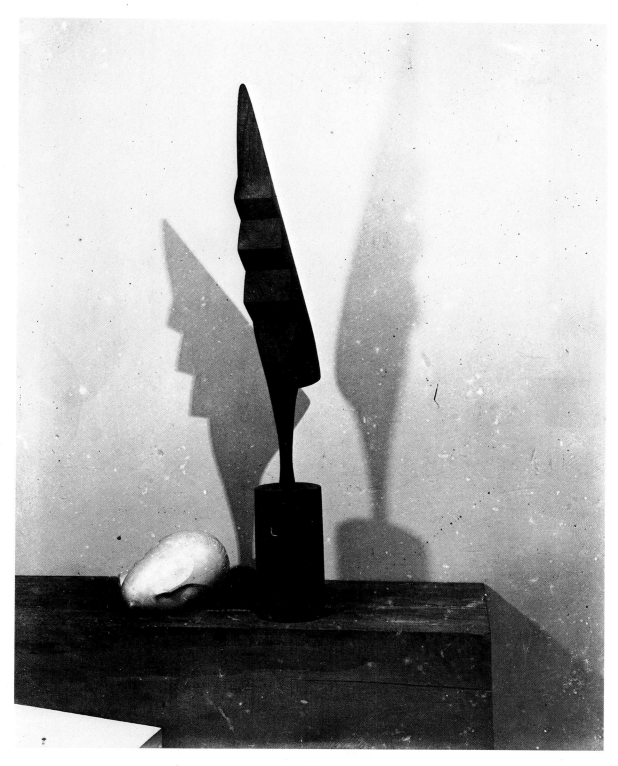

The Cock. [1924. Walnut. The
Museum of Modern Art (Gift of
LeRoy W. Berdeau), New York (Cat.
no. 144*a*)] and **Sleeping Muse II**
[1922. Plaster. Brancusi Studio,
MNAM, Paris (Cat. no. 132*l*)]. Photo
Brancusi

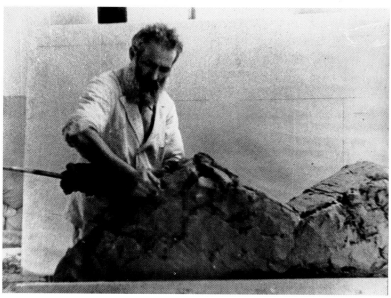

Brancusi working on a version of
The Cock, c. 1922–23. Photo
Brancusi

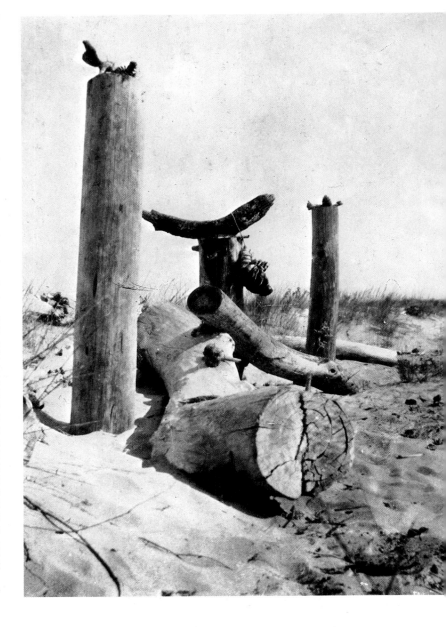

Temple of the Crocodile. Beach at Saint-Raphaël, 1925. Photo Brancusi (Cat. no. 149)

owed, thereupon Monsieur Brancusi took the liberty of striking him and tearing his clothes.'' In a judgment by default, Brancusi was ordered to pay a fine of 100 francs, plus the 100 francs Grand had requested in the first place, and an additional 100 francs for the torn clothing.

After that fracas, the sculptor used other founders: Florentin Godard (three bronzes) and P. Converset, who specialized in casting artwork (three bronzes).

On July 28, a card from Roché told him, ''Our friend John Quinn died this morning.'' Dumbfounded, Brancusi wrote Roché, who replied on August 6 to Saint-Raphaël, where the artist was then staying: the terms of Quinn's will were not yet known, but Roché was assured that everything possible would be done to keep Brancusi's works together in a gallery that Brancusi would set up, as Quinn had wished. Roché enclosed a handwritten receipt for 15,000 francs for Brancusi's polished bronze *Torso of a Young Man*; in case either should die, it was stipulated that the bronze, albeit in the artist's studio, did in fact belong to Roché. We know from a letter dated October 16, 1924, that Roché left for the United States on October 18; he did not return until February 1925.

While in Saint-Raphaël, Bran-

Brancusi's poem on **Temple of the Crocodile,** 1924. Archives I–D

162

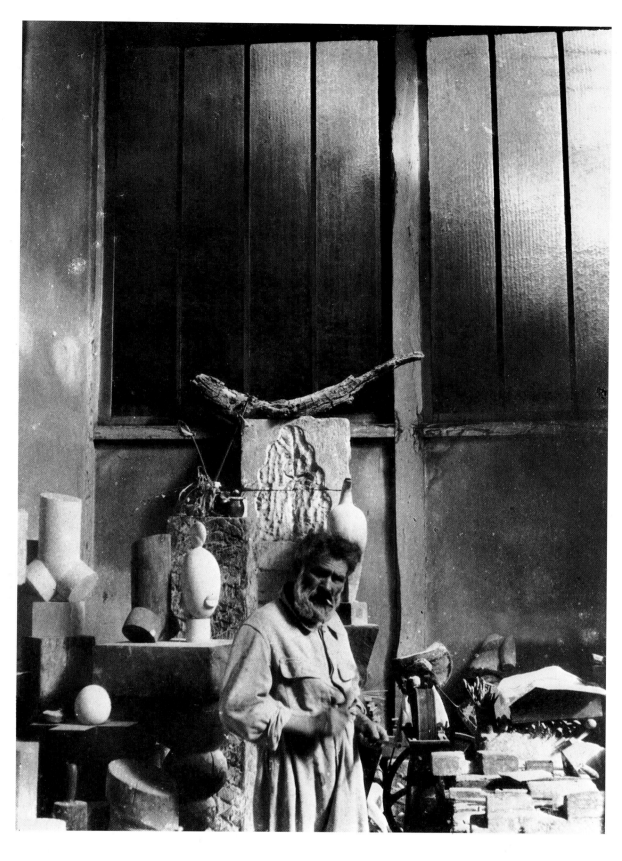

heart'.... After I placed the crocodile on the temple, I ran into the water like a seal, shouting 'Bravo, crocodile!'"

The following night, one of the creature's legs was blown off by a violent mistral. Brancusi, who had to return to Paris the next day, took the crocodile out of its temple like a sacrilegious thief, wrapped it in newspaper, and waited until everyone was asleep before bringing it back to the hotel and placing it under his bed with care. During the train ride to Paris, he propped it up in a corner seat. Back at Impasse Ronsin, he decided to mend its leg. "All the calamities are over," he wrote. "Now everything is very calm."

On March 14, the Russian Artists Association held the Bal Banal, a benefit for the Caisse de Secours Mutuel (Mutual Relief Fund). Two drawings, one by Brancusi and one by Picasso, were reproduced on the cover of the program.

A "French and American Exhibition" in Portland, Oregon, included Brancusi's bronze *The Muse* and featured it on the catalogue cover. It was bought by Sally Lewis, who had organized the show. In addition, Brancusi sent a *Bird in Space* to the Salon des Tuileries, which opened May 7 at the Palais du Bois de la Porte Maillot, and two sculptures (*The Kiss*, stone, and *Maiastra*, bronze) to an international exhibition in Bucharest that opened December 1 under the auspices of *Contemporanul*, a Bucharest magazine, and showed works also by Klee, Arp, Brauner, and Maxy, among others.

As in previous years, Brancusi purchased a substantial amount of raw materials: stone blocks from quarries in Burgundy, poplar timber, and the sapwood of oak timber (invoices of August 23, September 5, October 9, and October 17, 1924).

It was also in this year that Brancusi met his future fiancée, a young dancer with long blond hair.

In 1924, Brancusi carved *Beginning of the World* and *The Cock*, a walnut sculpture that was in a bizarre episode in 1934 (*New York Herald Tribune*, September 25, 1934: "Brancusi Piece Is Mixed with Cheap Vases"). Audrey Chadwick, who had known Brancusi for some years, fell in love with *The Cock* and bought it, taking the

cusi experienced a mishap that might have proved fatal. Years later, when we were whitewashing his studio walls, we were about to move a piece of cork oak from between two beams; Brancusi admonished us, "Be very careful, it saved my life," and proceeded to tell us the story: "I was taking a dip in a river, not far from the beach at Fréjus. It was hot. Suddenly a torrent came rushing down the mountainside and swept me away. I floundered in the water

and was about to go under when I saw a piece of cork oak swirling in the waves, and I grabbed it. It carried me down to the mouth of the river. I ended up on the beach at Fréjus, choking but overjoyed, as you can well imagine. Then I had an idea: I would use this piece of wood to build a temple to Providence as a token of gratitude."

He jotted his thoughts on a scrap of paper. "I couldn't go into that water that was like the

lake in the Black Forest. The Muses that dwell there punished me, but, fortunately, the crocodile came to my rescue. [The piece of cork oak had the shape of a crocodile.] 'Crocodile,'" he went on, "'I'm putting you on the sand, I'm going to make a grotto for you, I'll spread out some beams for a raft, and with the first stones I find I'll dig a hole for a spring and pour in a ten-liter flask of sea foam. Whosoever disturbs this water shall die of a broken

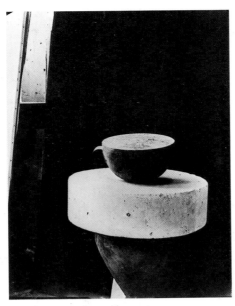

Cup III. 1923. Wood. Brancusi Studio, MNAM, Paris. Photo Brancusi (Cat. no. 140)

Fish. 1924. Polished bronze. Collection Mr. and Mrs. James W. Alsdorf, Winnetka, Illinois. Photo Brancusi (Cat. no. 142*a*)

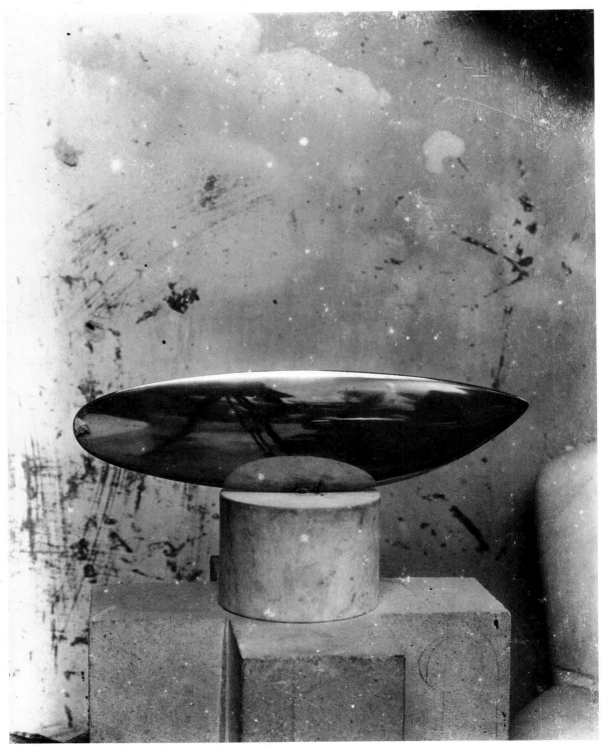

precaution of putting it in the basement of the hotel on the Champs-Elysées where she was staying. The manager assured her that it would be safe there. A few days later, she bought two inexpensive large pink vases from a store near the Opéra, thinking they were the color of a room in her residence in the United States. She had them put in the hotel basement with the Brancusi, but then changed her mind about them and asked the store to take the vases back. They complied.

A week went by, then the store manager telephoned her that his office had received an incomprehensible note concerning a particularly heavy parcel that seemed to belong to her. She tried, unsuccessfully, to get more information. Suspecting that it might have something to do with her Brancusi sculpture, she asked the manager of the hotel to go to the basement at once to see if the Brancusi was still there. It was not; the wood sculpture had been taken away along with the two vases! And here for six whole days she had thought her masterpiece was safe in the hotel basement—and it was being lugged about from warehouse to warehouse! Why, it might even be damaged now!

What could she do? At first she thought of Count S., who would have moved heaven and earth to get the French government to help her locate the sculpture, but then she asked herself, ''Audrey, can't you do it yourself?'' She jumped into her car and went in search of *The Cock*. For seven hours she drove fruitlessly from one warehouse to another, then she returned to alert the president of the store. She was told he could not possibly see her about a mere receipt.

She refused to give up, and made the rounds of the warehouses again, finally locating the sculpture in Clichy. ''I'm so very grateful! How nice that it's not broken. And what a tale, the story of the lost Brancusi. It's become doubly valuable. It's back at the hotel now. I really must take it home.''

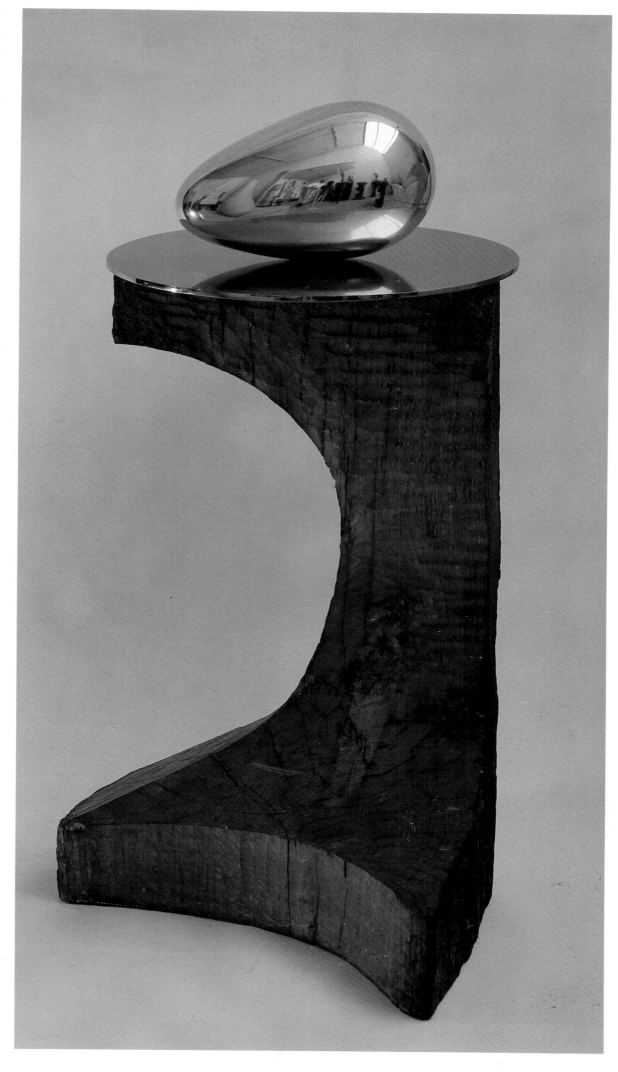

Beginning of the World. 1924. Polished bronze. Brancusi Studio, MNAM, Paris (Cat. no. 143*a*)

1925

In this year *This Quarter* (Ernest Walsh and Ethel Moorhead, Paris publishers[16]) devoted its "Art Supplement" to Brancusi: nine aphorisms[17] and a story by the sculptor, followed by a set of forty-six plates that included thirty-seven photographs of dated works, four portraits of the artist, and five drawings.

Tall Tale, by Constantin Brancusi (from *This Quarter*, 1925):

"Once upon a time, long, long ago, when men did not know how animals come into the world...

"One day way back then, a man came across a hen sitting on some eggs. Since people and animals understood each other, he asked the hen what she was doing. And since the hen was considerate and did not want to keep him on his feet—in those days animals had great respect for people, so very, very, very much more than now—she got up and went off to tell him.

"She took a very, very long time doing so, and by the time she got back, the eggs had gone rotten.

"That is why brooding hens nowadays get spitting mad at us when we get close to their nests!"

In May, the artist sent *Golden Bird* (bronze, 1919), *The Newborn* (stone), and a wood sculpture to the Durand-Ruel Gallery for the "Exhibition of Tri-National Painting and Sculpture" (French, British, American). Organized by De Zayas, it subsequently traveled to London (October) and New York (February 1926). Camille Mauclair wrote the preface to the catalogue, which lists works by Brancusi, Braque, Matisse, Picasso, Picabia, Arthur B. Davies, Walt Kuhn, Roger Fry, Frank Dobson, and Jacob Epstein.

On July 1, one of Brancusi's dearest friends, Erik Satie, died at the Hôpital Saint-Joseph in Paris. Years later, Brancusi would still heave a sigh and say, "Oh, Satie, why aren't you here anymore?" A music enthusiast, the sculptor knew that Satie, for all his wit and lightheartedness, was a true creator and a man of unshakable conviction.

"Satie dazzled Brancusi," Roché later wrote (*Arts*, 1957). "He taught him repartee, self-confidence, lucidity. Brancusi was the disciple of Satie-Socrates."[18]

Whereas Brancusi rarely went out, Satie moved in all the artistic circles; therefore, the musician kept him abreast of society gossip, complete with a matchlessly spirited critique. For Satie himself was anything but a society person! One day, Brancusi told him he was having a hard time finishing one of the *Bird* sculptures. "In the creative process," his friend replied, "you've got to know how to persevere and follow your concept to its logical conclusion, as I have always done." When he was dissatisfied with his score for *La Mort de Socrate*, didn't he decide to do it over? Didn't he slave away at it for a solid year?

One version of "Histoire de Brigands" ("Tall Tale"), handwritten on notebook paper and signed, 1925. Archives I–D

166

"As he said that," Brancusi told us, "his face beamed with satisfaction." The sculptor heeded the musician's advice. He overcame the obstacles facing him, one by one, finished the sculpture, and achieved the state of euphoria Satie had so eloquently described. "If Satie could see it through to the end," he would ask himself, "why can't I?"

Not widely known, largely unappreciated by the public, slighted by other musicians, Satie had very little to live on. To help him out, Brancusi mentioned his plight to Mrs. Eugene Meyer, Jr. "But what can *I* do?" she asked. "Well," the sculptor suggested, "you could commission him to write a page of music." And so she did. Satie gave his friend a photograph of it, and Brancusi always looked at it with pleasure.

The composer lived in Arcueil. (Brancusi once took a picture of the entrance to the house.) "After he died," Brancusi told us, "they opened up his pathetic room and found a clutter of books, papers, and scores. Behind the piano there was a pile of stiff detachable collars and cuffs, which Satie never washed and threw away after use. Moreover, he apparently used the place as a bathroom on occasion, probably between two flashes of inspiration."

On November 7, at 2 P.M., the musician's effects were sold at auction in Arcueil (27 Rue Cauchy). However, as the following letter from Satie's brother to Brancusi attests, the manuscripts were not sold:

"Please believe me," he wrote on October 20, 1925, "this sale is not being held to indulge the greed of Satie's heirs, namely, my sister and myself. We were planning to hand out all of these things as mementoes to faithful friends and donate the linen and such to the poor of Arcueil.

"However, what seemed to be a simple solution was, in fact, wasteful. It would make more sense, it seems, to proceed in accordance with the rules Napoleon laid down in 1802.

"The manuscripts shall not be auctioned off."[19]

Later on, certain books and manuscripts which had not been put up for auction were left with Brancusi. Anxious to keep the collection together, the sculptor handed them over to the curator of the Bibliothèque Jacques Doucet. He received from her the following acknowledgment:

"I should be writing you a formal letter, but feelings have swept away that hackneyed talk and cleared the path for plain speaking, for the same emotion-filled words that sprang to your lips when we [the Bibliothèque]

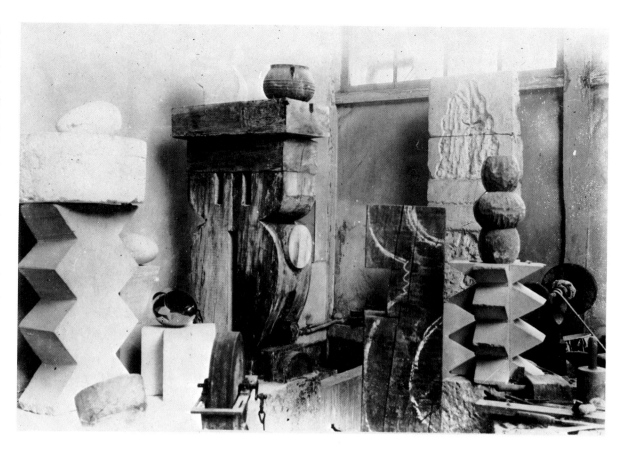

Brancusi's studio, 1925: among other works, a **Sleeping Muse,** a bronze **Newborn,** and **Exotic Plant** (Cat. no. 156). Photo Brancusi

The Chief. 1925. Wood and iron. Collection Phyllis Lambert. Photo Brancusi (Cat. no. 148)

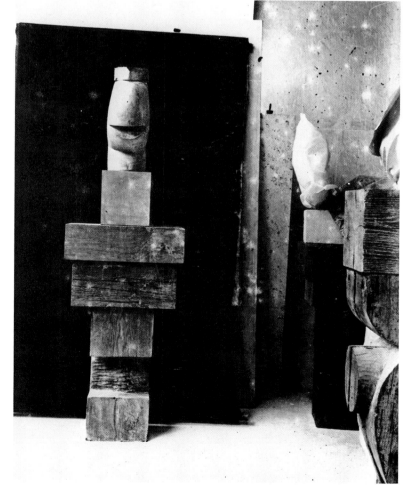

approached you. All the things you turned over to me so freely—the documents, the cherished keepsakes of your friend, Erik Satie—shall be treasured in the Jacques Doucet Library, which, thanks to you, is the richer and prouder for them.

"I am mounting all of these 'pearls' myself and I hope to get you here one day to see them where they now are. Should additional letters follow, I intend to fill in the gaps of this moving testament to a man of note whose memory still sheds a lovely light.

"All my gratitude, all my sincere and heartfelt friendship.
Rose Adler"

There was talk of a monument to Satie that Brancusi offered to carve. De Beaumont organized a gala at the Théâtre des Champs-Elysées to raise funds for the project, but the plan fell through, as a letter from Satie's brother indicates: "Crash, crash, crash! It's all falling down around us. Monsieur de Beaumont has just added up all the figures and counted what's left in the till. It comes to 580 francs. Under the circumstances, we'll have to settle for a run-of-the-mill gravestone like any one of the thousands they turn out every year for ordinary people in cemeteries everywhere. It's appropriate and 'suitable,' to be sure, but as cheerless and absurd as death [itself]. It'll be ordered tomorrow and will be finished in two months.

"It's already been a year since you came up with that noble idea of yours, and for that I offer my warmest thanks, my dear friend and close friend of Erik Satie."

The municipality of Arcueil gave permission to Robert Caby (a friend of both Brancusi and Satie) to affix a commemorative plaque to the house the composer lived in. He advised

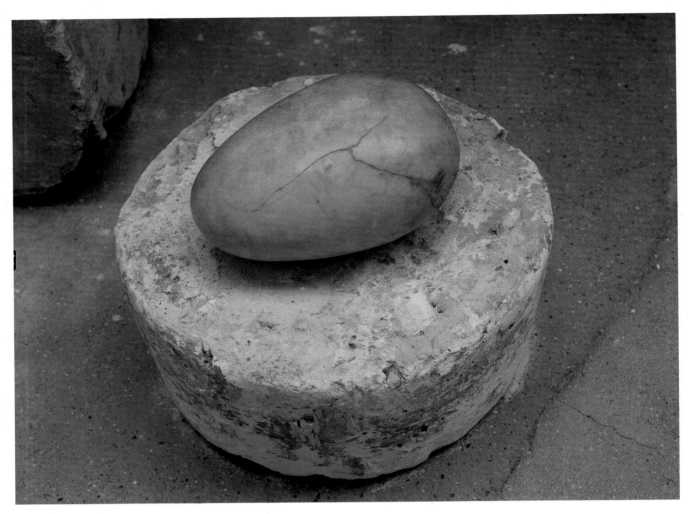

Sculpture for the Blind. 1925. Onyx. Brancusi Studio, MNAM, Paris. Photo Flammarion (Cat. no. 158)

Little Bird. 1925. Colored marble. Private collection. Photo rights reserved (Cat. no. 152a)

Exotic Plant. 1925. Wood. Brancusi Studio, MNAM, Paris. Photo Brancusi (Cat. no. 156)

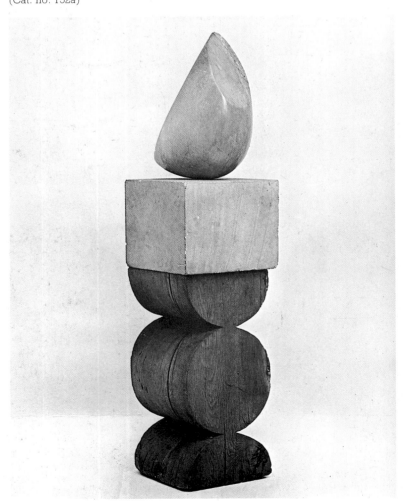

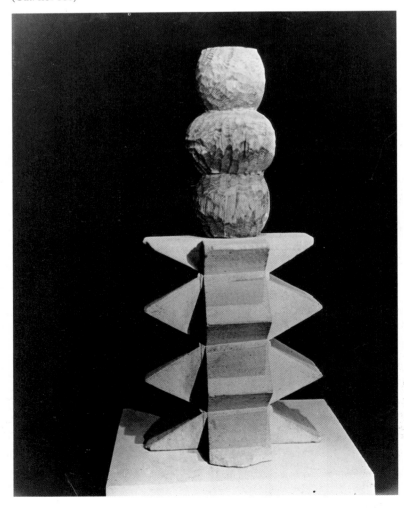

Brancusi that the modest ceremony, scheduled for Sunday, June 30, 1926, would be followed by a Satie concert in the community center. "I am counting on you to have the plaque made," he added.

Since the "Exhibition of Tri-National Art" would also travel to London (New Chenil Galleries[20]) and New York, *Vogue* magazine notified Brancusi on September 3 of its intention to publish an article on him in English. Across the Channel he went."I've found my sea legs," he noted on the way over. "Since *it is very nice* [last four words in English], I'm going out onto the deck" He checked into the Royal Court Hotel. Lulled into a sense of security by their sympathetic mood, he agreed to share some of his thoughts about his art with a group of English journalists and art critics. Here is part of what he said: "The decline of sculpture started with Michelangelo. How could a person sleep in a room next to his *Moses*? Michelangelo's sculpture is nothing but muscle, beefsteak, beefsteak run amok. His painting gives one the impression of a stable. Sculpture everywhere felt his impact in one way or another, and we have Rodin to thank for steering clear of the grandiloquent and the colossal and for bringing [sculpture] back down to human scale." His remarks had a chilling effect. The next day, a critic came out with an article stating that Brancusi certainly had a great deal of talent and that his works were well liked, but that he would do better not to tamper with Michelangelo. "Why not tamper with Michelangelo?" Brancusi wondered. "If I don't, who do you expect will?"

Brancusi sent *Bird in Space* with its bases (wood and stone), *Endless Column* (wood fragment), and an unspecified work of polished bronze to the "Art d'Aujourd'hui" exhibition that ran from December 1 to December 12 at the Chambre Syndicale de la Curiosité et des Beaux-Arts. When asked about his nationality, he replied in a covering note, "Terrestrial, human, white species"—as a profession of faith, not a joke.

Roché informed him that the fate of the Brancusis in the Quinn estate was still undecided:

"Dear Friend,
"No decision yet concerning your sculptures.
"None, except that we must not rush things or do anything rash (as there was talk of doing at one point). I intend to stop by to see you in Paris before the end of February."

The year was marred by two unfortunate events. On June 13, the labor arbitration board ordered Brancusi to pay 300

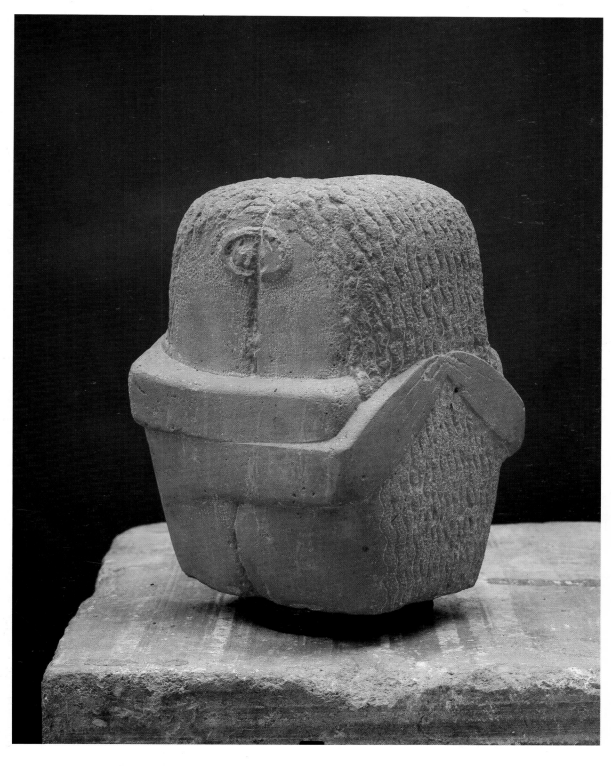

The Kiss. 1925. Stone. Brancusi Studio, MNAM, Paris (Cat. no. 151*a*)

Brancusi and Polaire. Photo Brancusi

francs for wages to a Rumanian woodcarver who had assisted him and now claimed the right to be paid. The statements of other young sculptors who studied under Brancusi make it clear that they customarily worked without remuneration, their payment coming in the form of acquired experience, in the growth of knowledge. This time the two reached an amicable settlement, and Brancusi agreed to pay the plaintiff 200 francs out of sheer kindness; the plaintiff withdrew the charge, even wrote a letter of apology.

Brancusi became very fond of Polaire, the dog he bought in 1921. "She was almost human," he said later. He used to take her everywhere, even to the movies; she would not leave his

side. Whenever one wrote to the sculptor, it was customary to ask about Polaire. She was a possessive dog and could not abide the women who crossed the threshold of the studio. One day, opposite Impasse Ronsin, Polaire dashed away from Brancusi, whose arms were full of baskets. She was run over by a car. It broke his heart. He told himself that she used to take him from his work, but this was just so he would not miss her so much. Polaire was buried in the dog cemetery in Asnières.

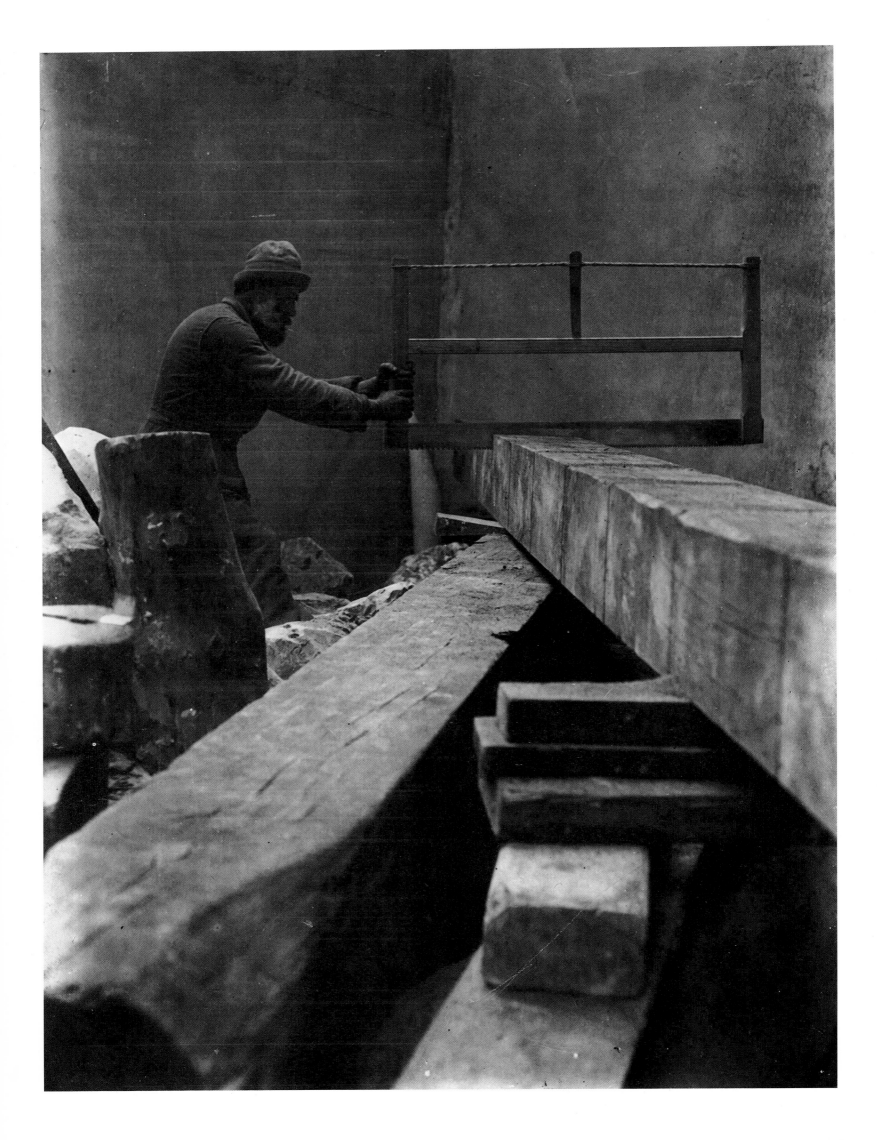

a pegue les loi des hommes
me donne une moitie d un
secle — et pour tout j'ai
reçu du milieu des années

1926

1926 was a momentous year for Brancusi in several respects. On February 19, he turned fifty (though he ironically noted "a century" on a drawing), an age when people start to look back on their past and take stock of what they have accomplished. He also made two trips to the United States, although the premature death of John Quinn, the eminent collector, had completely upset his plans. His troubles with United States Customs started in the fall of this year. The litigation that ensued, distasteful though it was for the sculptor, ended in a brilliant victory.

With a trip to America in the offing, Brancusi resigned himself to taking English lessons. Friends recommended a teacher by the name of Miss Kelly. After grounding her pupil in basic vocabulary, she encour-

Portrait of Myself a Century Old. 1926. Blue pencil on notebook paper. Archives I–D

Opposite page:
Brancusi working on **Endless Column**, c. 1925. Photo Brancusi

aged him to form sentences. He thought a bit, then came out with "Miss Kelly missed the boat," an innocent play on "Miss" and "miss." He meant nothing by it, but the negative sense of the colloquial expression cut the poor woman to the quick. "I can still see her," Brancusi told us, "hanging her head like an injured bird, and to this day I can hear her saying to me, 'What can I say, Mr. Brancusi? I've had a luckless life!'"

That was enough to cast a pall of uneasiness over all subsequent lessons. At the slightest mistake, she would upbraid her pupil with comments like "Stupid boy! Bad boy!" Brancusi's English lessons came to an end, and with them his study of the language.

Shortly before he left for America, he received an invitation to the official opening of the "Memorial Exhibition of the John Quinn Collection" at 4 P.M. on January 7 at The Art Center, 65 East 56th Street, New York. His main reason for traveling abroad, however, was to take part in the "Exhibition of Tri-National Art" and, later that year, his one-man show, both at the Wildenstein Galleries in New York.

He took out an insurance policy for his sculptures, which were packed in two crates and loaded aboard the *France* on January 20, 1926. After a dreadful crossing, he arrived in New York on January 28 and checked into the Brevoort Hotel at Fifth Avenue and Eighth Street. A letter from Marcel Duchamp arrived a few days later:

"February 13, 1926.
"Got your letter this morning, I'm answering it at noon. I'm going to phone Roché and have him cable you Mrs. Foster's address. Delighted to hear from you.
"I knew you had an appalling trip; tell me all about it later.
"Don't worry about anything

Invitation to the Brancusi show, Wildenstein Galleries, New York, 1926. Archives I–D

in Paris. I'm going to see Léger about the Indépendants.
"Nothing of importance in your mail.
"I've paid your taxes.
"Stay as long as you like, and sell a lot.
"Sorry I can't be with you. Kindest regards to all New York, and see you soon.
 Marcel"
"Wildenstein is a very good gallery."

On February 4, the "Exhibition of Tri-National Art: French, British, American," opened at the Wildenstein Galleries. There were four works by Brancusi: *Torso* (No. 145), *Bird* (No. 146), *Figure* (No. 147), and *Figure* (No. 148). Roger Fry wrote the preface to the catalogue.

One of Brancusi's countrymen, a musician by the name of Cuclin, happened to be in New York at the time and wrote in a Rumanian-language newspaper (published in Cleveland) that the sculptor had come to find out what had happened to the thirty-odd sculptures in the Quinn collection. The same article reviewed the "Exhibition of Tri-National Art."

Brancusi's one-man show ran at the Wildenstein Galleries from February 18 to March 3, 1926. Here is what he wrote at the time: "On the occasion of my birthday—I've just turned

half a century—and to mark the end of my apprenticeship after thirty years of work, I mustered the courage to bring together and exhibit a little assortment. I apologize," he added, "for coming with so little so late, but the road I took has been long and hard."

In addition to listing the works in the show, the catalogue includes four aphorisms written by the artist:

"Direct carving is the true road to sculpture, but also the worst for those who have not learned how to walk. When all's said and done, it doesn't matter whether the carving is direct or indirect. It's the end result that counts."

"High polish is needed to give certain substances a nearly absolute form. For certain other forms, however, it is not required and even harmful."

"In art, one does not aim for simplicity; one achieves it unintentionally as one gets closer to the real meaning of things."

"Things are not hard to make. The hard part is getting into the mood to create."

Brancusi did not leave the United States until March 22, and in the interim he did anything but idle away his time. He met William E. Lescaze, the American architect, at the Wildenstein Galleries. Lescaze later recalled in a letter the ideas they exchanged during their brief conversation: "How pleasant it was to find out that you were looking for, and had found, a form in sculpture that I am looking for, but have not yet achieved, in architecture. You spoke of the *Column*, and you were trying to decide what shape it should take. Let me know how you're coming along. Don't give up this project." Proof, therefore, that the concept of *Endless Column*—even the *Colonne Habitable*—was already very much on his mind.

Robert Chanler, who had purchased *Mlle Pogany* after the Armory Show in 1913, had the sculptor over for dinner; so did Beatrice Wood, a friend of both Duchamp and Roché, and also Frank Crowninshield, editor of *Vanity Fair* magazine. He spent the weekend of his birthday, February 19, with Mr. and Mrs. Maurice Speiser. (Speiser, an attorney, later argued his case during the litigation with U.S. Customs.) On February 22, Mrs. Foster and he were the guests of George Christ, who informed him that he would be giving a lecture on Brancusi's work at the Art Center on March 25.

And what about Mr. Quinn's Brancusis? What had he found out about them? A scathing article by Frederick James Gregg in *The Independent* (February 27, 1926) shed some light on the matter. Walter Arensberg would buy some of the sculptures through Marcel Duchamp; Brancusi, who feared nothing so much as seeing his work scattered among various collectors, gave his consent. The rest would go to Henri-Pierre Roché.

On March 22, Brancusi left New York for France on the liner *De Grasse*. On board was a letter for him from Mrs. Foster: "… I found out through Miss Thomson that you cleaned the sculptures at Quinn's. I'll stop by and see them this week…" This is corroborated in a letter from the artist: "I am busy reconditioning the sculptures in the Quinn collection—miraculously, none was damaged—but all of them are dirty and rusty, and the corners of the bases are chipped, but I can fix them."

Crossing the Atlantic, he pondered the *Pyramid of Fate* and jotted down his thoughts.

"In today's world, everyone is trying to scramble to the top of the pyramid. Once they're up there, they inevitably fall down the other side.

"In my world, there is no struggle for a higher position—the pyramid is demolished, the field is wide open—here, everyone is what he came with—in his place. No more is there such a thing as greater or lesser, worthy or undeserving; he is what he is."

Several letters were waiting for him, back in Paris on March 31. One was from *Integral*, a Bucharest magazine, requesting negatives and photographs, inquiring on behalf of a collector what were the prices of *Maiastra* and *Mlle Pogany* (shown at the *Contemporanul* exhibition in Bucharest), and informing him that an article by the poet Ion Minulescu would be appearing in the April issue. Another was a special invitation from the Ministry of Fine Arts, Bucharest, signed by Minulescu, requesting three works for the official exhibition on May 1, 1925.

There was also a letter from Ferand Léger:

"Dear old chap,

"Here you are. In theory, a viable project. (This is not the one you got advance proofs of.) This one will be called "Independent French Art," an exhibition that would be held in the fall with works grouped by trend. I'll organize the modern group.

"The location has not yet been decided on; probably Tuileries or Palais du Bois.

"So, do what you wish for the Tuileries. That doesn't mean you can't send (work) to this other exhibition in the fall, if need be. Till Monday, then. Yours."

There was also a note from Albert Dreyfus thanking Brancusi for the *Bust of a Woman* he had admired so much in the studio. "The only great art is pure art, and that is what yours is."

But landlord trouble was brewing again, and before it was over it would turn into nothing less than a nightmare. The management of the Vaugirard Press, which now owned Brancusi's studio on Impasse Ronsin, notified the sculptor of his impending eviction. "Under Article 4 of the statute of April 1,

Catalogue, Brancusi show, Wildenstein Galleries, New York, 1926. Archives I–D

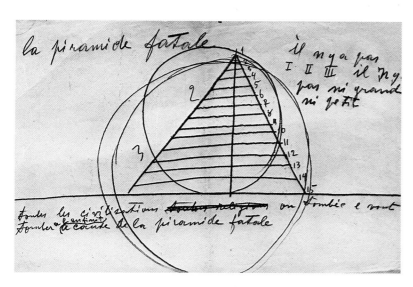

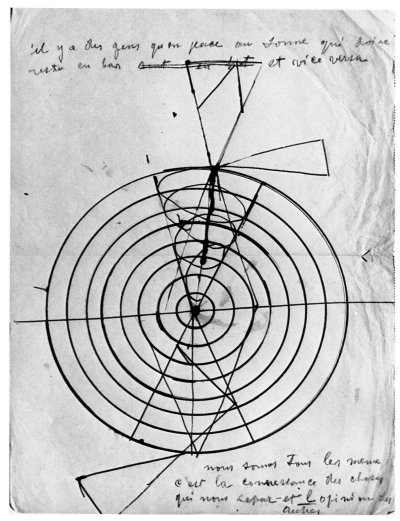

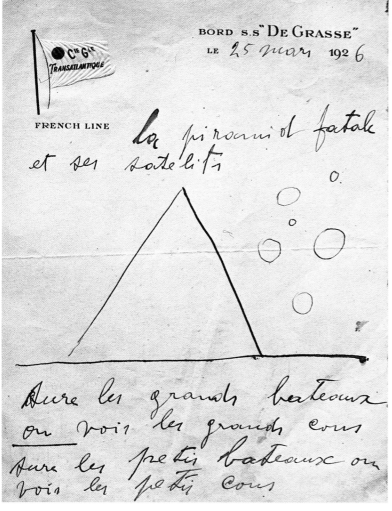

The Pyramid of Fate and Its Satellites. Pen and ink on letterhead. March 25, 1926. Archives I–D

At top, left:
The Pyramid of Fate. 1926. Pencil on paper, 23.2 × 35.2 cm. Archives I–D

Above, right:
Spiral and Pyramid of Fate, with two aphorisms. 1926–29. Pen and ink on notebook paper, 34.5 × 24.5 cm. Archives I–D

Right:
Spiral and Pyramid. 1926–29. Pen and ink on torn paper, pasted on cardboard, 39 × 24 cm. Signed at bottom and dated. Archives I–D

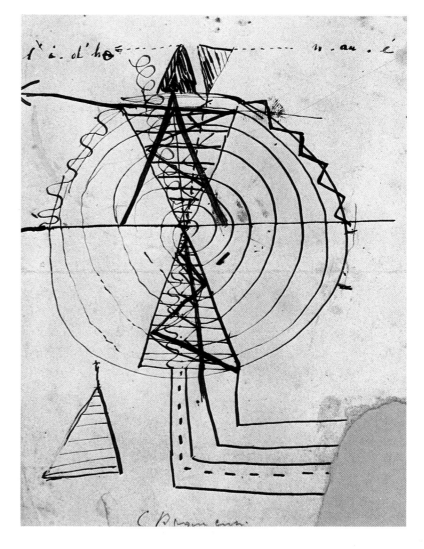

Poster for "L'Art Français
Moderne," Antwerp, 1926.
Archives I–D

Far right:
Brancusi, Irene Codreanu, and
Fernand Léger at a street fair, 1962.
Archives I–D

Estimated expenses for show at
Brummer Gallery, New York, 1926.
Archives I–D

1926, aliens in your circumstances do not have the right to the extension provided for in said statute." The eviction was to take place on January 1, 1927, but the management expressed its willingness to grant the tenant temporary use of the premises subject to review of the statutory rent. Though preoccupied with this problem, Brancusi got sidetracked by an exhibition of French art in Antwerp and another one-man show in New York. He failed to answer the owner's letter, and the printing firm threatened to take the matter to court. Again, no response from the sculptor; a process server then handed him his eviction notice on July 29. On October 25, back in New York for the second time that year, Brancusi wrote to the management, which gave him until July 1, 1927, to vacate the premises. Certainly the landlord's letters and actions did not make life any easier for him.

The "Exhibition of Modern French Art" in Antwerp ran from May 15 to June 20, and the artist attended the opening-day banquet.

Was Brancusi planning to go to Rumania once he got back from Belgium? We know that in Rome the Maroli Company issued a voucher on May 23 made out to "Signor Brancusi, Constantin" good for one fare from Naples to Constanţa on May 27. But his second trip to the United States was already in the offing. On June 20, Steichen sent a telegram advising him that Eugene Meyer intended to buy Bird in Space for four thousand dollars. Could Brancusi himself bring it to New York? Certainly, since Joseph Brummer, Paris representative of the Brummer Gallery in New York, had sent him a *pneumatique* requesting urgently to see him, followed by a letter:

"I've just received a letter from The Brummer Gallery in

New York informing me that your exhibition will take place around the 15th of October next.

"It is imperative that you be in New York by that date. In fact, if I were you, I'd leave September 1 so that you have time to make preparations for your exhibition."

Before sailing, Brancusi drew up a list of expenses he was likely to incur, and by September 13, his sculptures for the show were on their way to New York, with Marcel Duchamp as "chaperon."

Brancusi had sailed on September 1, as advised, leaving the studio in the care of his friend Marthe. In his haste, he had forgotten his glasses, but not Steichen's dog, Stoor, which he had been instructed to bring along to the United States. Someone on board took a snapshot of the two of them, and he sent a print to Marthe. She noted, "You *do* look like emigrants in the photo, really rather woebegone."

After checking in at the Brevoort, he received a letter from Duchamp confirming arrangements:

"Dear Morice,[21]

"Nothing's changed. I sail on the *Paris* on the 13th. Your sculptures and frames are aboard the *Paris*, but as freight, that is, the charges will be a good deal lower and it will be easier to clear customs in New York. The consular invoices are filled out and customs has been cleared.

"Morand's preface enclosed herewith. I made a few minor changes in the English. I'm bringing along a complete package of photos. Before leaving I'll see Marthe and ask her what she sent you. Today I got the 24 × 30 lens at Demaria's.

"Everything is going very well.

"If you can, take some pictures before I get there so that

the catalogue can be done promptly.

"Tell Norton[22] to meet the boat if he can, but I won't have anything of importance to get through customs when I come ashore since the crates won't be delivered until the following day.

"So long, dear Morice. I can't wait to leave.

"Paris is daft.

"Do be careful, with the temperature and all.

"My fond regards to the Sheelers and everybody.

Marcel Morice"

But things were to go awry. While the sculptures were clearing customs in New York, the expert whose job it was to inspect incoming goods refused to let the bronze *Bird in Space* pass duty-free. "It's a work of art," they assured him, "it is not subject to tax." But the expert, who was himself a sculptor, would not give in. "It's an ordinary piece of metal; you've got to pay on it." A protracted lawsuit would ensue, and it generated a great deal of publicity. (In late December, after returning to Paris, Brancusi wired Duchamp, who was still in New York: "Protest customs strongly. Gross injustice.")

The artist spent nearly three months in the United States. His one-man show at the Brummer Gallery (27 East 57th Street) ran from November 27 to December 15. The catalogue included seven of the sculptor's aphorisms and an introduction by Paul Morand, of which this is an excerpt:

Bird in Space. 1925. White marble. National Gallery of Art, Washington, D.C. Photo Brancusi (Cat. no. 153). The sculpture was unfinished at the time; Brancusi is just visible at left.

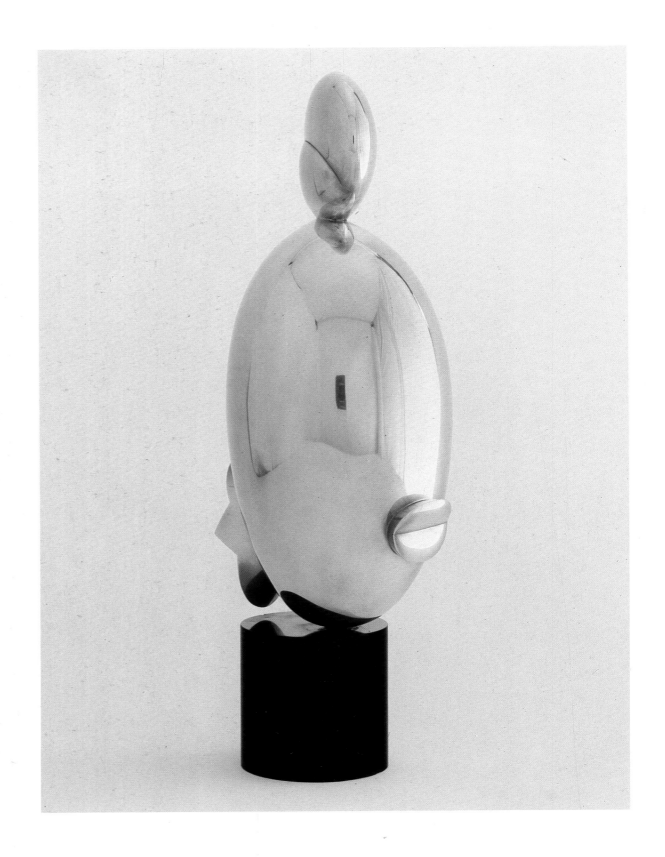

Blond Negress I. 1926. Polished bronze. San Francisco Museum of Modern Art (Gift of Agnes E. Meyer and Elise Stern Haas). Museum photo (Cat. no. 160*b*)

Catalogue of Brancusi show, Brummer Gallery, New York, 1926. On this copy Brancusi noted his prices. Archives I–D

EXHIBITS

1	Child's Head (bronze)	1910	300	
2	Maiastra (marble and stone)	1912	18,000	
Soldé x 3	Caryatid (old oak)	1915	500	
4	The Kiss (stone)	1908	800	
5	New Born (marble)	1915	600	
6	Prometheus (marble)	1911	600	
7	Child's Head (wood)	1913	800	
8	Penguins (marble)	1914	1,200	
Soldé 9	Chimera (old oak)	1918	600	
10	Yellow Bird (marble)	1921	800	
11	Torso of a Young Man (walnut)	1922	600	
12	Torso of a Young Girl (onyx)	1918	800	
13	Fish (colored marble)	1922	600	
14	Fish (polished bronze)	1926	500	
15	Portrait (marble)	1916	1,500	
16	Base (old oak)	1920		
17	Adam (old oak)	1921	1000	
18	Eve (old oak)	1921		
19	Mlle. Pogany (polished bronze)	1920	800	
Soldé 20	Golden Bird (polished bronze)	1919	800	
Soldé 21	Torso of a Young Girl (onyx)	1922	800	
x 22	Prodigal Son (wood)	1915		
23	Socrates (old oak)	1923	800	
Soldé 24	Mlle. Pogany (marble)	1919	1,200	
x 25	Portrait (polished bronze)	1916		
26	Bird in Space (marble)	1923	2,500	
x 27	Blond Negress (polished bronze)	1926		
Soldé 28	Cock (walnut)	1926	600	
29	The Chief (walnut)	1925	1,000	
x 30	Bird in Space (marble)	1925		
31	Column Without End (old oak)	1918	1000	
32	The Beginning of the World (marble)	1926	800	
x 33	Bird in Space (polished bronze)	1925		
34	Cup (wood)	1920		
35	Child's Head (gilded bronze)	1917	600	
36	New Born (polished bronze)	1926	600	
Soldé 37	Bird in Space (yellow marble)	1925	2,000	
38–42	Five Bases			
43	Painting	1916	300	
44–70	Studies	1910-1916		
			150 – 100 – 75	

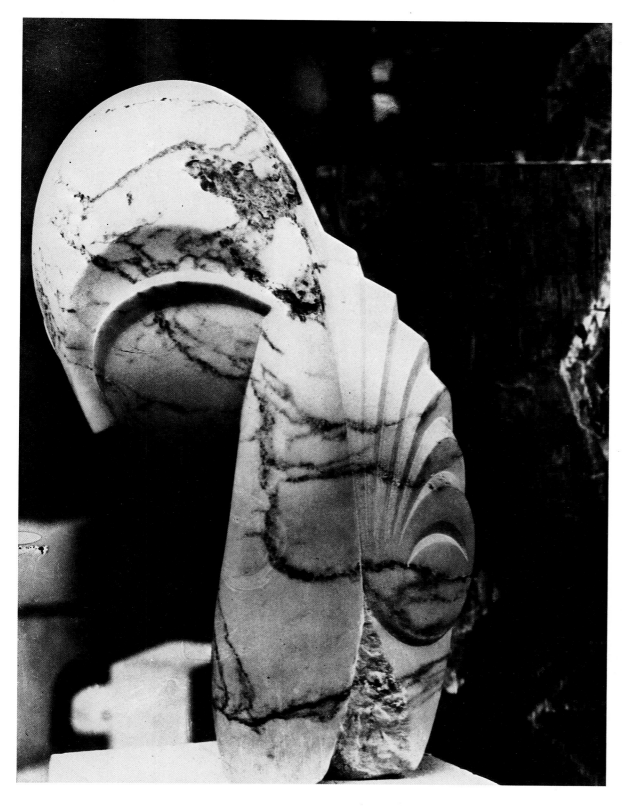

Mademoiselle Pogany II. 1919. Veined marble. Collection Mr. and Mrs. James W. Alsdorf, Winnetka, Illinois. Photo Brancusi (Cat. no. 110)

"There are two kinds of simplicity. One is the sister of ignorance, the other of intelligence. The sister of intelligence is complexity itself; the sister of ignorance is at the same time stupidity itself."

Brancusi boarded his ship and notified Marthe that he would be arriving at the Gare Saint-Lazare, while Duchamp stayed behind in New York to attend to the Brancusis soon to be shown in Chicago. On December 12, he assured Brancusi that the Brummer exhibition was gaining momentum.

"Dear old chap,

"No letup in the show's success. Still lots of people. The catalogue is selling. We've topped 150 dollars.

"This Wednesday Lévy will decide whether he intends to buy *White Bird*. Several customers have not yet reached a decision about *Little Torso* or *The Newborn*.

"Got a letter from Miss Rouiller in Chicago; she is very pleased and is getting things ready for a January 4 opening. I'm having catalogues printed for Chicago.

"*Stieglitz is not taking the fish*, even for 500 dollars. He wrote me a very nice letter explaining that he doesn't feel he can afford it. Too bad.

"Saw Mrs. Rumsey, who has finally *made up her mind*: She wants you to make a bronze *Bird* like Steichen's for 1,500 dollars. What's more, she's taking the *Torso* she had picked out for 800 dollars. So, as far as payment goes, you'll get 800 dollars from her and 700 dollars from me. (That way, she gets back her 1,500 dollars, partly in money, partly in work.)

"Work and send it to her.

"To avoid trouble with customs, I'm going to ask her to have the *Bird* shipped to a port other than New York (probably Philadelphia).

"We're closing the exhibition Wednesday, and the pieces will be on their way to Chicago two days later. Brummer wants to open a painting exhibition on the 16th.

"No reply from Los Angeles, but it didn't cost us any time.

"Enclosed is a letter from an 'artist' who would like you to see his works—of no importance.

"You'll be hearing from me again soon. Keep on writing to the same address: 111 West 16th Street. My mail will be forwarded to Chicago.

"Fondly,

Marcel"

"...Here we are with Brancusi at the extreme pole of purity. The satisfaction we experience before his art is of a quality already so immaterial that, though we owe it to the senses, it is to the spirit that we offer thanks.
September, 1926"

Meanwhile, Mrs. Rumsey had made a studio available to him, and Brancusi was doing some work. He also took time to reply to the Gillian Service, a press agency that requested photographs and expressed its intention of running an article on him in a newspaper chain. At the invitation of the Theatre Arts Institute, he attended a dinner at the Hotel Astoria presided over by Otto H. Kahn. Then, Mrs. Eugene Meyer asked him if he would like to spend some time at her place at Mount Kisco, near New York. The sculptor not only took her up on the invitation, but personally set up a bronze she had purchased (*Blond Negress* I) and played the violin at a party given in his honor.

Brancusi was now in the habit of jotting down his thoughts in French every day.

"I did not come to America to make a bundle, as the good people thought—the road to emancipation."

"America is a land of make-believe. They all believe in money. We believed in a princess and prince who didn't do anything, and that's why they're not around anymore."

"America is on the move. It starts out with the indispensable. Europe started with the superfluous, which stands in the way of progress."

"What we call civilization is nothing but maintaining an order that the masses need or make necessary."

"Meyer's attorney, Moulton, told me that the customs matter would turn out all right. He is taking care of it and keeping me posted."

Brancusi wired instructions: "Advisable take crates with you. Leave big bases and Arensberg sculptures Rumsey studio. Bring negatives."

On the 31st, Duchamp sent Brancusi a complete rundown of his financial standing with Brummer.

"Happy New Year!
"I'm leaving tomorrow for Chicago; the exhibition opens the 4th, closes the 18th.
"The crates will be opened in my presence Sunday, and Steichen's *Bird*[23] is among them.
"After trying four or five times to get Brummer to advance you the money from your sales, I had to give up. He is writing you a registered letter (by the same mail boat), and with that the total amount is immediately negotiable if you pay 10 or 11%.
"I did that in case you needed it right away. If you don't you can wait until Mrs. Hare and Horter pay.
"Brummer is taking 10% over 4,000, which is very reasonable, and today he even told me that he might not take anything.
"I saw Mrs. Rumsey two or three times. The commission for the bronze *Bird* like Steichen's is firm. And she is also taking the onyx *Torso* she picked out for 800 dollars.
"So, when the bronze *Bird* gets here, I'll write and ask her for the 800 dollars in addition to the 1,500, and I'll pay you the 700 difference.
"Would you please find out whether this *Bird* can be sent through the port of Baltimore or

Philadelphia (what company will take care of that?)
"I'll be sending you the address of a Philadelphia friend of Mrs. Rumsey's who is willing to accept the *Bird* on her behalf, which would avoid problems with customs in New York.
"The article in *Dial* is coming out January 15.
"I had the painter [Yasuo] Kuniyoshi take some pictures of the Brummer show; he takes decent shots for 20 dollars. I didn't approach [Charles] Sheeler about it. Write me about Sheeler, I'll go and find out what's what before I head back to Paris.
"Am leaving for Paris around February 15. I had 250 catalogues made up for Chicago. I'll bring some back to Paris.
"I've been invited to stay at the Racquet Club in Chicago. Here is my address until January 20:
"'Marcel Duchamp, Racquet Club, 1361 North Dearborn Street, Chicago Ill.'
"So long, dear friend, you'll be hearing from me again soon.
"Here is the receivables total as of January 1, 1927:

Sales at Brummer's:
Bird, Mrs. Hare 2,000
Cock, Mrs. Horter 600
 ——————
 2,600
Less 10% commission
to Brummer — 260
 ——————
 2,340
With Brummer's letter, this amount is negotiable in Paris.
Bird, Rumsey 1,500
Advance expenses
paid out by you
in New York 190.15
Round trip New
York, as agreed 500
 ——————
 [$]4,530.15

"The catalogues for this exhibition sold out promptly."

In addition to these major shows in the United States, the artist took part in two Parisian exhibitions: the Salon des Indépendants at the Palais du Bois (*Sculpture for the Blind*) and the Salon des Tuileries (*Endless Column*, wood, and *Little Bird*, colored marble). Four invoices from the Fonderie Coopérative des Artistes indicate that several bronzes were cast this year: three 20-kilogram pieces on April 10, nine special castings on May 14, and three special castings on June 2 and July 22.

The currency of France was in a bad way at the time, so De Waleffe organized an auction to stabilize the franc. Foreign artists donated their work as a way of expressing their gratitude to France for her hospitality. On October 26, Brancusi, though not present, had a white marble sculpture valued at 12,000 francs (*The Newborn*) sent to the so-called Salon du Franc. On October 29, it was sold at the Musée Galliera to Rolf de Maré for 7,000 francs. (*The Newborn II* is now in the Moderna Museet, Stockholm.)

Proceeds from the sale were deposited in the Caisse des Contributions Volontaires, and Brancusi received an official letter of thanks from the chairman of the Fund, Marshal Joffre. During the auction, however, the Surrealists made their disapproval known and the police had to step in. *Le Nouveau Siècle* reported the incident in its October 30 issue:

"Incident at the Salon du Franc. Some young men intent on preventing the sale of Futurist works.
"Paintings exhibited as part

Pen-and-ink drawing on gilded cardboard, each 28.5 × 22.8 cm. 1926. Archives I–D

of the Salon du Franc were auctioned off yesterday at the Musée Galliera. At two o'clock the hall was filled to capacity, and Mr. Loir-Dubreuil, Esq., proceeded with the bidding, which was fairly high.

"It looked as though everything would go off without a hitch when, about four o'clock, a volley of hisses from the back of the hall greeted a work by the Rumanian sculptor Constantin Brancusi.

"The police stepped in at once and took the seven young men to the station: Roland Tual, Breton André[24], Eugène Grindel, Félix Jacques, Perret Victor, Unik Pierre, Prévert Jacques.

"The aforementioned stated that their intention had been to protest the presence of works by Futurist artists like Picasso, Brancusi, etc., at the Salon du Franc. After their identification was checked, the protestors were released.

"Now it is our turn to hiss these unruly young men for whom the rules of art are as arcane as the laws of hospitality..."

Other newspapers, such as *Liberté* and *Le Petit Journal*, reported the incident with the same censure.

"Two incidents took place during the sale, one caused by a troublemaker who called Van Dongen's *Anatole France* 'filth' and had to be ejected from the hall; the other when they called out the name of the sculptor Brancusi, whose white marble sculpture of a head went for 7,000 francs. Sustained hissing, and shouts of 'Down with Brancusi!' rang out for a good ten minutes, after which silence was finally restored. H.R." (*Liberté*, October 31, 1926)

"The sale of modern paintings organized by Monsieur de Waleffe took place yesterday in the main hall of the Musée Galliera. The proceeds were to help in the recovery of the franc. All of the paintings were donated by foreign artists who are living in France and saw this as an oppertunity to show thanks for her hospitality. Messrs. Loir-Dubreuil and Schoeller, Esq., donated their services and, like all those who worked with them, gave unstintingly of themselves to make sure the event would be a success.

Brancusi's studio, 8 Impasse Ronsin, c. 1926. Readily identifiable: **The Chief** (Cat. no. 148), a **Torso of a Girl,** a bronze **Fish, Little Bird** (Cat. no. 152), **The Crocodile** (Cat. no. 149), two **Birds in Space, Endless Column** (nine modules), and the winepress screw. Photo Brancusi

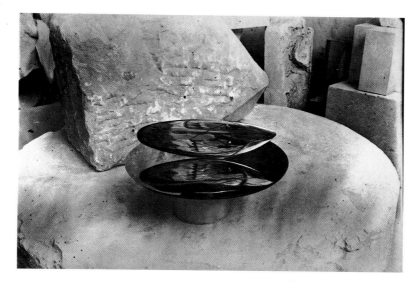

Fish. 1926. Polished bronze. Photo Brancusi (Cat. no. 161)

"The bidding started. There was an incident at the very outset of the session. A Brancusi sculpture was on the block. This artist does not have the good fortune to meet with the approval of *Messieurs les Surréalistes*, who turned out in force to make their displeasure known. There was shouting and hissing; the police had to step in. Seven of them were arrested and escorted to the Chaillot station where—we need hardly tell you—they were not detained for very long." (*Le Petit Journal*, October 30, 1926)

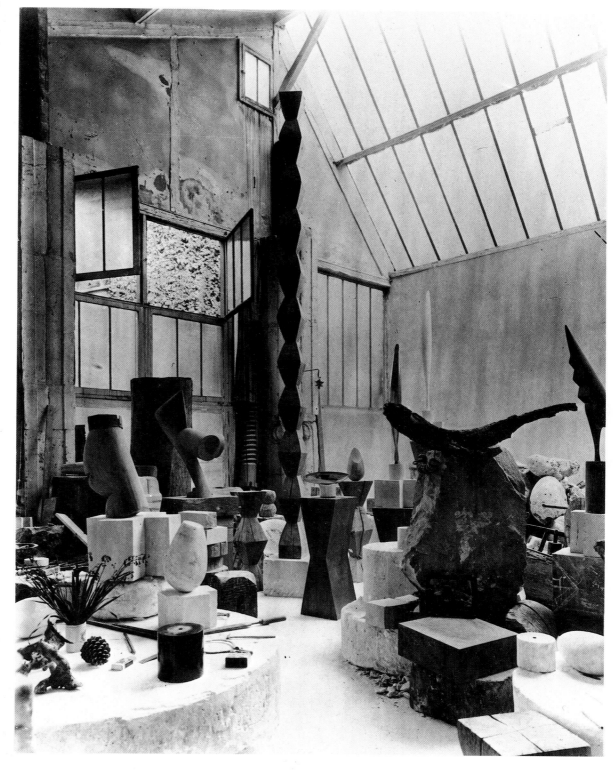

ce n'est que de l'esprit qu'on peu être réalement positif

des choses matérielle ou n'est que le gar...

provisoir

1927

Writing from Chicago, Marcel Duchamp shared his first impressions of Brancusi's one-man show at the Chicago Arts Club with the sculptor in a letter dated January 4:

"Opening today—big success. The room [is] quite large, 13 m. by 7 m. [$42\frac{1}{2}$ by 23 feet], specially hung with grey canvas as [it was] at Brummer's.

"Everything got here in good condition: I did my best to display things in groups.

"In the middle, Steichen's *Bird*; at either end, *Golden Bird* and *Maiastra*; and, between Steichen's *Bird* and *Golden Bird*, the *Column*.

"I arranged the rest around these four focal points. The effect is really satisfying; I'll send you some photos.

"We may be selling *Golden Bird*, which I set at 2,000 [francs].

"There has been interest in the drawings—the catalogues are selling.

"Am here until end of exhibition (18th)—I'll leave for New York on the 19th.

"In New York write [to me at] 111 West 16th Street.

"Arts Club footing all my bills here.

"I'm staying at a comfortable club and saving money.

"The Racquet Club, 1361 North Dearborn Street, in Chicago.

"If you need to, cable before the 20th.

"Fondly, and you'll be hearing from me again soon.
Marcel"

"Chicago, January 23, 1927.
"Dear old chap,
"Chicago [exhibition] over yesterday. We extended [it] four days as it was scoring, if nothing else, a moral success.
"We sold *Golden Bird* to the Arts Club for 1,200 [dollars] and

two drawings for 100 and 150: one to Mrs. Porter, one to Mr. Arthur Heun.

"Deduct 10% from those prices. I'll deposit the 225 dollars for the two drawings in your bank Wednesday or Thursday.

"I'm going back to New York tomorrow. I'll monitor the packing, and I think everything will go as smoothly [going back] as it did coming out.

"Expenses here—food, lodging—paid for. I'm pleased with the outcome because lots of people who liked certain things will buy in Paris.

"Mrs. Carpenter is in Egypt.

"I'm going to see Brummer so he'll decide if there's anything he wants [to buy] or hold on to, and I'll do everything I can to get Mrs. Rumsey to buy the column.

"Will write you.

"Not sailing from New York before February 26.

"Send the Morices my affection,

"Very Truly Yours,
Marcel"

On January 27, Duchamp sent Brancusi an update on the matter concerning U.S. Customs in New York:

"New York, January 27, 1927.
"No sooner was I back in New York than I found out that the American government is insisting on the 200 dollars for Steichen's *Bird*.

"I saw Steichen and we agreed to file a protest. We are retaining Speiser, who came to see me yesterday and will be pursuing the matter legally.

"There is no charge for filing the protest, which is standard procedure, except for services rendered by Speiser. (I think he'd be delighted to do it all for nothing.)

"In any event, I think you'd better hold off sending Mrs. Rumsey's *Bird* until a decision

has been handed down concerning Steichen's *Bird*.

"All the crates from Chicago—12 crates—arrived in New York in good condition—at Mrs. Rumsey's.

"Yesterday I deposited 225 dollars in your bank for the two drawings sold in Chicago.

"Brummer would like to hold on to *Torso of a Girl*, which he plans to sell, and I'll try my best to get him to hold on to *Maiastra*, too.

"I'm going to inquire about having the 12 crates transported 'slow goods service,' which would be a considerable savings.

"In the meantime, I'll do all I can to sell the *Column* to Mrs. Rumsey and one or two things to Miss Dreier.

"Fondly,

Marcel"

Here is Brancusi's reply:

"Paris, February 7, 1927.
"My dear Duchamp,
"I got your letter of February 23 at the same time as the notification from Downing and Co. I cabled you to protest strongly, for it is a gross injustice.

"Customs labors under the delusion that all of the *Birds* I showed in New York are all the same and that only their titles differ. To put an end to this misconception we would have to exhibit them all together in public—only then will they see the mistake [they've made]. Then they'll realize that it's the outgrowth of legitimate work, that my purpose was not to turn out mass-produced goods for a profit.

"As for the sculptures you are bringing back to Europe, I think it would be much better for you to bring them back with you, because on freighters they'll get damaged by the dampness and all the vibration they'll be subjected to; or they could get lost, and then they wouldn't get here until months

after you do. If worse comes to worst, you can, in any event, leave the big bases and *Endless Column* in the Rumsey studio. Come what may, take the most delicate ones with you: *Fish, Child's Head, Mlle Pogany.* If *Maiastra* is not staying at Brummer's, you could leave the big stone [base] in the studio, as well as the mirrors and bases the *Fish* were exhibited on.

"Leave Steichen one of the X-shaped bases for his bird and the cross-shaped stone or any other he may like better. If Arensberg hasn't come back yet, leave his sculptures in the Rumsey studio with a tag on them. Ask Sheeler what he's planning to do about paying for *Torso.*

"I got Brummer's letter for the discount; I'll write and thank him—give him my kindest regards."

February 12: another letter from Duchamp:

"Dear old chap,

"Got your cable—and the matter is in Speiser's hands. I saw him, and he's seeing to it that all the necessary protests are filed. Between Steichen and him, I think the odds are that everything will turn out all right.

"The protest we are filing is a standard legal procedure that takes place every day, and the plaintiff often wins.

"All of the crates are back from Chicago, and I am putting *Maiastra* and *Penguins* in the warehouse. The only thing Brummer wants to take is *Torso of a Girl,* which he is going to sell.

"In addition, Stieglitz has put me in touch with a Mrs. Wertheim, who intends to buy something. I'm to see her day after tomorrow.

"Mr. Hekking of the Buffalo museum [Albright Art Gallery] asked me to send *Mlle Pogany* to the exhibition that is opening on the 25th. He has hopes of getting someone to buy it for the museum in Buffalo [successful].

"Mrs. Rumsey isn't taking the *Column* after all. I pestered her about it, and she turned me down flat. All I can do is leave the *Column* and its stone [base] in the Rumsey studio.

"I also left the big wooden base and the white cross-shaped stone [base] with Steichen for his *Bird;* the other base is at [Julien] Levy's.

"That way, I'll have only 7 or 8 crates aboard with me when I sail on February 26.

"Therefore, I shan't be writing to you between now and when I arrive, unless something important comes up.

"Don't send the *Bird* to Rumsey before I get back; it's more prudent, and she's in no hurry.

"Fond regards to the Morices, and see you soon.

Marcel"

On February 26, Duchamp boarded the *France* for the return trip to Paris.

On June 8, Brancusi received an invitation to the wedding of Marcel Duchamp and Lydie Sarazin-Levassor, along with the following letter:

"Very sorry I didn't find you in. Would you care to come to the ceremony tomorrow at noon at the Temple de l'Etoile on Avenue de la Grande Armée? How about all of us—Picabia and Germaine, Lydie, Marthe, you, and me—getting together at your place tomorrow at 7? Don't reply if that's all right with you. Marthe can come to the ceremony, if that strikes her fancy."

And that's what they did.

The sculptor was beset anew by housing problems. Come July, he would have to vacate the studio he was currently renting at No. 8 Impasse Ronsin. Most uneasy, he got Duchamp's permission to rent in his name a studio at No. 11. On June 28, he took the further precaution of purchasing a property on Rue Sauvageot in the 14th arrondissement.

"The contract hereinbelow was submitted to Mr. Lesguillier, Esq., and Mr. Lefebvre, Esq., notaries, in Paris, on June 28, 1927. La Foncière de la Seine, Inc., with offices at 63 Blvd Haussmann, Paris, has sold to Mr. Constantin Brancusi, sculptor, a Rumanian, residing at No. 8 Impasse Ronsin, Paris, a parcel of land located at No. 18 Rue Sauvageot, Paris, and the structures situate thereon."

Payment for the land was made in several installments to the notary between 1927 and 1931.

Brancusi's relationship with Marthe motivated him to provide the young woman with a place of his own design and making, where she could feel secure and he could work relaxed. In those days, artists were encouraged to settle in the Montparnasse district. Braque was already living on Rue du Douanier, Léger on Rue Notre-Dame-des-Champs. Not far from the housing project where Gauguin once owned a studio, and a stone's throw from Henri Rousseau's former studio on Rue Perrel, Brancusi set about providing his sculpture, and the woman he loved, with a place where harmony would reign supreme. There was no containing his enthusiasm; he found it impossible to sleep, jotted down ideas for building his retreat, talked to friends about his plans. At one point, he contemplated having the studio Stei-

chen had put up in Voulangis relocated to his property on Rue Sauvageot, but he decided against it. He got in touch with an architect and building contractors, and an unfortunate turn of events provided added incentive.

As it extends downward from Rue de Vaugirard, Impasse Ronsin used to slope gently between the studios on either side of the cul-de-sac. In rainy weather, the runoff would collect here and there, forming pools of standing water. In the summer of 1927, a violent cloudburst unleashed a veritable flood that left a big hole right in the middle of the beloved studio Cocteau had described in *Le Peuple* (Brussels, May 18, 1926).[25] That was the *coup de grâce.*

"What a disaster for our poor cul-de-sac," wrote one of his neighbors, Mariette Mills. "I'd be very glad to let you use my studio."

For his part, the landlord insisted that Brancusi vacate the premises. "...This morning," he wrote, "we noticed new cracks that could have adverse effects on the soundness of our building, in which you are a tenant." In effect, the landlord was relieving himself of all responsibility toward the artist, and he followed up with another letter on October 25: "Since July 1, we have not claimed any rent because it was agreed that you were going to move, and after the ground settled we sent a registered letter advising you that continued occupancy of your studio was unsafe.... But since the present condition of the Impasse prevents you from moving your stone blocks [anyway], we shall not ask you to vacate the premises until work on the pavement is finished."

"Sir," Brancusi wrote back, "if you have the right or need to put me out of the studio and lodgings I occupy at No. 8 Impasse Ronsin, would you kindly do so without asking my permission..."

"I went to see the *Endless Column* at Voulangis yesterday," Roché wrote on October 24. "Superb." Since Steichen had vacated his place in Voulangis, Brancusi wanted to salvage the 23½-foot-high sculpture he had set up in the garden back in 1920. One morning, he went there with Man Ray, who took a picture of *Endless Column* before it was moved. Here is how he described the operation in his memoirs:

"A rope slung about his waist, Brancusi climbed up the *Column,* and when he got three-quarters of the way up, he wrapped another rope around one of the notches and let the ends of it fall to the ground.

"Then he made his way down to a point from which he could saw through the middle of the *Column.* The cut was so perfectly horizontal that the upper part stayed right where it was. Once he was back on the ground, he fastened one end of the rope to a tree and the other end to another tree directly across from it. Up he went again. This time, he secured a third rope to a point slightly above the spot at which he had sawn through the column. When he got back on the ground, he gave the third rope a tug, thereby dislodging the upper part of the column. Since it had been secured to trees on either side, it fell gently to the ground without sustaining the least damage. The lower part still had to come down, but that presented no difficulties; he simply sawed it off flush with the ground."

Before heading back to Paris with Man Ray, Brancusi left the caretaker in charge of transporting the column to Impasse Ronsin. This was easier said than done. It took no fewer than seven men to load the truck, and two horses to move it. Even though the distance was not great, the driver did not reach Paris until the following day.

Around this time, Pierre Loeb

Studio plan for 18 Rue Sauvageot. 1928. Pencil on cardboard, 23.2 × 16.7 cm. Archives I–D

Studio plan for 18 Rue Sauvageot. 27.5 × 42 cm. Signed at lower right. Archives I–D

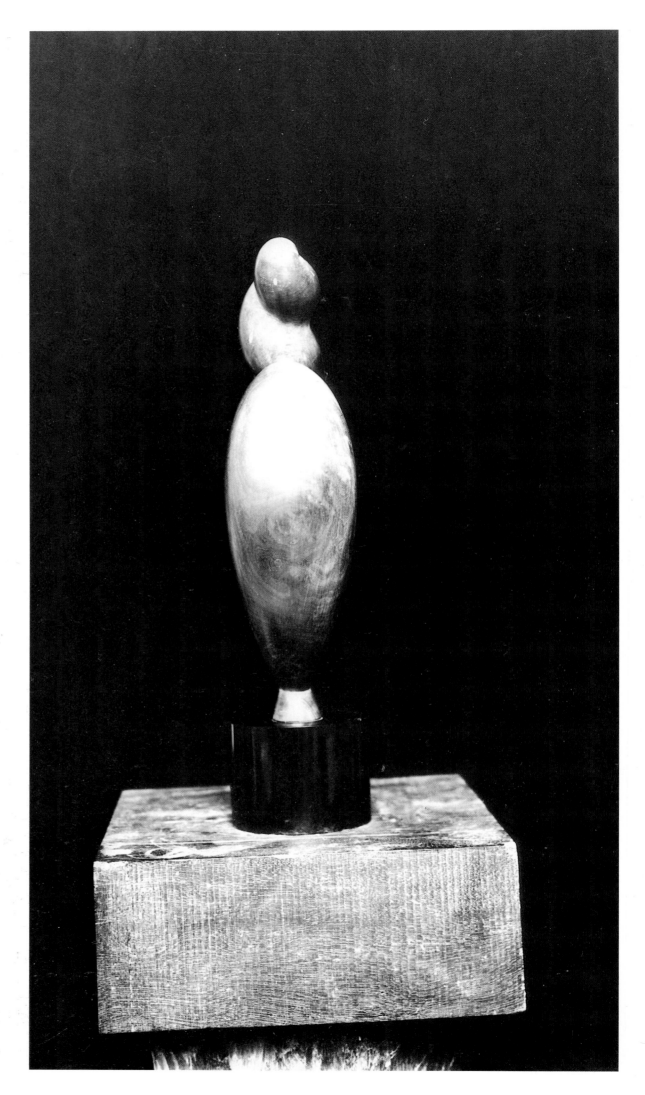

Portrait of Nancy Cunard. 1927. Wood. Collection Mrs. Marcel Duchamp. Photo Brancusi (Cat. no. 164)

approached Brancusi about showing his work in his Galerie Pierre in Paris, but the sculptor was preoccupied with moving and turned the offer down. The exhibition never took place. One day in the 1950s, Loeb knocked on the door of our studio on Impasse Ronsin. "Do you know me?" he asked. We said that we did, as we had met him in his gallery on varnishing days or when he visited Max Ernst. (Ernst had by then come back from the United States and owned a studio near ours.) He looked at our paintings, chatted awhile, and mentioned that he had stopped by one day to see Brancusi. "I yanked the cord that sounded the gong in his studio. Brancusi opened the door. 'Do you recognize me?' Brancusi took a good long look at me. 'No,' he said, then he slammed the door in my face."

The artist hated it when people dropped by unannounced. "You don't come into my place as though it were a tavern," he told us. "I put in a phone so that people can give me advance notice."

In April, Brancusi exhibited *Leda* at the Salon des Tuileries in Paris. Then came a visit from Mrs. Anlus-Hestermann and her husband to select works for "Europäische Kunst der Gegenwart," an exhibition being hosted by the Hamburg Kunstverein. In early July Brancusi sent *The Kiss* (stone), *Fish* (polished bronze on disk), and *Chimera* (wood). Then a Mr. Charlet, who ran the Brussels gallery, Le Centaure, approached him about exhibiting work on October 10 or thereabouts.

In October, R. Carpenter, president of the Chicago Arts Club, thanked Brancusi for his gift of a drawing that he described as "a perfect companion for the *Golden Bird* which the Club bought early this year." On the 25th, Anastase Simu, the prominent Bucharest collector, bequeathed his museum to Rumania and sent Brancusi a catalogue bearing a dedication to him. (The Simu collection included Brancusi's bronze *Portrait of Nicolae Dărăscu* and his first direct carving in marble, *Sleep*.)

From December 1 to December 15, the Bernheim Jeune Gallery in Paris exhibited work by a group of sculptors—Gargallo, Laurens, Zadkine—and three guest exhibitors (Brancusi, Despiau, Maillol). Tériade wrote the introduction. "Your *Fish*," Bernheim wrote on December 16, "was the chief attraction of my exhibition, and I am grateful to you for having helped to make it a success."

On December 8, the Dutch periodical *De Stijl* requested three photographs for an upcoming special issue: *Princess X* (marble), *Sculpture for the Blind*, and a photograph of the artist.

On December 30, Brancusi received a letter from Ezra Pound that bears quoting:

"I had the displeasure of receiving the news that some son of a swine in New York made you pay Customs for your sculpture.

"The newspaper said that 'he,' the swine, said that it was metal, not art.

"I had little hope of giving them a good swift kick, but I did manage to spit in the department's face, and the department, the revenue people, that is, the sub-underling of the secretary of the paper-pusher who attends to these matters, has promised me a review [of the case].

"And also that he would 'grant' you every possible consideration the law currently allows. Could you provide me with the date (when you went through Customs), or the number of the receipt indicating payment, or even the name of the representative (if any) who acted on your behalf.

"Please reply, because such an outrage must not be allowed to occur without impunity. Besides, if you do go back, it would be better for the underlings to treat you decently.

"Sincerely yours,

Ezra Pound"

"Please give me all the particulars you recall."

In 1927, Brancusi received extensive coverage in the press. There was an article by Albert Dreyfus in *Querschnitt*, a Frankfurt periodical, and another (with nine plates) by the same author in *Cahiers d'Art*.[26] Dreyfus asked the artist some questions concerning his work and art in general. At one point Brancusi exclaimed, "Art—but there hasn't been any art yet. Art is just beginning." "*The Newborn*," Dreyfus noted, "is nothing but an ovoid relieved by two or three flat surfaces at the most. And *Beginning of the World* is nothing more than an egg. What emotion can works like these elicit? Through them there arises a primeval yearning for eternity. Expressed in sculptural terms, it will move any person for whom art is more than a distraction for the eye and entertainment for the mind."

In addition to several articles in France and Belgium, there was a spate of stories on Brancusi in the American press. Some newspapers devoted full-page spreads to the case of Brancusi *vs.* U.S. Customs, complete with his picture and photographs of his work.

An invoice issued June 3, 1927, indicates that Brancusi paid the Fonderie Coopérative des Artistes 2,200 francs to cast a *Bird in Space* measuring $72\frac{7}{8}$ inches high.

In addition, Bridanet and Co. delivered two smoothed and polished circular disks.

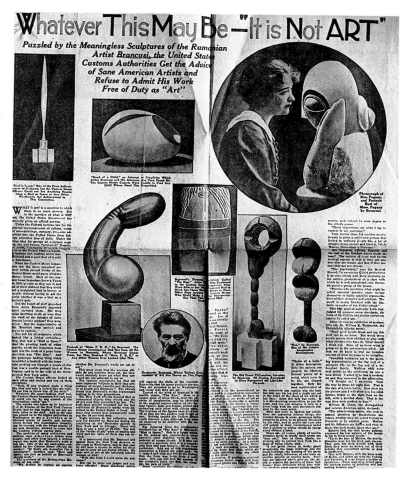

Two pages from *America*, March 13, 1927

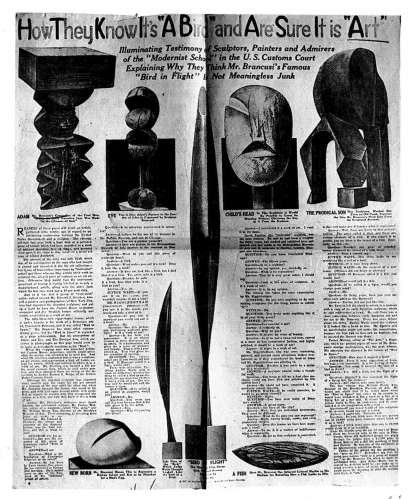

1928

On January 1, Brancusi officially became the lessee of the studio at No. 11 Impasse Ronsin. Now that he had access to another studio (courtesy of Mrs. Mills) as well as a rental in Duchamp's name, the problem of accommodations seemed behind him for the time being.

He signed another lease on April 1 and a third on February 11, 1930. His landlord was Alfred Boucher (1850–1934), a traditional sculptor who had worked for the Paris Exposition Universelle in 1900. (Boucher also started the *Ruche* in Vaugirard that was home to such famous artists as Modigliani, Soutine, and Chagall, and built on a vacant lot on Impasse Ronsin a pavilion, thirty-odd studios, and a studio known as *La Chapelle*—all amid shade trees and ornamental flowerbeds that made for a pleasant place to go for a Sunday stroll.)

With the move behind him, Brancusi wasted no time setting up his forge. More than an essential tool for shaping pieces of iron into armatures for his sculpture, the forge now awakened in him an urge to work with metals on an everyday basis: this is when he turned out pieces like *Sign* and *Chimney Hook*.

News about his dispute with U.S. Customs came in the form of a letter (January 12) advising him to pay the duty, then to initiate proceedings in the courts. To substantiate his claim that *Bird in Space* was a work of art and not merely an object manufactured of metal, Brancusi as the plaintiff had to satisfy three requirements of proof under Paragraph 1704:

1) That it was not an object of utility.

2) That Brancusi was a professional sculptor.

3) That the bronze was an original sculpture. (The last

point was readily established, since it was a first cast and thus an "original," not a "reproduction," under the law.)

The United States government called on two academic sculptors, Robert Ingersoll Aitken and Thomas H. Jones, as expert witnesses on its behalf. Testifying for the plaintiff were Edward J. Steichen, painter and photographer; Forbes Watson, editor of *The Arts*; Frank Crowninshield, editor of *Vanity Fair*; William H. Fox, director of the Brooklyn Museum; Henry McBride, art critic for *The Sun* and *The Dial*; and the sculptor Jacob Epstein.

Brancusi was not in New York during the trial, but testified in writing that he had made the object in his studio in Paris during the years 1925–26. The concept was entirely his own. It was an original work of art.

"I fashioned it myself with my own two hands from the raw bronze casting. I alone came up with the idea for the subject of the bronze, and I alone created it. The question of determining whether or not the bronze is original does not even arise, because it is the only piece of work I have ever done on this subject, and the first copy has not yet been finished.

"I solemnly declare that no similar bronze exists; the bronze I sold is the original."

Nor, he went on, had he made the original version of the subject in question in wood or marble; he had finished the original—the only one on this subject in existence—in 1926. "There is no reproduction of any kind, in any medium. I am presently working on the first copy in bronze. Ever since the piece was cast, all of the work has been done by no one but me, with my own two hands, and the polishing was done by me and by hand. No polishing machine or any other kind of mechanical device was used."

The government's experts

countered with arguments based on personal evaluation.

"For me, the piece arouses no aesthetic pleasure. As I see it, it is not a work of art" (Robert I. Aitken).

"I do not feel it is a work of art because it is too abstract and constitutes an abuse of the normal form of sculpture" (Thomas H. Jones).

It took two years and a voluminous brief to establish that *Bird in Space* was indeed a work of art, not a piece of metal subject to a duty of two hundred and ten dollars. At one point, the sculptor was advised to drop the suit; but he persisted, convinced that the legitimacy, not only of his ideas, but of modern art in general, hung in the balance. The decision in his favor brought him even more celebrity.

Brancusi sent a letter to his friend and attorney, Maurice Speiser, to back up his statements:

"Pursuant to your letter of March 2 to Duchamp and my cable of the 17th, I am writing this letter to confirm that the bronze in question, entitled *Bird in Space*, is an original and completely separate work. It is not a copy of any other bird subject I have done up to now. The same subject, *Bird in Space*, shipped to Steichen's address and which I exhibited at the Wildenstein Galleries in 1926, is also an original, likewise produced separately. It has neither the same form nor the same dimensions...

"I got your cable of the 17th, and I am pleased."

On November 30, attorney Charles J. Lane sent the following letter from New York:

"Dear Mr. Brancusi,

"I am sure that by now you are aware of the court's decision regarding your statue *Bird in Space*.

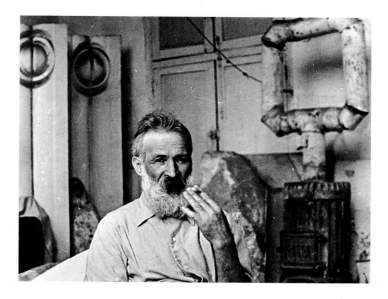

Self-portrait in the studio, 1928.
Photo Brancusi

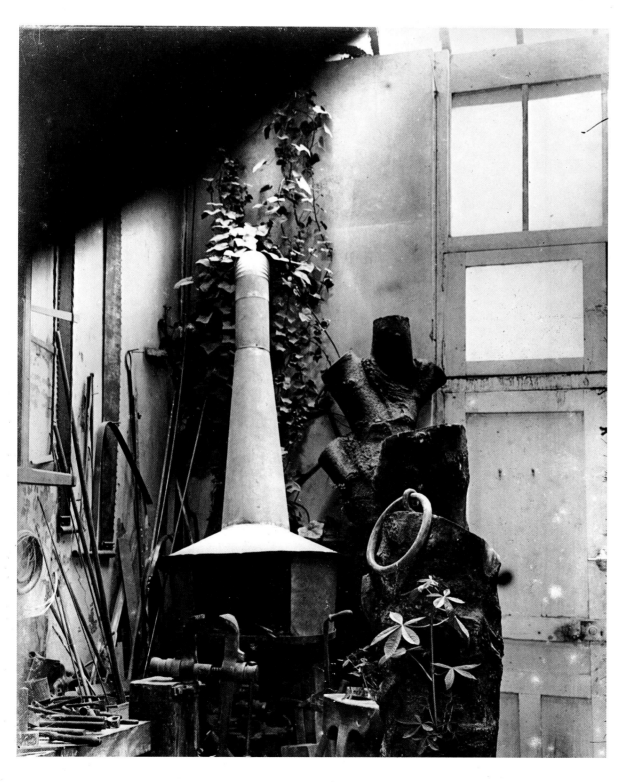

Sign. 1928 (?). Wrought iron.
Collection Istrati–Dumitresco (Cat.
no. 169)

Brancusi's studio, 11 Impasse
Ronsin, c. 1937, with forge, anvil,
vise, treetrunk with young shoots
and an iron ring. Photo Brancusi

"You will also be pleased to learn that an engraving of *Bird in Space* is appended to the decision, so that future casebooks will likewise contain illustrations of your work, an honor which a court of law has rarely, if ever, bestowed on an artist.

"With best wishes, I am, dear sir,

"Very sincerely yours,
Charles J. Lane"

Enclosed was a French translation of the ruling, dated November 26. A few excerpts from Justice Waite's decision follow:

"...there has been developing a so-called new school of art, whose exponents attempt to portray abstract ideas rather than to imitate natural objects. Whether or not we are in sympathy with these newer ideas and the schools which represent them, we think the facts of their existence and their influence upon the art world ... must be considered.

[The Brancusi bronze] is beautiful and symmetrical in outline, and while some difficulty might be encountered in associating it with a bird, it is nevertheless pleasing to look at and highly ornamental, and as we hold under the evidence that it is the original production of a professional sculptor and is in fact a piece of sculpture and a work of art according to the authorities, ...we sustain the protest and find that it is entitled to free entry under Paragraph 1704."

In an interview published in the *New York Herald Tribune* (January 12, 1930), Brancusi conceded that his sculpture having been in the Quinn collection unquestionably worked in his favor.

While the suit was under way in New York, a similar case was making news in Philadelphia. Sturgis Ingersoll, an attorney, bought Brancusi's marble sculpture *Little Bird*. However, as far as U.S. Customs in Philadelphia was concerned, it was a machined object and came under the heading of industrial goods subject to a duty of fifty percent of intrinsic value. Ingersoll paid the four hundred dollars but recovered the entire amount once the outcome of the New York case was known.

As the following letter indicates, Duchamp was living in Villefranche-sur-Mer, and here he got Brancusi to visit him in 1928:

Little Bird. 1928. Polished bronze. The Museum of Modern Art (Gift of Mrs. William A. M. Burden), New York. Museum photo (Cat. no. 166)

"Dear Morice,
"Weather here absolutely delightful: as warm as you please on the terrace from 8 in the morning to 4 in the afternoon. At night I go to bed under a mosquito net and I sleep quite comfortably. All right, a *few* mosquitos come in the evening before I get under the net, I confess. But with the citronella and above all the mosquito net for sleeping, life is very pleasant. You ought to plan on coming down.

"There is a room on the same floor as the terrace, and you could live there without being disturbed.

"The rest of the house is downstairs. You would feel completely at home.

"I strongly advise you to come.

"Gallina sends her regards, and I my affection.

Morice"
"La Marguerite, Route Nationale, Villefranche-sur-Mer."

In August, while Brancusi was taking the waters at Aix-les-Bains, Duchamp, who was spending some time in the Jura Mountains (Les Rousses, on the Franco-Swiss border), returned the favor.

"Les Rousses, August 23, 1928.

"Dear old chap,

"Well, now, since you're staying until September 2, we are planning to come to Aix-les-

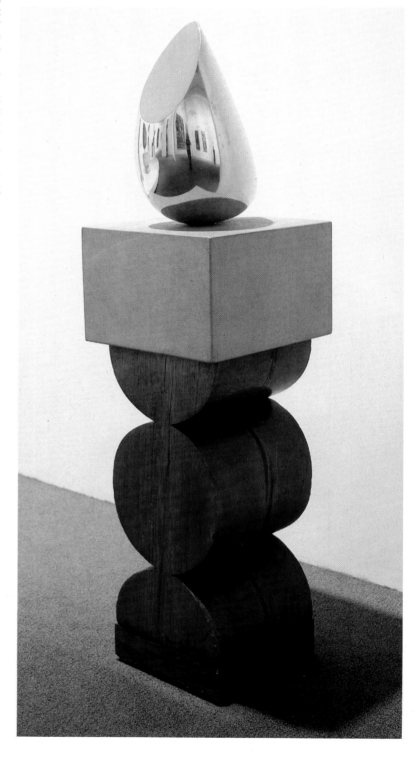

Bains the evening of the 1st to spend two days with you. We could all go back to Paris together on the 4th, if that's all right with you. Send reply in the next mail. With affection from both of us,

Morice''

''Give me the rates of your hotel (room and board, like you, I imagine).''

But the major event of 1928 was an exhibition in Moscow (May 1–June 30) organized by the Academy of Arts and Sciences and sponsored by Edouard Herriot and Lunacharsky, the People's Commissar of Public Education. The purpose of the exhibition, which subsequently traveled to Len-

ingrad, was to make known the most highly qualified representatives of French art. One of the two drawings that appear on this list was to remain in Moscow (letter from Francis Jourdain, March 29, 1932).

On October 13, 1928, Brancusi received a note from the Billiet Gallery in Moscow. ''In light of the exhibition's success, we request permission to exhibit in Leningrad the works you have loaned to us.'' This would mean a two-month delay in getting them back to France, but the sculptor agreed. ''I give my consent for my works to be shown in Leningrad, provided they be insured against all risks.'' These assurances were given.

However, Brancusi turned down an invitation to take part in the sixteenth ''International Exhibition'' in Venice. And in March, the Rumanian city of Sibiu sponsored a competition to build a monument to Ferdinand I, the father of Rumanian unification; with Brancusi's dislike of competitions, he refused to take part.

In May, Brancusi's *Bird in Space* was shown at the Salon des Tuileries. Louis Vauxcelles wrote in *Excelsior*, ''This bird is a kind of long copper cigar, meticulously polished and set upright on its tail, precariously poised on a pile of paving blocks. Apparently, North America is wild about objects of this sort. I fear for Monsieur

Brancusi that in the land of Houdon, Rude, Barye, Carpeaux, Rodin, Maillol, and Despiau he will remain an unsung hero!'' A truly insightful critic!

In June, Kurt Schwitters asked Brancusi if he would like to join a society of avant-garde artists whose membership included Mondrian, Schlemmer, Van Doesburg, Malevich, El Lissitsky, Picabia, Ernst, and Gabo. Exhibitions were being planned.

October witnessed the pre-

The Newborn II. 1925. Polished bronze. Brancusi Studio, MNAM, Paris (Cat. no. 150*a*)

Above:
List of works sent to exhibition in Moscow, May 1–June 30, 1928. Archives I–D

Below:
Study of a Vase. Pencil, sepia, and ink on paper, 10.4 × 9.4 cm. Private collection, France

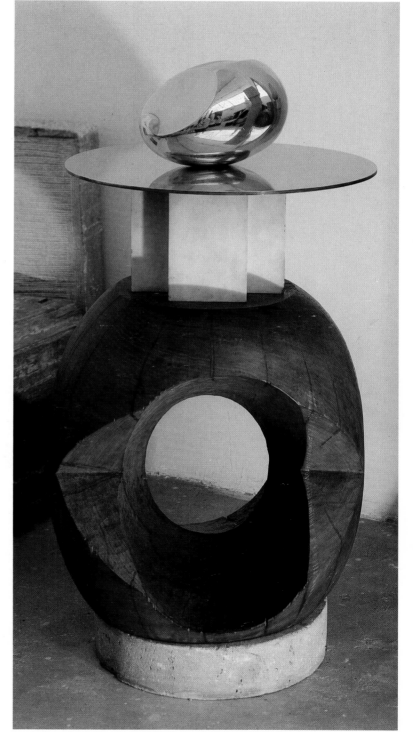

sentation of some of the sculptor's work at the Tinerimea Artistică in Bucharest. There were also letters from the writer Michel Georges-Michel, who requested a line drawing for a reissue of his novel *Montparnos*, and from Julio González, mentioning his mother's death. (González, the Spanish sculptor in metal, was a close friend of Brancusi's, and several times he had helped him with his work.)

A Russian sculptress, Vera Mukine, asked for permission to visit Brancusi's studio. He must have acquiesced, since later she asked when she might pick up the photographs of his sculpture that he had promised her.

March 27: Fèvre and Co. delivered a block of semi-fine soapstone (2.25 meters) for 380 francs.

June 13: Horstmann and Co. issued him an invoice for a 110-volt Black and Decker sander/polisher for 2,332 francs, as well as invoices for thirty-five disks designed for use with the machine.

July 3: the Paul Girod Steelworks issued Brancusi an estimate for stainless-steel disks of hot-rolled P12 steel, to measure 500 mm (19⅝ ins.) in diameter and between 4 and 5 mm. (⅕ in.) thick.

This year, *XXᵉ Siècle*, a magazine published by G. de San Lazzaro, featured Brancusi's *Endless Column* on one of its covers, and Carola Giedion-Welcker visited the sculptor for the first time. Carola and her husband, the writer Siegfried Giedion, were to become his close friends in the years ahead.

Coalburning stove (boiler plate,
h. 18 cm.) on base (stone, h. 19 cm.),
with accessories, 1928 (Cat. no. 225)

Opposite page:
Little Bird II. 1929. Colored
marble. Brancusi Studio, MNAM,
Paris. Photo Brancusi (Cat. no. 171)

188

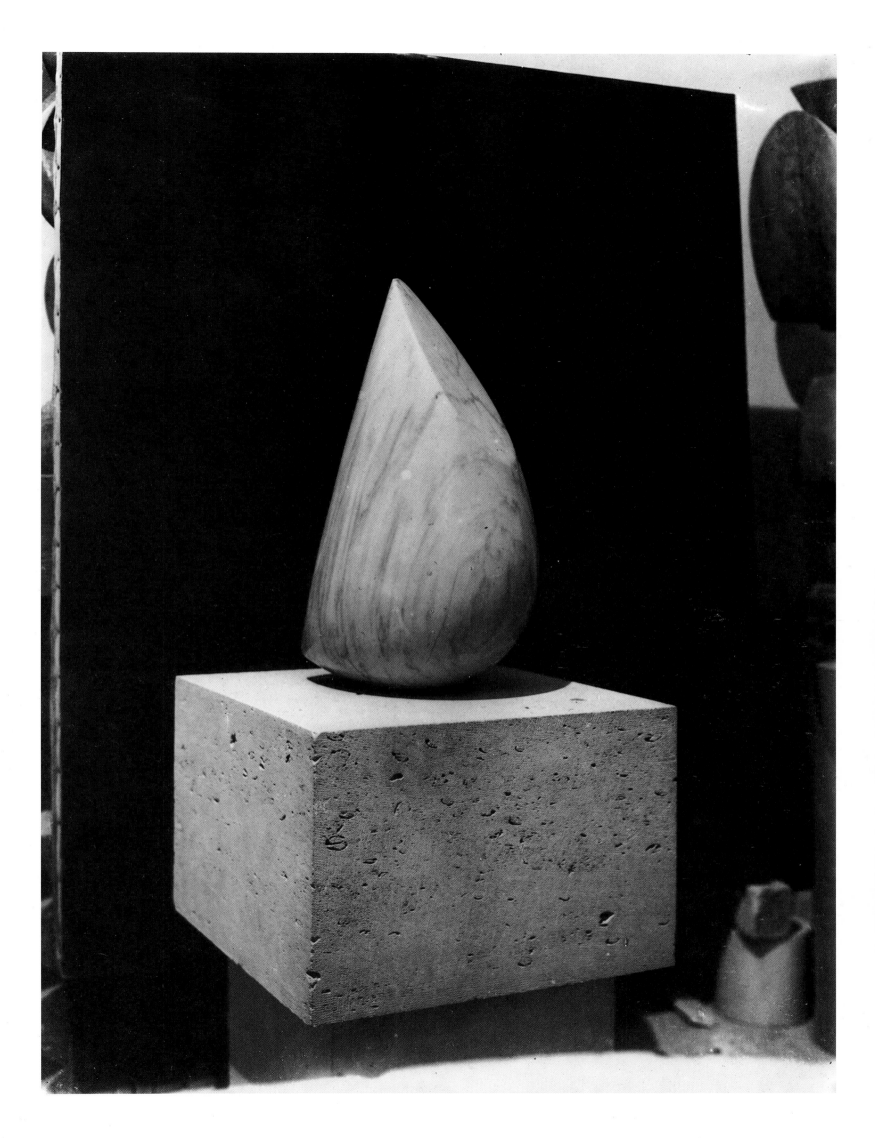

1929

James Joyce had heard from his friends John Quinn and Ezra Pound about Brancusi and his work, so one day he paid the sculptor a visit in Impasse Ronsin, asking if he would be willing to draw his portrait for reproduction in a book. Not speaking the same languages, they had some difficulty understanding each other; nevertheless, Brancusi obliged with several sketches and an abstract drawing, a spiral and three vertical lines. The writer chose that one for the frontispiece of *Tales Told of Shem and Shaun* (Brancusi's name was imprinted in a deluxe edition).

The sculptor then transposed the abstract drawing into three-dimensional form: a round piece of cardboard 30 inches in diameter, with a slit for the radius and a hairspring at the center (see p. 196). By Brancusi's own account, it was a portrait of Joyce's writings rather than of the writer himself. But his two abstract portraits set tongues wagging just the same. "My God," Joyce's father said as he contemplated the portraits, "how my son has changed." Stories about how Brancusi "made" eggs were already going the rounds of the studios; now word was out that he was drawing portraits with three straight lines.

Brancusi's dissatisfaction with professional photographic services prompted him to take the processing of his pictures into his own hands.[27] He hit upon the idea of positioning his new darkroom outside, against the outer wall of the studio and jutting into the courtyard. First he built a low wall about four feet high and fastened poles on this to support a roof of corrugated iron. Between some of the poles he put in windows, filling in the remaining spaces with square plaster slabs. From the main stu-

dio to this darkroom there was direct access, the entrance concealed by a yellow curtain. Inside, the darkroom was divided into two rooms and lined with plywood painted black.

In the room with the windows, a carpenter helped Brancusi install wooden shelves for the countless glass-plate negatives, printing blocks, cameras, lenses, and other photographic equipment that acids, stored in the other room, might corrode. The two rooms were separated by a light-proof door. Brancusi also put shelves in the darkroom proper, where he lined up the basins for developing and fixing prints on a work table. The sculptor himself secured to the ceiling and wall a very tall enlarger, which took up the entire back of the room; made of wood (as devices of this sort were back then), the bellows when fully extended were approximately six feet high. (The lenses he used with it were a 21-cm. Carl Zeiss Tessar 1:4.5 and a Jul. Laack Söhne 4.5f-150 mm.)

Processing photographs requires a constant temperature, so Brancusi fashioned a narrow stove out of thick boiler plate, placed it on a stone base, and ran a flue pipe the length of the room. This gave an even, comfortable warmth. One problem remained unsolved, however: a pipe that drained rainwater from the roof of the main studio ran through the inside of the darkroom, and it was forever springing leaks. After we moved to Impasse Ronsin, we often had to fill in the cracks. With every storm, the runoff would drench the darkroom and damage the negatives; we would find them mildewed, sometimes ruined.

Brancusi, to our astonishment, had always seemed to know ev-

Portraits of James Joyce. 1929.
Three sketches, one of them
abstract. Archives I–D

erybody's comings and goings, the exploits of the concierge, and other courtyard happenings. As we worked in the darkroom, we found out how. He had scraped away a tiny area of paint at eye level, and watched from inside without being seen.

A hardware store near the Impasse stocked photographic plates, photosensitive paper, film, developing and fixing solutions, a dryer, and other paraphernalia. If the many invoices from this store are any indication, Brancusi was a photography enthusiast who bought all manner of equipment: a projector, a still camera, a bellows-type enlarger, a 16.5-mm. Voigtländer Killinear 1:6.3 portable camera with cassettes for small glass-plate negatives, and a 16-mm. movie camera (later a 35-mm. model) for photographing nonstationary sculpture.

In August, Brancusi, feeling poorly, went to Aix-les-Bains to take the waters. Marcel Duchamp telegraphed him on August 27 that he was on his way to see him, but the same day Dorothy Harvey, sister-in-law of the writer Joseph Delteil, wrote Brancusi with an invitation to the château in Mouans-Sartoux (Alpes-Maritimes). The sculptor visited her after his cure at Aix-les-Bains, and while there he met up with the Picabias, then living nearby in the Château de Mai in Mougins.

Brancusi sent *Torso of a Young Man*, a *Cup*, and an *Endless Column* to "Abstrakte und Surrealistische Malerei und Plastik," an exhibition that opened at the Kunsthaus in Zurich on October 6. We know from a letter (Flechtheim to Brancusi, October 22, 1929) that the Pottier firm also packed *Sleeping Muse* (plaster), the onyx *Torso of a Girl* II, and a stone sculpture for shipment to "Seit Cézanne in Paris," an exhibition in Berlin from November 13 to 23, 1929; organized by Alfred Flechtheim, it featured watercolors, drawings, and sculpture by the most important early twentieth-century artists. Brancusi also took part in both the Salon des Tuileries and the second "Exposition de Sculpture Internationale" at the Bernheim Jeune Gallery (*Little Bird*, colored marble). In the fall, he sent the pen-and-ink drawings he had done for Ilarie Voronca's *Plants and Animals* to the "Black and White Exhibition" in Bucharest. But he declined to exhibit at "Der Schöne Mensch" (Darmstadt) and, despite two insistent letters, at the

Portrait of Agnes E. Meyer. 1929. Black marble. National Gallery of Art (Gift of Eugene and Agnes E. Meyer), Washington, D.C. Museum photo (Cat. no. 179)

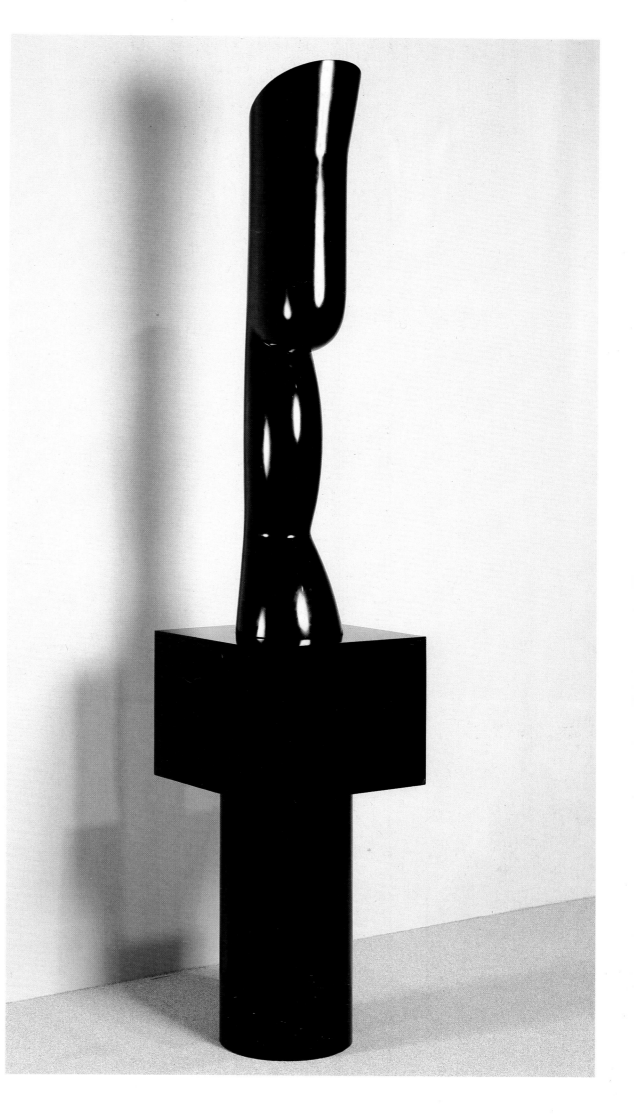

opening of the new Jeanne Bucher gallery. Though offered 300,000 lei to do the Lecca monument in Rumania, he turned this down, too.

The European director of Pathé News approached the artist about filming him in his studio. Brancusi, who could not bear to have photographs or movies taken of him, categorically refused.

Some of Brancusi's remarks were published in *Cahiers d'Art* under the title of "Brancusi, Propos de l'Artiste," which was followed by a fourteen-page study by R. Vitrac with fifteen illustrations.

A major article (with two full-page illustrations) appeared in *Les Cahiers de l'Étoile* (September–October 1929). Here are excerpts from Benjamin Fondane's interesting appreciation of the artist:

"In short, no posturing to speak of. None of the childish conceit of those artists intent on creating idols in their own image, idols so much like them as to be inaesthetic. His stone is the stuff of poetry; his sole purpose is to throw you off the scent, and in so doing, he courts misunderstanding. Brancusi stands aside. He is not in his work. He does not turn out bigger or smaller bearded Brancusis. Is this a mistake? His wood and marble sculptures seem not to express anything human nor to render everyday life. They do not seem navigable: just an upwelling of gentle curves, or an outburst of matter in ferment. I say 'seem' because I do not wish to mislead you or myself. Here, more than anywhere else, beware of appearances. Brancusi's art is an act of protest, an act of violence. The God who created objects, animals, and forms is to be faulted for incredible laziness: Creating the world in six days was really rushing things. With his knife, his saw, and his hands, Brancusi goes back to the creations that were shortchanged. He has already rectified the cock, the bird, and Socrates. For Brancusi is a logician, a passionate logician whom lucidity cannot satisfy and abstruseness does not daunt, who is forever wanting things to be leaner, more concentrated, more ineffable. In his work, movement—compressed, all aquiver, pouting—is ready for immediate takeoff. Even his gloves are fastened with thumbtacks so they don't fly away. 'The transparent glacier of flights unflown': Mallarmé had Brancusi in mind when he wrote that line of verse. Never do we find in his work the grimace of an unresolved angle, never a staircase leading nowhere. Who taught this peasant from the Danube the rules of his game—one which allows him to make

child's play of discovering the limits, the expressive maximum, of an art that has been groping for self-definition for thousands of years?

"Brancusi's purity would make birds sob, if they were not made of painted canvas. Some may mistake it for conceit, or for modesty: it is neither one nor the other, but both at the same time; it is something different. [The French word] *pureté* does not mean *propreté* (implying that it can get dirty), nor does it mean *propriété* (propriety), which is tantamount to *pauvreté* (poverty). Flame, I would tell you that Brancusi is a flame if I were not convinced that he is an alarm clock. Every time I pay him a visit, I feel like a loaded rifle, so astonished am I at seeing him walk about, laugh, smoke, live his day. Next to him, the probing of a Picasso is that of a raving maniac; he stands there, calmly offering bread crumbs even to the stone blocks in his studio, even to the elderly American ladies who come to visit him...

"Starting with stone, Brancusi invents a different kind of stone, nearly the same as what it was, yet terribly new. A new kind of stone, I tell you: bird or Socrates. His is the patience of geological eras. He smoothes out the seams, removes the thread, polishes away every trace of toil, of suffering. The incalculable strength he summons to make it look easy! How else could he elicit joy?...

"Understand that this bird—how much more at home it would look in Place de la Concorde than the obelisk!—understand that this bird—what a tombstone for a great poet (Apollinaire)!—understand, I say, that this bird is neither a concept nor a symbol nor an allegory of anything whatsoever; no more a statue of Joy than of Sorrow; no more something that sustains than something that misleads; no more an anguished reproach than a futile lament. Don't go looking for a lesson; a prognosis would be objectionable, diagnosing matters of the mind even worse. It is nothing more than the image of a naked, featherless Brancusi who speaks neither Rumanian nor French, not in the least a sculptor or stamp collector, as plain as he can be: no affectation, no tie, just poised there as though defying Chance, taunting Randomness, as serious-minded as the mounted policeman at Place de l'Opera, as pure in his intentions as a guardian angel.

"Yet, the work of Brancusi is not just a cleverly formulated question; it is an answer, pure and simple...

"Brancusi is a great artist of the 'religious' variety. He acknowledges no brethren save the primitives, the artists of

Gothic times, the Africans. I know what is 'finite' about this kind of art; but I know what is 'infinite' about it, too. There he is at work—that work of the mind which comes before that of the hands. Not that he is unhandy or clumsy, not in the least; he is versed in the stuff of what he handles and avoids gaps or loose ends. Yet, this, too, may just be a case of leaving things to chance. You see, Brancusi works without ulterior motives, without mapping out specific objectives, without doing *this* or *that*. His is not a *deliberate* art. If he manages to stay on track, it is because there's no need for him to choose among alternatives, because he does not give any thought to the act of choosing. The moment he gets down to work—which is to say, every moment of his life—he senses that the dice are cast. There's no point defying chance, so he goes along with it. An irresponsibility of sorts is the lot of an artist of this kind. Since he attaches no importance either to the rules or the vanities of his craft, the craft does his bidding, the rules yield to his will. Needless to say, an artist of the religious variety, so common in times of unshakable faith (and whom Brancusi likens to a slave devoted exclusively to things spiritual), is, in a way, an ichthyosaurus in times of apostasy. To expect of him a simplicity he cannot possess, a nearly total self-forgetfulness, would be asking the impossible. And yet, we have the miracle that is Henri Rousseau. The laws of so-called civilized man were as alien to him as the defects of modern society. Nothing had any hold over this man who did not go looking for what he needed to do, yet somehow discovered on his canvas what he needed to say. That he was an unschooled painter not only did not work against him; it stood him in marvelous stead. I could not say the same of Brancusi: no one could match him for knowledge of 'high fashion.' Yet, for all that skill—skill that has been instilled from without—when he stands before his plaster he is as pure as Henri Rousseau, and as irresponsible.... It will be said that he lived a simple life, like those worthy souls who, for reasons unknown, are canonized three centuries later."

Five Flowers. 1929. Pen and ink on paper, 37.5 × 28 cm. Archives I–D

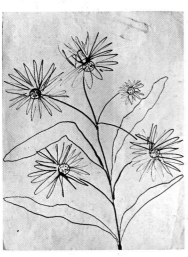

Brancusi's studio, 11 Impasse Ronsin, c. 1929. Photo Brancusi

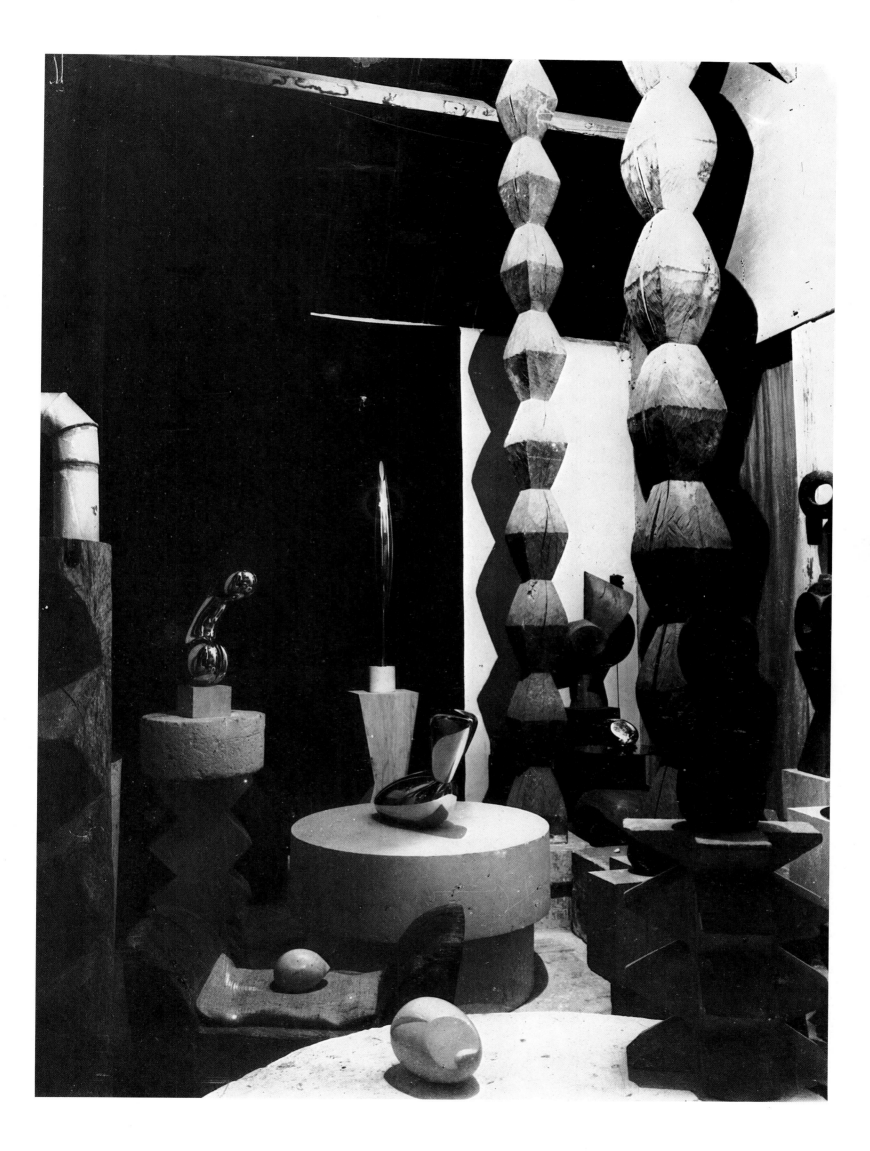

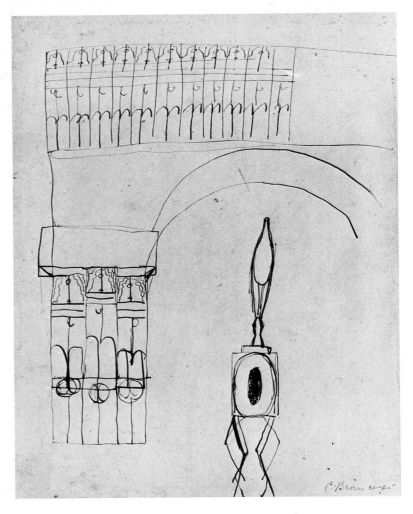

*avec l'arte on sera
Toujour a l A B C
on ne peut jormais
l'aprende que par soi même
et encor
et si on l'aprend
par les autres
on faira des choses
aprisen et a coté
une forme sterile ne
peut pas faire d'enfant*

1930:
Toward Tirgu-Jiu

In this year Brancusi finished a number of important sculptures and began to look ahead to projects of monumental proportions, as if bearing out a profession of faith he had jotted down: "Brancusi does not work to toot his own horn or to flabbergast people. He works out of a need that is peculiar to him and inherent in everyone else.... For we know of no other man more honest, more devoted and attached to those inexplicable, marvelous things that all religions have sought to give us and that lie beyond all artificial joy and sadness."

More and more, the sculptor was approaching his work from an architectural standpoint, as we can see in two especially accomplished pieces from 1929 and 1930: *Fish* (blue-gray marble; length 5 ft. 10 ins.) and *Portrait of Agnes E.* (black marble; height 7 ft. 5¾ ins.). The same may be said of the 23-foot *Endless Column* of plaster inside his studio, where the top module was set into the main beam overhead so that the column seemed to be holding up the ceiling.[28] The curve of the modules was much more rounded than in the *Endless Column* at Tirgu-Jiu.

Brancusi also made a preliminary design for a *Temple of Meditation*, which suggests that he was already in touch with the Maharajah of Indore and mulling over the structure the prince later commissioned him to build. He may have discussed the project with Roché, who had written as follows in 1929: "I shall be spending some time in Corrèze, then Austria, and in December I may go to India. But I'll stop by to see you beforehand so that we can have another nice long chat."

At this time Brancusi made the plaster *Grand Coq* II (height 12 ft.) as well as a near-duplicate in its size and rough surface, *Grand Coq* III, both much taller than their subsequent bronze counterpart (40¾ ins. high) but shorter than the later plaster *Grand Coq* that stood 15½ feet high. "I really must finish these cocks and do them in a durable substance," he would sigh as he looked at them. "They get damaged every time they're moved."

Brancusi was planning to cast *Fish*[29] in both polished bronze and stainless steel. To get an idea of what the finished work would look like, he painted two five-inch-square patches—one bronze, one silver—no longer visible, on the plaster version now in the Musée d'Art Moderne in Paris.

The installation of a telephone in the studio was one of the momentous events of 1930. This meant fewer letters and *pneu-*

Study for **Gate of the Kiss** and **Maiastra.** Violet ink on paper, pasted on cardboard, 53 × 38 cm. Signed in pencil at lower right. Archives I–D

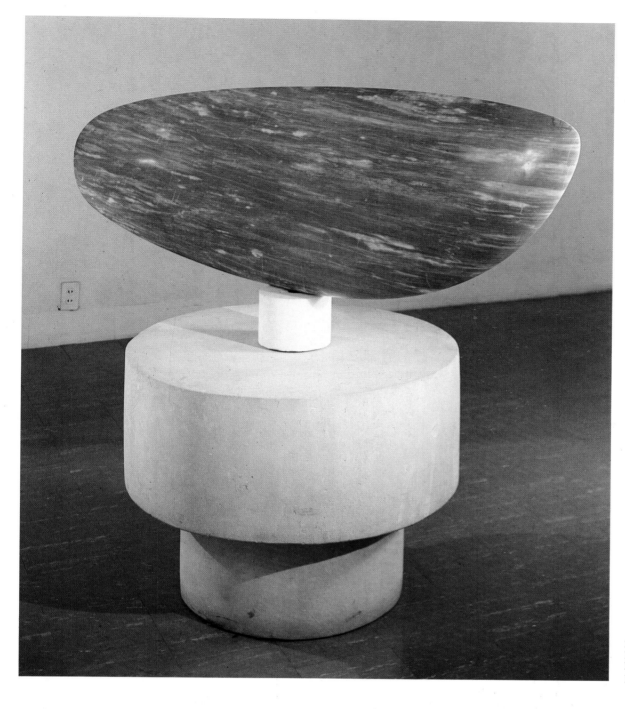

Fish. 1930. Blue-gray marble. The Museum of Modern Art (Lillie P. Bliss Bequest), New York. Museum photo (Cat. no. 181*a*)

matiques to write and receive, but woe to anyone knocking on his door without first letting him know! He even carved a special piece of furniture he called "my telephone chair" (sic) so that he could sit down while telephoning. He had mixed feelings about it: "You become its servant," he said. "It rings for you and off you go." But he was on good terms with the people working for his answering service, and once sent them a bunch of flowers, before leaving Paris. After he arrived at Villefranche-sur-Mer, he got a telegram from them: "The ladies at Ségur (squad A and B) send their thanks for the thoughtful present. The answering service."

On February 11, Brancusi and his landlord signed a lease for an adjoining studio, probably the one that had been in Duchamp's name. He started to make improvements, and in-

stalled two "improved" electric hammers that had attachments for roughing out, drilling, and riveting. How much easier it was to rough out a block of stone, instead of all that work with a maul and point! But the tool was heavy, and holding it soon tired his hand, so he devised a way of suspending it from a rope and attaching a counterweight, making it slide along an iron rod fastened to the studio ceiling.

The sculptor was already using a machine with chamois, felt, and cotton disks to polish his bronzes. He had a liking for tools (especially "improved" models) and was always on the lookout for new ones, buying them everywhere from B.H.V. to the Foire de Paris, with stops at foreign dealers along the way. He lined them up on his hand-made shelves and racks, and pampered them. The feeling of craftsmanship that they gave the

Bird. 1930. Fresco, 29 × 47 cm. Collection Istrati–Dumitresco

studio was an added incentive to work. What might have been drudgery became a delight. "When your work is done, you've got to give the tools a rest so that the next day they'll bid you continue. Otherwise, they'll impart their weariness to

you or get angry." He chatted with his tools and occasionally coaxed them along with a song.

Brancusi also enjoyed both going out and entertaining at home. He was a guest at an *aioli* dinner Darius Milhaud once gave, and Miró invited him with Tristan Tzara and his wife. And it is no wonder that the sculptor ordered two hundred and twenty liters of wine from the Loire, for his flair for cooking was well known and appreciated. He was expert at broiling meat in the fireplace or on the forge while baking potatoes in the ashes. He would seat his guests on handmade wooden stools around a big plaster table covered with a lovely tablecloth. One evening, a guest found him broiling some meat on the forge. "Guess what you're going to eat?" she said to the other guests. "Wrought steak!"

When Brancusi noticed that he was spending more time entertaining than sculpting, he decided to have people over less frequently. But he still found time for visits with his goddaughter, Alice Poiana, whose father was that old friend who had been so helpful when the sculptor first came to France. "Godfather," the teenager asked one day, "why don't you get married?" "Can't you just see me," Brancusi replied, "with a family, with children tugging at my beard and saying 'Papa, don't do this, don't do

that!'" Soon after this, Alice returned to Rumania.

In early July, Philippe de Rothschild paid 25,000 francs for a polished bronze *Bird in Space* (53½ ins. high).

Brancusi spent that August with Mary Reynolds, a friend who had a place in Villefranche-sur-Mer. On September 1, he went to Aix-les-Bains to take the waters; by the 26th he was in Rumania. He departed for Paris on October 6, whereupon the press—Adrian Maniu, to be exact, whose article appeared in the October 12 issue of *Dimineata*—expressed surprise that so famous an artist had not been chosen to restore the Roman ruins at Adamklissí, the town at one end of the great bridge that spans the Danube near Constanṭa. On the day he left the daily *Curentul* carried an interview in which Brancusi stated he would like to erect in one of the squares in the capital an *Endless Column* at least 150 feet high.

In late November, an oculist by the name of Paul Petit prescribed glasses for the sculptor to wear "while working, and to see close up."

Brancusi's stone *Child's Head* and bronze *Maiastra* were included in "Modern Rumanian Art," an exhibition that traveled to The Hague (May 3–25), Amsterdam (June–early July), and Brussels (Galerie Giroux, July 20–August 10).

He received a letter from

Petra van Doesburg [wife of Theo van Doesburg] in Amsterdam:

"My dear friend,

"My mother was quite ill, so I have been very busy. I am sorry you did not come this past Sunday. However, I did see the little room they've promised you, and I would suggest (if it's still there) that you show *Leda*, *Fish*, and two tall sculptures. Write me when you are going to come. My address in Amsterdam is: Haringvlietstraat 69, c/o Van Esteren of the Stedelijk Museum in Amsterdam.

"I'm having a hard time of it with all those men on the Committee!

"See you very soon, I hope.
"Yours truly,
Your Petra van Doesburg"

Marguerite Vessereau, a young French professor and poetess on friendly terms with composer Georges Enesco and other Rumanian celebrities, wrote that year *Roumanie, Terre du Dor* (Les Presses Universitaires de France, Paris, 1930), after an enchanting trip to Rumania. The chapter on Brancusi, entitled "Le Rythme Essentiel," based on her conversations with the sculptor, is a fairly solid recapitulation of his views on his art in particular and life in general.

"An ill-defined interaction of walls, plasters, and marbles be-

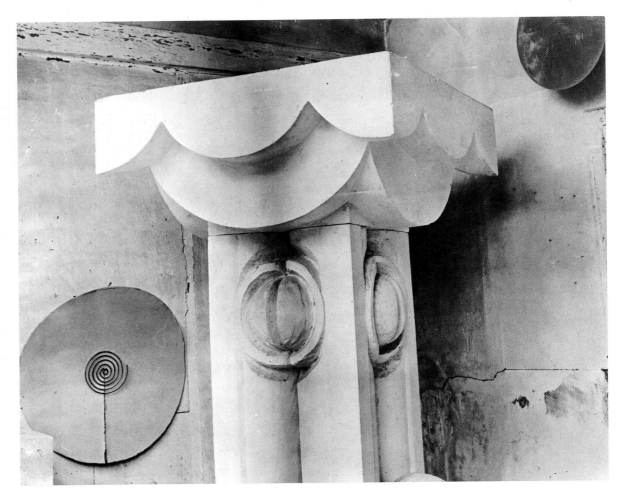

Upper part of **Column of the Kiss** (Cat. no. 183) and **Portrait of James Joyce.** Photo Brancusi

Opposite page:
Plaster Form. 1930. Plaster on wood base. Brancusi Studio, MNAM, Paris. Photo Brancusi (Cat. no. 182)

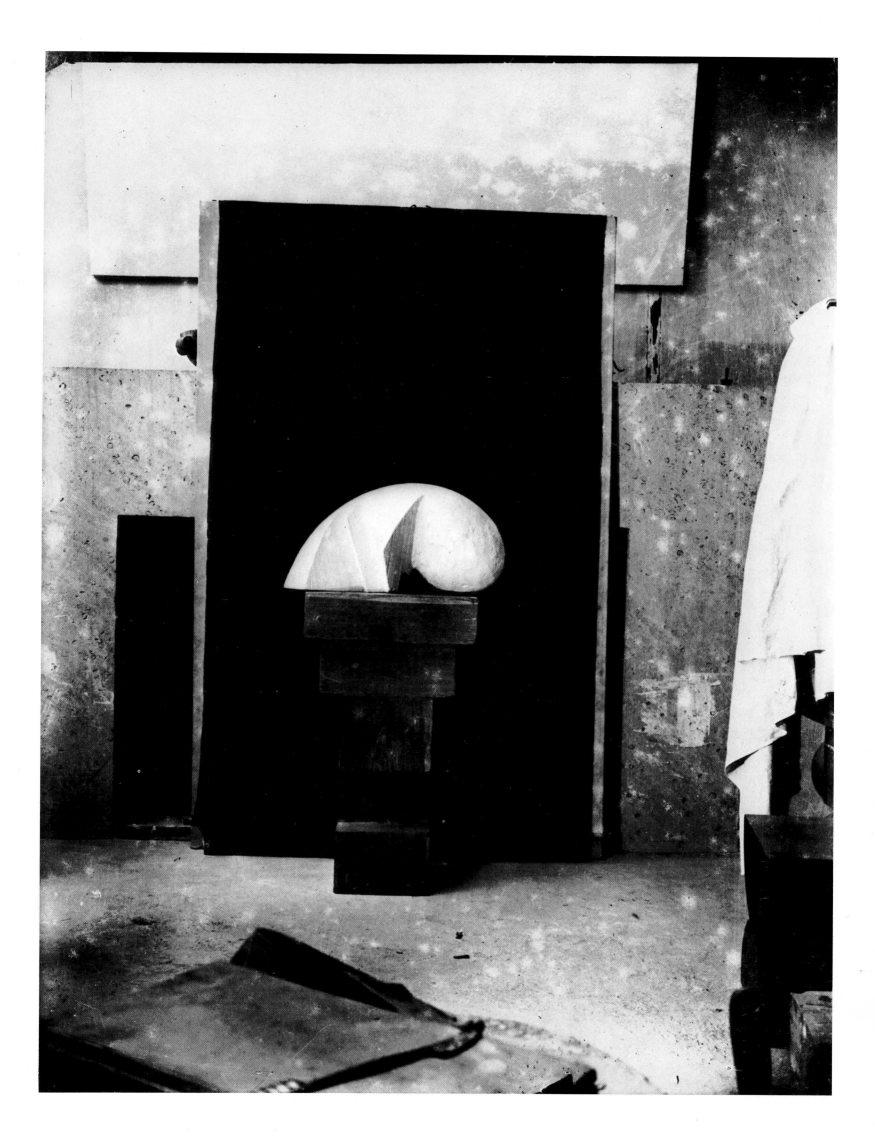

neath the skylight results in a pantheistic affinity that involves each form in all the others. But a few patches stand out: a black curtain in front of a white spindle, two columns of stacked oak octahedrons, some bright yellow cushions, a few copper figures tattooed with reflections. In the rear of the studio, blocks of stone await. 'We're free here, aren't we? It's like being in a quarry. It's nature.'...

"As he seeks primal unity, Brancusi does not deliberately brush aside the particular, which can also be an impulse. For anyone who has probed interacting energies, no force can be dismissed as insignificant; instead, it is a process of subordination. Thus, he subsumes what is distinctive into a synthesized totality. Likewise, a branch is implicit in the bud, because a sprouting bud, swollen with sap, contains its ultimate end. The more abstract the form, the farther removed from particulars, the more it condenses that lengthy gestation which artists experience. As the material is pared to essentials, it evinces

the exertion that is required to create that underlying implication of life, of which [human] consciousness is but the paltry outcropping. This ties in with the concerns of present-day philosophy. This time, however, it's not Rumanian any more. Ethnicity has resolved itself into essential rhythm.''

An invoice issued May 10, 1930, indicates that Brancusi had the Andro Foundry cast two subjects (1,000 francs) and two small finished heads. It is interesting to note that on March 10 he purchased some blue-gray marble (for this year's *Fish*), some black marble, some granite, and some sculptor's marble that he probably used for the *Bird in Space* pieces dating from 1931. He also bought a drill and fourteen square-shaped iron rods to make armatures for plaster sculptures.

An estimate issued this year mentions a concrete column to be set up in Saint-Cloud, proof that Brancusi was still thinking about the project of a column in this medium.

Nocturnal Animal. 1930. Wood. Brancusi Studio, MNAM, Paris. Photo Flammarion (Cat. no. 176)

King of Kings (formerly **Spirit of Buddha**). Early 1930s. Oak. The Solomon R. Guggenheim Museum, New York. Photo Carmelo Guadagno and David Heald (Cat. no. 200)

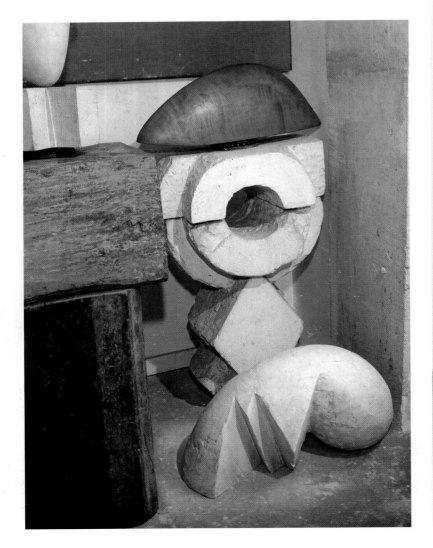

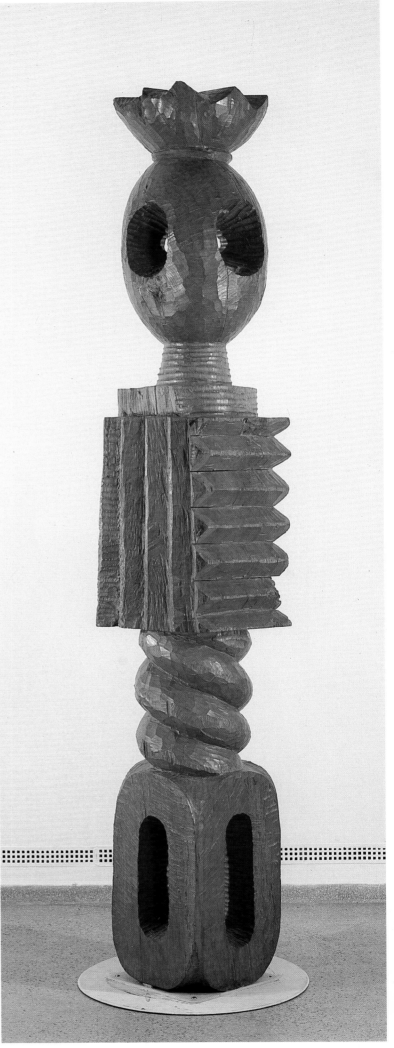

1931

Brancusi's growing enthusiasm for the *Temple of Meditation* brought his ideas for the project into sharper focus. At the very heart of the building he could visualize three versions of *Bird in Space*, in black marble, white marble, and bronze, hieratic sentinels poised around a pool of water inside the temple. (In 1936, the Maharajah of Indore purchased the bronze and black marble versions.)

"The greatest happiness is the contact between our essence and the eternal essence," Brancusi once said, and it is this that the *Bird in Space* series embodies. The spiritual lift that fills these works already raises them to a special place where the Beautiful and the Sacred become one, effortlessly. Did they belong in museums? We say only that Brancusi saw in them a religious power, a magic that he would have wished to see reigning in hospitals, where it could heal the sick.

About this time, the city of Ploesti, Rumania, was planning to erect a fifteen-foot memorial to the writer Ion Luca Caragiali. An old friend of Brancusi's named Tomesco sounded him out about it. Writing in Rumanian, the sculptor replied on February 16:

"I received both your registered letter and the one you sent to me c/o Marbais [Marbé] concerning the Caragiali monument. If I am given a completely free hand, as well as sufficient time, it behooves me to immortalize the spirit of Caragiali. Do you remember how eagerly in the old days we looked forward to the publication of his articles?

"As for the money this project requires, I could not estimate the total amount without first drawing up a preliminary design, and to do that I need a schematic diagram that shows the dimensions of the site and the surrounding buildings."

Regrettably, Brancusi would not create the monument.

Hoepli, the publishing firm in Milan, was planning to bring out a series of books on avant-garde painters and sculptors throughout the world, each volume to include an introduction and some thirty photographs. The publisher intended to devote the first volume to Brancusi. The press service of the Council of State in Bucharest, eager to promote Rumanian art, asked the sculptor for his agreement as well as for the necessary materials.

On February 20, Brancusi purchased his next "improvement" for the studio: a massive Godin stove with radiating plates to heat what was becoming a complex of studios. He

Brancusi's studio, 8 Impasse Ronsin, with the fireplace. Photo Brancusi

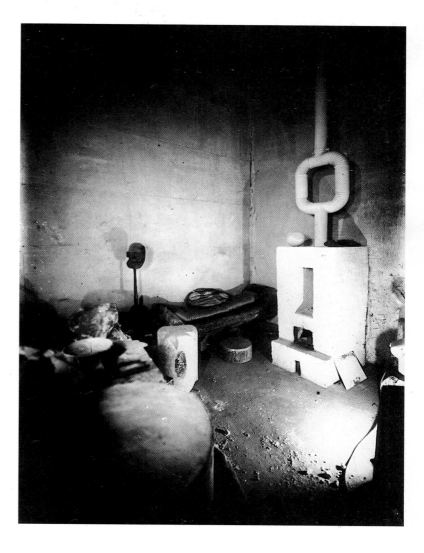

had already installed a Rumanian-style woodburning fireplace after his own design next to the entrance doorway. Made of ordinary bricks and firebrick, lined with fireclay, and whitewashed outside, it had three vertical openings: an oven on top, a hearth in the middle, and one at floor level for collecting ashes. Ducts on either side channeled the heated air toward the ceiling.

The adjoining studio, where Brancusi lived, was heated by another fireplace. In the hearth he had contrived a rectangular pipe with a hole for heating water or simmering his meals. When either fireplace had to have its annual cleaning—a job we took over when we arrived in Paris—it had to be taken apart brick by brick, then reassembled, relined with fireclay, and whitewashed again.

The new, bulky Godin in the main studio required two or three bucketfuls of coal a day. In the studio where the sculptor lived, a "cloche" burned all day long. The pipes from these four stoves spread warmth everywhere, albeit unevenly, but much time went into maintaining them. Outdoors Brancusi built a coal shed—he called it the *cagibi* (hut)—against the wall of the main studio and installed a flap-door, raking in the coal with a handmade tool without going outside.

Instead of displaying his *Leda* on a big slab of stone or plaster, Brancusi ordered a thin, polished metal disk (3 feet in diameter) from Fonderies et Laminoirs Louyot, attaching it to a marble base on a built-in set of ball bearings. An electric motor drove a belt that rotated both *Leda* and the metal disk. When there were visitors, he would ceremoniously remove the white flannel cloth covering the sculpture, plug in the motor, and let the slow rotation transform *Leda* into a shifting play of images on the shimmering surface, as though reflected in a stagnant pool of water.

Brancusi received requests for photographs of his work from *Uhu* magazine in Berlin (Pavel Barchan) and Willi Baumeister's *Das Neue Frankfurt*. His purchases this year included large beams of oak and pearwood, bags and square slabs of plaster, and a spiraling device for making screw holes.

While visiting Brancusi in June of 1931, W. Wartmann, director of the Kunsthaus in Zurich, received assurances that the sculptor would join in his upcoming exhibition; a bronze *Bird in Space*, on loan from a collector, was to have a room to itself.

In this year Brancusi also carved *Mlle Pogany* III (marble, Arensberg Collection, Philadelphia Museum of Art).

Right and opposite page:
Mademoiselle Pogany III, side, back, and front views. 1931. Marble. Philadelphia Museum of Art (Louise and Walter Arensberg Collection). Photos Brancusi (Cat. no. 192)

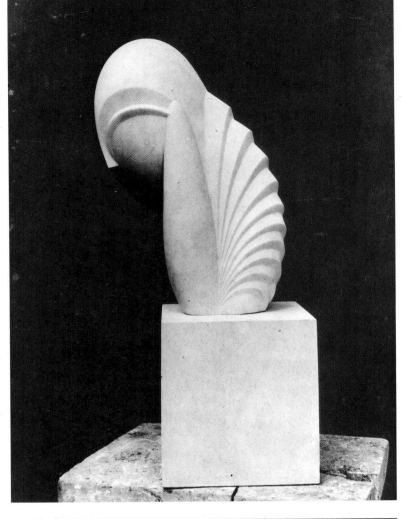

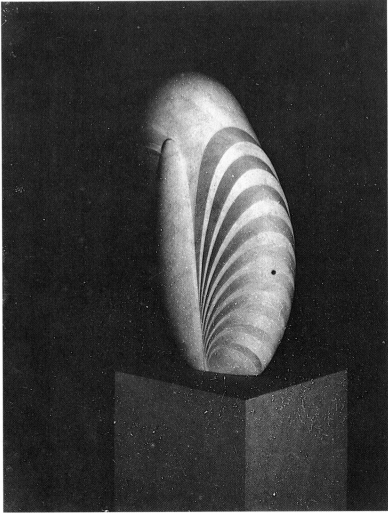

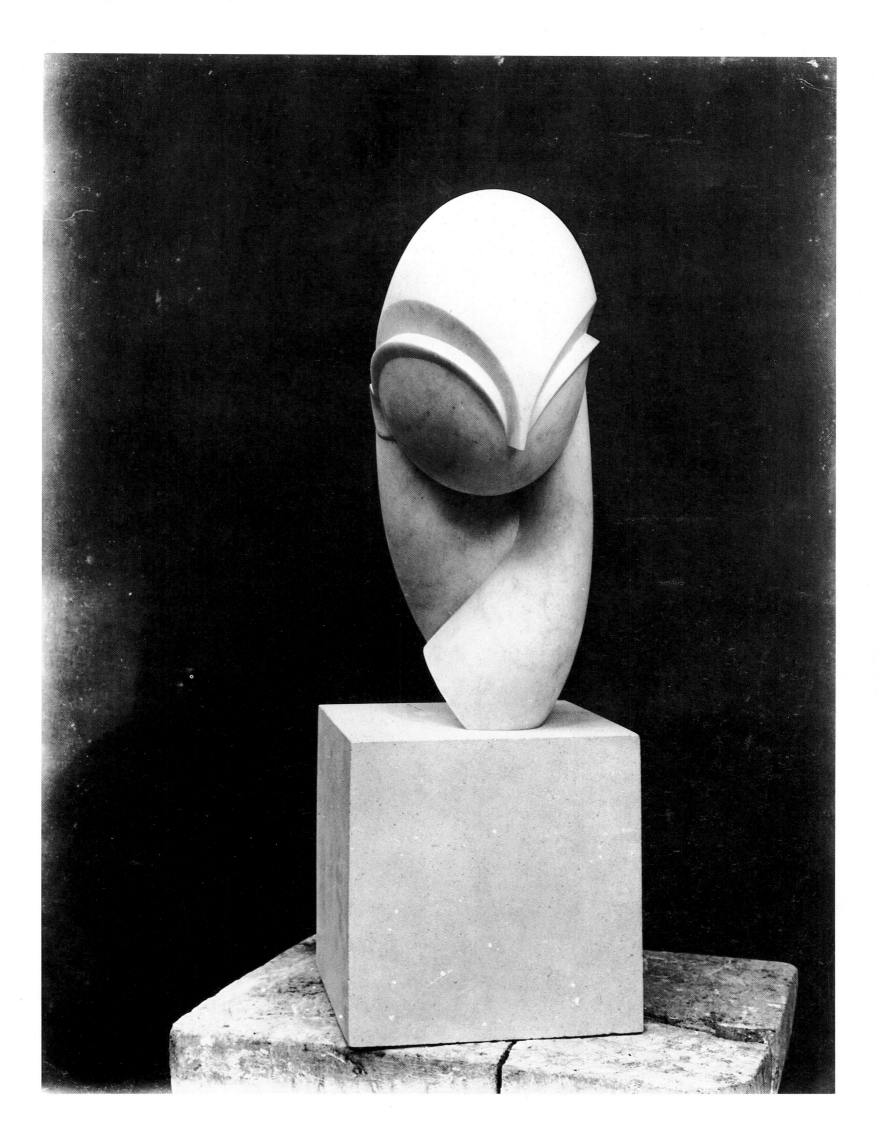

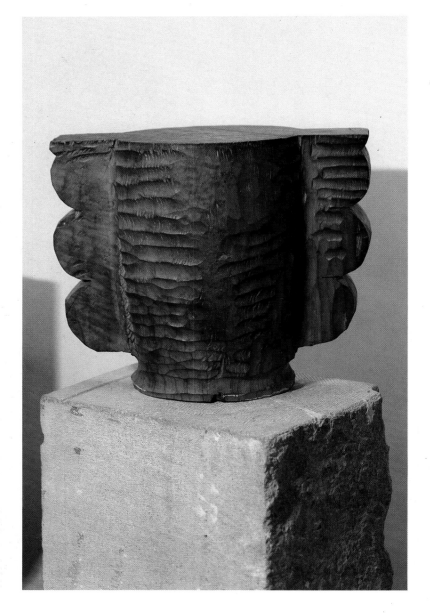

At the top of the page is a handwritten note in French (largely illegible cursive).

1932

In this year of economic crisis, the United States counted twelve million unemployed and numbers of bank failures. Conditions were no less deplorable in France or Germany. Brancusi received a moving letter from one of his painter friends, Else Fraenkel, and in her correspondence of 1932–33 we also learn that one of the phonographs Brancusi had tinkered with had greatly impressed her. To obtain better sound quality, he contrived a system with two tone arms at opposite sides of the turntable and a speaker built into a round slab of plaster overhead. As the 78 r.p.m. record was played, the gap produced a fullness of tone unequaled until the event of stereophonic sound.

Brancusi loved to experiment with sound. He came up with the idea of placing a record hole off center; as the needle moved across the record, the variation in tempo made a most surprising effect. He also replaced the phonograph cover with a handmade case—an example of his distaste for the standardized or mass-produced.

Through Else Fraenkel's letters we also know that the sculptor was finishing the massive stone fireplace against the left wall of the studio, the wall forming the area where the tall sculptures stood. When you walked in, your eyes would move from the *Endless Columns* to the *Cocks*, then come serenely to rest on the monumental fireplace. The pervasive whiteness of the space fostered a feeling of hushed peacefulness.

The beauty of the fireplace lay in its simple proportions: a stone mantel nine feet long, supported by a pair of standing blocks, each four feet high. (The same principle of construction prevailed in *Gate of the Kiss* at Tirgu-Jiu in 1937.) The draft rose through a pyramidal zinc flue to exhaust pipes along the wall, and up through the ceiling to the roof. A large piece of white canvas over a stretcher hid the flue and had a soothing effect on the space, forming a backdrop for the sculptures on the lintel of the fireplace; rarely lighted, it looked rather like a work of art in itself.

Opposite page:
Brancusi in his studio, 11 Impasse Ronsin, c. 1932–34; four **Endless Columns** in the background. Photo Brancusi

Vase. Late 1930s. Wood. Brancusi Studio, MNAM, Paris (Cat. no. 175a)

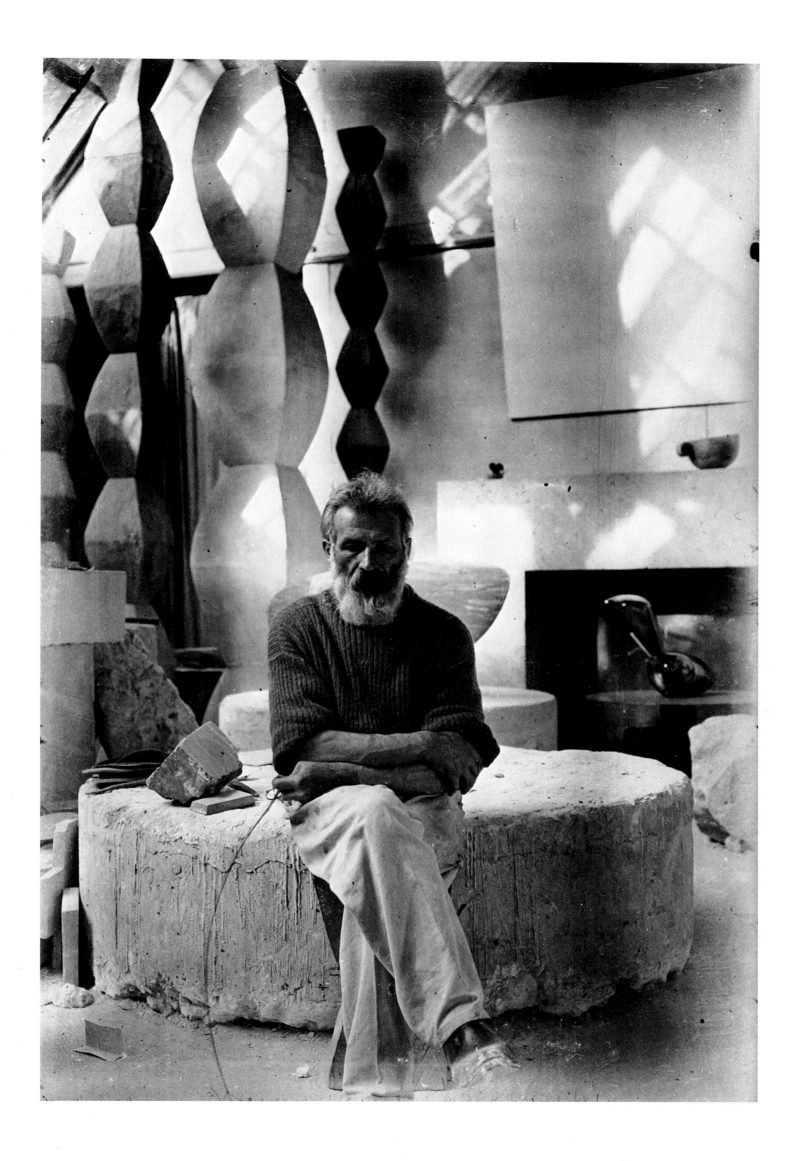

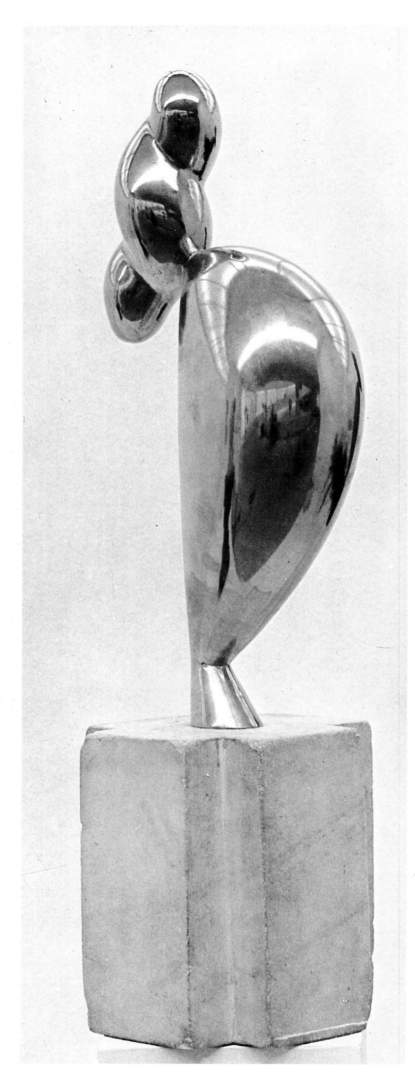

Portrait of Nancy Cunard (also titled **Portrait of a Sophisticated Young Woman**). 1928–32. Polished bronze. Collection Mr. and Mrs. Frederick Stafford, New York (on extended loan to The Isaac Delgado Museum of Art, New Orleans). Photo rights reserved (Cat. no. 194*a*)

To keep up with the increasing demand for photographs of his work, Brancusi added two pieces of equipment to his arsenal of supplies: one for still photographs, a Plaubel 6½ × 9, with a 2.9 Anticoma lens, No. 85440 (1,800 francs); another for motion pictures, a 35 mm. Zeiss Ikon Kinamo No. W23141, with a 1.4 Zeiss Biotar lens (5,640 francs). Sad to say, he had to sell them during World War II to keep body and soul together.

Two ladders he had recently purchased were to gain vital importance in the everyday running of the studio; without them he could not position sculptures, repair panes of glass, climb on the roof, or apply fresh whitewash to the walls. He gladly loaned these invaluable tools to neighbors, but if a ladder came back damaged it would upset him and he would not rest until he had mended it to perfection.

Never one for competitions, Brancusi turned down an invitation to take part in the Grand Prix de la Sculpture, sponsored by the Ministry of Education. He also decided not to send anything to an exhibition that the Paris-Tokyo association, Shinko Bijutsu Domei, organized in Tokyo under the auspices of the French embassy.

Brancusi received a letter on November 17 saying that he had sold a polished bronze *Bird in Space* of 1928 (height 54 ins.) to Stephen C. Clark of New York. "It is one of the most beautiful pieces of sculpture I have ever seen," wrote Clark, adding that he was sending a check for 50,000 francs toward the purchase price of 60,000 francs and that the balance would be remitted upon receipt of the sculpture. In 1934, it was presented to the Museum of Modern Art in New York as an anonymous gift.

Brancusi asked Alexis Rudier, a founder, to provide him with two metal disks; Rudier, in turn, approached Schneider and Co. about the request. On August 30, 1932, the latter firm sent Brancusi an estimate for two electroplated disks:

—One 6 mm. thick, 1 meter in diameter, 42 kg.
—Another 7 mm. thick, 1.50 m. in diameter, 110 kg., polished to a brilliant finish on one side and all around the edge.

Initially, Brancusi had planned to use these disks in conjunction with *Fish*, but he felt that the effect was not conclusive. He ended up putting *Fish* on stone bases instead, and the disks were never used.

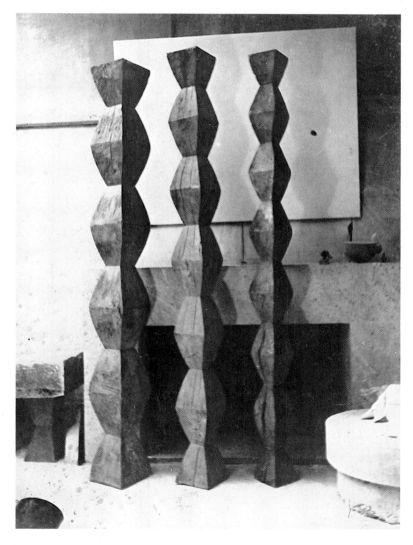

1933

The outstanding event of 1933 for Brancusi was his second exhibition at the Brummer Gallery in New York, bringing to four the number of one-man shows he had had in that city. James Johnson Sweeney, the American art critic, stopped by to see him, as we know from Brancusi's letter of thanks dated July 27; Sweeney continued to visit the sculptor on subsequent trips to Paris. When he became director of the Solomon R. Guggenheim Museum (1952–60), he organized a major retrospective show of Brancusi's work.

On August 13, Duchamp invited him to Cadaqués:

"Cadaqués, August 13, 1933.
"Duchamp, Casa Lopez, Cadaqués, Gerona Prov., Spain.
"Dear old chap,
"I sent you a telegram last Monday as promised and got no reply. Did you get it? Anyway, tell us what you've been up to.
"We are ensconced here in Cadaqués, a kind of Spanish Villefranche, very pleasant, warm, breezy.
"We've rented a house for a month, and if you come down we can put you up. We have a servant to do the cooking, and prices are really half of [what they are in] France.
"Let us hear from you soon and tell us if you're coming.
"With affection from Mary and myself,
Morice"

Brancusi had never been to Spain, and he accepted, but was denied a visa. He complained to Duchamp, who was mortified: "Dear old chap, this business about not issuing a visa for Spain is idiotic! I think they gave Tzara the same song and dance." He mentioned the problem to another friend, Marina Chaliapin, daughter of the famous operatic basso. "We,

too, had to go to extraordinary lengths just to cross the border and spend a few hours in San Sebastian," she wrote back from Saint-Jean-de-Luz, where the Chaliapins were then living. "We had to write to Papa's impresarios so that they would go before the consuls and state in person and on oath that we were not Fascists or Communists or Nazis or monarchists or revolutionaries, and on and on…. We did not get a visa." Then, to console Brancusi after reading his "sad letter," she added, "Come here instead. Come, dear friend. You'll relax, and Saint-Jean-de-Luz was never lovelier than it is right now… Anyway, I'll have someone to smoke a cigarette with, because I'm not allowed to do so in the house and I smoke all by myself, bored to tears…"

Mr. and Mrs. Eugene Meyer's daughter, a friend of Marina's, dropped him a few lighthearted lines to persuade him: "Finish up whatever it is you're so involved with; get out of there and join us."

So off Brancusi went to Saint-Jean-de-Luz, where he saw a good deal of the Chaliapins. He was one of the basso's admirers and often listened to his records; Chaliapin thought highly of the sculptor, too. "You can go around with Marina. She may go to your place whenever she likes. With you I can rest easy."

Brancusi told us the following story: "One evening, after an excellent meal, Chaliapin cast covetous glances at a cupboard lined with bottles. 'You know the doctor has forbidden you to smoke or drink,' his wife admonished. Whereupon I objected in a matter-of-fact way, 'The more you take care of yourself, the sicker you get.' This line of reasoning prevailed, and everyone had a glass or two."

On September 10 he received a letter from Duchamp, postmarked Cadaqués:

Brancusi's studio, 11 Impasse Ronsin, with the three versions of **Endless Column** shown at the Brummer Gallery, New York, 1933–34. Photo Brancusi

Brancusi Sculpture Exhibited

Most Representative Collection Ever Assembled Is Displayed At Gallery in New York City

AT the Brummer Gallery in New York City throughout the month and until January 13 there will be on exhibition the most representative collection of the works of the modernist sculptor, Brancusi, that has ever been assembled. In previous years when Mr. Brummer has had one-man shows of this artist's work, he felt that the true value and the many facets of Brancusi's genius somehow failed to convey themselves to the public and he therefore had the princely idea of carrying across the Atlantic practically everything which his large Paris studio now contains. Such generous consideration for an artist's integrity is rare among the commercial purveyors of art, and the exhibition should not be missed by those bold spirits whose blood pressure does not rise too rapidly when they are confronted by a new and challenging concept of life. For even today when the word revolution is hackneyed and our spirits are weary with the onslaught of new ideas, Brancusi still manages to enrage the critics and to fascinate a large and varied public.

Before the war Brancusi was one of a group of young people who made Paris the intellectual and artistic center of the world. Guillaume Apollinaire was still chanting his rhythmic and electrifying interpretations of new thoughts in a new poetic medium. Picasso was at the height of his cubistic period, his most genuinely creative contribution to the history of painting. "Les six," the six disciples of Erik Satie, provocative musical innovator, were pouring out compositions which caused the liveliest riots whenever they were played for the first time.

Now all that splendid ardor is stilled. Apollinaire was shot down in the trenches, Picasso has gone almost academic, poor old Satie died quietly of starvation, and his two greatest pupils, Darius Milhaud and Honegger, are played by the most conservative orchestras.

Of all that gay and gallant company only Brancusi remains to remind us that the world was once young and free and beautiful. The people who know too much about art will never accept him, but let those whose nerves have not been battered into insensibility by the New Deal not fail to go to see this oasis which Mr. Brummer has carried across the seas to his Fifty-seventh Street Gallery, of prewar independence of thought, of imagination, and of craftsmanship.

In looking for the first time at these broad surfaces, at the towering "endless columns" which alas must bump all too soon into Mr. Brummer's ceiling, the modern cliff dweller must first divest himself of his own cramped habitation and let his mind expand to the vast spaces in which alone a mentality such as Brancusi's feels itself at home. The "Bird in Space" with its bold upward thrust should be imagined as the dominating figure in some great garden setting, the Leda swims upon an endless sea, the massive white pillar is an empty pediment because its very magnificence would make any of our modern heroes look puny were he set upon it.

In other words, Brancusi has gone on his way alone refusing to join the rest of the world in its cynicism and despair, becoming ever more his own free and joyous self and heartening thereby all those who have had the privilege of watching his development. Like the poet Goethe, who continued uninterruptedly to give a war-torn Europe the untroubled and immortal outpourings of his serene philosophy of life,

Continued on page 15.

Three rooms in the Brancusi exhibition at the Brummer Gallery, New York City.

The narrow figure in the upper left-hand corner of the page and on the extreme right of the lower picture is the "Bird in Space." The large white pediment is part of an architectural project, whereas the three dark columns below it are called "Endless Columns" because the eye is impelled to continue the upward movement. The black marble in the lower center is an abstract portrait.

Seichi Sunami Photos.

Page from *The Washington Post Magazine*, December 1933, on Brancusi's one-man show at the Brummer Gallery, New York, 1933–34

"I got your letter informing me of your decision. I'm all for going to New York with the exhibition (November 15). We can work out the details when we get back to Paris.

"At the same time, I got Brummer's letter confirming the news.

"I'll be in Paris sometime in early October, the 5th at the latest.

"I'm writing to Brummer to find out whether he'll still be in Paris.

"Soak up the sun in Saint-Jean-de-Luz. Weather still glorious here. Leaving for Barcelona on September 14th, so write me c/o General Delivery, Barcelona, Spain.

"Fondly,

Morice"

The New York one-man show at Brummer's opened on November 17. Among the fifty-eight exhibits Duchamp had assembled for the show were Brancusi's first stainless-steel sculpture, *The Newborn*, a fresco study, and a photograph of the *Ecorché* of 1901. Other highlights of the exhibition—his largest to date—were *Fish*, *Leda* (1925), a polished bronze *Newborn*, and three versions of *Endless Column* (which had to be cut down, to fit in the gal-

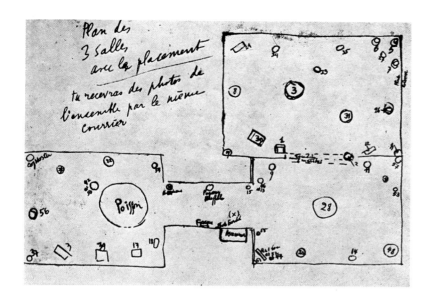

Installation plan of Brancusi show, Brummer Gallery, as drawn by Marcel Duchamp. 1933. Archives I–D

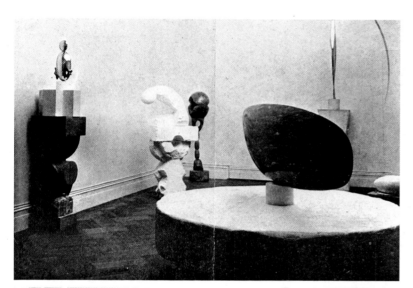

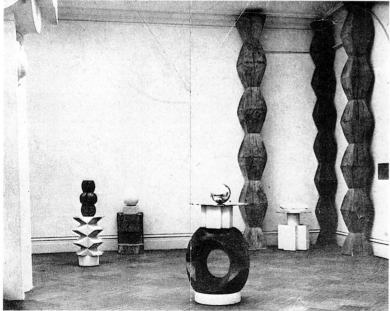

Two views of Brancusi show, Brummer Gallery, New York, 1933–34. Photographs published in *Art News*

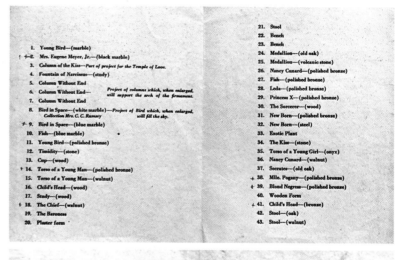

Checklist of Brancusi show, with aphorisms, Brummer Gallery, 1933–34. Archives I–D

lery). Of the latter the artist noted: "Project of columns which, when enlarged, will support arch of the firmament." With the exception of *Bird in Space*, all the works in the show came directly from Brancusi's studio.

For *Bird in Space* (Brummer catalogue No. 8) he added the following comment: "Plan for a bird which, when enlarged, will fill the vault of the sky." He elaborated on this in one of his random notes concerning sculpture in public gardens:

"Now, imagine if, instead of all the sculptures of women they've put in public gardens and which we feel sorry for because they are exposed to the wind and rain, instead of all those glorified men that nobody bothers to look at, instead of all that useless clutter, people took it into their heads one day to erect on a vast square a tall, sleek *Bird in Space*, perhaps right up to the sky. Then imagine the frenzy of a whole throng dancing about this new sun. And suppose, come spring, a swallow should alight on its golden tip—that would create a new kind of poetry."

In addition to the usual lists of exhibits, the catalogue for the Brummer show included a preface by Roger Vitrac. Duchamp, because Brancusi could not come to New York, drew him a sketch that showed the positions of his works in the gallery.

Brummer had hopes of taking his Brancusi show to Los Angeles and Denver, but, as Duchamp wrote on December 13, "They cannot take the exhibition. The expenses involved are too high. Brummer explained to me that they want everything for nothing. So, I'll be in Paris by the end of February at the latest." The exhibition ran until January 13, 1934.

On December 10, the *Washington Post* congratulated Joseph Brummer on having brought across the Atlantic nearly all of the sculpture in the artist's huge Parisian studio. When asked how Brancusi's work fared this time at U.S. Customs in New York, Duchamp replied with a friendly smile that everything had gone off without a hitch (*Art News*, November 13). He also mentioned for the benefit of the factual-minded that the Brancusi shipment from France weighed in at twenty-four tons (*New York Times*, November 18).

On December 27, Joella Levy wrote Brancusi from New York, giving an update on the exhibition:

"Marcel and Brummer have arranged your works so well that all of them seem to be in

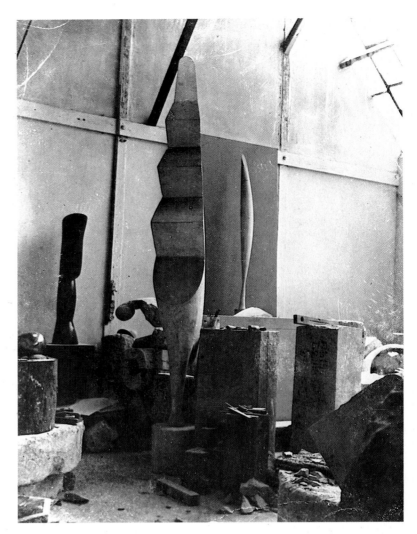

Brancusi's studio, 11 Impasse Ronsin, c. 1933: at center, **Grand Coq III** (Cat. no. 191). Photo Brancusi

Opposite page:
Mademoiselle Pogany III. 1933. Polished bronze. Photo Brancusi (Cat. no. 198)

their best possible position. No letup in the crowds, and Marcel tells me that on Saturdays it's positively incredible. I know lots of people who come regularly every week. One young man has seen it fifteen times.

"Too bad you're not here."

For Brancusi, however, life went on, with its tribulations (the government ordered him to put in a connecting sewer pipe for his property on Rue Sauvageot) and exhibitions: São Paulo, Brazil (with Picasso, Braque, Léger, Le Corbusier, Lhote, and Pompon) and, in June, the Salon des Tuileries (the black marble *Portrait of Mrs. Eugene Meyer, Jr.*). He also sold a large drawing of *Mlle Pogany* to collector Albert E. Gallatin for his Museum of Living Art at New York University.

Maurice Raynal, after making an exhaustive study of the studios of the sculptors Brancusi, Despiau, Giacometti, Laurens, and Maillol, wrote an article for

Albert Skira's magazine, *Minotaure* ("Dieu, table, cuvette," No. 3–4, October 1933). It included five views of Brancusi's studio and three aphorisms by the sculptor.

On August 5, 1933, Brancusi, bearing his 1926 passport issued by the Rumanian Legation in Paris, registered as a Rumanian subject at the Rumanian consulate:

"No. 73. Register No. 5902.

"Legation of Rumania.

"Consulate, Paris, 1932–1933.

"Registration certificate, valid until 31 December 1933.

"We hereby certify that Mr. Brancusi, Constantin, born 1876 in Pestisani-Gorj, a sculptor by profession, residing at No. 11 Impasse Ronsin, Paris, is registered as a Rumanian citizen at No. 73/9 of the registration book in our consulate. In accordance with Passport No. 223/27/12/1– 1926 issued by the Paris legation.

"August 5, 1933, Consul…"

Certificate of registry with the Rumanian consulate, 1932–33. Archives I–D

208

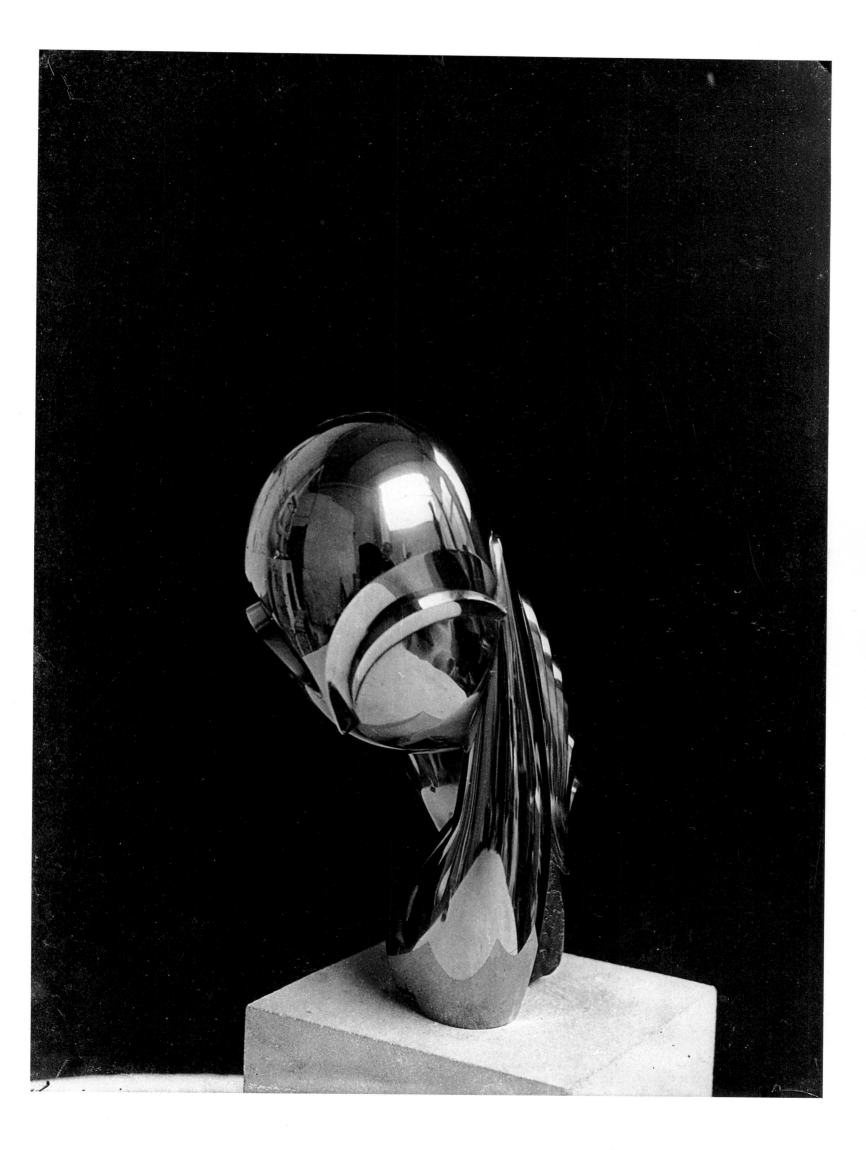

La joie le beaux
qui nous donne la
sensation estetique
n'ont rien a fair
avec le metier dans
l'art

1934

On January 9, Duchamp reported back to Brancusi that the response to his Brummer exhibition in New York was as enthusiastic as ever.

"Dear Morice,
"As my cable informed you, we have sold *Blond Negress* to Mr. Goodwin, who donated it to the Hartford Museum [Wadsworth Atheneum]. He did not take the stainless steel *Newborn*, I don't know why. When you come down to it, it's better for a museum (1,600 dollars less 10% = 1,440 dollars @ approximately 16.50 [francs] = approximately 23,500 francs on deposit in Brummer's bank).

"The same day, we sold the plaster *Sleeping Muse* that Mrs. Rumsey brought back in exchange for the marble she's paying a thousand dollars for. (We aren't converting the 1,000 dollars because we don't know when she will pay.) We sold the plaster to Mrs. Guggenheimer (no connection to Peggy), who paid 250 dollars (again 16.50 francs to the dollar). Do you remember where this plaster comes from (Quinn's, or some other collection)?

"I've seen Speiser, who's making it his business to sell *Leda* to the Philadelphia Museum. I took the liberty of allowing a reduction of 500 dollars, so the price for the Philadelphia Museum would be 3,000 dollars, with payments spread out if that helps the sale along. On Speiser's advice, I sent a photo of *Leda* to Ingersoll [Philadelphia attorney, later president of the museum], who is working with Speiser to conclude the deal."

About this time, the sculptor rented a room for several weeks in Sèvres, where the air was fresher and he could go for walks in the woods. During one of these strolls, he wrote a story entitled "The Uprooted Tree" (adding on another sheet of paper, "The Girls of the Bois de Clamart"):

"Its root was small, but it grew very, very tall. Around it there stood other trees a hundred times older; their shade prevented the sun from coming through, but thanks to them it could grow without having to worry about storms. Before long, it was as tall as the others and could see the sun. Mad with joy, it grew even taller, but still on its one small root. One day, the woodsman cut down the big trees, and it was left standing all by itself in the clearing. A storm came, and it fell (to the ground) right away, for all it had was that lone little root.

"I clasped all of its little branches (at the top), the way a person clasps the one he loves and will never see again. Then, seated on its young trunk, I recorded this story, writing it on some white bark which a passerby had seen fit to cut away. While I was writing, four girls who had lost their way walked past and asked me if I knew the way out of the woods...."

His correspondence with Marina Chaliapin at this time suggests that he was obsessed with the idea of leaving Paris.[30] Later he told us that he had seen an advertisement in a newspaper: island for sale, somewhere off the coast of France. He considered buying it so that he could be finished with the property on Rue Sauvageot, his dilapidated building, and the precarious accommodations on Impasse Ronsin.

"I could have erected my *Endless Column* right in the middle of [the island]," he told us. "But it was just a dream. Perhaps I was asking for too much. Today, I'd just as soon leave the way I came: singing in the streets. There are always kind souls who give a few *sous* for one to get by on." Thus in his later years spoke the admirer of Milarepa.

At Brancusi's request, Duchamp approached the biggest and oldest foundry in the United States, General Alloys Company of Boston, about the possibility of casting sculpture in stainless steel. Now that Brancusi had given that material a trial in *The Newborn*, he was thinking of doing more work in it. We know, for example, that *Grand Coq* was originally conceived as a stainless steel sculpture.

The Brummer exhibition closed on January 13. On the 16th, the exhibits—thirty-one crates in all—were shipped back to France through La Rancheraye. On the 28th, Brancusi received a check for 900 dollars from Joseph Brummer; this was payment (less the gallery's commission) for the white marble *Bird in Space*, which was sold to Mrs. Rumsey. Mrs. Meyer bought her own *Portrait of Mrs. Eugene Meyer, Jr.*, and wrote Brancusi on August 19:

"Since Brummer did not wish to quote me a price for the magnificent marble, I had a chat with Steichen, and we finally agreed on 3,500 dollars. If you feel that is not enough, you know full well that you only have to say so.

"Kate, Florence, and I talk about you constantly, and we all agree that the *Queen*[31] is as much a portrait of you as [it is] of me."

In August, Brancusi got a card, postmarked Vannes, from André Rolland de Renéville. Author of *Rimbaud le Voyant* and, along with Daumal and Gilbert-Lecomte, a member of *Le Grand Jeu*, he was one of the sculptor's faithful friends. His Rumanian wife, Cassilda, had a delicate constitution but considerable talent as a painter. Both of them figured prominently

throughout Brancusi's life, and Rolland de Renéville was a witness at the signing of the sculptor's will.

Several exhibitions this year featured work by Brancusi. Organized by the Société Auxiliaire du Palais des Beaux-Arts in Brussels, the ''Exposition du Minotaure'' (May 12–June 13) also included work by Kandinsky, Klee, Picasso, and Miró. And on June 20, ''A Selection of Works by Twentieth-Century Artists'' opened in Chicago (Renaissance Society); Sweeney wrote to Brancusi that he was sending him a catalogue of the show. And plans were already being laid for future exhibitions. On December 7, Claude Roger-

Marx, acting on behalf of the Association Française d'Expansion et d'Echanges Artistiques, inquired if Brancusi would loan a work for exhibit in Warsaw, Prague, and Vienna. The artist obliged by sending his wooden *Socrates* on a stone base, insured for 20,000 francs (exhibited in 1935).

On December 29, Brancusi sent out an original New Year's greeting: a photograph of himself with two kisses and a letter.

We know from a four-page synopsis among the sculptor's possessions after his death that he was planning to write a screenplay for a movie entitled *120 Years from Now*, a look ahead to what he thought was

the future for technology. The fourth and final part, set in the year 2054, raises the question: when the world is unified, will it differ from what it is today? The answer is yes; it will be different in spirit. The Creator (aggression) will have entered the human soul and triumphed over the instinct of tradition (conformity). Brahma the Creator, after subjugating Shiva the Destroyer, will supersede Vishnu the Preserver.

In this year Brancusi had the Andro Foundry cast some bronzes (a *Cock*, two heads, two busts, and *Blond Negress II*); he also ordered four black marble bases from Attenni, a marble dealer.

Letter from Brancusi, late 1934.
Archives I–D

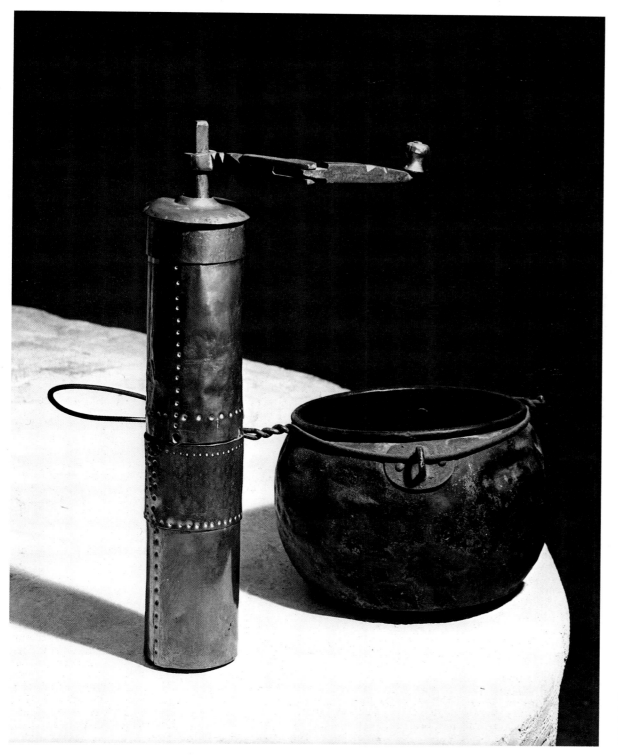

Handmade utensils in Brancusi's studio: coffee mill (h. 29 cm.); coffee roaster (hammered copper, h. 13 cm.) with wire handle (iron, l. 16 cm.)

1935

Brancusi's approach to monumental sculpture underwent a transformation at this time that ranks as a watershed in the history of twentieth-century art.

The chain of these events that would have worldwide repercussions began with a simple request from a local group in Rumania, the National Women's League of Gorj, that was planning to erect a monument to the memory of "heroes from the region slain during the war of 1914–1918." Acting on behalf of Mrs. Tătărăscu (an artist who happened to be the wife of the then Prime Minister), sculptress Militza Patrasco asked Brancusi if he would travel to Rumania to study the project.

Mrs. Tătărăscu was no stranger to Brancusi's work, and she prevailed upon her husband to give the sculptor free rein and to break away from the traditional "eagle with broken wings" commonly used for monuments of this sort. Brancusi once wrote about these: "People see crows everywhere, and with lots of goodwill they end up believing it's an eagle."

Brancusi was toying with some original ideas for the subject and felt within himself the power to create a major work of art. Had he not already created funerary sculpture according to his personal conception? It was surely with a sense of deep satisfaction that he wrote back that he would indeed accept the commission (letter in the Rumanian Academy, Bucharest).

Although the original concept for the memorial called for a single piece of sculpture, Brancusi found something truly fulfilling in sculptural groups. Whether in the Quinn collection or in his studio complex on Impasse Ronsin, his sculptures were conceived and arranged in harmony with one another.

The three works at Tirgu-Jiu provide an unparalleled example of unity in a vast open space. For *Endless Column*, the artist designed a module appropriate for its surroundings. The tables in his studio inspired the *Table of Silence*. And that year he made a plaster and stone model of *Gate of the Kiss*, a work that synthesizes architecture and sculpture. The stylized motif of *The Kiss* is carved repeatedly into the lintel, while the two supporting pillars bear the same repeated design, in larger dimensions. (The proportions of the *Gate of the Kiss* are those of the Golden Section, the ratio of 0.618 to 1, obtained when a line is divided into two segments such that the ratio of the original line to the larger segment is the equal of the ratio of the larger segment to the smaller.)

To make the model, Brancusi carved the front and one of the side sections in stone; he then cast them in plaster, assembled the entire piece, and photographed it in front and three-quarter views. (By 1937, the model had been moved to Rumania.)

Another major project we have already mentioned, the *Temple of Meditation*, also intrigued the artist at this time. "I had met a young Indian prince at Oxford," wrote Henri-Pierre Roché in *L'Œil* (May 1957), "and one day I brought him to see Brancusi. They took a liking to each other. The visitor slowly looked over all the works with that legendary imperturbability. He did not have a great deal of money at the time." This first meeting, which probably took place around 1930, fired the enthusiasm of this young Maharajah of Indore, who was especially taken with the *Bird in Space* sculptures. In the course of subsequent meetings, an idea gradually took shape: a place of meditation on the Maharajah's estate that would stand as a tangible expression of his religious beliefs. The project anticipated the sculptor's wishes; the wisdom of the Far East already held special fascination for him.

In 1935, the Rumanian writer Panaït Istrati died; Brancusi and he were close acquaintances and saw a good deal of each other in Paris. Once, when the sculptor was away, he slipped a card under his door with the message *Am calcat cu stângul*, literally, "I walked on my left foot" (a Rumanian expression for "Nobody at home").

In July, the Impasse Ronsin witnessed a gala occasion. On the day after Bastille Day, a troupe of Rumanian dancers on their way to London stopped off to visit the sculptor. These all-male groups trace their roots to pagan antiquity; their movements, handed down from generation to generation and from family to family, retain some of their initiatory flavor. Dressed in bright traditional costumes down to the little bells on their feet, the dancers and musicians broke into a frenzied *calusar* in the courtyard, shouting "Hala-isa!" In their enthusiasm, they grabbed Brancusi and lifted him into the air. People from the neighborhood flocked around to see what was happening. His eyes brimming with tears, the sculptor invited the dancers in for a hearty meal. It was a wonderful outpouring of health, strength, and life. Those who had witnessed this unexpected sight were still talking about it with amazement when we arrived in Paris ten years later.

212

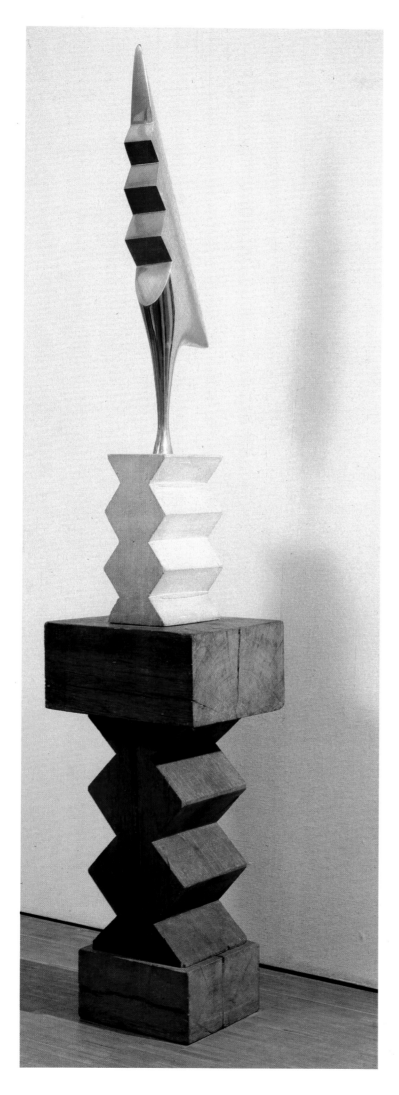

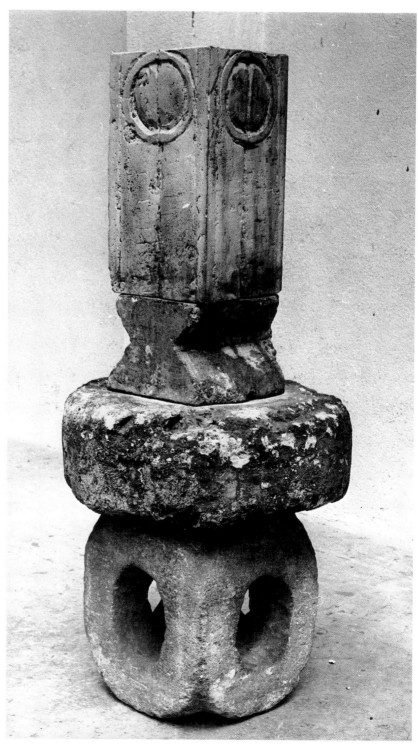

The Cock. 1935. Polished bronze on stone and wood bases. Brancusi Studio, MNAM, Paris (Cat. no. 201)

Column of the Kiss. 1935. Stone and plaster. Collection Istrati–Dumitresco (Cat. no. 202)

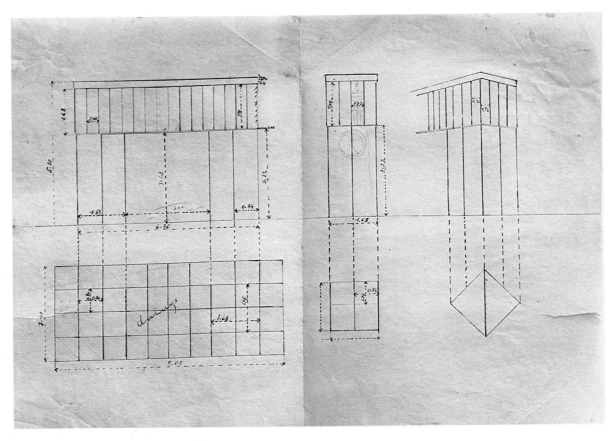

Preliminary drawings for **Gate of the Kiss.** Archives I–D

Model for Gate of the Kiss.
1935–37. Plaster. Private collection, France. Photo Brancusi (Cat. no. 203a)

214

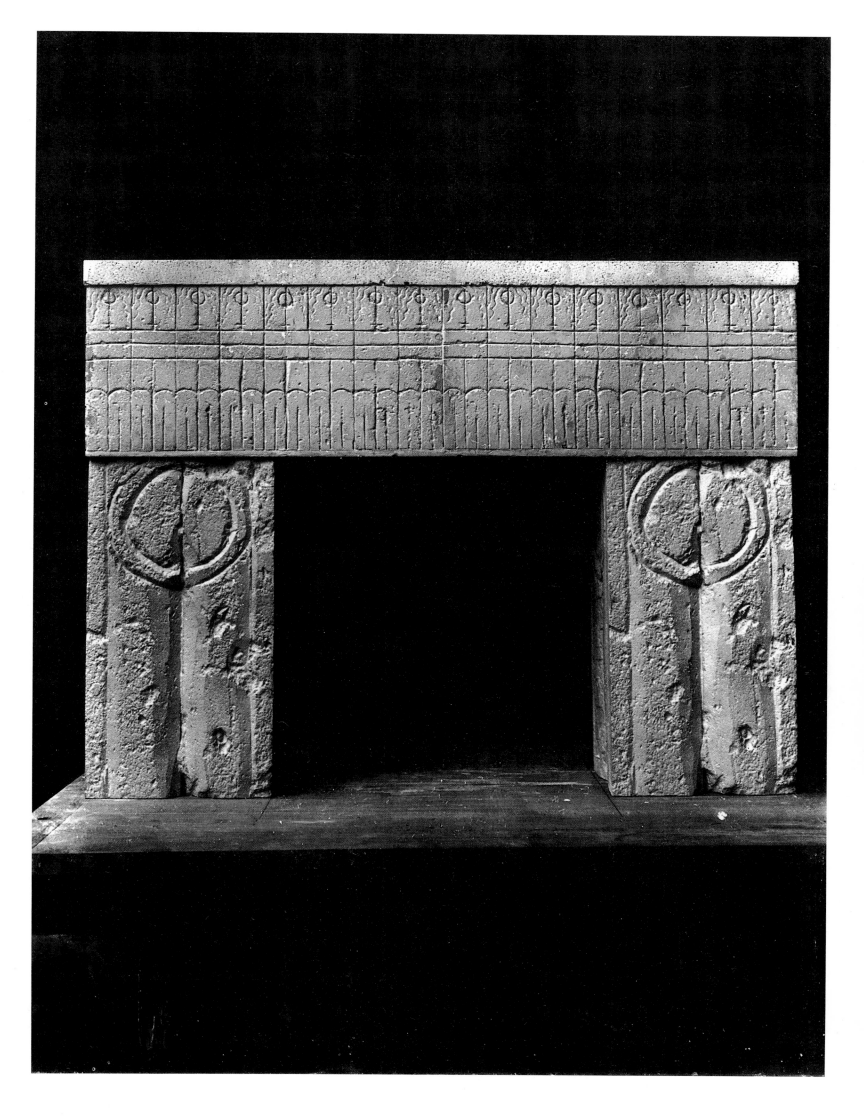

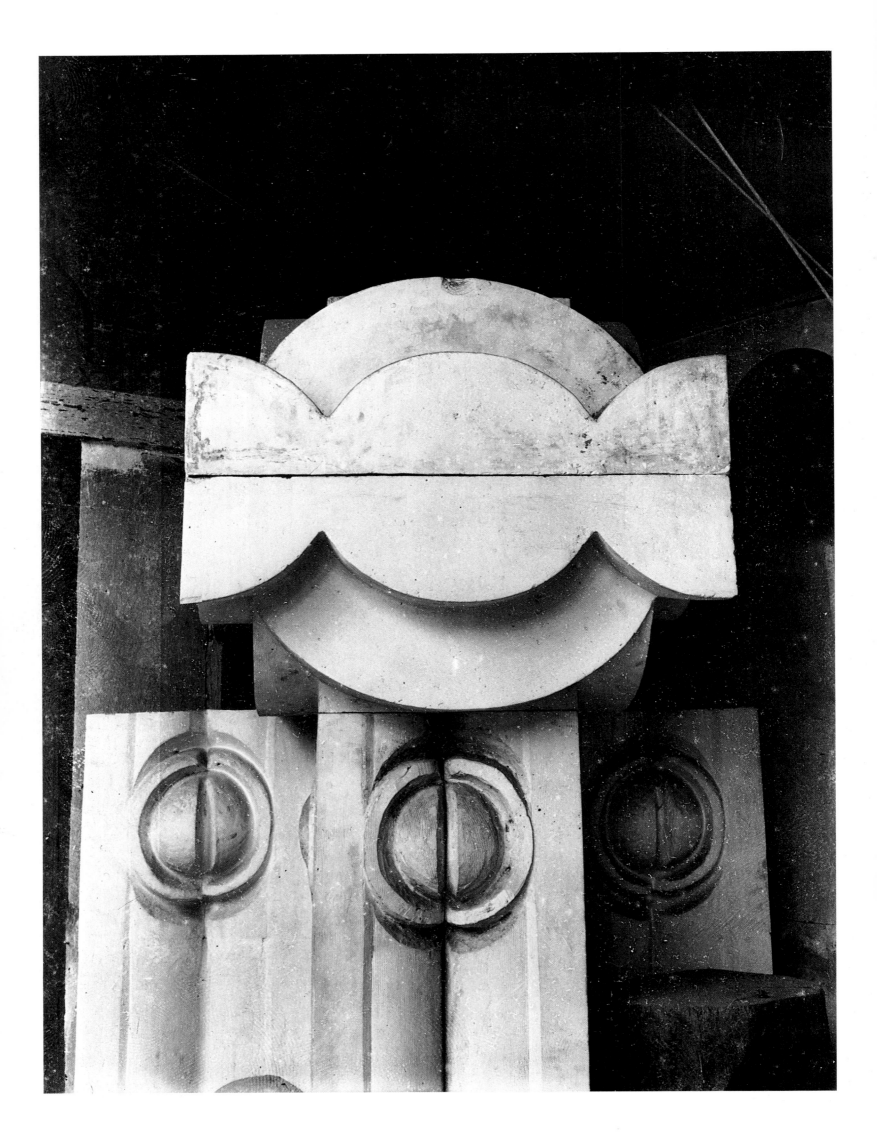

la chose la plus formidable c'est de marcher bien, étant conscient de soi et du chemin

1936

Little by little, the plan for the *Temple of Meditation* took shape. Two letters from Henri-Pierre Roché (dated April 25) gave Brancusi an idea of what the Maharajah of Indore had in mind:

"His Highness visualizes:

"In the middle, a stream, or a reflecting pool (rectangular, elongated).

"On one side, the black *Bird in Space*.

"Across from it, the white *Bird in Space*.

"On one side, the bronze *Bird in Space*.

"Across from it: a small temple of the Indian God.

"A rough-hewn bridge, if need be.

"General layout, the size of niches, of the reflecting pool, of the Indian temple: to be determined by Brancusi.

"Hedges, wall, selection of trees, procedure for planting trees: Brancusi.

"This ought to be a simple structure that could be built without Brancusi, unless Brancusi comes to Indore between December 1937 and January 1938.

"Have him consult his physician to see if he can make this trip and, if necessary, extend his stay up to three months, that is, from November 1, 1937, to the end of January 1938.

"If need be, he could come two years in succession.

"Various kinds of stone that can be easily transported to Indore.

"The Indian temple for the Indian God: pure, traditional in style.

"There would have to be a way to close the niches during the three rainy months. Perhaps the bases of the *Birds* could be gently rolled into the back of their niches during these three months, then brought out again alongside the reflecting pool

during the nine dry months.

"The general orientation should be such that, at a certain time of day, the sun will be behind the Indian temple and across from the bronze *Bird in Space*, which at that moment would reflect the light toward the Indian God.

"The *Birds* shall be like the temple's [guardian] spirits.

"The whole of the 'sacred precinct' shall be enclosed by a tall, hardy hedge and, if need be, a wall farther out.

"This shall be a place of meditation.

"In-ground electric floodlights for illumination at night.

"Stones, with a bit of grass in between them, for the walkway around the reflecting pool.

"The rest of the ground, lawn (which, even if watered, will be scorched four months out of the year).

"Suggested fees for Brancusi—all expenses paid from the day he leaves Paris to the day he returns to Paris: a thousand rupees a month (approximately 5,500 francs a month).

"The *Birds* shall leave on the same boat as His Highness in February 1937."

The Hindu prince was staying at *Usha Vilas*, his estate in Villefranche-sur-Mer (Moyenne Corniche). Henri-Pierre Roché met him there and then sent Brancusi some notes that shed light on the evolving project:

"May 7, 1936.

"His Highness feels that a circular opening in the roof, like the Pantheon, would let in a diffuse light ill-suited to the *Birds* and that it would be preferable for all the light to be concentrated on them by means of three apertures above or facing them, horizontal, vertical, or diagonal, depending. He still likes the idea of sunlight directly striking the bronze *Bird* now and again.

"The rest of the monument interior could be illuminated with

suitable electric lights, if need be.

"Provision for electric lighting of the *Birds* at night.

"Overall, it must not be too big. It is not a public temple but something akin to a private chapel or place of worship in a castle. Basically, its size is to be determined by that of the *Birds*, just big enough for them to look right.

"(You would make an on-site estimate of the cost for each of the various materials in which the monument might be built).

"He would like to have a plan and a section in perspective (in English, an elevation) by way of an architect's rendering."

"August 9, 1936.

"Dear friend,

"After due consideration, His Highness has instructed me to tell you that your plans for the temple have his complete and unqualified approval.

"He has not yet visualized the interior and does not yet have a clear idea of what one would do upon entering.

"This is a place for meditation and contemplation. People will sit down, but there will be no seats as such since Hindus sit on their heels.

"The simpler, the better. Unlimited simplicity.

"There could be raised areas, like low platforms, on which to sit.

"His Highness would like to have a reflecting pool, level with the floor, if possible.

"The first thing a person should see as he walks in is the bronze *Bird*. (His Highness is giving the temple a great deal of thought.)

"Kindest regards,

"Did you have a good time at the seashore? I am at the Auberge du Coq Hardi, Corne d'Or, Moyenne Corniche, Villefranche-sur-Mer, Alpes-Maritimes, until August 16.

"His Highness sends you greetings.

H.-P. Roché"

Brancusi dictated his reply to Roché, who in turn handwrote the letter to Yashwant Rao Holkar, Maharajah of Indore (letter courtesy of Mme. H.-P. Roché, Paris):

"Spring 1936.

"I am going to give you some photos of my *Birds* with dates, starting with the first one.

"The height of the *Bird* is meaningless in itself (like the length of a piece of music). The main thing is the object's internal proportions.

"The prices have varied depending on the time and need. The buyers have a sense of privacy and do not want the amounts they paid to be divulged.

"I've sold some *Birds* for

Temple of Meditation, alternative design. 1933–37. Plaster. Photo Brancusi

more than 100,000 francs, others for less.

"The differences between the most recent *Birds* can scarcely be seen in the photographs.

"However, each is the product of fresh inspiration, unrelated to that of the one before.

"I shall be able to show your friend, on some plaster casts, their subtle differences.

"My *Birds* are a series of different objects on a central, unchanging theme. The ideal realization of this theme would be an enlarged work filling the vault of the sky.

"My two most recent *Birds*, the black one and the white one, have brought me closest to the correct proportion, and the more I've succeeded in ridding myself of myself, the closer I've gotten to it...."

It was probably about this time that Brancusi took a piece of cardboard and wrote on both sides of it a list of sculptures and collectors of the various versions of *Bird in Space*, *Mlle Pogany*, *Fish*, and *Sleeping Muse*.

In May 1936, Brancusi and the Maharajah signed a contract for the purchase for £6,000 of two *Birds in Space*. These were to be placed in the *Temple of Meditation*. While he was absorbed in the project, Brancusi turned out a number of drawings and was pleased to learn through Roché that they met with the Maharajah's approval. The prince asked Brancusi to come to India the following year to inspect the site on which the temple would be built. Later, when he recalled this period of his life, the sculptor relived the excitement and restlessness of his experience: "One would have had to enter [the temple] humbly," he said. "I had designed the door to be very low and so narrow that only one person could enter at a time, and would have to bow as he walked in." He planned that sunlight would fall through a narrow opening and strike each of the *Birds* at particular times of day. (His idea came from a shaft of sunlight that poured through the transom of the studio roof at a certain time and struck the bronze *Bird in Space* each day, setting the upper part aglow against the red ocher of the painted wall behind it.)

Roché mentioned the project in the piece he wrote for *L'Œil* in May 1957. "[The Maharajah] also wanted... to have Brancusi build a temple, twelve paces by twelve, on the lawn near his palace, as though dropped from the sky, without doors or windows, with an underground entrance; a temple for meditation, open to all, but only to one at a time.... Inside there was to be a square reflecting pool with three *Birds in Space* on three sides and a tall oak statue, *Spirit*

Brancusi's list of works and collectors, 1936. Archives I–D

Contract between the Maharajah of Indore and Brancusi, May 1936. Archives I–D

of Buddha [later entitled *King of Kings*], by Brancusi, on the fourth."

The artist's plan for the interior also called for sweeping frescos that would suggest birds taking wing toward the horizon, in counterpoint to the surging verticality of the bird sculptures. (Two designs survive, a fresco of a single bird and a gouache of three.) Brancusi saw the *Temple of Meditation* as his long-awaited chance to combine "architecture, painting, and sculpture" into a unified work of art, a concept first found in ancient Egypt, that pointed the way for the future.

On June 21, 1976, Thai Van Kiem, former curator of the museums in Saigon and Hué, discussed *Spirit of Buddha* in "Un Sage de l'Orient," a paper he read to a conference at the

A, B.

E.

F.

G.

C.

D.

H.

Musée d'Art Moderne de la Ville de Paris commemorating the one-hundredth anniversary of Brancusi's birth. Here is what he said, in part:

"As an admirer of Milarepa, the Tibetan philosopher, Brancusi was already steeped in the essential doctrine of Buddha, who in his sutras taught that form is illusory, matter perishable, and that all things in this world are subject to impermanence and the universal law of decay: everything, that is, except *dharma*—Idea, Essence, the Holy Law, ultimate reality, Supreme Truth—which is considered permanent.

"The fundamental teachings Buddha preached in his sermon at Benares can be found at the various levels of this piece of sculpture, namely: the quadrangular base, which represents the Four Noble Truths; the endless spiral, representing *samsara* or the indefinitely repeated cycle of birth, suffering, and death caused by karma; the four vertical furrows on one side and the four on the other, eight in all, that represent the Noble Eightfold Path; the five horizontal strata on the one side, representing the five aggregates of human experience, while the five on the other side represent the Five Precepts of the Bud-

Proposed **Temple of Meditation,**
Indore, 1936
A, B. Location of **Birds in Space,**
pencil on paper, 21 × 26.5 cm.
C. **Bird in Space** in niche, pencil,
33.7 × 48.7 cm.
D. Plans for three niches, pencil on
paper, 33.7 × 48.7 cm.
E, G. **Bird in Space,** pencil on
paper, 26 × 20 cm.
F. **Bird in Space** and **The Kiss,**
pencil on paper, torn at upper left,
26 × 20 cm.
H. Exterior of the monument, pencil
on paper, 26.5 × 43 cm.
Archives I–D

219

dhist faith. The hollow eyes represent profundity of thought as much as they do the nothingness into which everything in this world of dust is ultimately absorbed.

"We should point out that in conventional iconography the Buddha is usually depicted as being seated on a lotus blossom that serves as his pedestal; whereas in Brancusi's sculpture this same flower sits on the Buddha's head, like a crown, to signify the summum bonum of Buddhist doctrine, namely, Nirvana, the state of perfect bliss, the total extinction of care and suffering."

A letter from the Tate Gallery in London was forwarded to Saint-Raphaël, where Brancusi spent the entire summer. On October 1, he signed a lease for a fourth studio adjoining his other three on Impasse Ronsin.

Brancusi told the following story to explain his title of *The Miracle* for a white marble sculpture he finished this year. "The daughter of two of my American friends was in my studio one day. She had just been through an unhappy love affair. She was despondent and contemplating suicide. Once the thought of suicide crossed her mind, a kind of great black hole

kept beckoning her; try as she might to brush it aside, it always came back. I was fond of her, so I started to explain to her the meaning of life and love, to dissuade her from her fateful decision. Shortly thereafter, we were at the seashore. All of a sudden she rushed toward the waves, dived in, then bounded out of the water, calling, 'It's a miracle, Brancusi! I'm cured!'" Thus *The Miracle* was a natural title for the sculpture that her outburst of joy had inspired. Later it became known as *The Seal*. In 1943, he entitled a version in blue-gray marble *The Seal* (now *The Seal* II).

Preliminary studies for **Temple of Meditation.** 27.5 × 42 cm., each. Archives I–D

Opposite page:
The Seal (Miracle). 1924–36. White marble. The Solomon R. Guggenheim Museum, New York. Photo Brancusi (Cat. no. 204a)

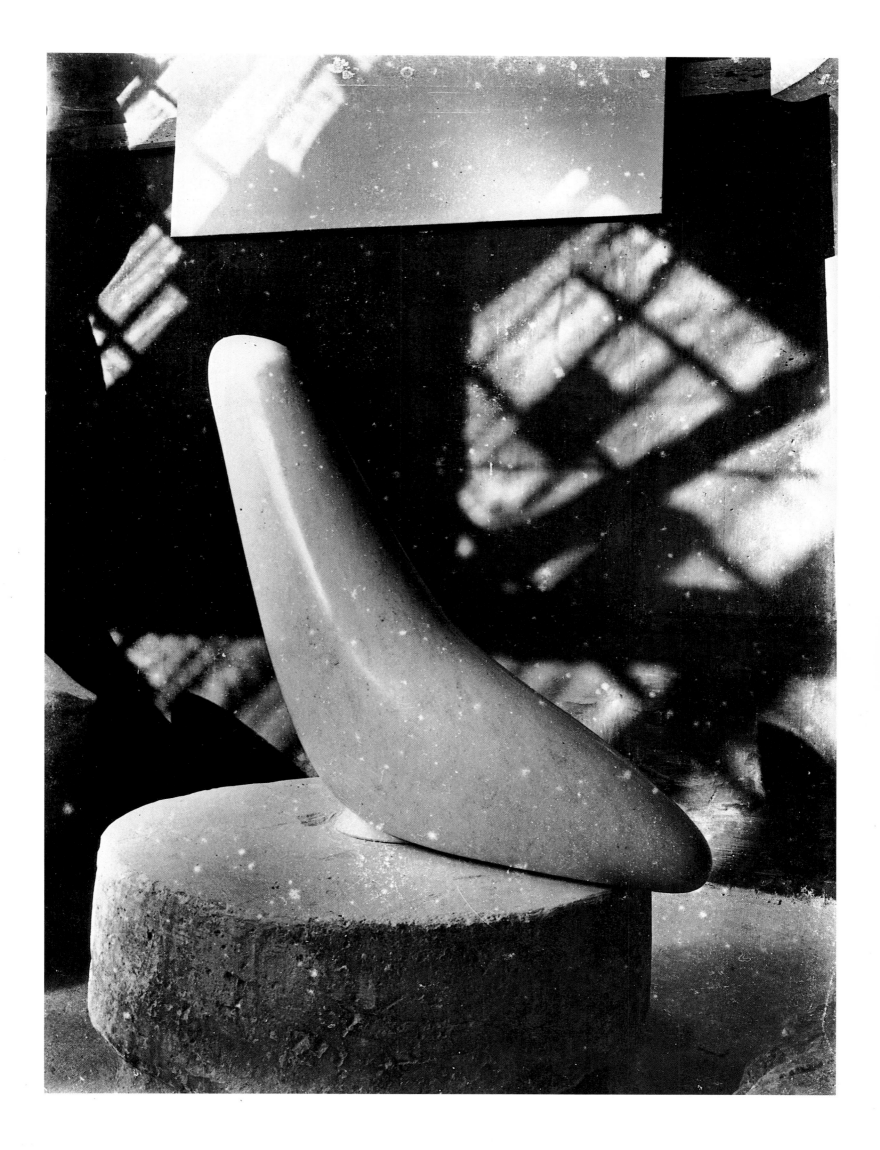

1937

In a letter dated February 2, Professor Gusti, the government official in charge of the Rumanian pavilion at the 1937 Exposition Universelle in Paris, reminded Brancusi that a room would be set aside for his sculpture.

Despite social unrest and frequent delays in construction, the Paris Exposition of 1937 proved to be a momentous event. Here Dufy created his enormous *La Fée Electricité*, while Robert and Sonia Delaunay made reliefs and other decorative work for other buildings. The Palais de Chaillot and the Palais de Tokyo were built for the occasion, and the pavilions of Hitler's Germany and the Soviet Union, both equally conventional, faced each other at the far end of the Pont Alexandre III, as many still recall.

The opening of the Rumanian pavilion was marked by folk dancing, a panpipe recital, and concerts, including one on June 12, with violinist Lola Bobesco and the distinguished musician Georges Enesco, at which Brancusi was present. Although the agreement called for Brancusi to build an *Endless Column* in the garden of the Rumanian pavilion, there was not enough time to see the project through. In the end, Brancusi showed at the Exposition Universelle only *Little Bird*.

The sculptor was caught up instead in another project: the complex at Tirgu-Jiu. He had long dreamed of creating sculpture for a vast out-of-doors setting. The person who turned that dream into reality, Prime Minister G. Tătărăscu, was, like him, a native of the Tirgu-Jiu region. Brancusi arrived in Tirgu-Jiu on July 25, if the statements of project engineer Stefan Georgescu-Gorjan are accurate, to select the site for a memorial to the Rumanian troops that

in 1916 had driven back the German offensive on the Jiu River. More interested in conveying a spiritual message than in commemorating armed conflict, the artist decided on the site of the old hay market, not far from town. "Ever since [I left] Paris," he calmly told the members of the committee, "my mind has been made up. The monument will be an *Endless Column*." He displayed a photograph of a sketch of the column.

While in Tirgu-Jiu, Brancusi stayed with Georgescu-Gorjan, whom he meanwhile recruited to work with him on the project. Years earlier, before leaving for Paris, he had carved a bust of Stefan's father (now in the Muzeul de Artă R.S.R., Bucharest), and during trips to Paris in 1934 and 1935, Stefan visited the sculptor, offering interesting technical suggestions about the building of *Endless Column*. Now that Brancusi needed a

for site specific

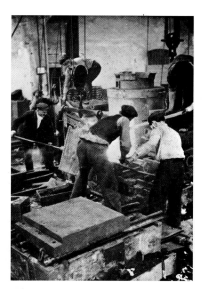

Foundry, Bucharest, 1937. Archives I–D

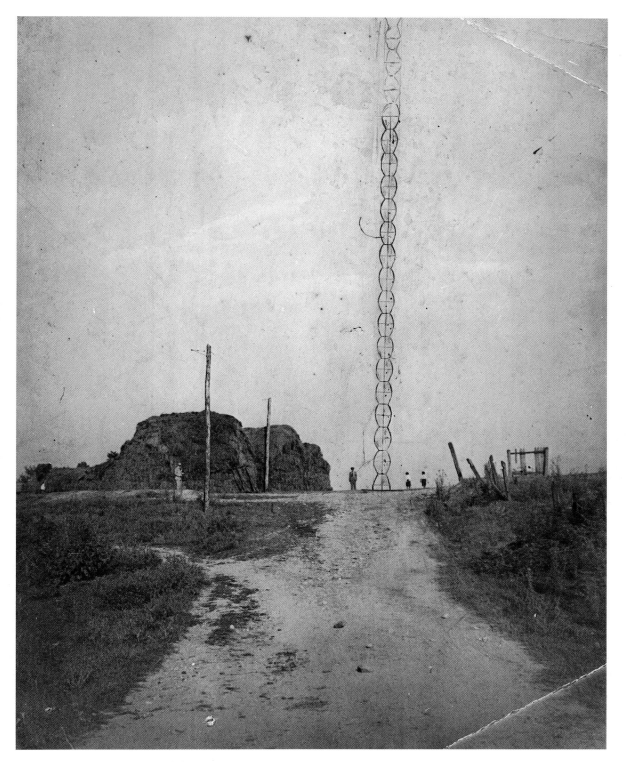

partner, Georgescu-Gorjan was his logical choice.

One morning in late July, he photographed the proposed site and drew a sketch of the column on it. He submitted this picture to the National Women's League of Gorj. Next, a decision had to be made concerning height. Using the sketch, Gorjan estimated eighty-five feet, then, after more detailed calculations, one hundred feet. The sculptor was delighted, for that was the figure he had in mind.[32] (Actual height of column: 29.33 meters, or 95 feet $5\frac{1}{2}$ ins.) Later on, when he drew up plans for an *Endless Column* in Chicago, he specified heights in the order of 60, 90, and 120 meters.

The Jiu, which flows nearby along a park, inspired Brancusi to design a complex of sculptures that would be attuned to these surroundings. Among the trees close to the river he could already see *Table of Silence*; in the distance, *Gate of the Kiss*; and at the far end of a long walkway, *Endless Column*, soaring heavenward on the site of the old hay market. Midway between the proposed column and the *Gate* stood the Church of the Holy Apostles, the white stone replacement of the wooden structure of 1747 that had burned down. Brancusi had no choice but to include this church in his project—another example of how environment determined the overall configuration. The

Study for **Endless Column,** Tirgu-Jiu. Sketch over photograph, 1937. Brancusi is visible at left. Fifteen modules and two half modules are clearly outlined, and Brancusi sketched in three more modules and two half modules. He may have been trying to ascertain the most suitable height for the setting, perhaps contemplating an even taller version. Archives I–D

Tirgu-Jiu trilogy is a self-contained organism tailor-made for its location, not, as some have alleged, a reflection of the obelisk in the Place de la Concorde and its incongruous companion, the Carrousel des Tuileries.

Needless to say, the *Endless Column* at Tirgu-Jiu was developed from the first wooden example Brancusi had made for Steichen's garden in Voulangis. The sculptor simply made it taller by adding modules and lengthening the bottom module so that it would not seem to be sinking into the ground.

Each module would weigh nearly a ton, bringing the total weight of the modules to over $15\frac{1}{2}$ tons. With the steel core alone weighing over 16 tons, the total weight of *Endless Column* would be slightly over 32 tons. Inside the column there would be four lightning rods, and the half module at the top would be capped with a waterproof plate to serve as a terminal piece and keep rainwater from seeping in.

Although the modules were completely assembled by November 1937, the scaffolding remained in place until July 1938 to accommodate the Swiss firm in charge of plating the cast-iron modules with yellow-gilded copper.

Each module is based on the proportion 1:2:4. The width at the base ($17\frac{3}{4}$ ins.), when doubled, yields the width at the widest point ($35\frac{1}{2}$ ins.); quadrupled, it yields the height of the module (71 ins.).

The first step was to carve a basswood model from which each module would be cast. Several days passed before Brancusi was heard to exclaim, "I've got it! I've found the form!" He shut himself up in a room with the carpenter who was supposed to assist him, though their work proceeded at a snail's pace, and the uneasy Georgescu-Gorjan asked the carpenter what was happening. "I sharpen an axe, and this gentleman keeps on checking to see if it cuts well. But I don't know what he intends to do. He doesn't tell me anything." Eight days later, the engineer inquired again. "I go to work every day," he replied, "but I still don't know what he intends to do. I get the feeling he doesn't, either." As Brancusi once put it in an aphorism, "Things are not hard to make. The hard part is getting into the mood to make them." The carpenter was getting a chance to witness this firsthand.

No sooner had Brancusi found the right proportions for the module than obligations associated with the *Temple of Meditation* called him back to Paris. He left a note for Georgescu-Gorjan:

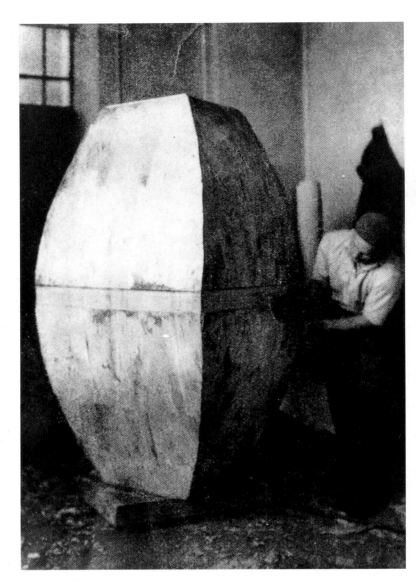

Worker with a module of **Endless Column.** Archives I–D

"My dear Georgescu,
"I met Mrs. Tătărăscu today. The iron has been ordered and will be here in a few days. You will be getting 50,000 lei so you may start work on the foundation right away. For galvanizing

Modules of **Endless Column.** Archives I–D

or the other procedures we need, contact Mrs. Tătărăscu; she is in charge of payment for the work. [The money had not yet been deposited in Tirgu-Jiu.] Apart from work-related outlay, you will be personally compensated for services rendered...."

At Mrs. Tătărăscu's request, on the way back to Paris he stopped off in Bucharest to see

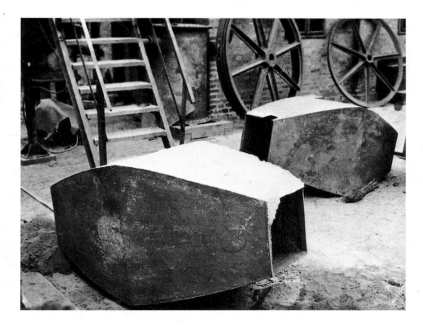

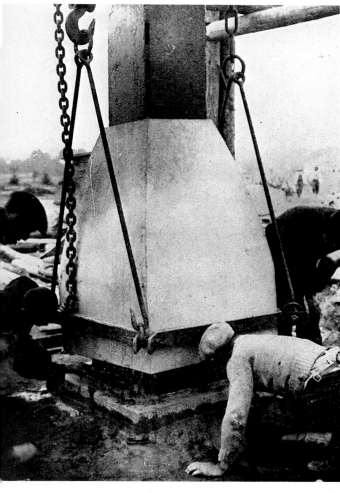

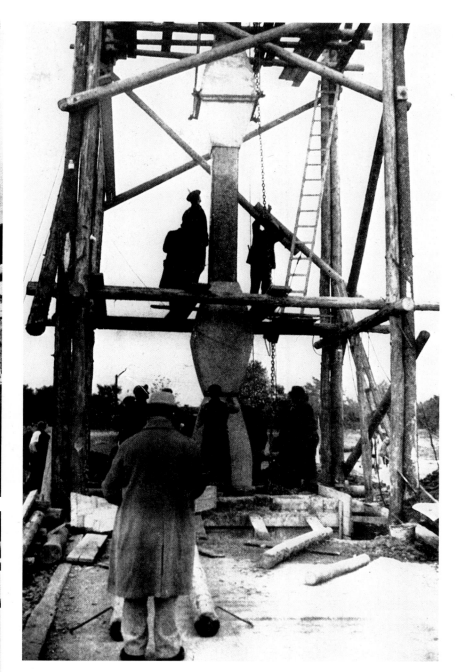

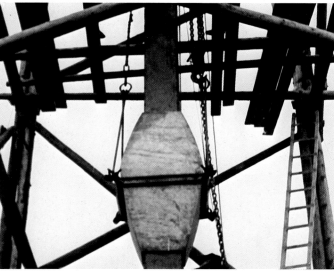

Installation of first modules of
Endless Column, Tirgu-Jiu. Photo
above shows Brancusi in
foreground, seen from the back.
Photo rights reserved. Archives I–D

Dedication of monument at
Tirgu-Jiu, 1938. Photo rights
reserved. Archives I–D

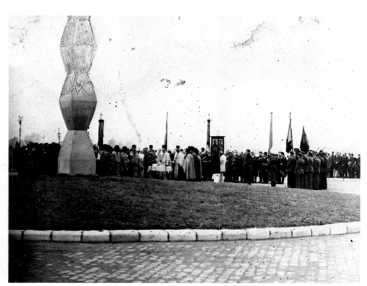

Endless Column. 1938. Cast iron and copper. Tirgu-Jiu, Rumania. Photo Brancusi (Cat. no. 205)

Mrs. Goga, the widow of a Rumanian poet, about the possibility of making a monument for her late husband.

From Paris he telegraphed to the engineer about *Endless Column:* "The plating must be yellow. Have you cast the modules?" Soon after, a letter dated September 3 informed him that "the wooden module was finished two days ago." The casting of the first metal unit was about to begin. Other letters kept the sculptor posted on the progress of the work.

Brancusi had left instructions that, while he was away, a pit would have to be dug to contain and conceal a cement cube, each side measuring 16½ feet. Into this would be set a square, hollow steel rod; a second and then a third rod would be placed on it to form a pylon-like internal support. From wooden scaffolding that would rise as work progressed, the metal modules would be threaded successively onto the three superimposed shafts like so many pearls.

Georgescu-Gorjan wrote Brancusi the following letter from Petrosani on October 12, 1937.

"Dear Mr. Brancusi,
"... Of the fifteen whole modules and two half modules, I have ten and one half ready. I am going to cast one more whole module and the bottom part (half module and base).

"I have already sent the metal pylon to Tirgu-Jiu, but the problem is that the people [at the building site] have done practically nothing. Mrs. Tătărăscu and I stressed the importance of finishing the excavation for the foundation, but they were not equal to the task. That is why I dispatched my men out there, so that something so simple would not delay the opening. The worker in charge of the metal plating arrives here Sunday, and he will start work on this final procedure. The plating will be done with bronze, not brass...."

Georgescu-Gorjan wrote him another letter from Petrosani on October 18, 1937.

"Mr. Brancusi,
"... When I asked the engineer from the Metalizator Company for information, I was told in person and in writing (I'll show you the letter) that the column must not be coated with brass because it turns dark in the rain, the way pig iron does. Mrs. Tătărăscu was for using bronze. Her opinion notwithstanding, I ordered both bronze and brass wire. However, upon receipt of the order, the people at the factory advised me not to use anything but bronze. I stressed that it had to be the yellowest bronze possible, not

226

dark bronze, and I hope you'll find the color to your liking. I started the plating just this morning, and I hope to have it finished in three or four days. I ran up against tremendous problems with the foundation (it rained for twenty days on end), but I sent my men [to the site] so that work could proceed night and day.

"... The first piece (almost ten tons) was loaded on an iron carriage drawn by two Caterpillar tractors (like in the Sahara) and escorted by two powerful trucks. At first, the problems seemed insurmountable—the carriage broke along the way, and the differential of one of the trucks gave out.

"The operation took three days, but I finally accomplished it. The other two sections of the framework are lighter and will not take as long to get there.

"The modules of the column are coming along: I have 13 and one half ready (I'm still short two whole ones and the half module for the top).

"... As for the welding of the column modules, I had planned to attach a collar, but I decided against it for fear that wind oscillations would cause it to break. The surfaces are so carefully finished where they touch that they fit perfectly when placed on top of each other. The modules are fastened to the inner shaft with iron pins.

"Anyway, given everything I've told you, you'll see for yourself once you get here that the problems I had to overcome were really formidable. The exterior (metal plating), technically speaking, was nothing compared to the problems with casting (manufacture). If the color doesn't appeal to you, it will be easier to change once you're here.

"I look forward with pleasure to seeing you on October 25.

"With kindest regards,

Georgescu-Gorjan"

Meanwhile, work on the foundation of *Gate of the Kiss* had gotten under way. Brancusi, not yet back in Paris, sent Mrs. Tătărăscu measurements for the stones to be used for the *Gate*, along with two plans and a photograph indicating exactly how the stone was to be carved. Mrs. Tătărăscu wrote back that she had ordered the stone from Deva [mountainous region north of Tirgu-Jiu] in accordance with his specifications. They were delivered on October 25. On the 27th, Brancusi arrived in Tirgu-Jiu and stayed at the Hotel Regal for two weeks. He looked on as the first modules were fitted onto the internal shaft. Walkways had been laid out, and necessary purchases of land were well under way. The sculptor attended both the dedication of the completely restored

Sketch for **Table of Silence.**
Archives I–D

Church of the Holy Apostles and a luncheon given by the National Women's League of Gorj.

The plans for *Table of Silence* called for two circular slabs of stone, the larger one atop the other; around them, spaced uniformly, were twelve stools, each made of two hemispheres. But work on this proceeded without him, for he returned to Paris, by way of Bucharest (November 10–14, Athénée Palace Hotel), to make preparations for his trip to India. At 3 P.M. on December 18, the *C. Biancamano* (registered with Lloyd Triestino, an Italian line) sailed from Genoa, bound for Bombay via Naples. Brancusi was first-class passenger No. 439. While on board, he bought himself a colonial hat, a pair of shorts, and a handsome silk jacket. "*Ho visto il signor Branca*," exclaimed a saleswoman who recognized him, "*come sta elegantissimo!*" The voyage brought 1937 to a joyous close, a year that had witnessed, among other events, the honor of being named (along with Braque, Eluard, and Léger)

Brancusi's reply to his being named a judge for the Prix Helena Rubinstein competition sponsored by the Ministry of Education. Archives I–D

to the jury of the Prix Helena Rubenstein, a 25,000-franc prize awarded, under the auspices of the Ministry of Education, to a French or non-French artist. It should also be mentioned that on May 22, the Mánes Union of Artists in Prague had unanimously elected Brancusi a corresponding member, and, on June 10, asked him to send one or two works to an exhibition scheduled to open in Prague that fall.

The sculptor had been complaining to Henri-Pierre Roché about his poor health and mentioned that one day he might need an operation for appendicitis. Roché suggested a Dr. Carton, who was not easy to reach but who finally gave Brancusi an appointment in Brévannes on April 20. "It is essential," the doctor wrote, "that you bring along a list of all the foods you have eaten at every meal during the past few days." He examined the artist. "Leave

your appendix alone," he advised. "Follow the diet I'm going to give you and read my books." So, to Brancusi's bedside collection were added *Traité d'Alimentation et d'Hygiène naturiste* (1920), *La Science occulte et les Sciences occultes* (1925), *La Cuisine Simple* (1925), and, later on, *Le Guide de la Vieillesse* (1940).

To his dying day, Brancusi followed the precepts of a man who, as far as he was concerned, had grasped the real meaning of life; an initiate, anxious to help others. He copied down the doctor's prescriptions and lived by them, after a fashion. "Are you religious, sir?" the doctor once asked the artist. "I don't know," he replied, caught off guard, "I am Orthodox Christian. I never asked myself." The question intrigued him, and when he went back to see Dr. Carton, he said, "Doctor, I've given it a lot of thought. I can assure you that I am religious."

Brancusi to the Rumanian prime minister's wife, Mrs. Tatarascu: "Dear esteemed Madame, I am sending you a sketch of the proposed Gate. I should have liked to get it to you sooner, but it was impossible to do so. As it now stands, the Gate is to be located a little way inside the garden so that people may walk around it, with a stone bench at the right and left, on the shorter sides. If placed at the very edge of the walkway, as we [originally] decided, it would not have much use either as an enclosing component for the garden or as a visually independent entity. Georgescu wrote me that you sent a letter I supposedly did not answer. Please believe me when I tell you that I received no such letter; and would you kindly send [future] correspondence by registered mail to the following address: 11, Impasse Ronsin (152 Rue de Vaugirard), Paris XVe. [Letters often got lost due to confusion between Rue Amiral Roussin and Impasse Ronsin, both in

the fifteenth arrondissement of Paris.] I am sending you a photograph to help you visualize the upper frieze. I am working on a model I intend to send to you; perhaps I'll bring it with me myself...."

Later, again from Brancusi to Mrs. Tatarascu: "Dear esteemed Madame, Yesterday I mailed you a tube with two sketches of the proposed Gate and a photograph to give you an idea of how the stone should be carved.... I did not have enough time to work out the project in its entirety, but in a few days I'll be there with models for carving the stone. In the sketches I sent yesterday there is a minor mistake in the measurements for the frieze, and today I am sending you another sketch with the correct measurements so that you may order the stone.... Hoping that everything will proceed smoothly now. Sincerely yours, C. B."

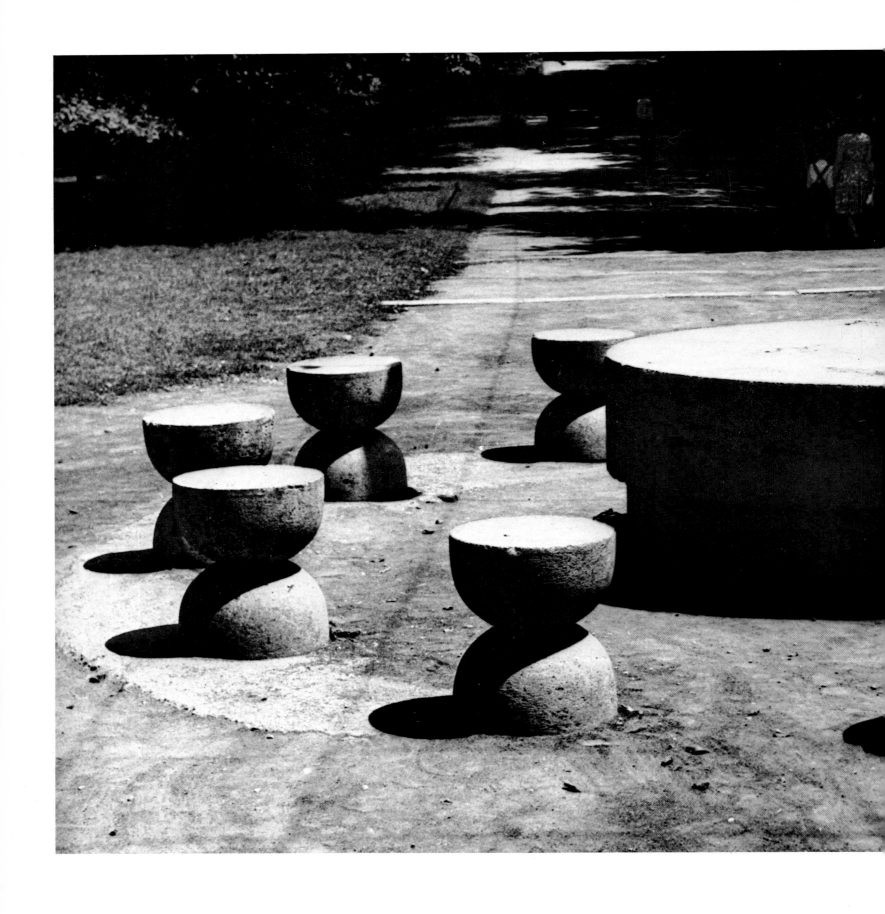

Table of Silence. 1937–38.
Bampotok limestone. Tirgu-Jiu,
Rumania (Cat. no. 207)

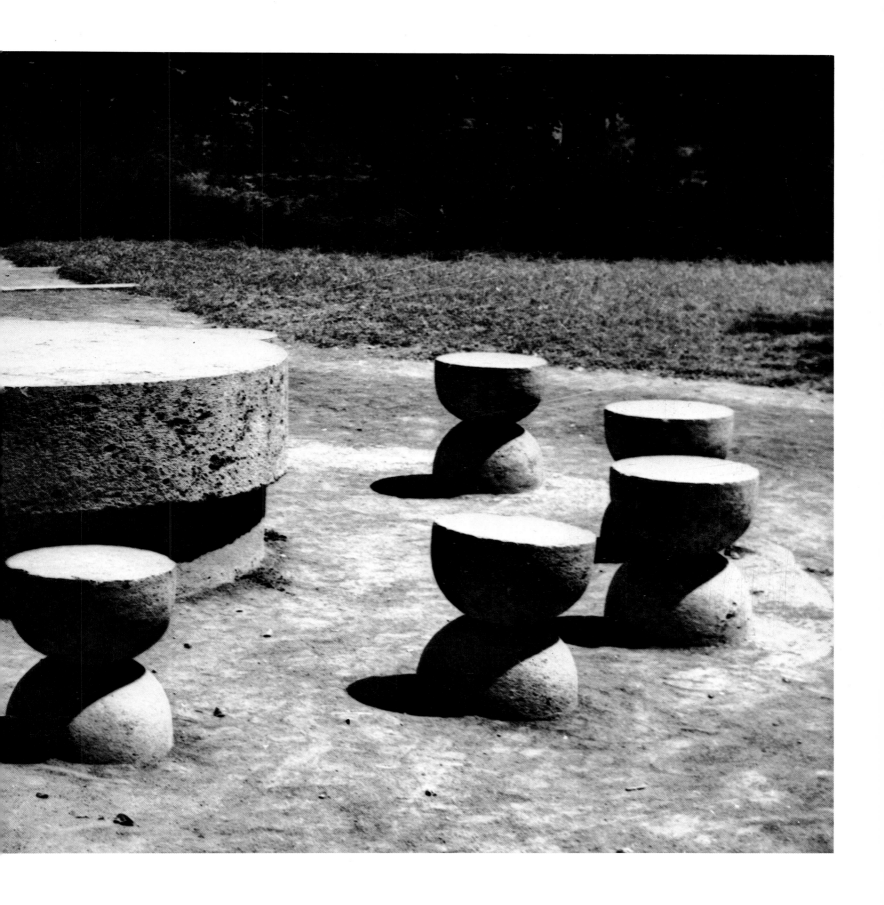

1938

Brancusi went ashore at Bombay and made his way to Indore, only to find the Maharajah gone. Several explanations have been suggested for his absence, but Brancusi himself later told us this version. A hunt and lavish procession had been planned before, and Brancusi had been invited to take part, but he was detained by his obligations in Rumania; when he failed to get to India in time, the Maharajah had to leave without him.

The prince had left instructions with the dignitary who welcomed Brancusi to Indore that his guest was to stay in the palace, use the car and chauffeur whenever he liked, wash with mineral water, and feel free to tour the area. While there, he decided to clean the sculptures the Maharajah had bought from him in his studio; he also changed one of the supporting pins. He found that the Indian civilization was indeed consistent with his spiritual beliefs, though sadly nothing ever came of all the planning for the *Temple of Meditation*. As the dignitary bid him good-bye, he asked if Brancusi had a pleasant stay. "Everything was perfect," he replied, "except that there were two beds in my magnificent bedroom, and the second one was always empty."

After a two-day stay at the Taj Mahal Hotel in Bombay, Brancusi sailed from India on the same ship that had brought him. He reached Suez on February 3 and made an excursion to Cairo to see the city, explore the museums, and, of course, visit the Sphinx and the Pyramids. "For all their size, [the Pyramids] are so flawlessly proportioned that they do not overwhelm us. When you see them, you get the feeling that you can hold them in your hand. They seem big and small at the same time." The Sphinx looked to him like something from a different civilization.

Ezra Pound had telegraphed to Brancusi that he would meet the boat in Genoa, but a scheduling change thwarted their plans. The Maharajah, for his part, was on the Riviera, but indisposed, as Brancusi learned in a letter from Roché of March 19: "Our Hindu friends have been ill; first the father, then the little princess. I had to go to Nice for two days. She's feeling all right now. Her father will start to go out again, I think, and I do hope he will feel well enough to come and see you." But Brancusi and his patron were to miss each other again.

Many years later, after he had lost his fortune, the prince visited Brancusi in his studio (the Maharajah was living in London at the time, and never failed to send the sculptor yearly greetings). Roché wrote in "Souvenirs sur Brancusi" (*L'Œil*, May 1957), "The Maharajah came back so that Brancusi and he could share a look at the model of the abortive temple. There they sat, legs folded in lotus position, just like the first time. They didn't say a word."

Fortunately, there was Tirgu-Jiu. On May 17, his goddaughter Alice sent a postcard to let him know that she had seen *Endless Column*; it was finished, but encased in scaffolding. What strength! What a feeling of infinity! And how beautiful the *Gate of the Kiss* was!

Two letters—one from Mrs. Goga (June 5) inviting him to the poet's house in Ciucia, another from a painter, Ressu, who wanted to see his old friend again—indicate that Brancusi was back in Rumania for a visit in June.

On July 29, a Rumanian friend informed the sculptor that work on the *Gate* and *Endless Column* "has been finished since yesterday. After the scaffolding in the park was removed, they began laying stones at the entrance, and today they're dismantling the scaffolding around the column, which is now free and majestic. Mrs. Tătărăscu stopped by these past few days to see how the work was coming along, and she was for putting flowers in along the sidewalks from the curch to the *Gate*." In the meantime, the Pietroasa firm had ordered benches and chairs of a Transylvanian limestone called *bampotoc* to complement the monuments.

Brancusi arrived in Tirgu-Jiu on September 20. The dedication was scheduled for October 14 but did not take place until the 27th. The newspaper *Gorjanul Tirgu Jiu* published an account of the proceedings, which were presided over by Mrs. Tătărăscu. "The ceremony, which took place in rainy weather, was held under the auspices of General Romulus Scorisoreanu, who had arrived the day before with Colonel Brosteanu, police inspector of Oltenia. The prefect, mayor of the town, the Bar, the Bench, and war veterans were present at the solemn occasion.

"At nine in the morning, sixteen priests celebrated mass, after which the *Endless Column* was sprinkled with holy water. The gathering then made its way toward the Church of the Holy Apostles, where a mass was celebrated in memory of those who had defended the district of Gorj. A last religious service was held in honor of the *Gate*. Then came the speeches. The district prefect, among other speakers, expressed his gratitude to Mrs. Tătărăscu, the moving force behind the extraordinary group of monuments that now enhance the town, and sang the praises of the artist, that great sculptor and native son of Gorj, who has expressed in iron and stone the country's gratitude to the heroes of the Resistance."

In Rumania, the talk was all of

Brancusi and the monument. The director of the Carol I Foundation was planning to publish a book on his work with a text by the sculptor. Brancusi gave the project his blessing, but the next war was to decide otherwise; the book never came out.

He was also approached about the possibility of a one-man show at the upcoming 1939 New York World's Fair. Gusti, the man in charge of the Rumanian pavilion, and Alfred Barr, director of the Museum of Modern Art in New York, pressed him repeatedly about it, assuring him that Americans would be honored to have such an exhibition take place in the United States.

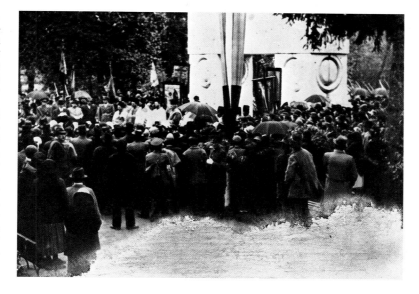

Dedication of **Gate of the Kiss,** Tirgu-Jiu, October 27, 1938. Photo rights reserved

Below:
Gate of the Kiss (with scaffolding). 1937–38. Bampotok travertine. Tirgu-Jiu, Rumania. Photo Brancusi (Cat. no. 206)

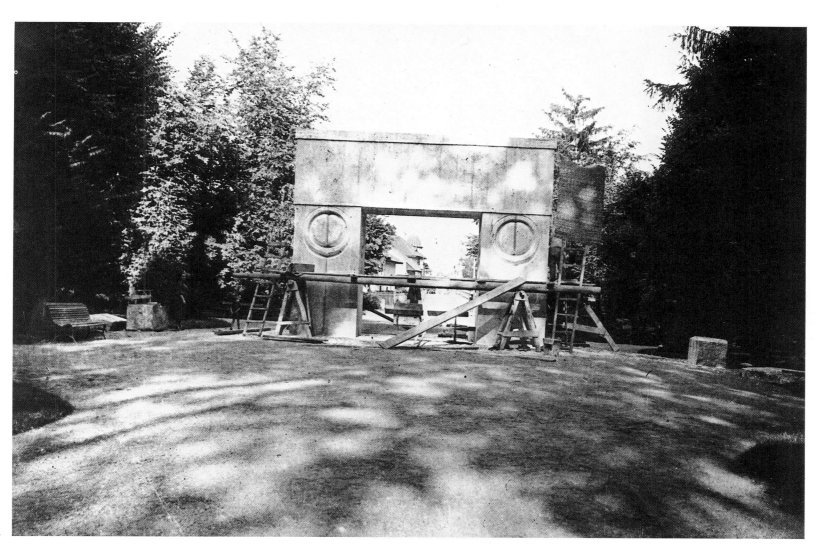

All of these activities kept the sculptor busy, but he still found time to take part in a number of exhibitions. He sent *Fish, Leda, Portrait of Nancy Cunard,* and *The Newborn* to the exhibition "Abstracte Kunst" in the Stedelijk Museum, Amsterdam, from April 2 to April 24. The catalogue included a photograph of *The Miracle* as well as articles by Mondrian, Kandinsky, and Prof. Siegfried Giedion, among others. The show also featured work by Arp, Calder, Delaunay, Kandinsky, Klee, Léger, Moore, and Pevsner.

From March 22 to April 22, the Guggenheim Jeune Gallery in London was the site of a sculpture exhibition with work by Brancusi, Laurens, Pevsner, Duchamp-Villon, Jean Arp, and Calder. To this Brancusi sent *Beginning of the World* (marble), *Penguins* (marble), and *Chimera* (wood), according to the *Daily Telegraph,* March 22, 1938, and the *Manchester Guardian,* April 18, 1938. Curiously enough, his sculpture met the same problem at British customs that *Bird in Space* had had twelve years earlier in the United States. They would not let it into the country duty-free.

It is interesting to note that in 1938 Brancusi bought three circular mirrors; he had pioneered the use of mirrors as bases for sculpture as early as 1922 (*Fish,* Arensberg Collection, Philadelphia Museum of Art). He also bought three hundred and fifty sheets of paper. And this year Alexis Rudier cast for him a bronze *Bird in Space* measuring six feet high (invoice of March 16, 1938).

The year ended with this telegram from Alexina and Pierre Matisse in New York: "Send bronze *Fish* Lenars. Stop. Confirm and I'll send 1,000 dollars at once. Stop. Happy New Year."

*les arts n'ont jamais exister pour elle même (dans tous les temps) (elles n'ont été que d'
apannage religion*

*Pour faire d'art libre et universelle
il faut être Dieu pour créer Roi
pour commander et esclave pour
exécuter*

1939

While Brancusi basked in the euphoria of Tirgu-Jiu, the first rumblings of the coming war were being heard throughout the world. The sculptor decided that 1939 would be the year to travel to the United States. For one thing, a one-man Brancusi show was to be a highlight of the Rumanian pavilion at the upcoming New York World's Fair.

However, according to a report to Gusti from Andrei Popovici, a government official, the organizers of the Brancusi exhibition felt that the Rumanian pavilion would not do his work justice, and looked for a more appropriate setting. They got in touch with the Metropolitan Museum of Art in New York whose curator, a Brancusi admirer, referred them to Alfred Barr, Jr., director of the Museum of Modern Art.

Alfred Barr at once invited Brancusi to show two works in the large exhibition "Art in Our Time," celebrating the opening of the new museum building and running concurrently with the World's Fair. Furthermore, he proposed to schedule an all-Brancusi exhibition in 1940, when "Art in Our Time" had closed in the Art Institute of Chicago, where it was shown after New York. Unfortunately the outbreak of World War II, with the dangers to transatlantic shipping, rendered it impossible to arrange this exhibition.

The Museum of Modern Art had already acquired a *Bird in Space* in 1934, and it was agreed that Brancusi would send *The Seal* to the "Art in Our Time" exhibition. The sculpture consisted of the marble work itself and two circular stone bases, a transformer, and a set of ball bearings on which the subject could slowly rotate, powered by a motor that the artist thought was so fragile he carried it with him to New York.

The marble and two bases were sent on April 12, 1939; Brancusi boarded the *Paris* on the 19th. He checked into the Brevoort Hotel and found a notice acknowledging receipt of his shipment waiting for him. In May, he relocated to the Hotel St. Moritz. Brancusi spent about a month in the United States and did not waste a moment. On May 5, he went with Florence Meyer out to the opening of the Rumanian pavilion at the World's Fair. The "Art in Our Time" exhibition, which included *The Seal* and *Bird in Space*, opened on May 10. On the 24th, he attended the

Brancusi with Prof. Siegfried Giedion and Marion Willard, Long Island, New York, 1939. Photo rights reserved

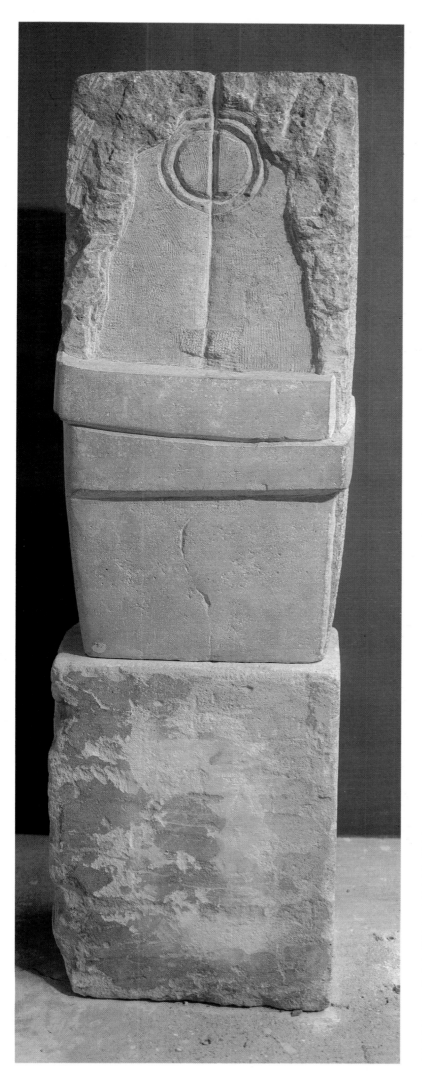

opening of the French pavilion at the fair. There were meals with friends (Patrick Hill, Katherine Dreier, Adele B. Norton) as well as excursions to visit attorney Maurice Speiser in Philadelphia and Marion Willard in Locust Valley, Long Island, where he met architect Alvar Aalto and Carola Giedion-Welcker. (In Giedion-Welcker's book we learn, among other things, that the sculptor gathered mussels, making a succulent dish of them.)

He also went out to Chicago, where he was a guest of the Chicago Arts Club. In an interview with a local newspaperman (*Chicago News*, May 27, 1939), he talked about the *Endless Column* at Tirgu-Jiu and his dream of erecting a much taller, "habitable" counterpart in stainless steel, complete with internal elevator. Each generation would add a module, making it truly a column without end. He was contemplating the shore of Lake Michigan as a site, and doubtless went to Chicago for this in the first place. Over the years, the sculptor exchanged many letters with prominent Chicagoans about this project, his love for the *Endless Column* theme undiminished. On May 25, he boarded the *Champlain* for the return trip to France.

Brancusi was well represented on the exhibition circuit in 1939. The Julien Levy Gallery in New York requested work for a show and contacted Duchamp in June. In October and November, the University of Chicago mounted an exhibition of work by Brancusi, Archipenko, Moore, and Maillol. Toward the end of the year, Brancusi sent work to the Galerie Mai in Paris for an exhibition organized by Yvonne Zervos that displayed works by Arp, González, Klee, and Laurens, as well as Brancusi.

Braun, a publishing firm, asked the sculptor to furnish them with three photographs, one of which would appear in a forthcoming book, *La Sculpture en France au XXᵉ Siècle*. Another request for a photograph came in June from E.H. Ramsden, who was preparing a book on art for Oxford University Press. An American architecture magazine, *Plus*, wished to publish several photographs of his sculpture in an upcoming issue. From various documents we also know that the founder Alexis Rudier cast a large subject (unspecified) for 4,200 francs; that Atteni, a marble dealer, cut and finished two stone bases for use with *The Seal*; that the sculptor bought an

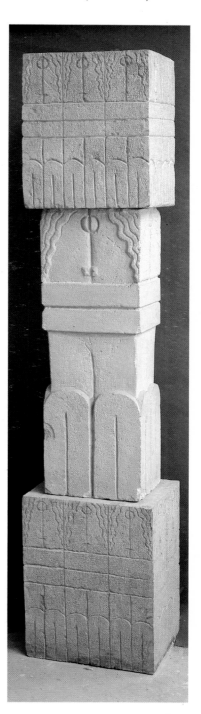

Boundary Marker. 1945. Stone. Brancusi Studio, MNAM, Paris. Photo Brancusi (Cat. no. 215)

Left:
The Kiss. 1940–45. Yellow stone. Brancusi Studio, MNAM, Paris (Cat. no. 212)

oak beam salvaged from a wrecking site and two sets of "S.K.F." brand ball bearings, one for use with the marble *Seal*; and that Brancusi's purchases this year included a gas mask!

Meanwhile, the stage was set for World War II when the Soviet Union and Germany signed a nonaggression pact in August 1939. Nazi Germany lunged into Poland, the first country to undergo the *blitzkrieg*, with its Panzer divisions and the Luftwaffe, decimating the Polish army within twenty days. On September 3, Great Britain, France, Australia, and New Zealand declared war on Germany; Canada followed suit on September 10. A chain reaction had been set in motion.

As the upheaval roiled about him, Brancusi wondered if the spirit of conquest and hate would ever give way to an age of brotherhood. The thought haunted him and crystallized in those recesses of the brain where forms patiently take shape. Once again the leitmotif of *The Kiss*, so eloquently expressed at Tirgu-Jiu, came to the fore. Amid the horrors of war, it became for Brancusi a symbol of the harmony to which all peoples should aspire. So that they would not lose sight of that hope, he made an appeal in stone: a boundary marker five feet high, with *The Kiss* motif repeated three times on the upper and lower parts of each side. Albeit now more geometric, more severe, the motif lost none of its sensitivity. It is a pity that *Boundary Marker* languishes in a museum; its full meaning would be restored if it were placed at a national boundary.

1940s: Impasse Ronsin

Late in January 1940, Mariette Mills—the friend who once offered Brancusi free use of her studio on Impasse Ronsin—invited him to her country place in Clairefontaine, seven kilometers from Rambouillet. A cousin of her husband, Gertrude Moulton, was organizing a benefit auction for French artists in the United States, and Mills wondered if Brancusi would donate a drawing.

Brancusi requested a renewal of his passport in 1940, and on June 11 the Rumanian embassy in Paris issued him one, valid for Europe and the United States. This would be his last passport, and no visas were ever stamped in it.

Now there were fewer contacts with the world outside France. In a letter dated March 28, 1940, Milan de Baumbach asked Brancusi for photographs and other material for an article to be published in Italy and Switzerland, two countries in which the sculptor's work was virtually unknown.

In cold weather, his ration of forty-four bags of coal was barely enough to heat his studios. The Dutch army laid down its arms, then the Belgian forces, and German tanks reached Paris on June 14, 1940. The subsequent armistice divided France into occupied and unoccupied zones, and many people fled southward, past the demarcation line to the unoccupied zone. Mariette and her husband pressed on down to Aveyron, and their place outside Rambouillet was "occupied by wave after wave of German soldiers." On July 29, Mariette Mills asked Brancusi if he could find a studio for her in Paris; she wished to take up her sculpture again. Could he pay the first quarter's rent? Brancusi looked around and located a space for rent at 8 Rue de la Grande Chaumière.

Benjamin Fondane, who had written a major article on Brancusi in 1929, now wrote to the sculptor from the Val-de-Grâce, where he had undergone an operation. "How I should like to get together with you," he wrote, "and spend an hour forgetting about this dreadful nightmare!"

News from the unoccupied zone was infrequent and subject to censorship; only postcards, half filled with preprinted messages, were allowed. Nevertheless, he learned that Peggy Guggenheim was in Grenoble for an exhibition of her collection at the local museum; Marguerite Duthuit also got back in touch with him in this way.

The major problem, however, was getting hold of certain materials. It was at this time that Brancusi bought large quantities of huge wooden beams from wrecking sites. In October, he made an attempt to

Brancusi's handcrafted still. Archives I–D (Cat. no. 237)

improve the heating in his studio in the manner of Rumanian peasants. He built two of those fireplaces that work for a while, then are pulled down when there is no more draft and rebuilt. In the reconstructed Brancusi studio outside the Pompidou Center in Paris, we rebuilt them again.

He also bought sheets of boiler plate, and by snipping notches every few inches along the bottom edge he fashioned a rounded firescreen and heat convector. Hardly a day went by that the sculptor did not assemble plates and pipes for his heating system.

When an adjoining studio suddenly became available in July 1941, he rented it, bringing to five the number of his studios. He noted the total volume of his studio complex—955 cubic meters (nearly 34,000 cubic feet) in all!—on the back of a receipt, probably intending to ask for more fuel coupons. In time, he cut a doorway into the new studio, which was set aside for carving wood and making plaster molds. His workbench was an old beam resting on two carved blocks of wood; an iron rod, passing through a bored opening, steadied the piece of wood he was working on.

Opposite page:
Brancusi's studio, 11 Impasse Ronsin, c. 1943: four plaster versions of **The Cock; The Cock** (polished bronze, Cat. no. 201); a **Princess X, Bird in Space** (Cat. no. 193); **Portrait of Nancy Cunard** (Cat. no. 194); **Flying Turtle** (Cat. no. 214) in progress. Photo Brancusi

Brancusi's Rumanian passport. Archives I–D

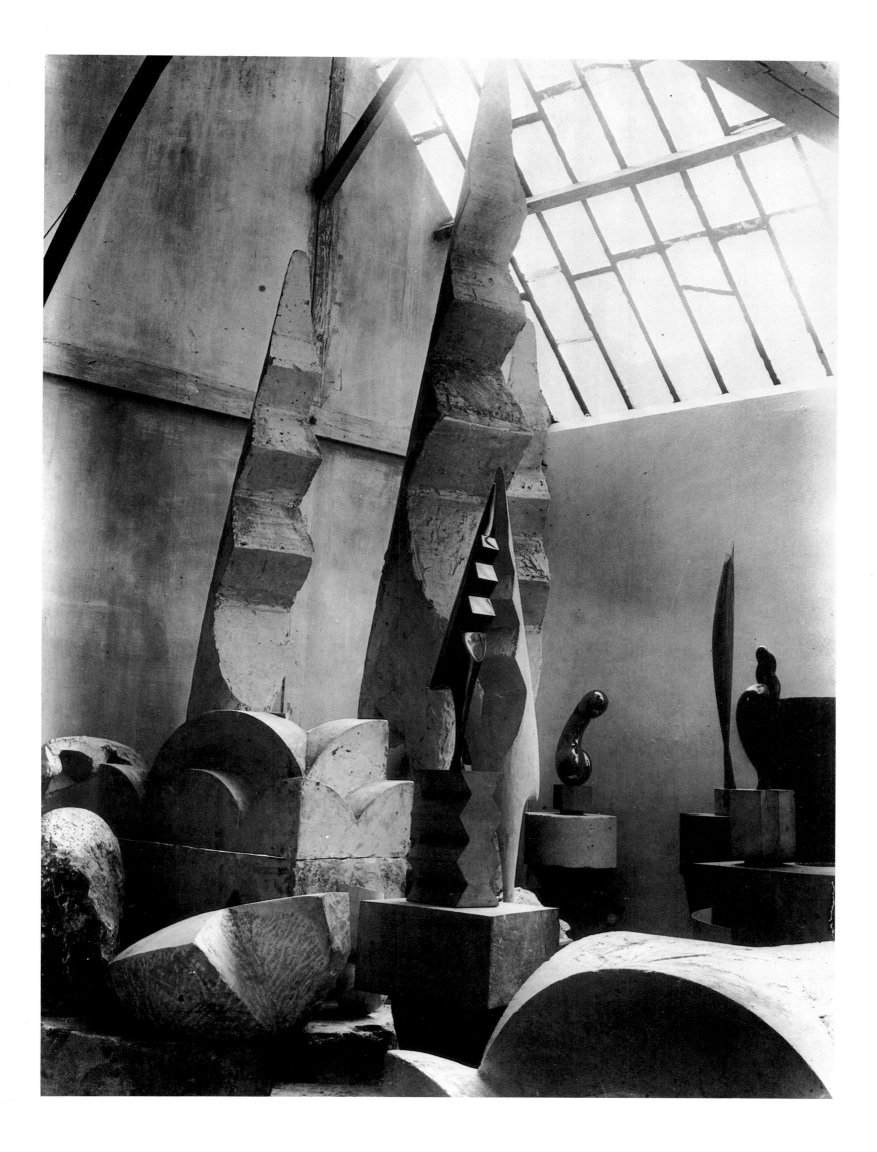

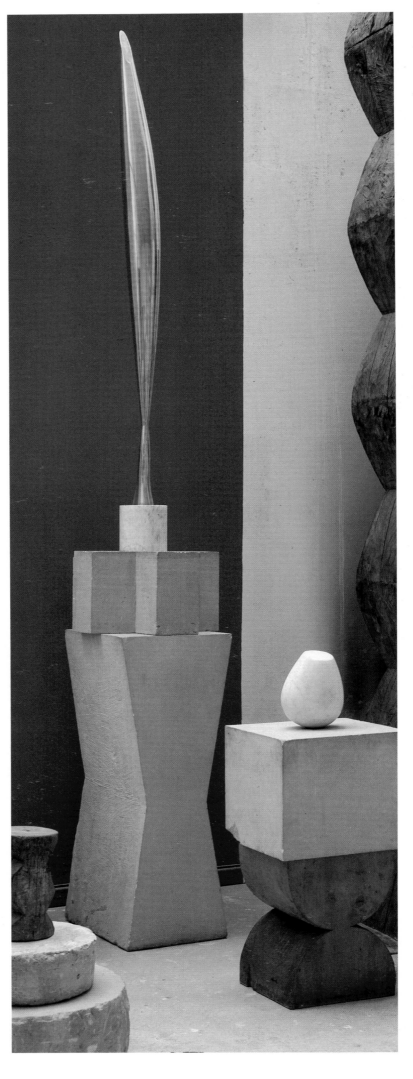

Opposite page:
Brancusi's studio, 11 Impasse
Ronsin, c. 1940–45: **Socrates** (Cat.
no. 130), **Exotic Plant** (Cat. no. 156),
Flying Turtle (Cat. no. 214), **The
Cock** (Cat. no. 201). Photo Brancusi

Installation view, Brancusi Studio,
MNAM, Paris: **Bird in Space.** 1941.
Polished bronze (Cat. no. 210a);
Torso of a Girl III. 1925. Onyx
(Cat. no. 154)

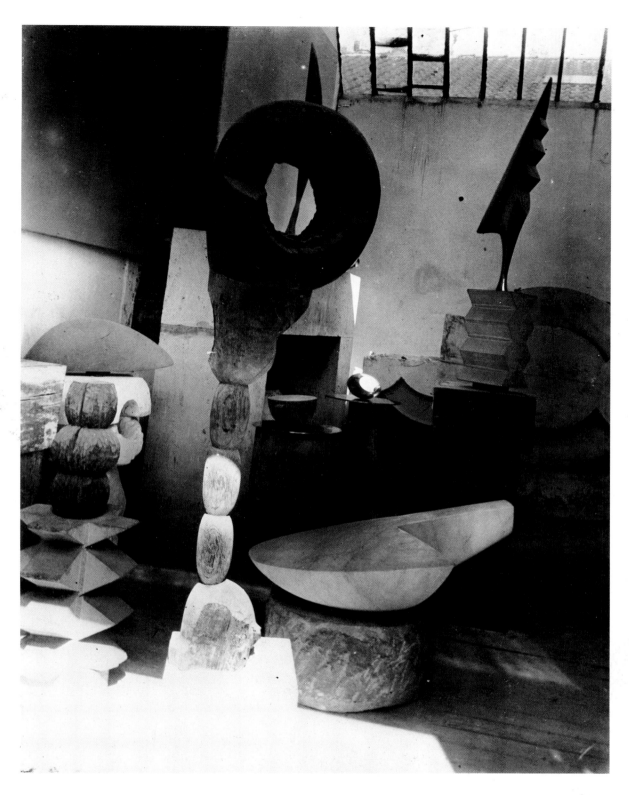

place against the Pompeian red wall facing the main door. It gleamed in the least ray of light filtering in through the transom overhead, impressing all visitors as they walked into the studio, which was Brancusi's reason for choosing this location.

In January 1942, he received a letter from the Rumanian church in Paris requesting him to get in touch with the church architect and consider the feasibility of building a crypt to serve as an ossuary for Rumanians now buried in cemeteries throughout the city. Nothing came of this project.

Modestly and unobtrusively, Brancusi lived on in his often damp studios, subsisting on bitter cabbage and on cottage cheese and cream cheese that he made. He had constructed a little still out of a large tin can and a length of coiled tubing; from wine that a friend would get for him, he distilled small quantities of alcohol. Throughout the German occupation, the sculptor regularly received food packages from Florence Homolka, the person who had inspired *The Miracle*. He would share them with neighbors, keeping only enough to ameliorate his daily diet.

Brancusi was a heavy tobacco user, and his ration scarcely met his needs. Tobacco stalks were available at the flower market, but the florist could sell only one to a customer. "Look at my beard and mustache, sir," Brancusi once said to the vendor, "they're yellow because I'm a heavy smoker. Won't you be kind enough to sell five stalks?" The vendor gave in, and Brancusi planted his tobacco stalks in a big pot of earth and cared for them lovingly. They thrived beneath the glass roof, grew to enormous size, and produced enough leaves for his pipe and cigarettes.

On March 27, 1942, one of Brancusi's friends, the sculptor Julio González, died in Arcueil.

During February, the Buchholz Gallery in New York held an exhibition entitled "From Rodin to Brancusi."

In 1943 there was a letter from Rumania: Militza Patrasco had had news of him (through a minister, then through Paul Morand) and was delighted to hear that he was in good health. She had seen Mrs. Tătărăscu, and he would be receiving provisions from both of them.

From this year date *The Turtle*, a marble sculpture, and *The Seal* II, a new, more spirited version of *The Miracle* in blue veined marble (44 inches long). Purchased by the Musée National d'Art Moderne, it consists of the marble subject upon a circular stone base that is slowly rotated by a motor, with a stationary stone slab underneath.

Brancusi never completely

Pierre Brugières, a friend, magistrate, and art critic, wrote Brancusi a letter around this time: "I often think about you and that wonderful studio of yours, that retreat where I so loved to stop by and see you and forget life's cares for a while. The lovely photographs you gave me make me very happy."

In 1941, the artist finished a polished bronze *Bird in Space* measuring 76⅜ inches high, the tallest one to date. This sculpture was accorded a special

Plan of Brancusi's studios, Impasse Ronsin

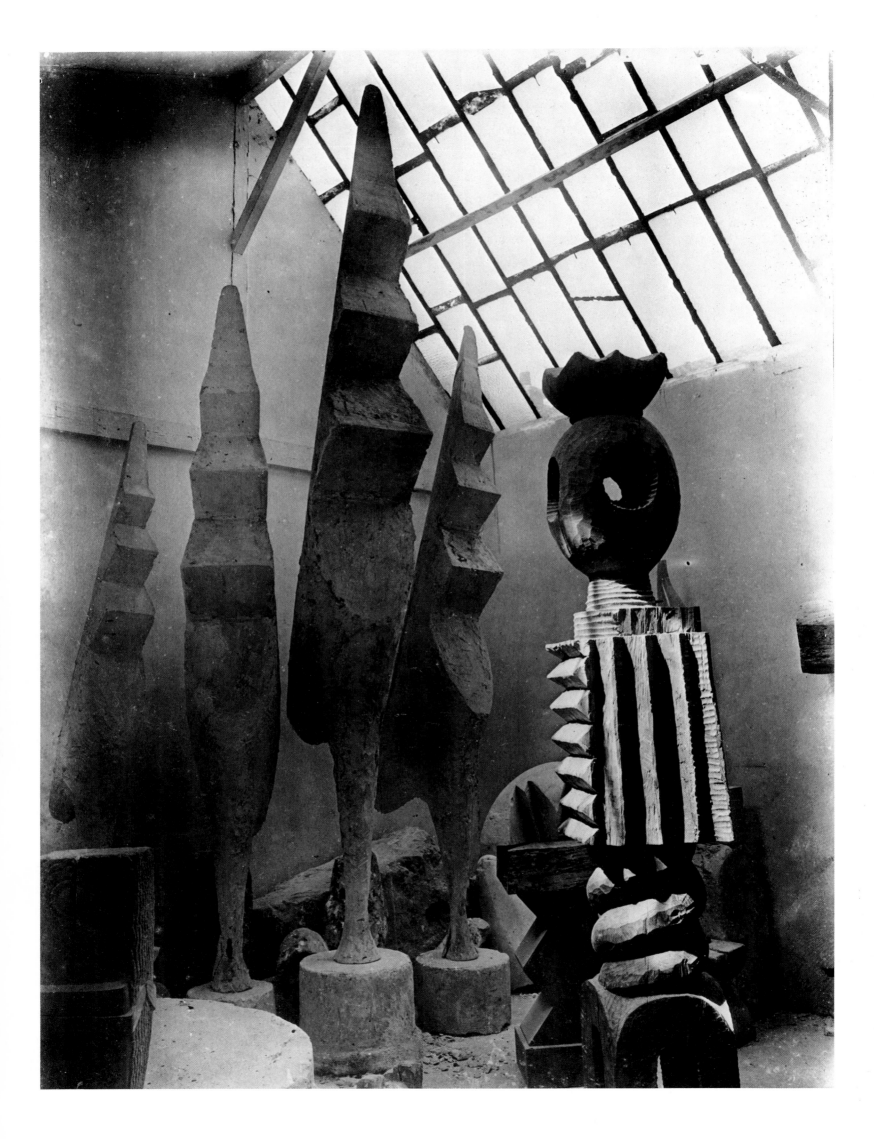

lost the Rumanian peasant's fear of legal entanglements. In 1944, he noticed that his rent receipts from his new landlord (the previous owner, Boucher, had since died) bore the unusual phrase: "No lease." Was he planning to put him out? Brancusi went at once to see Mr. Rambaud, the father of a friend of his, and this attorney advised the sculptor to send the landlord a registered letter. The disputed phrase did not reappear on his rent receipts. (On November 17, 1941, he had written to his former landlord's agent as follows: "Please advise the heirs of Monsieur Boucher that at the present time it is impossible for me to vacate the five studios I occupy at No. 11 Impasse Ronsin. With my regrets to Monsieur Boucher's heirs, I remain...")

In April 1944, Brancusi received a parcel from the United States containing photosensitive paper for black-and-white pictures (value 6,200 francs), courtesy of Florence Homolka. Clearly, the sculptor's interest in photography had not flagged, but conditions two months later compelled him to sell two cameras, for still and for motion pictures.

On June 6, 1944, Allied troops landed in Normandy. The internal revenue authorities advised Brancusi on August 3 that his assessment for essential war materials was 55 hectograms (about 12 pounds) of copper. But as the Allies advanced, the mood in Paris became less strained; liberation came on August 15. "I hope this card reaches you," wrote Pierre Matisse from New York, "with it comes our fondest thoughts and our joy over your liberation." Writing from Switzerland, Max Bill requested photographs of Brancusi's work for an article he was doing for a magazine.

Carola Giedion-Welcker had found a publisher for the book she was planning to write on Brancusi, complete with biography, photographs, plates, and "a text by you, on your thoughts about art."

This year had witnessed the deaths of Mondrian and Kandinsky, towering figures in the world of art. 1945 witnessed the collapse of the Third Reich.

1946–1949

On November 8, 1946, Brancusi received this letter from Jean Cassou, just named the director of the Musée National d'Art Moderne in Paris: "In reference to our telephone conversation, I wish to inform you that the gentlemen from the Comité des Conservateurs and the Conseil des Musées [Nationaux de France] will be stopping by at your studio at 10:15 on Monday, November 25, to have a look at the purchases I have recommended to them." The Musées Nationaux, which until then had never shown any interest in Brancusi's work, ended up purchasing *The Seal* II (blue-gray marble), a polished bronze *Cock*, and a polished bronze *Sleeping Muse*. (All three pieces remained in the studio for several months.) Brancusi was elated, except for one small sticking point: they relegated *The Seal* II to a tiny room near the stairway. "They've stuck me in the cellar," he grumbled.

Everywhere came a resurgence of cultural activity, now that the war was over. Rossetti, who headed the Royal Foundation for Art and Literature in Rumania, reminded the sculptor that back in 1939 he had given his blessing to a monograph, then only in the planning stages. Architect Paul Herbé made no secret of his admiration for Brancusi in an article for the April issue of *Architecture d'Aujourd'hui*: "These totems, these animals of stone or polished copper [sic], all of these magnificent pieces, as beautiful as pebbles worn smooth by rushing mountain streams, all of these surfaces one longs to touch and stroke, this insight into flux, this tremendous proposition—this is a cry, a cry of joy toward the future.

"You emerge from [the studio] as if swept away by a mighty gust of pure air.

"How fascinating it would be for an architect to work with Brancusi, to study the new peculiarities of our rebuilt cities, to set up his huge metal totems, to strew beautiful gardens with animals that, as he himself put it, 'children could play with.' For he sees children sliding down the back of his big marble *Seal*. And can you think of a finer symbol for our Fourth Republic than Brancusi's *The Cock*?

"If you compare Brancusi with another giant of contemporary art, Picasso, the latter works black magic, the former, white magic.

"In Brancusi's work, everything is lucidity, a process of building up. Nothing in it involves tearing down."

The United States was one of the first countries to hail Brancusi as a sculptor of moment. Several exhibitions in 1946 attested to the undiminished interest of Americans in his work: Detroit (January 22–March 3), St. Louis (March 30), New Haven (April 4–May 6), Newark (October 24), and Cincinnati (October 1–November 15).

In a letter dated October 9, James Johnson Sweeney notified the sculptor that the base of *The Miracle* (*The Seal*) had been damaged in handling and enclosed some photographs showing the part that had been repaired. He went on to ask if the museum might hold on to the sculpture as a loan. (The Guggenheim Museum would purchase it in 1955.)

We first met Brancusi in 1947. The French government, by way of its institute in Bucharest, had awarded us scholarships to study painting in Paris, and on October 9, our train arrived at the Gare de Lyon; a group from the Alliance Française met us and put us up in the Hotel Istria on Rue Campagne Première. Though humble, the hotel had its claim to fame, for Duchamp, Man Ray, Aragon, Satie, and Simone de Beauvoir had all stayed there at one time or another before the war. Dead tired, we were restored by twenty-four hours of sleep.

A Rumanian friend of ours, George Theodorescu, who also had a French scholarship to pursue sculpture in Paris, had already been there a few months. He lived in a studio on Impasse Ronsin, with Brancusi as a neighbor, a living legend for young Rumanians. Was there some way to meet him? Theodorescu acted as our go-between, and Brancusi agreed to see us on October 19—a red-letter day.

That Sunday we telephoned Brancusi that we were on our way over. Words cannot express our feelings as we walked up to his door and sounded the famous gong, a large copper disk made by the sculptor and installed inside to tell him when someone was at the studio door. Its soothing tone put the visitors in a contemplative mood.

The door opened, and there he stood, dressed in white. The sparkle in his eyes struck us at once. As we entered the studio, we seemed to be in a sort of sanctuary where light and serenity prevailed. Our host unveiled his sculptures, one by one, removing with a sweeping gesture the thick white cloths that protected the bronzes. He remarked on every piece: ceremoniously he unveiled *Bird in Space*, pulling back the cloth with a big stick; farther along, he pressed a button that set *Leda* in motion. The stainless steel disk under the sculpture rotated slowly and gently, looking like a pool of water come to life. In *Leda* we saw form transforming itself, breasts taking shape before our eyes, and realized that Brancusi was intrigued not so much by the myth as by the miracle of metamorphosis, of matter in flux.

He led us to the studio at the right to see the *Endless Column*, then to the left for the various versions of *The Cock*. Where the big fireplace loomed we found a diminutive *Cock*, several versions of *Mlle Pogany*, *Princess X*, *Blond Negress*, and *Portrait of Nancy Cunard*.

Brancusi watched us closely, waiting for our reactions as though trying to see through us with a sixth sense. Once back in the main studio, he asked about our life, our work, our plans. We assured him that nothing meant more to us than working in Paris as artists. When we left, he said that we should come in next time through the door of the adjoining studio, the one he lived in. We understood. He had accepted us.

Our curriculum that week scheduled fresco study at the Ecole des Beaux-Arts and in the studio of André Lhote. Sunday could not come too soon; after visiting Brancusi, always an enriching experience, we would drop in on our friend Theodorescu, who lived in a dilapidated studio next to the concierge's booth. He used another, even more run-down studio across from Brancusi's for his sculpture, and also worked for the master. But he hoped to travel to other continents, and the next January he emigrated to Argentina, no doubt sensing that the eminent sculptor's influence would stifle the development of his own, freer, style. Brancusi informed us that the studio opposite his was now vacant; we decided to sublet it from the tenant, a onetime Prix de Rome recipient, whose place was cluttered with uniformly pedantic sculpture. Our paths often crossed with Brancusi's, and

Brancusi's studio, 11 Impasse Ronsin, c. 1943–44: among others, four plaster versions of **The Cock; King of Kings** (Cat. no. 200). Photo Brancusi

now and then he had us over for a meal.

The thirty-year concession on Henri Rousseau's grave in Bagneux Cemetery had expired, and there was talk of returning his ashes to his birthplace in Laval. This elicited the following reply from Brancusi on January 6, 1947:

"I have received your invitation to the general meeting of the Association des Amis d'Henri Rousseau (January 7), and I thank you for it. Unfortunately, I am indisposed and unable to attend. However, I should like very much to let you know that I object to the plan to move Henri Rousseau's ashes and tombstone to his birthplace. This, in my opinion, would be sacrilege.

"If Henri Rousseau had stayed behind in that little town, he probably would not have accomplished anything. Paris is where the artist was born; that is where he met his friends, the ones who understood him, loved him, and helped him bring his work to fruition. In its sweetness and touching simplicity, the tribute that Henri Rousseau's Paris friends paid him—expressed by Guillaume Apollinaire and carved into his tombstone—evokes better than anything else the aura that surrounded the painter. To move him elsewhere would be to remove him from his element. Henri Rousseau's soul, his memory, his ashes, still belong to Paris...."

On a deeper level, this eloquent reply reflected Brancusi's wishes concerning his own burial, wishes he later confirmed to

us. And his marvelous response anticipated those who, after his death, sought to return his ashes to his birthplace in Rumania, without considering the sculptor's own decisions about his resting place.

In 1947, Brancusi sent work to exhibitions at the Palais Galliera in Paris (March–April), in Prague (May–June; then to Bratislava, Brno, and, in 1948, Munich), and in Avignon (June–September).

On June 19, Georges A. Salles announced that the Conseil des Musées was adopting a new policy "integrating [into public collections] sculptors heretofore omitted: Brancusi, González, Arp, Archipenko..." (Jean-José Marchand, *Combat*, July 10, 1947). The three works the French government had purchased from Brancusi in 1946 now went on public display. "*Now* there is a Museum of Modern Art in Paris," one journalist noted in *Point de Vue* (June 19, 1947).

In a letter dated March 24, 1947, Julius Bissier, the German painter, recalled his visit to the sculptor in his studio seventeen years earlier: "I must tell you," he wrote, "that that visit guided me then and guides me still in my work. I love your works, which express that hidden language of nature that will go a long way before it is overwhelmed by aesthetic theory."

Was Brancusi contemplating a move to the United States? It would have come as no surprise, for he wished beyond anything to escape the constant threat of eviction the landlord kept dangling over him. A letter

Opposite page:
The Seal II. 1943. Blue-gray marble. MNAM, Paris (Cat. no. 213*a*)

from Alfred Barr, Jr., suggests that the sculptor was indeed mulling the possibility, for he assured Brancusi that a warm welcome awaited him in the United States. He broached the subject again on October 8, adding that the Museum of Modern Art's acquisitions committee would be meeting on October 14 to discuss the purchase of *Fish* and *The Kiss*, and that he was still looking out for a studio in New York for the sculptor. A year later, the Museum of Modern Art added *Fish* to its permanent collection for $7,000, a price that Barr (in another letter) said he considered steep.

That summer, two works on loan from Peggy Guggenheim (*Maiastra*, 1912, and *Bird in Space*, 1930) were shown at the 24th Biennale in Venice. Brancusi also first refused, then agreed to send the four-part plaster *Cock* to the Stedelijk Museum in Amsterdam.

Publications continued to express interest in the sculptor. André Bloch of *Architecture d'Aujourd'hui* asked Brancusi to let Maywald, a photographer, do a photographic essay for an upcoming issue on sculpture that would also feature Picasso, Miró, Léger, Matisse, and Laurens. Biographies by Susan Hare and Carola Giedion-Welcker were in the offing, too, and the latter notified Brancusi that her book would soon be coming out in New York. "I didn't provide

Proposed medallion, front and back; below, a pendant. 1923. Drawing, 6.5 × 10.5 cm. Archives I–D

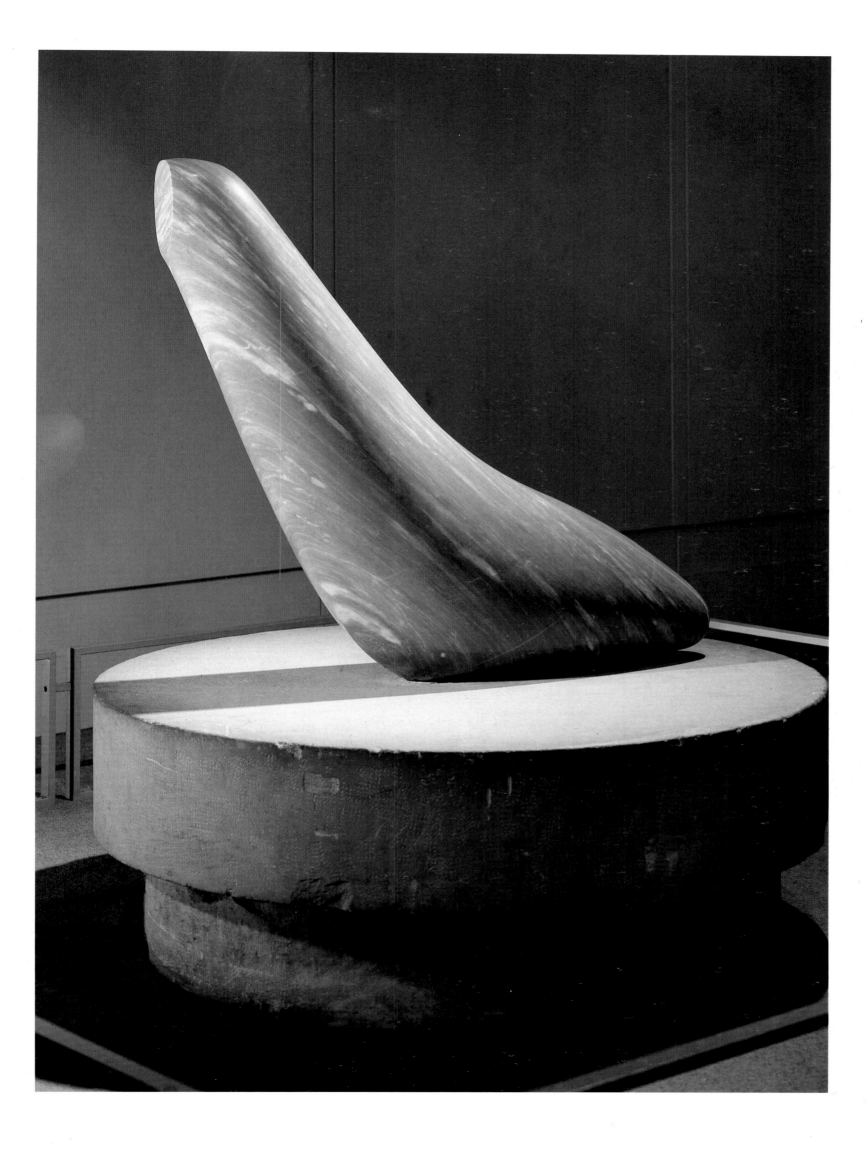

any photographs," he wrote back. "It cannot be. Please give me the name of the publisher so that I may take action."

Our dealings with Brancusi had remained smooth and friendly, and when our scholarships began to run out he said one day, while visiting us, "Stay with me." For several months Brancusi had noticed that we were at wit's end, and these few words were all it took to redirect our lives. Joy welled up, as if we had heard the voice of Fate. We immediately decided to make our home in the studio we already called our workplace, but what a mess it was! Broken skylight panes, dank walls and floors, and, needless to say, no gas, water, or electricity. Brancusi went out of his way to be helpful. In a few hours he had repaired the main entrance, and together we selected beams and pieces of wood from his private stockpile. Then, using his tools, the three of us built in a corner of the studio a sleeping loft of four uprights, nailing thick planks together across them to support it.

Brancusi would drop in ten times a day to spur us on or bring tools. As we sawed and hammered, our work took on a relaxed, low-keyed pace: our apprenticeship had begun. At his forge Brancusi worked a rod into a guard rail to go around the loft. He taught us to install and putty in the window panes. We did know how to whitewash walls, a common practice in Rumania, where peasant women whitewash their houses every year before Easter, then add a dark blue border along the bottom. (But Brancusi painted his studio walls red as a foil for his plaster sculptures.) A complication developed when the man who sold us our materials became suspicious of us and would let us buy whitewash only in small amounts; Brancusi smoothed things over. He gave us the velvet curtains he had used as backdrops for still photographs; he improved the efficiency of the old coal-burning stove by inserting a piece of boiler plate—we called it "the pipe"—so we could burn wood and cook on it, then he fitted out this tubing with iron rods for hanging things to dry—in a word, he turned it into a monument! And he gave us the famous winepress, proclaiming as he moved it into place, "May it be the guardian spirit of your studio!"

For our housewarming, Brancusi hung up near the wine-

Chimney hook. 1928. Wrought iron, 117 × 20.3 × 3 cm. Collection Istrati–Dumitresco (Cat. no. 168)

press a piece of wrought iron, saying, "Here's your chimney hook—I made it back when I first set up the forge." It reminded us of the Rumanian peasants' tradition of hanging empty earthenware pots on hook-shaped rods to dry in the courtyard. Later he gave us a *Signal* which we all installed at the studio door.

We ate at the sculptor's turntable, our "tablecloth" a big piece of white paper cut out by Brancusi. On that afternoon, he went out for a moment and came back with a large plate of fruit.

The sculptor outfitted us with white overalls and canvas hats to protect us from flying chips when working with stone and marble, and also gave us wooden shoes: a pair of his own went to Natalia; Alexandre's had to be ordered from Holland. They not only insulated our feet from the damp floor, but insured our footing when we moved blocks of stone weighing close to a ton. It was unusual to see Brancusi in anything but wooden shoes.

While cleaning the buildings on Rue Sauvageot, we came across a sawed beam having such an interesting shape that Brancusi urged Alexandre to make a sculpture out of it. He painted it, made some changes, and kept it in our studio. We also found a stone sink. We had no running water, but Brancusi made a drainboard and installed these in our studio; the sink was serviceable because, with an added pipe, the water we drew from the public well could drain into the courtyard tank. When the sole drain for runoff from the roof filled up and overflowed after heavy rain, flooding our studio and the master's, we laid down planks to get from one to the other. During one especially rainy time in June, Brancusi tried to liven things up by playing a record having a strong African beat, in hopes of stopping the rain. He did it as a joke, but our mouths fell open when the miracle worked, and the rain actually stopped. Back in Rumania, he had seen peasants try to stop storms by striking the earth with an axe.

On his doctor's advice, the artist would take a walk after dinner, for, as he put it, "You digest with your feet and dig your grave with your teeth." Everyone in the neighborhood knew him. He told us that once during the war he was standing in a line dressed in his overcoat and wooden shoes. It was nasty weather, and while waiting for what seemed an eternity he improvised a ditty to pass the time: "It's cold out, Mademoiselle; there's snow on the roofs and tram rails, so come home with me, there's fire there..." A passerby, taking him for a beggar, slipped two sous into his

hand, to everyone's amusement. "I let an excellent opportunity pass me by," he later observed. "I could have earned many a sou that way. Besides, I've always dreamt of wandering about with a song on my lips and then disappearing, like a Greek poet, leaving only joy in my wake."

He introduced us to the local shopkeepers, who had mostly been there since the turn of the century. Also he had us read Dr. Carton's book at once, and taught us how to prepare a number of Rumanian dishes, including his celebrated stewed chicken; he urged us to eat fruit, and simple, wholesome food. "What you eat determines your state of mind," he would say. "Children will filch fruit before anything else, when they play in gardens." Just the same, he brought over a piece of meat or some poultry on Sundays.

Brancusi's attitude toward nutrition was part of a larger spiritual adventure. His fascination with Milarepa, whose biography was one of his bedside books, is well known. He used to point out similarities between his life and that of the Tibetan recluse: both had lost their fathers at an early age, braved countless ordeals, performed

extraordinary feats, and always lived in solitude. But Milarepa's powers of levitation intrigued him more than anything else.

In 1948, Brancusi finished *Caryatid* (wood, 11¾ ins.). While working, Brancusi displayed concentration equaled only by his exactingness. Whether the job at hand was mixing plaster, moving blocks of stone or marble on rollers, loading them with a jack, transporting them, or polishing them, there was only one way to do it: his way. The task, whether routine or meticulous, had to be carried out as he wished. Perhaps that is why his assistants did not stay with him long. Brancusi could not abide people full of their own importance, who would come to him with their hands in their pockets, as if to say, "Don't you know who I am? Who do you take me for?" Since we were not aiming to become sculptors, we had no such problems.

Brancusi's nightmare about housing returned to haunt him. Some people living near the Rue Sauvageot lot had their eyes on the property; they threw garbage and refuse on it to force the sanitation depart-

Handcrafted drainboard, wood. Collection Istrati–Dumitresco (Cat. no. 243)

ment to take action. Their strategy worked, for the sculptor received not one, but two notifications of property endangerment (August 31 and December 22, 1948). Brancusi replied: "... If absolutely necessary, I agree to tear down the building, but I request a stay of six months to do it in." On January 4, 1949, Brancusi was notified that he had to tear down the building within five days, after which time the order would be carried out at his expense.

Brancusi told us about his predicament. "Would you care to tear down the houses on Rue Sauvageot? I'll help you." The next day, we loaded some tools, ladders, and bags of plaster into a handcart a coalman loaned us. Once at the site, Brancusi told us how to go about tearing down the building that faced the street. (The two behind were already collapsing.) We would have to fill in the windows opening onto the street with plaster slabs, prop up the walls from within, saw off the wooden framework supporting the roof tiles, and fill in the two cellars and the septic tank with the rubble. An agenda that would take weeks for us beginners to work through! In the evenings, we'd find a note on our door: "Knock across the way. Grub's waiting." So went the wrecking project.

When we got to the beams supporting the heavy tile roofing, we sawed them off and brought them back to Impasse Ronsin in the coalman's handcart. Now the time had come for the final operation. Our mentor had taken the trouble to make for us a long, hand-forged iron rod ending in a hook; the plan was to saw part way through the main beam, and, when it was about to give under the weight of the roof tiles, to pry it free with our makeshift crowbar. We both wielded it with all our strength and ended up bringing the whole roof crashing down around us with a frightful din, sending up a thick cloud of dust! We were shaken, but recalled the ordeals of Milarepa; it all could have turned out very differently. By some miracle, we both escaped without a scratch.

The task of clearing away the rubble dragged on through February 1949. While we were working we found a book that a neighbor had thrown into the courtyard: *Les Deux Nigauds* (*The Two Nincompoops*). We decided to laugh it off.

Brancusi, reassured with our progress, said to us, "When they throw you out of here, that's where you can build your studio." Indeed, our stay on Impasse Ronsin seemed tentative; the landlord, the Assistance Publique (Public Welfare Board), was planning to build a boiler room right next to our studio.

On December 24, we opened our studio door to find a pine tree decorated with little oranges. Brancusi kept up this tradition until he died.

The base for *Fish* was not yet finished. Since autumn, we had been working on the circular stone with points and a maul that Brancusi taught us to use without smashing our thumbs. Roughing out and polishing was usually done with an electric hammer fitted out with metal combs and notched heads that made an unbearable grating noise. ("The neighbors won't be overjoyed," the sculptor would say apologetically whenever he used it.) A second, smaller circular base also had to be made to support the first one. Neither was anywhere near as wide as the slab on which *Fish* had always been poised. Was this to make it easier to ship to New York? Probably, but above all the new proportions brought out the monumental quality of the subject.

After *Fish* and its bases had left the studio, the preparation of *Grand Coq* began. The president of the Philadelphia Museum of Art, B. Sturgis Ingersoll, had seen a plaster version of it early in the year, and Brancusi

said wistfully at the time, "Oh, if only this piece could be cast in stainless steel!" On March 11, Ingersoll informed the sculptor that he had talked with the museum committee and could make the following proposal: *Grand Coq* would be shown at an international sculpture show in Philadelphia (May 15–September 15), after which the Budd Company would have it cast in stainless steel and polished. All procedures would be carried out under Brancusi's supervision. The finished *Grand Coq* would then become the property of the museum.

Brancusi did not know where to begin. Soaring more than 16 feet high and weighing over one and a half tons, *Grand Coq* was still in a "raw" state and would require a tremendous amount of work. It would have to be laid on its side, smoothed, and brought back to an upright position after all four sections of the mold had been made.

Little wonder the piece was not ready in time for the Philadelphia sculpture exhibition (though it was mentioned in the catalogue).[33]

Besides, the museum's offer did not fully satisfy Brancusi. He considered *Grand Coq* a major work and did not want to be rushed into perfecting this sculpture, this burst of song that heralds the first glimmers of morning light. First of all, he would have to widen the doorway between the studios and saw off the lintel in order to move the piece around and work on it comfortably. Removing the beam might bring down the whole studio just when the moving operation was under way. "We'll have ourselves a coup d'état!" Brancusi declared.

Grand Coq was laid on its side on a large circular plaster slab, then propped, steadied, and chocked with every possible precaution. Months were spent scraping, combing, filling in, filing, and smoothing the upper side with emery paper; when that surface was finished, we turned the work over and started on the other side. Now and then we would stop work on this project, and come back to it later; it was 1954 before the molds and the base were completed.

Brancusi was represented at a number of exhibitions in 1949. Under the auspices of the Grenoble museum, a two-part show, "Les Maîtres de l'Art abstrait," was held at the Galerie Maeght in Paris (late April–May

Mailbox for Impasse Ronsin studios. Sheet metal, 26 × 17.5 × 12 cm. Collection Istrati–Dumitresco (Cat. no. 247)

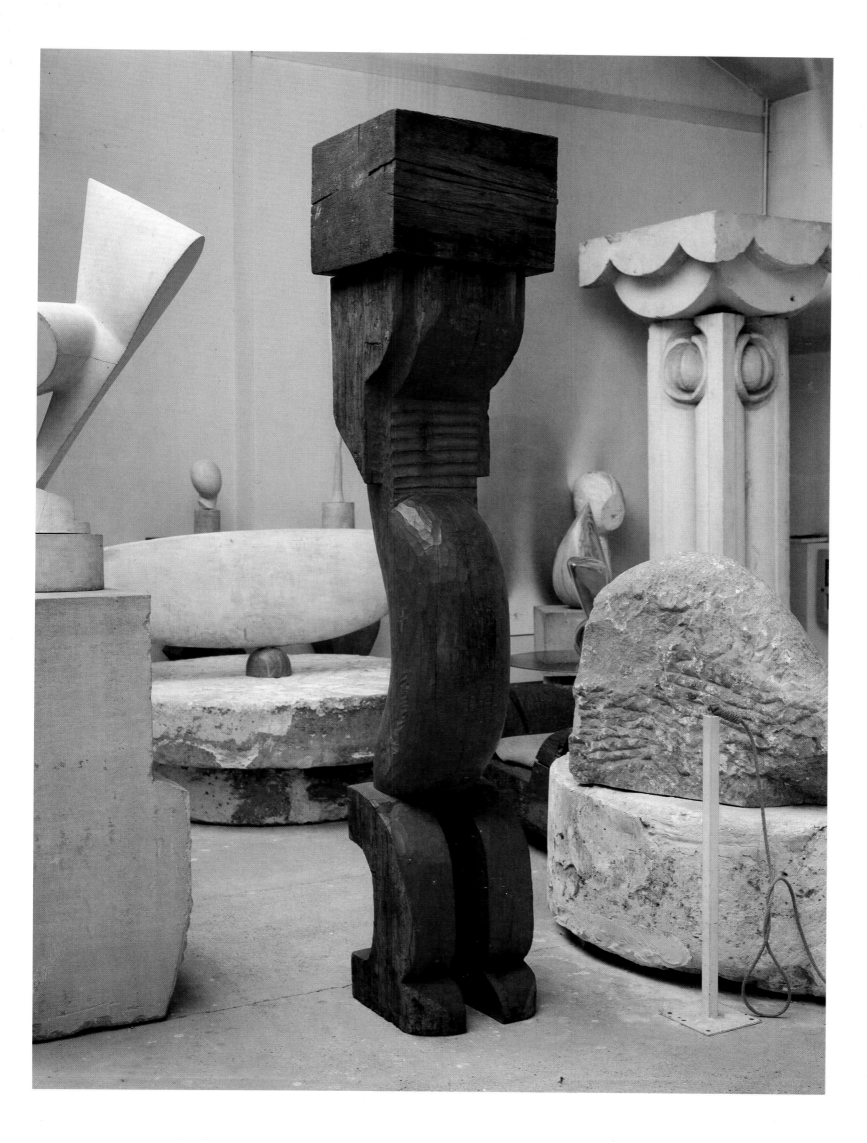

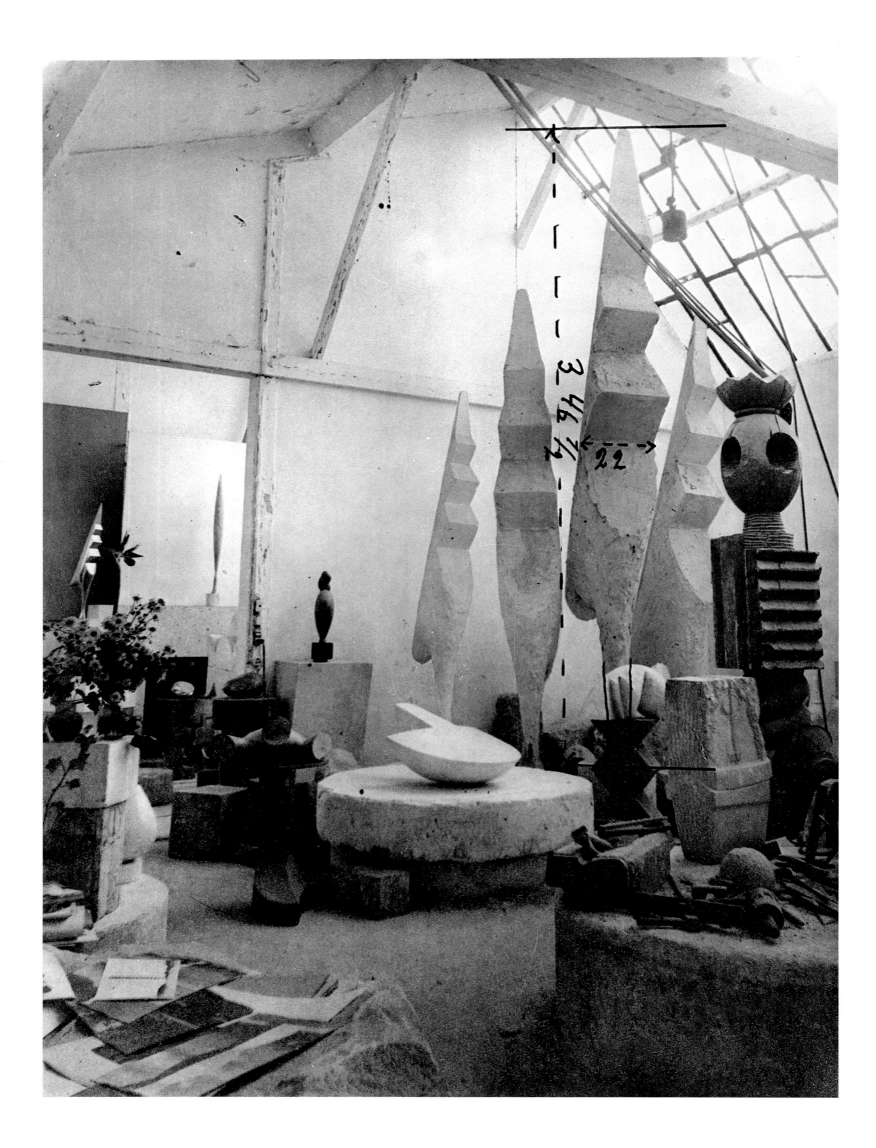

Lamp. 1928–30. Stone base, copper stem. Collection Istrati–Dumitresco (Cat. no. 229)

Opposite page:
Brancusi's studio, 11 Impasse Ronsin, c. 1945–46: among others, **Flying Turtle** (Cat. no. 214), **King of Kings** (Cat. no. 200), four versions of **The Cock.** Brancusi noted in India ink the measurements of **Grand Coq** (h. 346.5, w. 22 cm.) and sketched its foot. These are the dimensions of the intermediate version. **Grand Coq** in this photograph is still rough and unfinished; in 1949, the authors began assisting Brancusi in smoothing the surface and making the negative molds. Photo Brancusi

23; May 27–June 30). In *Art abstrait*, published at the same time as this event, Michel Seuphor hailed the work of Brancusi and Mondrian as the two highwater marks of contemporary art.

Brancusis were also shown at: Waldemar George's "La Sculpture Française de Rodin à Nos Jours," which ran from July to October at La Maison de la Pensée Française; Arnhem, Holland (July 1–September 30); and São Paulo, Brazil (July). From October 20 to December 18, nineteen Brancusi sculptures were displayed as part of "Twentieth-Century Art from the Louise and Walter Arensberg Collection" at the Art Institute of Chicago. At this time the Arensbergs were looking for a museum willing to give their extensive collection a permanent home.

The Museum of Modern Art approached Brancusi about a retrospective exhibition of his work, asking if they might discuss the matter with him.

And in a letter from the United States dated December 6, 1949, Alexina Matisse advised Brancusi that she had sold a polished bronze *Bird in Space* (72 ins.) to the collector John Senior, who could hardly wait to get it into his spacious studio. (A voucher issued on December 5 by Lénars and Co. indicates that this sculpture and its three bases had already been removed from Brancusi's studio.)

1950s:
The Brancusi Studio

A good part of 1950 was devoted to *Grand Coq*. We worked on it during the day with the sculptor, and in the evening, stimulated by the atmosphere of creativity, we returned to our painting. The only light we had was a kerosene lamp, as the wire Brancusi had hooked up to his electrical circuit had fallen victim to the elements.

Brancusi was a constant source of encouragement and advice. He supplied us with drawing paper and—a godsend—stretchers covered with white canvas, bought years before as backdrops for his sculpture. Occasionally he would give us money to go to the Marché aux Puces, where we scrounged up old canvases to clean and reuse.[34] We also found there an old gramophone with only one record, *Un Monsieur Attendait au Café de Paris*, and we played it from morning to night. Brancusi loaned us records, and gave us some of Rumanian tunes and dances.

Brancusi had been living in self-imposed exile when we arrived in Paris. Aware of having accomplished his major work, he was now pondering his life and destiny. Pevsner, Laurens, Richier, Arp, Giacometti, Le Corbusier, Braque, Picasso, Léger, Chagall, Severini—all lived in Paris, yet, except for Severini, Brancusi was rarely in touch with any of them. It rather surprised us when he joined in with our burst of activity, for everything in Paris was new to us, and we could not get our fill of museums, exhibitions, and galleries. Little by little, our enthusiasm proved contagious. Often Brancusi would wait for us late into the night to hear our impressions.

At that time, abstract art was still struggling to gain a foothold; few artists or galleries showed any real interest in it. Gradually, two conflicting schools emerged, a geometrical abstraction and a lyrical abstraction. Each had its own critics, votaries, and galleries, and the battle lines were drawn. We exhibited our paintings at the *salons*, for in this way we were assured of new contacts when they were accepted. Although Brancusi was asked every year to be a judge for one competition or another, he had dropped out of the exhibition circuit—precisely when his impact on the development of art was becoming increasingly decisive. He felt that he stood outside the mainstream of abstract art, even though he had once described a work to John Quinn as a *tête abstraite*.[35] To his way of thinking, he started from nature and worked his way toward pure form by distilling the "essence of things." He had freed sculpture from its burden of representational elements and pushed his approach to so refined a point that, by its very purity, his work became an expression of pure thought. Neither geometrical nor lyrical abstraction, it was more akin to the Platonic concept of the Idea: not an idle image but the primeval reality that man created words to describe. In this respect, Brancusi was in a special position. He was delighted to see that he had not been lumped together with all of the "isms" in Alfred Barr's diagram tracing the birth and development of abstraction (reproduced in Seuphor's *Art abstrait*)—and he took a picture of the diagram and pasted it on a piece of cardboard.

Since he hardly went out except for some errand in the neighborhood, he would send us to exhibitions and previews he had been invited to attend. He insisted that we see Picabia's show at the Galerie Drouin, "Cinquante Ans de Plaisir."

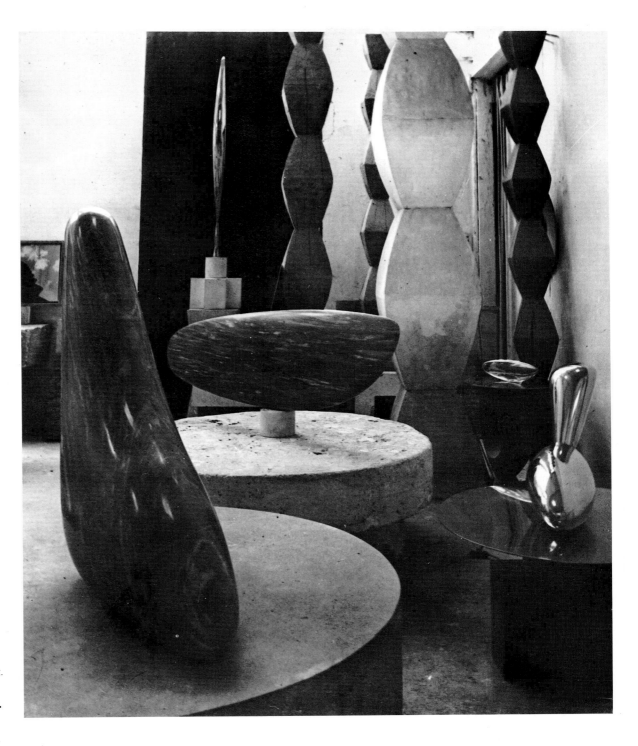

Brancusi's studio, 11 Impasse Ronsin, after 1946: **The Seal II** (Cat. no. 213), **Fish** (Cat. no. 181), **Leda** (Cat. no. 157), four versions of **Endless Column,** a **Bird in Space.** Photo Brancusi

"Brancusi is sorry he couldn't come, and sends you his friendliest regards," we announced, whereupon Picabia, who was very fond of Brancusi, jumped for joy and asked us for news of him; Olga Picabia too was very moved and started to reminisce. The next day, Picabia stopped by to see Brancusi and when the visit was over, Brancusi entertained us with stories about the old times. This gave him pleasure, as he could be talkative and we never tired of listening to him. Picabia came several times again.

Few people had the opportunity to meet Brancusi, and many tried to get to him through us. Wolfgang Wols, for example, had once met him and wished to see him again. One day, a friend brought Wols to us and we spoke of him with the sculp-

tor, who agreed to the visit. Dressed in an old raincoat, Wols walked into the main studio and reminded Brancusi that twenty years ago he and his Rumanian wife had stopped by to see him; Brancusi started to show him his sculpture, but Wols took from his pocket a pathetic little book by Paulhan that he had illustrated and held it out to Brancusi. The sculptor waved it aside and said, "Sir, you've come to my place to see my work. Look at it." As the flustered Wols took his leave, he said, "Forgive me, master, for having bothered you." "If you come once every twenty years," Brancusi replied, "you won't be much of a bother." We admired Wols' work and sensitivity, but Brancusi seemed to take the artist's casual behavior for insolence.

On January 31, 1950, a letter from Alfred Barr[36] informed Brancusi that the Museum of Modern Art was prepared to buy *Socrates*, the wood sculpture for which the sculptor had once asked $3,000. Was that sum still all right with him? No reply from Brancusi; Barr soon wrote again, upping the offer somewhat, but Brancusi stood his ground.

The footing of *Socrates* had become split, and repairs had been newly carved by a sculptor in New York. Brancusi flew into a rage when he saw the result; he intended to restore the piece himself, but no longer felt up to the task when Barr broached the subject again in 1953.

In 1950 came the distressing news that the polished bronze *Bird in Space* which John Senior

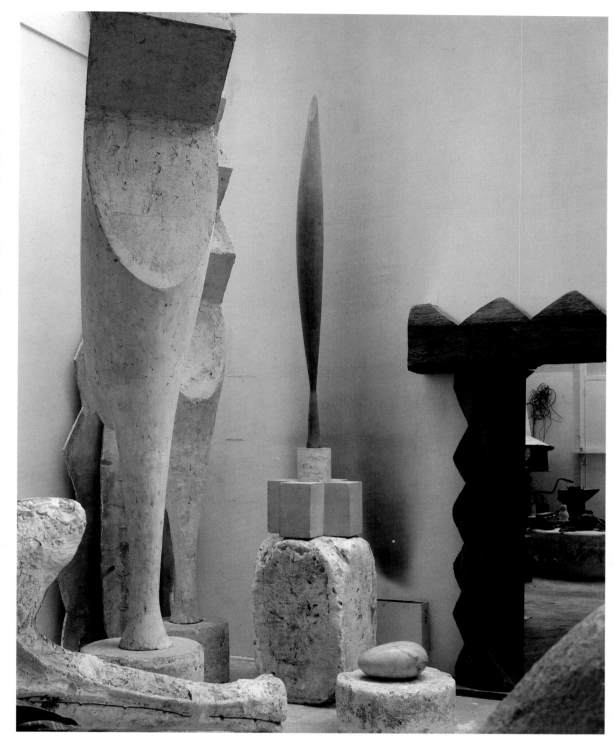

had purchased the year before had been damaged upon arrival in New York. It was sent back to Impasse Ronsin. There was no break, but the work was thrown out of alignment at the narrow section where the body meets the foot—precisely where U.S. Customs had affixed the lead seal that would be needed to import it back to the United States. The sculpture had to be straightened without breaking it *and* without damaging the lead seal, which Customs refused to remove despite the sculptor's requests.[37] Brancusi took a piece of wood and shaped it to fit the slender part where the sculpture curves. With Alexandre Istrati holding the bronze firmly in his arms, he then struck the piece of wood with one solid blow. The misalignment straightened out perfectly.

Among artistic events in 1950, outstanding was the donation of the Louise and Walter Arensberg collection to the Philadelphia Museum of Art, which took place officially on December 27. Ingersoll notified Brancusi of it on October 14, and added his regrets that nothing had come of the project to cast *Grand Coq* in stainless steel. In addition to nineteen Brancusis—ten of which, all important pieces, came from the estate of John Quinn—the Arensberg collection included works by Cézanne, Picasso, and Braque, and Duchamp's *Nude Descending a Staircase*. The Arensbergs[38] wished to donate their collection to an American institution, but the museums that approached them would not commit themselves to take it for more than a limited time: the Art Institute of Chicago, for example, stipulated only five years. Philadelphia agreed to twenty-five, which have long since elapsed, and the Arensberg collection continues to enhance Philadelphia's standing among the great museums. (Louise Arensberg died in 1953, her husband the following year.) The Brancusis have a spacious wing to themselves, and in one room the superb veined marble bust of *Mlle Pogany* watches over Cézanne's *Group of Bathers*.

Brancusi found himself caught once more in the wheels of French bureaucracy. A police inspector who had once helped him get an extension for his alien resident's card had since retired, and Brancusi, vexed by petty administrative formalities, now decided to apply for French citizenship. Two of the daughters of Jules Supervielle, the French poet, had gaps in his

file filled in; another member of their family happened to be an upper-level official in the prefecture; and the Musée d'Art Moderne did what it could to speed the process.

In October 1951, his old friend Gino Severini urged him to take part in the 1952 Venice Biennale. (Giovanni Ponti had tried in 1949, but Brancusi sent the following telegram: "Sick. Cannot possibly do show. Terribly sorry. Best wishes. Brancusi." After stopping by to see the sculptor, Severini wrote the following letter:

"My very dear Brancusi,
"Words cannot express how moved I was to see you again after so long a time, and to see

the splendid continuity of your work. My only regret is that I found you a bit worn out and feeling out of sorts. But I am sure that with that sound constitution of yours, you'll be enjoying good health again in no time.

"As for the purpose of my visit—and I don't mean to be so tiresome—I say it again: Believe me, the younger generation of Italian sculptors sorely needs a model of pure, genuine art such as yours to look up to. They look forward to your exhibition in Venice as a *message*, a *signpost*, and an *incentive*. There are some promising individuals in Italy, but unfortunately they have so far been steered wrong, largely by second-rate

values and a singularly undistinguished set of critics. If you could find within yourself the strength to fulfill the expectations of the younger generation, they would owe you a tremendous debt of gratitude. That is why I am taking it upon myself to bring their case before you, old and beloved friend.

"I'll phone sometime Monday morning, as we agreed, to [arrange a time to] see you again as soon as possible with Jeanne, who asks to be remembered to you.

"Madame Paul Fort, who is living with us, also wishes to be remembered to you and sends you the greetings of an old comrade from the Closerie [des Lilas] days.

"Believe, dear friend, in the affectionate friendship of your Gino Severini"

Severini's letter brought back fond memories, so the sculptor welcomed him with enthusiasm: "I do want to go to Venice, but only if [pointing to us] they come with me, because I'll have to move all the pieces in my studio. It'll be an impressive show all right, but it'll involve a great deal of work." Severini, who was the soul of kindness, got caught up in the excitement, and from then on, we all talked only about the upcoming trip. Brancusi, now seventy-five, had been in seclusion for several years, and so, for that matter, had we, because he did not like to be left alone. But in time his enthusiasm flagged. "What business do I have going all the way out there to show off?" he asked himself. Then Severini broke the exciting news: "It's all set! The committee has given the go-ahead. You're to bring all your work and the Istratis, too!" "We're not going," Brancusi replied sadly. "Getting about is too complicated. I don't feel up to it." Severini pressed him. "They don't say it in writing, but it's understood that you'll get the Grand Prize if you come." Brancusi would not give in. Severini asked, "Then what will we do with the Grand Prize?" "Give it to Arp," the sculptor replied; "he needs it more than I do." The plan faded away, together with our dreams of Venice.

On June 24, 1952, Severini sent a postcard from Venice. "...A pity your work isn't here, where sculptors don't seem to know what sculpture is any more....They need decent examples ..."

When Dr. Löffler, a collector who was on the committee of the Zurich Kunsthaus, accompanied Carola Giedion-Welcker on a visit to Brancusi, he offered to show Brancusi's work the following year. Brancusi gave his consent, and on August 15 the museum director, R. Wehrli, confirmed the invitation. However, the Zurich show too was never to take place; little wonder, given his unwillingness to go to Venice.

After Brancusi's death, the 1958 Venice Biennale paid tribute to the sculptor with a loan exhibition of his works in foreign museums. We were there, but we still regret that his great exhibition of 1952 never took place.

That is not to say that Brancusis were not exhibited elsewhere in 1951. In February, his work was at the Galerie Mai in Paris (along with paintings by Léger and Miró) and at the Stedelijk Museum in Amsterdam. In March, the Palais des Beaux-Arts in Brussels showed the

Peggy Guggenheim collection. *Adam and Eve* was on display at the Sidney Janis Gallery in New York ("From Brancusi to Duchamp," September 17–October 27).

The year 1951 ended on an unpleasant note. After visiting Brancusi, Waldemar George wrote on June 2 to thank him for his hospitality and to request some photographs of his work and studio for use in a future article in *Art et Industrie*. The sculptor obliged, but on December 28, George had to apologize for a most unfortunate blunder in the layout. The printer had taken it upon himself to cut the sculptures out of the photographs and to silhouette the mutilated images throughout the text as decorative "graphics," with disastrous effect. Horrified, the sculptor vented his indignation.

We were still working on *Grand Coq*, but evenings (and, occasionally, days) were spent painting, stimulated by the artistic milieu of Paris and Brancusi's inspiring presence. He often dropped by to look at our paintings, without necessarily saying a word. In the evening, however, when we allowed ourselves to relax at his place, he would draw out our ideas by offering his own thoughts, rarely on technical matters, more often linked with problems of creativity.

"You've got to make a clean sweep and start with fresh, unbroken ground, with white. Do you know how to get a flawless white? Watch the people who paint big ships. They lay on a coat of pitch black, let it dry, and then paint it over in white, and it fairly leaps out at you."

Once he asked, "Do you like what you've just painted?" When we hesitated, he exclaimed, "How do you expect others to care for your painting if you don't like it yourself?"

Noting our wish to see all the masterpieces of Western art, he said, "You only have to go to the Louvre. Look at the Egyptians and the ancient Greeks, but not at the contorted figures or even the overrefined ones, for they verge on decadence." Along these lines, he urged us to read Plato, Aeschylus, Aristophanes (*The Birds*, of course!), and the aphorisms of Hippocrates. He loaned us his favorite books, sometimes giving them to us.

Whenever he sensed in us apprehension or distress about our painting, he would bolster our spirits. "Take the bull by the horns, press on, never give up!" Sometimes he would elaborate: "You've got to get rid of that 'don't-you-know-who-I-am?' attitude and not pity yourself. You can't get to the real things if you don't repudiate the I."

On the subject of the fame that many artists aspire to: "The

more you run after it, the more it will escape you. Turn your back on it, and you'll be free to create the works that matter."

Life went on peacefully: work in the studio, commissions, an occasional brief stroll, and a meal with Brancusi in the evening or sometimes late at night. He would speak to us from near the stove, the shadows of his statues looming silently around us. As he reminisced, he kept coming back to the same topic: the meaning of life.

Brancusi left his windows open summer and winter, and one day a sparrow flew in; round and round it flew in a desperate search to get out, wildly crashing into the walls and the skylight. At last it fell dead from exhaustion. Soon after, another sparrow lost its way and flew in, but it found the window it had flown through and promptly escaped. "It's the same with art," the sculptor noted. "Some don't find the way out and come to grief; others find their way out right away." The incident made such an impression on him that he jotted down a version of it:

"A beautiful butterfly died beneath the skylight. I opened the two big doors and the six transoms—four over the two doors and two in the roof across from the skylight. But it was no use. I took a pole and tried to coax it out [of the studio]. Again, no luck.

"The beautiful butterfly, drawn by the light, flew at the skylight until it died.

"So it goes with us. When our inner light outshines our intellect, we go crashing into impassable walls, and all the time the way out is so easy to find."

These conversations often revolved around some book he had read when he couldn't sleep. Now and then he came up with most original thoughts. "God is everywhere. God is the keynote; he is the 'do' [of 'do-re-mi']. He makes love from morning to night. Microbes that multiply, all creatures that procreate—that's love, isn't it? Certain insects live no more than a single day. They are born one morning and die that very evening. That is their law. God laid down the laws. Go against them, and you go against Him."

He constantly talked about great mythological figures, especially of the fabulous legends of India. He extolled the virtues of Tibetan wisdom. "I am your guru," he said to us, only half joking, and we liked the idea of freedom from worldly contingencies. Lest we take his teachings too literally, however, Brancusi pointed out that the Western way of life did not permit us to practice the disciplines of the sages of the Far

East, and that the quest for ecstasy was not compatible with our burden of obligations.

He was obsessed with Milarepa. Once, while discussing the saint's power of bilocation, he said, "I've been in two places at the same time, too," and he told us about it. Before the war, Brancusi used to go every day to a little shop on Rue de Vaugirard, right next to Impasse Ronsin, to buy a newspaper. The shop woman was a fine person, except for her frequent complaints that the newspaper delivery made her keep such early hours. Heaving a sigh, she said, "Waking up at five every morning! That's no way to live, Mr. Brancusi!" Some days later, when the sculptor happened to wake up unusually early, the thought crossed his mind, as clear as could be: "The poor lady must be awake right now." He went back to sleep. When he went to get his paper at the regular time, the woman greeted him: "You've come back again, Mr. Brancusi. I saw you here this morning at five o'clock." Try as he might to convince her that he had not been out since the day before, she had seen what she had seen.

"We receive all influences, all thoughts from the outside, through our natural antennae," he explained. "I mean the hairs on our head, our face, our body. [That is why he kept his beard.] We pick up stray thoughts that come our way from the outside; others pass by unnoticed. When you achieve a certain state of mind that excludes intelligence [he once said, 'Intelligence is useless, piss on it'] you can transmit your own thoughts." He told us that twice he had used his powers of telepathy; once was with a collector who had not paid him, and all he did was focus his thoughts on the man, and a money order arrived from him two days later. The other time, the subject was a taxi driver. "One day, I jumped into a cab and lit a cigarette. The driver seemed in a bad mood. I asked him if he would please open the window. 'I can't, sir,' he snarled in an arrogant tone. I asked him several times more, and got the same answer: 'I can't!' Aggravated, I warned, 'Oh, you can't, can't you? We'll see about that! Just you wait!' The taxi lurched to a stop as if on cue. The driver tried to start it. No luck. He got out, opened the hood, checked the motor. Still no luck. Then he turned toward me. 'Sir,' he said meekly, 'would you please get another cab? There's a taxi stand right near here.'"

"There are forces that stand by us, provided we have the right intentions," he said time and again. "But there is black magic too: unknown forces that destroy you." He taught us never

to give up hope. He was convinced that help comes from an unknown source just when things look bleakest. "One bitterly cold winter day, I was alone, not a penny to my name. I was out of coal and shivering and unable to work. I couldn't go on. 'What am I going to do?' I cried out, and stamped the floor with my wooden shoe. Just then,

Brancusi's French identification card, 1952. Archives I–D

some coal came tumbling down from the plaster column [part of a model from the *Temple of Meditation* project] that I kept spare fuel in, and I scooped it out through the bottom opening. The coal had got caught in the wood and iron armature inside, and my stamping on the floor jostled it free. That was an act of Providence."

On June 13, 1952, he became a naturalized citizen. "It is my pleasure to inform you that you are French," wrote Jean Cassou. The prefecture of police in Paris issued his identity card on October 9.

Late in May things went awry, unfortunately, and over the sculptor hung a new cloud of uncertainty. A registered letter from the Assistance Publique put him on notice that the five studios he occupied were dilapidated and had to be vacated forthwith. On June 6, he wrote back requesting protection under the law of 1948. Filled with apprehension, he wondered what would become of his work. Would it be scattered to different locations, if he were evicted? And the Americans were talking about building a museum just for his work—complete with fallout shelter! The irony of it! Some doing their best to get rid of him and his work, others wanting to ensure that his genius would survive an atomic apocalypse! With his future in limbo, Brancusi became skeptical and sarcastic. "What's the point of it all? Why get all worked up? There's already been one flood; that was the eleventh. The next one will sweep everything away." Out of this welter of conflicting

thoughts, however, an idea took shape: he could make a donation of his work.

Despite these ups and downs with his landlord and the authorities, people were forever making requests of the sculptor. On November 6, Dr. Werner Haftmann invited him to take part in an international open-air sculpture exhibition sponsored by the city of Hamburg. But with things at home as they were, he had no choice but to refuse.

James Johnson Sweeney organized a major exhibition—including Brancusi's wood sculpture *Adam and Eve*, sent back from the United States—at the Musée d'Art Moderne in Paris

Grate and stove implements, made by Brancusi in 1952. At right, double-handed sieve (metal, 36 × 32 cm.) made by Alexandre Istrati (Cat. nos. 226, 227)

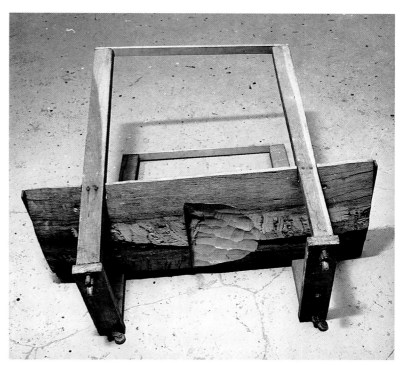

Wood portfolio with relief carving, made by Brancusi in 1952. Collection Istrati–Dumitresco

(May–June). This extraordinary event drew comments from Pierre Schneider, André Chastel, Robert Rey, Jacques Lassaigne, and Frank Elgar. By July 15, the exhibition had traveled to the Tate Gallery in London, shown as "Twentieth-Century Masterpieces" until August 17; it was then seen in Philadelphia, as "Sculpture in the Twentieth Century," from October 11 to December 7.

Now that the plaster *Grand Coq* was smooth and tight, the time had come to make the molds that would turn Brancusi's dream into reality: a stainless steel casting. This, together with *Endless Column* at Tirgu-Jiu, was to have been the crowning achievement of his art. Its form symbolizes not just the broken rhythm of the cock's crowing, but the break of day, the triumph of light over darkness, the spiritual triumph of man escaping from the mind's gloomy labyrinth.

The mold was made in four sections: one for the foot, two for the sides (crest included), and a thicker, heavier piece shaped like a curved scallop shell to hold the other three in place. First the sculpture was shellacked, to prevent the wet plaster from sticking to the surface. Then came the first layer of plaster; the placing of iron reinforcing rods (already worked on the forge to match the sculpture's curving surfaces) and the tying of the rods to each other with strands of hemp fiber soaked in plaster; and the final layer of plaster. Brancusi had inserted pieces of string at the places where he wanted the molds to separate. Before the plaster was completely set, he pulled back and forth on the strings, producing clean, beautifully matched edges. A few holes and stud bolts ensured a perfect fit for the future casting.

While busy supervising this project, the artist took time out to make objects we needed. "Let's go to the *maquis*," he would say, referring to the rear of the courtyard with its pile of rubble from demolished studios, scrap iron, and other debris. (The *maquis* was a source of delight for Jean Tinguely, who lived on Impasse Ronsin at the time.) He made us a portfolio stand out of a plank of wood and carved a design into it. Times were hard, but the constant exchange of work and ideas made these years perhaps the best of our lives. Every now and then, it would occur to him that these happy days would sometime come to an end. "When I'm not here any more, you'll see! Just call me, and I'll come."

About this time, Roché asked Brancusi to see to rearranging the sculpture in his apartment, and we went along also. Brancusi, shedding his white clothes, donned a business suit, and slipped some little cigars into his pocket. The sight of the nine Brancusis Roché owned was breathtaking. I was elected to move the white marble *Penguins* II. Roché seemed doubtful, but I took hold of the sculpture in both arms and carried it to the designated spot. I still wonder how I managed to move something so heavy; Roché was amazed, and gave me a box of Havana cigars.

All the way home in the Métro we sang Brancusi's praises, but he, visibly peeved, said nothing. "How did he manage to get hold of so many pieces?" we asked. Finally he blurted out: "He bought them, but with my money." He went on to explain that when John Quinn died, Quinn's collection, including twenty-seven Brancusis, was put up for auction in France. Anxious to keep these works together, Brancusi had advanced money to Roché so that Roché could buy all of the sculpture, and made him promise the collection would never be broken up. Duchamp, however, finally sold nine works by Brancusi from the Quinn estate to Walter and Louise Arensberg.

Back in 1951, we participated in an exhibition of abstract art in Madrid by Rumanian-born painters. The Museum of Modern Art in Madrid purchased two of our paintings, and we were invited to attend a conference on the problems of painting. The trip looked promising at the start, but nearly ended in disaster when the train hit a truck and jumped the tracks. Once safely back in Paris, we found Brancusi beside himself: "Did you really have to go?" He was so overwrought that words failed him, but we sensed that he was glad to see us.

Brancusi's life now consisted of rearranging pieces of sculpture, replacing worm-eaten pieces of wood, and returning to an occasional project still waiting to be finished. Just looking at his sculpture gave him new ideas. He contemplated making one that could be moved about on water by means of a float.

There were two letters from Duchamp, one dated June 3, the other September 22.

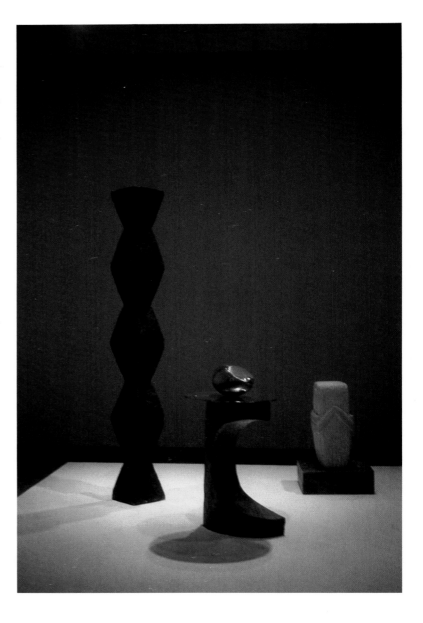

"June 3, 1953.

"Dear Morice,

"No doubt you'll be surprised to hear from me. I'm doing pretty well and hope you're all right. Anyway, here's a plan I hope you'll find tempting.

"Sweeney was named director of the [Solomon R.] Guggenheim Museum last year, replacing Baroness Rebay after Solomon Guggenheim died.

"Sweeney has completely altered its tone and structure by eliminating the title *nonrepresentational*, which the baroness had adhered to religiously.

"The other day, in the course of conversation, Sweeney asked me if there was any chance of your agreeing to let the Guggenheim host as complete an exhibition of your work as possible. I told him that you might be willing to go along with it if I agreed to set things up in your stead.

"Moreover, it would be understood that you'd be *invited* to make the trip to New York, spend as much time as you like, and join me in taking care of preliminaries.

"I also told Sweeney that you yourself would see to the catalogue dummy, with your photographs, and that we could have it printed in Paris, if need be.

"Anyway, think it over. Sweeney will be in Paris next week, from June 7 to June 14, and *will drop by to see you* and go over the offer with you at greater length.

"I hope you'll be tempted by the prospect of traveling, and as for me, I'd be truly delighted to relive with you the good times we had in 1927 and 1933.

"Fondly,
Marcel Duchamp. Morice."

"September 22, 1953

"Dear Morice,

"Sweeney's back and he still has hopes of doing an exhibition of [your work] at the Guggenheim Museum this winter. If you haven't yet made up your mind, let me tell you that this show would provide all the safeguards you could possibly ask for.

"I promise to be there and to attend to everything if you don't come to America. Aren't you supposed to be in Pittsburgh this winter? [The sculptor was contemplating a trip to Pittsburgh because a collector, David T. Thomson, offered to cast *Grand Coq* at the foundry he owned.] We could arrange it so that the two coincide.

"Well, do give it some thought and let me know what you want to do.

"See you soon, perhaps.

"Fondly,
Your Morice"

On November 11, René d'Harnoncourt advised the sculptor that the Museum of Modern Art in New York was open to doing a one-man show but did not want to compete with the Guggenheim. "...I venture to say," he went on, "that this does not in any way mean, dear Master, that we are any less enthusiastic about showing your work [in our museum]. On the contrary, we sincerely hope that we shall continue to work together with you on future exhibitions.

"I am writing just to tell you that, in our view, the fact that our museum is unable to pay tribute to you with an exhibition next year should by no means set you against a major showing of your work at [that] distinguished an institution, and to assure you that, if it should come to pass, we shall help Mr. Sweeney all we can and still look forward to honoring you in our museum sometime in the future."

On December 21, Alfred Barr sent the sculptor a transparency showing the five Brancusis owned by the Museum of Modern Art: *Mlle Pogany*, *Fish*, *Maiastra*, a polished bronze *Bird in Space*, and *The Newborn*. Barr asked him if he was willing at long last to part with *Socrates*, which was still in the Impasse Ronsin studio, and made him a new offer.

Works by Brancusi appeared in several exhibitions in 1953: at the Art Institute of Chicago (January 22–March 8); in "Le Cubisme, 1907–1914," at the Musée d'Art Moderne, Paris ("Needless to say, Brancusi's presence here is unjustified," wrote André Breton in *Le Médium* in February 1953); at the Museum of Modern Art, New York (April 29–September 7); and at the second Biennial of Sculpture, Middelheim Park, Antwerp (June 20–September 30). (The Musée d'Art Moderne sent the blue marble *Seal II* on to the Antwerp show, and it was damaged by a nail in the packing crate. Brancusi never found out about this.)

With the procedures for finishing *Grand Coq* now behind us, the time had come to hoist the one-and-a-half-ton sculpture to an upright position. Theoretically, the pully mechanism designed to lay it on its side would also raise it back up, though the risk remained of bringing the roof down in the process. *Grand Coq* was wrapped in straw matting, and the end of a rope knotted around it. First we had to fix it to its base by sliding the base onto the rod protruding from the foot of the statue. Around the middle of the afternoon, although the traction was gentle, the whole *Grand Coq* started to rise. Breathlessly we placed supporting chocks under the base the moment there was space between it and the floor. Fresh matting kept the plaster from damage. By sundown, *Grand Coq* was upright. We were all elated, and Brancusi could not refrain from letting out a "cock-a-doodle-doo!" We broke open champagne to celebrate, and danced about the huge plaster sculpture. "Let's look at it with all the lights on," Brancusi suggested, but all the

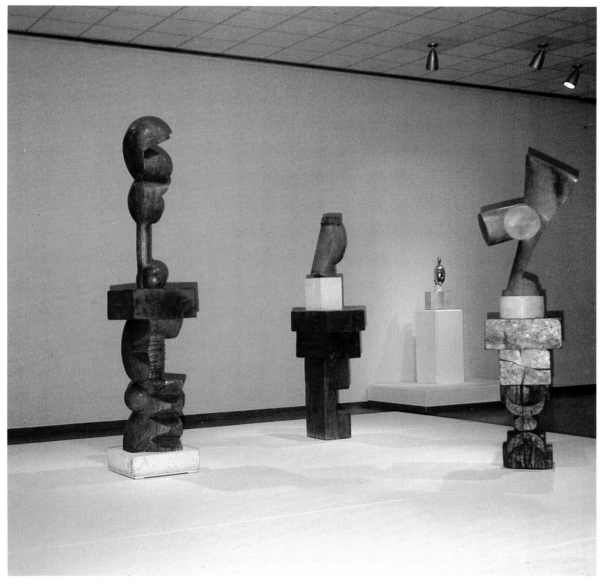

Two installation views, "Constantin Brancusi, 1876–1957: A Retrospective Exhibition," Art Institute of Chicago, which included some eighty sculptures and twenty drawings, 1970. Museum photos

fuses blew out, dousing our enthusiasm along with the lights. (The sculpture and its molds are now in the Brancusi Studio, Centre Georges Pompidou.[39])

In 1954, Brancusi again discussed the possibility of donating his work to the Musée d'Art Moderne in Paris. It was mentioned by Léon Degand in *Le Soir*, a Brussels newspaper, on February 22.

From July 17 to September 30, *Sleeping Muse*, *Child's Head* (1910), *Bird in Space* (1925), and a drawing were shown at the town hall of Yverdon, Switzerland, as part of "Sept Pionniers de la Sculpture Moderne," an exhibition that subsequently opened in Zurich as "Begründer der modernen Plastik" (November 27–December 31). All four Brancusis belonged to the Roché collection, and after the exhibition opened, Roché stopped by our studio in Impasse Ronsin with a catalogue for us to show to Brancusi. He had loaned these pieces to the exhibition to fulfill certain obligations, but the sculptor had not been informed, and Roché was afraid he would refuse to see him. Not daring to offend Brancusi any more than he already had, he let us handle it for him. When Brancusi saw the catalogue, he was very upset and hurled it to the floor. His rage erupted all over again when anyone mentioned it, and when *L'Argus* sent him reviews of the show. "How could Roché have

loaned my sculpture without saying anything to me about it?"

Meanwhile, the Assistance Publique was doing everything in its power to take possession of the property on Impasse Ronsin then occupied by artists. A friend, after paying Brancusi a visit, wrote to Jacques Jaujard, then head of *Les Arts et les Lettres*, asking if he might put in a good word for the sculptor. Jaujard wrote back on December 28: "I approached the directors of the Assistance Publique and called their attention to the plight of this great artist in particular." His plea notwithstanding, an official delegation came knocking on the sculptor's door and asked him to move. Brancusi flatly refused and sent them away. "Get out!" he shouted. "If that's Public Assistance, then to hell with it!" In the end, Brancusi was allowed to stay until his death, thanks to Jaujard's intervention and, probably, the artist's advanced years.

Near the end of 1954, Mr. and Mrs. Frederick Stafford of New York bought the polished bronze *Portrait of Nancy Cunard* (1931). Brancusi went out of his way to make a festive Christmas. He gave us a roast suckling pig, hot off the forge, and we shared it with the Ionescos, Director Sylvain Dohme, Prof. Constantin Brailoiu, Dr. Hélène Ionesco, and architect Marcel Schiller and his wife.

On December 31, we learned of the death of Margit Pogany.

1955–57

The year 1955 started off well, but late in the afternoon of January 6, Brancusi stumbled against his cane and broke his leg in the fall. We were at home, showing our paintings to Gildas Fardel, a collector, when we heard Brancusi's cries for help. He had given us the key to his studio, so I rushed in and found him on the floor, his left leg doubled up beneath him. I was sure at once that it was a fracture. Brancusi was deadly pale and groaning. After running to fetch Natalia, I straightened his leg as best I could, carried him with difficulty up the narrow wooden staircase, and placed him on his bed. "Doctors are out of the question," he said, recalling his accident in Alès and wanting to secure his leg between two wooden slats, as he had done back then. But the pain grew worse and we had no choice but to call the doctors in. They urged Brancusi to let himself be taken to the hospital. Brancusi balked, with Alès still fresh in his mind: "I'll get better care at home, with them here, and we'll make a fine cast ourselves." But it was no use, and indeed we feared infection and complications. A ambulance took the sculptor to the Foch Medical Center in Suresnes, where he was treated from January 11 to May 3 for a serious fracture of the thigh bone.

We saw him every other day, and on our first visit Brancusi exploded: "Look what they've done to me!…" and showed us his leg, encased in a heavy, crude mass of plaster. "I *tried* to tell them how a cast should be made! They didn't even pretend to listen to me. When I think of the one *we* could have made!" He carried on so that they changed casts—twice. He felt more comfortable after that.

He was bored, and asked us to sneak in a spot of rum. His

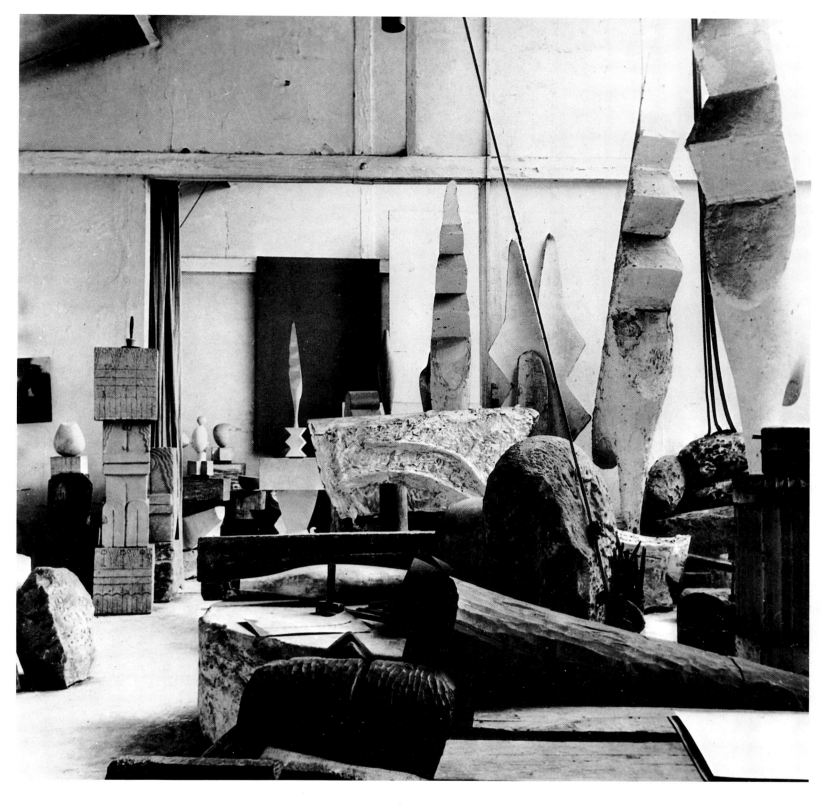

mood brightened, but that was not all the doctors noticed! We found a sign in his closet: "Bringing the patient alcoholic beverages is strictly forbidden." We would have to be more resourceful.

His birthday, February 21, came and went without the usual festivities. Duchamp and Roché stopped by to see him, and there were messages from Miró, Magnelli, and Severini. "You are hale and hearty," wrote Severini, "and I'm sure you'll have a speedy recovery." Once the cast was removed, his rehabilitation could begin.

Easter Sunday fell on April 10, and we brought him some painted eggs in the Rumanian tradition: one would tap an egg against a guest's and say "Christ is risen," to which the guest would reply, "He is risen indeed." Brancusi had often asked Natalia to decorate an Easter egg with *The Kiss*; he would draw the subject, she would copy it with a bit of paint and gold leaf, and he gave them to visitors and friends. But a dealer from New York told us that an acquaintance of Brancusi's had offered to sell him an egg "that the sculptor had decorated." Natalia pointed out that it was she who had painted the eggs, and that they were made to be eaten—and nothing else. One of these eggs is illustrated in *The Kiss* by Sidney Geist (1978), however, and credited to Brancusi. Others have echoed this mistaken allegation, although our Rumanian custom is known to many people.

On May 3, 112 days after entering the hospital, Brancusi was discharged, having undergone numerous operations, radiology sessions, and laboratory examinations. He came home in a taxi, and was excited to catch sight of the Bois de Boulogne and then to see his studios, where we had kept up the fire to protect his sculptures from the damp. Artists and other tenants came by

to welcome him home again; one neighbor, despite their long-standing feud, came up and kissed his hand. "Why, even my enemies rolled out the red carpet!" he later said. He inspected the premises. "You splurged! There's even a bottle of wine!"

Brancusi had trouble getting about, and decided to customize his crutches. He shortened them, put new rubber on the tips, and cushioned the armpieces with soft thick cloth, all the while humming a song: "Oh, she 'ad a wooden leg and they

255

used to criticize 'er, so a rubber disk went 'neath the peg and now no one's the wiser!''

We rejoiced in the sculptor's homecoming, though every evening he had to be lifted into the loft and undressed, and then brought down in the morning and dressed again. We put a gong at his bedside, in case he needed help during the night. He would strike it so hard that people could hear it all the way to Rue de Vaugirard (fortunately, the neigbors did not complain).

The artist now began to get about more easily. He discarded his crutches and made canes to use instead. On August 10, Cassou wrote, "I hear you're back up again in your pose of the Thracian god who made the stones sing." But his convalescence was slowed by an annoying case of hiccups. Nothing stopped them until one day Carola Giedion-Welcker came by with her collector friend Dr. Löffler, who wanted to buy a ten-foot-high *Cock*. "I have the hiccups, as you can hear," Brancusi said to him. "Cure me!" The doctor examined him and pressed his thumb against a certain spot on his collarbone. No more hiccups. "Ah!" Brancusi said, breathing a sigh of relief. "I'm going to think seriously about that *Cock*, if it's a work that might help heal the sick."

Since Brancusi spent much time lying down, his legs remained swollen. Massage brought no relief, and he was "fed up with doctors and their treatments." Someone introduced him to a faith healer, a short, slight, nondescript man named François, who stopped by several times. "This man has a real gift," Brancusi told us. "He makes hypnotic passes, and whenever he brings his hands close to me, without touching me, mind you, I feel an intense warmth. But I don't feel he's done me much good." As it turned out, the artist and the healer were not on the same "wavelength," and he soon stopped coming. But when he attended Brancusi's funeral in the Rumanian church, he came up to us and muttered, "Don't cry. That keeps him from breaking free of us."

In mid-summer, Sweeney stopped by the studio to see if Brancusi would loan several works for the retrospective show at the Guggenheim, and he sent a list on August 18. Brancusi went along with the project at first, then demurred, saying he could only part with the smaller pieces. At Sweeney's request, we urged the sculptor to include two large wood pieces, *King of Kings* and *Caryatid*, in the loan. The artist relented, and on September 26 *Caryatid*, *The Sorceress*, *The Turtle*, and *King of Kings* were

deposited with Lénars and Co. for shipment. Later a gouache (*Blue and White*) and two drawings (*Nude Study of a Woman* and *The First Step*) were sent over by plane.

The Brancusi retrospective opened in the old Guggenheim Museum building on October 25, 1955, and lasted until January 8, 1956. In the catalogue were listed fifty-nine pieces of sculpture and ten drawings and gouaches. The show generated tremendous interest as soon as it opened, and news of its success spread throughout Europe. The press gave it extensive coverage.

The day after the opening, the artist received a telegram from Sweeney thanking him on behalf of the Solomon R. Guggenheim Foundation for the magnificent exhibition. Edward Steichen's daughter, Kate, also expressed her admiration and mentioned that the retrospective included the bronze *Maiastra* that once stood in Steichen's garden in Voulangis, which her father had since given her. A spate of tribute followed. "That art of yours, dear Brancusi," wrote Pierre Matisse, "is so rewarding, so munificent, incomparably noble. I just wanted to tell you how grateful I am for all the joy and beauty you give and to thank you for bringing us a little closer to 'that sublime truth that is within you."

We cannot conclude our discussion of the Guggenheim retrospective without quoting a remark Brancusi once made, which was mentioned by Sweeney himself and echoed by several journalists: "Without the Americans, I would not have been able to produce all this or even to have existed" (Aline Saarinen, "The Strange Story of Brancusi," *The New York Times Magazine*, October 23, 1955). In November, Louise Averill

Swendsen and Georgina Oeri gave the first of ten lectures on Brancusi's work.

If the master chose at this moment to reactivate a project that had lain dormant for years, the new showing of his work in New York doubtless had something to do with this. Back in 1939, during a brief stay in Chicago, when Brancusi was looking for a site for another *Endless Column*, he suggested the shore of Lake Michigan. An exchange of letters meanwhile had kept this dream alive, for certain people in Chicago were equally hopeful of seeing it through. One such letter, dated October 19, 1955, came from the attorney Barnet Hodes, who wanted to know what such a project would require in money, materials, and time. The sculptor wrote back that he was willing to go ahead with it, but he asked what material the Chicago column would be made of and how tall it would be. "As I have just come out of the hospital," he added, "I am unable to go to Chicago for the time being," but he hinted that perhaps he could make the trip the following spring. On October 28, Hodes replied that he was pleased, and that the column's height and material would be up to the sculptor; he also wanted to reach a definite agreement with Brancusi before he came to the United States.

The retrospective at the Guggenheim Museum and the plans for an *Endless Column* in Chicago were the high points of 1955, but other events transpired that year. His accident prevented his accepting an invitation to at-

Page from *Newsweek*, November 14, 1955, on the Brancusi retrospective exhibition at The Solomon R. Guggenheim Museum, New York

Opposite page:
Brancusi in front of **Doorway** (Cat. no. 174). Photo Brancusi

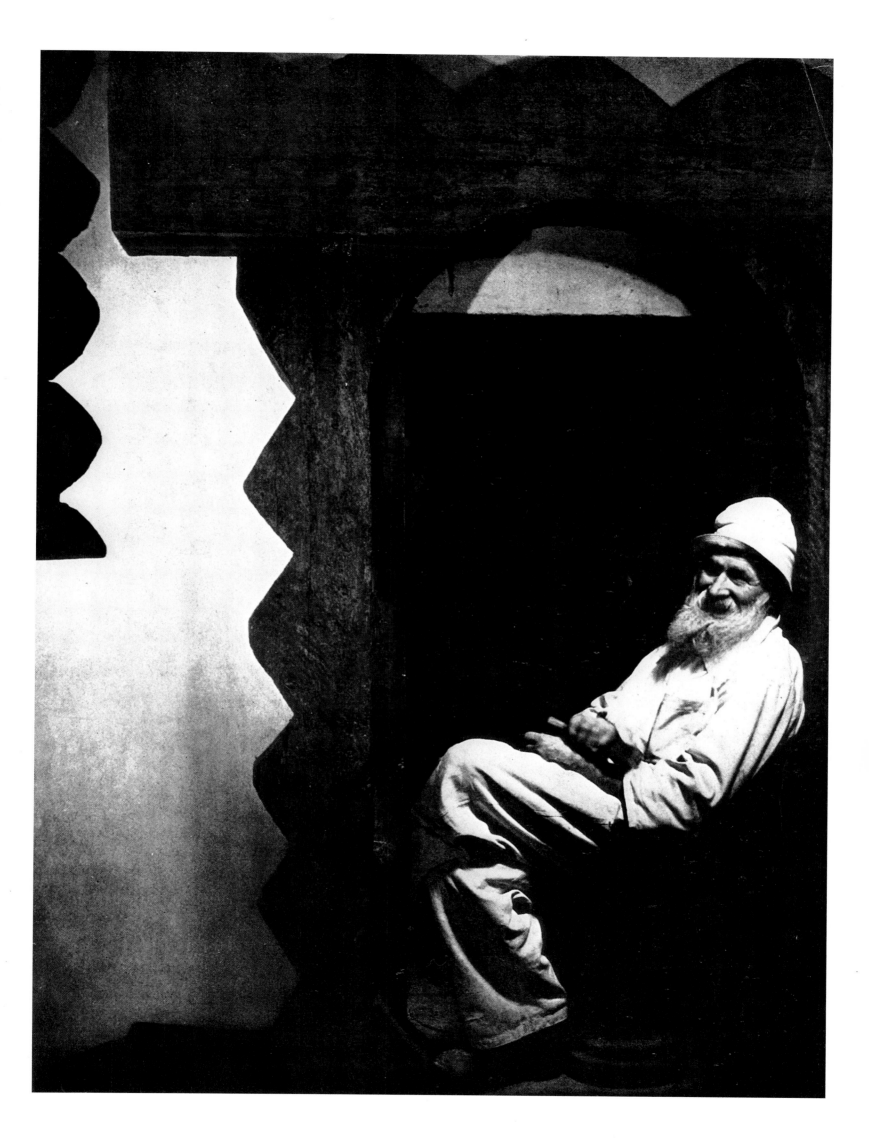

ART

BEARDED AND BUNDLED UP, Brancusi sits in his cold studio, smilingly contemplating his work.

Great Recluse

BRANCUSI AND ART COME FROM HIDING

For nearly 25 years one of the greatest artists of the 20th Century has been living in almost complete obscurity, a hermit in a cluttered studio off a blind alley in Paris. He is Constantin Brancusi, a Romanian sculptor whose streamlined birds, egg-shaped heads and rough-hewn idols have revolutionized modern sculpture, provoked national debates (*p. 139*) and made him famous around the world.

But renown is of no concern to 79-year-old Brancusi who, having long ago dedicated his life to the search for "true form," has resolutely shunned photographers and made little effort to exhibit his work. Recently, however, he was persuaded to send some sculpture to his first big retrospective show, now at New York's Guggenheim Museum. And last month, after a lapse of years, he let himself be photographed in his studio. On these pages LIFE presents the first up-to-date pictures of the great recluse, along with some shining examples of the work which brought him his unsought fame.

BRONZE BUST entitled *Mlle. Pogany* sums up → Brancusi's art of highly simplified, stylized forms.

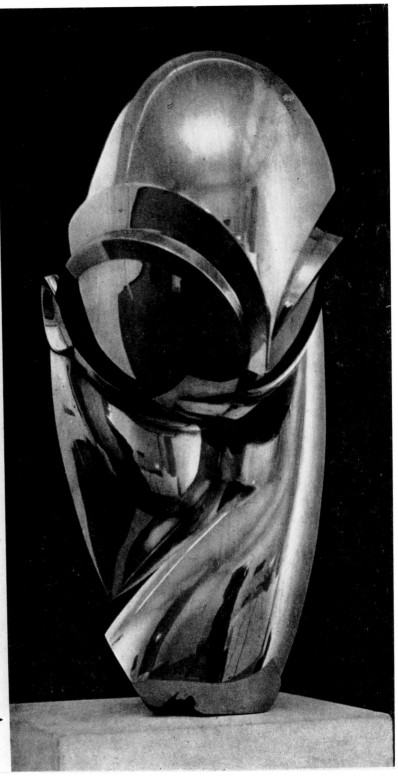

Pages from *Life*, December 5, 1955

tend the third Biennial of Sculpture ("De Rodin à nos jours," Middelheim Park, Antwerp), but other proposals came his way. First, a Father Couturier wished to place a *Bird in Space* in front of the Sainte-Baume Grotto of the Magdalen in Provence. The religious aspect of the idea appealed to Brancusi, but unfortunately nothing came of it. Next, Mies van der Rohe, who was finishing the ultramodern Seagram Building in New York, was contemplating a *Bird in Space* for the plaza in front of

Page from *The New York Times Magazine*, October 23, 1955

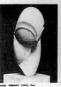
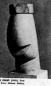

258

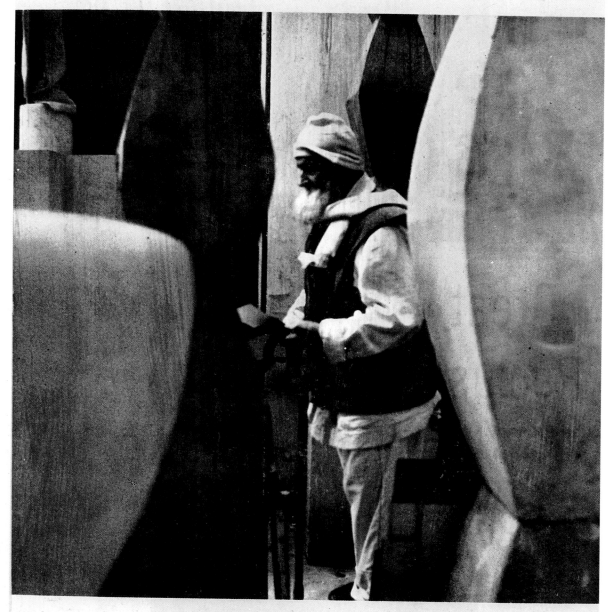

A HUMBLE LIFE OF 'PURE JOY'

Wearing white pajamas and a yellow, gnomelike cap, Brancusi today hobbles about his studio tenderly caring for and communing with the silent host of fish, birds, heads and endless columns which he created. The old man leads the same humble life he led as a peasant boy in Romania before the turn of the century. At that time, after studying carpentry, he took up sculpture in Bucharest, later set off on a two-year walk over Europe which landed him in Paris in 1904. There he began his lifelong quest for forms which would convey the essence of things rather than imitate their superficial appearance. Gradually Brancusi evolved an art of polished purity and primitive power which was so simple it both shocked and baffled spectators. But Brancusi counseled them, "Don't look for obscure formulas or mystery. It is pure joy that I am giving you."

132

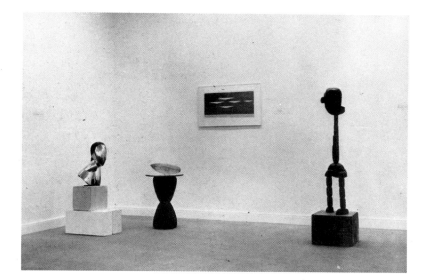

it. A series of letters from Roché sheds some light on the project.

". . . Sweeney-Guggenheim cabled me that preparations for your big exhibition are *under way*; that many works will be loaned from museums and private collections in the United States and South America; that they're still hoping you'll agree to loan some of your major works, even if you can't or won't come to New York to set them up yourself; and that it's going to be an almost unprece-

Installation view, The Solomon R. Guggenheim Museum, New York, 1955

dented exhibition and tribute. They'll probably approach me about loaning several of the works I have of yours."

"February 20, 1955.
"Would you consent to loaning the white marble *Seal* (in the Modern Art Museum [sic] in New York) to the Guggenheim Museum in New York for the big Brancusi show next October?..."

"July 17, 1955.
"Dear Brancusi!
"A matter of great importance. Mrs. Lambert writes me that they'd like to put a gigantic Brancusi on the little plaza in front of Mies van der Rohe's gigantic building, which—if I heard correctly over the telephone—is supposed to be 500 meters tall, or 300 (?).
"If that winning little plaza in front of the Rockefeller Building [sic], which is perhaps 100 meters lower, is any indication, it'll be an ideal location for one of your works—*The Cock*? Or better yet, a *Bird in Space*? Or an *Endless Column*?"

"August 16, 1955.
"Dear Brancusi,
"Mrs. Lambert sent me the enclosed material to pass on to you. The photo shows a model of the elevation; the little plaza (piazzetta) is in front (33 × 66 m. [100 × 200 feet]). The tower is supposed to be about 130 meters high [425 feet] (I *didn't* hear right over the phone). Mrs. Lambert says that Mies van der Rohe has definitely decided on *Bird in Space*. She wants to know if you recommend stainless steel, if you have any advice to give concerning the way *Bird in Space* should be cast, and whether or not you want to be active in the engineering part of it. Also, how much you are asking.
"...Don't you think it's only right for you to design the fountains and determine where they should go, and how the jets of water should look, and how the green areas should be laid out?
"Would Istrati be so kind as to drop me a line giving me your answer and letting me know how you are?
"Your old

H.-P. Roché"

We should also mention that Fernand Léger died in 1955. Brancusi took it hard, for the two had been friends over many years.

When the Guggenheim retrospective was over, Brancusi was presented with a scrapbook of photos and newspaper clippings to give him some idea of how his work had been displayed. He was delighted with it; his only regret was that certain pieces of sculpture had been perched atop tall and

259

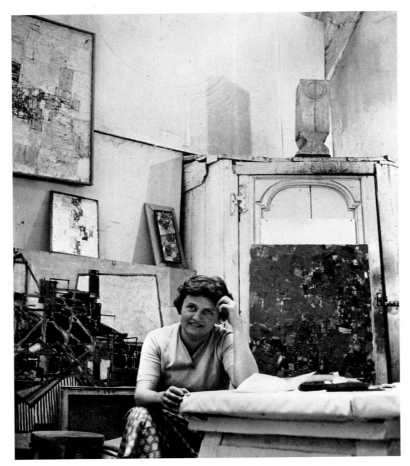

Natalia Dumitresco in her studio, 11 Impasse Ronsin, 1956. The model for **Gate of the Kiss** (Cat. no. 202) is on top of the armoire. Archives I–D

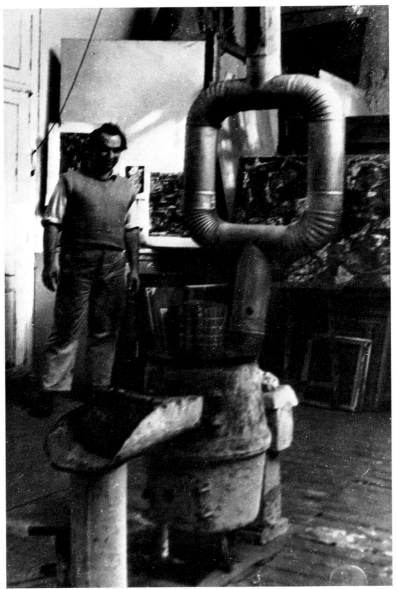

Alexandre Istrati in his studio, 11 Impasse Ronsin, 1949. In the foreground, the stove made by Brancusi. Archives I–D

completely inappropriate iron rods.

On another front, the Assistance Publique advised the sculptor that henceforth he, as well as other persons residing in Impasse Ronsin, would have to pay an "occupancy penalty" in lieu of rent. This fee meant that they were no longer considered tenants, but trespassers, whose presence was merely tolerated. The specter of insecurity was back to haunt the artist just when he was longing to safeguard the future of his studios and his art. The mean-spirited landlords dogged him until his death and their aggravations helped to shape some of his decisions.

On January 1, 1956, the Brancusi retrospective moved on to Philadelphia. Not all of the works Brancusi had sent so reluctantly came back to Impasse Ronsin: in a telegram dated October 26, 1955, Sweeney requested *King of Kings* on behalf of the Guggenheim Museum. "If the museum wishes to buy it," Brancusi wrote back, "keep it." It was paid for in 1956, and the museum later purchased *The Sorceress* and *Flying Turtle* (so called because it had been exhibited upside down; when the astonished Brancusi saw it illustrated in the scrapbook Sweeney sent him, he exclaimed, "My *Turtle*'s flying now!"). The Museum of Modern Art bought *Socrates* on January 25, Steichen taking care of the banking formalities. The sculptor asked his old friend over for a meal, fixing it himself on the forge. Taller than Brancusi, Steichen radiated a buoyant, easygoing air. "You asked me how I manage to get along," Brancusi said at one point. "Well," he declared, pointing to us, "they're the ones who help me out."

On February 21, 1956, Brancusi received letters and telegrams congratulating him on his eightieth birthday. The celebration, usually lasting three days, was restrained this year. The artist looked preoccupied, not so much by the prospect of death—he had long since seen this as a cosmic phenomenon—as by the fate of his work.

Of all the proposals that came his way (and some were farfetched), it was Sweeney's that intrigued him most: to build a museum in New York to house the bulk of the sculptor's life work. That it would be equipped with a fallout shelter did not displease Brancusi, for he too was obsessed with the thought of worldwide catastrophe. And the Musée d'Art Moderne in Paris was also pressing for a donation to France or even to the city of Paris.

Brancusi would have preferred to keep the sculptures right where they were. He

dreaded to think about moving them, not only for the inevitable damage they would sustain, but because their future arrangement could never be the same. In his studio, the space around them was a work of art in its own right; works were often shifted in his unending quest for the most harmonious arrangement.

Soon after Brancusi's eightieth birthday came another cause for rejoicing: Natalia Dumitresco had just been awarded the Kandinsky Prize, two years after Alexandre Istrati had received the same honor. We decided to celebrate both occasions at once, and the guest list of twenty or so included Mme. Kandinsky, Sonia Delaunay, Ionesco, Roland de Renéville, Deyrolle, Fardel, and San Lazzaro. Since Brancusi did not know Kandinsky's widow, the two of them met before the party; he gave her a tour of his studios, talked about the fate of his work, and suggested building a Brancusi–Kandinsky museum in Neuilly, of which she would be head—a startling, unfulfilled proposal. On the day of the dinner, Brancusi fixed his specialty, leg of mutton *à la forge* with a purée of beans.

On March 9, Brancusi got up

during the night, stumbled into a board, and fell; the accident was not serious, but it left him shaken. Ten days later, he missed a step while making his way up to his loft, and on April 30, he dislocated a finger. These mishaps lodged in his mind, and he felt less and less steady on his legs. "They've always been my weak spot," he said. "It has to do with the fact that I'm a Pisces." It put a damper on his spirits.

Late in March, there was talk of building a studio for his work on the grounds of the Musée Rodin in Meudon. He took out his gray suit and overcoat, changed from clogs into shoes, and went to the house where Rodin had once had him over for lunch, but when he got there, he saw how the place had changed. Gone was the poetry of the old days; it was a letdown. "What business do I have out there, where Rodin has the place of honor? Why, I'd look like a poor relation." It was also suggested that a studio for Brancusi's works could be built on Rue de la Manutention, alongside the Musée Nationale d'Art Moderne. He liked the idea but it was not followed through.

It was now time to decide about a bequest, which re-

quired him to draw up a will. On April 9, Georges A. Salles, director of the Musées de France, and Jean Cassou, director of the Musée Nationale d'Art Moderne, stopped by to discuss the matter with him. Brancusi balked; it is common belief in Rumania that to draw up a will is tantamount to making an appointment with death. His visitors pressed the sculptor and finally prevailed upon him to donate his work to France, with the proviso that the government would have possession only on his demise.

The United States was then home to some twenty-four Brancusis; Rumania boasted Tirgu-Jiu and work from his youth. In France, his adopted country, where the sculptor had spent more than fifty years, there were only three pieces of sculpture to show for it. He made up his mind that he would keep his oeuvre intact by bequeathing the contents of his studios to France. The date for signing the will was set for April 12.

It was a momentous decision, and Brancusi felt the hovering spirit of patriarchal Rumania—in the old days, matters concerning the village or the family were settled by menfolk. (Young men stood respectfully

behind the elders at these meetings, and no women were admitted.) But who should turn up on the morning of the 12th but a woman! "I'm Mr. Cassou's secretary," she said. "You are *not* Mr. Cassou's secretary," Brancusi snapped back, "I know her, and besides, I'm not expecting her." Dumbfounded, the secretary turned back in tears; we met her in the courtyard, and found it hard to explain the reason for his rebuff. Later that morning, at 11:30, the notary from the Musées de France and a male clerk arrived at Impasse Ronsin. Brancusi and Roland de Renéville, a writer, friend, and magistrate whom he had asked to be present, were waiting.

"I hereby make, publish, and declare this to be my Last Will and Testament, revoking all prior wills and codicils heretofore made.

"I hereby make, constitute, and appoint Mr. and Mrs. Alexandre Istrati, residing at 11 Impasse Ronsin, Paris, as my sole

Installation view, Brancusi retrospective exhibition, Philadelphia Museum of Art, 1969. Museum photo

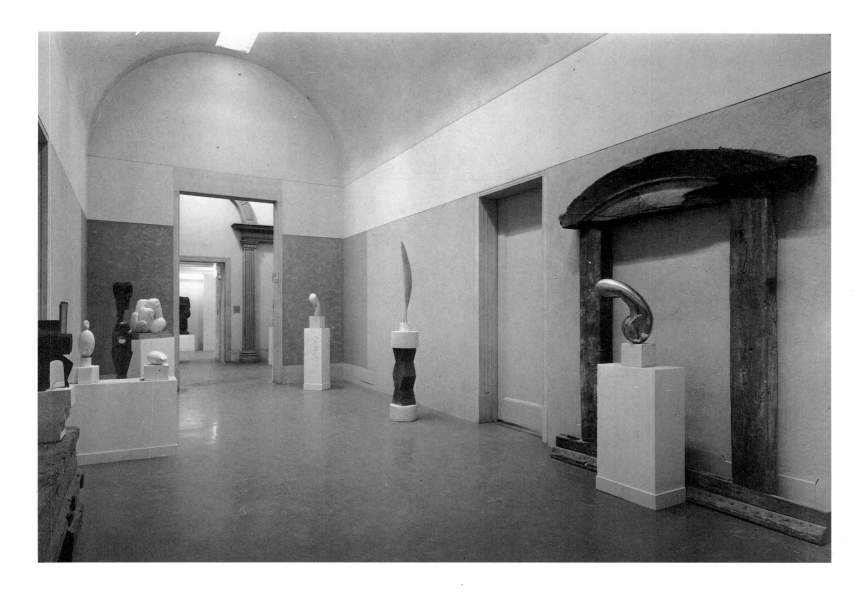

heirs, share and share alike. If either of my sole heirs shall predecease me, then and in that event, all legacies naming the deceased shall be given, devised, and bequeathed to the survivor.

"I give, devise, and bequeath the contents of my studios at 11 Impasse Ronsin, Paris, at the time of my death to the government of France, on behalf of the Musée National d'Art Moderne, to be theirs absolutely and forever, except for such cash, assets, and [negotiable] instruments as may be situate thereat, which shall revert to my sole heirs.

"This bequest is made with the understanding that the French government shall reconstruct, preferably on the premises of the Musée National d'Art Moderne, a studio to contain my works, both finished and roughed out, as well as workbenches, tools, and furniture.

"In the event that one or more of my works shall be removed from my studios for use in an exhibition, or for any other reason whatsoever, it is my wish that they be included under the terms of the bequest hereinabove...."

When he came into our studio, he looked greatly relieved. "I've made you my sole heirs," he announced. From then on he treated us as his children, his heirs, and confided his schemes to us as though we were dutybound to see them carried through. What would come of these plans? Would the *Endless Column* in Chicago ever be built? Would one of his monumental sculptures someday grace a public square in Paris? The more he divulged, the more he seemed at peace with himself, and he wanted everything in his life to stay just as it was. Once, when the police station of the fifteenth arrondissement telephoned to ask if he would see a relative from Rumania, he replied, "I don't want to see anyone, I'm not expecting anyone any more."

Often, he admitted, pressures were brought on him to change his will, but he wouldn't hear of it. And after his death, unsuccessful attempts were made to contest the will.

On March 22, attorney Barnet Hodes informed Brancusi that he was coming to Paris to discuss Chicago's *Endless Column.* Delighted, Brancusi wrote back that he would "muster every ounce of strength to do something without equal anywhere in the world." Hodes came twice to Impasse Ronsin and at his request Brancusi set down an official go-ahead in writing on June 26 for an *Endless Column* that would rise on the shore of Lake Michigan. "Nothing shall be done without your full and express consent," the attorney assured him.

On September 25, Hodes

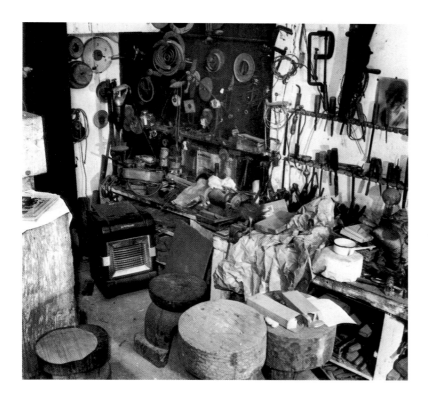

Corner of Brancusi's studio with his tools

wrote that he was still waiting for Brancusi's sketches, plans, and recommendations. Brancusi replied on October 9 that he was sorry, but his health prevented him from going to Chicago. He had no plans or drawings, he went on, but the basic concept was a module that he himself would make once the height and material of the column had been ascertained. Hodes replied on November 23: the height would be 200, 300, or 400 feet. He enclosed a small book he had written on preserving America's artistic heritage.

In the meantime, Brancusi refused to sell *Leda* and the bronze *Bird in Space* (76¾ ins.; molds destroyed by Brancusi) to Theodore Schempp, an American dealer, and he turned down

Sweeney's request to purchase *Bird in Space* for the Guggenheim Museum. The sculptor was determined to keep these with the other pieces in his studios, bequeathed to the French government.

On April 23, he celebrated St. Gregory's day as is done in Rumania. To proclaim the arrival of spring, everyone hangs pussy-willow branches bursting with catkins on their doors; then everyone gets weighed, to see the pounds gained or lost during the winter: shopkeepers bring their scales out into the street and invite people to weigh themselves. We settled that day for the scale in our local pharmacy, and Brancusi, who stood 5 feet 8 inches tall, seemed pleased with his weight of 143 pounds. Afterward we went over to the tobacconist's. Brancusi was a regular customer and would buy a good supply of Turkish tobacco (Yaset), little cigars, pipe tobacco, and

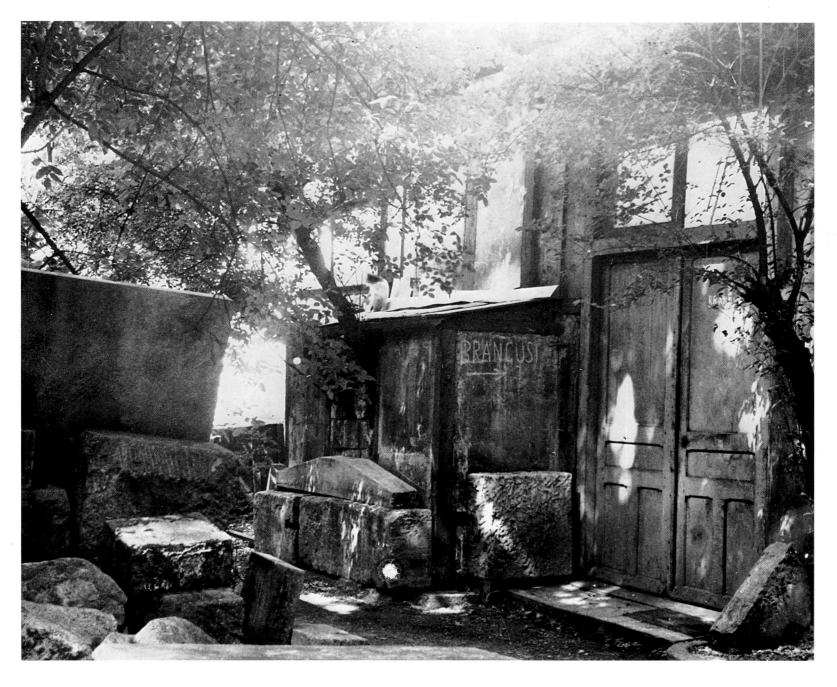

denicotinizing filters (which we made necklaces out of when he was done with them). Since he ran his own errands, all the shopkeepers in the neighborhood knew who Brancusi was. He recounted one conversation he had: "One day, I decided to show my sculptures to the laundress. She looked at them, awestruck. 'Monsieur Brancusi,' she exclaimed, unable to contain her admiration, 'it's as beautiful as a fireman's helmet!'"

The matter of purchasing a grave site in Montparnasse Cemetery came up that May, though Brancusi was much more concerned about the Chicago column. Few plots were available. A marble dealer he had worked with suggested one that had a "good location," but the artist showed him to the door. "Very well," he finally said to us, "I'm willing to buy a plot, but only if we're all buried there together." Then he added, "Whatever you do, don't put the whole Rumanian colony there, too!" He decided that he should be laid out in white clothes. No cast of his hands, no death mask (he had tried the procedure once, albeit reluctantly, because the plaster tore out his facial hair); that sort of thing was not consistent with his attitude toward art. "Cover my grave with a simple stone slab, and the flowers you place on it should be simple, too."

On June 22, an American collector bought several of our paintings, and the following day, when we got home, Brancusi was holding a letter from the Guggenheim Museum. They wished to purchase, among other things, a gouache for a thousand francs. We cried, "A thousand francs! At that price, we'd like to buy a gouache, too."

"One of *my* gouaches?"

"At that price? Yes indeed!"

"Now, then, which one would you like?" he asked gleefully. "Do you have any money? [Knowing that, at the moment,

we did.] Well, go fetch it." We did.

"Take your pick!" We had our eyes on a fresco ($11\frac{1}{2} \times 18\frac{1}{2}$ ins.) of a stylized bird, a fragment of his project for the *Temple of Meditation*. That was all right with him. He asked for a pencil, but the signature was hardly visible on the rough surface. "Bring me a metal point," and he incised another signature. He instructed us where the fresco should go in our studio, and whenever he came in, he checked to see if it was there.

On December 30, 1956, he received a letter from Bucharest. The Rumanian government was planning an exhibition of his work and wanted to include sculpture that had not been seen in Rumania; he was also invited to visit for one or two months in his homeland. Brancusi did not reply, having apparently reached that level of transcendent wisdom from which a person contemplates life and its vicissitudes with a degree of detachment.

Close at hand he always kept a copy of Camille Flammarion's *Traité d'Astronomie* and a little globe. "When you stop to think that all mankind is on a rotating sphere that travels through space, destination unknown, you realize how paltry human beings are, and how pointless their ambitions." Yet, he found the envelope of a letter that arrived from Texas on October 2 very entertaining.

Brancusi seemed to be feeling better, and kept himself busy with small tasks and planning the Chicago column. He began to have friends over again and enjoyed reminiscing about old Rumanian customs; at New Year's, he recalled the children going from house to house in the evening, singing and tossing wheat to bring people happiness and prosperity in the coming year, while the grown-ups would drive up with ox-drawn plows, punctuating their New Year's greetings with cracks of the whip.

We baked Rumanian-style cakes (*cozonaci*) in the chimney oven, as he instructed us. He gave candied chestnuts to visitors. This festive atmosphere lasted until January 6, the day of the Epiphany and also of Christ's baptism in the Jordan River; to commemorate this, Brancusi took a bath in his tub. As he intoned a Gregorian chant from his youth that had something to do with the Jordan River, we helped him bathe. He put on his winter underwear, then his white clothes and wooden shoes; taking a censer he had made,[40] he filled it with embers and incense and then strolled through the studios swinging it back and forth, as when he had served in the Rumanian church, chanting, "Evil begone and Good come this way!" By purifying the air he recaptured a feeling of sanctity, not that he had lost it: he kept a votive lamp burning in his studio day and night.

That evening, he listened to records and sang old Rumanian tunes as he played the guitar or the violin. (These instruments, always within his easy reach, are now in the Pompidou Center.) After the meal, we passed around the Twelfth Night cake to see who would get the bean. Since he took childlike pleasure in wearing the crown, we always saw to it that his piece would have the bean—but this time, by mistake, Alexandre got it. We thought he would take this with a smile, but he seemed somewhat put out. A little later, however, he broke into a song: "I'm a dethroned king."

The sculptor suffered from prostate trouble as well as from eczema, which gave him irritation more than real pain. He consulted a Dr. Besançon, who had written books on medicine and whose precepts were diametrically opposed to those of Dr. Carton. "Take care of your eczema like a prize possession," the new doctor advised, "that's how you will get rid of

Envelope of a fan letter from Waco, Texas, 1956. Archives I–D

the disease." So, we did nothing more than keep his skin lesions clean with an antiseptic. Brancusi had no faith in traditional medicine, and one could hardly blame him; for months he had been taking a great deal of medication: biomycin, methionine, cortizone, tonics, vitamins, cures for the heart, cures for the prostate. In a doctor's notebook we read, "The patient refuses medication." But Brancusi muttered, "The more you take care of yourself, the sicker you get." And when all was said and done, he himself decided what treatment he would receive.

Sometimes, when he thought about his struggles throughout his life, he became dispirited. He took no pleasure in the clippings sent from *L'Argus de la Presse*, testaments to his worldwide fame and influence—indeed, they had the opposite effect. "So I've got all that, but what can I do *now*? It's impossible to work. I don't eat any more. There's nothing I long for. Besides, what's the use of working? Everything will disappear anyway. There's going to be another Flood." And he would come back to his obsession, that a cataclysm would engulf the world. However, he rallied from these spells of depression without much difficulty.

On Candlemas (February 2), he made pancakes and had us toss them with a twenty-franc piece in our hands. He spent his birthday listening to records of folk music: some Egyptian and Japanese melodies reminded him of Rumanian tunes: "Folklores are alike at certain points on the globe," he noted. "What miracle brought that about? Was it due to migrations, or were they spontaneously created in similar milieus? You'll come across a Rumanian doina that sounds like an Egyptian melody or a Japanese song."

Little by little, the master found it harder to move about. His belly was swollen, and he lay most of the time on the sofa, under the loft. We fitted it out with a backrest, and a rope to pull himself up with, and nails for hanging his watch, spectacles, and magnifying glass at hand. If a visitor happened by, he would let us show his sculptures, and we would unveil them one by one, as he himself had done.

On Sunday, March 10, 1957, there was something strange in the air. Brancusi asked us to stay with him. He was composed, and very gentle. We had no music that evening; we carried him up to bed, tucked him in, and he said, "Take my bed down tomorrow. I'd rather sleep down there." He gave us a hug and said good-night. The next day, when we urged him to go to the hospital, where he would get better care, he said

that he would sooner wait for the Good Lord at home. We brought his big bed down and placed it near the stairway and the fireplace. On Tuesday, Brancusi woke up fidgety and stayed that way all day long. He had always spoken French, but now he began to speak Rumanian, not only with us but with others who came to see him or care for him, as though reverting to his childhood. The doctor stopped by every day, and when Brancusi said he wanted to sit up, a bed with a railing was delivered on Wednesday, with the doctor's approval; he was more comfortable, and could watch the comings and goings of the two nurses the doctor recommended to be on hand. They tapped fluid from his belly, and he was hooked up for intravenous nourishment.

He would look at people and things with a quizzical expression, while gradually his strength flagged. On Thursday evening, he suddenly said, "*Haide ba, haide ba*" ("Come along, me lad, come along"; those were to be his last words), and we stayed with him most of the night. The next day he was drowsy, except for an occasional light spasm. We lighted a candle, for Rumanians believe that its gentle glow shows the way toward the spiritual light in the world to come. Early Saturday morning, at two o'clock, he took a deep breath, then his breathing stopped. His face was peaceful, as though to say what he had so often said: "I'm not afraid. I'm ready to go."

The nurses dressed him in white, as he had wished, and placed him on some dry ice. That morning, we reported the death to the authorities, requesting that seals be affixed to the premises after the body was removed, and notified the museums and a few friends. "Look how handsome he is," said Henri-Pierre Roché, with tears in his eyes.

Not long after Brancusi died, an American dealer knocked on our door, wishing to see "Monsieur Brancusi." We assumed he knew of the sculptor's death, and unlocked the door to the studio, bringing in the dealer. When he saw Brancusi laid out on his deathbed, he turned pale and rushed out without another word. Years later, in Los Angeles, he told us that he had come to Impasse Ronsin to purchase a sculpture and had not known of Brancusi's death; the shock had been overwhelming.

In keeping with the sculptor's wishes, services were scheduled in the Rumanian church on Rue Jean de Beauvais, where he had once served. A priest came each day to offer prayers for the dead. From Saturday, March 16 on, many people stopped by to see the remains

of the great sculptor and to reflect.

The press and the radio announced Brancusi's death upon learning of it, and reports began to appear in foreign newspapers. Word spread in the United States, England, Italy, and Portugal, and also in Australia, India, Pakistan, and Hong Kong.[41]

The body was placed in a coffin Monday morning and taken to the Rumanian church early that afternoon; a justice of the peace immediately sealed the doors of the studios. Mass was said at 2 P.M. on Tuesday, March 19, 1957. Everyone present—and a great many people came—held a small lighted candle. The Byzantine chants of the Eastern Orthodox liturgy filling the church induced a deeply contemplative mood. At the conclusion of the service, Georges A. Salles, director of the Musées de France, Jean Cassou, director of the Musée d'Art Moderne, and Professor Basile Minteanu, a native of Rumania, delivered the eulogies.

Georges A. Salles said the following:

"Since we shall never again hear that lilting voice that floated up from your beard to carry us off to the land of legend,

"Since we shall never again see those bright, beady eyes that sparkled with mischief and seemed to be laughing at something they could see and we could not,

"Since we shall never again be welcomed into that studio of yours by a venerable Homeric shepherd amid his fabulous flock,

"I bid you farewell,

"A sorrowful farewell,

"On behalf of your friends,

"On behalf of those who admired and cherished you,

"On behalf of those to whom you brought delight,

"On behalf of those who know that with your death a true poet has gone from our midst, and a divine hand has closed, never to open again.

"I bid you farewell.

"But your works remain, radiant and pure.

"They are more alive today than ever,

"And they shall never die."

The casket was placed in a temporary vault in Montparnasse Cemetery, as the grave the sculptor would be buried in was not yet ready. After the priest said the traditional prayers, each person tossed flowers and a spadeful of earth on the coffin. Then, in the Rumanian custom, the priest blessed a *coliva* of wheat, sugar, and walnuts, and passed it around to the mourners.[42]

By nightfall, the tomb was covered with flowers: humble bouquets from artists and friends mingled with sprays and wreaths from the Musées de France, the Museum of Modern Art in New York, the American embassy. The following day, Henri-Pierre Roché wrote: "It was an intimate and affectionate, yet deferential burial, steeped in his invisible presence.... A halo of glory hung gently round him these past few years. His wisdom became genial and fatherly. He has bequeathed the contents of his studios to the people of France, and to all peoples everywhere."

ma Patrie

Ma famille c'est la
Terre qui tourne —
la brise du vent :
les nuages qui passe
l'eau qui ~~�># verse
le feu qui chof
Herbes verts - herbes
seche — de la bou
de la neige

NOTES

1 A number of new galleries opened in New York after the Armory Show: in 1913, the Daniel Gallery; in 1914, the Montross Gallery and the Carroll Gallery; in 1915, Marius de Zayas's Modern Gallery. All were to become showcases for European and American avant-garde art. A whole new market was about to be tapped, and the great modern art collections of Arthur J. Eddy, Walter and Louise Arensberg, John Quinn, Albert C. Barnes, and Lillie P. Bliss, among others, began to take shape in America.

2 In 1905, Alfred Stieglitz opened a gallery at 291 Fifth Avenue, the site until 1917 of many exhibitions that featured leading artists of the day. It enjoyed a new surge of interest after the Armory Show in 1913. Stieglitz was already publishing *Camera Work* (first issue: December 19, 1903), a magazine devoted at first to photography, but later widening its scope to include work by Rodin, Picasso, and Brancusi.

3 After the bronze of *Sleeping Muse*.

4 This is *Princess X*.

5 De Zayas had wired him to send *Golden Bird* so that he could exhibit it and sell it to the museum in San Francisco.

6 Georges de Zayas, who ran a gallery in Paris.

7 There can be no mistaking Brancusi's view of how *The Kiss* should be displayed. Usually a base is added to give the sculpture greater "presence," but this creates precisely the opposite effect.

8 Society of Independent Artists.

9 *A Muse*. Quinn confused the plaster (*Mlle Pogany*) with *A Muse*.

10 The sketch Brancusi mentions is in John Quinn's correspondence, The John Quinn Memorial Collection, Rare Books and Manuscripts Division, The New York Public Library.

11 *The Child in the World* originally consisted of three wooden pieces: *Little French Girl*, a column, and *Cup III*. The artist later separated these components and made other changes. Published in *The Little Review*, 1927.

12 Original title: *Autoportrait*, Robert Laffont, Paris, 1964.

13 In *Vanity Fair*, 1927. Actually, it was Steichen who took this picture of *Bird in Space*.

14 A first draft of the list includes two items that do not appear on the one sent to Quinn: "Nos. 2 and 3, *Adam and Eve*, inseparable" and, after No. 10, an additional entry, *Abstract Head*, 12,000 frs."

15 Although Brancusi himself gave it this title, V.G. Paleolog, a Rumanian critic, maintains that Brancusi's *Cock* is not the Gallic rooster, but the Dacian one.

16 On April 17, Ethel Moorhead, head of *This Quarter* magazine, wrote Brancusi a letter. "...It is due to come out next week.... With all the Brancusis, it will be the most magnificent [issue] of all.... You have been a staunch friend to us, once again you have come to our assistance, and we are fully aware that we owe the success of the first issue to you."

17 "Remarks by Brancusi concerning direct carving, high polish, and simplicity in art. A few of his aphorisms [as told] to Irene Codreanu." Codreanu, a sculptress, visited Brancusi regularly at this time and helped him in his studio. Brancusi put together an original costume for her sister, Lizica, a dancer who was appearing in Satie's *Gymnopédies*. The sisters' friendship with the sculptor lasted throughout his life.

18 Brancusi enjoyed recalling some of Satie's witty remarks. Of a friend who had been awarded the Legion of Honor, Satie said: "Getting the Legion of Honor means nothing in itself. The main thing is not to deserve it." Once Satie spotted a sentry posted at the entrance of the Naval Ministry, whose uniform looked for all the world like a child's sailor suit. He walked up to the serviceman and said, "They're still dressing you up like that—and at your age!" On another occasion: "All through my youth, people were forever telling me, 'When you're fifty, you'll see!' I'm fifty, and I haven't seen anything."

19 However, the sale did include a few works printed in 1895 at the composer's expense and unknown to the music world: *Uspud*, two *Psaumes*, *Cartulaire de l'église métropolitaine d'art* (letter from Satie, November 1, 1925).

20 Exhibits: *The Sorceress* (wood), *Fish* (bronze), *Torso* (marble).

21 "Among themselves, Brancusi's close friends called each other Maurice [Morice]. Not just anyone qualified: to be a Maurice you had to bare your innermost self, show that you were very pure in your heart of hearts. I was no end flattered when, after two or three get-togethers, Brancusi called me Maurice. 'You're very nice. Completely unaffected. Reliable and fit for anything. Heart and intellect, that's what's needed, and above all to be yourself. No more, no less. [You too] know how to clear your head of clutter, keep an open mind, pay no heed to doctrines, never be a joiner. [You] always act instinctively, not rationally. Yes, yes, consider yourself a genuine Maurice.'" (Lydie Levassor, Duchamp's first wife)

22 Duchamp stayed with Allen Norton, who helped them with publicity.

23 This is the *Bird in Space* that triggered the conflict with U.S. Customs.

24 Brancusi had signed a document opposing the Congrès de Paris in 1922, and this may have been Breton's way of showing, however belatedly, that he had not forgotten.

25 "Brancusi's studio looks like a prehistoric landscape: tree trunks, stone blocks, an oven where the master, primitive that he is, broils meat on the end of an iron spit. A brontosaurus has deposited eggs in its four corners, and the glistening statues lure beautiful American women like so many birds.

"Satie thrived in this setting. It is fitting that something on his grave should bring back the days beyond recall when, laughing and joking, he showed us the way."

26"Brancusi," *Cahiers d'Art*, 1927, II, pp. 67–74 (with nine illustrations).

27 A longstanding complaint: "I shall attend to the photos personally" (Brancusi to Stieglitz, Apr. 24, 1914).

28When Brancusi's studio was first reconstructed in the Musée d'Art Moderne in the Palais de Tokyo, the topmost module of *Endless Column* had to be cut off at a slant because the museum ceiling was lower than at Impasse Ronsin. In the present reconstruction at the Pompidou Center, the cross girder of the ceiling has been replaced by a narrower iron rod; hence, *Endless Column* no longer touches the ceiling. The severed topmost module was replaced by the model Brancusi had made for it.

29In the studio on Impasse Ronsin, the blue-gray marble *Fish* was atop a big slab of plaster. When *Fish* was sent to the Museum of Modern Art in New York, the sculptor designed smaller bases for it. Alexandre Istrati carved these in 1948 in accordance with the new measurements. The sculpture lost none of its presence.

30With no word from Brancusi since June, and no reply to her letter of August 16, Marina Chaliapin, who was in Davos at the time, wrote on September 2 to Gaston, the concierge of Impasse Ronsin, for news of the artist. Lately she had tried, and failed, to reach him by telephone. At last Brancusi wrote to Marina and apologized for his silence. "Thanks for your letter and for the herbs you so thoughtfully enclosed," she wrote back on September 23. After bringing him up to date on her health, she went on, "...Now, let's change the subject and talk about you. What is troubling you so? Heavens, you're getting out of Paris all by yourself? Or have you been talking it over with friends? What can we do for you? Who dares to bother you like that? If only we could get together and talk! Anyway, take things easy and, like a knight, build up your strength in the beauty of nature and then sally forth with joy and truth as your shield and lance..." In this letter Marina Chaliapin also thanked the sculptor for the photographs he had sent her. "My room is positively delightful. I've got photos all over the place, yours, too, the ones of *Leda*, *Blond Negress*, and *Endless Column*."

31The year before, Mrs. Meyer had already sent the sculptor a letter concerning her portrait. "I happened to hear that you've actually finished the portrait. Is that so?... Drop me a line.... Am I beautiful?"

32Estimate for *Endless Column*, Tirgu-Jiu, Rumania, August 12, 1937. "Monument: length 30 m., consisting of cast-iron modules 154 mm. thick, assembled and plated with yellow bronze, foundations and installation included. Deadline for delivery: two months. Cost: 500,000 lei. If thickness of bronze is increased to 8 mm., then deadline for delivery: six months. Cost: 1,000,000 lei. Georgescu-Gorjan, Engineer."

33Even after Ingersoll knew that *Grand Coq* would not be finished in time for the "International Sculpture Show" in Philadelphia, he wrote Brancusi on May 19 as follows: "Everyone was disappointed not to find your work here. No matter how long may be the delay, we want it."

34After looking everywhere for a gallery willing to show our paintings, René Breteau agreed to a joint exhibition. But there were expenses to cover, and our scholarship had run out. We turned to a student organization for help, and a certificate from Brancusi gave our request added weight.

35It should not be inferred from Brancusi's participation in the previous year's exhibition of abstract art at the Galerie Maeght that he considered himself part of the abstraction movement.

36This letter was not sent through the mail, but hand delivered to its addressee by Curt Valentin.

37Letter from Arthur Lénars to Brancusi: "Paris, February 13, 1951. Sir, It is our pleasure to inform you that we have cleared [through Customs] a sculpture of yours that is being returned from the United States for repair. At the point where the piece becomes narrow there is a lead Customs seal which *must not be removed under any circumstances*. This seal will be checked when the sculpture is shipped back. In the event you need to remove this seal to make repairs, would you be so good as to let us know, for we shall have to notify Customs, whereupon they will dispatch an official to remove the seal and monitor repairs. Awaiting further word from you, we remain, sir, sincerely yours, ..."

38After living in New York, where their door was always open to artists, Walter and Louise Arensberg moved to California, to a house at 7065 Hillside Avenue in Hollywood. Architect Richard Neutra designed an addition, all in glass, for Brancusi's *Bird in Space*, as well as a second floor for the rest of their collection. In a letter dated March 23, 1950, Walter Arensberg informed Brancusi that he was sending two friends, Bruno and Sadie Adriani, to Paris to learn the sculptor's wishes about what the Arensbergs should do with their Brancusis. He would abide by the artist's wishes, whatever they were. No doubt Brancusi wanted all of his works to be brought together under one museum roof.

39As it turned out, it was not cast in stainless steel until much later, between 1972 and 1979. (See article in *Artis*, June 6, 1980, Konstanz.)

40Brancusi made several censers out of little metal containers which he coated with aluminum. He punched holes into the underside of these hollow spheres to vent the smoke, then threaded a piece of iron wire through two little openings at the top. He held onto the wire as he swung the censer back and forth.

41His longtime friend, Paul Morand, wrote in "Adieu à Brancusi" (*Art*, March 20, 1957): "Brancusi, our dinners in his Montparnasse studio, ...the springtime of my life Radiguet and I often got together there in the evening: some red wine on the anvil block. Brancusi himself grilled [the meat]. There was nothing this craftsman did not know how to handle...."

42Whenever Brancusi had Masses said for his mother, he would also order a *coliva* for congregants to share in church. We, too, have a priest say Mass and bless a *coliva* to commemorate the day Brancusi died.

APHORISMS

Page 56
Works of art are mirrors in which everyone sees his own likeness.

Page 64
Destiny, where are you leading me, Destiny?
 Do you want me to learn new things along wearisome paths, or do you drag me toward a wretched death?

Page 68
Direct carving is the true road to sculpture, but also the worst for those who do not know how to walk. And in the end, it doesn't matter whether the carving is direct or indirect. It's the work itself that counts.

Page 90
Shrewdness has its points—but sincerity's worth the trouble—

Page 94
Art generates ideas, it doesn't represent them—which means that a true work of art comes into being intuitively, without preconceived motives, because it *is* the motive and there can be no accounting for it a priori.

Page 100
Ethics is the religion of beauty.

Page 103
The good Lord is dead. That's why the world is adrift.

Page 110
Every substance has its own individuality that we cannot destroy as we please, but we can only make it speak with its own language.

Page 116
No one but ordinary people can make playthings, because they are the only ones who live in joy.
 Pedants are the living dead, and it is only toward death that they beckon us.

Page 121
I am weeping. There's such loveliness in my soul that my heart is breaking. No one is around me. No one.

Page 128
March 5, 1920
 Today I am cutting the towline and casting myself adrift on the vast ocean toward the unknown, with joy to steer me. And if I should veer toward Thee, Lord, it's just a joke!

Page 139
We are witnessing the birth of new arts. They are like wonderful flowers that no one has ever seen. But everyone swoops down on them to pick some for himself, and these wonderful flowers fade as soon as they've been touched because they don't want to belong to anyone in particular, they are universal.

Page 146 (above)
Theories are nothing but colorless equations. The doing is all that matters.

Page 146 (below)
The arts have been beating a retreat ever since artists were invented.

Page 154
When one is in the sphere of the beautiful, no explanations are needed.

Page 160
High polish is a necessity that relatively absolute forms demand of certain materials. It is not obligatory for other forms, and is even harmful.

Page 166 (above)
Happiness or love is the fragrance of our being. It occurs only in the direct contact of two beings, and it lasts only as long as that contact is altogether pure and sincere.

Page 166 (below)
The greatest happiness is contact between our essence and the eternal essence.

Page 171
By human standards, I've lived half a century—and yet, I've lived thousands of years.

Page 180
Our inner self is all that is truly our own; material things we merely tend awhile.

Page 184
Not always dost thou smile and cherish things divine, my fickle muse;
 Thou art mortal, base, and full of earthly desires—like me.

Page 190
Mind you, that's just what I invented—I knew perfectly well that I'd made something that hadn't been made before (I was no more stupid than anyone else)—But I didn't know how to say what it was—That's what longevity's all about.
 As long as no one asks me for explanations.

Page 194
With art, you're forever back at the ABC's. You can only learn them on your own. And what's more, if you learn through others, you'll end up with things secondhand and unimportant.
 A sterile woman cannot bear children.

Page 199
If we restrict ourselves to making exact copies, we stunt the development of our inner selves.
 If whatever we are making is not part of the absolute need for growth, it is useless and detrimental.

Page 202
Like something light that's been put on the ocean floor, I've had to make my way up like a blind man, not knowing why, and struggling against all currents and obstacles to reach the surface—
 Fortunate are they who come into the world knowing their place, and who quietly play their role [and then take their leave].

Page 205
Everything comes our way when we choose not to be masterful; and everything vanishes when envy makes us want to have or to hold. So there's the forbidden fruit!

Page 210
The joy that beauty gives us, the aesthetic sensation, has nothing to do with the profession of art.

Page 212
Art has been made to dominate, to mourn, to pray.
 We want to make it *live*.

Page 217
The hardest thing is to walk well, fully aware of who you are and the path you're on.

Page 222
It's finally happened:
 The muses sing of my accession;
 I am King,
 But not by the grace of men,
 I am king by my victory over myself.
 I am wholly free and God has vested me with royalty.

Page 230
The endless column is like a timeless song that lifts us into infinity ... [see p. 265]

Page 232
The arts have never existed for themselves. Throughout the ages, they have only been the adjunct of religion.
 For art to become universal and free, one must be God to create it, a king to commission it, and a slave to make it.

Page 265 (above)
[see p. 230] ...beyond all suffering and artificial joy. Whatever people say, whatever people do, Brancusi's Work shall remain for all time to come as the only solid pivot.

Page 265 (below)
Brancusi's Work—it is not an expression of the particular, it is the essence of the highest expression of universal purity, and it shall remain in the centuries to come as the only insurmountable obstacle for the *future*.

Page 266
My homeland, my family—it is the earth going round, the breeze blowing, clouds drifting by, water flowing, a fire warming, green grass—parched grass—mud, snow—

ACKNOWLEDGMENTS

Always, Brancusi had his heart set on writing a book about himself. By 1926, he had worked out a series of drawings (*New York to Paris*, *Paris to New York*) for the cover of his future autobiography, jotted down his now-famous aphorisms, and taken countless pictures of his studio and his sculpture; later he taught us to use a camera, and asked for our help in the project. When he died with it unfulfilled, we decided to write in his memory an account of our life with Brancusi, of his work habits, and of his concept of art.

In this task we had the advice of several friends, some of whom—Carola Giedion-Welcker, Nina Kandinsky, Jacques Lessaigne, Gaultieri de San Lazzaro, Mireille Rambaud, and André Roland de Renéville—are here no longer. Marcel Altmeyer convinced us to add the material and information we had accumulated during our travels and visits to museums and private collections. It is sad that he, too, has since died.

Francis Bouvet, then head of the art book division at Flammarion, was contemplating a book on Brancusi and consulted us about choosing an author. When he found that we had spent several years preparing such a book, he looked over our archives and material. We had found our publisher: we have only fond memories of him.

To all of these we extend our gratitude.

During our research, we have had the assistance of those who head the museums containing Brancusi's work. We are also indebted to those who gave us verbal accounts or valuable material: Lee Ault; William Benenson; Georges Bernier; E. Beyeler; Jean-Pierre Calon; Lizica Codreanu and her late sister, Irina; Mrs. Marcel Duchamp; Heins Fuchs; Dan Haulica; Eugène Ionesco; Sidney Janis; Mr. and Mrs. Louis Kaufman; Guy Landon; Mrs. Eileen Lane; William S. Liberman; Mr. and Mrs. Eugene Meyer; Mrs. Olga Picabia; the late Jean Prouvé; Vivi Rankine; Mrs. Margit Rowel; Theodore Schempp; Mrs. Jeanne Severini; David M. Solinger; James Speyer; Al Stendhal; Mrs. Dina Vierny.

We also thank Pierre Joseph-Lafosse and the Erik Satie Foundation for the photographs they made available to us, and likewise the New York Public Library.

We are grateful to the following at the Centre Georges Pompidou for their help and kindness: Robert Bordaz; Dominique Bozo; Isabelle Fontaine; Germaine de Liancourt; Jean-Yves Moch; Gilbert Paris; Antoinette Rézé Huré.

We should like to pay special tribute to the memory of Henri Flammarion, who gave the French publication of this book his blessing.

Our thanks to Charles-Henri Flammarion and everyone at Flammarion: Adam Biro, head of the art book division; Claire Lagarde, for her active help in all phases of manuscript preparation, and her readiness to share in our work, with her enthusiasm and passion for Brancusi's art; Brigitte Benderitter, press attaché; Françoise Dios, proofreader; Jacques Maillot, designer; Michel Moulins, chief of production; Jacques Nestgen, staff photographer.

N.D. and A.I.

CATALOGUE OF WORKS

Each entry in the catalogue includes what is pertinent of the following information:

Catalogue number and title

Date and material (versions specified *a*, *b*, *c*, etc.)

Measurements in centimeters (measurements of versions of a work, such as *Bird in Space*, may include circumference or depth, according to data supplied)

Inscribed signature and date (sig.)

Other inscriptions (inscr.)

Foundry mark

Present location; followed by inventory number

Remarks

Provenance

Exhibitions

Bibliographical references

Brancusi photograph and number (all Brancusi photographs are in MNAM unless otherwise noted)

Posthumous plasters and bronzes ([T] *tirages*)

Commentary by Pontus Hulten

Measurements (in centimeters):

h. = height

w. = width

d. = depth

diam. = diameter

circum. max. = maximum circumference

circum. min. = minimum circumference

Other abbreviations:

MNAM = Musée National d'Art Moderne, Paris

Arch. I–D = Archives Istrati–Dumitresco

In the bibliographical references:

Spear = A. Spear, *Brancusi's Birds*, 1969 (plate numbers only)

Geist = S. Geist, *Brancusi*, 1975 (catalogue numbers only)

Brezianu = B. Brezianu, *Brancusi in Romania*, 1976 (catalogue numbers only)

1. Portrait of Gheorghe Chitu

1898. Plaster
Whereabouts unknown

Made in Brancusi's last year at the School of Arts and Crafts, Craiova

Exhib.: Craiova, Oct. 18, 1898
Bibl.: Brezianu, 1974 (p. 14)

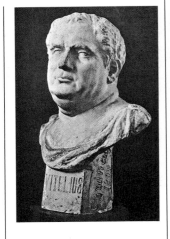

2. Vitellius

a. 1898. Plaster: h. 61, w. 43, d. 27
Sig. (base, right side): C Brâncuş 1898
Inscr. (front): Vitelius
Muzeul de Arta, Craiova

Exhib.: Brancusi Retrospective, 1969–70
Bibl.: Geist, no. 1; Brezianu, no. 1

b. 1964. Bronze: h. 61, w. 43, d. 27
Muzeul de Arta, Craiova

Unauthorized cast

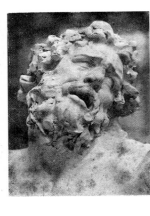

3. Laokoön

a. 1900. Plaster
Whereabouts unknown

b. Clay original
Whereabouts unknown

Bibl.: *This Quarter*, 1925

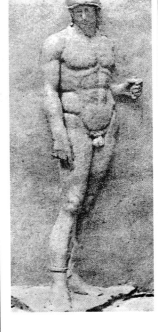

4. Borghese Mars

1900. Clay
Whereabouts unknown

Bibl.: Brezianu, 1974 (pl. 14); Geist, no. 3; Brezianu, no. 48

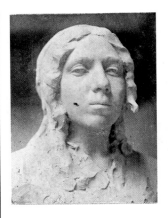

5. Character Study

1900. Clay
Sig.: C. Brancusi
Whereabouts unknown

Bibl.: Geist, no. 6; Brezianu, no. 50

Photo Brancusi, inscribed "Studiu premiat la scoala de Arte Frumoase din Bucuresti" ("This study won a prize at the Bucharest School of Fine Arts")

Brancusi began very early to be as aware of the spaces between objects as of the volumes themselves. This idea was nowhere realized more fully or clearly than in his studio, in which the interactions of each sculpture with the others were carefully calculated. To fragment Brancusi's oeuvre into these separate entries may seem to run counter to his concept of sculpture, but the need for clear identification of his works of sculpture is served by the format of this catalogue. (P.H.)

6. Anatomical Study

1900. Clay
Whereabouts unknown

Bibl.: Brezianu, no. 49

Photo Brancusi

7. Male Nude I

1901. Clay relief
Whereabouts unknown

Bibl.: Geist, no. 8; Brezianu, no. 52

Photo Brancusi ph. 154

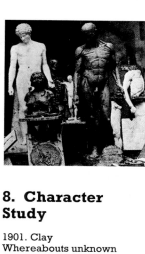

8. Character Study

1901. Clay
Whereabouts unknown

Bibl.: *Brancusi photographe*, 1977 (pl. 1, left foreground)

Photo Brancusi ph. 160

9. Medallion

1901. Clay
Whereabouts unknown

Bibl.: Geist, no. 7; *Brancusi photographe*, 1977 (pl. 1, lower left)

Photo Brancusi, inscribed "Premiat 1901"

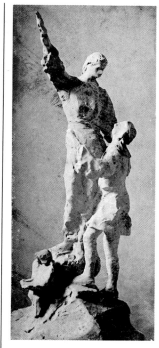

10. Allegory

1901. Clay
Whereabouts unknown

Bibl.: Geist, no. 8A; Brezianu, no. 54

Photo Brancusi ph. 156

Brancusi's early school exercises show him to be no ordinary student. Already he was displaying a remarkable expressiveness, even with academic subjects, that set him apart from the others. His work has always had an original and often unsettling touch. (P.H.)

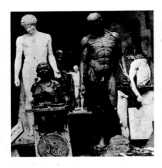

11. Ecorché

1901. Clay
Sig. and inscr. (underneath, in oval): Medalia de bronz 1901. C. Brancusi
Whereabouts unknown

After *Antinoüs Flayed* (2nd century A.D.)

Bibl.: Brezianu, no. 55; *Brancusi photographe*, 1977 (pl. 1, center)

Photo Brancusi ph. 160

12. Ecorché

a. 1901–2. Plaster: h. 177, w. 52, d. 32
School of Fine Arts, Bucharest

Bibl.: *This Quarter*, 1925; Geist, no. 10(a); Brezianu, no. 2

b. 1902. Painted plaster
Inscr. (on plaque): Lucrat după natură de Prof. Dr. Gerota și Brâncuș 1902
Medical Institute, Jassy

Bibl.: Geist, no. 10(d)

c. 1902. Painted plaster
Inscr.: Lucrat după natură de Prof. Dr. D. GEROTA și Brâncuș 1902
Muzeul de Arta, Craiova

Bibl.: Geist, no. 10(b)

d. 1902. Painted plaster
Inscr. (on plaque): Atitudinea clasicului "Antinous." Anatomia muschilor superficiali. Lucrat după natură de Prof. Dr. Gerota și C. Brâncuș 1902.
Liceul N. Balcescu, Craiova

Bibl.: Geist, no. 10(c)

e. Painted plaster (deteriorated)
Museum of the Faculty of Medicine, Cluj

Bibl.: Geist, no. 10(e)

Photo Brancusi ph. 167

In this astonishing photograph we see (in a studio setting) the anatomy study which, more than any other work, took his contemporaries at school by surprise. Academic, yet revolutionary, *Ecorché* marked the completion of Brancusi's studies at the School of Fine Arts in Bucharest. There are several versions of this sculpture in his native Rumania. (P.H.)

13. Portrait of Ion Georgescu-Gorjan

1902. Plaster: h. 53.5, w. 45, d. 27.5
Muzeul de Arta R.S.R., Bucharest

Bibl.: Geist, no. 11; Brezianu, no. 91

14. Anatomical Study

c. 1902. Clay
Whereabouts unknown

Photo Brancusi, inscribed: Bucarest-Studiu de anatomie

The uncanny presence with which Brancusi managed to invest his portraits, even when wholly conventional, set him apart from his contemporary sculptors. No doubt this had to do with his habit of establishing a special rapport with his models. This kind of personal involvement characterized his entire career. (P.H.)

15. General Dr. Carol Davila

.1903. Plaster relief: h. 18, w. 13.2, d. 4.5
Šig. (right side): C. Brâncuși
Liceul Matei Basarab, Bucharest

Bibl.: Geist, no. 13; Brezianu, no. 4

16. General Dr. Carol Davila

1903. Plaster: h. 71, w. 61, d. 33
Institutul Sanitar Militar, Bucharest

Brancusi's only monument in Bucharest. Not accepted at first by the military authorities. After the artist had left for Paris, it was restored; Rascanu cast two unauthorized bronzes in 1912 and 1930.

Bibl.: *Adevarul Bucarest*, October 28, 1908; Brezianu, no. 5

Photo Brancusi, inscribed: Bustul generalului Dr Davila comandat de spitalul militar Regina Elisabeta Bucuresti (fata) facut inainte de a pleca in strainatate ("made before going abroad")

17. Portrait of a Concierge

1905. Plaster
Whereabouts unknown

Bibl.: Brezianu, 1974; Geist, no. 14

18. Portrait of Dr. Zaharie Samfirescu

1905. Clay
Whereabouts unknown

Bibl.: Brezianu, 1974; Geist, no. 15

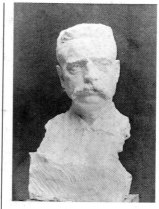

19. Portrait of a Waiter

1905. Plaster
Sig. (lower front): C. Brancusi 1905
Whereabouts unknown

Bibl.: Geist, no. 16

Photo Brancusi ph. 176

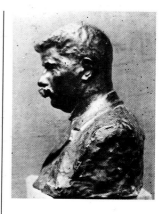

20. Portrait of M.G.

1905. Plaster
Whereabouts unknown

Bibl.: Geist, no. 17

The title of this sculpture indicates that, from early on, Brancusi's dealings with people from every stratum of society were casual and unbiased—an attitude that lasted a lifetime (P.H.)

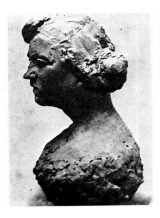

21. Portrait of Mrs. Victoria Vaschide

1905. Clay
Whereabouts unknown

Bibl.: Brezianu, 1964; Geist, no. 18

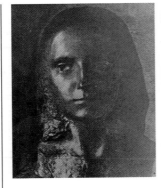

22. Pride

a. 1905. Bronze: h. 30.5, w. 20, d. 22
Sig.: C. Brâncuși 1905
Foundry mark: A.A. Hébrard
Muzeul de Arta, Craiova

Prov.: Popp
Bibl.: Geist, no. 26(a); Brezianu, no. 6

b. 1905. Bronze: h. 31, w. 20, d. 22
Sig.: C. BRANCUSI
Foundry mark: C. Valsuani
Collection Ralph Colin, New York

Letter dated Oct. 31, 1955, from Mrs. Percival Farquhar (Cattuja Popescu) to Brancusi after visiting the Brancusi exhibition at the Guggenheim Museum in New York. (Arch. I–D)

Prov.: Farquhar, U.S.
Bibl.: Geist, no. 26(b)

c. 1906? Plaster
Whereabouts unknown

Exhib.: Salon d'Automne, Paris, 1906
Bibl.: Zervos, 1957 (dated 1907)

One of the first examples of the intense, concentrated heads that were to figure so prominently in the development of Brancusi's concept of sculpture. (P.H.)

23. Repose

1906. Plaster
Whereabouts unknown
First version of Cat. no. 24

Dated Aug. 25, 1906, on a postcard to Maria Ionescu

Bibl.: Geist, no. 28

Brancusi usually depicted the human head either straight up and down or, as we see here for the first time, in the tilted or horizontal position that would recur time and again in his work. (P.H.)

24. Repose

1906. Plaster
Whereabouts unknown

On a postcard dated Dec. 31, 1906, inscribed: Repaos, C. Brancusi, 1906 Paris. On another postcard inscribed: Studiu Paris—1906; on back, addressed to: Monsieur C.J. Stancescu, str. Armeneasca, Bucarest, Rumania. (Arch. I–D)

Bibl.: Geist, no. 35; Brezianu, no. 18

25. Head of an Old Man

c. 1906. Plaster
Whereabouts unknown

Bibl.: Geist, no. 27

Photo Brancusi ph. 179

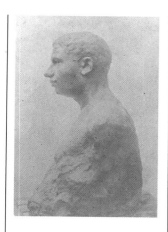

26. Portrait of G. Lupescu

1906. Patinated plaster
Sig. (lower front): C. Brancusi
Whereabouts unknown

On two postcards (publ. Jougla): one is dated Dec. 24, 1906, and inscribed: G. Lupescu. Salon d'Automne 1906.

Exhib.: Salon d'Automne, Paris, 1906; Tinerimea Artistica, Bucharest, 1907 (where listed *Fiul Pamantului*)
Bibl.: Geist, no. 30

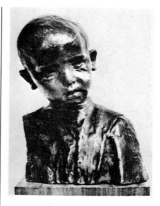

27. Bust of a Boy

a. 1906. Plaster
Pinacoteca Nationala, Bucharest

Purchased by the museum in 1907 for 700 lei. Damaged. The shoulders are missing; all that remains is the head. A poor restoration completely changed its angle and expression. A photograph of the original bust survives, inscribed: l'enfant. Salon de 1906. Paris.

Exhib.: Société Nationale des Beaux-Arts, Paris, 1906; Tinerimea Artistica (no. 179), Bucharest, Spring, 1907

b. 1906. Bronze: h. 34.2, w. 25.7, d. 22.5
Sig.: Brâncuși Paris 1906
Foundry mark: C. Valsuani
Muzeul de Arta R.S.R., Bucharest

Prov.: Popp (subscription raffle prize); Oprescu
Exhib.: Brancusi Retrospective, 1969–70
Bibl.: Geist, no. 29(b)

c. 1906. Bronze: h. 35, w. 25.7, d. 22.5
Sig.: C. Brancusi Paris
Foundry mark: C. Valsuani
Private collection, Great Britain

Sold for 32,000 fr. at the Palais Galliera, Paris, on March 24, 1963.

Prov.: Pogany
Bibl.: Geist, no. 29(a)

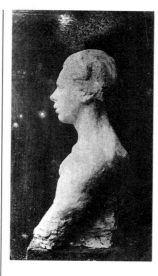

28. Portrait of Nicolae Darascu

a. 1906. Plaster: h. 66.3, w. 47.6, d. 26.8
Pinacoteca Statului, Bucharest

The back of the sculpture was partially damaged during the war. The restored plaster bears the foundry mark of Hébrard because the mold was made from the existing bronze (28b).

Exhib.: Tinerimea Artistica, Bucharest, 1908 (where listed *Ebos*)

b. 1906. Bronze: h. 66.3, w. 47.6, d. 26.8
Sig.: C. Brancusi
Foundry mark: A.A. Hébrard
Muzeul de Arta R.S.R., Bucharest

Purchased by Simu in 1910. In a letter to Brancusi dated Nov. 3, 1910, Simu acknowledges receipt of the sculpture. (Arch. I–D)

Prov.: Simu, Rumania
Exhib.: Société Nationale des Beaux-Arts, Paris, 1907 (no. 141) and 1908 (no. 1864); Bucharest, 1956–57
Bibl.: Geist, no. 31

29. The Redskins

1906. Clay
Whereabouts unknown

On a photograph inscribed: Rosi. Croqui

Bibl.: Geist, no. 34

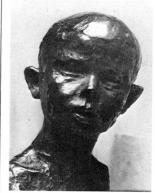

30. Head of a Boy

a. 1907. Plaster
Whereabouts unknown

On a postcard, inscribed: C. Brancusi, Eboche, Salon d'Automne (no. 201), Salon de Paris, 1907.

Exhib.: Société Nationale des Beaux-Arts, Paris, 1907 (no. 144), where listed *L'Enfant*
Bibl.: Brezianu, 1974

b. 1907. Patinated bronze: h. 34.5, w. 22.5, d. 18.8
Sig. (back): C. BRANCUȘI PARIS
Foundry mark: C. Valsuani
Muzeul de Arta R.S.R., Bucharest

Prov.: Mortun, Rumania
Exhib.: Bucharest, 1956–57; Brancusi Retrospective, 1969–70
Bibl.: Geist, no. 39(b); Brezianu, no. 11

c. 1907. Patinated bronze: h. 34.5, w. 22.5, d. 18.8
Sig.: C. Brâncuși
Foundry mark: A.A. Hébrard
Muzeul de Arta, Craiova

Prov.: Popp
Bibl.: Geist, no. 39(a)

[An unauthorized bronze cast of 30c is in the Muzeul Zambaccian, Bucharest.]

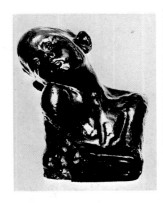

31. Torment I

a. 1907. Plaster: h. 37, w. 27, d. 23
Sig. (lower right): C. Brancusi
Whereabouts unknown

On a postcard inscribed: C. Brancusi, Supplice, Salon de 1907 Paris.

Prov.: Zoe Dumitrescu Busulenga, Bucharest
Exhib.: Société Nationale des Beaux-Arts, Paris, 1907 (no. 142)
Bibl.: Brezianu, no. 14

Photo Brancusi 1979 × 300 ph. 186

b. 1907. Bronze: h. 36.2, w. 24, d. 24.5
Sig.: C. Brâncuşi
Foundry mark: A.A. Hébrard
Collection Fotino, Bucharest

Prov.: Popp
Exhib.: Tinerimea Artistica, Bucharest, 1908; Brancusi Retrospective, 1969–70
Bibl.: Catalogue, Muzeul de Arta R.S.R., Bucharest; Geist, no. 36(a); Brezianu, no. 15

c. 1907. Bronze: h. 36.2, w. 24, d. 24.5
Sig.: C. Brancusi
Foundry mark: C. Valsuani
Collection Dr. Jean Levaditi, Paris

Bibl.: Geist, no. 36(b)

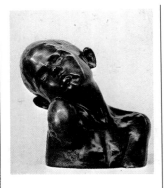

32. Torment II

a. 1907. Plaster: h. 30, w. 23.5, d. 29
Sig.: C. BR.
Collection Lucia Brandl, Bucharest

Exhib.: Salonul Oficial, Bucharest, 1912 (no. 295)
Bibl.: Catalogue, Muzeul de Arta R.S.R., Bucharest; Brezianu, no. 16

b. 1907. Bronze: h. 29.9, w. 23, d. 29
Sig.: C BRANCUSI 1907
Foundry mark: C. Valsuani
Collection Richard S. Davis, New York

Prov.: Farquhar, U.S.
Exhib.: The Solomon R. Guggenheim Museum, New York, 1955–56
Bibl.: Geist, no. 37(a)

c. 1907. Bronze: h. 30, w. 23.5, d. 29
Sig.: C. BRANCUŞI
Foundry mark: C. Valsuani
Collection Florence N. Constantinescu, Bucharest

Bibl.: Geist, no. 37(b); Brezianu, no. 17

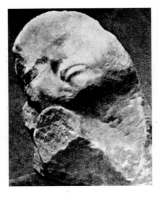

33. Torment III

1907. Marble
Whereabouts unknown

Appears in a studio photograph. Photo Brancusi.

Bibl.: Geist, no. 52

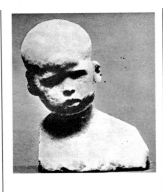

34. Bust of a Boy

c. 1907. Stone
Whereabouts unknown

Prov.: Mugur, Rumania
Exhib.: Exhibition of Modern Rumanian Art, Amsterdam and Brussels, 1930
Bibl.: Geist, no. 42; Brezianu, no. 59 (dated 1906)

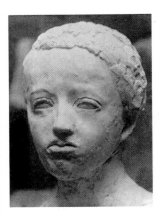

35. Head of a Girl

1907. Clay
Whereabouts unknown

Probably the head of a girl mentioned in two postcards to Irina Blanc in 1907, dated April 26 and Nov. 28,

Bibl.: Geist, no. 40

Photo Brancusi 1983 × 483 ph. 1906 and Arch. I–D

A soft, semiliquid mass encased in a hard shell: be it the egg or the human head, this paradoxical fact of life, as anti-sculptural as it is self-evident, was a phenomenon Brancusi probed throughout his career, in works both early and late. (P.H.)

36. Sleeping Child

a. 1907. White marble: h. 12, w. 18, d. 14
Brancusi Studio, MNAM (inv. S 15)

b. 1907. Bronze: h. 12, w. 16, d. 14
Sig.: BRANCUSI PARIS 1907
Collection Jean Le Moal, Paris

Bibl.: Geist, no. 38(a)

c. 1907. Bronze: h. 12, w. 16, d. 14
Sig.: C. BRANCUSI
Detroit Institute of Arts

Bibl.: Geist, no. 38(b)

d. 1907. Plaster: h. 12, w. 16, d. 14
Sig.: BRANCUSI. Paris
Collection J.M. Rambaud, Paris

Prov.: Rambaud, Paris

1908

e. 1908. Bronze: h. 12, w. 15.8, d. 14
Sig.: C. Brâncuşi 1908
Collection Mr. and Mrs. David L. Kreeger, Washington, D.C.

Bibl.: Geist, no. 38(c)

f. 1908. Bronze: h. 12, w. 15.8, d. 14
Sig.: C. Brâncuşi 1908
Collection Mrs. David Bortin, Philadelphia

Bibl.: Geist, no. 38(d)

g. 1908. Bronze: h. 12, w. 15.8, d. 12
Sig.: C. Brâncuşi
Collection Mr. and Mrs. Malcolm C. Eisenberg, Philadelphia

Prov.: Speiser U.S. (purchased 1921)
Bibl.: Geist, no. 38(e)

h. 1908. Bronze: h. 12, w. 15, d. 12
Sig.: C. Brancusi
Private collection, Paris

Prov.: Alex Maguy, Paris
Bibl.: Geist, no. 38(f)

i. 1908. Plaster: h. 12, w. 15, d. 12
Brancusi Studio, MNAM (inv. S 31)

j. 1908. Plaster: h. 12, w. 17.5, d. 14
Collection Atanasiu, France

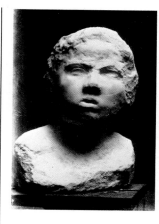

37. Head of a Girl

1907. Marble
Whereabouts unknown

On a photograph inscribed: première oeuvre en marbre ("first work in marble")

Bibl.: Geist, no. 50; *Brancusi photographe*, 1977 (pl. 5, general view)

Photo Brancusi ph. 196

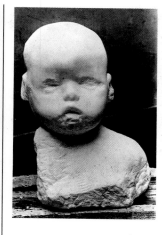

38. Child's Head

1907. Marble
Whereabouts unknown

Prov.: Bogdan-Pitesti, Rumania
Bibl.: Geist, no. 51; Brezianu, no. 62; *Brancusi photographe*, 1977 (pl. 5, general view)

Photo Brancusi ph. 196

39. Bust of a Boy

1907. Stone
Whereabouts unknown

Bibl.: Geist, no. 53; *Brancusi photographe*, 1977 (pl. 5, general view)

Photo Brancusi ph. 196

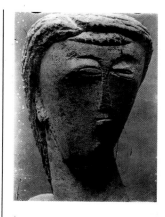

40. Head of a Girl

1907. Stone
Whereabouts unknown

On a photograph inscribed: Première pierre directe ("First stone cut direct"), 190– (year missing)

Bibl.: *This Quarter*, 1925; A. Dreyfus, *Cahiers d'art*, 1927; Geist, no. 54

Photo Brancusi 1975 × 465 ph. 201

Brancusi was probably swayed by several schools of sculpture at the outset of his career. The primitive sculpture of his native Rumania, Rodin, classical Greece, and, occasionally, the Middle Ages— each had an influence at one time or another. However, medieval sculpture seemed to affect him only when derived from classical forms. More than anything else, Brancusi seems to have been inspired by a particular *type* of sculpture: restrained, pent-up, fraught with meaning. The classicizing severity of Pre-Gothic central France had more of a hold on him than did the transcendent sculpture of the High Gothic. (P.H.)

41. Head of a Woman

c. 1907. Plaster
Whereabouts unknown

Bibl.: *This Quarter*, 1925;
Geist, no. 44

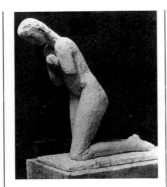

42. The Prayer

a. 1907. Plaster
Whereabouts unknown

Bibl.: *Brancusi photographe*,
1977 (pl. 2)

Photo Brancusi ph. 193

b. 1907. Bronze: h. 111.4,
w. 45.2, d. 130
Sig. (under right arm): C
BRANCUȘI
Inscr. (on the back): CRISTE
CRSITE
Foundry mark: C. Valsuani
Base (installed 1914): Magura
marble; h. 65, w. 101, d. 96.5;
signed (right side) C. Bran-
cusi:
Muzeul de Arta R.S.R., Bu-
charest

Both this sculpture and the
Portrait of Petre Stanescu
(Cat. no. 44) were installed at
Dumbrava Cemetery, Buzau,
Rumania, in 1914. The origi-
nal base, signed, remains *in
situ*. The base of the original
bronze, now in the Muzeul de
Arta R.S.R., Bucharest, is not
by Brancusi.

Prov.: Stanescu, Rumania
Exhib.: Salon des Indépen-
dants, Paris, 1910 (where
listed *La Prière, fragment
d'un tombeau*, no. 717); Tin-
erimea Artistica, Bucharest,
1914; Musée Rodin, Paris,
1961; Brancusi Retrospective,
1969–70
Bibl.: *This Quarter*, 1925;
Geist, no. 48; Brezianu, no. 19

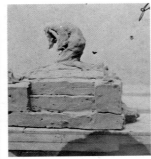

43. Studies for The Prayer

a. 1907. Clay
Whereabouts unknown

On a photograph inscribed:
Praecte pentru un monument
funerar ("project for a funer-
ary monument")

Bibl.: Geist, no. 45; Brezianu,
no. 19

b. 1907. Plaster
Whereabouts unknown

Closest to the final version,
although the body is at a dif-
ferent angle.

Bibl.: Geist, no. 47

c. 1959. Imitation stone, after
the bronze (42*b*)

Unauthorized copy installed
on the original base at Dum-
brava Cemetery, Buzau, Ru-
mania.

d. 1960. Plaster
Muzeul de Arta R.S.R., Bu-
charest

Unauthorized copy

e. 1964. Bronze
Serban Voda Cemetery, Bu-
charest

Unauthorized copy

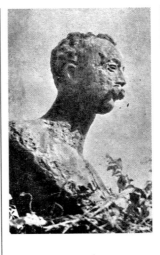

44. Portrait of Petre Stanescu

1907. Bronze: h. 77, w. 55.5,
d. 40
Sig. (on the back): C. Brâncu-
și
Foundry mark: C. Valsuani
Base: two blocks; h. 106,
w. 52, d. 41; and h. 175, w. 52,
d. 41
Behind, a niche (h. 38, w. 18)
inscribed: 1914
Dumbrava Cemetery, Buzau,
Rumania

Shown with *The Prayer* (Cat.
no. 42) at the Tinerimea Ar-
tistica, Bucharest, of 1914 be-
fore both were installed that
year at Dumbrava Cemetery,
Buzau

Bibl.: Geist, no. 49

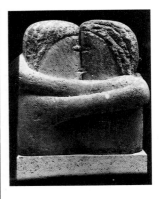

45. The Kiss

a. 1907–8. Stone: h. 28, w. 26,
d. 21.5
Sig.: Brancusi
Muzeul de Arta, Craiova

Exhib.: Tinerimea Artistica,
Bucharest, 1910 and 1914;
Brancusi Retrospective,
1969–70
Bibl.: *This Quarter*, 1925 ("In
1907 he gave up modeling
and began '*la taille directe*'
with *Le Baiser* and *La Sa-
gesse*," p. 264);
Geist, no. 55; Brezianu, no. 21

Photo Brancusi

b. Plaster: h. 28.4, w. 26,
d. 21.5
Muzeul de Arta R.S.R., Bu-
charest

Prov.: Storck, Rumania

Exhib.: Tinerimea Artistica,
Bucharest, 1928
Bibl.: Brezianu, no. 22

c. Plaster: h. 28, w. 26, d. 21.5
Chokoku no Mori Bijutsukan,
Hakone, Japan

d. Plaster: h. 28, w. 26, d. 21.5
Kunsthalle, Hamburg

Purchased in 1955 through
the Springer Gallery, Berlin

Photo Brancusi ph. 211

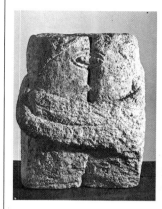

46. The Kiss

c. 1908. Stone: h. 32.5,
w. 24.5, d. 20
Private collection, New York

Prov.: Ricou, Paris; Resor,
U.S.; Laughlin, U.S.; Dia-
mond, U.S.
Exhib.: Tokoro Gallery, To-
kyo, 1985
Bibl.: Geist, no. 57

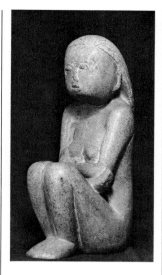

47. Wisdom of the Earth

a. 1908. Soapstone: h. 50.5,
w. 16.5, d. 24.5
Base: travertine; h. 15.8,
w. 9.5, d. 30.5
Muzeul de Arta R.S.R., Bu-
charest

In a letter dated Jan. 22, 1911,
G. Patrascu, writing on be-
half of Romascu, offered
Brancusi 500 lei for this work.
(Arch. I–D)

Prov.: Romascu, Rumania
Exhib.: Tinerimea Artistica,
Bucharest, 1910; London,
1966
Bibl.: *This Quarter*, 1925, pl.
41; Geist, no. 56; Brezianu,
no. 23

Photo Brancusi ph. 202

b. Plaster
Muzeul de Arta R.S.R., Bu-
charest

Unauthorized copy

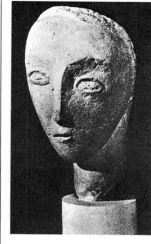

48. Head

c. 1908. *a*. Stone: h. 30, w. 16,
d. 18
Apollinaire Collection, Paris

Bibl.: Geist, no. 59

b. Plaster: h. 31, w. 16, d. 18
Base: marble cylinder; h. 9,
diam. 9
Base: stone; h. 12, w. 15,
d. 14.5
Brancusi Studio, MNAM (inv.
S 35)

c, d. Plasters: h. 30, w. 16,
d. 18
Brancusi Studio, MNAM, and
[Collection I–D]

49. Danaïde, or Head of a Girl

a. 1907–9. Stone: h. 34, w. 26,
d. 24
Collection Fulvia Rimni-
ceanu, Bucharest

Brancusi originally placed
Danaïde on a plain stone
block.
Ilinea Darvari then set it up
on a base with floral decora-
tion, the head incorrectly
tilted.
On a photograph, inscribed:
Tête de jeune fille 1908,
pierre sculptée à Bucarest,
colectia Bogda (Arch.
MNAM).

Prov.: Darvari, Rumania;
Bogdan–Pitesti, Rumania
Exhib.: Tinerimea Artistica,
Bucharest, 1914
Bibl.: Geist, no. 63; Brezianu,
no. 24

Photo Brancusi ph. 206

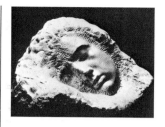

50. Sleep

1908. Marble: h. 26, w. 43.5,
d. 32.3
Sig.: C Brancusi 1908
Muzeul de Arta R.S.R., Bu-
charest

According to Brancusi's
statements made to the au-
thors, this was his first direct
carving in marble.

Prov.: Simu (purchased
1909), Rumania
Exhib.: Bucharest, 1956–57;
London, 1966
Bibl.: Geist, no. 60; Brezianu,
no. 18

Photo Brancusi

These are the earliest
versions of *The Kiss*, a
subject Brancusi re-
turned to a number of
times throughout his
career, in sculpture
and drawing alike.
Though probably in-
spired by Rumanian
folk sculpture, the motif
also harks back to the
Early Christian
"Tetrarchs" of por-
phyry on the southeast
corner of St. Mark's in
Venice. (P.H.)

Paul Gauguin brought
about a rebirth of
sculpture that even
sculptors usually un-
derestimate; we cannot
rule out the possibility
that Brancusi, too, may
have been influenced
by him. In any event,
both artists sought in-
spiration in non-aca-
demic sculpture, and
this manifested itself in
similar ways. (P.H.)

The supple form
emerging from the
hard stone—that con-
trast is expressed here
with unmistakable ten-
derness and emotional
involvement. (P.H.)

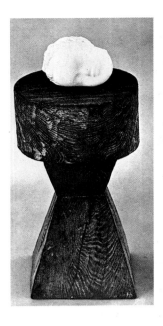

51. Sleeping Child

c. 1908. Marble: h. 17.1, w. 30.5
Base: wood
Whereabouts unknown

Bought by Yolanda Penteado from the artist in 1950. Sold at Christie's, London, on March 27, 1980.

Prov.: Penteado, Brazil
Exhib.: The Solomon R. Guggenheim Museum, New York, 1955–56; Duisburg and Mannheim, 1976
Bibl.: Geist, no. 62

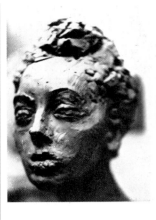

52. Portrait of Renée

c. 1908. Clay
Whereabouts unknown

Two photographs in Institutul de Arte Plastice, Cluj (Arch. Bölöny).

Bibl.: Geist, no. 64

Photo Brancusi ph. 208

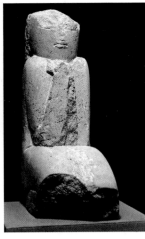

53. Ancient Figure

1908. Limestone: h. 56, w. 38
Art Institute of Chicago (Ada Turnbull Hertle Fund)

Dated 1906–8 in the Art Institute of Chicago catalogue.

Prov.: Stoppelaire, Paris; Galerie Pierre Loeb, Paris; Curt Valentin, New York
Exhib.: The Solomon R. Guggenheim Museum, New York, 1955–56

54. Torso of a Girl

a. 1909. Marble: h. 24, w. 16, d. 15
Sig.: Brancusi
Muzeul de Arta, Craiova

Brancusi gave this sculpture to Victor Popp in 1910 as a wedding present.

Prov.: Popp, Rumania
Bibl.: Geist, no. 66; Brezianu, no. 25

b. Plaster: h. 24, w. 16, d. 15
Brancusi Studio, MNAM (inv. S 74)

c. Plaster: h. 24, w. 16, d. 15
Collection Harold Diamond, New York (purchased 1964)

Prov.: Foinet, Paris

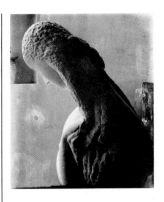

55. Woman Looking Into a Mirror, or Madame P. D. K.

1909. Marble
Whereabouts unknown

Bibl.: *This Quarter*, 1925; Geist, no. 67

Photo Brancusi, 1979 × 374 ph. 407

By 1909, Brancusi was completely acclimated to the Paris art world, an exuberant milieu that spawned the first mature Cubist works of art. Already several of his dominant themes, such as the torso and the tilted head, had crystallized. (P.H.)

1910

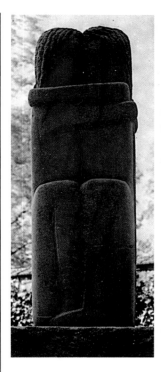

56. The Kiss

1909. Stone: h. 89, w. 30, d. 20
Base: stone; h. 155, w. 64,
d. 33
Sig. (right side of base): C.
BRĂNCUȘI; dated (back of
base): 191–1910 [sic]
Montparnasse Cemetery,
Paris
Installed in 1911 on the grave
of Tanya Rachewskaia

Bibl.: *Little Review*, 1921, pl.
19; *This Quarter*, 1925; Geist,
no. 68

Photos Brancusi ph. 213, ph.
217

Brancusi again
sounded the theme of
The Kiss, this time for a
commission. The result
was an unforgettable
sculpture, now seen as
a high point in his ca-
reer. It stands where
Brancusi placed it—
outdoors, in Montpar-
nasse Cemetery—for
all to visit and contem-
plate. (P.H.)

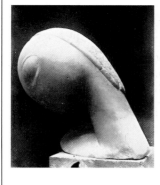

57. Narcissus

1910. Marble
Whereabouts unknown

Bibl.: *This Quarter*, 1925; Zer-
vos, 1957; Geist, no. 69; *Bran-
cusi photographe*, 1977 (pl.
61)

Photo Brancusi ph. 318

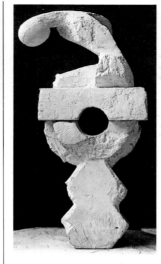

58. Narcissus Fountain

a. c. 1910. Plaster: h. 150,
w. 67, d. 45 (base included)
In three sections: upper,
h. 53, w. 67, d. 45.5; center,
h. 20, w. 60, d. 38; lower,
h. 77, w. 60, d. 36
Brancusi Studio, MNAM (inv.
S 57)

Photo Brancusi 323?

b. c. 1910. Plaster
In three sections: upper,
h. 53.5, w. 65, d. 43; center,
h. 20, w. 60, d. 38; lower,
h. 77, w. 69, d. 35.5
Brancusi Studio, MNAM (inv.
S 57)

Project for a memorial in Bu-
charest to Spiru Haret, 1912;
not built.

Exhib.: Brummer, 1933–34
(no. 4)
Bibl.: *This Quarter*, 1925;
Geist, no. 70

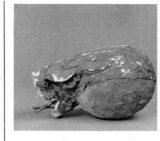

59. Head of Narcissus

a. c. 1910. Plaster: h. 36, w.
68, d. 31
Brancusi Studio, MNAM (inv.
S 60)

b. Plaster: h. 37, w. 69, d. 35.5
Brancusi Studio, MNAM (inv.
S 59)

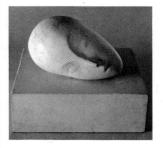

60. Sleeping Muse I

a. 1909–11. Marble: h. 17.8,
w. 27.9, d. 20.3
The Hirshhorn Museum and
Sculpture Garden, Smithson-
ian Institution, Washington,
D.C.

On a list in Brancusi's hand-
writing: Muse endormie
1909. (Arch. I–D)

Prov.: Davies, U.S.
Exhib.: Salon des Indépen-
dants, Paris, 1913; Armory
Show, New York, 1913 (men-
tioned on list sent to Pach;
Arch. I–D); Photo-Secession,
New York, 1914
Bibl.: *This Quarter*, 1925 (dat-
ed 1911); Geist, no. 71

Photo Brancusi 1979 × 435 ph.
271

b. 1909?–1917? Marble:
h. 15.2, w. 28, d. 15.2
Collection Rumsey, New
York

Letter dated Jan. 9, 1934,
from Marcel Duchamp to
Brancusi: "... We sold the
plaster *Sleeping Muse* that
Mrs. Rumsey had brought
back in exchange for the
marble she's paying a thou-
sand dollars for ..."

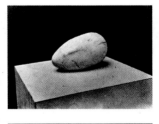

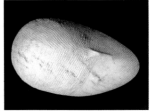

c. Plaster: h. 15.2, w. 28,
d. 15.2
Collection Guggenheimer,
Los Angeles

1910

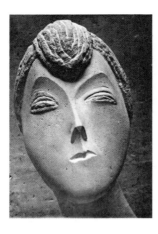

61. Baroness R.F. (Renée Frachon)

1909. Stone
Whereabouts unknown

Photograph by Brancusi, inscribed: 75 cm.

Prov.: Private collection, Rumania
Bibl.: *This Quarter*, 1925; Geist, no. 65; Brezianu, no. 63

Photo Brancusi ph. 209

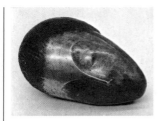

62. Sleeping Muse I

a. 1910. Bronze: h. 17.5, w. 26.5, d. 19
Sig. (on chignon):
C. BRANCUSI 1910
Foundry mark: C. Valsuani
MNAM, Paris (inv. S 818)
(purchased in 1947)

Someone other than Brancusi made a hole beneath the face to attach the work to the base.

Bibl.: Geist, no. 72(a)

b. 1910. Bronze: w. 27.45
Sig.: BRANCUSI
Foundry mark: C. Valsuani
Art Institute of Chicago

Prov.: Eddy, U.S.
Bibl.: Geist, no. 72(b)

c. 1910. Bronze: w. 27.45
Sig.: BRANCUSI
Foundry mark: C. Valsuani
Metropolitan Museum of Art, New York

Prov.: Stieglitz, U.S.
Exhib.: Photo-Secession, New York, 1914
Bibl.: Geist, no. 72(c)

d. 1910. Gilded bronze: h. 16, w. 27, d. 18
Foundry mark: C. Valsuani
Collection Stavros Niarchos, Athens

Sold at Christie's, London, in 1972 to the Niarchos collection for £71,400

Prov.: Darvari, Rumania; Bogdan-Pitesti, Rumania
Exhib.: Tinerimea Artistica, Bucharest, 1914
Bibl.: Geist, no. 72(d); Brezianu, no. 65

e. 1910. Bronze: h. 16, w. 27, d. 18.5
Sig.: C. Brancusi
MNAM (Gift of Renée Frachon), Paris (inv. S 1374)

Exhib.: Milan, 1980; Venice, 1982
Bibl.: Geist, no. 72(e)

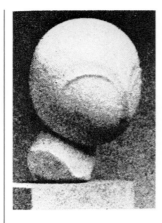

63. Danaïde

1910. Marble: h. 28.3
Whereabouts unknown

Mentioned in a list by Brancusi and a letter from Steichen. (Arch. I–D)

Exhib.: Photo-Secession, New York, 1914
Bibl.: Geist, no. 73

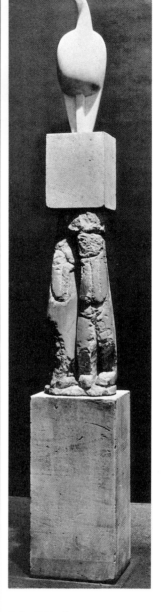

64. Maiastra

1910–12. White marble: h. 56, max. circum. 60.3
Base in 3 sections: stone rectangle: h. 29.8, w. 22.8, d. 19.6; stone double caryatid: h. 75.2, w. 26.6, d. 16.5; stone rectangle: h. 73.4, w. 33, d. 27.3
The Museum of Modern Art (Katherine S. Dreier Bequest), New York

Prov.: Quinn, U.S.; K.S. Dreier, U.S.
Exhib.: A. Stieglitz, 1914; Sculptors Gallery, 1922 (no. 7); Brummer, 1926; Arts Club of Chicago, 1927; The Solomon R. Guggenheim Museum, New York, 1955–56
Bibl.: Spear, 1969 (pl. 2); Geist, no. 75

Photo Brancusi 1980 × 417 ph. 460

The year 1910 witnessed several changes that were to prove decisive in the evolution of Brancusi's oeuvre. Subject and base now became a totally integrated unit; the distinction between the upper and lower parts of a sculpture ceased to exist. One of the most compelling examples of this phenomenon is *Maiastra*. One section of its base is a double caryatid that, in all likelihood, was originally intended to be a separate piece of sculpture. A fabulous creature from Rumanian mythology, Maiastra was but the first of the birds which, in their various manifestations, would become a thematic thread running throughout his sculpture. To Brancusi, few things in nature were as wonderful as birds and their flight. (P.H.)

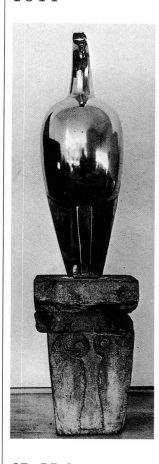

65. Maiastra

1911. Polished bronze:
h. 55.5, w. 17, d. 17.8
Inscr. (underneath): C.
VALSUANI
Foundry mark: C. Valsuani
Base in two sections: stone,
and stone relief, with pair of
stylized birds: total h. 35,
w. 27.3, d. 17
Tate Gallery, London

Bought by E. Steichen in
1911; shown in garden of his
house in Voulangis. His
daughter, Kate Rodina Stei-
chen, sold it later to the Tate
Gallery.
 Shown on a postcard (dat-
ed 1911) and in the catalogue
of the Brancusi exhibition,
Guggenheim Museum, 1956
(dated 1911).

Prov.: Steichen, U.S.,
Exhib.: Salon des Indépen-
dants, Paris, 1911; The Solo-
mon R. Guggenheim Muse-
um, New York, 1955–56;
Knoedler Gallery, New York,
1966; Brancusi Retrospective,
1969–70
Bibl.: Spear, pl. 3; Geist, no.
76

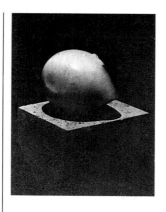

66. Prometheus

a. 1911. Marble: h. 12.7,
w. 17.7
Sig.: C. Brancusi
Philadelphia Museum of Art,
Louise and Walter Arens-
berg Collection

Bought by John Quinn in
1919. Letter dated Jan. 24,
1919, from Brancusi to Quinn:
"Prometheus must lie on the
right side and Sleeping Muse
on the left" (Arch. I–D). Ap-
pears on Brancusi's list to
Brummer, 1926: "No. 8
Sleeping Muse and Prome-
theus (mother and child),
Asian marble."

Prov.: Quinn, U.S.; Arens-
berg, U.S. (purchased 1933)
Exhib.: Salon des Indépen-
dants, Paris, 1912; Brummer
Gallery, New York, 1926;
Arts Club of Chicago, 1927;
The Solomon R. Guggenheim
Museum, New York, 1955–56
Bibl.: Revue de France et des
pays français, 1912; Geist, no.
78

b. 1911. Gilded bronze:
h. 12.7, w. 17.6
Sig.: C. Brâncusi 1911
Collection Eileen Lane Kin-
ney, Washington, D.C.

Bibl.: Geist, no. 79(a)

c. 1917? Polished bronze:
h. 12.7, w. 17.6
Sig.: C. Brâncuşi
The Hirshhorn Museum and
Sculpture Garden, Smithson-
ian Institution, Washington,
D.C.

Prov.: Amaral, U.S.
Bibl.: Geist, no. 79(b)

d. 1917? Polished bronze:
h. 13, w. 15, d. 14
Brancusi Studio, MNAM (inv.
S 22)

Bibl.: Geist, no. 79(c)

e. 1917? Polished bronze: h.
13, w. 15, d. 14
Private collection, France

Bibl.: Geist, no. 79(d)

f. Cement: h. 15, w. 15, d. 13
Private collection, Great Brit-
ain

g. Plaster: h. 15, w. 15, d. 13
Muzeul de Arta R.S.R., Bu-
charest

Prov.: Cuclin, Bucharest

h. Plaster: h. 15, w. 15, d. 13.5
Brancusi Studio, MNAM (inv.
S 21)

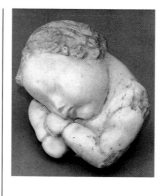

67. Portrait of George

1911. Marble: h. 23.8
The Solomon R. Guggenheim
Museum (Gift of Mrs. George
Farquhar, Jr.), New York

Letter dated October 31,
1955, from Mrs. Percival Far-
quhar to Brancusi. (Arch. I–
D) Brancusi photographed
the Farquhar family. (Arch.
I–D)

Prov.: Cattuja Popescu Far-
quhar, U.S.
Exhib.: Venice, 1960
Bibl.: Geist, no. 80

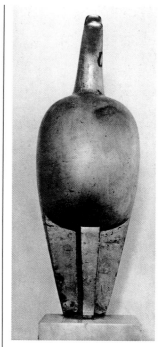

68. Maiastra

c. 1911. Gilded bronze:
h. 55.8, circum. 59.6
Inscr. (underneath): C.
VALSUANI
Collection Katherine M. Gra-
ham, Washington, D.C.

Originally gilded, this piece
was subsequently polished
by Brancusi. The pink mar-
ble base is not the original.
Entitled Golden Bird on Bran-
cusi's list for the Photo-Seces-
sion show in New York, 1914.

Prov.: Meyer, U.S.
Exhib.: Salon des Indépen-
dants, Paris, 1913; Photo-Se-
cession, New York, 1914
Bibl.: Spear, pl. 5; Geist,
no. 77

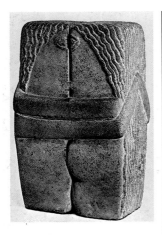

69. The Kiss

a. 1912. Stone: h. 58.4, w. 34, d. 25.4
Sig.: C. Brâncuşi
Philadelphia Museum of Art, Louise and Walter Arensberg Collection

Bought by Quinn in 1916 (letters from Pach to Brancusi, 1915 and 1916; letters from Brancusi to Quinn, 1916). Dated 1908 in the catalogue of the Arensberg Collection, Philadelphia Museum of Art.

André Allard wrote as follows in *La Revue de France et des pays français* (April 1912): "Its captivating purity of style notwithstanding, Brancusi's *Sleeping Muse* cannot match *Prometheus* and especially the calm, yet powerfully structured *Kiss* for sheer expressiveness and impact." (Arch. I–D)

Prov.: Quinn, U.S.; Arensberg, U.S.
Exhib.: Salon des Indépendants, Paris, 1912; Sculptors Gallery, New York, 1922; Moscow, 1928; The Solomon R. Guggenheim Museum, New York, 1955–56; London, 1973; Washington, D.C., 1978
Bibl.: Geist, no. 81

b. Plaster: h. 28, w. 26, d. 21
Whereabouts unknown

This was a wedding gift from Brancusi to Pach. Letter dated September 23, 1916, from Pach to Brancusi: "...Quinn had me over for dinner and has asked me for news of the original version of the sculpture *The Kiss*, a cast of which is in my possession."

Prov.: Pach, U.S.
Exhib.: Armory Show, New York, 1913

Photo Brancusi ph. 218

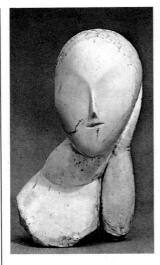

70. The Muse

1912. White marble: h. 44.5, w. 23, d. 20.5
Sig.: C. BRANCUSI
The Solomon R. Guggenheim Museum, New York (purchased 1985)

Bought at the Photo-Secession Gallery by Arthur B. Davies, according to a letter from W. Pach dated April 10, 1914. (Arch. I–D)

Prov.: Davies, U.S.; Bulova, U.S.; Lindt, U.S.
Exhib.: Armory Show, New York, 1913 (appears on packing list from Pottier); Boston, 1913; Photo-Secession, New York, 1914; Sculptors Gallery, New York, 1922 (no. 25)
Bibl.: Geist, no. 84

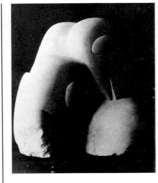

71. Three Penguins

1912–14. Marble: h. 61, w. 53.3, d. 35.9
Philadelphia Museum of Art, Louise and Walter Arensberg Collection

On a photograph (Arch. I–D), Brancusi dated this work 1912.
Bought by Quinn in 1916 through De Zayas, and by the Arensbergs in 1934 through Duchamp.

Prov.: Quinn, U.S.; Arensberg, U.S.
Exhib.: Sculptors Gallery, New York, 1922 (no. 8, dated 1915); Tokyo, 1970; Washington, D.C., 1978
Bibl.: *Little Review*, 1921 (pl. 15); Geist, no. 94

Animals never ceased to fascinate Brancusi; his own dog was the renowned Polaire. The sculptor often visited zoos, and his studio library included a book on Arctic wildlife with photographs of seals and penguins. No doubt their purity of form and extreme "functionalism" appealed to him; but so did the starkness of the frozen North, where everything seems so beautiful—and so cruel. (P.H.)

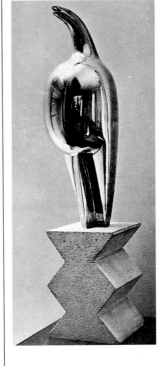

72. Maiastra

a. 1912. Polished bronze: h. 61, circum. 64
Base: stone, h. 11.5, w. 12.5
Sig. (underneath, stamped): C. BRANCUSI PARIS 1912
Des Moines Art Center

On October 24, 1919, Brancusi received a check (2,500 frs.) from Charles Vignier, a dealer in Asian art. After Vignier's death, it went to Hovannessian, then to Theodore Schempp and the Knoedler Gallery. It was sold to John Cowles, who donated it to the museum in Des Moines, Iowa, in 1960 (Arch. I–D)

Prov.: Vignier, Paris; Hovannessian, Paris; Schempp, Paris; Cowles, U.S.
Bibl.: Geist, no. 82

b. 1912. Polished bronze: h. 60.9, circum. 63.8
Base: stone, h. 15
Peggy Guggenheim Foundation, Venice
Paul Poiret, the couturier, bought *Maiastra* in 1912 for 10,000 francs, and Brancusi asked him and his wife one evening for a meal in his studio. Accustomed to society dinners, the Poirets were touched by their host's informal congeniality. On taking his leave, Poiret thanked the artist and told him that the dinner was the most "humane" he had ever been invited to; afterward, he had a few bottles of wine and spirits delivered to the studio. The dress designer displayed this *Maiastra* in his showroom, in front of a mirror. The Poiret estate sold it in 1940 for $1,000. (Arch. I–D)

Prov.: Poiret, Paris
Exhib.: Venice, 1982
Bibl.: Spear, pl. 7; Geist, no. 83

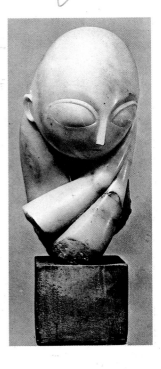

73. Mademoiselle Pogany I

a. 1912. Plaster: h. 44, w. 19, d. 27
Whereabouts unknown

Exhib.: Armory Show, New York, 1913 (appears on list from Pottier, who shipped the sculpture, and in a photograph of the Armory Show)

b. 1912. White marble: h. 44.5
Base: stone, h. 15.4
Sig.: C. BRANCUSI
Philadelphia Museum of Art, Gift of Mrs. Rodolphe Meyer de Schauensee

Dated 1913 by the museum.

Prov.: Quinn, U.S. (letter dated April 10, 1914, from W. Pach); Mrs. R.M. de Schauensee, U.S. (who donated it to the Philadelphia Museum of Art in 1933)
Exhib.: Sculptors Gallery, New York, 1913 (no. 5); Boston, 1913; Photo-Secession, New York, 1914; Art Center, New York, 1926
Bibl.: Geist, no. 85
Photo Brancusi ph. 288

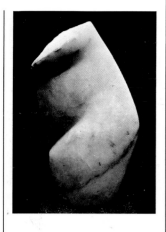

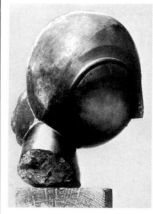

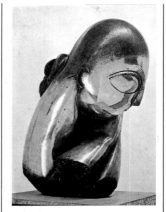

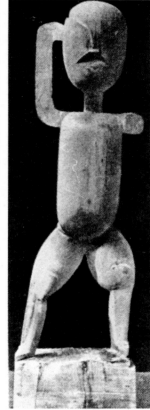

74. Torso of a Girl

1912. Marble: h. 31
Sig.: Brancusi 1912
Collection Petermann, Stuttgart

Prov.: Davies, U.S.
Exhib.: Armory Show, New York, 1913 (listed no. 620 in catalogue supplement)
Bibl.: Geist, no. 86

75. Danaïde

a. c. 1913. Partly gilded bronze: h. 27, w. 18, d. 20
Sig.: BRÂNCUŞI
Foundry mark: C. Valsuani
Collection Dr. Eugene Meyer, Baltimore

Exhib.: Photo-Secession, New York, 1914; Otterlo, 1975
Bibl.: Geist, no. 87(a)

b. c. 1913. Partly gilded bronze: h. 27.5, w. 18, d. 20.3
Base in two sections: stone: h. 11, w. 14; wood: h. 106, w. 24, d. 26
Sig.: C. BRANCUŞI
Foundry mark: C. Valsuani
Brancusi Studio, MNAM (inv. S 48)

Exhib.: Tinerimea Artistica, Bucharest, 1914
Bibl.: Geist, no. 87(b)

1918

f. 1918. Polished bronze: h. 28.3
Sig.: C. Brâncusi
Tate Gallery, London

Prov.: Doucet, Paris. Purchased in 1921 for 5,000 frs., according to letter dated March 1921 from Doucet to Brancusi (Arch. I–D)
Exhib.: Palais Galliera, Paris, 1957
Bibl.: Geist, no. 87(f)

c. c. 1913. Bronze: h. 27, w. 18, d. 20
Base: stone, h. 19.5, w. 23
Sig.: C BRANCUŞI
Foundry mark: C. Valsuani
Kunstverein, Winterthur, Switzerland

Exhib.: Duisburg and Mannheim, 1976
Bibl.: Geist, no. 87(c)

d. c. 1913. Bronze, patina on hair: h. 27.7, w. 18, d. 20.3
Sig.: C BRANCUŞI
Foundry mark: C. Valsuani
Philadelphia Museum of Art

Prov.: Mrs. S.S. White, U.S.
Bibl.: Geist, no. 87 (d)

e. c, 1913. Plaster: h. 28, w. 17.5, d. 21
Brancusi Studio, MNAM (inv. S 47)

g. 1918. Polished bronze: h. 28
Sig.: C. Brâncusi
Collection Mrs. G.H. Warren, New York

On November 7, 1922, Speiser advised Brancusi that he could not wait to get the sculpture for which he had already sent a check. On November 21, the Philadelphia judge acknowledged receipt of this "magisterial work."

Prov.: Speiser, U.S.
Bibl.: Geist, no. 87(e)

76. Mademoiselle Pogany I

a. 1913. Bronze, patina on hair: h. 43.8, w. 27, d. 30
Sig.: C BRÂNCUŞI
Foundry mark: C. Valsuani
The Museum of Modern Art (Acquired through the Lillie P. Bliss Bequest), New York

Prov.: Pogany, Australia
Bibl.: Geist, no. 88(a)

b. 1913. Bronze, patina on hair: h. 44.8, w. 27, d. 30
Sig.: C. Brâncuşi
Foundry mark: C. Valsuani
Muzeul de Arta R.S.R., Bucharest

Prov.: Storck Collection, Bucharest
Exhib.: Tinerimea Artistica, Bucharest, 1928
Bibl.: Geist, no. 88(b)

c. 1913. Bronze, patina on hair: h. 44.5, w. 27, d. 30
Sig.: Brancusi
Foundry mark: C. Valsuani
The J.B. Speed Museum, Louisville

Prov.: Degen, U.S.
Bibl.: Geist, no. 88(c)

d. 1913. Bronze: h. 44.8, w. 27, d. 30
Sig.: Brancusi
Foundry mark: C. Valsuani
Whereabouts unknown

Benenson bought this bronze at Parke-Bernet in 1950. Through Glarner he asked Brancusi's permission to polish the patinated hair.

Prov.: Chandler, U.S.; Chrysler, U.S.; Benenson, U.S.
Bibl.: Geist, no. 88(d)

e. 1913. Plaster: h. 50, w. 27, d. 30
Base in two sections: plaster: h. 19, diam. 19; wood: h. 90, w. 35, d. 35
Brancusi Studio, MNAM (inv. S 51)

77. The First Step

1913. Wood
Destroyed, except head (see Cat. no. 78)

Bibl.: Geist, no. 89

Through his extremely sensitive handling, Brancusi completely identified his love for the stone and his love for women in the *Torso of a Girl* series. At times, this symbiosis borders on the metaphysical. (P.H.)

By 1913, African art had caught on in Paris. Brancusi probably discovered it through hearing about it or seeing it in other Montparnasse studios. The "African" experiment we see here must not have pleased him very much; after photographing *The First Step* he destroyed it, except for the head, which he displayed in his studio. (P.H.)

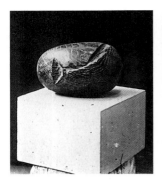

78. Child's Head

1913–c. 1915. Wood: h. 16, w. 25, d. 17
Sig.: C. Brancusi
Brancusi Studio, MNAM (inv. S 24)

Brancusi's photograph of this sculpture shows that the head was placed on its side.

Exhib.: Brummer, 1926 (no. 7); Arts Club of Chicago, 1927; Brummer, 1933–34 (no. 47)
Bibl.: *Little Review*, 1921 (pl. 6, head on its side); Giedion-Welcker, 1958 (view of studio, pl. 102); Geist, no. 90

Photo Brancusi ph. 249

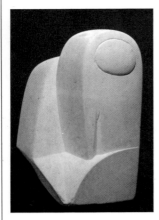

79. Two Penguins

1914. Marble: h. 54, w. 28.3, d. 30.8
Base: stone, h. 8.5, w. 66, d. 38
Sig.: CB
Art Institute of Chicago, Ada Turnbull Hertle Fund

Prov.: Roché, Paris
Exhib.: Sculptors Gallery, New York, 1922 (dated 1915); Brummer, 1926 (no. 8); Arts Club of Chicago, 1927; Musée National d'Art Moderne, Paris, 1953; The Solomon R. Guggenheim Museum, New York, 1955–56
Bibl.: Geist, no. 95

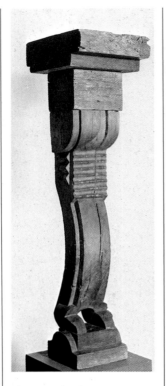

80. Caryatid

1914. Wood (old oak): h. 166.7, w. 43.2
Fogg Art Museum, Harvard University, Cambridge, Mass.

Purchased by Quinn in 1916 (letter from Pach dated July 17, 1916)

Prov.: Quinn, U.S.
Exhib.: Sculptors Gallery, New York, 1922 (no. 9); Brummer, 1926 (no. 3, dated 1915); Arts Club of Chicago, 1927
Bibl.: Geist, nos. 96, 97

Photo Brancusi ph. 1980 × 434 neg. B

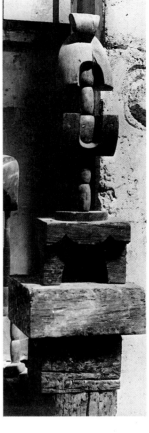

81. Portrait of Madame L.R.

1914–18. Wood: h. 96.8, w. 22.5, d. 22
Private collection, Paris (purchased 1980)

Dated 1914–17 by Brancusi on the back of a photograph (Arch. MNAM). Brancusi mentions this work in a letter to Quinn in 1917.

Prov.: Léger, Paris, (in exchange for a work by Léger); Diamond, U.S.
Exhib.: Galerie Maeght, Paris, 1958; Galerie Dina Vierny, Paris, 1960
Bibl.: *Little Review*, 1921 (pl. 7, view of studio); *This Quarter*, 1926; Geist, no. 93; *Brancusi photographe*, 1977 (pl. 16, view of studio)

Photos Brancusi ph. 12, ph. 608

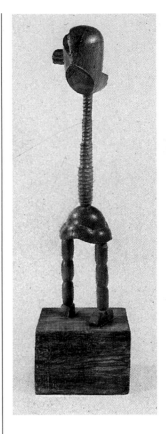

82. Little French Girl

c. 1914–18. Oak: h. 124.5, w. 22.2, d. 21.6
Sig.: C. Brâncuşi
The Solomon R. Guggenheim Museum, New York

Appears on Brancusi's list of works offered to Quinn in 1917 (see also Cat. no. 106)

Prov.: Dreier, U.S. (purchased 1920; letter dated Jan. 27, 1920, from Roché to Quinn)
Exhib.: Yale University Art Gallery, New Haven, 1946
Bibl.: *Little Review*, 1921 (pl. 7); *This Quarter*, 1926 (illus. with *Eve*); Geist, no. 92

Here, Brancusi carried integration of sculpture and base to the ultimate: the subject itself has become the base. (P.H.)

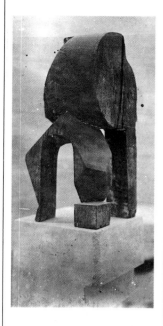

83. The Prodigal Son

1915. Oak: h. 44.5 (with stone base, 75.2), w. 21.6, d. 22.2
Philadelphia Museum of Art, Louise and Walter Arensberg Collection

Exhib.: Photo-Secession, 1914; Brummer, 1926 (no. 22, dated 1915); Arts Club of Chicago, 1927; Brummer, 1933–34 (no. 57); The Solomon R. Guggenheim Museum, 1955–56; Brancusi Retrospective, 1969–70
Bibl.: *Little Review*, 1921 (pl. 20); *This Quarter*, 1925 (dated 1914), Geist, no. 98

Photo Brancusi, ph. 1980 × 753 neg. B.

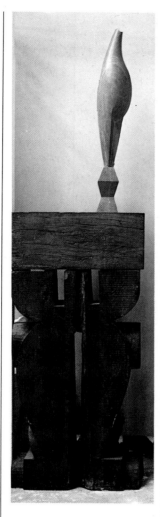

84. Maiastra

1915. Gray marble: h. 69.7
Base in 3 sections: truncated pyramids, marble: h. 22.8, w. 12.7, d. 10; carved wood; h. 99, w. 29, d. 53; rectangular: wood: h. 26, w. 29.8, d. 60
Inscr. (on base): bois 12 — 11 11 F CB (CB in circle)
Brancusi Studio, MNAM (inv. S 95)

Brancusi reworked *Maiastra* after it broke near the bottom (see also Cat. no. 85).

Bibl.: Giedion-Welcker, 1958; Spear, pls. 10, 11; Geist (1968), no. 83

Photo Brancusi ph. 463

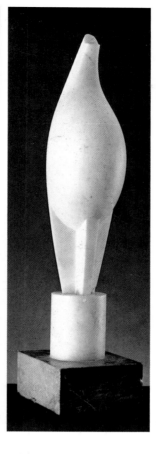

85. Maiastra

1915–c. 1930. Marble: h. 60.9
Base: marble cylinder, h. 15, diam. 12.7
Philadelphia Museum of Art, Louise and Walter Arensberg Collection
Draft of letter to Quinn, Jan. 24, 1919: "I cannot send you the *Bird* because it broke during the shelling of Paris. I stuck it back together, but now I don't have the heart to finish it ..." (Arch. I–D)

Arensberg purchased this sculpture through Duchamp in 1931.

Prov.: Arensberg, U.S.
Bibl.: Dreyfus, *Cahiers d'art*, 1927 (dated 1914); Spear, pl. 9; Geist, no. 100
Photo Brancusi ph. 463

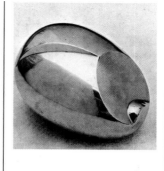

86. The Newborn I

a. 1915. Marble: h. 15, w. 21.2
Base: stone, h. 15.6
Philadelphia Museum of Art, Louise and Walter Arensberg Collection

Prov.: Quinn, U.S. (purchased 1922); Arensberg, U.S.
Exhib.: Brummer, 1926 (no. 5, dated 1915); Arts Club of Chicago, 1927; The Solomon R. Guggenheim Museum, 1955–56; Brancusi Retrospective, 1969–70
Bibl.: Geist, no. 101

1920

b. 1920. Polished bronze: h. 15, w. 20.6, d. 15
Sig.: C. Brancusi
Collection Wright Ludington, Santa Barbara, California

Prov.: Force, U.S.
Exhib.: Brummer, 1926 (no. 36); Univ. of California, Santa Barbara, 1972
Bibl.: Geist, no. 135(a)

c. 1920. Polished bronze: h. 14.6, w. 21, d. 15
The Museum of Modern Art. (Acquired through the Lillie P. Bliss Bequest), New York

Prov.: Bayer, U.S.
Exhib.: Brummer, 1933–34 (no. 53)
Bibl.: Alfred H. Barr, Jr., *Painting and Sculpture in the Museum of Modern Art*, 1967; Geist, no. 135(b)

d. Plaster: h. 15, w. 21, d. 15
Brancusi Studio, MNAM (inv. S 29)

e. [Bronzes: T1, Collection Mme. Georges Pompidou; T2, Collection I–D]

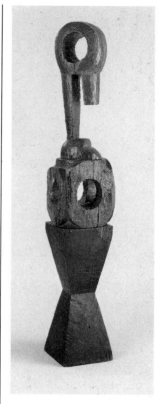

87. Chimera

1915. Oak: h. 92.6
Base: oak, h. 60.3
Sig.: Brancusi
Philadelphia Museum of Art, Louise and Walter Arensberg Collection

In a photograph, dated 1915 by Brancusi (Arch. MNAM). Arensberg bought it in 1938 through Duchamp.

Prov.: Quinn, U.S. (letter of December 27, 1917, Brancusi to Quinn); Arensberg, U.S.
Exhib.: Brummer, 1926 (no. 9, dated 1918); Arts Club of Chicago, 1927; London, 1937; London, 1938; The Solomon R. Guggenheim Museum, New York, 1955–56
Bibl.: Geist, no. 116

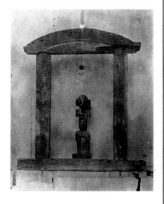

88. Doorway and Bench

1915. Wood (old beam)
Gate: h. 287.4, w. 222, d. 22.8
Bench: h. 69.8, w. 316, d. 25.4
Philadelphia Museum of Art, Louise and Walter Arensberg Collection

Date in a letter from Pach, September 23, 1915. Both dated 1917 in the catalogue of the Arensberg Collection. A photograph taken by Brancusi shows a wood sculpture (lost or reworked) inside the gate.

Prov.: Quinn, U.S.; Arensberg, U.S.
Exhib.: Brummer, 1933–34; The Solomon R. Guggenheim Museum, New York, 1955–56

Photos Brancusi ph. 592, ph. 704 (bench)

During this period, the distinction between the sculptures, the works commonly referred to as their bases, and the other objects in Brancusi's studio became ever more blurred. (P.H.)

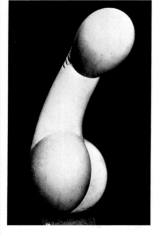

89. Princess X

a. 1909–16. Marble: h. 55.8, w. 28, d. 22.8
Bases: stone and wood
University of Nebraska Art Galleries, Lincoln

Purchased by Quinn in March, 1917, at the Modern Gallery, New York. During the controversy sparked by *Princess X* at the Salon des Indépendants (1920), Brancusi told journalists that the form of this sculpture could be traced back to *Woman Looking Into a Mirror* (no. 55, marble, 1909).

Prov.: Quinn, U.S.; Roché, Paris
Exhib.: Brummer, 1926 (no. 15); Arts Club of Chicago, 1927
Bibl.: Geist, no. 104

b. 1916. Polished bronze: h. 56, w. 42, d. 24
Base: limestone, h. 18.4
Philadelphia Museum of Art, Louise and Walter Arensberg Collection

Exhib.: The Solomon R. Guggenheim Museum, New York, 1955–56
Bibl.: Geist, no. 105(a)

c. 1916. Polished bronze: h. 56.5, w. 42, d. 24
Brancusi Studio, MNAM (inv. S 88)

Shown at the Society of Independent Artists, New York, from April 10 to May 6, 1917, and illustrated in catalogue (where captioned *Princesse Bonaparte*, no. 167).

Exhib.: Brummer, 1926 (no. 25); Arts Club of Chicago, 1927; Brummer, 1933–34 (no. 29)
Bibl.: *This Quarter*, 1925; Geist, no. 105(b)

d. Plasters: h. 61, w. 25, d. 28
Brancusi Studio, MNAM (inv. S 86), and [Collection I–D]

Photo Brancusi ph. 412

90. Sculpture for the Blind

a. 1916. Marble: h. 15.2, w. 30.4
Base: plaster, h. 25.4
Philadelphia Museum of Art, Louise and Walter Arensberg Collection

Prov.: Quinn, U.S.; Arensberg, U.S. (purchased 1935 through Duchamp)
Exhib.: The Solomon R. Guggenheim Museum, New York, 1955–56
Bibl.: Arensberg Catalogue, 1954 (dated 1924); Geist, no. 108

b. Plaster: h. 17, w. 29.5, d. 18
Brancusi Studio, MNAM (inv. S 61)

Photo Brancusi ph. 325A

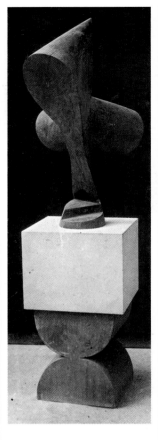

91. The Sorceress

a. 1916–24. Maple: h. 100, w. 56, d. 68
Bases: stone, wood (three pieces)
Sig.: C Brancusi Paris 1916
The Solomon R. Guggenheim Museum (Gift of the artist), New York

A photograph (Arch. MNAM) shows a chalk drawing of the sculpture at its earliest stage.

Exhib.: Wildenstein Galleries, New York, 1926; Moscow, 1928; Brummer, 1933–34 (no. 30); The Solomon R. Guggenheim Museum, New York, 1955–56
Bibl.: *This Quarter*, 1925; Geist, no. 107; *Brancusi photographe*, 1977 (pls. 17 and 38)

Photo Brancusi (of wood base) 1983 × 500 ph. 683

b. Plaster: h. 100, w. 55, d. 68
Brancusi Studio, MNAM (inv. S 126)

Photos Brancusi ph. 69, ph. 683

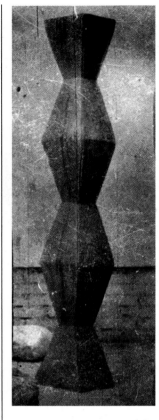

92. Endless Column (two modules)

1916? Wood
Whereabouts unknown

Giedion-Welcker dates the earliest examples of Brancusi's *Endless Column* from 1916 (*Du*, Zurich, April 1959).

Photo Brancusi ph. 5

This was probably the first in the *Endless Column* series, which would loom so large in his oeuvre for the next twenty years. This work may well have been the pioneering example of serial sculpture, for the number of conical modules varies from one version to the next. Brancusi himself pointed out that "units" could be added to his columns in years to come. (P.H.)

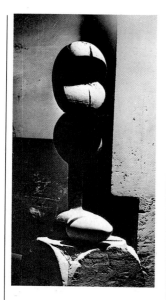

93. Eve

1916. Oak: h. 118 cm.
Sig.: C.B.
The Solomon R. Guggenheim
Museum, New York (see Cat.
nos. 121, 122)

Prov.: Quinn, U.S.
Exhib.: Brummer, 1926 (no.
18, dated 1921); Arts Club of
Chicago, 1927
Bibl.: *This Quarter*, 1925 (dat-
ed 1922); Geist, no. 106;
Brancusi photographe, 1977
(pl. 17, first state of *Eve*, and
pl. 18)

Photo Brancusi ph. 18

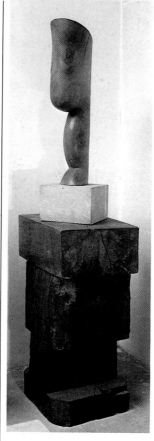

94. Study of Mrs. Eugene Meyer, Jr.

1916–30. Wood: h. 83, w. 18,
d. 24
Base in 3 sections: stone:
h. 19, w. 27.5, d. 26; wood;
h. 23, w. 55.5, d. 41; and
wood; h. 79, w. 44, d. 40
Sig.: 17 C Brancusi PARIS
1916
Brancusi Studio, MNAM (inv.
S 69)

Exhib.: Brummer, 1933–34
(no. 17)
Bibl.: Geist, no. 196

Photo Brancusi 1980 × 217 ph.
338

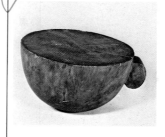

95. Cup I

a. 1917. Wood: h. 15, w. 28,
d. 24.7
Brancusi Studio, MNAM

Gift from Brancusi to Quinn
(letter from Brancusi, dated
Dec. 7, 1920)

Exhib.: Sculptors Gallery,
New York, 1922 (no. 20, dat-
ed 1921)
Bibl.: Geist, no. 109

b. Plaster: h. 15, w. 28, d. 24.7
Brancusi Studio, MNAM (inv.
S 128)

96. Column of the Kiss

1916–18. Plaster: h. 700

Made in the studio at 8 Im-
passe Ronsin. It originally
consisted of two plaster
uprights that rose to a con-
siderable height, but was
subsequently altered.

Bibl.: *Little Review*, 1921 (pls.
7 and 22); *This Quarter*, 1925
(with *Portrait of Madame
L. R.*); Geist, no. 103

Photo Brancusi ph. 223

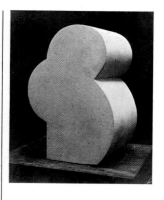

97. Timidity

c. 1916–17. Stone: h. 36.5,
w. 25, d. 22
Base: wood, h. 121, diam. 44
Sig.: F1 12 III B C. Brâncusi
PARIS 1917
Brancusi Studio, MNAM (inv.
S 127)

Exhib.: Brummer, 1933–34
(no. 12)
Bibl.: *Little Review*, 1921 (pl.
22, view of studio); Geist, no.
112

Photo Brancusi 1980 × 213 ph.
626

This somewhat decora-
tive sculpture inspired
a great many artists
after World War II,
such as Arp, and even
Max Ernst. But people
really began to grasp
Brancusi's contribution
to the redefinition of
sculpture only two dec-
ades later, when Mini-
malist, serial, and envi-
ronmental sculpture
came into their own.
(P.H.)

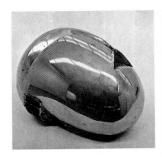

98. The First Cry

a. 1917. Polished bronze: h. 17, w. 25.8, d. 18
Sig.: C. Brâncuşi
Collection Lady Nika Hulton, London (on loan to Louisiana Museum, Humlebaek, Denmark)

Prov.: Quinn, U.S.
Exhib.: Brummer, 1926 (no. 35); Arts Club of Chicago, 1927
Bibl.: Geist, no. 111(a)

b. 1917. Polished bronze: h. 17, w. 26, d. 18
Sig.: C. Brâncuşi
Private collection (on loan to Kokuritsu Seiyo Bijutsukan, Tokyo)

Prov.: Roché, Paris
Bibl.: Geist, no. 111(b)

c. 1917. Polished bronze: h. 17, w. 26, d. 20
Sig.: C. Brâncuşi
Collection Walter A. Bechtler, Zurich

Exhib.: Lausanne, 1964; Saint-Paul-de-Vence, 1981
Bibl.: Geist, no. 111(c)

d. 1917. Polished bronze: h. 17, w. 26, d. 20
Sig.: C. Brâncuşi
Collection C.E. Gamborg, London

Prov.: Duchamp-Villon, Paris
Bibl.: Geist, no. 111(d)

e. 1917. Cement: h. 17, w. 25.8, d. 18
Private collection, Switzerland

Prov.: Léger, Paris; Diamond, U.S.

f. Plasters: h. 17, w. 26, d. 18
Brancusi Studio MNAM (inv. S 25), and [Collection I–D]

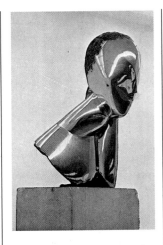

99. The Muse

a. 1917. Polished bronze, patina on hair and base of neck: h. 49.8, w. 26.6, d. 24.4
Stone base: h. 25.4, w. 28.5, d. 24.7
Sig.: C. Brancusi
Museum of Fine Arts, Houston

Letter of June 20, 1917, from Brancusi to Quinn. The bronze was delivered on March 14, 1918.

Prov.: Quinn, U.S.
Exhib.: Sculptors Gallery, New York, 1922 (no.19, dated 1921); Univ. of California at Santa Barbara, 1972
Bibl.: Geist, no. 114(a)

b. Plaster on wood base: h. 151 (head, h. 45), w. 25, d. 21
Brancusi Studio, MNAM (inv. S 43)

c. 1918. Polished bronze: h. 49.5, w. 25.4
Sig.: C Brâncuşi
Portland Art Museum, Gift of Sally Lewis

Appears on the cover of the catalogue of "French and American Paintings, Drawings, Bronzes," an exhibition organized by the Portland Art Association (April 1924). The Portland Art Museum dates this bronze 1918.

Prov.: Lewis, U.S. (purchased 1924)
Bibl.: Geist, no. 114(b)

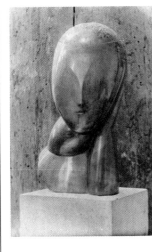

100. The Muse

a. After 1918. Polished bronze: h. 43.5, w. 24, d. 20
Sig.: C. BRANCUSI
Collection Herbert and Nannette Rothschild, Ossining, New York (purchased 1952)

In this variant of *The Muse*, Brancusi simplified the lower part of the sculpture by filling in the area between the arm and the bust proper as well as the empty area on the other side.

Bibl.: Geist, no. 114(c)

b. Plasters: h. 43.5, w. 24, d. 18
Brancusi Studio, MNAM (inv. S 42), and [Collection I–D]

c. [Bronzes: T1, Norton Simon Collection, Pasadena, California; T2, Galerie Beyeler, Basel; T3, Collection I–D (shown at Tokoro Gallery, Tokyo, 1985)]

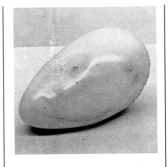

101. Sleeping Muse II

1917–18. Alabaster: h. 16.5, w. 29.9, d. 21
Sig.: C. Brâncuşi
Collection Mrs. H. Gates Lloyd, Haverford, Pennsylvania

Letter of Dec. 27, 1917, from Brancusi to Quinn: "They [*Bird* and *Sleeping Muse*] are not yet finished, but one can see what they will be" (photograph enclosed).

Prov.: Quinn, U.S.; Moon; Roullier; Curt Valentin, U.S.
Exhib.: Sculptors Gallery, New York, 1922; Staempfli, 1960
Bibl.: Geist, no. 115

Photo Brancusi ph. 271

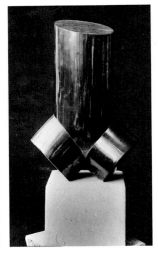

102. Torso of a Young Man I

a. 1917. Polished bronze: h. 46.3, w. 31, d. 17.1
Sig.: C Brancusi PARIS 1917
Cleveland Museum of Art, Hinman B. Hurlbut Collection

Exhib.: Brummer, 1933–34 (no. 14)
Bibl.: *This Quarter*, 1925; Geist, no. 159(b)

b. Plaster: h. 44, w. 28, d. 15
Brancusi Studio, MNAM (inv. S 78)

For Brancusi, geometrical shapes—cubes, cylinders, and pyramids—lay hidden within a shapeless mass of raw material, waiting to emerge from disorder as joyously as the "tourists" who manage to break free from their group. (P.H.)

1918

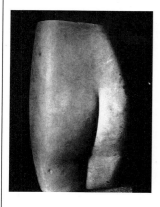

103. Torso of a Young Woman

1918. Marble: h. 32.7
Stone base: h. 21.3
Sig.: C. BRANCUSI
Kunstmuseum, Basel (purchased 1980 through Wertheimer)

Prov.: Quinn, U.S. (purchased 1922 for 15,000 francs); Roché, Paris; Drey, London
Exhib.: Brummer, 1926 (no. 12); Arts Club of Chicago, 1927
Bibl.: Catalogue, Sculptors Gallery, March–April 1922 (no. 17); Geist, no. 117

Photo Brancusi ph. 364

Sculpture from the golden age of Greece, such as the *Hera of Samos*, bursts with the joy of living. A complicated but orderly concept of woman, from a world that looks to us now like a heaven on earth, seems to have found in this torso a timeless echo. (P.H.)

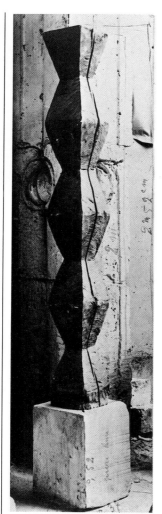

104. Endless Column

1918. Oak: h. 202, w. 25.4, d. 25.4 (consists of 3 modules and 2 half modules)
Stone base: h. 52, w. 37, d. 37
Sig.: CB (in a circle)
Collection Mary Sisler, Palm Beach, Florida

Letter of May 25, 1922, Brancusi to Quinn: "I asked Roché to write to you regarding the base for the *Column*. If that stone is too heavy for your apartment, you may dispense with it. It was intended solely for [use during] an exhibition in a great big room. ..." He noted the dimensions of the column on a photograph he sent to Quinn.

Prov.: Quinn, U.S. (purchased 1922)
Exhib.: Brummer, 1926 (no. 31); Arts Club of Chicago, 1927; The Solomon R. Guggenheim Museum, New York, 1955–56; Washington, D.C., 1978
Bibl.: *Little Review*, 1921 (pl. 7); Geist, no. 118

Photo Brancusi ph. 20

More than any other work, *Endless Column* is probably Brancusi's most compelling contribution to the spiritual heritage of the twentieth century. A distillation of his principal ideas, it seems more advanced than everything else he produced. His endless columns are just that: expandable works of art. Brancusi avoided prescribing the number of modules an "ideal" column should contain. He may have had in mind the kind of infinitely expandable sculpture and architecture exemplified by Mexican pyramids, which grew in size from generation to generation until they became veritable mountains, to be reclaimed by the forest. (P.H.)

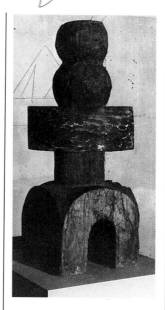

105. Architectural Project

1918. Wood (two superimposed spherical forms): h. 34, w. 17
Wood base: h. 63.5, w. 41, d. 31
Brancusi Studio, MNAM

Exhib.: Brummer, 1933–34 (no. 46)
Bibl.: *This Quarter*, 1925; Zervos, 1957 (dated 1918); Giedion-Welcker, 1958 (dated 1920); Geist, no. 119

Photos Brancusi ph. 54 × 122; 1980 × 226 neg. B; 1980 × 437 neg B

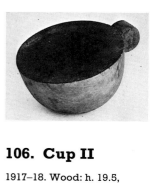

106. Cup II

1917–18. Wood: h. 19.5, w. 36, d. 29
Brancusi Studio, MNAM (inv. S 130)

Bibl.: *Little Review*, 1921 (pl. 21, with *Mobile Group*); Geist, no. 110

Photo Brancusi ph. 1980 × 713 neg B

This sculpture was part of Brancusi's earliest "environment"; a so-called mobile group (with *Little French Girl*, Cat. no. 82) that he tried to sell to John Quinn in 1917. He called the group *The Child in the World*, an original title calculated to make it clear that it was an entirely new work of art. (P.H.)

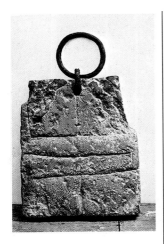

107. Medallion of the Kiss

c. 1919. Volcanic stone with iron rings: h. 59.5, w. 48, d. 9
Brancusi Studio, MNAM (inv. S 2)

Exhib.: Brummer, 1933–34 (no. 25, *Medallion*)
Bibl.: Geist, no. 121

Photo Brancusi ph. 219

A twofold refinement: the contours of *The Kiss*, pared to essentials, then translated into a world of giants who might wear a rough stone such as this around their necks. (P.H.)

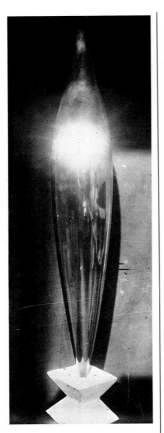

108. Golden Bird

a. 1919. Polished bronze: h. 95.8; circum. max. 53.5, min. 9.5
Sig. (underneath): C Brâncusi
Base (3 sections): truncated pyramids, stone, h. 21.5; rectangular block, wood, h. 43.6, w. 21.5, d. 28.5; signed twice: C.B. (in circle); paired truncated pyramids, wood, h. 54.5, w. 22.8, d. 28; signed (upper part): C.B. (in circle)
Arts Club of Chicago

Prov.: Quinn, U.S. (purchased 1920 for 16,000 frs.; Quinn's letter of Dec. 3, 1920)
Exhib.: Sculptors Gallery, New York, 1922; Brummer, 1926 (no. 20); Arts Club of Chicago, 1927
Bibl.: Spear, pl. 13; Geist, no. 125

Photo Brancusi ph. 467

b. c. 1919. Polished bronze: h. 95.8; circum. max. 53.3, min. 10.6
Base: Truncated pyramids on two rectangular steps, h. 20.6
Sig. (underneath): C Brancusi
Minneapolis Institute of Arts

After purchasing this bronze in 1955, the Knoedler Gallery, New York, sold it to the Minneapolis museum in 1956.

Prov.: Pitney
Bibl.: Spear, pl. 14; Geist, no. 126

c. Plasters: h. 100; circum. max. 53.3, min. 10
Brancusi Studio, MNAM (inv. S 96), and [Collection I–D]

d. [Bronzes: T1, Collection I–D; T2, Collection Nelly Baer, Zurich; T3, Private collection, Parma]

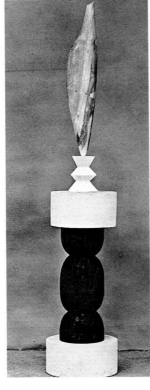

109. Yellow Bird

1919. Yellow marble: h. 92; circum. max. 52, min. 9
Sig. (underneath): C Brancusi
Base (4 sections): truncated pyramids, white marble: h. 21.5; cylinder, stone: h. 19, diam. 385; carved wood: h. 68, diam. 24.3; cylinder, stone: h. 19, diam. 38.5 (sig.: C.B. [in circle])
Yale University Art Gallery, New Haven

This sculpture was about to be sent to New York when a minor complication arose and occasioned an exchange of letters between Brancusi, Roché, and Pottier (the shipping firm). Roché informed Brancusi that the beak of *Yellow Bird* had broken off; irked, the sculptor advised Pottier that "... the allegedly broken sculpture is meant to be that way," and indeed Roché had jumped to conclusions. Originally, *Yellow Bird* was a *Maiastra*-like figure with a head ending in a curving "beak," but then, to heighten the sense of vitality and upward thrust, Brancusi did away with the protuberance and left only a gaping angle straining toward the sky.

Brancusi to Quinn, December 2, 1920: "... In the middle of the marble bird there is what is called in quarry parlance a "lie" (flaw) in the stone. This does not in any way make the bird less valuable, especially as this variety of marble is fairly uncommon."

Prov.: Quinn, U.S. (Brancusi to Quinn, October 27, 1920); Dreier, U.S. (purchased 1926)
Exhib.: Salon des Indépendants, Paris, 1920; Sculptors

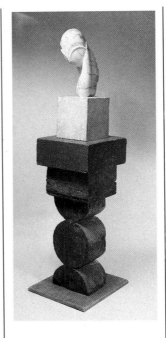

110. Mademoiselle Pogany II

1919. Veined marble: h. 44.2, w. 20, d. 27
Sig.: C Brâncusi
Base (4 sections): one stone, three wood
Collection Mr. and Mrs. James Alsdorf, Winnetka, Illinois

Prov.: Quinn, U.S.; Ault, U.S.; Pollack, U.S.
Exhib.: Salon des Indépendants, Paris, 1920; Sculptors Gallery, New York, 1922; Brummer, 1926 (no. 24); Arts Club of Chicago, 1927; Brummer, 1933–34 (no. 54); The Solomon R. Guggenheim Museum, New York, 1955–56
Bibl.: *Little Review*, 1921 (pl. 6); Geist, no. 127

Photo Brancusi ph. 295

Gallery, New York, 1922; Brummer, 1926 (no. 37); Arts Club of Chicago, 1927; The Solomon R. Guggenheim Museum, New York, 1955–56
Bibl.: Spear, pl. 15; Geist, no. 124

Photo Brancusi ph. 465

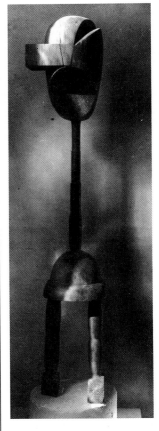

111. Plato

1919–20. Wood: h. 109
Reworked by Brancusi (see Cat. no. 112).

Bibl.: *Little Review*, 1921 (pl. 6); *This Quarter*, 1925; Geist, no. 122

Photo Brancusi ph. 1980 × 120 neg B

112. Head

a. 1919–23. Wood: h. 19, w. 30.5, d. 22
Tate Gallery, London (purchased Christie's, 1980)

The head of *Plato* (Cat. no. 111), removed by Brancusi and laid on its side.

Prov.: Penteado, Brazil
Exhib.: The Solomon R. Guggenheim Museum, New York, 1955–56
Bibl.: Geist, no. 152

b. Plasters: h. 19, w. 30, d. 22
Brancusi Studio, MNAM (inv. S 31), and [Collection I–D]

c. [Bronzes: T1, Private collection, Belgium; T2, Collection I–D; T3, Musée d'Art Moderne de la Ville de Paris]

[Exhib.: Ratilly, 1977; Municipal building, 15th arrondissement, Paris, 1978; Artcurial, Paris, 1984; CNAC, Paris, 1984]

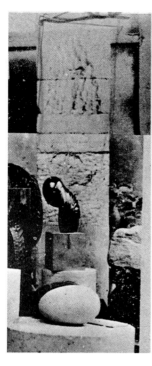

113. Study for The Kiss

c. 1919. Plaster: h. 331, w. 54, d. 21.5
Mirror: diam. 43
Brancusi Studio, MNAM (inv. S 11)

Reworked by Brancusi.

Bibl.: *Little Review*, 1921 (pl. 6); *This Quarter*, 1925; Geist, no. 120; *Brancusi photographe*, 1977 (pls. 39, 40)

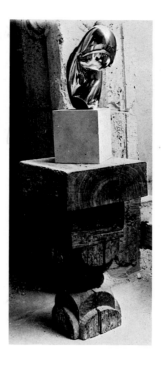

114. Mademoiselle Pogany II

a. 1920. Polished bronze: h. 43.2, w. 18, d. 26
Sig.: C. Brâncuși
Dated (on base): 1920
Albright-Knox Art Gallery, Buffalo (purchased 1927)

Prov.: Quinn, U.S. (purchased 1920); Brummer Gallery, U.S.
Exhib.: Sculptors Gallery, New York, 1922 (no. 16); Brummer, 1926 (no. 19); Arts Club of Chicago, 1927; Brummer 1933–34 (no. 58)
Bibl.: *Little Review*, 1921 (pls. 10, 11); Geist, no. 128(a)

b. 1920. Polished bronze: h. 43, w. 18, d. 26
Sig.: C. Brancusi 1920
Museu de Arte Moderna, Rio de Janeiro

Prov.: Bittencourt, U.S.
Bibl.: Geist, no. 128(b)

c. c. 1925. Polished bronze: h. 43.2, w. 18, d. 26
Sig.: C. Brâncuși
Collection Katherine Ordway, New York

According to a letter from Roché (Sept. 7, 1924), Katherine Ordway was supposed to see Brancusi about buying a bronze *Mademoiselle Pogany*. Therefore, this version must have been in the artist's studio at that time. (Arch. I–D)

Bibl.: Geist, no. 128(c)

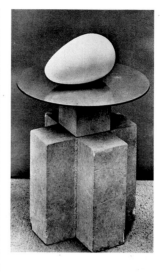

115. Beginning of the World

c. 1920. White marble on polished metal disk: h. 17, w. 30.5, d. 23
Sig.: CB (in a circle)
Whereabouts unknown

Prov.: Quinn, U.S. (purchased 1923); Roché, Paris; James Clark, U.S.
Exhib.: Brummer, 1926 (no. 32, dated 1924); Arts Club of Chicago, 1927; The Solomon R. Guggenheim Museum, New York, 1955–56; Sidney Janis Gallery, New York, 1960
Bibl.: Geist, no. 131

Photo Brancusi ph. 326

1925

d. 1925. Polished bronze: h. 44.5, w. 18, d. 26
Sig. (stamped, except sculptor's name): C. Brâncuși PARIS–1925
Norton Gallery, West Palm Beach, Florida

Exhib.: The Solomon R. Guggenheim Museum, New York, 1955–56
Bibl.: Geist, no. 128(d)

e. Plasters: h. 45, w. 19, d. 30
Brancusi Studio, MNAM (inv. S 51), and [Collection I–D]

f. [Bronze: T1, shown at Tokoro Gallery, Tokyo, 1985]

Photo Brancusi ph. 304

1920

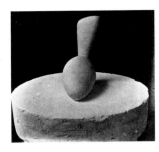

116. Leda

1920. White marble: h. 55, w. 74, d. 24
Art Institute of Chicago

Originally on two stone bases (diam. 123 and diam. 97). The bases on which *Leda* now rests are not by Brancusi.

Prov.: Dreier, U.S.
Exhib.: The Museum of Modern Art, New York, 1936; Cleveland, 1937; Yale University Art Gallery, New Haven, 1946; The Solomon R. Guggenheim Museum, New York, 1955–56
Bibl.: *Little Review*, 1921 (pl. 14); *This Quarter*, 1925 (dated 1922); Geist, no. 132

Photo Brancusi ph. 382

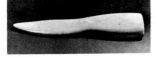

117. A Hand

1920. Yellow marble: h. 6.3, w. 30.5, d. 5.8
Inscr.: C. Brâncuși à John Quinn Paris 1920 and BRANCUSI a Mᴱ HARE NEW-YORK 1926
Fogg Art Museum, Harvard University, Cambridge, Massachusetts

Prov.: Quinn, U.S. (gift from Brancusi to Quinn, 1920 [Arch. I–D])
Exhib.: Sculptors Gallery, 1922 (no. 18, dated 1921)
Bibl.: Geist, no. 133

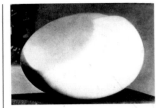

118. The Newborn II

c. 1920. White marble: h. 26
Moderna Museet, Stockholm

Purchased by Rolf de Maré for 7,000 frs. at a sale (1926) to benefit the Salon du Franc at the Palais Galliera. (Arch. I–D)

Prov.: Rolf de Maré, France
Bibl.: Geist, no. 134

Photo Brancusi ph. 25

A typical example of the problems raised by exhibiting Brancusi's work, *The Newborn* is most effective when displayed not on a base or pedestal, but left as if by accident on a table or the floor. The original owner of *The Newborn II*, Rolf de Maré, was a close friend of the sculptor; Brancusi placed it on the floor of De Maré's residence to emphasize its direct contact with the earth. (P.H.)

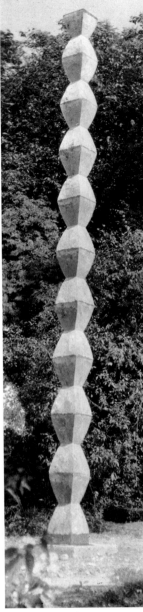
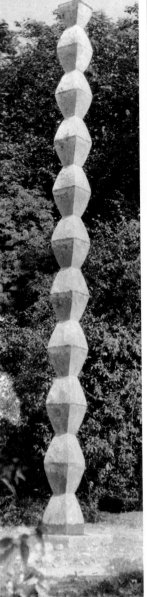

119. Endless Column

1920. Wood (old oak): h. 558, w. 34, d. 34
Brancusi Studio, MNAM (inv. S 117)

Originally installed in Steichen's garden in Voulangis, near Paris, where it remained until 1928 (letter from Roché, 1928, in Arch. I–D). Its original dimensions were: h. 717, w. 34, d. 34. The reworked column now consists of two pieces joined by a wooden pin.

Exhib.: Brummer, 1933–34 (nos. 5, 6, and 7; catalogue illustration of lower part of column with two other columns, captioned: "Project of columns which, when enlarged, will support the arch of the firmament")
Bibl.: Geist, no. 136

Photos Brancusi ph. 520; 1979 × 1037 neg. B; 1980 × 733 neg. B

120. Medallion

1920–21. Oak with iron rings: h. about 57
Whereabouts unknown

Exhib.: Brummer, 1933–34 (no. 25)
Bibl.: Geist, no. 139

Photo Brancusi ph. 1980 × 215 neg. B

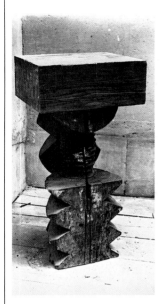

121. Adam

1921. Chestnut: h. 88.6
(see Cat. no. 122)

Prov.: Quinn, U.S.
Exhib.: Brummer, 1926 (no.
17); Arts Club of Chicago,
1927
Bibl.: Geist, no. 138

Photo Brancusi ph. 1980 × 712
neg. B

Here we see a fairly
radical example of
"minimalism" in Bran-
cusi's sculpture, dating
from a time when pio-
neers of quasi-geomet-
ric simplification had to
transcend every stylis-
tic current, however
sophisticated, around
them. Only the title,
with its existential
overtones, conveys a
clearly identifiable
message. (P.H.)

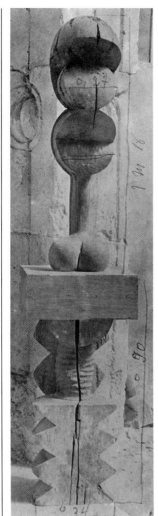

122. Adam and Eve

1916–21. Chestnut and old
oak: h. 224.8, combined;
stone base, h. 14
Sig.: CB (three times)
The Solomon R. Guggenheim
Museum, New York (see Cat.
no. 93)

Purchased by Quinn in 1922
(Brancusi to Quinn, May 25,
1922). Appears on list of
works Brancusi enclosed
with this letter, described
"No. 2 and 3—Adam and
Eve—inseparable." (Arch.
I–D)

Prov.: Quinn, U.S.
Exhib.: Brummer, 1926 (nos.
17 and 18, *Adam* and *Eve*,
considered separate works);
Arts Club of Chicago, 1927;
Sidney Janis Gallery, New
York, 1951; Musée National
d'Art Moderne, Paris, 1952;
Tate Gallery, London, 1952
Bibl.: Geist, no. 138; *Brancusi
photographe*, 1977 (pl. 21:
Adam and Eve on an iron
slab, no stone base)

Photo Brancusi ph. 656

123. Study for a Figure

Early 1920s. Plaster: h. 154.5,
w. 32, d. 35
Brancusi Studio, MNAM (inv.
S 27)

Shown leaning against a wall.

Bibl.: Geist, no. 145

124. The Baroness

Early 1920s? Plaster: h. 45,
w. 26, d. 23
Stone base: h. 18, w. 18, d. 19
Wood base: h. 68, w. 36, d. 34
Brancusi Studio, MNAM (inv.
S 46)

Exhib.: Brummer, 1933–34
(no. 19)
Bibl.: Geist, no. 146

Photo Brancusi ph. 280

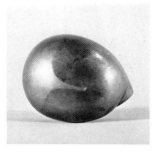

125. Prometheus

a. Black marble: h. 12, w. 20,
d. 14
Brancusi Studio, MNAM (inv.
4002 [18] S 18)

b. Plaster: h. 12, w. 20, d. 14
Brancusi Studio, MNAM

When naming his
sculptures, Brancusi
drew freely on sym-
bols of creation from
the world over, at
times with a deliberate
irony or ambiguity that
could be associated
with the intellectual ex-
uberance of Dadaist
Paris. (P.H.)

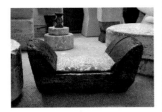

126. Bench

1921–22. Wood: h. 55, w. 105, d. 55
Brancusi Studio, MNAM (inv. S 85)

Bibl.: *Brancusi photographe*, 1977 (pls. 12, 19)

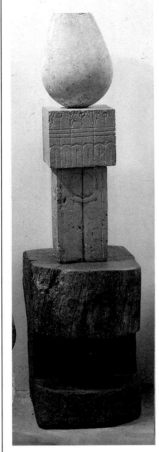

127. Torso of a Girl

a. 1922. Onyx: h. 32.7
Sig.: CB (in a circle)
Fogg Art Museum, Harvard University, Cambridge, Massachusetts

Prov.: Quinn, U.S. (purchased 1922; Brancusi to Quinn, May 25, 1922, with list); Orswell, U.S. (purchased 1926 by Brummer Gallery; Brancusi's notation in catalogue: "paid 800")
Exhib.: Sculptors Gallery, New York, 1922; Wildenstein Galleries, New York, 1926; Brummer, 1926 (no. 21); Arts Club of Chicago, 1927
Bibl.: Geist, no. 142

b. Plasters: h. 34, w. 26, d. 16
Two stone bases, with motif of *The Kiss*: h. 19, w. 21.5, d. 22; h. 35, w. 17, d. 17
Wood base: h. 47, w. 34, d. 38
Brancusi Studio, MNAM (inv. S 76), and [Collection I–D]

Photo Brancusi ph. 368

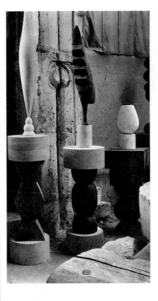

128. Coq Gaulois

1922. Walnut: h. c. 89
Whereabouts unknown

Brancusi noted the size (122 cm.) on a photograph. This first version is the only one with four salient angles in the cock's comb, as many as there are syllables in *co-co-ri-co*, French for "cock-a-doodle-doo." The title is mentioned in several letters: to Roché, June 8, 1922, in which "the 'coq gaulois'" is described as "not yet quite finished"; to Quinn, June 28, 1922; and on list from Brancusi to Quinn, May 25, 1922, where it is described as "No. 9. Walnut sculpture (*Coq Gaulois*), 10,000 Frs."

Bibl.: Geist, no. 148; *Brancusi photographe*, 1977 (pl. 20)

Photo Brancusi ph. 18

An overview of Brancusi's evolving oeuvre reveals that his entire repertory of forms was already in place as early as 1915–20. What came after was an elaboration and refinement. Some artists have maintained that every work of art takes shape for the artist before adolescence and is then put "on hold" until it surfaces, consciously or not, in adulthood. This may be said of Brancusi, for his work does not develop in a neat chronological sequence. (P.H.)

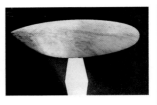

129. Fish

1922. Yellow marble on circular mirror: h. 12.7, w. 42.8, d. 3
Mirror: diam. 43
Wood base: paired truncated pyramids, rounded edges: h. 12.7, w. 42.8, d. 2.75
Philadelphia Museum of Art, Louise and Walter Arensberg Collection

Prov.: Quinn, U.S. (purchased 1923; list from Brancusi and Quinn–Brancusi correspondence, Jan. 1923); Arensberg, U.S. (purchased 1948 through Stendahl)
Exhib.: Brummer, 1926 (no. 13); Arts Club of Chicago, 1927; The Solomon R. Guggenheim Museum, New York, 1955–56
Bibl.: Geist, no. 143

Photos Brancusi ph. 427, ph. 432

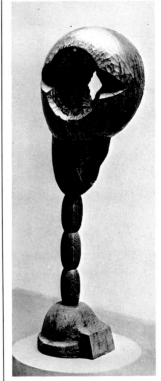

130. Socrates

1922. Wood: h. 130.2
The Museum of Modern Art (Mrs. Simon Guggenheim Fund), New York

Originally the work was to be surmounted by a cup, to symbolize Socrates's cup of hemlock (as told by Brancusi to authors, and according to photograph in MNAM). It was sent back to Brancusi on Feb. 16, 1934, after the Brummer show, with the lower part damaged (invoice issued by Rancheray, and letter from Duchamp to Brancusi).

Prov.: Simon Guggenheim, U.S.
Exhib.: Brummer, 1926 (no. 23, dated 1923); Arts Club of Chicago, 1927; Brummer, 1933–34 (no. 37); Metropolitan Museum of Art, New York, 1957
Bibl.: *This Quarter*, 1925 (dated 1923); Geist, no. 147

Photo Brancusi ph. 1980 × 560 neg. B

Brancusi's furniture was designed to create an ambience imbued with the spirit of the person living in it. The artist must have fashioned this bench with his own hands. There were prefabricated objects, too, in his studio, but they had to receive his special blessing before being received into his holy of holies. (P.H.)

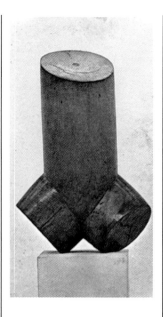

131. Torso of a Young Man I

1917–22. Wood: h. 48.3, w. 31, d. 17
Sig.: CB (in a circle, three times)
Philadelphia Museum of Art, Louise and Walter Arensberg Collection

Appears on a list (with the year 1923) Brancusi drew up in 1926 of works purchased by Quinn. This work is dated 1922 in the Brummer catalogue, 1926.

Prov.: Quinn, U.S.; Arensberg, U.S. (purchased 1948 through Stendahl)
Exhib.: Wildenstein Galleries, New York, 1926; Brummer, 1926 (no. 11); Arts Club of Chicago, 1927; The Solomon R. Guggenheim Museum, New York, 1955–56; Washington, D.C., 1978
Bibl.: Geist, no. 149

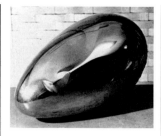

132. Sleeping Muse II

a. 1920s. Bronze with traces of gilt: h. 17, w. 28.6, d. 17
Sig.: C. Brancusi
Foundry mark: Gand
Collection Dr. Heinz Keller, Winterthur, Switzerland

Bibl.: Geist, no. 166(d)

b. 1920s. Polished bronze: h. 17, w. 29, d. 17
Sig.: C. BRÂNCUȘI
Private collection

Prov.: Ault, U.S.; Schempp
Bibl.: Geist, no. 166(b)

c. 1920s. Polished bronze: h. 17, w. 29, d. 17
Collection Katia Granoff, Paris

Prov.: Bagulescu, Rumania
Bibl.: Geist, no. 166(c)

d. 1920s. Polished bronze: h. 16.5, w. 29.2, d. 19
Private collection, U.S.

Prov.: Jean Cassou, Paris
Bibl.: Geist, no. 166(a)

e. 1920s. Polished bronze: h. 17, w. 29, d. 17
Sig.: C. Brâncuși (and illegible signature)
Collection Mr. and Mrs. Harold Diamond, New York

Sold for 1,150,000 frs. at the Palais Galliera, Paris, on March 21, 1974.

Prov.: Doucet, Paris
Bibl.: Geist, no. 166(e)

f. Plasters: h. 17, w. 29, d. 17
Brancusi Studio, MNAM (inv. S 43), and [Collection I–D]

Exhib.: Antwerp, 1926

g. [Bronzes: T1, Collection Takahata, Osaka; T2, Private collection, Paris; T3, Collection I–D]

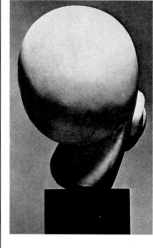

133. Study (Abstract Head)

a. 1910–25. Marble: h. 28.5, w. 20, d. 14
Three bases: marble, h. 16, diam. 13; wood, h. 31, w. 53, d. 42; carved wood, h. 66, w. 38, d. 29
Sig.: C BRANCUSI (and, on the base) 53 B C BRANCUSI PARIS 1925
Whereabouts unknown

Entry on Brancusi's list of works to Quinn reads "Abstract Head, 12,000 francs" (May 25, 1922). Letter from Quinn to Brancusi, June 28, 1922: "... Roché said that you still have the highly abstract female head you value at 12,000 F." It was sold at public auction in New York, 1982.

Prov.: Levin; Norton Simon Museum, Pasadena, California
Exhib.: Brummer, 1933–34 (no. 52)
Bibl.: Geist, no. 176

b. Plasters: h. 28.5, w. 21, d. 15
Brancusi Studio, MNAM (inv. S 42), and [Collection I–D]

c. [Bronzes: T1, Private collection, Belgium; T2, Collection I–D (shown at Tokoro Gallery, Tokyo, 1985)]

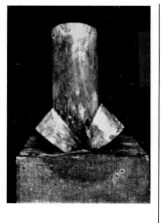

134. Torso of a Young Man II

1923. Walnut: h. 44, w. 28, d. 15
Sig.: 15 C. Brancus PARIS 1923
Brancusi Studio, MNAM (inv. S 79)

Slightly shorter than *Torso of a Young Man I* (Cat. no. 131).

Exhib.: Brummer 1933–34 (no. 15); Strasbourg, 1970
Bibl.: Geist, no. 150

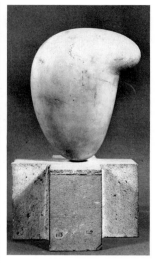

135. Eileen

c. 1923. White stone: h. 29, w. 24, d. 16
Cross-shaped stone base: h. 16, w. 24, d. 25
Two wood bases: h. 32, w. 50, d. 42; h. 70, w. 44, d. 44
Brancusi Studio, MNAM (inv. S 70)

Eileen Lane stated to us that she was not the subject of the portrait that bears her name, that she wore a chignon at the nape of her neck, never at the top of her head. Moreover, her hair was arranged to hide her face somewhat, prompting Brancusi to ask her why she did not let more of her face show.

Exhib.: Brummer, 1933–34 (no. 51)
Bibl.: Geist, no. 153

Photo Brancusi ph. 375

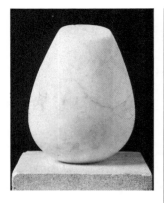

136. Torso of a Girl II

c. 1923. Onyx: h. 33, w. 23, d. 26
Stone base: h. 17
Philadelphia Museum of Art, A.E. Gallatin Collection

Exhib.: Philadelphia Museum of Art, 1943; The Solomon R. Guggenheim Museum, New York, 1955–56
Bibl.: Geist, no. 155; Catalogue, Gallatin Collection, 1954 (pl. 15)

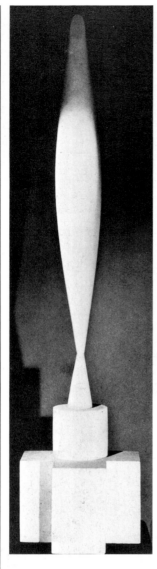

137. Bird in Space

1923. White marble, ring between foot and body:
h. 128.6; circum. max., 47.6, min. 8.2
Cylindrical base: white marble, h. 15.2, diam. 16
Cross-shaped base: stone, h. 28
Paired truncated pyramids: wood, h. 87.5
Collection Mrs. Wolfgang Schoenborn, New York

A photograph of this *Bird in Space* shows us that the foot consisted of two rounded forms (*Brancusi photographe*, pl. 20). Brancusi removed this marble foot (now on the main fireplace in the Brancusi Studio) and replaced it with a conical piece of white marble that he attached to the upper part by means of a ring.

Prov.: Quinn, U.S.; Levy, U.S. (purchased 1926 for $1,000); Pierre Matisse, New York (purchased 1940); Samuel Marx (purchased 1942)
Exhib.: Brummer, 1926 (no. 26); Arts Club of Chicago, 1927
Bibl.: Spear, pl. 19; Geist, no. 156

Photo Brancusi ph. 471

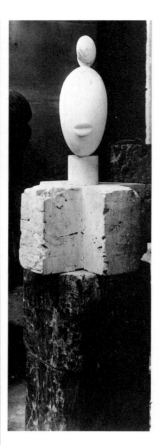

138. White Negress I

a. 1923. Veined marble: h. 48.3
Cylindrical base: marble, h. 16; cross-shaped base: stone, h. 25
Philadelphia Museum of Art, Louise and Walter Arensberg Collection

Eileen Lane tells the story of how Brancusi came to carve *White Negress* (see p. 148).

Prov.: Quinn, U.S. (purchased 1923); Arensberg, U.S. (purchased 1932 through Duchamp)
Exhib.: Wildenstein Galleries, New York, 1926; The Solomon R. Guggenheim Museum, New York, 1955–56
Bibl.: *This Quarter*, 1925; Catalogue, Arensberg Collection, 1954 (pl. 17); Geist, no. 157

b. Plaster: h. 42, w. 16, d. 18
Four bases: plaster, h. 9.5, diam. 9.5; cross-shaped stone, h. 15, w. 26, d. 15; wood, h. 27, w. 58, d. 44; wood, h. 66, w. 45, d. 40
Brancusi Studio, MNAM (inv. S 66)

Photo Brancusi ph. 328

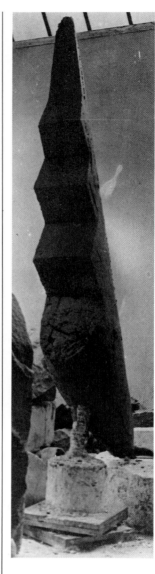

139. The Cock

c. 1923. Plaster
Project for metal casting, reworked by Brancusi

This plaster is the first version of the plaster *Grand Coq IV* (Cat. no. 218) in the Brancusi Studio, MNAM. Roché to Quinn, Jan. 14, 1923: "Brancusi is preparing a Coq Gaulois 2 to 3 meters high for casting in metal."

Bibl.: *This Quarter*, 1925

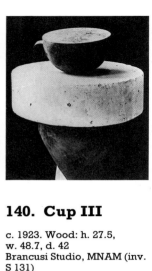

140. Cup III

c. 1923. Wood: h. 27.5, w. 48.7, d. 42
Brancusi Studio, MNAM (inv. S 131)

Bibl.: Geist, no. 158

Photo Brancusi ph. 1980 × 95 neg. B

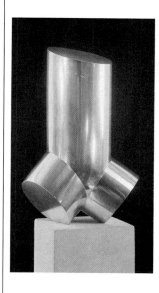

141. Torso of a Young Man

a. 1924. Polished bronze: h. 45.8
Sig. (stamped): C. BRANCUSI PARIS–1924
Foundry mark: P. Converset (invoice of June 24, 1924)
The Hirshhorn Museum and Sculpture Garden, Smithsonian Institution, Washington, D.C.

Purchased by Roché in 1924 for 15,000 frs. (letter from Roché, July 6, 1924)

Prov.: H.-P. Roché
Exhib.: The Solomon R. Guggenheim Museum, New York, 1955–56; Brussels, 1958
Bibl.: Geist, no. 159(a)

b. Plasters: h. 44, w. 28, d. 15
Brancusi Studio, MNAM (inv. S 78), and [Collection I–D]

c. [Bronzes: T1, Collection I–D; T2, Collection Takahata, Osaka]

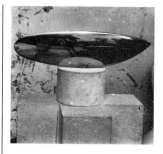

142. Fish

a. 1924. Polished bronze: h. 12, w. 42.9, d. 2.9
Veined marble cylindrical base
Sig. (stamped): N.1 C. BRÂN-CUȘI–PARIS–1924
Foundry mark: P. Converset (invoice of April 25, 1924)
Collection Mr. and Mrs. James W. Alsdorf, Winnetka, Illinois

Prov.: Rumsey, U.S.; Rodman, U.S.
Exhib.: The Solomon R. Guggenheim Museum, New York, 1955–56
Bibl.: *This Quarter*, 1925 (dated 1923); Geist, no. 160

b. 1924–26. Polished bronze: h. 12.7, w. 42.9, d. 3; on polished steel disk: diam. 50
Sig. (stamped): C. BRANCU-SI–PARIS–1924
Museum of Fine Arts, Boston

Purchased by H.S. Ede in 1927 for 10,000 frs. Ede to Brancusi, December 28, 1927: "My dear Brancusi, *Fish* has arrived; it's a marvel and I'm delighted to have it ..." Brancusi repaired the bronze in 1928 after it was damaged (Ede to Brancusi, Sept. 8, 1928).

Exhib.: Wildenstein Galleries, New York, 1926
Bibl.: Geist, no. 181(a)

c. Plaster: h. 13, w. 43, d. 3
Brancusi Studio, MNAM (inv. S 89)

Photos Brancusi ph. 428, ph. 429

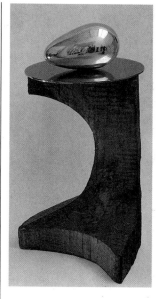

143. Beginning of the World

a. 1924. Polished bronze: h. 19, w. 28.6, d. 17.5; on polished steel disk: diam. 45
Wood base: h. 74, w. 48, d. 40
Foundry mark: P. Converset (invoice of Sept. 1, 1924)
Brancusi Studio, MNAM (inv. S 63)
Bibl.: Geist, no. 161(a)

b. 1924. Polished bronze: w. 28.5
Foundry mark: P. Converset
Collection Bernard Granet, Paris

Prov.: Georges Salles, Paris
Bibl.: Geist, no. 161(b)

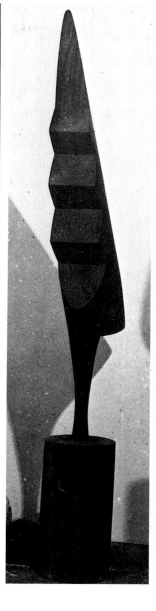

144. The Cock

a. 1924. Walnut: h. 91.8
Cylindrical base: wood, h. 29
Inscr. (on base): A AUDREY CHADWICK. C. BRANCUȘI PARIS
The Museum of Modern Art (Gift of LeRoy W. Berdeau), New York

Dated 1924 on a list drawn up by Brancusi. (Arch. I–D)

Prov.: Berdeau, U.S.
Exhib.: Brummer, 1926 (no. 28); Antwerp, 1926; The Solomon R. Guggenheim Museum, New York, 1955–56; Philadelphia, 1955
Bibl.: N.Y. *Herald Tribune*, September 25, 1934; Geist, no. 162

b. Plasters: h. 93, w. 10.2, d. 38
Brancusi Studio, MNAM (inv. S 111), and [Collection I–D]

c. [Bronzes: T1, Collection I–D; T2, Hyogo Kenristu Kindai Bijutsukan, Kobe]

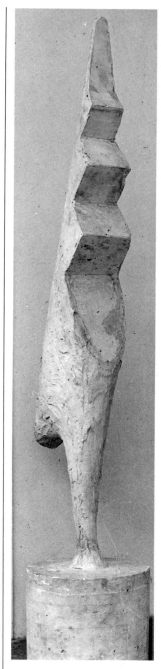

145. Grand Coq I

1924. Plaster: h. 254.8, w. 30, d. 57
Brancusi Studio, MNAM (inv. S 112)

To get it into the Brummer Gallery in 1933, Brancusi cut a piece off and reassembled the sculpture inside.

Exhib.: Brummer, 1933–34 (no. 48); Amsterdam, 1948; The Solomon R. Guggenheim Museum, New York, 1955–56
Bibl.: Geist, no. 163

Photo Brancusi ph. 28

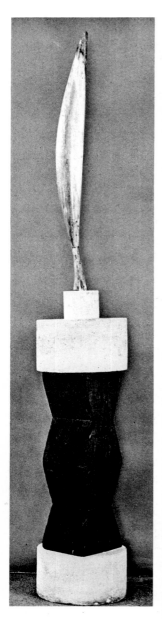

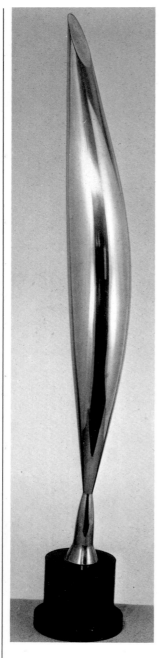

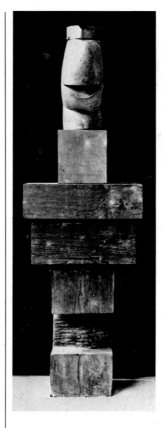

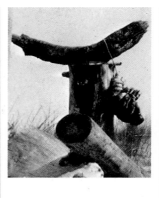

149. The Crocodile

1925. Wood, stone, and cork. Partly damaged.

Originally atop *Column of the Kiss* (Cat. no. 96) inside the studio at 8 Impasse Ronsin; *Crocodile* was propped up on a beam against a window in 11 Impasse Ronsin. See text pp. 161–63.

Bibl.: *Brancusi photographe*, 1977 (pl. 39)

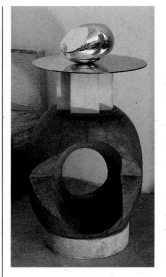

150. The Newborn II

a. 1925. Polished bronze: h. 17, w. 24.9, d. 17; on polished bronze disk: diam. 50
Three bases: cross-shaped stone, h. 20, w. 36; carved wood, h. 55, w. 45; cylindrical stone, h. 10, diam. 50
Brancusi Studio, MNAM (inv. S 33)

Bibl.: Geist, no. 171(a)

b. Plaster: h. 18, w. 25, d. 17
Brancusi Studio, MNAM (inv. S 32)

Photos Brancusi ph. 257, ph. 258

146. Yellow Bird (Bird in Space)

1925. Yellow marble: h. 116; circum max. 36.7, min. 9.5
Four bases: white marble: h. 12.3; limestone, h. 22.8, diam. 38; limestone, h. 21.3; oak, h. 79.6, w. 26, d. 21.8
Sig. (on bases): CB (in circle)
Philadelphia Museum of Art, Louise and Walter Arensberg Collection

Prov.: Hare, U.S. (purchased 1926); Arensberg, U.S. (purchased 1949 for $4,300 through Curt Valentin and Earl Stendahl)
Exhib.: Wildenstein Galleries, New York, 1926; Brummer, 1926; Arts Club of Chicago, 1927; New York, 1950; The Solomon R. Guggenheim Museum, New York, 1955–56
Bibl.: Spear, pl. 18 (dated 1923); Geist, no. 164

Photos Brancusi ph. 3809; ph. 1983 × 498 neg B; ph. 680(a)

147. Bird in Space

a. 1924. Polished bronze: h. 127.6; circum. max. 45, min. 7.9
Sig. (underneath): C. Brancusi
Cylindrical base: black marble, h. 16.7, diam. 15.5; sig.: CB (in circle)
Three rectangular bases: wood, h. 17.7, w. 34, d. 32; incised wood, h. 69, w. 32, d. 30.9; wood, h. 17.4, w. 34.5, d. 33.3
Philadelphia Museum of Art, Louise and Walter Arensberg Collection

Prov.: Arensberg, U.S.
Exhib.: Wildenstein Galleries, New York, 1926; Brummer, 1926 (no. 33); Arts Club of Chicago, 1927; The Solomon R. Guggenheim Museum, New York, 1955–56
Bibl.: Spear, pl. 19; Geist, no. 165; *Brancusi photographe*, 1977 (pl. 45, view of studio)

148. The Chief

1924–25. Wood and iron: h. 51.2
Stone and wood bases: h. 130.4
Sig.: 18 C Brancusi PARIS
Collection Phyllis Lambert

Prov.: Behrman
Exhib.: Brummer, 1926 (no. 29); Antwerp, 1926; Brummer, 1933–34 (no. 18); The Museum of Modern Art, New York, 1936 (no. 21); Cleveland, 1937; The Museum of Modern Art, New York, 1942; The Solomon R. Guggenheim Museum, New York, 1955–56
Bibl.: Geist, no. 169

Photo Brancusi ph. 1980 × 219 neg. B

b. Plaster: h. 129.5, w. 14, d. 17
Brancusi Studio, MNAM (inv. S 97)

To a large extent, Brancusi steered clear of the discussion and debate that were the stock-in-trade of Surrealist and other avant-garde circles, but a knowing allusion to their pursuits surfaces in his work every now and then. The crocodile he kept in his studio recalls the *objet trouvé*, a highly valued source of inspiration for Joan Miró and other Surrealists. Perhaps the lifelong presence of this sculpture in Brancusi's studio was his way of saying that some friendships, be they with people or ideas, never die. (P.H.)

A perfect example of Brancusi's approach to the problem of sculpture and base. The tiny newborn is proffered to the world atop a carefully arranged assemblage of forms, the whole signifying much more than the egg-like bronze that gives the composition its name. (P.H.)

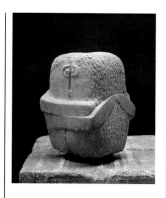

151. The Kiss

a. 1923–25. Stone: h. 36.5, w. 25.7, d. 23.8
Sig.: C Brâncuşi PARIS 1925
34
Brancusi Studio, MNAM (inv. S 3)

Exhib.: Brummer, 1933–34 (no. 34)
Bibl.: Geist, no. 172

Photo Brancusi ph. 220

1950

b. 1950. Plaster: h. 36.5
Private collection, France

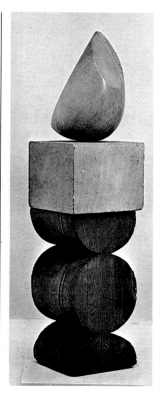

152. Little Bird

a. 1925. Colored marble: h. 40.35, w. 37, d. 25
Stone base and carved wood base
Sig.: C Brancusi PARIS 1925
Private collection

Stuart Ingersoll, a Philadelphia attorney, bought Little Bird in 1928. In a letter to Brancusi (March 6, 1928, with a check for 10,000 frs.) he mentions the problems he has been having with U.S. Customs. (For Brancusi's previous conflict with authorities in New York, see pp. 174–81). In a later letter, of March 10, 1930, he tells Brancusi how happy he is to have Little Bird (Arch. I–D). It was sold subsequently to the Norton Simon Museum through the Marlborough Gallery; now it is in a private collection.

Prov.: Ingersoll, U.S.; Norton Simon Museum, U.S.
Exhib.: Wildenstein Galleries, New York, 1926; Salon des Tuileries, Paris, 1926; Brummer 1933–34 (no. 1); The Solomon R. Guggenheim Museum, New York, 1955–56
Bibl.: Geist, no. 173

b. Plaster: h. 42, w. 20, d. 30.5
Brancusi Studio, MNAM (inv. S 81)

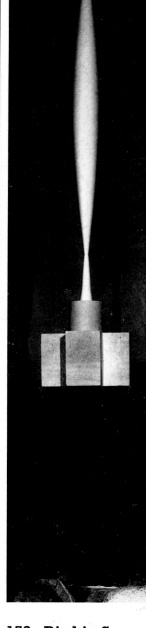

153. Bird in Space

a. 1925. White marble: h. 180.2; circum. max. 47, min. 9.3
Cylindrical base: stone, h. 17, diam. 15.8
Cross-shaped base: stone, h. 27.3, w. 25.3, d. 25.3
Base of paired truncated pyramids: wood, h. 99, w. 43.6, d. 33.6
Rectangular base: wood, h. 20, w. 45, d. 35
National Gallery of Art, Washington, D.C.

Prov.: Meyer, U.S. (purchased at Brummer, 1926)
Exhib.: Brummer, 1926 (no. 30); Arts Club of Chicago, 1927
Bibl.: Spear, pl. 22; Geist, no. 174

Photo Brancusi ph. 63

b. Plaster: h. 183, w. 14, d. 15.5
Brancusi Studio, MNAM (inv. S 99)

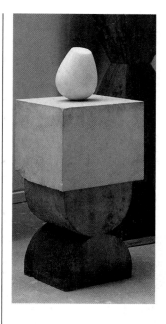

154. Torso of a Girl III

1925. Onyx: h. 26.4, w. 21.9, d. 16.3
Stone base: h. 40, w. 41.5, d. 47
Wood base (paired superimposed hemispheres): h. 50, w. 31, d. 47
Brancusi Studio, MNAM (inv. S 77)

Exhib.: Tri-National Art, London, Oct. 1925
Bibl.: Geist, no. 175

Photo Brancusi ph. 368

Brancusi's approach to the materials he worked with was highly distinctive, and in each transition, from plaster to stone or to bronze, his works acquire newfound individuality. His continual shifts from one medium to another probably had to do with practical necessities that arose as his career progressed as well as with his visceral response to the inherent qualities of a particular substance. Perhaps he could not sell a plaster Bird, but that Bird might well fulfill a mission in his studio "environment." (P.H.)

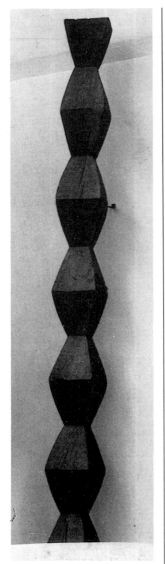

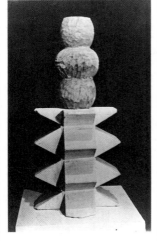

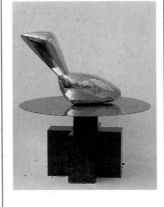

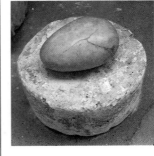

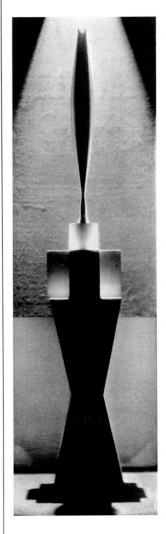

156. Exotic Plant

1925. Wood: h. 45, w. 21,
d. 20
Stone base: h. 48, w. 38, d. 37
Brancusi Studio, MNAM (inv.
S 135)

Exhib.: Brummer, 1933–34
(no. 33)
Bibl.: *This Quarter*, 1925;
Geist, no. 137

Photo Brancusi ph. 646

157. Leda

a. 1925. Polished bronze:
h. 54, w. 70, d. 24; on pol-
ished steel disk: diam. 90
Cylindrical base: black mar-
ble, h. 17, diam. 17
Cross-shaped base: black
marble, h. 35, w. 52, d. 52
Foundry mark: Rudier
Brancusi Studio, MNAM (inv.
S 85)

The steel disk, added in
1931, rotates on a set of mo-
tor-driven ball bearings.

Exhib.: Salon des Tuileries,
Paris, 1927 (no. 303); Mos-
cow, Leningrad 1928 (no. 4)
Bibl.: Geist, no. 177

b. Polished bronze: h. 54,
w. 70, d. 24
Private collection, France

Exhib.: Brummer 1933–34
(no. 28)

c. Plasters: h. 55, w. 70, d. 25
Brancusi Studio, MNAM (inv.
S 84), and [Collection I–D]

Exhib.: Paris-Paris, 1981

Photo Brancusi ph. 388

158. Sculpture for the Blind

1925. Alabaster: h. 17.5,
w. 32.3, d. 24
Plaster base: h. 26, diam. 53
Brancusi Studio, MNAM (inv.
S 64)

Exhib.: Salon des Indépen-
dants, Paris, 1926; Brummer,
1933–34 (no. 50)
Bibl.: Geist, no. 178

Photo Brancusi ph. 325A

155. Endless Column

Before 1925. Wood: h. 300,
w. 29, d. 31
Brancusi Studio, MNAM (inv.
S 118)

Exhib.: Brummer, 1933–34
(no. 6, shown with two other
columns, nos. 5 and 7; see
Cat. nos. 119 and 170)
Bibl.: Geist, no. 167

159. Bird in Space

a. 1926. Polished bronze:
h. 135.3; circum. max. 39,
min. 7.6
Cylindrical base: stone,
h. 15.8, diam. 15.8
Cross-shaped base: stone,
h. 27, w. 40, d. 40
Base of paired truncated pyr-
amids: wood, h. 111, w. 32,
d. 32
Sig. (on base): BRANCUSI
PARIS 1926
Collection Mrs. Edward Stei-
chen, New York

This was the sculpture that
triggered the conflict be-
tween Brancusi and U.S. Cus-
toms (see pp. 174–81).

Exhib.: "L'Art d'aujour-
d'hui," Paris, 1925; Brummer,
1926 (no. 33); Arts Club of
Chicago, 1927; The Solomon
R. Guggenheim Museum,
New York, 1955–56
Bibl.: *Vanity Fair*, 1927 (p.
57); Spear, pl. 20; Geist, no.
180

b. Plasters: h. 135, w. 11,
d. 12.5
Brancusi Studio, MNAM (inv.
S 98), and [Collection I–D]

c. [Bronzes: T1, National-
galerie, Staatliche Museen
Preussischer Kulturbesitz,
West Berlin; T2, Museum of
Modern Art, Shiga (Japan);
T3, Private collection, New
York; T4, Coll. Toninelli,
Rome]

Brancusi sometimes
used the same materi-
als for certain subjects,
but he also took liber-
ties with his own guide-
lines, as when he used
wood for the forms he
usually rendered in
stone, and vice versa.
(P.H.)

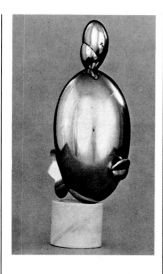

160. Blond Negress I

a. 1926. Polished bronze:
h. 38.6, w. 14, d. 18
Sig. (stamped, on chignon):
BRANCUȘI PARIS–1926
Cylindrical base: white marble, h. 9.4, diam. 10.4
Cross-shaped base: stone,
h. 25, w. 12, d. 12
Private collection, United
States

Baroness Gourgaud to Brancusi, Aug. 11, 1926:
" Thank you for taking such
pains to make it possible for
me to own your beautiful *Negress*. Enclosed please find a
... check for 25,000 frs., the
price we agreed upon. My
visit with you and the lasting
impression it made upon me
will make me want to see you
again when I get back in October." Sold to the Staempfli
Gallery for $40,000 at an auction at Parke-Bernet (1960). In
1974, the Marlborough Gallery bought it for $750,000,
again through Parke-Bernet.

Prov.: Gourgaud, France;
Maremont, U.S.
Exhib.: Brummer, 1926 (no.
27); Arts Club of Chicago,
1927
Bibl.: Geist, no. 179(a)

b. 1926. Polished bronze:
h. 38.5, w. 12.4, d. 18.8
Sig.: Brancusi Paris 1926
Cylindrical base: h. 9.5,
diam. 9.5
San Francisco Museum of
Modern Art (Gift of Agnes E.
Meyer and Elise Stern Haas)

Prov.: Meyer, U.S.; Haas,
U.S.;
Bibl.: Geist, no. 179(b)

c. 1926. Polished bronze:
h. 38.5, w. 14, d. 18
Sig. (stamped): C. BRANCUSI
PARIS–1926

Two stone bases
Wilhelm Lehmbruck Museum, Duisburg

Purchased by the museum in
1962.

Prov.: Penteado, Brazil
Bibl.: Geist, no. 179(c)

Photo Brancusi ph. 330

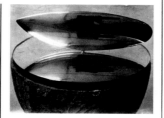

161. Fish

a. 1924–26. Polished bronze:
h. 12.6, w. 42.2, d. 3; on metal
disk
Sig. (on disk, stamped): C.
BRANCUSI PARIS 1926
Collection Mrs. Samuel
Bronfman, Montreal

Prov.: Maitland
Bibl.: Geist, no. 181(b)

b. 1924–26. Polished bronze:
h. 12.6, w. 42.2, d. 3; on
bronze disk. Reworked,
Sidney Janis Gallery, New
York

Sold for 6,500,000 frs. at the
Galerie Charpentier, Paris,
Dec. 6, 1959 (no. 31 in catalogue).

Prov.: Private collection
Exhib.: Sidney Janis Gallery,
New York, 1982
Bibl.: Geist, no. 181(c)

c. 1924–26. Polished bronze:
h. 12.7, w. 40, d. 3; on steel
disk
Wood base
Collection E. John Power,
London

Prov.: Schempp (purchased
1952); Ault, U.S.
Bibl.: Geist, no. 181(d)

d. Plasters: h. 13.5, w. 42, d. 3
Brancusi Studio, MNAM (inv.
S 89), and [Collection I–D]

e. [Bronze: T1, Collection I–D
(exhib.: Tokoro Gallery, Tokyo, 1985)]

Photo Brancusi ph. 434

Brancusi spent the latter part of his childhood alongside a river,
and the sight of fish
must have impressed
the contemplative
lad—their seeming defiance of gravity, their
graceful, elegant
movements in the watery element that is so
similar to, yet so different from, the airy element of birds. (P.H.)

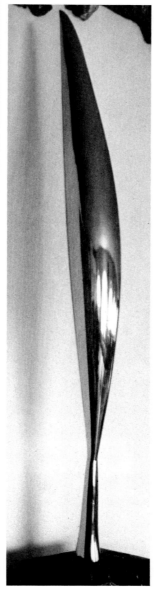

162. Bird in Space

1927. Polished bronze:
h. 136.5; circum. max. 40
Wood base (whereabouts unknown)
Collection Philippe de Rothschild, Pauillac

Bought from Brancusi in 1930
for 20,000 frs. During litigation with U.S. Customs, Brancusi stated: "... This [Cat. no.
159] is the first work on the
subject I have ever done.
The first replica [Cat. no.
162] is still not finished."

Bibl.: Spear, pl. 21 (dated
1925–28); Geist, no. 183

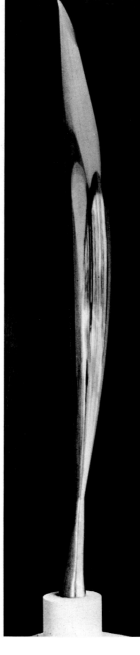

163. Bird in Space

a. 1927. Polished bronze:
h. 184.7, max. circum. 45
Cylindrical base: marble,
h. 17.7, diam. 17
Wood base: h. 82, w. 40
Sig. (on base): C. BRANCUSI
1927
Collection Taft B. Schreiber,
Beverly Hills, California

Sold for $140,000 on April 20,
1966, at Parke-Bernet, New
York (no. 13).

Prov.: Helena Rubenstein
(purchased 1932)
Exhib.: Foire de Paris, 1959
Bibl.: Spear, pl. 24–25; Geist,
no. 182

b. Plasters: h. 184, w. 14,
d. 15
Brancusi Studio, MNAM (inv.
S 101), and [Collection I–D]

c. Bronze: [T1, Collection
Nelson Rockefeller, New
York]

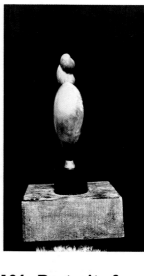

164. Portrait of Nancy Cunard

1925–27. Wood: h. 55,
w. 12.5, d. 25
Collection Mrs. Marcel Duchamp

Gift of Brancusi to Mrs. Duchamp.
Nancy Cunard, who belonged by marriage to the
wealthy family that owned
and operated the Cunard
Line, was very much her own
woman. Brancusi said of her,
"Everything about the way
she behaved showed how
truly sophisticated she was
for her day."

Exhib.: Brummer, 1933–34
(no. 36); The Solomon R.
Guggenheim Museum, New
York, 1955–56
Bibl.: Geist, no. 184

Photo Brancusi ph. 355

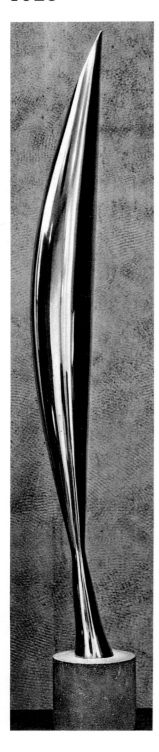

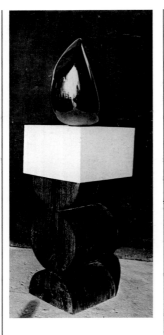

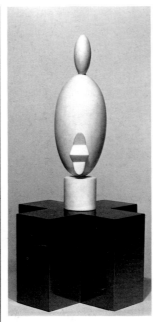

165. Bird in Space

1928. Polished bronze: h. 137; circum. max. 37.7, min. 9.5
The Museum of Modern Art (Given anonymously, 1934), New York

Cable from Brancusi to Stephen C. Clark, Oct. 20, 1932: "Bird, polished bronze sculpture with two-part base (stone cylinder and wood): FF 60,000—FF 50,000 right away and 10,000 upon arrival of *Bird* in the United States."

Prov.: Clark, U.S.
Exhib.: Brummer 1933–34 (no. 56)
Bibl.: Spear, pl. 23; Geist, no. 185

166. Little Bird

1928. Polished bronze: h. 40.5
Sig.: C. Brancusi PARIS 1928
Stone base and wood base: h. 90.7
The Museum of Modern Art (Gift of Mr. and Mrs. William A.M. Burden), New York

Acquired through Theodore Schempp.

Exhib.: Brummer, 1933–34 (no. 11)
Bibl.: Geist, no. 186

Photo Brancusi ph. 377

167. White Negress II

1928. Marble: h. 40.6
Cylindrical base: white marble, h. 9.2, diam. 9.2
Sig.: C. Brancusi 1928
Cross-shaped base: black marble, h. 25.5, w. 11.8
Art Institute of Chicago, Grant J. Pick Purchase Fund

Prov.: Helena Rubenstein
Bibl.: Geist, no. 189

168. Chimney Hook

1928? Wrought iron: h. 117, w. 20.3, d. 3
Collection Istrati–Dumitresco, Paris

Gift from Brancusi to the authors, 1948.

Exhib.: Wilhelm Lehmbruck Museum, Duisburg, 1976 (cat. no. 14); Städtische Kunsthalle, Mannheim, 1976
Bibl.: Jianou, 1963

169. Sign

1928? Wrought iron: h. 284, w. 67, d. 5
Collection Istrati–Dumitresco, Paris

Gift from Brancusi to the authors, 1948. The sculptor told them he made both this object and the chimney hook [Cat. no. 168] when he set up his forge in 11 Impasse Ronsin in 1928.

Bibl.: Jianou, 1963

The importance that Brancusi attached to materials cannot be underestimated. For him, there was always a direct and indissoluble link between form and substance. Yet, it was not unusual for him to toy with his gamut of materials by transforming a sculpture into wood, marble, or stone, each time working subtle changes in representation. This *modus operandi* surely accompanied his evolving concept of the studio as an art environment. (P.H.)

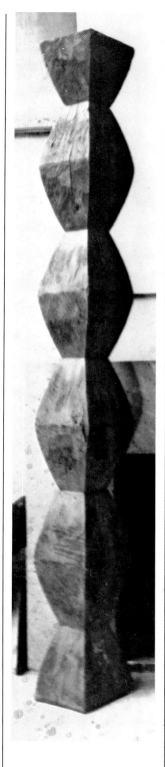

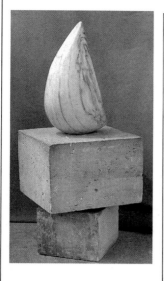

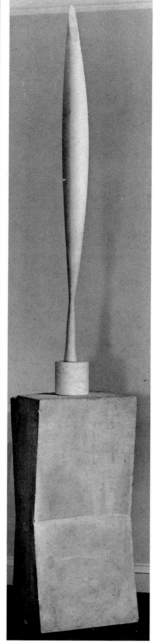

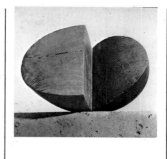

173. Form

c. 1929. Wood: h. 24, w. 38, d. 24

Reworked by Brancusi. The middle section is in the Brancusi Studio, MNAM (inv. S 68).

171. Little Bird II

1929. Colored marble: h. 64, w. 28, d. 36
Brancusi Studio, MNAM (inv. S 82)

Exhib.: Galerie Georges Bernheim, Paris, 1929
Bibl.: *L'Intransigeant*, April 1929; Geist, no. 190

Photo Brancusi ph. 378

174. Carved Doorway

c. 1929. Oak. Each upright: h. 178, w. 43, d. 24; lintel: h. 42, w. 174, d. 40
Brancusi Studio, MNAM (inv. S 86)

Made in 11 Impasse Ronsin to partition off the studios where the artist lived and worked from those set aside for exhibiting his sculpture.

Bibl.: Giedion-Welcker, 1959

172. Bird in Space

1930. White marble: h. 189.5; circum. max. 45.7, min. 9.5
Cylindrical base: stone, h. 16.9, diam. 17.7
Paired truncated pyramids: stone, h. 119, w. 43, d. 53
Private collection, United States

Broken and restored in 1966.

Prov.: Rumsey, U.S.; Ault, U.S. (purchased 1948); Curt Valentin, U.S.; Nelson Rockefeller, U.S.
Exhib.: Brummer, 1933–34 (no. 8); Curt Valentin, New York, 1952
Bibl.: Spear, pl. 27; Geist, no. 191

170. Endless Column

Before 1928. Wood: h. 410, w. 25, d. 25 (in two pieces)
Brancusi Studio, MNAM (inv. S 119)

The larger of the two pieces (h. 304) was shown at the Brummer Gallery in 1933–34 along with two other columns (see Cat. nos. 119 and 155).

Bibl.: *American Art News*, 1933; Geist, no. 187

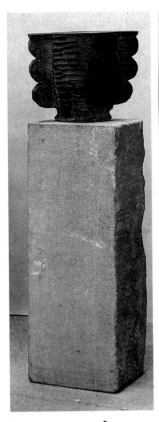

175. Vase

a. Late 1930s. Wood: h. 30.5, w. 36, d. 21
Brancusi Studio, MNAM (inv. S 136)

Bibl.: Geist, no. 218

b. Drawing of Vase
Ink, sepia, and pencil on paper: h. 10.4, w. 9.4
Private collection, France

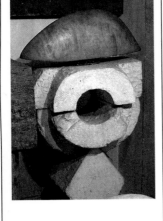

176. Nocturnal Animal

c. 1930. Wood: h. 24.7, w. 69.3, d. 17.8
Brancusi Studio, MNAM (inv. S 91)

Exhib.: Brummer, 1933–34 (no. 40)
Bibl.: Geist, no. 200

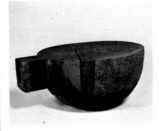

177. Cup IV

After 1925? Wood: h. 25, w. 53, d. 44
Brancusi Studio, MNAM (inv. S 132)

Exhib.: Brummer, 1933–34 (no. 13)
Bibl.: Geist, no. 170

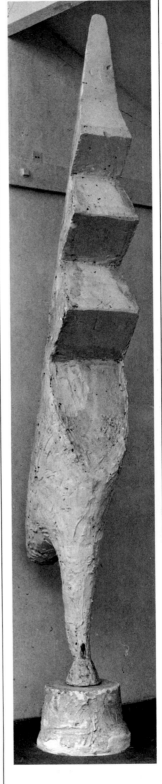

178. Grand Coq II

1930. Plaster: h. 365, w. 45, d. 80
Brancusi Studio, MNAM (inv. S 113)

Bibl.: Geist, no. 192; *Brancusi photographe*, 1977 (pls. 55 and 56)

Photo Brancusi ph. 92

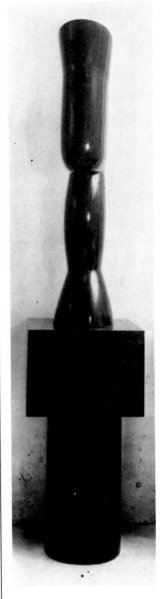

179. Portrait of Agnes E. Meyer

1929–33. Black marble: h. 133
Two black marble bases: h. 95
National Gallery of Art (Gift of Eugene and Agnes E. Meyer), Washington, D.C.

Purchased in 1934 by Agnes E. Meyer for $3,500 (letter from Mrs. Eugene Meyer, August 19, 1934).
The sculpture was finished in 1933. "I happened to hear that you've finished the portrait," Mrs. Meyer wrote to Brancusi on March 10, 1933. "Drop me a line. Am I beautiful?"

Prov.: Meyer, U.S.
Exhib.: Salon des Tuileries, Paris, June 1933; Brummer, 1933–34 (no. 2); Brancusi Retrospective, 1969–70
Bibl.: Geist, no. 195

Photo Brancusi ph. 342

180. Portrait

1930. Oak: h. 55.5, w. 25.5, d. 7
Collection Istrati–Dumitresco, Paris

Gift from Brancusi to the authors.

181. Fish

a. 1930. Blue-gray marble: h. 53.7, w. 180.3, d. 13
Sig.: C. Brancusi Paris 1930
Two stone bases, carved by A. Istrati, 1948: h. 23, diam. 81.5; and h. 18.5, diam. 45
Cylindrical base: marble: h. 13, diam. 18
The Museum of Modern Art (Acquired through the Lillie P. Bliss Bequest, 1949), New York

Exhib.: The Solomon R. Guggenheim Museum, New York, 1955–56
Bibl.: Geist, no. 194

Photo Brancusi ph. 449

b. Plasters: h. 63, w. 183, d. 13
Three bases: marble, h. 14, diam. 18; plaster, h. 28, diam. 155; plaster, h. 28, diam. 125
Brancusi Studio, MNAM (inv. S 90), and [Collection I–D]

Two small patches of color on the plaster surface (one silver, one gold) of the Brancusi Studio *Fish* prove that Brancusi was thinking of having it cast in bronze or steel.

c. [Bronze: T1, Städtische Kunsthalle, Mannheim; shown in Duisburg and Mannheim, 1976]

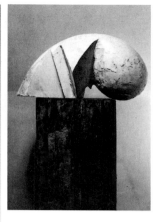

182. Plaster Form

1930. Plaster: h. 36.5, w. 69, d. 34.5
Sig.: 20BF C. Brancusi Paris 1930
Wood base: h. 77, w. 25, d. 28
Brancusi Studio, MNAM (inv. S 59)

A variant of *Narcissus* (Cat. no. 57), much simplified.

Exhib.: Brummer, 1933–34 (no. 20)
Bibl.: Geist, no. 199

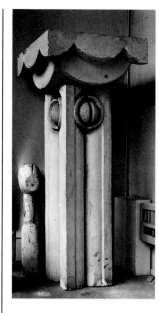

183. Column of the Kiss

c. 1930. Plaster: h. 300, w. 121, d. 121
Brancusi Studio, MNAM (inv. S 5)

Part of the project for the *Temple of Meditation.*

Exhib.: Brummer, 1933–34 (no. 3)
Bibl.: Geist, no. 198

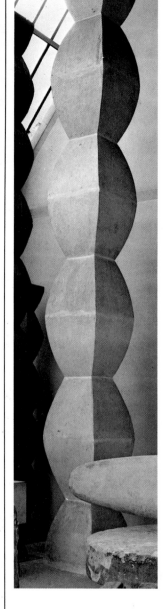

184. Endless Column

c. 1930. Plaster: h. 603, w. 61, d. 61
Brancusi Studio, MNAM (inv. S 120)

This version of *Endless Column* consists of four modules and two half modules. In 1962, when Brancusi's studio was first reconstructed at the Musée National d'Art Moderne, the topmost module had to be cut off because the museum ceiling was too low. When the studio was rebuilt at the Pompidou Center in 1978, the module that had been removed (and rendered useless) was replaced by the plaster cast of it from the museum storeroom.

Bibl.: Geist, no. 197

185. Module for Endless Column

c. 1930. Plasters: h. 60, w. 60, d. 60
Brancusi Studio, MNAM (inv. S 121), and [Collection I–D]

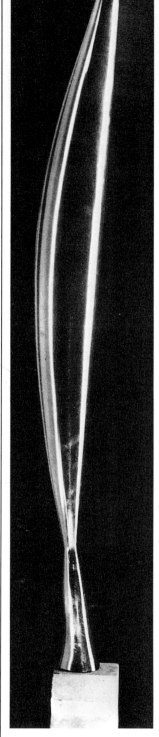

186. Bird in Space

1930s–1940. Polished bronze: h. 135; circum. max. 36.7, min. 7.6; foot: h. 22.8
Peggy Guggenheim Foundation, Venice

Brancusi sold this piece to Peggy Guggenheim in 1940 for $4,000.

Bibl.: Spear, pl. 29; Geist, no. 219

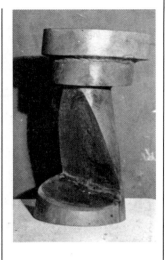

187. Telephone Chair

1930. Wood: h. 47, w. 29, d. 22
Brancusi Studio, MNAM (inv. S 1)

Brancusi dubbed this stool his "telephone chair" because he used it while telephoning.

Photo Brancusi ph. 1980 × 230 neg. B

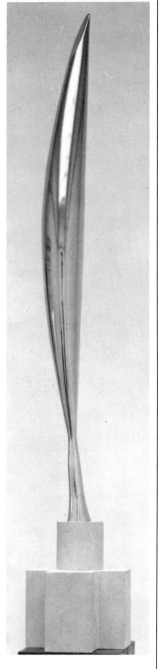

188. Bird in Space

1927–31. Polished bronze: h. 185.5; circum. max. 45.7, min. 10
Sig.: C BRANCUSI PARIS 1931
Norton Simon Museum, Pasadena, California

Bought in 1933 by the Maharajah of Indore, who gave it to his wife at the time of their divorce (1943).

Prov.: Yeshwant Holkar, Maharajah of Indore, India
Bibl.: Geist, no. 201

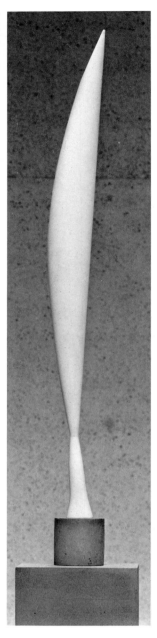

189. Bird in Space

1931–36. White marble: h. 184, circum. max. 44.3
Ring between foot and body.
Cylindrical base: h. 17
Stone base: paired truncated pyramids, h. 119
National Gallery of Art, Canberra

On a list made in 1936, Brancusi noted: "X Olcar white 1.84."

Prov.: Yeshwant Holkar, Maharajah of Indore; Maharani Usha Devi, India (see also Cat. no. 190)
Bibl.: Spear, pl. 30 (dated 1931–36); Geist, no. 210

Photo Brancusi ph. 482

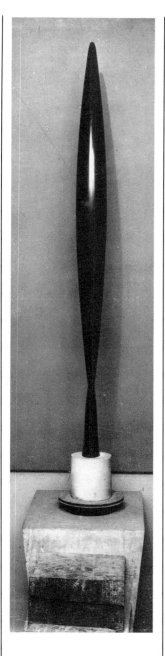

190. Bird in Space

1931–36. Black marble:
h. 194, circum. max. 48.3
Ring between foot and body
Cylindrical base: h. 17
Stone base: paired truncated
pyramids, h. 119
National Gallery of Art, Canberra

The Maharajah of Indore
bought the white marble and
black marble *Bird in Space*
(Cat. nos. 189 and 190, respectively) in 1936 for £3,000
each. See text p. 218.

Prov.: Yeshwant Holkar, Maharajah of Indore; Maharani
Usha Devi, India
Bibl.: Giedion-Welcker,
1959; Spear, pl. 32; Geist, no.
211

Photo Brancusi ph. 500

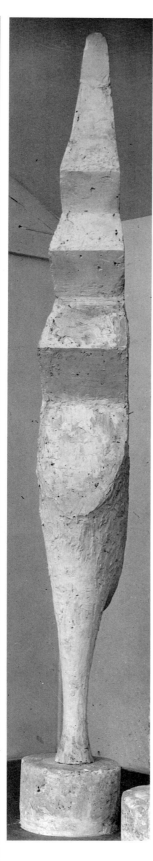

191. Grand Coq III

c. 1930. Plaster: h. 372, w. 45,
d. 82.5
Brancusi Studio, MNAM (inv.
S 114)

Geist, no. 193; *Brancusi photographe*, 1977 (pls. 55 and
56)

Photo Brancusi ph. 372

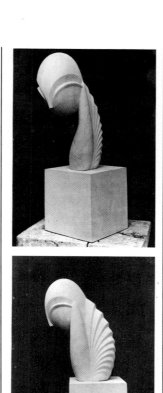

192. Mademoiselle Pogany III

1931. Marble: h. 48
Sig.: C. Brancusi Paris 1931
Stone base: h. 23.4
Philadelphia Museum of Art,
Louise and Walter Arensberg Collection

Exhib.: The Solomon R. Guggenheim Museum, New
York, 1955–56; London, 1965
Bibl.: Catalogue, Arensberg
Collection, 1954 (pl. 21);
Geist, no. 202

Photos Brancusi ph. 309, 311,
312, 314

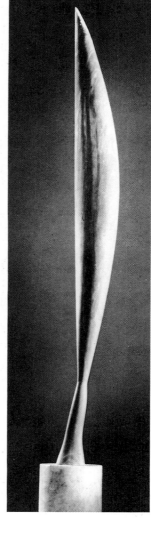

193. Bird in Space

1925–31. Gray marble: h. 134;
circum. max. 31, min. 7.9
foot (separate piece): h. 21.9
Cylindrical base: white marble, h. 14, diam. 16
Kunsthaus, Zurich

The Kunsthaus purchased
this *Bird in Space* from Brancusi in 1951. Appears as "No.
IX" on Brancusi's list from
1936. In 1932, Roché noted as
follows: "Bird in Space, bluegray marble: FF 75,000."

Exhib.: Brummer, 1933–34
(no. 9)
Bibl.: Spear, pl. 28; Geist, no.
168 (dated c. 1925–31)

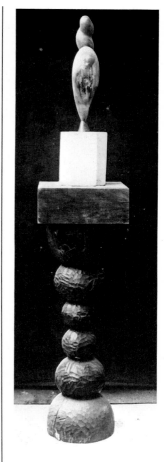

194. Portrait of Nancy Cunard

a. 1928–32. Polished bronze:
h. 55.2, w. 17, d. 22
Sig.: C. Brancusi PARIS 1928
(and) Brancusi PAR 1932
Marble base: h. 15
Collection Mr. and Mrs. Frederick Stafford, New York
(on extended loan to The
Isaac Delgado Museum of
Art, New Orleans)

Also titled *Sophisticated
Young Woman*. The lower
part is longer than in the
wood *Portrait of Nancy
Cunard* (Cat. no. 164), and
the chignon is different. Mr.
and Mrs. Stafford bought the
bronze from Brancusi in
1954.

Exhib.: Brummer, 1933–34
(no. 26); The Solomon R.
Guggenheim Museum, New
York, 1955–56; World House
Gallery, New York, 1957;
Brancusi Retrospective,
1969–70
Bibl.: Geist, no. 205

b. Plasters: h. 55.5, w. 15,
d. 22
Cylindrical base: stone, h. 14,
diam. 15
Wood base: h. 118.5, w. 38
Brancusi Studio, MNAM (inv.
S 72), and [Collection I–D]

c. [Bronzes: T1, Collection I–
D (shown at Tokoro Gallery,
Tokyo, 1985); T2, Collection
I–D (shown at Artcurial, Paris, 1984)]

Photo Brancusi ph. 359

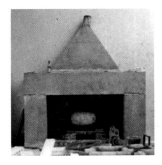

195. Fireplace

c, 1933. Soapstone: h. 174, w. 278, d. 45
Brancusi Studio, MNAM

The lintel (h. 54, w. 278, d. 45) rests on two upright blocks (each h. 120, w. 45, d. 45).
A letter from Else Frenkel to Brancusi (Jan. 1933) gives an approximate date for it.

The huge fireplace Brancusi built for the studio at 11 Impasse Ronsin fits right in with the combination of domicile and temple that he fashioned as a place to live in and a space in which to refine his concept of art. The large size of the stones indicates the importance he attached to his feeling of hearth and home in this "total space." (P.H.)

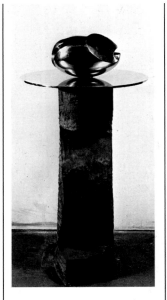

196. The Newborn

c. 1932. Stainless steel: h. 18, w. 25, d. 17; on polished steel disk: diam. 45
Brancusi Studio, MNAM (inv. S 34)

According to Jean Prouvé, with whom Brancusi stayed during the casting operation, this work dates from 1932.

Exhib.: Brummer, 1933–34 (no. 32)
Bibl.: Geist, no. 171(b) (dated c. 1928)

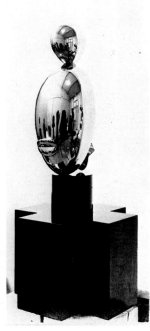

197. Blond Negress II

a. 1933. Polished bronze: h. 40.3
Cylindrical base: marble, h. 10, diam. 9
Cross-shaped base: stone, h. 25, w. 36
Carved wood base: h. 106
Sig. (on cylinder): C. Brâncusi 39B Paris F 1933
Foundry mark: Andro
The Museum of Modern Art, New York

Prov.: Goodwin, U.S.
Exhib.: Brummer, 1933–34 (no. 39); The Solomon R. Guggenheim Museum, New York, 1955–56
Bibl.: Geist, no. 206(a)

b. 1933. Polished bronze: h. 40.3
Sig. (under head): C. Brancusi
Sig. (under lip): C. BRANCU-SI
Foundry mark: Andro
Collection Dr. and Mrs. Barnett Malbin, New York

Prov.: Winston, U.S.
Bibl.: Geist, no. 206(b)

c. Plasters: h. 40.5, w. 15, d. 21
Brancusi Studio, MNAM (inv. S 66), and [Collection I–D]

d. [Bronzes: T1, Private collection, U.S.; T2, Private collection, Switzerland]

Photo Brancusi ph. 330

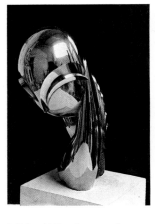

198. Mademoiselle Pogany III

a. 1933. Polished bronze: h. 44.5, w. 17.8, d. 24.1
Sig.: BRANCUSI PARIS 1933
Stone base: h. 22, w. 21.5, d. 20
Wood base: h. 112, w. 30, d. 42
Private collection, U.S.

Prov.: Mrs. John Wintersteen, Villanova, Pennsylvania
Bibl.: Geist, no. 207(a)

b. 1933. Polished bronze: h. 48, w. 20, d. 27
Plaster base: h. 19, diam. 19
Cross-shaped base: wood, h. 90, w. 35, d. 35
Brancusi Studio, MNAM (inv. S 54)

Exhib.: Strasbourg, 1970
Bibl.: Geist, no. 207(b)

Photo Brancusi ph. 299

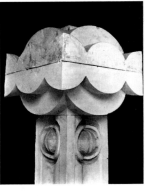

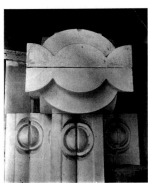

199. Model for Temple of Meditation (fragment)

a. 1933–37. Plaster: h. 60, w. 121, d. 110
Brancusi Studio, MNAM (inv. S 7.6)

One of the models Brancusi made for *Temple of Meditation*: one half of the capital of *Column of the Kiss* is superimposed on the other half to form a structure. Inside was a fresco of a bird (see text p. 195); an enlarged version of this was to have decorated one of the temple walls. One of Brancusi's alternate designs was a large egg-shaped structure (akin to *Beginning of the World*) "laid," as if by some miracle, on a lawn. A traditional entrance would have marred its perfect beauty, so an underground passageway was planned instead.

b. Variant. The upper part consists of the two halves of the capital, but this time with one atop the *Column of the Kiss*, the other on four columns arranged to form a cross. Only photographs of this configuration survive (Arch. MNAM).

Photos Brancusi 1980 × 506 neg. B. ph. 236; 1980 × 507 neg. B. ph. 239; 1980 × 526 neg. B. ph. 235

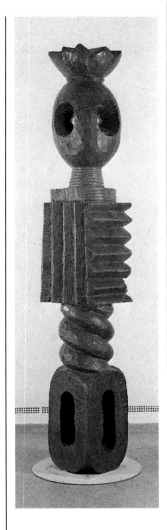

200. King of Kings

Early 1930s. Oak: h. 300
The Solomon R. Guggenheim Museum, New York

Like the white marble, black marble, and polished bronze *Birds in Space* (Cat. nos. 189, 190, 188), *King of Kings*—first entitled *Spirit of Buddha*— was to have been part of the *Temple of Meditation*. The Guggenheim Museum bought it from Brancusi in 1956.

Exhib.: The Solomon R. Guggenheim Museum, New York, 1955–56; Venice, 1960
Bibl.: Giedion-Welcker, (pl. 90, dated 1937); Geist, no. 204

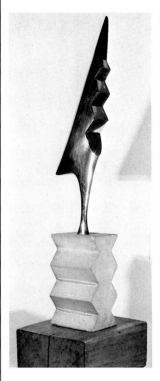

201. The Cock

1935. Polished bronze: h. 103.4, w. 21, d. 11
Sig. (underneath): C BRAN-CUSI 1935
Stone base and wood base: h. 193.4
MNAM (inv. S 817, purchased 1947)

Exhib.: Yverdon, 1954; The Solomon R. Guggenheim Museum, New York, 1955–56; Philadelphia Museum of Art, 1956; Athens, 1965; Montreal, 1966; Brancusi Retrospective, 1969–70; Duisburg–Mannheim, 1976; Biennale, Venice, 1982
Bibl.: Geist, no. 209

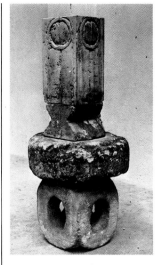

202. Column of the Kiss

1935. In four sections: h. 95 (total)
Plaster column from model of *Gate of the Kiss*: h. 33, w. 17, d. 17
Paired truncated pyramids: stone, h. 15, w. 15, d. 18
Plaster: h. 15, diam. 39
Carved stone: h. 32, w. 23.5, d. 25
Collection Istrati–Dumitresco, Paris

Gift from Brancusi to the authors, 1950.

Bibl.: Jianou, 1963 and 1982 (pl. 16, cat. no. 32)

This four-part column is typical of the way Brancusi assembled his sculptures in the studio to make a composite work. In all probability, they were originally individual works, dating from different periods, which he put together; as they accumulated, the space around them evolved. (P.H.)

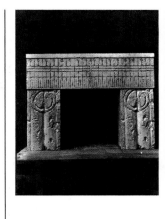

203. Model for Gate of the Kiss

a. 1935–37. Plaster columns: each h. 33, w. 17, d. 17
Plaster cast of stone frieze (in two parts): h. 16, w. 17.5, d. 4; and h. 16.2, w. 32.2, d. 6
Private collection, France

To make a model of the frieze, Brancusi first carved eight identical examples of *The Kiss* across the long stone slab and four across the other. Then he made two plaster casts of the longer slab (for the front of the *Gate*) and one cast of the shorter one (for the side), and assembled these to form the frieze on the lintel. He photographed the model.
Mrs. Tatarascu telegraphed him on Sept. 21, 1937: "Send measurements of stones for *Gate* at once." Brancusi mailed her a tube containing two sketches and a photograph of the model, adding that he had not had time to work out the project in its entirety, but that in a few days he would be at the site with the finished model.

Bibl.: Geist, no. 214

b. Plaster. Column: h. 33, w. 17, d. 17
Muzeul de Arta R.S.R., Bucharest

Prov.: Rosianu, Rumania
Bibl.: Brezianu, no. 29

c. Plaster. Frieze (negative): h. 16, w. 17.5, d. 1
Brancusi Studio, MNAM (inv. M 5)

d. Stone. Base for *Torso of a Girl* (Cat. no. 127), 1922, with *The Kiss* carved into front: h. 19.5, w. 21.5, d. 21.8
Brancusi Studio, MNAM (inv. S 12)

Photo Brancusi ph. 225

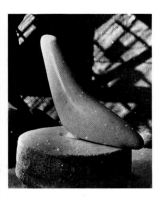

204. The Seal (Miracle)

a. 1924–36. White marble: h. 108.6, w. 114, d. 33
Two stone bases: h. 29, diam. 150; and h. 25, diam. 130
The Solomon R. Guggenheim Museum, New York

On Oct. 9, 1946, J. J. Sweeney informed the sculptor that the small piece of marble wedged between the subject of *The Miracle* (later *The Seal*) and its base had been damaged in handling and repaired. (Brancusi eliminated this "prop" in his 1943 variant *The Seal* II [Cat. no. 213].) He had sent *The Miracle* to New York in 1939 for "Art in Our Time," the exhibition celebrating the opening of the Museum of Modern Art's new building; it remained at the museum until 1955, at which time it was exhibited as *The Seal* and purchased by the Guggenheim Museum.

Bibl.: Geist, no. 212

b. Plaster: h. 108.5, w. 122, d. 32
Brancusi Studio, MNAM (inv. S 92)

Photo Brancusi ph. 454

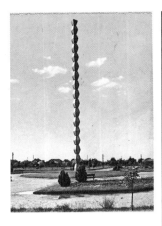

205. Endless Column

1937. Cast iron, copper coating
Entire column: h. 29.35 meters
Each module: h. 180, w. 90, d. 45
Top module: h. 90, w. 45
Base module: h. 145, w. 45
Tirgu-Jiu, Rumania

Brancusi made a pattern in basswood, after which the modules were cast in iron, sanded clean, and polished. The *Endless Column* at Tirgu-Jiu consists of fifteen modules and two half modules. Each module weighs 860 kg., while the steel armature that runs up the center of the monument weighs 15 metric tons. Total weight of the column: approximately 29 metric tons.

The inner shaft (in three sections) emerges from an underground concrete cube (5 meters each side). The modules were cast in September and October, 1937. The half module at the top was capped with a watertight plate that seals and stabilizes the structure. Four lightning rods are embedded in the column interior. Work at the site began in October 1937 and ended in July 1938; the engineer Georgescu-Gorjan supervised the installation. The scaffolding remained in place from June to July, 1938, while the column was plated with metal (Georgescu-Gorjan to Brancusi, Oct. 12 and Oct. 18, 1937).

Bibl.: Mocioi, 1971; Geist, no. 215; Brezianu, no. 28; Pogorilovschi, 1976

Photo Brancusi ph. 571

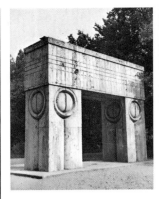

206. Gate of the Kiss

1938. Bampotoc travertine: h. 513, w. 645, d. 169
Two columns, each of two stone blocks: h. 332, w. 169
Lintel: h. 181
Tirgu-Jiu, Rumania

Sixteen identical stylizations of *The Kiss* run across each of the longer friezes on the lintel, four across each of the shorter (lateral) sections. The frieze is carved into stone slabs secured by an iron framework to the cement inside. Work on the *Gate* lasted from June 1937 to September 20, 1938.

The original site was alongside a new road, but a letter from Brancusi to Mrs. Tatarascu tells of the sculptor's misgivings. "The plans call for the *Gate* to be built a little way inside the garden, because if we place it at the edge as planned, it cannot function either as an enclosing element or as an independent entity. If we shift the location to just inside [the garden], not only could people then walk around it, but two stone benches could be placed at the sides. I was unable to send you the model in its entirety; in a few days I shall be there with the [completed] models."

During the carving phase, Brancusi brought sketches with him every morning and personally transposed the designs onto stone. Two assistants did the actual carving under his supervision.

The proportions of *Gate of the Kiss* match those of the so-called Golden Section. Set back, on either side of the *Gate*, are two granite benches (h. 79, w. 170, d. 82).

Bibl.: Mocioi, 1971; Geist, no. 216; Brezianu, no. 31; Pogorilovschi, 1976

Photo Brancusi ph. 228

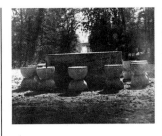

207. Table of Silence

1937–38. Bampotoc limestone
Table (two superimposed cylindrical slabs): upper, h. 45, diam. 215; lower, h. 45, diam. 200
Twelve stools (superimposed hemispheres): each h. 45, diam. 55
Tirgu-Jiu, Rumania

The original table was installed by Brancusi in 1937. After he left Tirgu-Jiu for Paris, local officials decided that an explanatory inscription including Brancusi's name should be carved into it, and the incisions filled with lead. When the sculptor returned to Tirgu-Jiu, he bristled at the inscription and insisted that it be removed. This procedure left the stone slab thinner than before and altered the table's proportions, to Brancusi's displeasure; at his request, a larger table and base were ordered from Deva (h. 45, diam. 215; base: h. 41, diam. 175). But by the time it reached the site, Brancusi had changed his mind again: the new upper slab would rest on the former upper slab from the original table.

Later, the former lower slabs were combined by a gardener into a second table, and placed along the main axis, beyond *Endless Column*. Brancusi did not intend this to be part of the monument; contrary to what has often been written, he never talked of adding another sculpture to the three masterpieces already in place.

The seats are now positioned symmetrically around the table, although Brancusi originally visualized them in pairs—symbolic couples—approximately 16 inches from the table. Afterward, he agreed to the present configuration.

As for the six square seats along the walkway, Brancusi stated: "They were Mrs. Tatarascu's idea, not mine." In one drawing, the measurements of the seats differ from those finally adopted (h. 50, diam. 55, instead of h. 45, diam. 55).

Bibl.: Mocioi, 1971; Geist, no. 217; Pogorilovschi, 1976

Photo Brancusi ph. 1980 × 508 neg. B

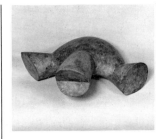

208. The Turtle

a. 1937. Pearwood: h. 20, w. 57, d. 51
Brancusi Studio, MNAM (inv. S 93)

This sculpture had become worm-eaten within Brancusi's lifetime, and he was planning to place it in a sealed container and burn sulfur inside to kill the worms. He never got around to this; later the Musée National d'Art Moderne undertook a restoration.

In 1955, Brancusi had a plaster mold (see 208*b*) made from the wood sculpture, which was to be used for casting *The Turtle* in bronze.

To mark the centennial of Brancusi's birth, a symposium was held on June 21, 1976, at the Musée de la Ville de Paris. Thai Van Kiem read a paper that included the following observations on the significance of *The Turtle*: "In ancient times, Asians regarded the turtle as sacred because it was believed to be nothing less than an image of the universe. Its high-domed carapace, often engraved with the cabalistic markings that were the source of writing and the calendar, bears a curious resemblance to the dome of the heavens; its squarish plastron was thought to represent the earth. Hence, the turtle symbolized the cosmogonic duality of heaven and earth—of Yin and Yang—the perfect harmony which could be likened to the squaring of the circle. The body of the turtle represented the third component of the visible world, set between the protective sky and the nourishing earth: humanity."

Bibl.: Giedion-Welcker, 1959 (pl. 72)

b. Plasters: h. 24.7, w. 57.9, d. 50.8
Brancusi Studio, MNAM (inv. S 94), and [Collection I–D]

Exhib.: Paris–Paris, 1981
Bibl.: Geist, no. 229

c. [Bronze: T1, Collection I–D (shown at Tokoro Gallery, Tokyo, 1985)]

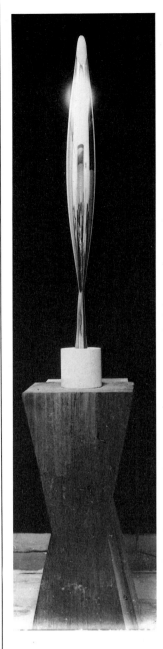

209. Bird in Space

c. 1941. Polished bronze: h. 182.9; circum. max. 44, min. 8
Cylindrical base: stone, h. 17.8
Cross-shaped base: stone, h. 25.4, w. 40.6, d. 40.6
The Museum of Modern Art (Gift of Mr. and Mrs. William A. M. Burden), New York

The original base, shown above, consisted of paired truncated pyramids.

Prov.: Senior, U.S. (purchased 1949 through Mrs. M. Duchamp; letter to Brancusi, Dec. 6, 1949); Janis, U.S. (purchased 1955); Burden, U.S. (purchased 1956)
Bibl.: Spear, pl. 31 (dated 1940?); Geist, no. 225 (dated c. 1941); Barr, 1977 (dated 1941?)

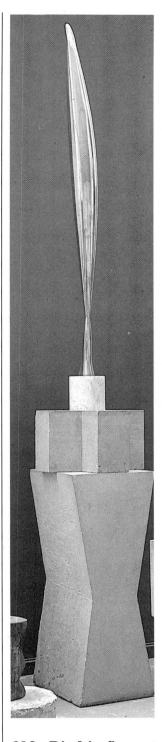

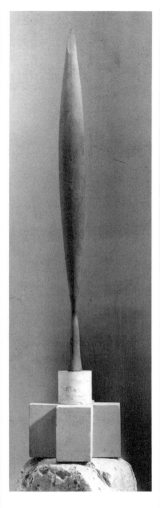

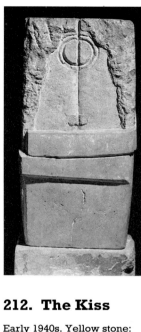

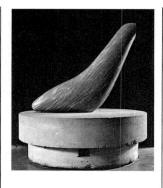

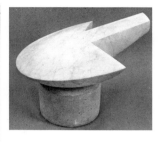

214. Flying Turtle

1940–45. Marble: h. 31.8, w. 93, d. 69
Base: diam. 45
The Solomon R. Guggenheim Museum, New York

Exhibited upside down at the Guggenheim Museum (1955) and the Philadelphia Museum of Art (1956), but Brancusi did not mind their mistake. When he saw the scrapbook of the show the Guggenheim Museum had sent him, he said "Now my turtle is flying!"

Bibl.: Giedion-Welcker, 1959 (pl. 73); Geist, no. 230

Photo Brancusi ph. 145

213. The Seal II

a. 1943. Blue-gray marble: h. 112, w. 100, d. 84
Stone bases: h. 29, diam. 150; and h. 25, diam. 130
MNAM (purchased 1947)

Exhib.: MNAM, 1953; Brussels, 1958; Middelheim–Antwerp, 1953 (no. 64)
Bibl.: Geist, no. 228

b. Plasters: h. 108, w. 122, d. 84
Brancusi Studio, MNAM (inv. S 92), and [Collection I–D]

On two superimposed plaster cylinders (h. 52).

Photo Brancusi ph. 144A

c. [1980. Superimposed stone slabs: h. 25, diam. 150 (upper): h. 25, diam. 130 (lower)
Musée de Sculpture en plein air de la Ville de Paris

Dimensions of the slabs approximate those of the base of *The Seal* II.
Gift of the authors to the City of Paris, 1980]

212. The Kiss

Early 1940s. Yellow stone: h. 71.8, w. 35.2, d. 26
Brancusi Studio, MNAM (inv. S 1)

This variant of *The Kiss* is more geometrical than previous versions. The heads are more elongated, and the arms are at about the midpoint of the sculpture.

Bibl.: Geist, no. 227

211. Bird in Space

1940–45. Painted plaster: h. 194; circum. max. 49, min. 11
Cylindrical base: plaster, h. 17.7, diam. 17
Cross-shaped base: plaster, h. 29, w. 47.6
Plaster base: h. 89.5, w. 55.8, d. 54.5
Brancusi Studio, MNAM (inv. S 105)

Bibl.: Spear, pl. 36

210. Bird in Space

a. 1941. Polished bronze: h. 193.6; circum. max. 48, min. 8.6
Cylindrical base: marble, h. 18.3, diam. 18
Cross-shaped base: stone, h. 32, w. 53.6
Paired truncated pyramids: stone, h. 116, w. 46, d. 52
Brancusi Studio, MNAM (inv. S 106)

This is the only existing bronze of this version; Brancusi destroyed the molds. Twice he was approached about an enlarged metal version of *Bird in Space*: for Antwerp (c. 1926) and for the Seagram Building in New York (1955).

Bibl.: Spear, pl. 33; Geist, no. 226

b. Plaster: h. 196, w. 14, d. 16
Brancusi Studio, MNAM (inv. S 107)

Brancusi had a lifelong affection for nature and animals: as a boy he had been a shepherd in Rumania. His understanding of animals was truly remarkable, even when the creatures that inspired him were seen only in captivity—such as the seals in the Paris Zoo. So complete is the identification of *The Seal* II with its material that we can almost feel its damp hide shuddering, or hear sounds coming from its mouth. (P.H.)

1945

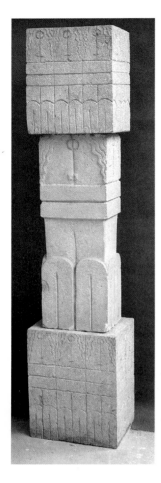

215. Boundary Marker

1945. Stone: three sections
Top to bottom: 1) h. 50,
w. 40.5, d. 30; 2) h. 89.5,
w. 30,
d. 22; 3) h. 44.5, w. 38, d. 30
Brancusi Studio, MNAM (inv.
S 13)

Bibl.: Geist, no. 231

1920?–47

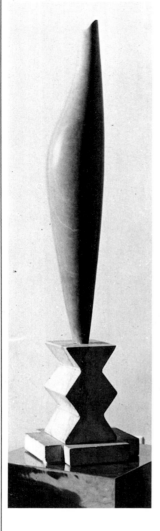

216. Bird

1920?–47. Blue-gray marble:
h. 90; circum. max. 48.2, min
16.4
Sig. (underneath): C BRAN-
CUSI
Stone base: h. 26.6, w. 14.6

Cross-shaped base: stone,
h. 29.4, w. 26.9, d. 26.6
Private collection

Probably begun about 1920;
finished by 1947.

Prov.: Penteado, Brazil (pur-
chased 1952 from Brancusi)
Bibl.: Spear, pl. 16 (dated
1920?); Geist, no. 221 (dated
c. 1923–52)

1943?–48

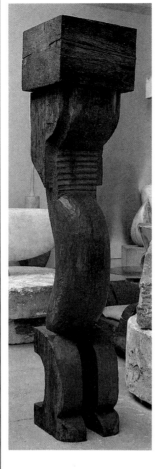

217. Caryatid

1943?–48. Wood: h. 228.9,
w. 45.5, d. 43.5
Brancusi Studio, MNAM (inv.
S 137)

In 1948, we helped Brancusi
complete this sculpture. J.J.
Sweeney came to see him in
1955 about a show at the So-
lomon R. Guggenheim Muse-
um in New York; Brancusi
did not wish to part with *Car-
yatid*, but we persuaded him
to let it out of the studio.

Exhib.: The Solomon R. Gug-
genheim Museum, New
York, 1955–56; Saint-Paul-de-
Vence, 1981
Bibl.: Geist, no. 223

1949–54

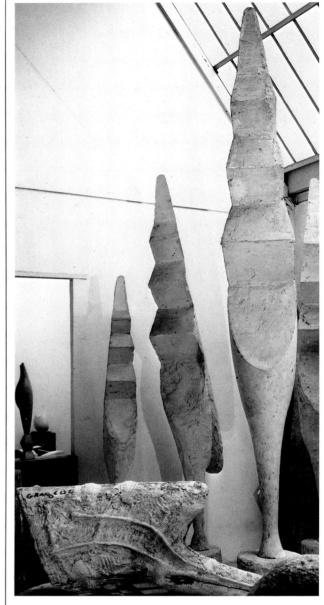

218. Grand Coq IV

a. 1949–54. Plaster: h. 480,
w. 57, d. 100
Base: h. 45, diam. 57
Plaster molds
Brancusi Studio, MNAM (inv.
S 116)

Brancusi and Istrati made the
plaster base and the negative
molds (with iron armature) in
1953–54. There are four sec-
tions: one for the foot; a sec-
ond and third for the sides;
and a thick, heavy curved
piece to hold the others in
place.
Brancusi's last monumental
work, *Grand Coq* IV was the
crowning achievement of a
sculptural approach that he
had elaborated over a life-
time.

b. Plaster. [Collection I–D]

Bibl.: Geist, no. 232

c. [1972–79. Stainless steel:
h. 477, w. 56, d. 98
Internal shaft: h. 130
Casing: h. 66

Granite base: h. 45, diam. 57
Fondation Pierre Gianadda,
Martigny

Cast at Lincoln Foundry, Los
Angeles. Polished at Fonde-
rie Suisse, Paris (1974–77).
This stainless steel *Grand
Coq* is attached at the base to
a steel rod built into a casing
that enables the sculpture to
rotate.

Prov.: Private collection,
Switzerland
Exhib.: Basel, 1980; Venice,
1982
Bibl.: N. Dumitresco and A.
Istrati, "Brancusis Grosse
Hahn," *Artis*, June 1980];
Geist, p. 193

316

CATALOGUE OF FURNITURE AND OBJECTS

Throughout his life, Brancusi crafted the furniture, utensils, and implements he needed, and he also made them for friends and acquaintances. These objects belonged as much in his environment as his sculpture. There was no separation between his work as a sculptor and his everyday life.

This catalogue does not claim to be comprehensive: some objects were discarded, and replaced by improved models; others disappeared, or found their way into unknown collections. A few are in the Catalogue Raisonné as works of sculpture: *Bench* (Cat. nos. 88, 126), *Carved Doorway* (Cat. no. 174), *Telephone Chair* (Cat. no. 187), *Fireplace* (Cat. no. 195), and *Chimney Hook* (Cat. no. 168).

Except for the bench, stools, and workbench in the Brancusi Studio (Centre Georges Pompidou, Paris), and two other stools (Cat. nos. 219, 220), all furniture and objects in this catalogue belong to the authors.

219. Stool

c. 1920. Wood: h. 38, w. 55, d. 32
Private collection

Exhib.: Staempfli Gallery, New York, 1960

220. Stool

c. 1920. Wood: h. 34.5, w. 56.5, d. 32.5
Private collection

Exhib.: Staempfli Gallery, New York, 1960

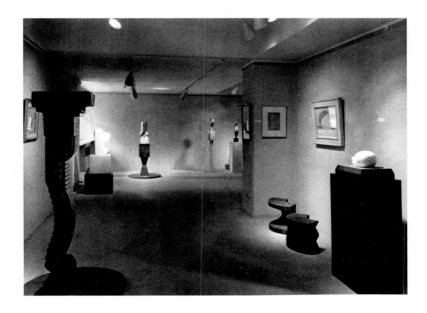

221. Bench

1920–21. Oak: h. 56, w. 102, d. 56
Brancusi Studio, MNAM (inv. So 85)

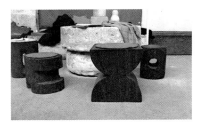

222. Distaff

1923. Wood: h. 104, w. 10.4, d. 1.9

Brancusi made this when he returned from his trip with Eileen Lane to Rumania. The roundel is decorated with a design in pencil.

Exhib.: Duisburg, 1976; Mannheim, 1976
Bibl.: Jianou, 1963

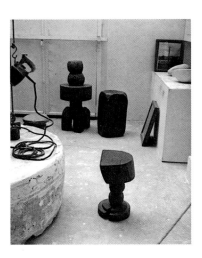

225. Coal Stove

1928. Sheet metal: h. 68, w. 22, d. 19

Accessories: coal scoop, two lids, grate, igniting device, hook. This stove was in Brancusi's darkroom.

223. Plumb Lines

c. 1925

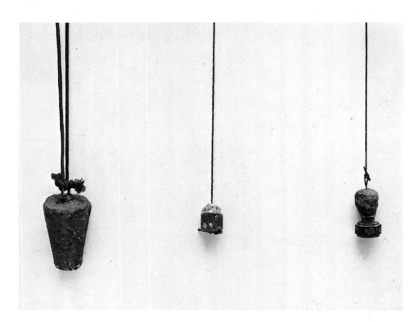

224. Stool

1925. Wood: h. 34, w. 38, d. 32
Brancusi Studio, MNAM (inv. So 11)

226. Stool

1928. Teak: h. 45, w. 41, d. 41
Brancusi Studio, MNAM (inv. So 35)

227. Stove Grate

1928. Sheet metal: h. 8, w. 25, d. 41

228. Stove Accessory

c. 1928. Notched sheet metal: h. 7,
diam. 17

229. Lamp

1928–30. Copper stem: h. 20; cross-
shaped stone base: h. 5.5, w. 14.5,
d. 14.5

230. Tray

1930. Copper: h. 2.5, diam. 22

231. Box

1930. Wood with velvet cushion:
h. 10.5, w. 35, d. 20

232. Coffee Mill

c. 1930. Hammered copper sheets:
h. 29, diam. 5.5

233. Trays

1932. Steel: diam. 23

234. Pipe

1934. Wood: h. 4, w. 15, d. 3.5

235. Vase

c. 1940. Plaster: h. 22; diam. max.
52, min. 15.5

236. Coffee Roaster

c. 1940. Copper receptacle: h. 13,
diam. 15; (wire handle)

237. Still

1942. Sheet metal: h. 48, diam. 15

Aluminum coil, with tap

Accessories: steel (w. 20, diam. 12)
and bronze (diam. 12.5)

238. "Furnace"

1948. Sheet metal: h. 20, w. 62,
d. 30.5

Opening for pans (diam. 15)
Accessories, sheet metal: scoop,
h. 23, w. 8 (with wooden handle);
notched lid, h. 32, w. 32.5; oval lid,
h. 30, w. 24

Brancusi placed the "furnace" (or
"pipe," as he called it) to extend
from the fireplace.

239. Tray

1949. Hammered copper: h. 3,
diam. 25.5

240. Brooch

1949. Lead: h. 8, w. 6

Wire safety pin and catch

241. Ladle for molten lead

1949. Sheet metal: h. 4.5, w. 7,
d. 6.5; wire handle: w. 14

242. Lead shapes

1949. Duck: h. 16, w. 7; Camel:
h. 14, w. 19; Airplane: h. 12, w. 5.5;
Crocodile: h. 9, w. 14

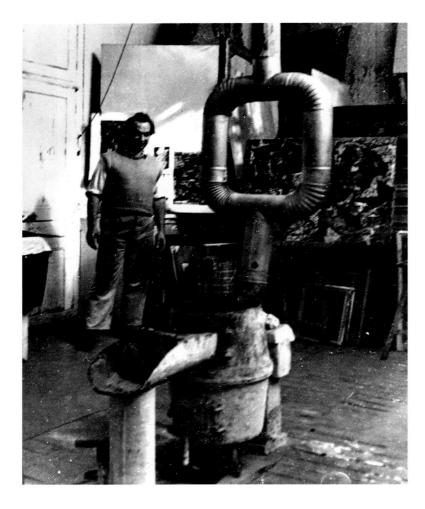

243. Drainboard

1950. Wood: h. 21, w. 36, d. 17

Bibl.: Jianou, 1963

244. Lamp

1950. Copper stem: h. 28; cross-shaped stone base: h. 8.5, w. 14.5, d. 14.5

245. Box

1950. Wood with velvet cushion: h. 5.5, w. 27, d. 18

246. Knitting Needles

1950. Wood (h. 42) and champagne corks

Brancusi made several pairs of knitting needles for Natalia Dumitresco.

247. Mailbox

1950. Sheet metal with silver paint: h. 26, w. 17.5, d. 12

248. Ladle

1950. Sheet metal: h. 10, diam. 11

249. Sieve for ashes

1950. Sheet metal: h. 32, diam. 36

Made by Brancusi and Alexandre Istrati.

250. Portfolio Stand

1952. Wood: h. 80, w. 85.5, d. 49; carved backboard: h. 85.5, w. 35, d. 6

251. Fruit-juice Strainer with lid

1953. Sheet metal: h. 12, diam. 11

252. Bell

1953. Sheet metal: h. 18, diam. 10.5; wire hook

253. Bell

1953. Sheet metal: h. 14.5, diam.
13.5

254. Movable Reading Stand

1954. Wood (painted yellow) and
iron: h. 30.5, w. 36, d. 10

255. Workbench

No date. Wood
Brancusi Studio, MNAM

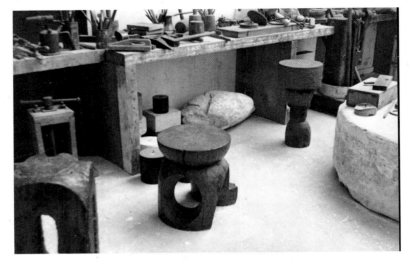

256. Stool

No date. Wood with raffia cushion:
h. 41.5, w. 41, d. 33
Brancusi Studio, MNAM (inv. So 10)

257. Stool

No date. Wood: h. 34, w. 38, d. 32
Brancusi Studio, MNAM (inv. So 11)

258. Stool

No date. Walnut: h. 46.5, diam. 26
Brancusi Studio, MNAM (inv. So 25)

259. Flute

No date. Wood: l. 36.5

260. Cigarette Holder

No date. Wood

261. Knives

No date

SELECTIVE LIST OF EXHIBITIONS

Note: The records of Brancusi's exhibitions are not always complete. Some exhibitions are not titled, and the duration of many exhibitions is indicated by the month or months, or by the opening date only.

One-man Exhibitions

1914
New York, Photo-Secession Gallery, March 12–April 1

1926
New York, Wildenstein Galleries, Feb. 16–March 3

New York, Brummer Gallery, Nov. 17–Dec. 15
 Traveled to The Arts Club of Chicago, Jan. 4–18, 1927

1933
New York, Brummer Gallery, Nov. 17–Jan. 13, 1934

1955
New York, The Solomon R. Guggenheim Museum, Oct. 25–Jan. 8, 1956, "A Retrospective Exhibition"
 Traveled to Philadelphia Museum of Art, Jan. 27–Feb. 26, 1956

1956
Bucharest, Muzeul de Arta R.S.R., Dec. 1956–Jan. 1957, "A Retrospective Exhibition on the Occasion of the Artist's Eightieth Birthday"

1960
New York, Staempfli Gallery, Nov. 29–Dec. 31

1962
Paris, Musée National d'Art Moderne, March: First reconstruction of Brancusi Studio

1967
Paris, Musée National d'Art Moderne, June 12, "Hommage à Brancusi"

1969
Philadelphia Museum of Art, Sept. 23–Oct. 30, "Constantin Brancusi, 1876–1957: A Retrospective Exhibition"(Brancusi Retrospective)
 Traveled to:
 New York, The Solomon R. Guggenheim Museum, Nov. 25–Feb. 15, 1970
 Art Institute of Chicago, March 11, 1970–April 26

1970
Bucharest, Muzeul de Arta R.S.R., June 5–Aug. 20, "A Retrospective Exhibition"

The Hague, Gemeentemuseum, Sept. 19–Nov. 29, "Brancusi—Turning Point in the Art of Sculpting"

1973
São Paulo, Museu de Arte Contemporanea, Oct. 3–21

1975
Paris, Musée National d'Art Moderne, Centre Georges Pompidou, Dec. 10–Feb. 8, 1976

1976
New York, The Solomon R. Guggenheim Museum, April 15–May 19, "Constantin Brancusi: From the Guggenheim Collection"

Bucharest, Muzeul de Arta R.S.R., May–July

Duisburg, Wilhelm-Lehmbruck-Museum, July 11–Sept. 5, "Constantin Brancusi: Plastiken—Zeichnungen"

Mannheim, Städtische Kunsthalle, Sept. 25–Nov. 7

Zurich, Kunsthaus, Nov. 12, 1976–Jan. 9, 1977, "Constantin Brancusi. Der Künstler als Fotograf seiner Skulptur: Eine Auswahl, 1902–1943"

1977
Munich, Städtische Galerie im Lenbachhaus, March 18–May 15

Paris, Musée National d'Art Moderne, Centre Georges Pompidou, June 21, "Inauguration de l'Atelier de Brancusi"

Tokyo, Gallery Tokoro, Oct. 15–Nov. 19

1978
Tokyo, Gallery Tokoro, Oct. 16–Nov. 18, "Constantin Brancusi: Photographs"

1979
Akron Art Institute, Ohio, Nov. 10–Jan. 6, 1980, "Brancusi as Photographer"
 Traveled to five other U.S. museums, 1979–81

1985
Tokyo, Gallery Tokoro, June 15–July 31, "Constantin Brancusi: Sculptures, drawings, photographs"

Paris, Galerie de France, June–July, "Délicatesse de Brancusi: L'Atelier 1946, Pascu Atanasiu"

Group Exhibitions

1903
Bucharest, Palatul Ateneului Roman

1906
Bucharest, Pavillon of Dr. D. Gerota, Filaret Park, March 15–May 10

Paris, Grand Palais, April 15–June 30, "Société Nationale des Beaux-Arts" (16th)

Paris, Grand Palais, Oct. 6–Nov. 15, "Société du Salon d'Automne" (4th)

1907
Bucharest, March 15–May 1, "Tinerimea Artistica" (6th)

Paris, Grand Palais, April 14–June 30, "Société Nationale des Beaux-Arts" (17th)

Créteil, L'Abbaye de Créteil, July

Paris, Grand Palais, Oct. 1–22, "Société du Salon d'Automne" (5th)

1908
Bucharest, March 19–May 10, "Tinerimea Artistica" (7th)

Paris, Grand Palais, April 15–June 30, "Société Nationale des Beaux-Arts" (18th)

1909
Bucharest, March 15–April 15, "Tinerimea Artistica" (8th)

Paris, Oct. 1–Nov. 8, "Société du Salon d'Automne" (7th)

Bucharest, "Salonul Oficial"

1910
Paris, Cours la Reine, March 18–May 1, "Société des Artistes Indépendants" (26th)

Bucharest, April–May, "Tinerimea Artistica" (9th)

Bucharest, Nov. 14–Dec., "Tinerimea Artistica" (autumn exhibition)

1911
Paris, Quai d'Orsai, April 21–June 13, "Société des Artistes Indépendants" (27th)

1912
Bucharest, May 1–June 20, "Salonul Oficial"

Paris, Quai d'Orsai, March 20–May 16, "Société des Artistes Indépendants" (28th)

1913
New York, The Armory of the 69th Infantry, Feb. 17–March 15, "International Exhibition of Modern Art" (The Armory Show)
 Traveled to:
 Art Institute of Chicago, March 24–April 16
 Copley Society of Boston, Copley Hall, April 28–May 19

Paris, Quai d'Orsay, March 19–May 18, "Société des Artistes Indépendants" (29th)

Bucharest, March 31–April 30, "Tinerimea Artistica" (13th)

Munich, June–Oct., "Die internationale Kunstausstellung im königlichen. Glaspalast"

London, Royal Albert Hall, July, "Allied Artists Association Exhibition"

London, Doré Gallery, Oct.

1914
Prague, U. Praze Moderni Umeni, Feb.–March, "Modern French Artists"

Bucharest, March 30–April, "Tinerimea Artistica" (14th)

1917
New York, Grand Central Palace, April 10–May 6, "Society of Independent Artists"

New York, Hotel Ritz-Carlton, Dec. 5, "Allies of Sculpture"

1920
Paris, Grand Palais, Jan. 28–Feb. 29, "Société des Artistes Indépendants" (31st)

Paris, Galerie La Boétie, March 3–16, "Deuxième Exposition de la Section d'Or"

Bucharest, March 21–April, "Arta Romana"

New York, Société anonyme, April 30–June 15, "First Exhibition"

New York, Société anonyme, Aug. 2–Sept. 11, "Third Exhibition"

1922
New York, Sculptors' Gallery, March 24–April 16, "Contemporary French Art"

Art Institute of Chicago, Sept. 19–Oct. 22, "The Arthur Jerome Eddy Collection"

1923
New York, American Art Association, May 21–June 9, "Spring Salon"

1924
Venice, Giardini di Castello, April–Oct., "XIV. Esposizione internazionale d'arte della città"

Bucharest, Nov. 30–Dec. 30, "First International Exhibition of the 'Contimporanul'"

1925
Paris, Galerie Durand-Ruel, May 28–June 25, "Tri-National Exhibition of Contemporary Art: American, French & English"
 Traveled to:
 London, New Chenil Gallery, Oct.
 New York, Wildenstein Galleries, Jan. 26, 1926–Feb. 17, 1926

1926
New York, The Art Center, Jan. 7–30, "John Quinn Collection: Memorial Exhibition of Representative Works"

Paris, Palais de Bois, March 20–May 2, "Société des Artistes indépendants" (37th)

Antwerp, May 15–June 20, "Salon d'Art contemporain: L'Art français moderne"

Paris, Palais du Bois, June, "Salon des Tuileries"

The Brooklyn Museum, Nov. 19–Jan. 1, 1927, "International Exhibition of Modern Art" (43rd Société Anonyme)

1927
Art Gallery of Toronto, April 1–24, "International Exhibition of Modern Art"

Paris, Palais de Bois, June, "Salon des Tuileries"

Bucharest, Sept. 30–Oct. 10, "Exposition d'Art roumain—Congrès de la Presse latine"

Paris, Galerie Bernheim, Dec. 1–15, "Première Exposition annuelle d'un Groupe de Sculpteurs"

New York University, Museum of Living Art, Dec. 12, "The A. E. Gallatin Collection"

1928
Bucharest, Palatul Ateneului Roman, March–April, "Arta Romana" (8th)

Moscow, Museum of Modern Art (Academy of Sciences and Arts), May 1–30, "French Art Today"
 Traveled to Leningrad

Paris, Palais de Bois, June, "Salon des Tuileries"

Bucharest, Oct.–Nov., "Jubilee Exhibition of the 'Tinerimea Artistica'"

Philadelphia Museum of Art, "Inaugural Exhibition" (of new building)

1929
Paris, Galerie Bernheim, April, "Deuxième Exposition Internationale de Sculpture"

Paris, Palais des Expositions, June, "Salon des Tuileries"

Zurich, Kunsthaus, Oct. 6–Nov. 3, "Abstrakte und Surrealistische Malerei und Plastik"
 Traveled to Munich, Graphisches Kabinett

Bucharest, Drawing and Print Salon: "Black and White"

1930
The Hague, Gemeentemuseum, May 3–June 9, "Modern Rumanian Art"
 Traveled to:
 Amsterdam, June 14–July 13
 Brussels, Galerie Giroux, July 20–Aug. 10

Print Club of Philadelphia, Nov. 10–27, "Contemporary French Drawings"

1931
Philadelphia Museum of Art, Nov., "Living Artists"

Art Institute of Chicago, Dec. 22–Jan. 17, 1932, "The Arthur Jerome Eddy Collection"

1933
São Paulo, Sociedade Pro-Arte Moderna, April 28

Paris, Néo-Parnasse, June, "Salon des Tuileries"

Art Institute of Chicago, June 1–Nov. 1, "A Century of Progress Exhibition"

Philadelphia Museum of Art, Nov., "The Ingersoll Collection"

1934
Brussels, Palais des Beaux-Arts, May 12–June 3, "Exposition du Minotaure"

Chicago, Renaissance Society, University of Chicago, June 20–Aug. 20, "A Selection of Works by Twentieth-Century Artists"

New York, The Museum of Modern Art, Nov. 19–Jan. 20, 1935, "Modern Works of Art: Fifth Anniversary Exhibition"

New York, La France Institute: "Modern Drawings"

1936
Buffalo, Albright-Knox Art Gallery, Jan. 3–31, "Art of Today"

New York, The Museum of Modern Art, March 2–April 19, "Cubism and Abstract Art"
 Traveled to Cleveland Museum of Art, Jan. 8–Feb. 7, 1937

London, New Burlington Galleries, June 11–July 4, "International Surrealist Exhibition"

1937
Columbus Gallery of Fine Arts, Ohio, Feb., "Sculpture of Seven Civilizations"

Paris, Musée du Jeu de Paume, July 30–Oct. 31, "Origines et Développement de l'Art International Indépendant"

Paris, Exposition internationale, "Art roumain" (Rumanian Pavilion)

Cleveland Museum of Art, Nov. 4–Dec. 5, "Sculpture of Our Time"

1938
London, Gallery Guggenheim Jeune, April 11–May 2, "Exhibition of Contemporary Sculpture"

Amsterdam, Stedelijk Museum, April 2–24, "Abstracte Kunst"

1939
New York, The Museum of Modern Art, May 10–Sept. 30, "Art in Our Time"

University of Chicago, Goodspeed Hall, Oct.–Nov.

Paris, Galerie Mai

1940
New York, The Museum of Modern Art, Jan. 26–March 24, "Modern Masters from European and American Collections"

Art Institute of Chicago, April 25–May 26, "International Exhibition of Watercolors"

Philadelphia Museum of Art, May 18–Oct. 1, "Sculpture International"

New York, Museum of Living Art, Jan., "The A. E. Gallatin Collection"

1941
New York, Buchholz Gallery, Feb. 11–March 18, "From Rodin to Brancusi"

1942
New York, Buchholz Gallery, Nov. 10–Dec. 5, "Homage to Rodin"

New York, The Museum of Modern Art, Dec. 9–Jan. 24, 1943, "Twentieth Century Portraits"

1943
Philadelphia Museum of Art, May, "Mirror of Our Time: The Gallatin Collection"

Craiova, Rumania, Oct. 24–Nov. 10, "Saptamana Oltenie"

1944
Cincinnati Art Museum, March 18–April 16, "Pictures for Peace" (a reconstruction of "the 1913 Armory Show")

Philadelphia Museum of Art, March 29–May 17, "History of an American, Alfred Stieglitz: '291' and After: Selections from the Stieglitz Collection"

New York, Buchholz Gallery, April 10–29, "The Lee Ault Collection"

New York, The Museum of Modern Art, May 10–June 30, "Art in Progress: Fifteenth Anniversary Exhibition"

1946
Detroit Institute of Arts, Jan. 22–March 3, "Origins of Modern Sculpture"

St. Louis, City Art Museum, March 30–May 1, "Four Modern Sculptors: Brancusi, Calder, Lipchitz, Moore"
 Traveled to Cincinnati Art Museum, Oct. 11–Nov. 15

New Haven, Yale University Art Gallery, April 4–May 6, "Contemporary Sculpture, Objects, Constructions"

Newark Museum, Oct. 24–Dec. 1, "Owned in New Jersey"

1947
Paris, Palais Galliera, March 10–April 20, "Vingt-cinq Ans d'Art Sacré français"

Prague, May 14–June 15, "French Sculptors from Rodin to Our Time"
 Traveled to:
 Bratislava, Oct. 15–Nov. 15
 Brno, Dum Umeni, Nov. 20–Dec. 20

New York, The Museum of Modern Art, June 10–Aug. 31, "Alfred Stieglitz Memorial"

Avignon, Palais des Papes, June 27–Sept. 30, "Peintures et Sculptures Contemporains"

Paris, Club de Chaillot, July 1–4, "L'Art français au Secours des Enfants Roumains"

New York, Seligmann Gallery, Oct. 16–Nov. 6, "1910–1912: The Climactic Years in Cubism"

1948
Baltimore Museum of Art, April 15–May 23, "Themes and Variations in Painting and Sculpture"

Venice, Biennale di Venezia (24th), June 4–Sept. 8, "Peggy Guggenheim Collection"

New York, The Museum of Modern Art, Nov. 16–Jan. 23, 1949, "Timeless Aspects of Modern Art"

Amsterdam, Stedelijk Museum, Nov. 26, "13 Beeldhouwers uit Parijs"

London, Institute of Contemporary Art, Dec. 20–Jan. 29, 1949, "40,000 Years of Modern Art: A Comparison of Primitive and Modern"

1949
New Haven, Yale University Art Gallery, Jan. 14–Feb. 13, "Sculpture since Rodin"

Paris, Galerie Maeght, April 30–May 13, "Preliminaires de l'Art Abstrait"

Paris, Galerie Maeght, May 27–June 30, "Les Maîtres de l'Art Abstrait"

Arnhem, The Netherlands, Sonsbeek Park, July 1–Sept. 30, "Outdoor Sculpture"

Paris, Maison de la Pensée Française, July–Oct., "La Sculpture française de Rodin à nos Jours"

São Paulo, Museu de Arte Moderna, July

New York, Buchholz Gallery, Sept. 26–Oct. 14, "Sculpture"

Venice, Palazzo Venier dei Leoni, Sept., "Mostra di Sculptura Contemporanea"

Art Institute of Chicago, Oct. 20–Dec. 18, "Twentieth Century Art from the Walter and Louise Arensberg Collection"

New York, M. Knoedler & Co., Nov. 29–Dec. 17, "To Honor Henry McBride"

1950
New York, The Museum of Modern Art, Jan. 31–May 7, "Recent Acquisitions"

Philadelphia Museum of Art, Feb., "The S. S. White Collection"

Providence, Rhode Island School of Design, Museum of Art, March 30–May 18, "A Century of Sculpture, 1850–1950"

Philadelphia Museum of Art, May, "Masterpieces of Philadelphia Private Collections"

Antwerp, Openluchtmuseum voor Beeldhouwkunst Middelheim, July–Sept.

New York, Buchholz Gallery, Sept. 26–Oct. 14, "Contemporary Drawing"

New York, Buchholz Gallery, Dec. 6–Jan. 6, 1951, "The Heritage of Auguste Rodin"

1951
Paris, Galerie Mai, Feb.

Zurich, Kunsthaus, April–May

Amsterdam, Stedelijk Museum, July 6–Sept. 25, "De Stijl"

New York, Sidney Janis Gallery, Sept. 17–Oct. 27, "From Brancusi to Duchamp"

Scottsdale, Ariz., Desert School of Art, Dec., "Sculpture from Rodin to Today"

Brussels, Palais des Beaux-Arts: "Surréalisme et Abstraction: Collection Peggy Guggenheim"
 Traveled to Amsterdam, Stedelijk Museum

1952
Melbourne, National Gallery of Victoria, Feb.

Paris, Musée National d'Art Moderne, May–June, "L'Oeuvre du XXᵉ Siècle"
 Traveled to London, Tate Gallery, July 15–Aug. 17, "Twentieth Century Masterpieces"

Philadelphia Museum of Art, Oct. 11–Dec. 7, "Sculpture of the Twentieth Century"
 Traveled to:
 The Art Institute of Chicago, Jan. 22–March 8, 1953
 New York, The Museum of Modern Art, April 29–Sept. 7, 1953

New Haven, Yale University Art Gallery, Dec. 15–Feb. 1, 1953, "In Memory of Katherine S. Dreier, 1877–1952: Her Own Collection of Modern Art"

1953
New York, Sidney Janis Gallery, Jan. 19–Feb. 14, "French Masters from 1905 to 1952"

Paris, Musée National d'Art Moderne, Jan. 30–April 9, "Le Cubisme, 1907–1914"

Antwerp, Openluchtmuseum voor Beeldhouwkunst Middelheim, June 20–Sept. 3, "Second Biennial of Sculpture"

Houston, Museum of Fine Arts, Nov., "75 Years of Sculpture"

São Paulo, Museu de Arte Contemporanea, Nov.–Feb. 1954, "II Bienal de São Paulo"

New York, Buchholz Gallery, Dec. 22–Jan. 24, 1954, "Sculpture and Sculptors' Drawings"

1954
Yverdon, Switzerland, Hôtel de Ville, July 18–Sept. 28, "Sept Pionniers de la Sculpture Moderne"
 Traveled to Zurich, Kunsthaus, Nov. 27–Dec. 31, "Begründer der modernen Plastik"

Philadelphia Museum of Art, Oct. 16, "The Louise and Walter Arensberg Collection"

1955
Paris, Galerie Creuzevault, Jan.–Feb., "Dessins de Sculpteurs"

Bloomfield Hills, Mich., Cranbrook Academy of Art Museum, Jan. 12–March 6, "The Levin Collection"

Paris, Musée National d'Art Moderne, April–May, "50 Ans d'Art aux Etats-Unis: Collection du Museum of Modern Art de New York"

New York, Buchholz Gallery, June 8, "Closing Exhibition: Sculpture, Paintings and Drawings"

Ann Arbor, University of Michigan, Museum of Art, Oct. 30–Nov. 27, "20th Century Paintings and Sculpture from the Winston Collection"

Los Angeles, University of California, "Sculpture in Europe Today"

1956
Paris, Musée Rodin, June–July, "Exposition Internationale de Sculpture Contemporaine"

New York, Fine Arts Associates, Oct. 9–Nov. 3, "Rodin to Lipchitz, Part II"

New York, The Museum of Modern Art, Nov. 28–Jan. 20, 1957, "Recent European Acquisitions"

Paris, Galerie Le Cercle, Nov. 30–Dec. 22

1957
New York, M. Knoedler & Co., Jan. 14–Feb. 8, "Minneapolis Institute of Arts Benefit"

New York, World House Galleries, Jan. 22–Feb. 23, "The Struggle for New Form"

Philadelphia Museum of Art, Feb., "The T. Edward Hanley Collection"

New York, World House Galleries, March 28–Apr. 20, "Four Masters: Rodin, Gauguin, Brancusi, Calder"

Saint-Etienne, France, Musée d'Art et d'Industrie, April 7–May 26, "Art Abstrait, 1910–1939"

New York, Sidney Janis Gallery, April 22–May 11, "Brancusi to Giacometti"

Musée de l'Art Moderne de la Ville de Paris, May 4–31, "Salon de Mai"

Paris, Musée Rodin, June

Paris, Musée Galliera, June–Aug., "Paris 09–29"

Milan, Palazzo dell'Arte al Parco, July 27–Nov. 4, "Triennale di Milano" (11th)

Detroit Institute of Arts, Sept. 27–Nov. 3, "Collecting Modern Art: Paintings, Sculpture and Drawings from the Collection of Mr. and Mrs. Harry Lewis Winston"
 Traveled to:
 Richmond, Virginia Museum of Art, Dec. 13–Jan. 5, 1958
 San Francisco Museum of Art, Jan. 23, 1958–March 13
 Milwaukee Art Institute, April 11, 1958–May 12

Boston, Museum of Fine Arts, Oct. 11–Nov. 17, "European Masters of Our Time"

1958
Amherst College, Mass., Jan. 5–Feb. 3, "45th Anniversary of the Armory Show"

New Haven, Yale University Art Gallery, Feb. 1–March, "In Memoriam Katherine S. Dreier"

Paris, Galerie Claude Bernard, Feb., "Sculpture contemporaine"

Brussels, Exposition Universelle, April 17–Oct. 19, "50 Ans d'Art Moderne"

Portland Art Museum, Ore., May 3–21, "Sculpture from West Coast Collections"

Louvain, Collège de Saint-Pierre, June, "Exposition d'Art sacré"

Paris, Galerie Maeght, June, "Sur Quatre Murs"

Houston, Contemporary Arts Museum, Sept. 25–Nov. 9, "The Trojan Horse: Art Exhibit of the Machine"

New York, Sidney Janis Gallery, Sept. 29–Nov. 1, "Tenth Anniversary Exhibition"

1959
New York, World House Galleries, Feb. 25–March 28, "Daumier to Picasso"

Paris, Palais des Nations (Foire de Paris), May, "Prestige de l'Art dans l'Industrie"

Dortmund, Museum am Ostwall, May–June, "Französische Plastik des 20. Jahrhunderts"

Kassel, Orangerie, July 11–Oct. 11, "Documenta II"
New York, The Solomon R. Guggenheim Museum, Oct. 21–June 19, 1960, "Inaugural Selection"

New York, Fine Arts Associates, Sept. 21–Oct. 10, "Sculpture and Sculptors' Drawings"

Dallas Museum for Contemporary Arts, Oct. 28–Dec. 7, "Signposts of 20th Century Art"

New York, World House Galleries, Dec. 8–Jan. 9, 1960, "Drawings, Watercolors and Collage by 20th Century Masters"

1960
Berkeley, University of California Art Museum, March 3–April 3, "Art from Ingres to Pollock"

New York, World House Galleries, March 8–April 12, "Selected Works by the French Impressionists and German Expressionists: Brancusi, Arp, Ernst, Fautrier, Giacometti"

Marseilles, Musée Cantini, March 8–April 25, "La Sculpture Contemporaine"

Rotterdam, Museum Boymans-van-Beuningen, March 25–Sept. 25, "Beeldenstoonstelling Floriade"

New York, M. Knoedler & Co., April 12–May 14, "The Colin Collection"

The Arts Club of Chicago, April 19–May 19, "Sculpture and Drawings by Sculptors from the Solomon R. Guggenheim Museum"

Kansas City, William Rockhill Nelson Gallery of Art, May 8–June 6, "Art and Anatomy"

New Haven, Yale University Art Gallery, May 19–June 26, "Paintings, Drawings and Sculpture Collected by Yale Alumni"

Paris, Galerie Dina Vierny, May 20–June 20

Venice, Biennale di Venezia (30th), June 18–Sept. 30, "Hommage à Brancusi"

New York, Sidney Janis Gallery, Oct. 3–Nov. 5, "20th Century Artists"

Cleveland Museum of Art, Oct. 4–Nov. 13, "Paths of Abstract Art"

Paris, Musée National d'Art Moderne, Nov. 4–Jan. 23, 1961, "Les Sources du XXᵉ Siècle"

Saint-Etienne, France, Musée d'Art et d'Industrie, "Cent Sculptures de Daumier à nos Jours"

Luxembourg, Musée d'Art Moderne, "La Sculpture Moderne de Maillol à nos Jours"

1961
St. Louis, City Art Museum, Jan. 18–Feb. 13, "A Galaxy of Treasures from St. Louis Collections"

Paris, Galerie Europe, Feb. 10, "Klee, Kandinsky, Brancusi"

Brussels, Palais des Beaux-Arts, Feb. 27–March 15, "Collection de M. et Mme. William Burden"

Art Institute of Chicago, April 5–30, "Maremont Collection"

Philadelphia Museum of Art, spring, "The 19th and 20th Centuries at the Philadelphia Museum of Art"

Cambridge, Mass., Harvard University Museums, Fogg Art Museum, June 11–Aug. 25, "Works of Art from the Collections of Harvard Class of 1936"

Paris, Musée Rodin, July–Sept., "Deuxième Exposition Internationale de Sculpture"

Stockholm, Svensk-Franska Konstgalleriet, Sept., "Fautrier—Brancusi"

Paris, Musée National d'Art Moderne, Oct. 25–Dec. 4, "L'Art Roumain du XIXᵉ Siècle à nos Jours"

New York, Sidney Janis Gallery, Oct. 30–Dec. 2, "European Artists from A to V"

Philadelphia Museum of Art, Nov. 2–Jan. 7, 1962, "Solomon R. Guggenheim Museum Exhibition"

1962

New York, Staempfli Gallery, Jan. 2–20, "Twenty Sculptors"

New York, World House Galleries, Feb. 20–March 17, "Sculpture: Daumier to Picasso"

Paris, Galerie de l'Oeil, May 23–July 1, "Exposition Minotaure"

Houston, Museum of Fine Arts, June

Cologne, Wallraf-Richartz-Museum, Sept. 12–Dec. 9, "Europäische Kunst 1912"

New York, The Solomon R. Guggenheim Museum, Oct. 3–Jan. 6, 1963, "Modern Sculpture from the Joseph H. Hirshhorn Collection"

1963

Utica, N.Y., Munson-Williams-Proctor Institute, Feb. 17–March 31, "Armory Show: 50th Anniversary"
 Traveled to New York, The Armory of the 69th Infantry, April 6–28

New York, M. Knoedler & Co., May 15–June 8, "Reader's Digest Collection"

Vienna, Künstlerhaus, May 28–June 30, "Rumänische Malerei und Plastik: Ciucurencu, Brancusi, Caragea"

Philadelphia Museum of Art, Oct. 3–Nov. 17, "Philadelphia Collects 20th Century Art"

1964

New York, Sidney Janis Gallery, Feb. 4–29, "The Classic Spirit in 20th Century Art"

New York, Staempfli Gallery, Feb. 25–March 21, "Stone, Wood, Metal"

Paris, Galerie Creuzevault, Feb. 28–March 28

New York, Sidney Janis Gallery, March 3–April 4, "Two Generations: Picasso to Pollock"

Lausanne, Palais de Beaulieu, May 1–Oct. 30, "L'Art européen dans les Collections suisses"

Kassel, Museum Fridericianum, June 27–Oct. 5, "Documenta III"

Vienna, Museum des 20. Jahrhunderts, July 3–Aug. 30, "Meisterwerke der Plastik"

Baltimore Museum of Art, Oct. 6–Nov. 15, "1914: 50th Anniversary of the Baltimore Museum of Art"

London, Tate Gallery, Dec. 31–March 7, 1965, "Peggy Guggenheim Collection"

1965

New York, Staempfli Gallery, Feb. 23–March 20, "Stone and Crystal"

Dallas Museum of Fine Arts, May 12–June 13, "Sculpture of the 20th Century"

Athens, Sept. 8–Nov. 8, "Panathenea of World Sculpture"

Irvine, University of California, Oct. 2–24, "20th Century Sculpture, 1900–1950"

Houston, Museum of Fine Arts, Oct. 21–Dec. 8, "The Heroic Years: 1908–1914"

Cologne, Wallraf-Richartz-Museum, Oct. 23–Dec. 12, "Traum—Zeichen—Raum"

Paris, Musée National d'Art Moderne, Dec.–Jan. 1966, "Groupe 1–65"

1966

Cambridge, Mass., Harvard University, Carpenter Center for Visual Arts, Jan. 6–Feb. 20, "Light and Color"

Bourges, Maison de la Culture, Jan., "Dessins de Sculpteurs de Rodin à nos Jours"

New York, Sidney Janis Gallery, Feb. 8–March 5, "Old Masters in 20th Century Art"

Cleveland Museum of Art, Feb. 8–March 8, "Fifty Years of Modern Art"

Frankfurter Karmeliter-Kloster, June, "Ecole de Paris"

Providence, Rhode Island School of Design, Museum of Art, Oct. 7–Nov. 6, "Herbert and Nannette Rothschild Collection"

London, Royal College of Art, Oct. 26–Nov. 26, "Rumanian Art of the 20th Century: Brancusi and His Countrymen"

New Orleans, Delgado Art Museum, Nov. 11–Jan. 8, 1967, "Odyssey of an Art Collector: Mr. and Mrs. Frederick Stafford Collection"

1967

New York, Sidney Janis Gallery, Jan. 3–27, "Two Generations of European and American Artists"

Paris, Galerie Claude Bernard, Jan. 10, "Portraits"

Montreal, Expo 67, April 28–Oct. 27, "Man and His World"

Paris, Orangerie des Tuileries, May 10–Oct. 2, "Les Chefs-d'Oeuvre des Collections suisses"

Bucharest, Muzeul de Arta R.S.R., Oct. 12–21, "Colloque Brancusi"

New York, M. Knoedler & Co., Dec. 5–29, "Space and Dream"

1968

St. Louis, City Art Museum, Jan. 23–March 24, "Works of Art of the Nineteenth and Twentieth Centuries Collected by Louise and Joseph Pulitzer, Jr."

London, Grosvenor Galleries, July, "Twentieth Century Paintings and Sculpture"

1969

New York, Sidney Janis Gallery, Jan. 8–Feb. 1, "20th Century Masters"

New York, The Solomon R. Guggenheim Museum, Jan. 16–March 23, "Selections from the Peggy Guggenheim Collection"

New York, The Museum of Modern Art, June 25–Oct. 12, "Five Recent Acquisitions"

Paris, Bibliothèque Nationale, Oct.–Nov.

1970

Strasbourg, Ancienne Douane, May 14–Sept. 15

Tokyo, Expo 70, May

1971

Mayenne, France, Château de Sainte-Suzanne, June 19–Sept. 12, "Figuration—Défiguration"
 Traveled to Amiens, Maison de la Culture, 1972

Paris, Musée Rodin, May

Nevers, France, Maison de la Culture, Sept. 21–Oct. 30

Cambridge, Mass., Harvard University Museums, Fogg Art Museum, Nov. 15–Jan. 9, 1972, "Collection Joseph Pulitzer, Jr."
 Traveled to Hartford, Wadsworth Atheneum, Feb. 2, 1972–March 19

Malines, Belgium, Centre Culturel de la Ville, "La Figura Humaine dans l'Art Contemporain, 1910–1960"

1972

New York, The Museum of Modern Art, Jan. 18–March 5, "Recent Acquisitions"

Santa Barbara, University of California, University Art Museum, Feb. 22–March 26

Princeton University Art Museum, Feb. 27–May 7, "20th Century Sculptures from Southern California"

Los Angeles, University of California, Frederick S. Wight Gallery, Feb. 29–April 14

Strasbourg, Ancienne Douane, Sept. 15–Oct. 14, "Occident—Orient"

Otterlo, Rijksmuseum Kröller-Müller, "Modern French Art in Soviet Collections"

1973

London, Hayward Gallery, July 20–Sept. 23, "Pioneers of Modern Sculpture, 1890–1918"

Pittsburgh, Carnegie Institute, Museum of Art, Oct. 18–Jan. 6, 1974

New York, The Solomon R. Guggenheim Museum, Nov. 16–Feb. 3, 1974, "Futurism—A Modern Focus: The Lydia and Harry Winston Collection—Dr. and Mrs. Barnett Malbin"

1974
Washington, D.C., Hirshhorn Museum and Sculpture Garden, Smithsonian Institution, Sept.

Paris, Musée National d'Art Moderne, Nov. 2–Jan. 20, 1975

Paris, Orangerie des Tuileries, Nov. 30–Feb. 24, 1975, "Collection Peggy Guggenheim"

1975
Otterlo, Rijksmuseum Kröller-Müller, Jan.

New York, Sidney Janis Gallery, Oct. 29–Nov. 22, "20th Century Masters" (Brancusi, Arp, Mondrian, Kandinsky)

Venice, Galleria civica d'Arte moderna, Dec. 3–Feb. 29, 1976, "Peggy Guggenheim Collection"

Mannheim, Städtische Kunsthalle, Dec. 10–Feb. 8, 1976

1976
Calais, Musée des Beaux-Arts, March, "Un Siècle de Dessins de Sculpteurs (1875–1975)"

Bucharest, Muzeul de Arta R.S.R., April 22–Sept. 19, "Exhibition on Brancusi's Centennial"
 Traveled to Craiova, Rumania, Muzuel de Arta, Oct. 2–May 11

Mannheim, Städtische Kunsthalle, July 11–Sept. 5

Malines, Belgium, Centre Culturel de la Ville, Sept.–Nov., "L'Art en Europe: 1920–1960"
Paris, Pavillon de Marsan, Oct. 15–Feb. 2, 1977

1977
Paris, Musée National d'Art Moderne, Centre Georges Pompidou, June 1–Sept. 19, "Paris—New York"

Yonne, France, Château de Ratilly, June 18–Sept. 10, "Espace—Lumière"

Tokyo, Gallery Tokoro, Oct. 15–Nov. 19

New York, The Solomon R. Guggenheim Museum, Dec. 16–Feb. 1, 1978

1978
New York, The Museum of Modern Art, April 28–July 4, "A Treasury of Modern Drawing: The Joan and Lester Avnet Collection"

Washington, D.C., Hirshhorn Museum and Sculpture Garden, Smithsonian Institution, July–Sept.

Washington, D.C., National Gallery of Art, Oct., "Aspects of 20th Century Art"

1979
Paris, Musée National d'Art Moderne, Centre Georges Pompidou, May 31–Nov. 5, "Paris—Moscou: 1900–1930"

1980
Milan, Palazzo Reale, Jan. 18 (closing date), "Le Origini dell'Astrattismo"

New York, The Solomon R. Guggenheim Museum, March 23–Aug. 17, "From the museum collection"

Basel, Wenkenhof-Park, May 11–Sept. 14

Paris, Musée National d'Art Moderne, Centre Georges Pompidou, May 28–Nov. 2, "Paris—Paris, 1937–1957"

1981
Paris, Artcurial, May 14–July 31, "Au Temps du Boeuf sur le Toit"

Saint-Paul-de-Vence, Fondation Maeght, June 5–Oct. 4, "Retrospective sur la Sculpture du XXᵉ Siècle à la Fondation Maeght"

Washington, D.C., National Gallery of Art, June 28–Jan. 31, 1982, "Rodin Rediscovered"

Madrid, Fundacion Juan March, Oct.–Nov., "Medio de Sculptura"

Cologne, Galerie Gmurzynska, Oct.

Toronto, Art Gallery of Ontario, Nov. 7–Jan. 3 1982, "Primitivism in Modern Sculpture"

1982
Rome, Campidoglio, Pinacoteca Capitolina, Jan. 23–March 28, "Guggenheim, Venezia—New York: 60 Opere, 1900–1950"

London, Marwan Hoss Gallery, May 4–June 15

Venice, Biennale di Venezia (40th), International Pavilion, June 13–Sept. 12

Tokyo, Mitsukoshi, Oct., "Le Minotaure"

New York, Sidney Janis Gallery, Dec. 2–31, "Brancusi+Mondrian"

1984
Paris, Artcurial, May–July, "Un Art autre, un autre Art"

Basel/Brüglingen, Switzerland, Merian Park, June 3–Sept. 30, "Skulptur im 20. Jahrhundert"

Paris, Centre National des Arts Plastiques, June–July, "Charles Estienne et l'Art à Paris, 1945–1966"

New York, The Museum of Modern Art, Sept. 19–Jan. 15, 1985, "Primitivism in 20th Century Art: Affinity of the Tribal and the Modern"

1986
Paris, Musée National d'Art Moderne, Centre Georges Pompidou, July 3–Oct. 13, "Qu'est-ce que la Sculpture moderne?"

BIBLIOGRAPHY

General Works on Modern Sculpture

Basler, Adolphe. *La sculpture moderne en France*. Paris, G. Crès, 1928.

Barr, Alfred H., Jr. *Masters of modern art*. New York, The Museum of Modern Art, 1954; 3d. ed., rev., 1958.

Bénézit, Emmanuel. *Dictionnaire critique et documentaire des peintres, sculpteurs, dessinateurs et graveurs...* 3d. ed. Paris, Grund, 1976. Vol. 2, p. 270–71.

Berckelaers, Ferdinand Louis. *L'art abstrait: origines et ses premiers maîtres*. 4 vols. Paris, Maeght, 1971–74.

———. *The sculpture of this century*. New York, G. Braziller, 1960.

Breton, André. *Le surréalisme et la peinture*, suivi de *Genèse et perspectives du surréalisme*. New York, Brentano, 1945.

———. *Surrealism and painting*. New York, Harper & Row, 1972 (Icon Editions).

Cabanne, Pierre. *Dictionnaire international des arts*. Paris, Bordas, 1959.

———. *Entretiens avec Marcel Duchamp*. Paris, Belfond, 1967.

Caws, Mary Ann. *The eye in the text: essays on perception—mannerist to modern*. Princeton, Princeton University Press, 1981.

Chapon, François. *Mystère et splendeurs de Jacques Doucet*. Paris, J.-C. Lattes, 1984.

Clark, Kenneth. *The nude: a study in ideal form*. New York, Pantheon, 1956, 1972.

Duthuit, Georges. *L'Image en souffrance*. Paris, Georges Fall, 1962.

Eddy, Arthur Jerome. *Cubists and post-impressionism*. Chicago, A. C. McClurg, 1914.

Edouard-Joseph, René. *Dictionnaire biographique des artistes contemporains, 1910–1930*. 4 vols. Paris, Art et Edition, 1930–35. Vol. I, p. 197.

Elsen, Albert E. *Origins of modern sculpture: pioneers and premises*. New York, G. Braziller, c. 1974.

Fondation Maeght (Saint-Paul-de-Vence). *Sculpture du XXe siècle, 1900–1945: tradition et ruptures*. Exhibition, 4 July–30 Sept. 1981.

Francastel, Pierre. *Les sculpteurs célèbres*. Paris, Mazenod, 1954 (La Galerie des hommes célèbres, 8).

Fuchs, Heinz R. *La sculpture contemporaine*. Paris, Albin Michel, 1970 (Collection L'art dans le monde).

Giedion-Welcker, Carola. *Contemporary sculpture, an evolution in volume and space*. [English ed.] New York, George Wittenborn, 1955; new ed., augmented. 1964 (Documents of modern art, 12).

Gertz, Ulrich. *Plastik der Gegenwart*. Berlin, Rembrandt Verlag, 1953.

Grohmann, Will. *Bildende Kunst und Architektur*. Berlin, Suhrkamp, 1953.

Guggenheim, Peggy. *Out of this century: confessions of an art addict*. Foreword by Gore Vidal; Introduction by Alfred H. Barr, Jr. New York, Universe Books, 1979.

Haftmann, Werner. *Painting in the twentieth century*. Newly designed and expanded. 2 vols. New York, Praeger, 1965.

Hammacher, A. M. *The evolution of modern sculpture: tradition and innovation*. New York, Harry N. Abrams, 1969.

Hoffman, Malvina. *Sculpture: inside and out*. New York, W. W. Norton, 1939.

Jianou, Ionel. *La sculpture et les sculpteurs*. Paris, Fernand Nathan, 1966 (Collection Petite histoire, art et science).

Johnson, Una E. *Les plus beaux dessins du XXe siècle, 1940–1965*. Paris, Le Chêne, 1965.

Krauss, Rosalind E. *Passages in modern sculpture*. London, Thames & Hudson; New York, Viking, 1977.

Marchiori, Giuseppe. *Modern French sculpture*. New York, Harry N. Abrams, 1963.

Moholy-Nagy, Laszlo. *Vision in motion*. Chicago, Paul Theobald, 1947, 1965.

Morand, Paul. *Papiers d'identité*. Paris, Bernard Grasset, 1931.

Muller, Joseph-Emile. *L'art du XXe siècle*. Paris, Larousse, 1967 (Le livre du poche).

National Gallery of Art (Washington, D.C.). *Rodin rediscovered*. Exhibition, June 28, 1981–May 2, 1982. Washington, D.C., 1981. Essay by Sidney Geist on Brancusi and Rodin.

Ozenfant, Amédée. *Foundations of modern art*. New York, Brewer, Warren & Putnam, 1931; New American ed., augmented. New York, Dover, 1952.

Pach, Walter. *The masters of modern art*. New York, B. W. Huebsch, 1924.

Pischel, Georges. *La sculpture des cyclades à Brancusi*. Paris, Fernand Nathan, 1983.

Prut, Constantin. *Dictionar de artă moderna*. Bucharest, Albatros, 1982.

Ragon, Michel. *L'aventure de l'art abstrait*. Paris, Laffont, 1956.

Read, Herbert Edward. *A concise history of modern sculpture*. New York, Washington, Praeger, 1964.

Ritchie, Andrew Carnduff. *Sculpture of the twentieth century*. New York, Museum of Modern Art, 1952.

Seuphor, Michel. see above: Berckelaers, Ferdinand Louis.

Tucker, William. *Early modern sculpture: Rodin, Degas, Matisse, Brancusi, Picasso, Gonzalez*. New York, Oxford University Press, 1974 (Eng. ed. titled: *The language of sculpture*. London, Thames & Hudson, 1974).

Vallier, Dora. *L'interieur de l'art: entretiens avec Braque, Léger, Villon, Miro, Brancusi*. Paris, Le Seuil, 1982.

Vessereau, Marguerite. *Roumanie-Terre du dor*. Paris, Presses Universitaires de France, 1930, p. 115–24.

Wilkinson, Alan G. *Gauguin to Moore: primitivism in modern sculpture*. Exhibition, Art Gallery of Ontario, Toronto, 7 Nov. 1981–3 Jan. 1982. Toronto, 1981.

Monographs on Brancusi

Brezianu, Barbu. *Brancusi in Romania*. [English ed.] Bucharest, Editura Academiei Republicii Socialiste România, 1976.

Caraion, Ion. *Masa Tacerii. Antologie de texte: Simposium de metafore de Brancusi*. Bucharest, Univers, 1970.

Colocviul international Brancusi. Bucarest, Oct. 1967. Bucharest, Meridiane, 1968 (texts by J. Lassaigne, G. C. Argan, E. Trier, W. Hoffmann, T. Spiteris, P. Bucarelli, C. Giedion-Welcker, G. Oprescu, G. Marchiori, M. Popescu, S. Geist, P. Comarnescu, I. Frunzetti, B. Brezianu, A. Pavel, D. Haulica, et al).

Comarnescu, Petru. *Brâncusi. Mit şi metamorfoză în scultura contemporană*. Bucharest, Meridiane, 1972.

———, Mircea Eliade, & Ionel Jianou. *Témoignages sur Brancusi*. Paris, Arted, 1967, 1982 (Collection: Essais sur l'art).

Csaba, Sik. *Brancusi*. Budapest, Corvina, 1972.

Deac, Mircea. *Brancusi: 1876–1976: text, anthology, and chronology*. Bucharest, Litera Pub. House, 1976.

———. *Constantin Brancusi*. Bucharest, Meridiane, 1966.

Geist, Sidney. *Brancusi: a study of the sculpture*. New York, Grossman, 1968 [c. 1967].

———, *Constantin Brancusi, 1876–1957: a retrospective exhibition*. New York, Solomon R. Guggenheim Museum. New York, Solomon R. Guggenheim Foundation, 1969.

———, *Brancusi: The Kiss*. New York, Harper & Row, 1970 (Icon Editions).

———, *Brancusi: the sculpture and drawings*. New York, Harry N. Abrams, 1975.

Giedion-Welcker, Carola. *Constantin Brancusi*. [Eng. ed.] New York, Braziller, 1959.

Grigorescu, Dan. *Brâncusi*. Bucharest, Meridiane, 1980; French ed., 1977.

Hague, The. Gemeentemuseum. *Brancusi*. Tentoonstelling, Sept. 19–Nov. 29, 1970. Catalogue, 1970.

Haulica, Dan. *Brancusi ou l'anonymat du génie*. Bucharest, Meridiane, 1967.

Jianou, Ionel. *Brancusi*. Paris, Arted, 1963; 2d ed., rev., 1982; English ed., New York, Tudor Publishing Co., 1963.

——— and Constantin Noica. *Introduction à la sculpture de Brancusi*. Paris, Arted, 1976.

Kramer, Hilton. *Brancusi, the sculptor as photographer*. London, D. Grob; Lyme, Conn., Callaway Editions, 1979.

Lewis, David N., *Brancusi*. London, Alec Tiranti, 1957. Re-edited edition, *Constantin Brancusi*, London, Academy Editions; New York, St. Martin's Press, 1974.

Micheli, Mario de. *Brancusi*. Milan, Fratelli Fabri, 1967 (I maestri della scultura).

Miclea, Ion. *Brâncuşi at Tîrgu Jiu*. Bucharest, Publishing House of Tourism, 1973.

Neagoe, Peter. *The saint of Montparnasse*. Philadelphia, New York, Chilton, 1965.

Pagini de artă moderna rômanească. Academia de Stiinte Sociale si Politice a Republicii Socialiste România, Institutul de Istoria Artei. Bucharest, Editura Academiei Republicii Socialiste România, 1974, p. 59–106.

Paleolog, V. G. *Brâncuşi-Brâncuşi*. Craiova, Scrisul Românesc, 1976.

———. *C. Brancusi*. Craiova, Ramuri, 1938.

———. *C. Brancusi*. Bucharest, Forum, 1947.

———. *A doua carte despre C. Brancusi*. Craiova, Ramuri, 1944.

———. *Tinerețea lui Brâncuși*. Bucharest, Tineretului, 1967.

Pandrea, Petre. *Brâncuși amintiri și exegeze*. Bucharest, Meridiane, 1967 (Biblioteca de artă, 177); new ed., 1976.

Pogámy-Balás, Edit (Balas, Edith). *The sculpture of Brancusi in the light of his Rumanian heritage*. 2 vols. in 1. Pittsburgh, University of Pittsburgh Press, 1973 (dissertation).

Spear, Athena Tacha. *Brancusi's Birds*. New York, New York University Press for The College Art Association of America, 1969 (College Art Association of America Monographs on Art History and Archaeology, 21).

Stănculescu, Nina. *Carte de inimă pentru Brancusi*. București, Editura Albatros, 1976.

Tabart, Marielle. *Brancusi, photographer*. Pref. by Pontus Hulten; photos. introduced and selected by Marielle Tabart and Isabelle Monod-Fontaine. Amer. ed. New York, Agrinde Pubs., 1979. Also Exhibition catalogue for Centre National d'Art et de Culture Georges Pompidou. 1979.

Zervos, Christian. *Constantin Brancusi: sculptures, peintures, fresques, dessins*. Paris, Cahiers d'Art, 1957 (Contributors: U. Apollonio, G. C. Argan, J. Arp, P. G. Brugière, A. Calder, L. Degand, G. Duthuit, F. Fierens, C. Giedion-Welcker, W. Grohman, P. Guggenheim, E. Hajdu, V. Hugo, H. L. C. Jaffé, G. Marchiori, H.E. Read, G. Richier, F. Roh, J. Rothenstein, G. Schmidt, R. Stoll, J. J. Sweeney, D. Vallier, L. Venturi, J. Villon).

Magazine Articles

Adlow, Dorothy, "Brancusi and modern sculpture," *Christian Science Monitor*, Oct. 26, 1955.

Alexandrescu, Ion, "Mărturiile unui cioplitor," *Ramuri*, 23 martie 1965.

Al-George, Sergiu, "Brancusi et l'Inde," *Revue Roumaine d'Histoire de l'Art*, XVIII, 1981, p. 3–53.

Alvard, Julien, "L'atelier de Brancusi," *Art d'Aujourd'hui*, Ser. 2, no. 3, 1951, p. 5, 8, ill.

Balas, Edith, "Brancusi, Duchamp and Dada," *Gazette des Beaux-Arts*, XCV, April 1980, p. 165–74.

———, "The myth of African Negro art in Brancusi's sculptures," *Revue Roumaine d'Histoire de l'Art*, XIV, 1977, p. 107–25.

———, "Object-sculpture, base and assemblage in the art of Constantin Brancusi," *Art Journal*, XXXVIII, no. 1, Fall 1978, p. 36–46.

Benson, E. M., "Forms of Art: III," *American Magazine of Art*, 28, May 1935, p. 290–99.

Blazian, Eric, "Constantin Brancusi," *Poligono: Rivista Mensile d'Arte*, Anno 5, no. 2, 1931, p. 100–105.

Brest, Jorge Romero, "Recuerdo de una visita a Constantin Brancusi," *Ver y Estimar*, no. 5, March 1955, p. 3–5.

Brezianu, Barbu, "The beginnings of Brancusi," *Art Journal*, XXV, no. 1, 1965, p. 15–25.

———, "Brancusi l'artisan," *Revue Roumaine d'Histoire de l'Art*, VI, 1969, p. 19–30.

———, "Danaida," *Artă*, no. 9, 1973, p. 31.

———, "Iconografie brancusiana," *Tribuna*, 24, Feb. 1966.

———, "Pages inédites de la correspondance de Brancusi," *Revue Roumaine d'Histoire de l'Art*, I, no. 2, 1964, p. 385–400.

———, "Reportaj in jurul unei camere," *Secolul 20*, II, 1967, p. 182–89.

———, "O statuie de Brancusi," *Gazeta Literara*, Bucharest, April 9, 1964.

Casson, Stanley, "Sculpture of today," *The Studio*, Special Spring Number, 1939, p. 29, 129.

Cassou, Jean, "Visite à Brancusi," *Cahiers France-Roumaine*, no. 5, 1946.

Chelimsk, Oscar, "Memoir of Brancusi," *Arts Magazine*, XXXII, no. 9, June 1958, p. 18–21.

"Constantin Brancusi: sculptor roman," *Contemporanul*, Annul 4, no. 52, Jan. 1925 (Issue devoted almost entirely to Brancusi, with texts by Jarcel Janco and Militia Patrascu, and a poem by I. Venea).

Doesburg, Theo van, "Constantin Brancusi," *De Stijl*, no. 79–84, Jubileum-Serie (XIV), 1927, p. 81–86; reprint ed., Amsterdam, Athenaeum et al, 1968, vol. 2, p. 569–71.

Dreyfus, Albert, "Constantin Brancusi," *Der Querschnitt*, Vol. III no. 3/4, 1923, p. 119–21.

———, "Constantin Brancusi," *Cahiers d'Art*, II, no. 2, 1927, p. 69–74.

Duthuit, Georges, "Brancusi revisited and the Arensberg Brancusis," *Art News*, LIII, October 1954, p. 24–26, 64–66.

Fry, Roger, "The Allied Artists Exhibition," *The Nation*, Aug. 1913.

George, Waldemar, "Brancusi," *Les Arts*, 2 December 1919.

———, "Grandeur et solitude de Constantin Brancusi," *Art et Industrie*, no. 22, 1951, p. 15–16.

Georgescu-Gorjan, Stefan, "Ansamblul monumental de la Tîrgu-Jiu: 40 de ani la inaugurare," *Artă*, XXV, no. 10, 1978, p. 32–35; summary in French.

———, "Brancusi et ses colonnes infinies: nouvelles contributions," *Revue Roumaine d'Histoire de l'Art*, XVI, 1979, p. 89–104.

———, "Ovoidul (I)," *Artă*, XXVI, no. 9, Sept. 1979, p. 19–21.

———, "Ovoidul (II)," *Artă*, XXVI, no. 10, 1979, p. 30–33; summary in French.

Giedion-Welcker, Carola, "Constantin Brancusis Weg," *Werk*, no. 10, 1948, p. 321–33; *Magazine of Art*, XLII, Dec. 1949, p. 290–95.

———, "Constantin Brancusi," *Werk: Werk-Chronik*, 1957, p. 92–93.

———, "Constantin Brancusi," *Horizon*, XIX, 1949, p. 193–202 plus plates.

———, "Sept pionniers de la sculpture moderne," *Werk: Werk-Chronik*, no. 9, 1954, p. 209–10.

———, "Zum Tode von Constantin Brancusi," *National Zeitung*, Sonntage-Beilage, no. 137, March 24, 1957.

Gindertael, R. V., "Brancusi l'inaccessible," *Cimaise*, 3rd series, no. 3, Jan.–Fév. 1956, p. 9–15.

Goldwater, Robert, "The Arensberg collection for Philadelphia," *Burlington Magazine*, XCVI, no. 620, November 1954, p. 350–52.

Guéguen, Pierre, "Brancusi: méditation sur l'oeuvre Brancusian," *Art d'Aujourd'hui*, 2ème année, no. 12, Avril 1957, p. 4–11.

———, "Brancusi l'ancien," *XXe Siècle*, n.s., XXIVème année, no. 19, 1962, p. 20–21.

———, "La sculpture cubiste," *Art d'Aujourd'hui*, no. 3/4, 1953, p. 50–52.

Herbé, Paul, "Visite à Brancusi," *Architecture d'Aujourd'hui*, Special number, 1946, p. 54.

Hoctin, Luce, "Grandeur et solitude de Brancusi," *Arts*, no. 612, 27 mars–2 avril 1957, p. 16.

———, "Le testament de Brancusi: le plus grand sculpteur depuis Rodin a légué son atelier à la France...," *Arts*, no. 614, 10–16 avril 1957, p. 16.

"Hommage des sculpteurs à Brancusi," *Les Lettres Françaises*, no. 664, mars/avril 1957, p. 11.

Howe, Russell Warren, "The man who doesn't like Michelangelo: Interview," *Apollo*, XL, 1949, p. 124, 127.

Huszar, Vilmos, "Aesthetische beschouwing V," *De Stijl*, no. 12, 1918, p. 146–50; reprint ed., Amsterdam, Athenaeum et al, 1968, Vol. I, p. 218–22.

Jakovski, Anatole, "Brancusi," *Axis*, no. 3, July 1935, p. 3–9.

M., M., "Constantin Brancusi, a summary of many conversations," *The Arts*, IV, July 1923, p. 14–29.

Miller, Sandra, "Brancusi's column of the infinite," *Burlington Magazine*, CXXII, no. 928, July 1980, p. 470–80.

———, "Constantin Brancusi's photographs," *Artforum*, XIX, no. 7, March 1981, p. 38–44.

Oeri, Georgine, "Constantin Brancusi in Amerika," *Werk*, no. 6, 1956, p. 199–204.

Paleolog, V. G., "Brancusi, valeur internationale," *Arcades*, no. I, 1947, p. 39–58.

Pound, Ezra, "Brancusi," *The Little Revue*, Autumn, 1921, p. 3–7. Special issue devoted to Brancusi.

Roché, Henri-Pierre, "Souvenirs sur Brancusi," *L'Oeil*, no. 29, mai 1957, p. 12–17.

San Lazzaro, Gualtieri di, "Brancusi," *XXe Siècle*, n.s., no. 9, juin 1957, p. [86–87].

Schildt, Gören, "Colloqui con Brancusi," *La Biennale de Venezia*, no. 32, juin–sept. 1958, p. 21–25.

Seiwert, Franz W., "Constantin Brancusi der Bildhauer," *a bis z...*, no. 2, 1929, p. 5–7.

———, "Kunstform-Zweckform," *a bis z...*, no. 18, 1931, p. 69.

Solier, René de, "Brancusi," *Nouvelle Revue Française*, no. 53, 1er mai, 1957.

Sweeney, James Johnson, "The Brancusi touch," *Art News*, LIV, no. 7, Nov. 1955, p. 22–25.

Teodorescu-Toboc, C., "Ass. Ansamblul de la Tîrgu-Jiu (citeva consideratiuni)," *Artă*, XXVIII, no. 3, 1981, p. 25.

XXe Siècle, Année II, no. 1, 1939. Special number "Sculpture" with reproductions of Brancusi's work.

Vitrac, Roger, "Constantin Brancusi," *Cahiers d'Art*, IV, no. 8/9, 1929, p. 382–96.

Volboudt, Pierre, "Espace et sculpture," *XXe Siècle*, n.s., no. 18, 1962, p. 3–11.

Westheim, Paul, "Bildhauer in Frankreich," *Das Kunstblatt*, 6th year, no. 2, 1922, p. 53–56.

Zahar, Marcel, "In Brancusi's Studio," *Studio* (London), no. 19 (*Studio* no. 119), Feb. 1940, p. 67.

Zervos, Christian, "Réflexions sur Brancusi: à propos de son exposition à New York, 17 novembre 1933–13 janvier 1934," *Cahiers d'Art*, no. 9, 1–4, 1934, p. 80–83.

Zorach, William, "The sculpture of Constantin Brancusi," *The Arts*, March 9, 1926, p. 143–50 plus ill.

Aphorisms

Amsterdam. Stedelijk Museum. *De Stijl*. Exhibition, July 6–September 25, 1951. Amsterdam, 1951 (Catalogue 81), p. 96.

Berckelaers, Ferdinand Louis. *L'Art abstrait: origines et ses premiers maîtres*. 4 vols. Paris, Maeght, 1971–74. Vol. 1, 1910–1918, p. 131.

Cahiers d'Art, no. 8–9, 1929, p. 382; no. 1–4, 1934, p. 40.

De Stijl, no. 79–84, 1927, p. 81–82; reprint ed., Amsterdam, Athenaeum et al, 1968, Vol. 2, p. 569.

Minotaure, no. 3–4, Paris, 1933. p. 41.

New York. Brummer Gallery. *Brancusi exhibition*. New York, 1926. Illustrated catalogue, p. 5; unillustrated catalog, p. 3.

Palealog, Tretie. *De Vorbă cu Brancuşi Despre "Calea Sufletelor Eroilor."* Bucharest, Sport-Tourism, 1976. "Note," p. 79–105. Most extensive citation.

Ritchie, Andrew Carnduff. *Sculpture of the twentieth century*. New York, Museum of Modern Art, 1952. p. 40.

This Quarter, I, no. 1, Paris, 1925, p. 235–37.

Zervos, Christian. *Histoire de l'art contemporain*. Paris, Cahiers d'Art, 1938, p. 323.

Zurich. Kunsthaus. *Begründer der modernen Plastik: Arp, Brancusi, Chauvin, Duchamp-Villon, Gonzalez, Laurens, Lipchitz, Pevsner.* Exhibition, Nov. 27–Dec. 31, 1954. Zurich, 1954. p. 5–6.

Films

"Eighty sculptures and twenty-three drawings by Constantin Brancusi," film made by Paul Falkenberg and Hans Namuth. The Solomon R. Guggenheim Museum, New York, August 1972.

"Heureux comme le regard en France," film made by Frédéric Rossif. Centre National d'Art et de Culture Georges Pompidou, Paris, June 1978.

PHOTOGRAPHIC CREDITS

INDEX OF WORKS

Italic page numbers refer to illustrations

INDEX OF NAMES AND PLACES

Italic page numbers refer to illustrations